Interpreters of
Early Medieval Britain

Interpreters of Early Medieval Britain

Edited by
MICHAEL LAPIDGE

Published for THE BRITISH ACADEMY
by OXFORD UNIVERSITY PRESS

Oxford University Press, Great Clarendon Street, Oxford OX2 6DP

Oxford New York
Auckland Bangkok Buenos Aires Cape Town Chennai
Dar es Salaam Delhi Hong Kong Istanbul Karachi Kolkata
Kuala Lumpur Madrid Melbourne Mexico City Mumbai Nairobi
SãoPaulo Shanghai Singapore Taipei Tokyo Toronto

Oxford is a registered trade mark of Oxford University Press
in the UK and in certain other countries

Published in the United States
By Oxford University Press Inc., New York

© The British Academy, 2002
Database right The British Academy (maker)

All rights reserved. No part of this publication may be reproduced,
stored in a retrieval system, or transmitted, in any form or by any means,
without the prior permission in writing of the British Academy,
or as expressly permitted by law, or under terms agreed with the appropriate
reprographics rights organization. Enquiries concerning reproduction
outside the scope of the above should be sent to the Publications Department,
The British Academy, 10 Carlton House Terrace, London SW1Y 5AH

You must not circulate this book in any other binding or cover
and you must impose this same condition on any acquirer

British Library Cataloguing in Publication Data
Data available

ISBN 0-19-726277-5

Typeset by
J&L Composition, Filey, North Yorkshire
Printed in Great Britain
on acid-free paper by
Antony Rowe Limited
Chippenham, Wiltshire

CONTENTS

Preface	vii
Acknowledgements	ix
Introduction MICHAEL LAPIDGE	1
I. Whitley Stokes, 1830–1909 KUNO MEYER	29
II. Walter William Skeat, 1835–1912 MICHAEL LAPIDGE	37
III. Sir John Rhŷs, 1840–1915 SIR JOHN MORRIS-JONES	51
IV. Henry Bradley, 1845–1923 MICHAEL LAPIDGE	65
V. Charles Plummer, 1851–1927 P. S. ALLEN, F. M. STENTON and R. I. BEST	77
VI. Arthur Sampson Napier, 1853–1916 NEIL RIPLEY KER *revised by* MICHAEL LAPIDGE	91
VII. Joseph Wright, 1855–1930 SIR CHARLES HARDING FIRTH	119
VIII. W[illiam] P[aton] Ker, 1855–1923 R. W. CHAMBERS	139
IX. Sir Israel Gollancz, 1863–1930 SIR FREDERIC KENYON	155
X. Sir William Craigie, 1867–1957 J. M. WYLLIE	173
XI. Hector Munro Chadwick, 1870–1947 J. M. DE NAVARRO	195
XII. Raymond Wilson Chambers, 1874–1942 C. J. SISSON	221

CONTENTS

XIII. Sir Allen Mawer, 1879–1942 SIR FRANK MERRY STENTON	237
XIV. Sir Frank Merry Stenton, 1880–1967 DORIS M. STENTON *revised by* MICHAEL LAPIDGE	247
XV. Sir Ifor Williams, 1881–1965 IDRIS LLEWELLYN FOSTER	287
XVI. Robin Ernest William Flower, 1881–1946 SIR HAROLD IDRIS BELL	307
XVII. Kenneth Sisam, 1887–1971 NEIL KER	331
XVIII. Bruce Dickins, 1889–1978 R. I. PAGE	351
XIX. Florence Elizabeth Harmer, 1890–1967 DOROTHY WHITELOCK	369
XX. Nora Kershaw Chadwick, 1891–1972 KENNETH JACKSON	383
XXI. Sir Thomas Downing Kendrick, 1895–1979 RUPERT BRUCE-MITFORD	399
XXII. Dorothy Whitelock, 1901–1982 HENRY LOYN	427
XXIII. Francis Wormald, 1904–1972 JULIAN BROWN *revised by* MICHAEL LAPIDGE	441
XXIV. Neil Ripley Ker, 1908–1982 A. I. DOYLE	473
XXV. Gabriel Turville-Petre, 1908–1978 PETER FOOTE	485
XXVI. Kenneth Hurlstone Jackson, 1909–1991 J. E. CAERWYN WILLIAMS	503
XXVII. Peter Hunter Blair, 1912–1982 PETER CLEMOES	519
XXVIII. Thomas Julian Brown, 1923–1987 JONATHAN J. G. ALEXANDER	533
Appendix: Printed bibliographies of scholars whose obituaries are included in the present volume	553
General Index	557

PREFACE

The present volume contains the obituaries, for the most part reprinted from *Proceedings of the British Academy*, of twenty-eight scholars, all Fellows of the British Academy, who, during the course of the late nineteenth and twentieth centuries, transformed our knowledge of all aspects of the culture—philological, historical, literary, palaeographical, archaeological, art-historical—of early medieval Britain during the period from the departure of the Romans until the advent of the Normans, roughly, that is, from A.D. 400 to A.D. 1100. The geographical span of their scholarship encompasses early medieval Britain in the widest sense: not only Anglo-Saxon England, but also Wales, Scotland, and Ireland, as well as Scandinavia, particularly Iceland: for the reason that, during the centuries in question, these various cultures, though they had different languages and cultural traditions, were intimately related to each other, and that developments in one area inevitably had reflexes in the others. Taken together, the obituaries provide a fascinating intellectual history of how the study of this vast field developed during the past century and a half; they provide clear justification for the observation of Sir Mortimer Wheeler, formerly Secretary of the Academy, who stated that 'collectively the Academy's obituaries constitute a primary and invaluable contribution to the history of British scholarship.'[1]

As can be seen from the Acknowledgements (pp. ix–x), most of the obituaries have been reprinted from the Academy's *Proceedings*. However, in several cases, and for reasons not now recoverable, Academy obituaries were never prepared. Two such cases are Walter William Skeat (d. 1912) and Henry Bradley (d. 1923). Because of their cardinal importance for the development of Old English studies, I have thought it essential to supply biographies, however brief, so that their place within scholarly tradition will be apparent. In another case, that of A. S. Napier (d. 1916), no obituary was printed in the *Proceedings*; but many years after Napier's death Neil Ker—who had never known him in person—prepared an obituary which was printed in 1970 in a Festschrift for an American medievalist. Because of Napier's importance for Anglo-Saxon studies, I have thought it important to include Ker's obituary in the present volume. It is also the case that

[1] M. Wheeler, *The British Academy, 1949–1968* (Oxford, 1970), p. 5.

the early volumes of *Proceedings* did not include photographs with the memoirs of individual scholars. I have thought it essential to remedy this defect.

It will be clear to anyone familiar with the field that the number of obituaries included in the present volume could have been greatly expanded, if one were to include those scholars whose work impinged on the field of early British studies—an example might be M.R. James, whose manuscript catalogues are a fundamental resource for anyone working in the field—but whose main interests lay elsewhere. I have tried to mention the contributions of all such scholars in the introductory chapter even if, for reasons of space, it was not possible to include their obituaries here. (It must also be said that a number of scholars who would deserve to be included have died during the past decade, but obituaries for them have yet to appear in the *Proceedings*.) In order to keep the size of the volume within reasonable limits, I have also been obliged to take various (minor) editorial decisions. Some early obituaries included bibliographies of publications of the scholars in question. In order to save space, and to impose a standard format on the obituaries, I have not reprinted these bibliographies; but the Appendix (pp. 553–5) contains a list of where printed bibliographies of the scholars included in the present volume may be found, whether in the Academy's *Proceedings* or elsewhere. By the same token I have in one case—that of Sir Frank Stenton (no. **XIV**)—thought it necessary to provide an abbreviated version of the original obituary, which extended to 108 pages and included a substantial amount of information on Sir Frank's domestic life which (in my view) has no place in a volume on the interpretation of early medieval Britain. I have also reformatted the obituary of Francis Wormald (no. **XXIII**) in order to bring it into accord with the other obituaries printed here, but have not altered the obituarist's words in any other way.

The obituaries are printed in order of the individual scholars' dates of birth, and cover a period of some 150 years, from 1830 (when Whitley Stokes was born) to 1987 (when Julian Brown died). Given the multiple authorship, the style of the obituaries inevitably varies; but taken in combination, they communicate a powerful impression of the giants who created the field of early Insular studies. To read all the twenty-eight obituaries printed here is an invigorating, if ultimately a profoundly humbling, experience.

MICHAEL LAPIDGE
8 January 2002

ACKNOWLEDGEMENTS

The following obituaries were first published as specified; permission to reprint materials originally published elsewhere than the *Proceedings of the British Academy* is hereby acknowledged.

I. *Proceedings of the British Academy* IV (1909–10), 363–7.

II. Printed here for the first time.

III. *Proceedings of the British Academy* XI (1924–5), 187–212.

IV. Printed here for the first time.

V. *Proceedings of the British Academy* XV (1929), 463–76.

VI. *Philological Essays. Studies in Old and Middle English Language and Literature in Honour of Herbert Dean Meritt*, ed. J.L. Rosier (The Hague: Mouton, 1970), pp. 152–81.

VII. *Proceedings of the British Academy* XVIII (1932), 423–38.

VIII. *Proceedings of the British Academy* XI (1924–5), 413–26.

IX. *Proceedings of the British Academy* XVI (1930), 424–38.

X. *Proceedings of the British Academy* XLVII (1961), 273–91.

XI. *Proceedings of the British Academy* XXXIII (1947), 307–30.

XII. *Proceedings of the British Academy* XXX (1944), 427–45.

XIII. *Proceedings of the British Academy* XXIX (1943), 433–9.

XIV. *Proceedings of the British Academy* LIV (1968), 315–423.

XV. *Proceedings of the British Academy* LIII (1967), 361–78.

XVI. *Proceedings of the British Academy* XXXII (1946), 353–79.

XVII. *Proceedings of the British Academy* LVIII (1972), 409–28.

XVIII. *Proceedings of the British Academy* LXIV (1978), 341–57.

XIX. *Proceedings of the British Academy* LIV (1968), 301–14.

XX. *Proceedings of the British Academy* LVIII (1972), 537–49.

XXI. *Proceedings of the British Academy* LXXVI (1990), 445–71.

XXII. *Proceedings of the British Academy* LXX (1984), 543–54.

XXIII. *Proceedings of the British Academy* LXI (1975), 523–60.

XXIV. *Proceedings of the British Academy* LXXX (1991), 349–59.

XXV. *Proceedings of the British Academy* LXIV (1978), 467–81.

XXVI. *Proceedings of the British Academy* LXXX (1991), 319–32.

XXVII. *Proceedings of the British Academy* LXX (1984), 451–61.

XXVIII. *Proceedings of the British Academy* LXXV (1989), 341–59.

INTRODUCTION

MODERN SCHOLARSHIP IN THE HUMANITIES, in the form of its presentation[1] as well as in the assumptions which underpinned it, is essentially a phenomenon of the nineteenth century. It was during the nineteenth century, especially in the British Isles (but in Europe as well), that many of the humanities disciplines, in forms which are still recognizable and are still pursued today, developed and began to attract adherents, both amateur and professional. And as these disciplines began to be taught at universities from the mid-nineteenth century onwards (and indeed as more and more universities came to be founded in the British Isles in order to accommodate them), characteristic forms of publication accompanied the development. The phenomenon has been recognized in the case of historical studies,[2] as also of classical studies.[3] English studies, the development of which is in many ways linked to classical studies, became a part of university curricula from the mid-nineteenth century onwards.[4] And in the wake of English studies, the study of Celtic languages and literatures, and of early Scandinavian literature, soon followed. The result is that much of the pioneering work in these disciplines (especially English and Celtic philology) was done in the generation or so which preceded the

[1] See A. Grafton, *The Footnote. A Curious History* (Cambridge, MA, 1997), pp. 62–93 (esp. on Leopold von Ranke).

[2] G.P. Gooch, *History and Historians in the Nineteenth Century*, 2nd ed. (London, 1952), esp. pp. 317–34 (the 'Oxford school' of William Stubbs and E.A. Freeman, and the emergence of 'exact methods' of historical writing in the wake of the popularizing histories of Macaulay, Carlyle and Froude).

[3] See C. Stray, *Classics Transformed. Schools, Universities, and Society in England, 1830–1960* (Oxford, 1998), esp. pp. 7–113, and the earlier study by M.L. Clarke, *Classical Education in Great Britain 1500–1900* (Cambridge, 1959), esp. pp. 111–27 (on teaching of the classics at Oxford and Cambridge).

[4] D.J. Palmer, *The Rise of English Studies* (Oxford, 1965), esp. pp. 29–65 and 72–7 (on the nineteenth-century history of Anglo-Saxon studies). See also J. McMurtry, *English Language, English Literature. The Creation of An Academic Discipline* (Hamden, CT, 1985), pp. 7–35. There is an excellent bibliographical guide to the emergence of English as a discipline in H. Gneuss, *English Language Scholarship: a Survey and Bibliography from the Beginnings to the End of the Nineteenth Century* (Binghamton, NY, 1996).

founding of the British Academy in 1902, and many of the great pioneers in these fields were among the earliest Fellows of the Academy.[5]

By the middle of the nineteenth century, an awareness was dawning that the traditional ways of studying classical literature, through composition in Greek and Latin prose and verse, were in some senses sterile; and alongside this awareness was the realization that the English language had a history and literature of its own, comparable in excellence to those of the ancient world. The realization was partly fuelled by the vast advances in understanding the Indo-European languages, and the particular place which Germanic and Celtic languages occupied within it. The growth of Germanic philology in nineteenth-century Scandinavia and Germany is a subject in its own right; but crucial points in the development were the grammar of Old English published in 1817 by the Danish scholar, Rasmus Rask,[6] and the huge philological labours of the two Grimm brothers, Jacob and Wilhelm.[7] In England various scholars in the field of English philology had received their inspiration and orientation from the Continent, notably John Mitchell Kemble (1807–57),[8] who produced the first scholarly edition of *Beowulf* (1833) as well as a pioneering, six-volume edition of Anglo-Saxon charters (1839–48) and who had studied with Jacob Grimm in Göttingen; and Benjamin Thorpe (1782–1870),[9] who had studied with Rasmus Rask in Copenhagen, produced an English translation of the latter's Old English grammar (1830), and this, used in combination with Thorpe's elementary reading book, *Analecta Anglo-Saxonica* (1834), enabled Old English to be taught at university level. Thorpe produced a substantial number of first editions of Old English texts, and by the middle of the nineteenth century it must have been clear to those

[5] Among those whose obituaries are included in the present volume, Whitley Stokes (no. **I**), Walter William Skeat (no. **II**), and Sir John Rhŷs (no. **III**) were founding Fellows of the Academy: see Sir Frederic G. Kenyon, *The British Academy: the First Fifty Years* (London, 1952), p. 12.

[6] On Rasmus Rask (1787–1832), see K. Wolf, 'Rasmus Rask (1787–1832)', in *Medieval Scholarship. Biographical Studies on the Formation of a Discipline. II. Literature and Philology*, ed. H. Damico (New York and London, 1998), pp. 109–24.

[7] See M. Dobozy, 'The Brothers Grimm: Jacob Ludwig Carl (1785–1863) and Wilhelm Carl (1786–1859)', in *Medieval Scholarship*, ed. Damico, pp. 93–108.

[8] The best study of Kemble is a Gollancz lecture by Bruce Dickins (no. **XVIII**): 'John Mitchell Kemble and Old English Scholarship', *PBA* 25 (1941), 51–84; but see also *John Mitchell Kemble and Jacob Grimm: a Correspondence 1832–52*, ed. R.A. Wiley (Leiden, 1971), and R.A. Wiley, 'Anglo-Saxon Kemble 1807–57, Philologist, Historian, Archaeologist', *Anglo-Saxon Studies in Archaeology and History* 1 (1979), 165–273.

[9] See P. Pulsiano, 'Benjamin Thorpe (1782–1870)', in *Medieval Scholarship*, ed. Damico, pp. 75–92.

interested in English philology that there was a vast sea of unpublished medieval English literature waiting to be charted. Through the offices of the Philological Society, and in particular through the energies of the indefatigable scholar Frederick James Furnivall (1825–1910),[10] the decision was taken to produce a 'New English Dictionary', which would be founded on historical principles and would be well situated to draw on the emerging philological sciences of etymology and lexicography. Furnivall himself would never have had the discipline and determination to bring such a project to completion, and that the *New English Dictionary* ever came to be published is due largely to the genius and enduring determination of its first editor, Sir James Murray (1837–1915),[11] as well as to the three editors who succeeded him, Henry Bradley (no. **IV**), Sir William Craigie (no. **X**), and Charles Talbut Onions.[12]

Furnivall and his colleagues quickly realized that if the *New English Dictionary* was to reach far beyond the scope of existing dictionaries, it must necessarily be founded on a wide and historically complete base of citations; which implied in turn that editions of unprinted texts in Old and Middle English were quickly needed. To that end Furnivall founded, almost single-handedly, the Early English Text Society in 1864. It was a mark of Furnivall's genius that he was able to inspire co-workers for his vast enterprises, and through personal contact with Furnivall, Walter William Skeat (no. **II**) and Henry Bradley (no. **IV**) were both drawn into the orbit of the *Dictionary* and into the business of editing texts for the Early English Text Society. As the number of editions of early texts grew apace, the availability of materials necessary for compilation of the dictionary made other enterprises possible. Bradley in 1891 completed a comprehensive revision of Stratmann's *A Middle-English Dictionary* (a work which has only recently been superseded by the recent completion of Kurath, Kuhn and Lewis's *Middle English Dictionary*), and Skeat single-handedly produced his *Etymological Dictionary of the English Language* in 1879. Another aspect of the English language which these pioneering philologists were well aware of, and which has implications for the

[10] Furnivall was elected to the Academy in 1903; see W.P. Ker, 'Frederick James Furnivall, 1825–1910', *PBA* 4 (1909–10), 375–6, as well as D. Pearsall, 'Frederick James Furnivall (1825–1910)', in *Medieval Scholarship* II, ed. Damico, pp. 125–38, and W. Benzie, *Dr F.J. Furnivall: Victorian Scholar Adventurer* (Norman, OK, 1983).

[11] On Murray, one of the founding Fellows of the Academy, see Henry Bradley, 'Sir James Murray, 1837–1915', *PBA* 8 (1916), 545–51. The story of the *New English Dictionary* is told compellingly by K.M. Elisabeth Murray, *Caught in the Web of Words. James Murray and the Oxford English Dictionary* (Oxford, 1977).

[12] See J.A.W. Bennett, 'Charles Talbut Onions, 1873–1965', *PBA* 65 (1979), 743–58.

understanding of Old English as well as for its more modern descendants, was dialect. In 1873 Skeat had founded the English Dialect Society, and begun the vast work of compiling slips to illustrate dialect words. In 1891 Joseph Wright (no. **VII**) took over the slips, and produced *The English Dialect Dictionary* in six massive volumes between 1896 and 1905.[13] With the availability of these works (the *New English Dictionary* was finally completed in 1928, and the First Supplement published between 1928 and 1933),[14] students of the English language had and have at their disposal a wealth of scholarly resources which is not matched by those of any other modern language. In light of his experience with the *New English Dictionary*, Sir William Craigie (no. **X**) undertook in 1925 the compilation of a *Dictionary of the Older Scottish Tongue*, a project of which the first volume was published in 1931, and which is now finally nearing completion (vol. VIII, Ru-Sh, was published in 2000).[15] The only relevant lexicographical enterprise which these pioneers did not broach was the compilation of a new dictionary of Old English, presumably because it was known that Joseph Bosworth's *A Dictionary of the Anglo-Saxon Language*, first published in 1838, was being thoroughly revised by T.N. Toller in Manchester (Toller's enlarged and revised *An Anglo-Saxon Dictionary* was published between 1882 and 1898).[16]

Students of Old English at that time must have been aware that, in spite of the large numbers of texts being published by the Early English

[13] In some ways the life of Joseph Wright is the most extraordinary of all the scholars whose obituaries are collected in the present volume (he had no formal education, and spent his childhood working as a 'doffer' in a woollen mill in order to support his impoverished mother, and only subsequently taught himself how to read and write, but he rapidly thereafter acquired a command of the Indo-European languages which few scholars have ever possessed, as is reflected in the numerous handbooks which he published to Old English, Middle English, Gothic, Old High German, Middle High German, etc.): see Elizabeth Mary Wright, *The Life of Joseph Wright*, 2 vols. (London, 1932), and idem, *The Story of Joseph Wright, Man and Scholar* (London, 1934).

[14] There is a valuable account of the history of the *New English Dictionary* and its various supplements—or *Oxford English Dictionary* (as it subsequently came to be called)—in *The Oxford English Dictionary*, 2nd ed. by J.A. Simpson and E.S.C. Weiner, 20 vols. (Oxford, 1989), I, pp. xxxv-lxi.

[15] The first volume was published in 1931, the most recent (Ru-Sh) in 2000; the Dictionary thus far consists of eight large volumes.

[16] A complete dictionary of Old English, based on the entire (and now machine-readable) corpus, is still a desideratum, but since 1986 steady progress on the Toronto *Dictionary of Old English*, ed. A. diP Healey, has been made; thus far the letters A, Æ, B, Beon, C, D, and E have been published in microfiche. The present intention is that, with the proximate publication of F, the entire dictionary thus far will be issued on CD-ROM.

Text Society, an enormous corpus of smaller Old English texts, often in the form of interlinear glosses, remained to be explored.[17] Arthur Stanley Napier (no. **VI**), who had been trained in Germany with scholars such as Julius Zupitza, was appointed to the Merton Chair of English Language in 1885, and with the Bodleian Library easily accessible, began recording and publishing such texts; his *Old English Glosses, Chiefly Unpublished* (1900) drew to the attention of the scholarly world the wealth of material lying unpublished in manuscript. A year previously, H.M. Chadwick (no. **XI**) had, in his *Studies in Old English*, established criteria for dating Old English sound changes and assigning such changes to the various Old English dialects. Thanks largely to the work of such pioneers, drawing on the achievements of nineteenth-century German philologists, it may be said that by the beginning of the twentieth century the corpus of Old English had been more or less precisely defined, and the principles for analysing its chronology and dialects established. It remained to apply this knowledge to the analysis of Old English literature.

In the late nineteenth century, before the establishment of faculties of English literature at Oxford and Cambridge, the disciplines of philology and literature were perceived as discrete, and a brilliant philologist such as Napier would scrupulously refrain from expressing literary judgements, preferring to leave such activity to those who professed literature. The giant in the field of literature (as distinct from philology) at the turn of the nineteenth century was William Paton Ker (no. **VIII**) who in two epoch-making books—*Epic and Romance* (1897) and *The Dark Ages* (1904)—had persuasively analysed the distinctive nature of Old English poetry, and placed it in the wider context of the early medieval literature in all European languages, especially Old Icelandic, which shares many analogues with Old English. In *The Dark Ages* Ker had briefly sketched the nature of literature produced in a 'heroic age'; it remained to Hector Munro Chadwick (no. **XI**) to develop comprehensively the idea of 'heroic' society as a phase through which all societies passed, and characterized by the particular relationship which existed between a lord and his retainers. In *The Heroic Age* (1912), Chadwick drew on his formidable knowledge of Greek literature in order to use the Homeric poems as a standard against

[17] One interesting, if relatively minor, form of Old English was that written in runes. J.M. Kemble had in effect initiated the serious study of runes in England, particularly as regards the so-called 'runic signatures' in the poetry of Cynewulf. At a later time (1888) Napier discovered and deciphered the runic signature in the poem preserved in the Vercelli Book and now known as 'The Fates of the Apostles', and Bruce Dickins (no. **XVIII**) contributed a number of important studies in addition to his youthful edition of such texts, *Runic and Heroic Poems of the Old Teutonic Peoples* (1915).

which to measure the heroic literature of the Teutonic peoples; and this procedure was extended some years later in the massive three-volume study of *The Growth of Literature* which Chadwick published in conjunction with his wife, Nora Kershaw Chadwick (no. **XX**), between 1932 and 1940. In this book the Chadwicks anticipated much of the discussion of oral-formulaic composition, illustrated by the *ex tempore* compositions of Serbian poets, which dominated the study of Old English verse during the second half of the twentieth century.

In the same year in which Chadwick published *The Heroic Age*, Raymond Wilson Chambers (no. **XII**) published his pioneering edition of *Widsith*, a work similarly inspired by interest in the 'heroic age' of the Germanic peoples. The Old English poem 'Widsith' purports to record the memories of an itinerant poet who has travelled widely ('wid-sith' means 'far-traveller') among Germanic tribes of the so-called migration period, and Chambers's text, with its massively erudite annotation, remains to this day the standard edition of the poem. Chambers applied the same scholarly procedure to the elucidation of *Beowulf*, in his *Beowulf. An Introduction to the Study of the Poem* (1921), an influential work which has passed through several editions (the most recent, the third, with addenda by C.L. Wrenn, was published in 1959) and is still valuable for its detailed discussion of Germanic analogues to the poem. Chambers subsequently began to devote his scholarly attention to Middle English verse and Tudor prose, and made no further major contributions to the study of Old English literature; but at about this time Kenneth Sisam (no. **XVII**) began to publish the first of a series of brilliant essays on Old English literature which *inter alia* transformed our understanding of the chronology of the verse and the way in which it has been transmitted, beginning with his influential analysis of the *Beowulf* manuscript (1916), and including his study of Cynewulf, which was delivered to the British Academy as the first Sir Israel Gollancz Memorial Lecture in 1932 (Sisam reprinted the most important of his essays in his *Studies in the History of Old English Literature* in 1953).

Israel (later Sir Israel) Gollancz (no. **IX**) had been a student of W.W. Skeat at Christ's College, Cambridge, and was for some time a Lecturer in Skeat's department in Cambridge, before moving to the Quain Professorship of English in King's College, London. Although Gollancz is perhaps best known for his work on Middle English literature and on Shakespeare, he made a number of important contributions to the field of Old English literature, including an edition of the Exeter Book Riddles and a lavish facsimile of the Junius Manuscript, which was published and presented to the Academy in 1927 in commemoration of the

first twenty-five years of its existence. It is interesting to note how the great pioneers ensured the continuation of their subject by training outstanding scholars of a succeeding generation. Gollancz was a student of W.W. Skeat. Chambers had been a student of W.P. Ker. Sisam was a student of A.S. Napier. Three other scholars who made important contributions to the study of Old English literature were students of H.M. Chadwick: Bruce Dickins (no. **XVIII**), Nora Kershaw Chadwick (no. **XX**), and Dorothy Whitelock (no. **XXII**). Dickins worked as a miniaturist, but, alongside his edition of *Runic and Heroic Poems of the Old Teutonic Peoples* (1915), a number of his short papers touch on Old English literature; Nora Chadwick published across the entire range of Anglo-Saxon, Norse and Celtic (especially Welsh and Irish) literatures, including her edition of *Anglo-Saxon and Norse Poems* (1922) and various essays which draw on folk-lore to elucidate aspects of *Beowulf*, including a study of 'The Monsters and *Beowulf*' published in the Festschrift for Bruce Dickins; and Dorothy Whitelock, who, although remembered chiefly as an Anglo-Saxon historian (see below), published an important book on *Beowulf* (*The Audience of Beowulf*, 1951), and a brilliant interpretation of 'The Seafarer', which appeared in the volume of memorial essays for H.M. Chadwick in 1950 and is still regarded as the defining interpretation of that poem half a century later.

As we have seen, the study of Old (and Middle) English language was driven in the first instance by the work of nineteenth-century German philologists such as the Brothers Grimm. To such philologists, the study of the English language was but one element in the wider understanding of Indo-European; and among the Indo-European languages, the medieval Celtic languages (Irish and Welsh) were thought to be of crucial importance, particularly Old Irish, which was thought to preserve many Indo-European features otherwise best preserved in Sanskrit. The serious study of Celtic philology (and Old Irish philology in particular) began in the mid-nineteenth century. Although great advances had been made in the earlier nineteenth century by native scholars in Ireland—for example Eugene O'Curry (1794–1862), James Henthorn Todd (1805–1869), and John O'Donovan (1806–1861)—in fact the pioneers in the field of Irish philology were largely Germans: one thinks of Johann Kaspar Zeuss (1806–1856), whose epoch-making *Grammatica Celtica* (1853) is one of the foundation stones of Celtic philology, Ernst Windisch (1844–1918), Heinrich Zimmer (1851–1910), Rudolf Thurneysen (1857–1940), and Kuno Meyer (1858–1919). But there is one native Irish scholar who easily stands comparison with these German pioneers, namely Whitley Stokes (no. **I**), who has been described as 'the greatest scholar in philology that Ireland

has produced'.[18] But although Stokes was born in Ireland and studied law at Trinity College, Dublin, he moved to London in 1856, from where he was sent to India to help in drafting Indian legislation; he spent the years 1862 to 1882 in India, and thereafter returned to London, where he remained for the rest of his life, and where he became one of the Founding Fellows of the British Academy. The achievement of Stokes has often been described as prodigious, and it has been calculated that 'of the Old and Irish literature now available in scholarly editions and translations a much larger portion is due to him than to any one other man.'[19] The bibliography of his published writings extends to more than fifty pages.

For productivity few scholars in any field of the humanities could bear comparison with Whitley Stokes, but a number of significant achievements in the field of early Irish studies are due to Fellows of the Academy whose obituaries are included in the present volume.[20] In later life Charles Plummer (no. **V**), having devoted his early studies to (monumental) editions of *The Anglo-Saxon Chronicle* and Bede's *Historia ecclesiastica* (see below), turned his attention to Ireland, and produced equally monumental editions of Hiberno-Latin saints' Lives (*Vitae Sanctorum Hiberniae*, 2 vols., 1910), of Middle Irish saints' Lives (the *Bethada Náem nÉrenn*, 2 vols., 1922), and of Irish litanies (1925). One wonders how many scholars have ever lived who had the skill and knowledge to edit texts in Old English, Latin and Irish. The edition of Irish texts, in particular, is an on-going process: in spite of the Herculean efforts of scholars such as Stokes and Plummer, there are many such texts lying in manuscript awaiting the attentions of an editor.

[18] J.F. Kenney, *The Sources for the Early History of Ireland: Ecclesiastical* (New York, 1929), p. 74. (Kenney includes a useful account of the early development of Irish studies in Ireland and elsewhere, pp. 48–84; and cf. *Progress in Medieval Irish Studies*, ed. K. McCone and K. Simms (Maynooth, 1996), esp. pp. 7–19.) In addition to the Academy obituary of Stokes reprinted below (no. **I**), see R. Henebry, 'Whitley Stokes', *Celtic Review* 6 (1909), 65–85, and R.I. Best, *Whitley Stokes (1830–1909): a Memorial Discourse* (Dublin, 1951).

[19] Kenney, *The Sources*, p. 74. These words were written in 1926; but cf. *Progress in Medieval Irish Studies*, ed. McCone and Simms, pp. 56–7: 'The editing of texts has been proceeding at a snail's pace; for many of them we still depend on the editions of Whitley Stokes, which were produced at speed, and which need to be replaced' (written in 1996).

[20] It is slightly odd that, of the many distinguished scholars in Ireland who did so much to advance the field of early Irish studies during the twentieth century—Richard Irvine Best (1872–1959), Osborn J. Bergin (1873–1950), Thomas F. O'Rahilly (1883–1953), Daniel A. Binchy (1899–1989), Myles Dillon (1900–1972), James Carney (1914–1989), David Greene (1915–1981), and others—none was ever elected a Corresponding Fellow of the British Academy. There are brief biographies and photographs of the scholars mentioned here in *School of Celtic Studies: Fiftieth Anniversary Report, 1940–1990* (Dublin, 1990).

Such texts can only be identified if reliable catalogues of the Irish manuscripts preserved in the great depositories are available, and it was one of the principal achievements of Robin Flower (no. **XVI**) that, during the years of his employment in the Manuscripts Department of the British Museum, he was able to produce his *Catalogue of Irish Manuscripts in the British Museum* (1926). Works such as this *Catalogue* help to make scholars aware of the riches of Irish literature; but if there are to be sufficient workers in the field to exploit them, elementary texts and grammars are needed alongside the scholarly editions. Nora Kershaw Chadwick (no. **XX**) had a perduring interest in Celtic literature, and one of her first publications was *An Early Irish Reader* (1927), which, in spite of its faults (it was reviewed ferociously by Osborn Bergin), nonetheless served to introduce beginners to the subject (it consists almost entirely of an edition, with facing page translation and accompanying commentary, of one of the best known Irish tales, the *Scéla Muicce Meic Da Thó*, 'The Tale of Mac Dathó's Pig'). One of the greatest Celticists of the twentieth century, Kenneth Jackson (no. **XXVI**), confessed to having 'cut his first Celtic teeth' on this edition [of the *Scéla Muicce Meic Da Thó*]. And although Jackson would be more appropriately described as a general Celtic philologist than as a student specifically of Old Irish, there is no doubt that he had a profound knowledge not only of Old Irish, but of all periods of Irish, including Scots Gaelic (witnessed in his edition of the Gaelic notes in the Book of Deer). As a young man he had spent several summers on the Great Blasket (Kerry) with Robin Flower, learning to speak Irish and taking down stories told by Peig Sayers from dictation into the I.P.A. The stories were later printed in his *Scéalta ón mBlascaod*, and the interest in folktales which was nurtured on the Great Blasket later issued in his study of *The International Popular Tale and Early Welsh Tradition* (1961). His last publication was the edition of an early Irish text, the *Aislinge Meic Conglinne* (1990).

During the later nineteenth century there was an ever-increasing awareness of the wealth of medieval literature preserved in the Celtic languages. Matthew Arnold, in the last lectures which he delivered in Oxford as Professor of Poetry under the title *On the Study of Celtic Literature* (1866), lamented the fact that there was no established chair of Celtic studies anywhere in England, and suggested bluntly that Oxford should found one (John Rhŷs was by chance in the audience at that point, 26 May 1866). Arnold's remarks prompted the University to establish a chair of Celtic in 1876. The first holder was John (later Sir John) Rhŷs (no. **III**),[21] who was

[21] See also the brief remarks by Sir Idris Foster, 'Sir John Rhŷs', in *Proceedings of the Seventh International Congress of Celtic Studies*, ed. D.E. Evans, J.G. Griffith and E.M. Jope (Oxford, 1986), pp. 10–14.

elected in 1877 and held the chair until his death in 1915. Although various students of early medieval literature were aware of the riches of Welsh literature—W.P. Ker had devoted a chapter to it in *The Dark Ages* and Nora Chadwick wrote about it at various stages of her career—Rhŷs's appointment marked the beginning of the study of Welsh as an academic discipline, and the initiative taken by Oxford was soon supported by the establishment of the University College of Wales in 1893.[22] The work of Rhŷs followed a trajectory similar to that of Whitley Stokes and the nineteenth-century pioneers of English philology; that is to say, his earliest publications were on the relationship of Welsh (and Irish) to other Indo-European languages. His *Lectures on Welsh Philology* appeared in 1877, the first year of his Oxford appointment (a second edition was printed in 1879). Although he continued to publish occasional articles on early Welsh language and literature, his interests moved on to Celtic ethnology and folk-lore, and particularly to Celtic inscriptions. The huge task of editing and expounding the corpus of medieval Welsh literature was taken up by the indefatigable Ifor (later Sir Ifor) Williams (no. **XV**). In effect Sir Ifor accomplished for medieval Welsh literature something analogous to what Whitley Stokes had done for Irish: he produced editions, with commentary, of most of the principal Welsh texts, including *Breuddwyd Maxen* (1908), the Four Branches of the *Mabinogion* (1930), the *Canu Llywarch Hen* (1935), the *Canu Aneirin* (1938), and the *Canu Taliesin* (1960), and a host of editions of minor works. These editions remain definitive after a half century and more.

Sir Ifor Williams spent his academic career at the University College of North Wales at Bangor, which during the first half of the twentieth century was the outstanding centre for the study of medieval Welsh literature and culture. The Professor of History was Sir John Edward Lloyd (1861–1947), whose two-volume *History of Wales from the Earliest Times to the Edwardian Conquest* (1910; 2nd ed., 1912) has not been superseded after nearly a century.[23] At a later time Thomas Parry (1904–1985) was Professor of Welsh there.[24] Parry is known for his edition of the poetry of Dafydd ap Gwilym (*Gwaith Dafydd ap Gwilym*, 1952) and above all for his history of Welsh literature up to 1900 (*Hanes Llenyddiaeth Gymraeg Hyd 1900*, 1944, translated into English as *A History of Welsh Literature* by Sir Idris Bell, 1955),

[22] See E.L. Ellis, *The University College of Wales, 1872–1972* (Cardiff, 1972).
[23] See J.G. Edwards, 'Sir John Edward Lloyd, 1861–1947', *PBA* 41 (1955), 319–27.
[24] See J.E. Caerwyn Williams, 'Thomas Parry, 1904–1985', *PBA* 73 (1987), 567–99. The obituary includes a valuable account of the development of medieval Welsh studies during the twentieth century.

the first comprehensive history of that literature to be published. It was to Bangor that the young Kenneth Jackson (no. **XXVI**) went to study with Sir Ifor Williams and to perfect his knowledge of Welsh. As we have seen, Jackson's prodigious knowledge embraced the entire field of Celtic languages, and in addition to Welsh and Irish he published books on Manx, Scots Gaelic, and Breton; but in some ways the focal point of his vast publication was Britain and the P-Celtic (or Brittonic, of which Welsh is the best attested) languages. In any event, the Brittonic languages constitute the focus of his *magnum opus*, *Language and History in Early Britain: a Chronological Survey of the Brittonic Languages, 1st to 12th c. A.D.* (1953), like Zeuss's *Grammatica Celtica* one of the milestones in the field of Celtic philology. Another great Welsh scholar who went to Bangor to study with Sir Ifor Williams and Thomas Parry was J.E. Caerwyn Williams (1912–1999),[25] who was subsequently Lecturer and then Professor of Welsh at Bangor from 1953 until 1965 (when he went to the newly-created chair of Welsh at Aberystwyth), and whose voluminous publications have done much to illuminate medieval Welsh religious prose and poetry, and in particular the poetry of the 'Gogynfeirdd' ('poets of the Welsh princes').

Another people who were a major constituent of the civilization of early medieval Britain were the Scandinavians, whose impact on Ireland, Wales, Scotland and England was mediated first by Viking raiders and subsequently by settlers from Norway and Denmark. Almost from the beginnings of English settlement in Britain, native art was influenced by the art of Scandinavia; Scandinavian settlements in Britain and Ireland inevitably influenced native social patterns and government; and, at a later stage (from the thirteenth century onwards), the extensive literature of Iceland provides many relevant analogues to literature in Old English and medieval Irish. During the past century Fellows of the Academy have played an important role in interpreting these various influences. One of the earliest monographs in English on the Vikings was written by Sir Thomas Kendrick (no. **XXI**) in 1930 (*A History of the Vikings*), and much of his later publication was devoted to Viking art (see below). Allen (later Sir Allen) Mawer (no. **XIII**) began his scholarly career with a fellowship dissertation on the effects of the Scandinavian settlements in England, and he contributed chapters on the Scandinavians to the *Cambridge Medieval History* (1922) as well as a brief book entitled *The Vikings* (1913). He subsequently realized that one of the principal keys to understanding the Scandinavian settlement was English place-names, and after this realization he spent the remainder of his scholarly career working on

[25] See D. Ellis Evans, 'John Ellis Caerwyn Williams, 1912–1999', *PBA* 111 (2001), 697–716.

place-names (see below). Much of the vast scholarly output of Sir Frank Stenton (no. **XIV**) was devoted to elucidation of the counties of the Danelaw, both in the pre-Conquest period and afterwards. He was a pioneer in the study of post-Conquest documents for the light they throw on patterns of land tenure in the Danelaw (*Documents illustrative of the Social and Economic History of the Danelaw*, 1920; *The Free Peasantry of the Northern Danelaw*, 1925, reprinted 1969; but also many essays and lectures). Like Sir Allen Mawer, with whom he collaborated closely until the latter's death in 1942, he was sharply aware of the importance of place-name study in interpreting the Danelaw.

In many ways the most interesting aspect of the Scandinavian peoples of the early Middle Ages is not their settlement patterns but their literature—prose sagas, Eddic and scaldic verse, and many kinds of historical and pseudo-historical texts (to say nothing of the religious literature which is found in all early Germanic languages). One of the first scholars to draw attention to the fascination of Old Icelandic literature was W.P. Ker (no. **VIII**), much of whose *Epic and Romance* (1897) is taken up with analysis of many of the best-known prose sagas (including *Njals Saga* and *Laxdæla Saga*), as well as with the poems of the *Poetic Edda*. The same fascination was clearly felt by H.M. Chadwick (no. **XI**), who once described 'early Norse literature [as] the most independent and original that Europe has produced since the times of ancient Greece'.[26] This fascination is reflected in one of his early publications (*The Cult of Othin: An Essay in the Ancient Religion of the North*, 1899), and although he never subsequently turned in detail to the elucidation of Old Norse literature, he evidently communicated his enthusiasm for the subject to his pupils. Both Bruce Dickins (no. **XVIII**) and Nora Kershaw Chadwick (no. **XX**) published on Old Norse at various times in their careers: Dickins included editions of both the Old Icelandic and Old Norwegian 'Rune Poems' in his *Runic and Heroic Poems* (1915), and Nora Chadwick included editions seven Old Norse poems in her *Anglo-Saxon and Norse Peoms* (1922).

Old Norse scholarship of a more sustained nature was undertaken by Sir William Craigie (no. **X**), who was the third editor of the *New English Dictionary* (following Murray and Bradley) and was sometime Rawlinson and Bosworth Professor of Anglo-Saxon in the University of Oxford. He wrote a brief introduction to the Icelandic sagas (*The Icelandic Sagas*, 1913) as well as an elementary guide to the language (*Easy Readings in Old Icelandic*, 1924); but his major contributions were of an editorial nature,

[26] H.M. Chadwick, *The Study of Anglo-Saxon*, 2nd ed. (Cambridge, 1955), p. 34.

including an edition of *Skotlands Rímur* (Icelandic ballads on the Gowrie Conspiracy) published in 1908, a work which set the standard for the way *rímur* were to be edited (he unfortunately never completed the comprehensive edition of *rímur* which he had planned, and which he lectured on in Reykjavik towards the end of his life: *Nokkrar Athuganir um Rímur*, 1949), and a three-volume edition of Icelandic metrical romances (*Synisbók Íslenzkra Rímna*, 1952). He also produced in the last year of his life a Supplement to the Cleasby-Vigfusson *Old Icelandic Dictionary*, which remains for English-speakers the standard dictionary of that language. In the English-speaking world, however, the giant in the field of Old Icelandic literature is Gabriel Turville-Petre (no. **XXV**), whose expertise ranged across the entire spectrum of that literature, and has left a substantial number of monographs which lay out the field brilliantly for those readers who do not have access to earlier scholarship in the various Scandinavian languages: *The Heroic Age of Scandinavia* (1951), *The Origins of Icelandic Literature* (1953; 2nd ed., 1967), *Myth and Religion of the North* (1964), *Nine Norse Studies* (1972), and *Scaldic Poetry* (1976), as well as numerous essays and editions of texts (including *Víga Glúms Saga* (1940), *Hervarar saga ok Heiðreks* (1956), etc.). In sum his writings provide as good an introduction to Old Icelandic literature as could be imagined.

On the whole, then, the vernacular languages and literatures of the early British Isles have been well studied. But it should be remembered that, throughout the period in question, the Church was the crucible of all written culture, and the language of the Church was Latin. From the seventh century onwards, huge *corpora* of Latin literature—poetry, hagiography, historiography, liturgy, legislation, charters—survive from Ireland and England (and to a lesser extent from Wales), such that the British Isles were in the vanguard of European learning until at least the ninth century, and probably again in the tenth. Authors such as Aldhelm and Bede were studied intensively in continental schools, and Alcuin, while serving as Charlemagne's adviser in cultural matters, helped to effect a renaissance of Latin studies un the Carolingian kingdom. Yet Insular Latin literature, in comparison with the vernacular, has been studied relatively little, and has scarcely been treated by Fellows of the Academy during the first century of its existence. But there are some notable exceptions. Charles Plummer (no. **V**) published in 1896 a monumental edition of Bede's *Historia ecclesiastica* together with some of Bede's minor historical works, and equipped the edition with a full commentary that, after a century of progress in Anglo-Saxon studies, still contains much that is valuable. Plummer subsequently turned his attention to Ireland, and produced a massive edition in two volumes of the Latin *Vitae Sanctorum Hiberniae*

(1910).²⁷ Plummer's edition of Bede's *Historia ecclesiastica* was based on collation of a substantial number of manuscripts; but unfortunately Plummer did not know about an important early manuscript then in St Petersburg which was written in Bede's own scriptorium soon after his death and which is a precious witness to the original state of the text. This defect of Plummer's edition was made good by Sir Roger Mynors,²⁸ who in his edition of the *Historia ecclesiastica* published in 1969, was able to collate the St Petersburg manuscript and use its readings to establish that Bede issued his great work in two distinct stages.²⁹ Another scholar who devoted much of his scholarly career to Bede and Bede's Northumbria was Peter Hunter Blair (no. **XXVIII**), whose book, *The World of Bede* (1970), remains the best available monograph on Bede. Other scholars represented in the present volume contributed essays on various aspects of Insular Latin literature—Nora Chadwick (no. **XX**) on the Latin writers of late eleventh-century Wales, Julian Brown (no. **XXVIII**) on the use of Classical Latin authors in the British Isles from the fifth century to the eleventh—and F.J.E. Raby³⁰ treated various Insular Latin authors in passing in his two magisterial volumes, *Christian-Latin Poetry* (1927) and *Secular Latin Poetry* (1934). But a comprehensive history of pre-Conquest Insular Latin literature remains to be written.

The preceding paragraphs have been concerned with scholarship within the Academy on the principal languages and literatures that were written and spoken in the British Isles in the early medieval period. During the century of the Academy's existence a number of new disciplines developed—principally through the work of those scholars whose obituaries are printed in the present volume—which have become fundamental to the understanding and interpretation of the literature and history of the British Isles during the period in question: palaeography, diplomatic, place-name studies, archaeology, numismatics, and art history. We may consider each of these disciplines briefly in turn.

[27] On Plummer's work on Irish hagiography, and the *Vitae Sanctorum Hiberniae* in particular, see R. Sharpe, *Medieval Irish Saints' Lives. An Introduction to Vitae Sanctorum Hiberniae* (Oxford, 1991), pp. 79–88 *et passim*.

[28] See M. Winterbottom, 'Roger Aubrey Baskerville Mynors, 1903–1989', *PBA* 80 (1991), 371–401.

[29] Mynors's account of the textual transmission of the *Historia ecclesiastica* is a masterpiece; unfortunately his edition is disfigured by the superficial annotation of his collaborator, Bertram Colgrave. Nor is the annotation provided by J.M. Wallace-Hadrill (*Bede's Ecclesiastical History of the English People: a Historical Commentary*, 1988) much better.

[30] See M. Lapidge, 'Frederic James Edward Raby, 1888–1966', *PBA* 94 (1996), 687–704.

First, palaeography. By 1902 the major outlines of the history of Latin handwriting were broadly understood, as was the overall chronology, as may be seen from the handbook to the subject by Edward Maunde Thompson (1840–1929),[31] Director of the British Museum and one of the Founding Fellows and sometime President of the Academy, namely his *Handbook of Greek and Latin Palaeography* (1893, later revised and expanded as *An Introduction to Greek and Latin Palaeography*, 1912); but the development of local varieties of Latin script within the British Isles, and above all vernacular script, was as yet little understood. Major advances in the understanding of Welsh and Irish script were made by W.M. Lindsay (1858–1937),[32] the great Latinist who was also one of the pioneers of modern palaeography, and the multi-volume enterprise of E.A. Lowe, the *Codices Latini Antiquiores*, was eventually to provide a solid basis for the dating and localization of all manuscripts written before *c*.800.[33] The many catalogues compiled by M.R. James (1862–1936)[34] of manuscripts in Cambridge, Lambeth Palace and Eton, were (and are) an invaluable resource for students working on individual texts or manuscripts. But the close study of Anglo-Saxon manuscripts, begun in the early years of the twentieth century, was eventually to revolutionize the field of Old English studies. Here again one of the great pioneers was A.S. Napier (no. **VI**), whose work on manuscripts of homilies and above all on manuscripts containing glosses in Old English, led to the discovery of many previously unknown texts, and was to point the way for a century and more of manuscript research. He communicated his enthusiasm for manuscripts to his pupil Kenneth Sisam (no. **XVII**), who continued his master's research on homilies and like him discovered many new Old English texts. Sisam's interest in manuscripts was communicated in turn to Neil Ripley Ker (no. **XXIV**), whose thorough searches for Old English texts and glosses led eventually to the publication of his epoch-making *Catalogue of Manuscripts containing Anglo-Saxon* in 1957. This great work, which was dedicated to Kenneth Sisam, has had a huge impact on the field of Anglo-Saxon studies, to the extent that, half a century after its publication, much of the research done in the field is manuscript-based and derives its orientation

[31] See F.G. Kenyon, 'Sir Edward Maunde Thompson, 1840–1929', *PBA* 15 (1929), 477–90.

[32] See H.J. Rose, 'Wallace Martin Lindsay, 1858–1937', *PBA* 23 (1937), 487–512; the works of Lindsay in question are his *Early Irish Minuscule Script* (Oxford, 1910) and *Early Welsh Script* (Oxford, 1912).

[33] E.A. Lowe, *Codices Latini Antiquiores*, 11 vols. and suppl. (Oxford, 1934–71; 2nd ed. of vol. II, 1972). Lowe was made a Corresponding Fellow of the Academy in 1928.

[34] See S. Gaselee, 'Montague Rhodes James, 1862–1936', *PBA* 22 (1936), 418–33; and see also R.W. Pfaff, *Montague Rhodes James* (London, 1980).

from Ker's *Catalogue*. Ker identified some 400 manuscripts containing Old English, and these manuscripts provided the solid basis for future work on Anglo-Saxon script (it may also be said that Ker's introduction to his *Catalogue* remains one of the best introductions to the varieties of script encountered in Anglo-Saxon manuscripts). It was now open to other palaeographers to explore individual aspects of Anglo-Saxon script. Francis Wormald (no. **XXIII**) contributed substantially to techniques for dating Anglo-Saxon manuscripts by identifying criteria to judge the ways in which manuscript decoration evolved. T.J. Brown (no. **XXVIII**), who in 1960 succeeded Wormald as Professor of Palaeography at King's College, London, devoted his attention to manuscripts written particularly in Northumbria (and to a lesser extent in Ireland and Southumbria) before *c*.800, and evolved helpful criteria—and above all a helpful nomenclature—for classifying, dating, and localizing English script of that period. T.A.M. Bishop (1907–1994),[35] sometime Reader in Palaeography in the University of Cambridge, turned his attention to manuscripts of the later Anglo-Saxon period, in particular to those written after the Benedictine reform movement in an English style of Caroline minuscule. The importance of this palaeographical research is reflected in the fact that Helmut Gneuss has recently been able to compile a comprehensive handlist of all manuscripts written or owned in England before *c*.1100; his list provides an indispensable point of departure for the study and understanding the intellectual culture of early England, and should inspire scholarship well into the twenty-first century.[36]

One valuable accessory to the study of Anglo-Saxon script is the study of Anglo-Saxon diplomatic, that is to say, the technique of analysing the form and content of a charter in light of what is known of contemporary documents. Approximately 280 original Anglo-Saxon charters survive from the period before 1066 (and of course many more are preserved as copies in later cartularies). The script of dated original charters can often throw light on the development of script used in contemporary library books. But diplomatic also has exceptional importance in its own right, since charters were instruments of royal government, and they help to illustrate the means and personnel by which government was implemented. Although multi-volume editions of Anglo-Saxon charters had been undertaken during the nineteenth century by scholars such as J.M. Kemble (whose *Codex Diplomaticus Aevi Saxonici* was published in six vol-

[35] See D. Ganz, 'Terence Alan Martyn Bishop, 1907–1994', *PBA* 111 (2001), 397–410.
[36] H. Gneuss [Corresponding FBA, 1991], *Handlist of Anglo-Saxon Manuscripts. A List of Manuscripts and Manuscript Fragments Written or Owned in England up to 1100* (Tempe, AZ, 2001).

umes in 1839–48) and W. de G. Birch (whose three-volume *Cartularium Saxonicum* was published, with full index, in 1885–93), and although these editions are still widely in use today, it could not be said that they are sufficient for the purposes of modern diplomatic. The full historical importance of Anglo-Saxon diplomatic became clear during the course of the twentieth century, largely through the work of Sir Frank Stenton (no. **XIV**), who used charter evidence to solve many historical problems of topography and royal government; a comprehensive knowledge of Anglo-Saxon diplomatic underpins his great *Anglo-Saxon England* (see below). Late in life he gave a series of lectures on Anglo-Saxon diplomatic, and the resulting book—*The Latin Charters of the Anglo-Saxon Period* (1955)—can still serve as a valuable introduction to the way charters were used and preserved. In any event, no-one today would attempt to write Anglo-Saxon history without having a firm control of diplomatic; and some impression of the importance which is attached to charters by Anglo-Saxon historians can be gleaned from the number of them which is included (in translation) by Dorothy Whitelock (no. **XXII**) in her *English Historical Documents, c.500–1042* (1955; 2nd ed. 1979). One of the pioneering works of modern diplomatic was an edition, published in 1895, of the Crawford collection of charters, then recently purchased by the Bodleian Library in Oxford, by A.S. Napier (no. **VI**), and W.H. Stevenson.[37] Napier and Stevenson provided a clear model for the layout and presentation of original charters, in combination with the sort of commentary which is required to elucidate them, and (with modifications) their model has been followed by subsequent students of Anglo-Saxon charters, including the editors of the British Academy's current series of editions of Anglo-Saxon charters.[38]

[37] William Henry Stevenson (1858–1924), sometime Librarian of St John's College Oxford, pioneer of Anglo-Saxon diplomatic, editor of a monumental edition of Asser's *Life of King Alfred* (1904), admired colleague of scholars such as Arthur Napier and Henry Bradley, and revered mentor to younger scholars such as F.M. Stenton. It is a mystery that Stevenson was never elected to the Academy. See A.L. Poole, 'William Henry Stevenson', in *Dictionary of National Biography, 1922–1930*, ed. J.R.H. Weaver (Oxford, 1937), pp. 811–12, at 812: 'He had an exact knowledge of all the languages requisite for the study of early English history, and no professed philologist could compare with him in extent of historical learning and knowledge of diplomatic.'

[38] Nine volumes in the Academy's 'Anglo-Saxon Charters' series have so far been published. The series is guided by a joint Committee of the Academy and the Royal Historical Society established in 1966: see Wheeler, *The British Academy 1949–1968*, p. 136. One of the first publications of the Committee was P.H. Sawyer, *Anglo-Saxon Charters. An Annotated List and Bibliography*, Royal Historical Society Guides and Handbooks 8 (London, 1968). This work, 'Sawyer' as it is known to students of the field, is the indispensable foundation for all study of Anglo-Saxon charters. P.H. Sawyer was the first Secretary of the joint Committee.

The Napier and Stevenson model was followed, for example, by Florence Harmer (no. **XIX**) in her edition of *Select English Historical Documents of the Ninth and Tenth Centuries* (1914), a work produced at the suggestion of H.M. Chadwick. Later in life, and this time at the suggestion of Sir Frank Stenton, Harmer produced her magisterial edition of *Anglo-Saxon Writs* (1952), an indispensable resource for the study of the workings of royal government in the eleventh century, particularly during the reign of Edward the Confessor (during whose reign most of the surviving writs were produced).

The study of English place-names is a discipline which emerged in the late nineteenth century, largely at the hands of those English philologists—notably W.W. Skeat (no. **II**) and Henry Bradley (no. **IV**)—who through their involvement with the Philological Society and the *New English Dictionary* had pioneered the study of etymology and lexicography. Although during the nineteenth century place-names had been the province of amateur and uncritical guess-work, Skeat and Bradley showed that the same rigorous philological methods which were applied to (say) etymology were also to be applied to place-name study: Bradley in a sequence of some twenty essays and lectures,[39] Skeat in six volumes concerning the place-names of six counties (Bedfordshire, Berkshire, Cambridgeshire, Hertfordshire, Huntingdonshire, and Suffolk), published between 1901 and 1913. Once philological procedures for the correct interpretation of place-names had been established, historians rapidly recognized the potential which place-names offered for interpretation of settlement patterns in England, from the earliest Germanic settlements in the fifth century, through the Scandinavian settlements in the Danelaw and elsewhere, to Norman settlement in the wake of the Conquest.[40] As we have seen, both Sir Allen Mawer (no. **XIII**) and Sir Frank Stenton (no. **XIV**) recognized the historical importance of place-name evidence for the study of the Danelaw; and together they established the English Place-Name Society in 1921, with Mawer as its first Director, succeeded by

[39] For Bradley's principles and method, see his 'English Place-Names', repr. in *The Collected Papers of Henry Bradley* (Oxford, 1928), pp. 80–109.

[40] See A. Mawer, 'English Place-Name Study: its Present Condition and Future Possibilities', *PBA* 10 (1921–3), 31–44, as well as the more recent assessments by K. Cameron, 'The Significance of English Place-Names', *PBA* 62 (1976), 135–55, and *Place-Name Evidence for the Anglo-Saxon Invasion and Scandinavian Settlements*, ed. K. Cameron (Nottingham, 1975). Kenneth Cameron (1922–2001), FBA, was sometime Director of the English Place-Name Society and author of *English Place-Names* (1961); an Academy obituary is in preparation, but for now see K.I. Sandred, 'Kenneth Cameron (1922–2001)', *Nomina* 24 (2001), 105–6.

INTRODUCTION 19

Stenton on Mawer's death in 1942 (and Stenton by Bruce Dickins (no. **XVIII**) in 1946, and he eventually by Dorothy Whitelock (no. **XXII**)).[41] The first two volumes (published in 1924) contained discussion of place-name elements,[42] and these were followed by a steady (and still continuing) flow of volumes dedicated to the place-names of individual counties.[43] To date some seventy-seven volumes have been published.[44]

Place-names throw valuable light on settlement patterns in England. But one important discipline, the significance of which could scarcely have been guessed in 1902, is medieval archaeology, and it is from this source that the primary evidence for the early medieval settlement of the British Isles now derives. Medieval archaeology as a modern scientific discipline dates in effect from the years following the Second World War;[45] and much of it, it must frankly be said, is carried on outside the Academy by local historical and archaeological societies and by impromptu rescue operations. But one excavation which caught the public's attention and no doubt inspired much later work in Anglo-Saxon archaeology was the discovery of the ship-burial at Sutton Hoo in Suffolk in 1939. The excavation was overseen by the then Director of the British Museum, Sir Thomas Kendrick (no. **XXI**); the full publication, which followed many years later, was undertaken by Rupert Bruce-Mitford (1914–1994).[46] Although the decoration of the metalwork excavated from Sutton Hoo is astonishing in its

[41] The English Place-Name Society was a research project of the Academy; for various aspects of its administration, see Wheeler, *The British Academy 1949–1968*, pp. 106–8.

[42] The first published volume was dedicated 'To the memory of Henry Bradley, greatest of English place-name scholars' (*Introduction to the Survey of English Place-Names*, ed. A. Mawer and F.M. Stenton (Cambridge, 1924). Bradley was to have written the General Introduction (see pp. vii–viii).

[43] For a brief account of the field in general and the Society's achievements in particular, see B. Dickins, 'The Progress of English Place-Name Studies since 1901', *Antiquity* 35 (1961), 281–5.

[44] Although the present paragraph is concerned principally with *English* place-names, it should be noted that there is extensive discussion of Celtic (especially Brittonic) place-names by Kenneth Jackson (no. **XXVI**) in his *Language and History in Early Britain* (1953). But on the whole Brittonic place-names have been less extensively studied than English place-names; and little has been done on Irish place-names in Ireland since Edmund Hogan's *Onomasticon Goedelicum* (Dublin and London, 1910): see *Progress in Medieval Irish Studies*, ed. McCone and Simms, pp. 142–3.

[45] There is a valuable overview by Martin Biddle, 'Medieval Archaeology in England', *ZAM. Zeitschrift für Archäologie des Mittelalters* 9 (1995), 105–16.

[46] R.L.S. Bruce-Mitford, *The Sutton Hoo Ship Burial*, 3 vols. (London, 1975–83). Bruce-Mitford was elected to the Academy in 1976; an obituary is in preparation by Martin Biddle. For now, see M. Biddle, 'Rupert Bruce-Mitford, 1914–1994', *Medieval Ceramics* 21 (1997), 119–22.

lavishness, much more can be learned about the Anglo-Saxons by studying more humble aspects of their daily life. John Nowell Linton Myres (1902–1989),[47] sometime Bodley's Librarian, pioneered the study of Anglo-Saxon pottery and showed that analysis of styles of Romano-British and Anglo-Saxon pottery, as set out in his *Anglo-Saxon Pottery and the Settlement of England* (1969), could revolutionize our understanding of the early Germanic settlements (his later publications—his two-volume *Corpus of Anglo-Saxon Pottery of the Pagan Period* (1978) and his narrative account of the early Germanic settlements of England (*The English Settlements*, 1986)—build on the achievements of the pioneering study of 1969).[48] J.K.S. St Joseph (1912–1994) pioneered the use of aerial photography in the identification of Anglo-Saxon sites.[49] Much important archaeological work has also been done on the prehistory of Wales. Sir Thomas Kendrick (no. **XXI**) produced, with C.F.C. Hawkes, a study of *The Archaeology of England and Wales* (1932), as well as an earlier study of *The Druids* (1927). Sir Cyril Fox (1882–1967),[50] who began his career in Cambridge under the direction of H.M. Chadwick with a dissertation on the archaeology of the Cambridge region, subsequently became Director of the National Museum of Wales and an authority on the Bronze age in that region; with Bruce Dickins he edited the collection of memorial essays for H.M. Chadwick (*The Early Cultures of North-West Europe*, 1950), and with Sir Frank Stenton he reissued his earlier survey of Offa's Dyke (1955). The crowning work of the career of E.M. (Martyn) Jope (1915–1996), one of the outstanding prehistoric archaeologists of the British Isles, was published posthumously in 2000: *Early Celtic Art in the British Isles* (2 vols.).

Closely dependent on archaeology are the disciplines of numismatics, because so large a proportion of early British and Anglo-Saxon coins is recovered through excavation, and art history, because the decoration of Anglo-Saxon metalwork provides a framework for the analysis of (for example) manuscript decoration. An understanding of coinage can provide valuable insight not only into the economy of Anglo-Saxon England, but also into its royal administration, and substantial numbers of Anglo-Saxon coins have been recovered. Sir Frank Stenton, for one, was fully

[47] A. Taylor, 'John Nowell Linton Myres, 1902–1989', *PBA* 76 (1990), 513–27.

[48] It must be said, however, that a pioneer who in many ways anticipated Myres' pioneering work was E.T. Leeds, *The Archaeology of the Anglo-Saxon Settlements* (1913; reprinted with an introduction by J.N.L. Myres, Oxford, 1970).

[49] D.R. Wilson, 'John Kenneth Sinclair St Joseph, 1912–1994', *PBA* 87 (1994), 417–36. St Joseph's identification of the royal site at Yeavering led to the exemplary excavation of B. Hope-Taylor, *Yeavering: An Anglo-British Centre of Early Northumbria* (London, 1977).

[50] S. Piggott, 'Sir Cyril Fox, 1882–1967', *PBA* 53 (1967), 399–407.

aware of the importance of Anglo-Saxon coinage, and had acquired his own collection (now deposited in the University of Reading). In 1956 the Academy established, under the Chairmanship of Sir Frank, a project to publish all English (including Anglo-Saxon) coinage, and the first of the magisterial series of its publications—the *Sylloge of Coins of the British Isles*—saw light in 1958.[51] More than fifty volumes have been published to date. Of the various scholars who served on the Academy's Committee and contributed to the understanding of Anglo-Saxon coinage, perhaps the greatest was Christopher Blunt (1904–1987),[52] who was the guiding light of the British Numismatic Society and the principal architect of the Academy's *Sylloge* project. His studies of the Cuerdale hoard, on King Æthelstan's coinage, and tenth-century English coinage in general (published in a collaborative volume, *Coinage in Tenth-Century England*, 1989) are regarded as landmarks in the field. In the field of art history, a knowledge of Anglo-Saxon and Viking metalwork evidently informs the work of Sir Thomas Kendrick (no. **XXI**), as may be seen from his *Anglo-Saxon Art to A.D. 900* (1938) and *Late Saxon and Viking Art* (1949). Francis Wormald (no. **XXIII**), although he had worked in the Department of Manuscripts in the British Museum and held at one time the chair of palaeography at King's College, London, was essentially interested in art history, and his many studies of manuscript illumination and line-drawing established a chronological framework for the interpretation of such decoration in manuscripts particularly of the late Anglo-Saxon period. This chronological framework established by Wormald is valuable in turn to students of the decoration of Anglo-Saxon metalwork. The best art-historical research combines the evidence of manuscript decoration with that of metalwork, as may be seen (for example) in the publications of C.R. Dodwell (1922–1994),[53] particularly his *Anglo-Saxon Art: a New Perspective* (1982), one of the most original and influential books in the field.

During the course of the early twentieth century it must have become increasingly clear to students of Anglo-Saxon England that, in order to understand the culture and society as a whole, it was necessary to have expertise in the wide range of disciplines that have been canvassed in the previous paragraphs. The undertaking to write a synthesizing history of Anglo-Saxon England necessarily implied command of all these disciplines. Not surprisingly, very few scholars can claim to have

[51] See Wheeler, *The British Academy 1949–1968*, pp. 116–20.
[52] See I. Stewart, 'Christopher Evelyn Blunt, 1904–1987', *PBA* 76 (1990), 347–81.
[53] Charles Reginald Dodwell (1922–1994), elected to the Academy in 1973; an Academy obituary is in preparation.

had (or do have) such command. But there were a few scholars, who are now rightly regarded as giants in the field, who did have such command; and although the individual disciplines have moved on, and indeed are still in motion, their scholarship remains valuable and unsurpassed. Of such scholars, Hector Munro Chadwick (no. **XI**) had all the philological skills necessary to interpret the languages and literatures of Anglo-Saxon England, including charters and place-names, but he also had a superb grasp of social institutions, of the way society and royal government functioned; and although he lived before the science of medieval archaeology had developed, he had some personal (if undoubtedly amateur) experience of excavation. Two books demonstrate the range of his control. *Studies on Anglo-Saxon Institutions* (1905) contains detailed discussion of the monetary system of early England (focussed not on coins but on monetary values as they can be deduced from written texts), of the social and administrative system as it can be deduced principally from the law codes, and of various aspects of land tenure and hidation. Because he had such thorough control of texts and documents, much of his discussion is as valid today as it was a century ago. In a second book, *The Origin of the English Nation* (1924), Chadwick treats the first few centuries of the English peoples, from the sixth century to the eighth; he analyses the philological and historical evidence for distinguishing Angles, Saxons and Jutes, and sets their social institutions in the wider context of Germanic peoples on the Continent during and after the Roman empire. And although archaeology can now illuminate the migrations in a way that Chadwick could not have glimpsed in 1924, it seems unlikely that the historical texts could ever be subjected to more searching and productive analysis. In a word, these two books of Chadwick moved the study of Anglo-Saxon society on to a new plane.

Whereas Chadwick came to Anglo-Saxon history by way of philology and literature, Sir Frank Stenton (no. **XIV**) was trained in Oxford as a historian, and cut his historical teeth working on post-Conquest materials such as Domesday Book. His interest in the Danelaw arose from these materials (and also from his family origins in Southwell), but he quickly realized the importance of (for example) place-names and charter evidence in the interpretation of Anglo-Saxon history; and these, in combination with his utter command of historical sources, put him in a position to write Anglo-Saxon history as it had never been written before. He worked for over fifteen years (amidst other distractions and occupations) on an integrated history of the period, and the first edition of his *Anglo-Saxon England* was first published in 1943. With the hindsight of fifty or more years it is possible to see ways in which he sometimes strayed from

his normal Olympian vision (as in his tart comments on the achievements of Norman culture at the time of the Conquest), and someone writing in 1943 could hardly be expected to realize the full implications of the discovery at Sutton Hoo, made only a few years earlier, to say nothing of the excavation of settlement-sites in years to come.[54] Yet there is no integrated study of Anglo-Saxon England which begins to approach it for accuracy of detail and accuracy of overall vision. Every sentence is clearly, often elegantly, expressed and laden with meaning. Even on topics at the periphery of his knowledge—let us say on the literary achievements of Aldhelm—what he writes is sensible and judicious. One wonders whether another book of this stature on the subject of Anglo-Saxon England could ever be written. In any event it transformed our knowledge of pre-Conquest England.

Dorothy Whitelock (no. **XXII**) had been a student of H.M. Chadwick at Cambridge, but later in life was drawn more closely to the guidance and inspiration of Frank Stenton. Her historical writing combines the best features of both masters. In *The Beginnings of English Society* (1952) she shows close (and deeply imaginative) control of literary texts, in the manner of Chadwick, but is able to ask searching questions about trade, finance and administration which are reminiscent of Stenton. Her massive *English Historical Documents c.500–1042* (first published in 1955, 2nd ed. 1979) is unmatched as an instrument of teaching and provides accessible translations of all the texts which are needed to provide illustration to Stenton's *Anglo-Saxon England*. A year later, in 1956, Peter Hunter Blair (no. **XXVII**), also a student of Chadwick, published his *Introduction to Anglo-Saxon England*. The book is inevitably overshadowed by Stenton's great volume, but it aims at a more modest form of presentation, and has much of value (particularly concerning the findings of archaeology) that is not to be found in Stenton; and this aspect of the book was enhanced in the second edition (1977; reissued with updated bibliography, 1995), which included a greater amount of illustration and treatments of subjects such as Anglo-Latin literature. Also in this prestigous company should be mentioned the work of Henry Loyn (1922–2000),[55] whose *Anglo-Saxon England and the Norman Conquest* (1962) is a definitive treatment of the social and economic history of Anglo-Saxon England.

[54] There are some penetrating evaluations of Stenton's book in *Stenton's 'Anglo-Saxon England' Fifty Years On*, ed. D. Matthew (Reading, 1994) (I refer particularly to the essays by James Campbell, Kenneth Cameron and Simon Keynes).
[55] An obituary for *PBA* is in preparation.

Brief mention should also be made of a number of scholars who made substantial contributions to our understanding of Anglo-Saxon history, though they were not dedicated Anglo-Saxonists: J. Armitage Robinson,[56] whose *Somerset Historical Essays* (1921) and Ford Lectures, printed as *The Times of St Dunstan* (1923), throw much light on the Anglo-Saxon church in the tenth century, especially on the reign of Æthelstan; David Knowles,[57] whose *Monastic Order in England* (2nd ed., 1963) still contains the fullest account of the tenth-century Benedictine reform movement in England; R.R. Darlington,[58] who was Sir Frank Stenton's first doctoral student and who devoted a number of penetrating essays to the English church in the eleventh century; and J.M. Wallace-Hadrill,[59] much of whose publication touched obliquely on Anglo-Saxon England (for example, *Early Germanic Kingship in England and on the Continent*, 1971) and whose commentary on Bede's *Historica ecclesiastica* goes some way towards supplementing and updating Plummer's great commentary of 1896. No doubt there are others.

One final aspect of the study of Anglo-Saxon England deserves mention. The early English antiquaries, in the sixteenth and seventeenth centuries, very often had access to manuscripts which have subsequently perished (notably at the time Henry VIII's dissolution of the monasteries in the 1530s, but also through negligence thereafter). Accordingly, a knowledge of the working methods of these antiquaries—John Bale, John Leland, Sir John Prise, Lawrence Nowell and others—is an essential adjunct to the study of pre-Conquest England. In many ways the best general introduction to the study of the English antiquaries is a brief book entitled *British Antiquity* (1950) by Sir Thomas Kendrick (no. **XXI**). But Kendrick's book needs to be supplemented by studies of individual antiquaries: the Gollancz lecture by Robin Flower (no. **XVI**) on Laurence Nowell (1935); studies of Humfrey Wanley and Lambard's *Archaionomia* by Kenneth Sisam (no. **XVII**); and one by N.R. Ker (no. **XXIV**) on Sir John

[56] See J.M. Creed, 'Joseph Armitage Robinson, 1858–1933', *PBA* 20 (1934), 297–308. The pages of this obituary concerning early English church history (pp. 306–7) were written by Sir Frank Stenton.

[57] See C.N.L. Brooke, 'David Knowles, 1896–1974', *PBA* 61 (1975), 439–77.

[58] R. Allen Brown, 'Reginald Ralph Darlington, 1903–1977', *PBA* 66 (1980), 427–37; cf. p. 431: 'Darlington's heart . . . lay first and foremost with the Anglo-Saxons, as Stenton's did in the years of his final maturity'.

[59] John Michael Wallace-Hadrill (1916–1985); an obituary for *PBA* is reportedly in preparation.

Prise (1955)—a subject Robin Flower had also worked on—as well as Ker's brief but classic essay on the migration of manuscripts from English medieval libraries in the wake of the dissolution (1942–3). And although John Mitchell Kemble (1807–1857) was in no sense a Renaissance antiquary, he was a great pioneer of Anglo-Saxon studies; and the best introduction to his life and work is to be found in a Gollancz lecture (1941) by Bruce Dickins (no. **XVIII**).

During the century of the Academy's existence, the darkest period in the history of the British Isles has been brilliantly illuminated by the Fellows of the Academy whose obituaries are contained in the present volume. Of course new techniques will inevitably provide new solutions to old problems: information retrieved from archaeological excavation grows at an unfailing rate, and the storage of such information in computer data-bases greatly facilitates its analysis; techniques of photography and digital enhancement are beginning to transform the field of palaeography; and computer data-bases have already revolutionized (for example) the making of dictionaries and the analysis of Anglo-Saxon charters. But for all these modern techniques, the net gain in overall understanding of the British Isles in the early medieval period is not likely to be significant, since as information accumulates the linguistic skills necessary to interpret it— knowledge of Latin and of the Germanic and Celtic languages—disappears at an alarming rate. The knowledge and linguistic skill of an H.M. Chadwick or F.M. Stenton, or of the many other scholars represented in this book, are not likely to be seen again. One can only think that it was an inexpressible privilege to have known even a few of them.[60]

MICHAEL LAPIDGE

[60] I am immensely grateful to Simon Keynes for guidance and encouragement throughout the preparation of this volume, and to Martin Biddle and Oliver Padel for help with various aspects of archaeology and Celtic studies respectively.

WHITLEY STOKES

I

WHITLEY STOKES

1830-1909

It has rarely fallen to the lot of any scholar to have been spared to devote himself to his chosen study for nearly sixty years, to have seen it emerge from infancy to manhood, and to be able to say that much of this development was due to his own exertions. This was the case of Whitley Stokes. Born on February 28, 1830, he was only 23 years of age when the *Grammatica Celtica* appeared. His own first publication on a Celtic subject—a paper on Irish Declension—dates from October, 1857. From that time onward to his dying day not a year passed in which he did not make one or several important contributions to Celtic scholarship. No other Celtic scholars—few scholars in *any* field of research—have left such a record of work behind them. And when it is remembered that all this was achieved while he won the highest distinctions in his professional career—that of Law—and did work there which alone would have sufficed to make a great reputation, it must be confessed that such energy, such devotion, have rarely been seen.

In was a favourable period in the life of the Irish nation into which Whitley Stokes was born. During the first quarter of the last century, immediately after the Union, the mind of Ireland was sunk in apathy and dejection, and a marked decline of intellectual vitality was seen everywhere. But in the period from 1830 to 1850 a reaction took place, and a singular development of energy in almost every department of mental culture, in art and literature, in science and learning, sprang up.[1] In the cultivated home of his father, the celebrated physician William Stokes (1804–1878), young Whitley early imbibed that love for literature, music and art, which he retained all through his life. At a later time he became the intimate friend of many well-known men of letters and artists: the Rossettis, Sir Theodore Martin, John Ormsby, Sir Frederick Burton, Sir Samuel Ferguson, and of distinguished scholars in the most varied branches of learning: Max Müller, Bühler, Windisch, Charles Tawney, Sir John Rhŷs, Sir Charles Lyall, and others.

[1] See *William Stokes, his life and work* in Hart's *Masters of Medicine*, 1898, p. 29.

He was fifteen years old when his grandfather, after whom he was named Whitley, died, a man of remarkable scientific attainments, Regius Professor of Medicine in the University of Ireland (1763–1845), and of such a noble and lovable character that even his political enemies spoke of him with admiration and almost with affection. Having studied and graduated at Trinity College, Dublin, he chose the legal profession. In any other country he would naturally have adopted an academic career in philology, for there lay his chief interest, as well as his most brilliant gifts. But in Ireland and England the study of philology had not yet been properly recognized by the Universities—it is hardly recognized even now—and could offer no prospect which would have satisfied his activity or ambition. Called to the Bar in 1853, he first practised as an Equity draftsman and conveyancer in London from 1855 to 1862, when he went out to India. Here in 1865 he was gazetted Secretary to the Legal Department, and in 1877 became Law member of the Council of the Governor-General, a post which he held until his retirement in 1882, when he returned to Europe. The rest of his life he spent in scholarly seclusion at his London residence in 15 Grenville Place and at Cowes and Camberley.

Stokes seems to have begun his Celtic studies in 1848, in his nineteenth year, while still an undergraduate at Trinity College. Here he also learned Sanscrit, and mastered Bopp's Comparative Grammar. The scholar who had the greatest influence upon him during these years of preparation was Rudolf Thomas Siegfried of Dessau, who came to Dublin early in the fifties, was made Assistant Librarian of Trinity College in 1855, and later on became Professor of Sanscrit and Comparative Philology. Siegfried had been trained at Tübingen in the best school of philological studies. An affectionate friendship soon united the two young men, and a new zest was imparted to their studies when in 1853 the *Grammatica Celtica* appeared.

At this time Stokes also found much sympathy in his studies from two native scholars, Curry and O'Donovan, to whom he often turned for information on modern Irish. When in 1856 he removed to London he kept up a constant correspondence with them. The following letter from O'Donovan, dated April 30, 1857, will be read with interest:—

'I met your father at Dr. Wilde's (the last day that the late Mr. Kemble dined out), and he told me that your steadiness, good conduct and highly honourable bearing had afforded him more happiness than he had for many years derived from any other source. This, I assure you, gave me much sincere pleasure, for although I have known, I may say, nothing of your history since you were about 13 years old, I had then formed a high estimate of your future

career. The only thing I then feared was the weakness of your eyes, which, I am told, is now completely removed. You, and the rising generation (young Ireland!), will completely throw us into the shade in the philosophical pursuit of Irish studies; but I must, as a sincere old acquaintance, entreat of you not to neglect your profession for any Quixottick study. I too was called to the Bar, but neglected it for favourite studies!! of little profit!!'

In London Stokes joined the Philological Society, in whose Transactions he published in 1859 his first text, *Irish Glosses from a MS. in Trinity College, Dublin*, signed W. S. It was not a critical edition, for which to the end of his life he did not believe the time had come, but a faithful transcript with all contractions marked in italics. In publishing this and other glossaries he wished to supply continental philologists with trustworthy material for their etymological researches. At this time Stokes had great hopes of a revival of philological studies in England. 'You have heard of Aufrecht's appointment to the chair of Sanscrit and Comparative Philology at Edinburgh,' he wrote to Siegfried in 1860. 'Now for a good English Philological Journal, with him as editor, Williams and Norgate as publishers, Wright and you, Lottner, Poole, Norris, Bühler and myself for contributors.'

In 1859 I find him working at Fiac's Hymn on St. Patrick, at the poem on King Aed of Leinster, the Lorica of Gildas and the Félire of Oengus. In the next year he published his first book, *Irish Glosses*, for which he received the Gold Medal of the Royal Irish Academy. On its publication Curry wrote to him: 'Of course the really valuable part of your book is quite beyond the range of my poor intelligence. Still I understand enough of it to satisfy me that it is the most remarkable book that has yet appeared among us on the subject of the ancient Irish language.'

In 1860 he was working at the Book of Deir, the oldest monument of Scottish Gaelic, the Irish MSS. in the Bodleian, and at Cornish. Now also he began his connexion with Kuhn's newly-founded periodical, the *Zeitschrift zur vergleichenden Sprachforschung*, in which appeared 'Bemerkungen über das altirische Verbum' and an article on the inscription of Todi.

By these publications, which betrayed the hand of the coming master, Stokes at once drew the eyes of all interested in Celtic philology upon himself. Scholars now everywhere looked to him for guidance in the maze of Celtic studies. He was the first—after Zeuss —to free Celtology from the discredit that had so long clung to it through the wild theories of Celtomaniacs and the inaccuracy of dilettanti. But for him and Heinrich Ebel there would have been no representatives of the Zeussian school during the sixties.

Pott, Diefenbach, Mone, Pictet, Schleicher, all welcomed his work

with delight. The latter wrote to him: 'Nur so weiter! und es wird im Celtischen bald ebenso hell werden, als es bereits auf manchem Sprachgebiete geworden ist, das vor wenigen Jahrzehnten noch völlig dunkel war.'

We may say that Stokes' Celtic work falls into two large sections: his grammatical, lexicographical, and etymological researches; and his editions and translations of Celtic texts, of Breton and Cornish, but more particularly of Irish, literature.

At one time it had been his intention to bring out a second edition of the *Grammatica Celtica*, an idea which he abandoned when he heard that Ebel was engaged on the same task.

His favourite pursuit was undoubtedly etymology. His *Urkeltischer Sprachschatz* still remains the standard book on the subject. It is the chief constructive work of his life.

While the name of Whitley Stokes the philologist is familiar only to the small circle of Celtic students and comparative philologists, his fame as an editor and translator of ancient Irish literature has gone abroad to a wider public. It is no exaggeration to say that but for his labours in this neglected field we should not now be in a position to gauge its extent or to know its merits. He had held this aim before him almost from the outset. Thus I find from his correspondence already in the fifties that he was thinking of an edition of the *Táin Bó Cualngi*, the largest and most celebrated epic of ancient Ireland. But he first served an apprenticeship, as it were, in editing less fascinating work, such as glosses and glossaries. Then in 1870 he opened his series of editions and translations of the masterpieces of ancient literature with the *Vision of Adamnan*. This was followed in 1876 by the *Death of Cuchulinn*, the *Martyrology of Oengus* (1880), and the Irish version of the *Destruction of Troy* (1881). On his return from India to Europe in 1883 he began at once to transcribe from the vellums in the great store-houses of Irish literature—the Bodleian, the British Museum, the Royal Irish Academy—all that seemed to him to call loudest for publication. Thus altogether about sixty longer and shorter tales, heroic and romantic, lives of saints, and religious poetry, were gradually edited and translated for the first time. One of the largest texts, an Irish version of Lucan's *Bellum Civile*, he finished during the last year of his life. The pen fell from his hand as he was writing the preface. His old friend, Professor Windisch, long associated with him in the publication of the *Irische Texte*, brought out the posthumous volume.

I must not pass over his contributions to another field of study, in which he had always taken the liveliest interest, Folk-lore. His

constant contributions on this subject to the *Academy* made both Celtic scholars and folk-lorists regret the cessation of that periodical. The wide range of his information may be seen from the titles: the legend of the oldest animals, on man octipartite, sitting *dharna*, on the compulsory fasting of cattle, on the effect of crime upon earth, on the employment of bees in war, heathen infant baptism, &c. It would be a useful undertaking and a fitting tribute to the departed scholar if the British Academy were to collect and bring out these scattered articles in a volume.

Stokes had the rare good fortune that his health and all his mental faculties remained unimpaired to the very end. A few weeks before his death, in the wretched light of a wintry day, he was able to decipher a dim passage in a manuscript, which would have tried much younger eyes. His marvellous memory, stored with the reminiscences of seventy years, was as fresh during the last year of his life as ever. He never repeated himself. On his death-bed he told his daughters an anecdote from his Indian life which they had never heard before. His interests and sympathies seemed to grow wider and deeper towards the end of his life, his affections stronger. His zest and delight in the discoveries of others as well as his own was touching to witness. He died on April 13, 1909, after a few days' illness, without pain, and thus we may pronounce him happy in death as in life.

<div style="text-align:right">KUNO MEYER.</div>

WALTER WILLIAM SKEAT

II

WALTER WILLIAM SKEAT

1835–1912

WALTER WILLIAM SKEAT WAS BORN IN London (on Mount Street, Park Lane) on 21 November 1835, the second son of William Skeat, a wealthy London architect, and his wife Sarah Black. From the age of two until approximately fourteen, the young Walter William's family lived at Perry Hill, Sydenham, at that time still situated in the countryside surrounding London. He attended King's College School in the Strand, where he was fortunate to have as his form-master the Rev. Oswald Cockayne (1807–73), one of the outstanding Anglo-Saxon scholars of the nineteenth century, whose *Leechdoms, Wortcunning and Starcraft of Early England*, printed in three volumes in the Rolls Series, 1864–6, contains editions of many texts, notably Bald's 'Leechbook', which have not been superseded during the following century and a half. From Cockayne Skeat learned his enthusiasm for the Old English language, and also (as he says himself) 'the notion of what is known as scholarship'. Among other scholarly activities, Cockayne was occupied in producing a dictionary of Old English, and had completed slips for the letters A to E (after Cockayne's death, the slips, together with many of Cockayne's books, were passed on to Skeat, and Skeat in turn passed the slips to T.N. Toller, a student of Skeat and sometime Fellow of Christ's College, Cambridge—Skeat's own college—and subsequently Professor of English in Manchester, who used them in his revision of Joseph Bosworth's *Anglo-Saxon Dictionary*, published between 1882 and 1898); so it might also be said that Skeat derived his first orientation in lexicography from Cockayne. In any event, he subsequently went to Highgate School (the school of Sir Roger Chomeley founded in 1565), where he spent three years (1851–4), during which time he gained, as he puts it, 'some notion of the excellence of English literature'—not so much by direct experience, but because passages of poetry were set for translation into Greek and Latin verse. But the headmaster at Highgate also had the apparently unusual idea of translating Latin poetry into English verse. Skeat's innate enthusiasm for the meanings of English words, particularly the diction of early English poets, was much enhanced by his years at Highgate.

In 1854 Skeat entered Christ's College, Cambridge, where he studied theology and mathematics. He numbered among his friends at Christ's Sir Walter Besant, John Wesley Hales (later Professor of English Literature at

King's College London) and John Peile (one of the early Fellows of the British Academy, whose obituary Skeat was himself later to write). Although he presumably spent much of his time at Christ's reading English literature, he took the mathematics tripos in 1858 and ranked respectably as fourteenth wrangler (that is, he ranked fourteenth of all those Cambridge students who took the examination in that year). As a result of this performance Skeat was elected a Fellow of Christ's (together with his friend Hales) in 1860. In the same year he took orders, and took up his first curacy at East Dereham, Norfolk. In 1860 he married Bertha, eldest daughter of Francis Jones, of Lewisham (London), and there were five children of the marriage, two sons and three daughters, of whom one son, Walter William, followed his father to Christ's and achieved some distinction in the Federated Malay States Civil Service (he is the author of various books on pagan magic in Malaysia), and one daughter, Bertha Marian, published *A Word-List Illustrating the Correspondence of Modern English with Anglo-French Vowel Sounds* for the English Dialect Society in 1884. His wife and children were all to survive him. (The distinguished papyrologist and New Testament scholar Theodore Cressy Skeat is Skeat's grandson.)

After two years at East Dereham, Skeat moved to a curacy in Godalming (Surrey), in order to be closer to relatives in London. Unfortunately, the climate of Surrey proved unsuitable for Skeat's constitution. He had an alarming attack of what he calls 'a diphtheritic character', which rendered him unfit 'for clerical work and made a long rest absolutely necessary'. He thus found himself in 1863, at the age of twenty-eight, in the desperate situation of finding his chosen career brought to a sudden end. But after a period of enforced recuperation, he was appointed, in October 1864, to a lectureship in mathematics at his old college, Christ's. It is difficult to form a clear notion of the responsibilities of such an appointment, but Skeat was delighted with it, because he only occasionally took pupils, which left him a good deal of leisure time to pursue his interests in Anglo-Saxon and Early English studies. (There was no financial need for him to take large numbers of students, since his father bought and furnished a house for him and the family in Cambridge, and provided him with a substantial income.) From this time begins the prodigious record of publication of Old and Middle English texts which mark Skeat as one of the great pioneers of medieval English studies.[1]

In 1858 the Philological Society of London had taken the momentous decision to prepare a *New Dictionary of the English Language*. In the first

[1] For an overall modern assessment of Skeat's achievement in the field of medieval English literature, see C. Brewer, 'Walter William Skeat (1835–1912)', in *Medieval Scholarship:*

instance, Herbert Coleridge and F.J. Furnivall were appointed editors. In 1859 Coleridge published a *Glossarial Index* to the printed English literature of the thirteenth century; but the result of this *Index* was to make it abundantly clear that serious work on the dictionary itself could not begin until the principal works of Middle English literature were available in printed editions. Accordingly, the Early English Text Society was founded by Furnivall in 1864: Furnivall assembled a list of subscribers who engaged to pay an annual subscription of one guinea apiece. The Society was thus able to pay the costs of publication, provided it could find enough 'patriotic editors' (Skeat's words) who would do the actual editing gratis. At this time, as Skeat recalls, 'my name was mentioned to [Furnivall] as that of one who was fond of Early English and had some leisure'; with the result that Skeat was asked to prepare an edition of *Lancelot of the Laik*. Skeat recalls: 'My objection, that I was unable to read a MS., was over-ruled on the grounds, first, that the sole MS. was always at hand in the Cambridge University Library; and secondly, that I could learn.' As far as learning to read the Cambridge manuscript was concerned, Skeat had the unstinting assistance of Henry Bradshaw, the legendary University Librarian. The edition was duly published in 1865, as the sixth in the original series of EETS editions. Skeat's knowledge of the Scottish dialect of the poem enabled him to introduce a number of emendations, and the publication of the text created a stir in learned circles, and showed both that the EETS meant business, and that Skeat was a highly competent editor. Accordingly, Skeat was urged to undertake a vastly more difficult, and more necessary task, namely a new edition of *Piers Plowman*. Skeat undertook this massive task by means of trial collations of various passages, which enabled him to identify textual affiliations and recensions (his identifications of the A-, B-, and C-texts of *Piers Plowman*, and the implied sequence of their composition, is still in force a century and a half later); the collations were published in 1866 as *Parallel Extracts from 29 MSS of Piers Plowman* (EETS o.s. 17), and the following year saw the publication of his edition of the A-text (EETS o.s. 28). He completed his edition of all three recensions by 1885, published in fascicles by EETS, and the whole was (re)printed by the Clarendon Press in two volumes in 1886 (*The Vision of William Concerning Piers the Plowman in Three Parallel Texts*).[2] And as if this publication were not a significant achievement for a lifetime, Skeat turned

Biographical Studies on the Formation of a Discipline. II. *Literature and Philology*, ed. H. Damico (New York and London, 1998), pp. 139–49.

[2] See C. Brewer, *Editing 'Piers Plowman': The Evolution of the Text* (Cambridge, 1996), pp. 113–78.

his attention to a host of other Middle English texts, nearly all published by the EETS: *The Tale of Melusine* (1866), *The Romance of William of Palerne* (1867), *The Lay of Havelok the Dane* (1868), John Barbour's *The Bruce* (1870–89), *Joseph of Arimathie* (1871), Chaucer's *Treatise on the Astrolabe* (1872), and eventually, after numerous other editions of Middle English texts, *The Complete Works of Geoffrey Chaucer*, published by the Clarendon Press in six volumes between 1894 and 1900.[3] There is no doubt that Skeat was one of the great pioneers in the editing of Middle English texts.

However, the concern of the present volume is with Skeat's contribution to the field of Anglo-Saxon literature. In 1867, Dr Joseph Bosworth, sometime Rawlinson Professor of Anglo-Saxon in Oxford, together with his second wife, Jane Elrington, had left to the University of Cambridge a sum of £10,000 for the endowment of a Professorship in Anglo-Saxon. The money was left to accumulate over a period of ten years, with the result that the post was only advertised and filled in 1878. Walter William Skeat was unanimously appointed the University of Cambridge's first Elrington and Bosworth Professor of Anglo-Saxon.[4] Skeat delivered his inaugural lecture in the Senate House, Cambridge, on 21 October 1878. In this lecture, entitled 'On the Study of Anglo-Saxon',[5] Skeat examined in detail a number of words which have survived from Old English into Modern English, in order to demonstrate the relevance of the study of Old English to understanding the modern tongue. But Skeat began his lecture by referring to the discovery of J.M. Kemble (1807–57), to the effect that some of the lines of Old English verse inscribed in runes on the Ruthwell Cross were also to be found in a poem in the 'Vercelli Book' (the

[3] See A.S.G. Edwards, 'Walter W. Skeat', in *Editing Chaucer: The Great Tradition*, ed. P.G. Ruggiers (Norman, OK, 1984), pp. 171–89.

[4] Skeat was appointed on the strength of testimonials from a number of eminent scholars, who, at the time he wrote his *A Student's Pastime* in 1896, were no longer alive: J.S. Brewer, H.O. Coxe (Bodley's Librarian), E.A. Freeman, Henry Morley, Richard Morris, R.C. Trench (archbishop of Dublin), Bernhard ten Brink, George Stephens, F.H. Stratmann, and Julius Zupitza. In his characteristically modest way, he goes on to thank, without naming, those scholars still living at the time he was writing who had written testimonials on his behalf (*A Student's Pastime*, p. lvi). One such person was evidently Henry Bradshaw, since a long and grateful letter by Skeat, sent to Bradshaw on 8 April 1878—that is, shortly after the election—survives, in which Skeat concludes by saying, 'it is merely and perfectly hopeless to say how much more I owe to you than to anyone else' (quoted by Edwards, 'Walter W. Skeat', p. 178). Skeat's edition of Chaucer is dedicated 'In grateful memory of Henry Bradshaw'.

[5] The lecture was printed in *Macmillan's Magazine* 39 (1879), 304–13.

poem is now known by its Victorian title as 'The Dream of the Rood'),[6] and goes on to say that Kemble's discovery 'furnishes a lesson on the value of patience, accuracy, careful collation, and minute care'. It is a lesson which Skeat himself learned and applied throughout his long tenure of the Elrington-Bosworth Professorship.

In the field of Anglo-Saxon literature, Skeat published several brief notes in *The Athenaeum* (one on the name 'Beowulf', one on the manuscripts of the Old English version of the gospels, and one on a riddle in Cotton Titus D. xxvii),[7] as well as two more substantial articles: 'On the Signification of the Monster Grendel in the Poem of *Beowulf*, with a Discussion of lines 2076–2100'[8] and '*Andreas* and *Fata Apostolorum*'.[9] But Skeat's principal contribution to Old English studies (apart from his work on etymology and lexicography, discussed below) lies in two massive editions, neither of which has been superseded a century and more after their first publication: a four-volume edition of the principal Old English version of the gospels, in their several dialects,[10] and a multi-volume edition of Ælfric's *Lives of Saints*.[11] The edition of the gospel versions was inherited by Skeat from a project conceived as early as 1833 by Kemble, but not completed during his lifetime; in Skeat's synoptic edition, the West Saxon version (called 'Anglo-Saxon' by Skeat) is printed in two parallel columns on each verso (from CCCC 140 and Bodleian Hatton 38 respectively), matched by two columns on the facing recto, from the Lindisfarne Gospels (Skeat's 'Northumbrian' version) and the MacRegol Gospels (Skeat's 'Old Mercian' version). Skeat's edition of the West Saxon version has recently been superseded by the more accurate two-volume edition by R.M. Liuzza (EETS, 1994–2000); but the value of Skeat's edition remains, in that all the surviving Old English versions of any particular biblical passage can

[6] J.M. Kemble, 'On Anglo-Saxon Runes', *Archaeologia* 28 (1840), 327–72; see discussion by B. Dickins, 'John Mitchell and Old English Scholarship, with a Bibliography of his Writings', *PBA* 25 (1941), 51–84, at 65–6.

[7] Publication details of these notes may be found in S.B. Greenfield and F.C. Robinson, *A Bibliography of Publications on Old English Literature to the End of 1972* (Toronto and Manchester, 1980), nos. 1808, 5779 and 6165 respectively.

[8] *Journal of Philology* 15 (1886), 120–31.

[9] *An English Miscellany presented to Dr Furnivall in Honour of his Seventy-fifth Birthday* (Oxford, 1901), pp. 408–20.

[10] *The Holy Gospels in Anglo-Saxon, Northumbrian and Old Mercian Versions, Synoptically Arranged: with Collations Exhibiting all the Readings of All the MSS.*, 4 vols. (Cambridge, 1871–87).

[11] *Ælfric's Lives of Saints: Being a Set of Sermons on Saints' Days formerly Observed by the English Church*, Early English Text Society, o.s. 74, 82, 94, and 114 (London, 1881–1900; repr. in two volumes, 1966).

conveniently be consulted at a single glance. In the case of Ælfric's *Lives of Saints*, Skeat's edition has not been superseded. Although editions of individual lives have been published from time to time, the collection as a whole must still be consulted in Skeat's edition, more than a century after its first appearance; and although scholars are well aware of defects in Skeats's edition (for example, that the manuscript on which the edition is principally based, Cotton Julius E. vii, does not represent either the orthography or morphology of Ælfric), no replacement is as yet in sight. It is rumoured that a large team of scholars is now contemplating the Herculean task which Skeat undertook and brought to completion by himself.[12]

From his schooldays, as is clear from his autobiographical *A Student's Pastime*, Skeat's principal scholarly interest was in English words, both their origins and their (changing) meanings. It was this interest in words which first led him to the Philological Society and to involvement in the Early English Text Society. As we have seen, the project to produce the *New English Dictionary* was conceived and promoted by the Philological Society, and Skeat will perforce have been involved in the early discussions. It was decided early on that the *NED* would provide brief etymologies for all words. As Skeat says in the preface to his *Etymological Dictionary*, 'it was chiefly with the hope of assisting in this national work, that, many years ago, I began collecting materials and making notes upon points relating to etymology'. His object was 'to clear the way for the improvement of the etymologies by a previous discussion of all the more important words, executed on a plan so far differing from that which will be adopted by Dr. Murray [editor of the *NED*] as not to interfere with his labours, but rather, as far as possible, to assist them'. As in the case of his many other projects, the compilation of a new etymological dictionary of English was a massive undertaking, and that he was able to bring it to completion shows what sort of single-minded application he possessed. In his obituary of Skeat, Kenneth Sisam remarked that, 'he would take part in a fireside conversation, all the while sorting glossary slips as tranquilly as a woman does her knitting.' By the same token, in the preface to the *Etymological Dictionary*, Skeat himself observes that, 'with many articles I am not satisfied. Those that presented no difficulty, and took up but little time, are probably the best and most certain. In very difficult cases, my usual rule has been not to spend more than three hours over one word. During that

[12] It must be said, however, that the greater part of the modern English translation, which in Skeat's edition accompanies Ælfric's text on facing pages, was prepared by Misses Gunning and Wilkinson, whose help Skeat readily acknowledges in his preface.

time, I made the best I could of it, and then let it go.' By such means Skeat was able to accomplish a task which today would involve dozens of workers. His *An Etymological Dictionary of the English Language* was published by the Clarendon Press in 1879, and a revised and enlarged edition issued in 1910.[13] It was a pioneering work in every respect; and although it has been superseded by more recent works (notably C.T. Onions's *Dictionary of English Etymology*, published posthumously in 1966 by the Clarendon Press), it is the indispensable foundation on which later works were able to build, among them the *New English Dictionary* itself.

A related project was Skeat's lifelong interest in English dialects. As the scientific study of the English language developed from the mid-nineteenth century onwards, scholars such as Skeat quickly realized that distinctive local dialects of English were in danger of being effaced by the spread of literacy and by the opportunities for travel and relocation which the railways offered. Skeat accordingly founded the English Dialect Society in 1873, and began the huge task of collecting dialect words for an eventual dialect dictionary. Amidst his other undertakings, the task of compiling such a dictionary was too large, even for Skeat. But Skeat was fortunate in having as a colleague Joseph Wright, who came from Yorkshire, and who in 1886 had compiled a grammar of his native dialect, which was published by the Dialect Society in 1892 as *A Grammar of the Dialect of Windhill in the West Riding of Yorkshire*. Because of his skill in phonetics (and his own vast energy, in which he rivalled even Skeat), Wright was asked by Skeat in June 1887 to edit the projected dialect dictionary. In 1891 Wright took possession of approximately a ton of materials (some million slips which had been collected by Skeat and others), and set about compiling the dictionary. The *English Dialect Dictionary*, edited by Joseph Wright, was issued in six massive volumes between 1896 and 1905. Although the final credit for this pioneering enterprise, which in the nature of things can never be repeated or superseded, belongs solely to Wright, the original inspiration was Skeat's.[14]

Another feature of Skeat's philological learning was his interest in place-names. At the time he first took up the subject, place-name study

[13] Skeat also issued a brief but valuable introduction to the science of etymology: *A Primer of English Etymology* (Oxford, 1892). He had evangelical zeal for the study of English, and was concerned throughout his life that the popular etymologizing which was practised be replaced by scholarly discipline founded on scientific principles. His last publication was a book entitled *The Science of Etymology* (Oxford, 1912).

[14] Skeat retained his interest in dialects to the end of his life. In 1911, the year before his death, the Cambridge University Press published his *English Dialects from the Eighth Century to the Present Day*.

was the province of amateurs; but largely through his efforts and those of his friend Henry Bradley, place-name study became a sound philological discipline, and was thus taken out of the hands of enthusiastic but untrained amateurs. Among his vast output, Skeat published between 1901 and 1913 some six volumes on place-names in the East Anglian counties (Bedfordshire, Berkshire, Cambridgeshire, Hertfordshire, Huntingdonshire, and Suffolk); and his approach to place-name study was later taken up by his student, Allen (later Sir Allen) Mawer, who with Sir Frank Stenton was one of the founders of the English Place-Name Society.

It is evident that Skeat's absorption in editing and publication must have left him little time to devote either to the administration of the university, or to his students. Yet he was among the first to urge on the University the establishment of a school of English (an undertaking which was finally brought to successful completion by his successor in the Elrington and Bosworth Professorship, H.M. Chadwick, in 1926);[15] already in 1880, in a letter published in the *Cambridge Review*, he was urging the creation of an English school in Cambridge.[16] In other respects, however, he was a less radical member of the University: on the question of the admission of women to the University, for example, he wrote: 'If given the B.A., they must next have the M.A. and that would carry with it voting and perhaps a place on the Electoral Roll; a vote for the University Livings and all the rest . . . I am entirely opposed to the admission of women to "privileges" of this character. And I honestly believe they are better off as they are.'[17]

When he was elected to the Elrington-Bosworth Professorship, Skeat noted that 'the chief result of my promotion has been that the work which was before a pleasure has now become, at the same time, a duty'. During his teaching career, Skeat typically offered as many as forty lectures a year on Anglo-Saxon subjects. He habitually lectured on Mondays and Wednesdays at 1.00 p.m. on elementary texts (usually from Sweet's *Anglo-Saxon Primer*) and on more advanced texts on Tuesdays and Thursdays at 12.00 (for which the set text was Sweet's *Anglo-Saxon Reader*). On rare occasions, judging from the Cambridge University *Reporter* (which

[15] The story of Chadwick's involvement in the creation of the English tripos is well told by E.M.W. Tillyard, *The Muse Unchained. An Intimate Account of the Revolution in English Studies at Cambridge* (London, 1958), pp. 41–7, 54–63.

[16] 'An English Tripos', *Cambridge Review* 1 (1879–80), 69–70.

[17] Quoted by R. McWilliams-Tullberg, *Women at Cambridge* (London, 1975), p. 89. It was perhaps Skeat's attitude to women which caused them to avoid (is it anachronistic to say 'boycott'?) his lectures; cf. the obituary in the *Times* (8 October 1912): 'The majority of the students of English at Cambridge are women, and they did not attend his lectures.'

has printed lecture lists since the early 1880s), he offered, for more advanced students, lectures on *Beowulf* running through three terms. Sometimes *Beowulf* was replaced with other texts: once the Old English prose 'Life of St Guthlac', once the 'Anglo-Saxon Chronicle', for which the text specified was Earle and Plummer's *Two of the Saxon Chronicles*. (One can assume that the teaching will primarily have been on philological matters; the level of historical commentary which Skeat attempted can perhaps be judged by the notice accompanying the announcement of the lectures on the 'Anglo-Saxon Chronicle': 'Students should also procure Freeman's "Old English History for Children".') In any event, especially in the early years, he seldom had many students ('in every year there have been some two or three'), which caused him to write to the *Cambridge Review* to advertise his lectures, and to advertise the fact that they are free: 'The lectures are entirely free to all members of the University, of whatever standing. It is impossible to make them more accessible than they are, thought they are but scantily attended.'[18] Skeat was not thought by contemporaries to be a great teacher,[19] but he continued to promote Anglo-Saxon studies with missionary zeal. The situation improved after 1886, when the new tripos of Medieval and Modern Languages was established, in which candidates could elect to offer papers in English (and hence, as a desirable propaedeutic, Anglo-Saxon). Numbers of students reading Anglo-Saxon subjects began slowly to increase. In the early 1890s there were, in addition to Skeat, two college lecturers—A.J. Wyatt of Christ's and H.M. Chadwick of Clare—who offered teaching supplementary to that offered by Skeat; but this arrangement was, by its very nature, an impermanent one. The matter was put on a more permanent footing by the creation, in 1896, of a University Lectureship to assist Skeat in the teaching of Anglo-Saxon. The Lecturer appointed was Israel (later Sir Israel) Gollancz, one of Skeat's former students at Christ's, who held the post until he was promoted to the Quain Chair of English in King's College, London, in 1906. The post was then filled by someone (G.C. Macaulay, later known for his editions of Gower) who did not offer teaching in Anglo-Saxon; but in 1910 H.M. Chadwick was appointed to

[18] Quoted from the *Cambridge Review* 1 (1879–80), 27, by A. Sherbo, 'Walter William Skeat (1835–1912) in the *Cambridge Review*', *The Yearbook of Langland Studies* 3 (1989), 109–30, at 114.
[19] Cf. the remarks of A.J. Wyatt in his obituary notice of Skeat: 'He was not a great teacher ... he left the teaching to those who had learnt from him; his teaching was episodic. Yet his lectures were eagerly followed by the fit though few; they were always interesting when least utilitarian, when he forgot examinations and syllabuses, and poured forth from the quaint storehouse of his motley memory things new and old' (*Cambridge Review* 34 (1912), 15).

Skeat's fledgling department of Anglo-Saxon, and offered teaching in Old Norse until the time he was appointed to the Elrington and Bosworth Professorship of Anglo-Saxon on Skeat's death in 1912. But by then Skeat had laid the firm foundation for the study of Anglo-Saxon in the University of Cambridge which during the course of the twentieth century achieved a position of international distinction.[20]

Skeat's single-minded absorption in his research created an impression of aloofness and unfriendliness, but to those who knew him well, the opposite was the case: he was perceived by Murray as 'a gentle, generous, optimistic man' who was 'extraordinarily humble. He early recognised the superiority of James' [Murray's] linguistic insight, and was always grateful for help and correction and apologetic about his mistakes.'[21] Henry Bradley noted in his obituary of Skeat that he was 'one of the most faithful and warm-hearted of friends.' Nevertheless, Skeat did not form many intimate friendships, either with colleagues or with students.[22] Among the older generation of scholars, he was devoted to Richard Morris (1833–94), Frederick Furnivall (1825–1910), and Henry Bradshaw (1831–86); among the younger, he was on affectionate terms with James Murray and Joseph Wright,[23] and especially with Henry Bradley. Among his students, he was most fondly remembered by Sir Israel Gollancz and by Sir Allen Mawer, who derived from Skeat his scholarly interest in place-names. Skeat's absorption also gave him something of the appearance of eccentricity (compounded by the fact that he was one of the first Cambridge dons to ride a bicycle, beginning as early as 1867): and late in life he was a familiar figure in Cambridge streets with his long beard and trailing gown.

Skeat's scholarly eminence was widely recognized by contemporaries. He was elected a Fellow of Christ's College in 1883. He was awarded the degrees of Litt.D. (Cambridge) and D.C.L. (Oxford). He was one of the

[20] Skeat donated his library of Anglo-Saxon books to his Cambridge department, including a complete set (as it then was) of the Early English Text Society's publications. This library still forms the core of the Anglo-Saxon, Norse and Celtic Department's library.

[21] K.M.Elisabeth Murray, *Caught in the Web of Words. James A.H. Murray and the 'Oxford English Dictionary'* (Oxford, 1979), pp. 85–6.

[22] Cf. the remarks of Wyatt: 'Though many of his pupils felt for him an almost chivalric admiration, there was hardly one whom he drew to himself with the bond of personal affection. He was easy of access; yet, in the deeper sense, inaccessible' (*Cambridge Review* 34 (1912), 15).

[23] A charming photograph of Skeat, Murray and Wright—the 'three dictionary makers'—dating from a period shortly before Skeat's death, is printed by K.M.E. Murray, *Caught in the Web of Words*, p. 333.

founding Fellows of the British Academy.[24] He lived a contented life, and produced a prodigious amount of scholarship,[25] much of which is still useful today, and much of which has yet to be superseded. He was unquestionably one of the great pioneers of Anglo-Saxon studies, as also of Middle English studies. He died peacefully at his home in Cambridge (2 Salisbury Villas, near the railroad station) on 6 October 1912, and is buried in St Giles' Cemetery on the Huntingdon Road, Cambridge.[26]

MICHAEL LAPIDGE

[24] See F.G. Kenyon, *The British Academy: the First Fifty Years* (London, 1952), pp. 9, 10 and 12.

[25] An anonymous obituarist in the *Cambridge Review* calculated that 'a complete collection of his works would extend to more than eighty volumes' (*Cambridge Review* 34 (1912), 27).

[26] No Academy obituary of Skeat was ever published, and perhaps Skeat himself intended that there should not be one; certainly he gave instructions that all his papers should be destroyed by his family after his death. After the lapse of nearly a century, there is no one now living who can have known him, and the present obituary has had to be compiled from his own writings (especially *A Student's Pastime*, the first part of which contains a long autobiographical account), and from secondary sources of various kinds. Brief obituaries were published at the time of his death (or shortly thereafter) by Kenneth Sisam (*The Dictionary of National Biography, 1912–21*, ed. H.W.C. Davis and J.R.H. Weaver (Oxford, 1927), pp. 495–6), Henry Bradley (*Modern Language Teaching* 8 (1912), 230–1), A.J. Wyatt (*Cambridge Review* 34 (1912), 15) and an anonymous obituary (*Cambridge Review* 34 (1912), 27). There is much useful material in modern studies of Skeat, notably J. McMurtry, *English Language, English Literature: The Creation of an Academic Discipline* (Hamden, CT, 1985), pp. 136–66 (who reproduces an excellent photograph, different from the portrait in the present volume, which was published first in *The Academy* for 15 July 1899), and esp. Charlotte Brewer, *Editing Piers Plowman*, pp. 91–112, whose account draws on papers still in the Skeat family.

SIR JOHN RHŶS

III

SIR JOHN RHŶS

1840-1915

WHEN the British Academy did me the honour to invite me to deliver the first "Sir John Rhŷs Memorial Lecture" the Secretary suggested that I might find it convenient to select a subject connected with some work of Sir John Rhŷs. I welcomed this suggestion; indeed, it seemed to me that the fittest theme for the inaugural lecture would be a general appreciation of the work of the scholar and Academician in whose memory the lectures have been founded. I promised the Secretary a long while ago to write such an appreciation for the *Proceedings* of the Academy; and I am glad now to have the opportunity not only to redeem that promise, but to be present here in person to pay my tribute to the memory of my old teacher. I have undertaken a difficult task: for days I have been struggling with the problem of how to compress into the compass of a single lecture any adequate, and at the same time clear, account of a life's work so voluminous and so many-sided. I will begin by recounting briefly the chief events of his life, confining myself to those that have some bearing on his work.

John Rhŷs was born in June 1840 in a cottage on a farm near Ponterwyd at the foot of Plinlimmon. His father's name was Hugh Rees; all the Rhŷses of Wales had tamely submitted to this mutilation of their name by English officials, except those who had adopted the French spelling *Rice*, which has come to be pronounced like the common noun *rice*. But John Rhŷs was a philologist from the cradle, and had the courage of his convictions; like Morgan Rhŷs, the hymn-writer of the eighteenth century, he adopted, early in life, the Welsh spelling of his Welsh name.

His father worked on the farm, and farmed a few acres of his own. The children had to help; but it became evident very early that John was not fitted by nature to be a farm-hand. At scaring crows and keeping the cattle from the corn he was an utter failure—he always had 'his head in a book'; so the farmer's daughter, a neighbour of mine, used to say many years later. So Hugh Rees, who was

himself a reader and had a small collection of Welsh books, allowed the boy, perhaps encouraged him, to follow his bent. At first the only educational facilities existing in the neighbourhood were classes, euphemistically called schools, held in farm-houses; young John attended and probably learned something at two of these; but the foundation of his life's work was laid by a weaver, one Dafydd Gruffudd of Wern Deg, who taught him the elements of Welsh grammar. When a British School was built at Ponterwyd, John became one of its first pupils; he did not remain there long, but left to attend a similar school under a better teacher at Pen Llwyn, about seven miles distant, where he became a pupil teacher. In due time he was admitted to the newly opened Normal College at Bangor, where he does not seem to have distinguished himself; in the pursuance of a course designed for the training of elementary teachers originality was perhaps a disadvantage. However, at the end of his two years' course he obtained his certificate, and was appointed master of a small British School at an out-of-the-way place called Rhos-y-ból, in the north of Anglesey.

Here he became known as a writer in the Welsh papers of letters and articles on the language and antiquities of Wales. He made the acquaintance of two clergymen of neighbouring parishes, the Rev. Chancellor Williams of Llanfair-ynghornwy, who is said to have given him some instruction in Latin and Greek, and the Rev. Morris Williams of Llanrhuddlad, a distinguished Welsh poet and Master of Arts of Jesus College, Oxford, who is said to have brought him to the notice of Dr. Charles Williams, the Principal of the College, when the latter was on a visit to Beaumaris in 1864. The history of these happenings is rather obscure; but the result was that the Anglesey schoolmaster was awarded a scholarship at Jesus College in 1865, and entered the College as an undergraduate in October of that year. In spite of his lack of early training he took a Second Class in Classical Moderations, and a First (said to be the best of his year) in Greats, which gained for him a fellowship at Merton College. He took his degree in 1869. During his vacations he had attended lectures at the Sorbonne and in Heidelberg, and had studied in the original manuscript the Luxembourg glosses, which he edited in the first volume of the *Revue Celtique* in 1872. In the year 1870 he studied in Leipzig under Curtius and Brockhaus; in 1871 he matriculated at Göttingen, but returned to Wales on being appointed Her Majesty's Inspector of Schools for the counties of Flint and Denbigh. He made his home at Rhyl; and before he left Wales again he had seen and studied on the spot nearly all the old inscribed

stones in the Principality. In 1874 he delivered at the University College, Aberystwyth, the series of lectures which formed the basis of his first book, *Lectures on Welsh Philology.*

When Matthew Arnold's reproach that at Oxford there was "no study or teaching of Celtic matters" was removed by the creation of the Chair of Celtic in 1877, all the authorities agreed that Rhŷs was the man to fill it; he submitted testimonials from Whitley Stokes, Prince Lucien Bonaparte, Nigra, D. Silvan Evans, Leskien, Curtius, Brockhaus, Schuchardt, Samuel Ferguson, D. R. Thomas, Hübner, U. J. Bourke, Ascoli, Robert Jones, d'Arbois de Jubainville, and Henri Gaidoz, the founder of the *Revue Celtique.* He held the chair until his death. In 1895 he was elected Principal of Jesus College. He was a member of the famous Departmental Committee of 1881, which gave Wales the University Colleges of Bangor and Cardiff; he acted as secretary or member of several Royal Commissions connected with Wales or Ireland; he served Wales on these bodies with a loyalty hardly realized by his fellow countrymen; and in particular, both as Commissioner and in other capacities, rendered invaluable services to Welsh education. He died suddenly, at his home in Jesus College, on the 17th of December, 1915.

John Rhŷs was the third great Welsh philologist. The statement sounds like a quotation from the *Mabinogion,* for it is the formula always used in referring to the triads. This seems to have struck M. Gaidoz, who had the *esprit,* as he says, to compose the appropriate triad, to be added to the triads of names:

 Tri doethion bro Gymru, dysgedig yn yr ieithyddiaeth Geltaidd: Gruffudd ap Robert, Edward Llwyd, ac Ioan Rhys.[1]

 'The three wise men of Wales, learned in Celtic philology: Gruffudd Robert, Edward Lhuyd, and John Rhŷs.'

Gruffudd Robert was a Catholic refugee in Italy in the 16th century. He published in Milan in 1567 a Welsh grammar written in Welsh,[2] in which he showed that a considerable number of Welsh words were derived from Latin. He compared these with their originals, and discovered that the Latin consonants underwent *regular* changes in Welsh; thus initial *v-* always becomes *gw-*: Latin *vīnum*, Welsh *gwīn*; medial *p* gives *b*: Latin *cupidus*, Welsh *cybydd* 'miser'; but after *r* it becomes *ff*: Latin *corpus*, Welsh *corff*; similarly *t* after *r* becomes *th*: Latin *porta*, Welsh *porth*; and so on, through all the

[1] *Revue Internationale de l'Enseignement,* 1917, p. 18.

[2] A page for page reprint made from the only two copies known to have survived (one in the British Museum and one less imperfect at Wynnstay) was issued in sheets as a supplement to the *Revue Celtique,* 1870–1883.

common combinations. Here, then, is the discovery made of *law* in sound-change—the root principle of comparative philology, which had to be re-discovered before a science of language became possible.

Edward Lhuyd's [1] *Archaeologia Britannica*, a large, closely printed folio of 460 pages, was printed at Oxford "at the Theater", and published in 1707. It consists of grammars and vocabularies of the Celtic languages, with a treatise on "Comparative Etymology", which contains remarkable anticipations of some of the methods and results of modern philology. The idea of development in language, which is usually traced back to Herder's *Ursprung der Sprache*, 1772, was laid down by Lhuyd in 1707 as the clearly defined principle which it was the object of his "Comparative Etymology" to prove. He describes "the division of a language into dialects"; it happens by what he calls "alteration", though he once suggests "deviation"—he is trying to find a term to express the exact idea which since Darwin is familiarly known by the technical term "variation"; dialects, he goes on to say, "by further changes growing unintelligible, become in time distinct languages". Here is the theory of development in a nutshell. To exemplify and prove it he compared the sounds of words which appeared to him to be cognate in Welsh, Irish, Latin, Greek, English, German, and the Romance and other European languages, and discovered some of the correspondences which, formulated more fully and correctly for Latin, Greek, and Germanic more than a hundred years later by Rask, and borrowed from Rask by Grimm, are now known as "Grimm's law".[2]

[1] *Lhuyd* was the spelling, in the phonetic alphabet adopted by him, of the name spelt in Welsh *Llwyd*, and in English modified to *Lloyd*.

[2] The following are some of Lhuyd's equations, with a selection from his numerous examples (his Welsh spelling normalized) :—

Latin *p* = German *f*: Lat. *piscis*, Ger. *fisch*; Lat. *pater*, Ger. *fatter*; Lat. *pes*, Ger. *fus*; Lat. *pedis*, Belg. *foet*, †Eng. *fot*, p. 19, col. c.

Welsh *p*, Greek π, Oscan *p* = Irish *k*, Ionic κ, Latin *qu*: W. *pa* 'what?' Ir. *ka*; W. *pen* 'head', Ir. *keann*, p. 20 *a*; Gk. πῶς, Ion. κῶς, etc.; Gk. ἵππος, Lat. *equus*, p. 20 *b*; Lat. *qui*, W. *pwy*; Lat. *quatuor*, W. *pedwar*; Lat. *quidquid*, Osc. *pitpit*, p. 24 *b*.

German(ic) *b*, Welsh *b* = Lat. *f*: Ger. *bruder* [W. *brawd*], Lat. *frater*; W. *brwd*, Lat. *fervidus*; W. *blodeu*, Eng. *blossom*, Lat. *flos*, pp. 20 c–21 *a*.

Greek, Latin, Welsh, Irish, Sclavonian *k* = Teutonic *h*: W. *cuddio*, Eng. *to hide*; W. *celyn*, Eng. *holly*; Gk. κύων, W. pl. *cŵn*, Lat. *canis*, Ger. *hund*, †Eng. *hunde*; Lat. *cor, corde*, Ir. *kroidhe*, Eng. *heart*; Lat. *centum*, W. *cant*, †Eng. *hund*, mod. *hundred*, p. 24 *a*.

These equations will perhaps be accepted as a sufficient justification of the above statement; as they are mixed up with others that are fanciful, and as derived and original sounds are confused, it is not claimed that Lhuyd discovered the *law* of Rask.

Rhŷs worthily completes the triad. His first published work, apart from fugitive letters in the Welsh weeklies, was a paper which he wrote before he left Rhos-y-ból, and which appeared in the *Transactions of the Philological Society* for 1865. The subject is "The Passive Verbs of the Latin and the Keltic Languages". The first and most important point dealt with is the Latin passive suffix *-r*. Bopp had explained it as representing the reflexive pronoun *se*, by rhotacism, or the change of *s* to *r*, which of course is common in Latin; thus *amatur* derives its passive meaning 'he is loved' through the middle 'he loves himself'. To this theory Rhŷs raises two objections:

(1) The pronoun *se* is third person; if *amor* comes from *amo-se*, it meant originally 'I love *him*self' instead of 'I love *my*self', as the theory requires. This objection does not settle the matter, because if the formation had come about in the third person it might have spread to the other persons by false analogy when its original meaning had been forgotten. This is, no doubt, what actually happened.

(2) The second objection is that the passive suffix *-r* is in common use in Irish and Welsh; and no such thing as the change of *s* to *r* is known in the Celtic languages. This is decisive; it was, in fact, the objection which ultimately proved fatal to the theory. Of course no notice was taken of it at the time. In my old school Latin Grammar, the fifth edition of Kennedy, 1879, I find, p. 181, the "passive personal endings are formed by agglutinating *se*".[1] Thus we were still taught in the eighties the theory which had been refuted by Rhŷs in the sixties.

Having thus disposed of the old explanation he proceeds to offer his own. The passive in Welsh and Irish is an impersonal; *cerir fi* is not really 'I am loved' but 'people love me', the exact equivalent in meaning of the French *on m'aime*. Now the French *on* is a reduction of *homme* from the Latin *homo* 'man'; and in German *man* itself is used in the same way. So he suggests that the ending *-r* is a reduction of *vir*, Welsh *gŵr*, Irish *fer* 'man'. This explanation is, of course, as erroneous as the other; but it shows a clearer perception of the direction in which the solution was to be sought. The starting-point has been found—it is the impersonal meaning of these *r*-forms: Welsh *molir fi*, Irish *moltar me* 'one praises *me*', not '*I* am praised'. This impersonal use is very common in Latin: "*sic itur ad astra*"—Latin *itur*, Welsh *eir* 'one goes'.[2] The suffix

[1] Cf. p. 58, where the supposed development of the passive conjugation is described in outline.

[2] On the impersonal use of the Latin passive see Ernout, *Mémoires de la Société de Linguistique de Paris*, xv. 273–333.

is found not only in Italo-Keltic but also in Indo-Iranian, where it is a third plural ending appearing in some tenses instead of the usual -*nt*. Sanskrit brings us pretty near the Aryan mother-tongue, and probably preserves the original value of the suffix. Thus the Welsh *dywedir* ' on dit ' is originally synonymous with *dywedant* ' they say '. ' They ', like ' we ', may be indefinite; the indefinite use of the third plural, as in ' they say ', is a natural and common way of expressing the impersonal meaning ' on dit ', from which the passive ' it is said ' differs only by a shade; and the fact that -*r* is a peculiar ending, not like -*nt* an obvious third plural inflexion, fully and satisfactorily accounts for its coming to be understood in the latter senses, and losing its definite third plural meaning.[1] When a formation has been thus traced to a suffix in the parent language it cannot be traced farther; the suffix -*r* is no more to be explained than the suffix -*nt*.

I look upon this first attempt of Rhŷs, in spite of its crudities, as a very remarkable feat. A young elementary schoolmaster, absolutely self-taught as a philologist, challenges one of the most widely received doctrines of historical grammar; shows that it is unscientific because it is not founded on comparison; and proves that by the test of comparison it falls to the ground. The comparison on which he insisted is now a commonplace of philology, and constitutes one of the strongest arguments for the close relationship of the Italic and Celtic languages.[2]

In the early seventies he continued the work begun by Gruffudd Robert, and made a systematic study of the Welsh words borrowed from Latin, the results of which appeared in a series of articles in the *Archaeologia Cambrensis* for 1873,-4,-5. The Latin element in Welsh

[1] The personal *r*-forms of the Latin passive and deponent and Irish deponent conjugation seem to have been developed out of a double 3rd pl. formation made out of the middle suffix *-*nto* and the parallel *r*-form *-*ro*, thus *-*nto-ro* or *-*ntro* (whence Latin -*ntur*, Irish -*tar*); when the pl. value of the *r* was forgotten a 3rd sg. was formed on the analogy of this, thus *-*to-ro* or *-*tro* (whence Latin -*tur*, Irish -*thar*, and the Old Welsh -*tor*, which can only come from the disyllabic *-*to-ro*); from the 3rd sg. the *r* spread to other persons. The only surviving *r*-forms in Welsh occur in the pres. ind. and pres. subj.; there is one for each tense, formed by adding -*r* directly to the stem. This is the equivalent of the original formation, and is found also in Oscan and Umbrian.

[2] Sommer, *Hdb. der lateinischen Laut- und Formenlehre*, 1902, p. 528. Pedersen has attempted to revive the old theory by making phonetic assumptions which are demonstrably untenable for Celtic, *Vergl. Gram. der keltischen Sprachen*, ii. 400 (1913). The discovery of the *r*-suffix in Tocharish proves it to be Indo-European, Meillet, *Bulletin de la Soc. de Ling. de Paris*, xxiii. 66 (1922). It occurs also in Armenian, see Iarl Charpentier, *Die verbalen r-Endungen der indo-germanischen Sprachen*, Leipzig, 1916, pp. 113 ff.

is of more importance for philology than loan-words generally are, because it consists of words borrowed into the British mother-tongue, and provides a considerable vocabulary in which the sound-changes by which British became Welsh can be traced. This field was worked so thoroughly by Rhŷs that he left little for his successors to discover in it.

His *Lectures on Welsh Philology* appeared in 1877, and in a revised and enlarged second edition in 1879. In this work he showed that the laws of sound-change revealed in the Latin element have operated over the whole vocabulary; he illustrated them from the remains of the British language—mostly proper names to be found in ancient authors, on coins, and in inscriptions: the inscriptions are dealt with in some detail. He traced the history of the Welsh sounds, and threw a flood of light on the initial consonant mutations which had seemed so mysterious a feature of the language. He compared Welsh sounds with Irish, and added Celtic equivalents to the list of Aryan correspondences. Of course he was applying established methods to new material; but discoveries are only made by the adoption of sound methods, and if every etymology and detail of phonetic change brought to light is to be accounted a discovery, this book teems with discoveries.

Of course he made mistakes—some big mistakes. He thought the British forms in Latin inscriptions of the sixth century represented the speech of the time, and post-dated the reduction of British to Welsh by several centuries. He stoutly held that the language of the Irish Ogam inscriptions was British; but it was not long before he saw his error here, and he corrected it in his *Celtic Britain*, which appeared in 1882, second edition 1884. In this work he brought his knowledge of the ancient British and Goidelic languages to bear on the ethnology and early history of Britain. It contains much philological matter that is still valuable, such as the numerous notes on Celtic names, though of course some of them need correction or revision.[1] But in his ethnology he was not so happy. He had adopted the theory, first propounded by Lhuyd, of the invasion of the island by two waves of Celts: first came the Goidels, or primitive Irish, and settled here; then followed the Britons, or primitive

[1] For example, the supposition that the *tt* of *Brittones*, which gave Welsh *Brython*, is more original than the *t* of *Britannia*, and the consequent absurd derivation of the name from the word which gave Welsh *brethyn* 'cloth', Irish *bratt*. It is now well known that "hypocoristic" doubling is common in proper names as well of tribes and places as of persons; cf. *Gallī* beside Γαλάται, and, for the exact form here (*Brittō*, pl. *Brittones*), Gk. Νικοττώ for Νικοτέλεια, etc.

Welsh, and drove the Goidels before them into Ireland and Scotland.[1] The Ogam inscriptions being now recognized by Rhŷs as Irish seemed to confirm the theory: he attributed them to the descendants of Goidels who had held their ground. Although the Ogam alphabet is a late Goidelic invention, and although the distribution of the stones points clearly to their being the monuments of settlers from Ireland, he clung to his view to the end. But I think it is now generally agreed that the theory has been definitely disproved by Zimmer, who vindicated the Irish tradition of direct migration from the Continent in his posthumous paper *Auf welchem Wege kamen die Goidelen vom Kontinent nach Irland?* published in 1912.

From his study of the ethnology of Britain Rhŷs was led further afield, and took part in the controversy concerning the cradle of the Aryans. He gave his adhesion to the European theory in a paper which appeared in the *New Princetown Review* for January 1888. He returned to the discussion of "The Early Ethnology of the British Isles" in his Rhind Lectures in 1890, and again in 1900 in *The Welsh People*, a composite work written in collaboration with Sir David Brynmor-Jones.

But ethnology was not the only subject of inquiry which drew him away from his studies in pure philology; he devoted even more time and thought to the subject of mythology. His Hibbert Lectures on *Celtic Heathendom* were delivered in 1886; but the matter was rewritten and much expanded before the book appeared in 1888. No literature in Gaulish or British has come down to us, and there is not much to say about historical Celtic gods and goddesses beyond their names and the rough identifications of them with Roman divinities made in inscriptions and in the works of Latin writers. But Rhŷs compared the oldest Irish and Welsh sagas, in which the heroes and heroines are degraded gods and goddesses; attempted to trace the mythology from which the tales had grown, and to reconstruct the Celtic Pantheon. Unfortunately he attempted also to explain the whole in terms of the solar myth theory, which in his undergraduate days, when Max Müller was a name to conjure with,

[1] Lhuyd's exposition of the theory is in his Welsh preface, *At y Kymry*, beginning at the bottom of the second page, where he explains that he derives it not from any recorded history, but from a comparison of the languages. "The old inhabitants of Ireland", he says, "were Goidels and Scots. The Goidels were old inha itants of this island [Britain], and the Scots came from Spain. . . . The Goidels anciently inhabited England and Wa es; . . . in my opinion they were most probably here be ore our coming into the island, and our ancestors drove them into the North," whence they ma e their way to Ireland. He goes on to say that this is news which no one has told before.

had seemed to be the clue to the interpretation of all mythology. His belief in the theory was shaken by the reception of the book, and in the preface to the supplementary volume, *The Arthurian Legend* of 1891, he half apologizes for continuing to use its terms:

> They are so convenient [he says]; and whatever may eventually happen to that theory, nothing has yet been found exactly to take its place.

I think the solid contribution to knowledge made in these volumes has been underrated by reason of this false theory of origins: they contain an enormous amount of material brought together from all manner of sources, much illuminating comment, and many sound comparisons; and for a long time to come they will remain indispensable to all students of the subject.

He began to collect Welsh folklore towards the close of the seventies. His collections appeared in *Y Cymmrodor* and in *Folk-Lore*, and were republished with some additions, and with his collection of Manx tales, in his *Celtic Folklore, Welsh and Manx*, which appeared in two volumes in 1901. He regrets in his preface that he did not commence his inquiries when he was a schoolmaster in Anglesey; but up to that date his education had been such, he says, as " to discourage all interest in anything that savoured of heathen lore and superstition"; and he " grew up without having acquired the habit of observing anything, except the Sabbath ". But " better late than *later*", as we say in Welsh;[1] he began early enough to make a great collection, much of which he himself rescued from oblivion. This unpublished matter he obtained "partly viva voce, partly by letter". The comment is valuable in spite of the unhappy intrusion of the ethnological theory in the last chapter;[2] and this work alone would have secured for its author a considerable reputation. Mr. Sidney Hartland refers to it as " the two precious volumes of *Celtic Folklore* ";[3] and M. Gaidoz believes it will survive all his other books because it is so largely of the nature of documentation, and while theories are for the time, facts are for all time.[4]

Rhŷs's ethnological and mythological researches in the eighties, together with his work in connexion with Royal Commissions, left him no time to follow up his brilliant early studies in pure philo-

[1] " Gwell hwyr na hwyrach."

[2] He was clearly unaware of the fact that his theory (that the Celtic fairies represented the aborigines) had been elaborated by David MacRitchie in *The Testimony of Tradition*, 1890, and that Mr. Sidney Hartland had briefly but conclusively answered MacRitchie in his *Science of Fairy Tales*, 1891, pp. 349-51.

[3] *The Transactions of the Honourable Society of Cymmrodorion*, 1914-15, p. 223.

[4] *Revue Internationale de l'Enseignement*, 1917, p. 201.

logy. With the exception of his *Outlines of Manx Phonology*, which appeared in 1894, and which is mainly descriptive, no purely philological work came from his pen after the publication of the second edition of his *Lectures on Welsh Philology* in 1879. He kept up his knowledge of the methods he had learnt, and of course of his own discoveries, by constantly applying them to the elucidation of names and to the interpretation of inscriptions. Epigraphy was the one subject which he never dropped; he would go anywhere to see a newly found inscribed stone; he was always interested in these monuments, and always finding something to write about them. The language of the British and Irish inscriptions was a subject which he had made his own, and on which he was undoubtedly the highest authority; but the continental Celtic inscriptions are older; they are written in dialects which perished, and their interpretation is still largely guesswork. In dealing with these in his last years, one feels that Rhŷs was using old tools which had become a little blunt; comparative philology had not stood still since he had ceased to make it the subject of his serious study. Yet his papers, which appeared in the *Proceedings of the British Academy*, are of great value for the full record preserved in them of his readings of these inscriptions, and for their wealth of Celtic learning.

I imagine Rhŷs possessed the most extensive knowledge of Celtic matters of any man who ever lived. Everything had come under his notice: words, idioms, names, tales, beliefs, customs, tribes, races, monuments; and he had a wonderfully retentive memory. Everything Celtic interested him—except one: for literature as literature he did not care. He never took the trouble to master the rules of Welsh poetry; he read Welsh verse not with an ear for its music, but with an eye for words and names. Welsh and Irish literature, especially of the oldest periods, he knew, and none knew better; but for him they were quarries in which he dug for his philological and mythological material.

His own works will long remain quarries in which Celtic students will dig; and he has paved the way for them by the provision of a full and accurate index to each of his books. When one knows what to look for, the information—the fact required—is generally to be found, whatever may now be thought of the theory which is there built on it. He himself never regarded a theory as more than a working hypothesis; and no one was ever readier to discard a theory when it was found not to be consistent with all the facts. To a tiresome person who had not followed the development of his ideas he once said in class, " My dear fellow, you ought to know that

I relinquished that theory many years ago." I sometimes think that if he had found it less easy to relinquish theories he would have taken more time and trouble to verify them before publication. But in his pioneer work new light was continually coming in, and he had to publish at some stage or not at all, as he explains in his preface to his *Lectures on Welsh Philology*. And there were other risks in delay. He lived for discovery, and had as it were to peg out his claims. Lest he should be forestalled he would often contrive some way to introduce his new find into something he was writing, with which it had nothing to do; he made no secret of this, and it accounts for many of the curious digressions that make it difficult to follow the argument in some of his books.

Sir John Rhŷs was an explorer of antiquity. When a question had been definitely settled, it ceased to interest him; he was led by the explorer's instinct to make discoveries in fresh fields. The more difficult and obscure the matter, the more it attracted him, as in the case of the Gaulish inscriptions. But in his lecture-room he naturally dealt with established results, including of course his own discoveries in Welsh philology; and some of his pupils in the late eighties believed that in the light of these the orthography of the Welsh language could be rescued from the hopeless confusion into which it had been thrown at the beginning of the century by a mad etymologist whom Rhŷs always referred to as "that charlatan Pughe". They had formed themselves into a Welsh society called "Cymdeithas Dafydd ap Gwilym"; the matter was discussed at its meetings, and a scheme was drawn up under Rhŷs's guidance, and published in 1888. It was received in Wales with derision, and labelled "Oxford Welsh". But after some modification it was adopted in 1893 by the Welsh Language Society for its schoolbooks; it was made familiar to Welsh readers in Sir Owen Edwards's publications; and now, after further correction of detail, it has become the recognized standard, and Welsh orthography is becoming as uniform as English, and of course much more rational. The root ideas were Rhŷs's, so that it may be said of him not only that he threw light on past periods in the history of the language, but that he made history by ushering in a new period.

For fifty years he pursued his studies with untiring diligence and with hardly a break. The total number of his books, articles, and papers must be very large: I have been able to mention only his more important works. He made for himself a great name, and the story of his discoveries will form a stirring chapter in the annals of Celtic learning.

Of the man himself I will say, in conclusion, that he was the most unassuming of men—genial, kindly, witty; and there was not one of his many friends who did not feel his death as a personal loss. In Wales, where learning is not without honour, he will live long in the memory of his countrymen as a great scholar and a great Welshman of whom they have every right to be proud.

HENRY BRADLEY *Elliott & Fry*

IV

HENRY BRADLEY

1845–1923

HENRY BRADLEY was the second chief editor of the *New English Dictionary* (he succeeded Sir James Murray in that post in 1915) and, even though he had the benefit of little formal schooling and of no university education whatsoever—he was entirely self-taught—he was regarded by all who knew him as a polymath, and was admired for the acumen of his expertise in languages ancient and modern. He devoted more than forty years of his life to work on the *Dictionary*, but somehow managed to find time to produce a substantial number of books, articles and reviews on an astonishing range of philological, literary and historical subjects.

Henry Bradley was born at Manchester on 3 December 1845, the only son of John Bradley, of Kirkby-in-Ashfield (Notts.) by his second wife, Mary Spencer, of Middleton-by-Wirksworth (Derbyshire), a gentle and somewhat delicate lady of a refined intellectual cast. John Bradley was a farmer who subsequently joined his two brothers in the ownership of a flour mill at Clowne in Derbyshire; but shortly after Henry was born, in 1846, the family moved to Brimington near Chesterfield. As a child Henry had taught himself to read upside down by observing his father reading lessons aloud to the family with a Bible open on his knees. (In later years he could astonish his friends by reading upside down as easily as rightside up.) In 1855 the precocious Henry entered Chesterfield Grammar School; one of his school-fellows later recalled that the delicate child was 'chivalrously protected from any roughness by the boys who, won by his superior mental gifts, his gentle manners, his patience, modesty, and courage under physical disabilities, had something of a hero-worship for him. Indeed the mass of his information, his inordinate love of reading, the excellence of his essays, and the ease with which he mastered his daily tasks seemed to our youthful minds uncanny.' Perhaps as a result of his physical frailty, the family moved in 1859 to Sheffield, where John Bradley had accepted the agency of a Staffordshire firm. In Sheffield, Henry, then aged fourteen, was billeted as companion and tutor to the sickly son of a local physician, Dr Lennard; while staying in Dr Lennard's house Henry was able to make use of the good library. His notebooks of the period provide an impressive index to the progress and interests of the developing polymath: facts of Roman history, scraps of science, lists of words peculiar to the Pentateuch and Isaiah, the form of the verb 'to be' in Arabic, cuneiform lettering,

Arabisms and Hebraicisms in the New Testament, rules of Latin verse, Hebrew accents, and a partial translation of Aeschylus's *Prometheus*; vocabulary-lists imply that he was also reading Homer, Vergil, Sallust and the Hebrew Old Testament. He evidently had an extraordinary natural aptitude for the study of languages.

The tutorship with the Lennard family lasted until 1861, at which time Henry found a similar occupation with another Sheffield physician. But it was clear that such arrangements could not constitute a career, and in 1863 he took a salaried appointment as corresponding clerk to Messrs. Taylor, a cutlery firm in Sheffield. The nature of his appointment allowed him to perfect his skills in writing French, German and Spanish, and during the lengthy period of his appointment with Messrs. Taylor—from 1863 until 1883—he also developed his skills in Greek and Latin as well as in the early Germanic languages, including Old and Middle English. On 9 April 1872 he married Eleanor Kate Hides, daughter of William Hides of Sheffield, by whom he had one son and four daughters. Before his marriage he managed to make several trips to the Continent, to France in 1867, and to Germany in 1870. It was during the early years of his marriage, while still working as a clerk for Messrs. Taylor, that he made his first venture into print, in an article entitled 'English Local Etymology' (printed in *Fraser's Magazine* for 1877, pp. 166–72), which was a devastating review of a book on English place-names by one Isaac Taylor. (Much to his credit, Taylor generously befriended his young adversary, and subsequently played a significant role in Bradley's academic advancement.) The study of place-names was then in its merest infancy, and was largely the preserve of amateurs with far-fetched and undisciplined notions of relationships between words. Bradley was one of those who helped to set the discipline on a sound scientific basis, and as Robert Bridges notes in his memoir of Bradley, 'though it was impossible entirely to quell the misguided conjectures of amateurs, he made it increasingly unwise and uncomfortable for anyone to indulge in them. His occasional later reviews of adventurous local experts or students for diplomas—for whom, as they wrote unsuspicious of danger, one must feel some commiseration—are the most diverting literature that the subject has produced.' Bridges continues: 'His castigations, even in the days when his authority was admitted, were not always suffered patiently; and though I do not think that his life was ever actually in danger, he received threatening letters, and I remember one victim whose objurgations he carried about with him for weeks in his pocket to show to his friends that they might share his wonder and amusement at the insensate fury that a simple philological statement could provoke. But they sometimes wondered at his pedantic delight in flogging

ignoramuses. Bradley, however, too well knew the hydra-headed vitality of error and the thick-skinned nature of conceit to feel any compunction in hitting hard.'

At this time too Bradley began to contribute brief articles on philological subjects to *The Academy*, on subjects such as the manumissions in the *Leofric Missal* (1882) and dialect in English place-names (1883). One such article, printed in *The Academy* in 1883, concerning the identity of the place-name *Trisanton* recorded by Ptolemy, won him the respect of a wide circle of scholars. These early publications in *The Academy* were a harbinger of his future career. In June of 1883 Isaac Taylor sent him to Oxford with letters of introduction to Sir John Rhŷs and A.H. Sayce, and through them he met in turn Gudbrandr Vigfusson, Kuno Meyer, Robinson Ellis and Henry Nettleship. And as scholars such as these were encouraging him to pursue his scholarship, the Sheffield firm which employed him (Messrs. Taylor), finding it impossible to sustain its overseas trade, reluctantly dismissed him with an honorarium of six months' pay. He by then had four children to support, and so was forced to seek new employment. He decided to try to make a living by scholarly writing, and accordingly moved with his family to London in January 1884. He went straightway to the offices of *The Academy*, where he was given the promise of work. Coincidentally, the first part of *The New English Dictionary* had been published on 29 January 1884, and Henry Bradley was given the opportunity of reviewing it for *The Academy*. His thorough and searching review was published in two instalments in *The Academy* (16 February and 1 March, 1884). The chief editor, Dr (later Sir) James Murray, recognized at once what an asset Bradley could be to the project, and he wrote immediately to Bradley offering him employment on the dictionary staff. Bradley did not at first accept Murray's invitation (though he agreed to contribute slips and advise on particular points), perhaps because it entailed leaving London for Oxford; instead, for the next five years, he remained in London, living hand-to-mouth by reviewing and journalism of various kinds. The temporary absence of the editor of *The Academy* (October 1884 until May 1885) led to a temporary appointment as editor of that journal, but had to be relinquished when the permanent editor returned from India. Applications for various secretarial positions (for example, of the Royal Asiatic Society) proved unsuccessful. In the meantime, he supported himself and his family by reviewing books on an amazing range of subjects (Bridges lists astronomy, biblical criticism, mathematics, conjuring, cookery, economics, philosophy, travel, and fiction).

It was during these years that Bradley wrote the volume entitled *The Goths* for Putnam's The Story of the Nations series, a substantial work of

some 400 pages. Although the format of the series was popular in intention, Bradley based his discussion wherever possible on primary sources. The publication brought some remuneration, and went through four editions between 1888 and 1902. Bradley will not have regarded publication in a popular format as beneath his station or dignity. Some years later, when there was no doubt that he was one of the world's outstanding authorities on the English language, he took considerable pains in expounding the history of the language in a popular and accessible format in his *The Making of English*, first published in 1904 and reprinted eleven times between then and 1925.

During the 1880s he was also occupied in the sort of lexicographical work which would subsequently be put to the advantage of the *New English Dictionary*. At the invitation of York Powell he undertook to revise Stratmann's *Dictionary of Middle English*. His revision was first published by the Oxford University Press in 1891, and reprinted on numerous occasions throughout the twentieth century. A glance at Bradley's original preface reveals both the vastness of the task, and his own dissatisfaction at what he was able to achieve. Stratmann's dictionary (published in its third edition in 1878) was scarcely a dictionary at all: the work's principal concern was with etymology, not with meanings of words; it was based on editions of texts printed in Germany and inaccessible even in the British Museum (as it then was); and examples were arranged according to grammatical form rather than sense. Bradley attempted to rectify these defects, above all by providing 'every word with an intelligible explanation in English'; and he enhanced the work by indicating (where possible) vowel quantities.

All the while, in the years following the publication of his reviews of the first part of the *New English Dictionary*, Bradley continued to compile slips for the dictionary, and it is clear that the dictionary was becoming the principal focus of his scholarly interest. During these years the *Dictionary* was encountering difficulties of its own, principally because the slow process of its preparation and publication failed to match the expectations of the Oxford University Press, particularly those of Lyttleton Gell, Secretary to the Delegates of the Press. Repeated exhortations to Murray to expedite publication bore little fruit, because Murray insisted that all proofs needed to be passed by him. The Delegates' solution was to appoint a second editor who would work independently of Murray and would have the responsibility, like Murray, of producing one fascicule of 350 pages per annum. Bradley was asked to submit a sample of his independent work (on the letter B) to Murray, and with Murray's approval, he was appointed as second Editor on 4 November 1887. An alcove in the Large Room of the British Museum was fitted up for him, with one assistant

working in London and two in Oxford. From that point until his death in 1923, the *New English Dictionary* was Henry Bradley's main occupation.

From this time onwards, Bradley's scholarly stature grew commensurate with his ability and learning. He served as President of the Philological Society from 1890–3 (and again from 1900–3 and 1909–10). In 1891 he received the honorary degree of M.A. from Oxford University. In 1892 he was granted a Civil List Pension of £100 (subsequently raised to £150), and, through the exertions of Dr Furnivall, was given a grant of £200 from the Royal Literary Fund. These awards must have helped to relieve the pressures under which he worked (he suffered a complete breakdown in 1892, for example); and as his responsibilities with the *Dictionary* increased, it became more appropriate for him to work in Oxford in proximity with Murray. Accordingly, in 1896, he and his family moved to Oxford, where he was installed in the North House of the Clarendon Press and was given a house rent-free. He was elected a 'member' of Exeter College in that year (we should now say that he was given 'dining rights'), and began to live the life of an Oxford don (with the exception that he did not teach undergraduates, though he did participate in examinations from time to time).

During his years in London, Bradley had contributed numerous entries to Letters B, C and D of the *Dictionary*; but it was especially during his Oxford years that very substantial progress began to be made, to the point that, when James Murray died in 1915, Bradley was his obvious successor as Chief Editor. The first volume which came out entirely under Bradley's editorship was vol. III (the Letter E). Thereafter, he produced vols. IV (FG), VI (LM), VIII (S–SH), IX (ST), and X (W—WEZZON). It has been calculated that the volumes produced entirely under his editorship total some 4,590 pages, which amount to approximately one-third of the total of 15,487 pages which make up the *New English Dictionary*. The steady pace of production, and the prodigious range of his learning, mark out these volumes, and, as Sir William Craigie (his successor as Chief Editor) observed, they 'gave opportunity for his unusual qualifications as a scholar—his extensive knowledge of ancient and modern languages, his thorough grasp of philological principles, his retentive and accurate memory, and his rare powers of analysis and definition . . . This was most evident to those who knew him most intimately, and by personal contact could realize that under a quiet and unassuming manner he possessed intellectual powers which transcended the ordinary bounds of scholarship and partook of the brilliancy of genius.'

Recognition for his achievement with the *Dictionary* came with the publication of volumes compiled under his editorship, the first of which, vol.

III (beginning with the letter E) was published in 1891, extending through publication of vol. IV (FG in 1900), and beyond. He was elected to the British Academy in 1907. In 1914 he was awarded the degree of D. Litt. from Oxford, and two years later, in 1916, was elected to a Fellowship at Magdalen College. Had he lived to bring the *New English Dictionary* to completion, he would no doubt have been given the knighthood which was bestowed on his predecessor James Murray in 1908, and was subsequently to be bestowed on his successor, Sir William Craigie, who brought the whole enterprise to completion (saving supplements) in 1928 and was knighted in that year.

Much of Bradley's life's work was undoubtedly absorbed into the *New English Dictionary*. Such work by its nature is necessarily anonymous, at least in detail: it is not permissible for an editor to sign his name to this or that brilliant etymology, or discovery of an ante-dating, or elegant simplification of a complex mass of data. But in spite of the anonymity of the *Dictionary*, there is no doubt about the range and penetration of Bradley's learning, which is evident in his many publications, some of which are reprinted in his collected essays (*The Collected Papers of Henry Bradley* (Oxford, 1928)). Although many of his articles are brief (and many were published either in *The Academy* or *The Athenaeum*), the range of learning which they embrace is astonishing: Arabic and Hebrew (including emendations to the Hebrew text of the Psalter), Greek inscriptions, Celtic philology, Scandinavian languages, Latin language and literature (including Anglo-Latin authors such as Aldhelm, Abbo of Fleury, etc.), Old and Middle English language and literature, and much more.

Various concerns predominate. One of these concerns was place-names. It is entirely fair to regard Bradley as one of the great pioneers of the scientific study of English place-names. Although the subject was finally put on a permanent foundation in the works of scholars of the succeeding generation, such as Sir Allen Mawer and Sir Frank Stenton, it was Bradley and the scholars of his generation, notably Walter William Skeat, who demonstrated that place-name study was a scientific, philological discipline, and not the province of uncontrolled and amateur guess-work. As we have seen, Bradley's first scholarly publication (in *Fraser's Magazine* for 1877) was a plea for philological discipline in place-name study; and throughout his career he published a substantial number of articles (plus many book reviews) on subjects such as 'Dialect in English Place-Names' (1883), British place-names in Ptolemy (1883, 1885, 1892), the ancient name of Manchester (1900), prehistoric river-names (1901), 'English place-names' (1910), and many more (place-name studies, including some of those listed above, constitute approximately one-quarter of the essays

republished in his *Collected Papers*). The pioneering quality of his work on place-names was acknowledged by Mawer and Stenton, who in 1924 dedicated the first published volume of the English Place-Name Society 'to the memory of Henry Bradley, greatest of English place-name scholars'.

It was a characteristic of Bradley's genius that he loved to solve literary puzzles. For example, his essay on Abbo of Fleury's *Quaestiones grammaticales* (*PBA* x (1921–3), 173–80)—which, presumably, attracted Bradley's attention because of Abbo's comments on the way Anglo-Saxons pronounced Latin—shows that the incoherence of the text as printed by Angelo Mai from a Vatican manuscript can be readily explained by the assumption of an exemplar in which the sequence of quires had been dislocated (and this conjecture was subsequently confirmed by the discovery of a manuscript in the British Museum in which there was no such dislocation). Another problem which attracted his attention, and was similarly explained by resort to hypothetical exemplars, was that of the numbered sections found in manuscripts of Old English verse (notably *Beowulf*, the Junius Manuscript and the Exeter Book). In a lecture delivered to the Academy in 1915 on 'The Numbered Sections in Old English Poetic MSS.' (*PBA* vii (1915–16), 165–87), Bradley suggested intriguingly that the numbers were taken over by scribes from numbered slips of parchment on which the poet had written out his poem. Although Bradley's hypothesis is discredited by today's students of Old English literature (most of whom have never handled a manuscript), it has never been convincingly refuted, and deserves fresh consideration. (It is also worth noting that Bradley's lecture was the first on an Old English subject delivered to the Academy, and is thus the forerunner of the Gollancz Lectures established after the death of Sir Israel Gollancz in 1930.) Another piece of Bradley's ingenious problem-solving may been seen in his article on the so-called 'First Riddle of the Exeter Book' (*Collected Papers of Henry Bradley*, pp. 208–10), a poem which immediately precedes the corpus of Old English riddles in the Exeter Book and which had been taken by various German editors (notably Moritz Trautmann) to be a riddle having the answer 'riddle'. Bradley showed that the poem is 'not a riddle at all but a dramatic soliloquy' by a woman concerning her lover Wulf and her husband Eadwacer. Since Bradley's time the poem has been known as 'Wulf and Eadwacer' and is now a fixed feature of Old English syllabuses.

Although he had very little time to pursue it, Bradley was a gifted textual editor and critic. Like most of his contemporaries in the field, he contributed an edition to Furnivall's Early English Text Society publications (in Bradley's case, the edition combined his skill in Middle English with his knowledge of French): *Dialogues in French and English by William Caxton* (EETS

e.s. lxxix (1900). He had a particular genius for textual emendation (which is problem-solving of a particular kind): many of his publications consist of incisive notes on difficult and disputed passages, especially in Old and Middle English, but also in Hebrew, Latin and Greek (the seventeen notes republished in his *Collected Papers*, pp. 237–57 give some indication of his powers as textual critic). Such was his brilliance in this domain that Arthur Napier, a formidable textual critic in his own right, was unwilling to publish any emendation to an Old English text if Bradley did not approve it.

Bradley's published work gives some impression of the vast breadth and precision of his learning. But the modest way in which this learning was combined with human warmth and penetrating intelligence may be felt directly from his posthumously published correspondence with Robert Bridges (*Correspondence of Robert Bridges and Henry Bradley, 1900–1923*, 1940). Bridges, the Poet Laureate (from 1913) was by origin a classicist, and much interested in classical metres and their adaptation into English verse. Bradley's letters to Bridges are a wonderful treasury of pointed observations *inter alia* on Greek and Latin scansion: 'Clearly, metrical quantity in Greek & Latin was not exactly determined by the duration of the syllable in natural pronunciation, for *strigilem* with its 3 initial consonants is homometrical with *agilem*'; 'I fancy Plautus probably could have written Greek verse quite correctly by ear, and his Latin verse may have been acoustically correct on Greek principles, though his rules of position did not coincide with the Greek rules'; 'I think Cicero was quite right as to the lengthening of the vowel before *nf* and *ns*. What happened seems to have been this. Before an open consonant we are not organically compelled to finish our *n*, as we are when it comes before *t* or *d*. In this position, therefore, in slovenly pronunciation, the *n* is liable to become shorter and shorter. But the habit of giving a certain relative amount of time to the whole syllable remains; and as the *n* gradually disappeared, becoming before disappearance a mere nasal affection of the end of the preceding vowel, the vowel would pari passu be lengthened . . . that vowels were lengthened before *ns* appears from Greek transcriptions like κῆνσος, Κωνσταντῖνος, Κλήμης for Clemens', etc. It beggars the imagination to think how someone who had little formal schooling, and had spent his formative years as a clerk in a cutlery firm, could have acquired such mastery. So it appeared to Bridges, who wrote soon after meeting Bradley: 'I enjoyed my talks with you immensely. I wonder how many of those who talk etymology with you have read Spinoza. It is delightful too to meet with anyone who reads both Spanish and Greek. Your general "erudition" amazes my small faculties.'

Bradley was able to accomplish as much as he did, not only because of his discipline and determination (to say nothing of his genius), but because

all his scholarly effort was underpinned by a completely happy home life. Robert Bridges comments that, 'Love and care for his children made the deepest of his emotions, and his chiefest thought was for their welfare . . . His own mutual married attachment never fell below its first ideal; and indeed his wife's devotion and courage were more indispensable to him and a stronger support than her delicate health would appear to lend colour to.' Bradley, too, had delicate health, and suffered occasional breakdowns, but to his great pleasure he and his wife were able to celebrate their golden anniversary on 9 April 1922. But by then he himself recognized that his intellectual powers were beginning to fail, and the following year, on 21 May, he collapsed of a stroke on the sofa in his study, pen in hand and at work writing letters, and he died two days later on 23 May 1923 without gaining consciousness.[1]

<div style="text-align: right;">MICHAEL LAPIDGE</div>

[1] No British Academy obituary of Henry Bradley was ever published, and after the passage of eighty years it is scarcely possible to base a memoir on the memories of those who knew him in person. The preceding pages have been drawn principally from the brief obituary by W.A. Craigie in *The Dictionary of National Biography, 1922–1930*, ed. J.R.H. Weaver (London, 1937), pp. 103–4; from Robert Bridges, 'A Memoir', in *The Collected Papers of Henry Bradley* (Oxford, 1928), pp. 1–56; and from incidental references to Bradley in K.M.E. Murray, *Caught in the Web of Words: James A.H. Murray and the 'Oxford English Dictionary'* (Oxford, 1979), *passim*. Interesting light is thrown on Bradley's character in the correspondence between him and Robert Bridges (1844–1930), O.M., Poet Laureate from 1913: *Correspondence of Robert Bridges and Henry Bradley, 1900–23* (Oxford, 1940).

CHARLES PLUMMER *J W Thomas*

V
CHARLES PLUMMER
1851-1927

CHARLES PLUMMER was born at Heworth in Durham County, the youngest of a long family; his father, the Rev. Matthew Plummer, being vicar of the parish. The associations of the neighbouring towns, Wearmouth and Jarrow, with Bede had an influence in determining the course of his subsequent studies.

One of his earliest recollections was the return of a soldier-brother from the Crimean War, and the family rejoicings thereat: in Sidmouth, where they were then residing for his father's health.

He first went to school at St. Michael's, Tenbury; which took such a hold upon him that to the last year of his life he never missed attending Commemoration there. Next, he was sent to Magdalen College School, Oxford. After rapid progress up the School he won a scholarship at Corpus in March 1869, and came into residence in the following autumn. His two Firsts followed in due succession; and in 1873 he was elected to a Fellowship, one of the last under the old Statutes, which imposed celibacy as a condition of tenure. Remaining single, he held his Fellowship for the rest of his life, so that he lived in College continuously for fifty-eight years—a position which under new conditions will barely be possible again.

In 1873 the number of Fellows was seventeen, with three Professors besides; of undergraduates about sixty. The Fellows were under no obligation to reside, and no doubt many of them were absentees; but even so, there cannot have been many rooms available for undergraduates. The dispensation by which they were allowed to live in lodgings had been adopted a few years before.

On his election Plummer began immediately upon a course of wide reading, and collected a considerable library

of texts. From 1875 to 1883 he held a Lecturership in Modern History; but in spite of his capacity for mastering any subject he took up, he did not enjoy teaching, and he retired into the secluded life of a student, busying himself with the work of writing history. Besides this he was first Assistant Chaplain and then Chaplain, an office in which he felt very earnestly his obligations to the religious life of the undergraduates.

His first considerable publication was a revised text of Fortescue's *Governance of England*, 1885: next a volume of reprints about *Elizabethan Oxford*, 1887, one of the earliest volumes of the Oxford Historical Society, to which he subscribed from the beginning. After this he helped Professor Earle in revising *Two Saxon Chronicles*, 1892–9.

In 1896 appeared the two volumes of his most eminent work, an edition of Bede's *Historia Ecclesiastica Gentis Anglorum*; equipped with introductions and copious notes. The book was dedicated to the undergraduates of the College, among whom he had a very large number of closely attached friends. Its index, planned by him, has served as a model to larger undertakings.

When the millenary celebrations of Alfred came in 1901, Plummer with his knowledge of Anglo-Saxon history, was marked out to address Oxford on the subject, and was specially invited to undertake a course of the newly founded Ford Lectures. This work occupied him through the summer, and was marked by his careful thoroughness, in sifting the difficult evidence. The lectures, in spite of this, were bright to hear and to read, enriched with his wide knowledge of literature.

For a time, 1891–8, he acted as College Dean, and was most successful in his conduct of that difficult office; often showing consummate wisdom. While able to be firm at need, he used the opportunity to throw himself into the undergraduate life of the College. With his quick sympathy, he knew everybody and understood or divined their wants: and there can have been few undergraduates of

those years who had not reason to be grateful to him not only for warm friendship, but also for well-chosen gifts. One owed to Plummer his first sight of the sea—an unusual possibility in England; another, who was saving on his battels, found a cheque awaiting him with a request that it should be used to make them rise. To another a considerable loan; to another the use of his rooms in the Long Vacation. Gifts of books of all sorts; and sumptuous breakfasts or dinners in his rooms, when the table was drawn out to its longest, to receive a party of fifteen to eighteen friends, all delighted to be there and their host as merry as any one. Or he would take one or two in a canoe, down from Burford to Oxford, or from Oxford to London; when the young arms did the paddling and he 'did the rest'. He was fond of walking tours abroad, with parties of one to three. One year he came out to Freiburg, where I was learning German, and carried me on into the Black Forest, for three weeks' walking: to Himmelreich, and up the Höllenthal to Titisee, and Schluchsee, and St. Blasien, and finally to Laufenburg and Basle. His early-rising (to attend church services)—we often shared a room—and abstinence, even after all-day tramps, put the 'average sensual man', as he called me, to shame. I learnt from him lessons of courtesy to innkeepers, and general politeness; also the principle of exploring a region thoroughly and seeing all that it had of interest instead of dashing about to show-places, wide apart and quite unconnected with each other. German and French he spoke fluently. His conversation was always interesting, with a large fund of stories; and he would often shorten the kilometres by quoting long staves of poetry: the *Church at Brou* was one of his favourites.

In 1902 Plummer entered upon a new phase of his life. Having resigned the Deanship, he withdrew into a quasi-retirement, seeing little more of the men than was possible in a lunch and an afternoon walk—his method of making acquaintance with the Freshmen one by one. His studies turned away from Anglo-Saxon to Celtic. He had thought

first of Welsh; but soon realizing its limitations he turned to Irish. Lives of the Irish Saints, first in Latin and then in Erse, were henceforward the objects of his studies; and his holidays were spent in Dublin, at work in libraries and making many friends, or wandering upon the West Coast.

For human interest he now looked to the Poor Law School at Cowley of which he had been for some years a Guardian. In course of time, as the consequence of his devotion to the children, he became Chairman of the School Committee, and used that position to care for the boys as he had done for the undergraduates. By great exertions and personal generosity he got a new chapel built: but his greatest work was in after-care, as it is now called. He found places for the boys—some as far afield as the Scilly Isles—fitted them out, and kept in close touch with them, writing monthly letters to all parts of the world, keeping their banking accounts and, when possible, visiting them. Their relations in Oxford, too, he put upon his list for occasional visits; that he might send news of them to Australia or Nigeria or the Indian frontier or to H.M.S. ——, China Station. From all parts of the world letters came to those rooms high up in the Fellows' Buildings; accompanied by photographs or books of views or 'curios'.

The keynote of his life was to take as little as he could for himself, in order to have the more to give to others. And so he continued to the end, always giving. By his will he left his library to the College, after the disposal of certain important collections which he had formed, the Celtic books to Jesus, the Icelandic to Christ Church, a set of French Chronicles to the University of Louvain, some of his manuscript notes and 'slips' to the Irish Academy, others to the Bollandists. The residue of his estate he devoted to the same purpose as the Oddie Trust, a purpose which he had much at heart—the assistance of undergraduates in want.

In thinking of Plummer one thinks specially of him in Chapel. He was at every service, Sundays and weekdays,

morning and night, throughout the Term: and on Sunday evenings he played the organ, with a little cushion set for him to kneel on, upright, at the step of the Chapel entry. Any one who kept an evening chapel on a week-day might see that gallant little figure, noways bowed with age, marching up to the lectern to read the lesson; and on return, pulling himself up to his seat with a hand on either side, while he began upon the *Nunc Dimittis*.

The Oxford custom by which the congregation begins the next Psalm, if the previous one has ended uneven, often left him with the last verse of all, before the final *Gloria*. Those who shared these daily orisons with him, will long hear his voice stressing Coverdale's cadences: 'with Thy favourable kindness wilt thou defend him as with a shield'; 'when I wake up after Thy likeness, I shall be satisfied with it'; 'doubtless there *is* a God that judgeth the earth'; 'that they may show how true the Lord my strength is, and that there is no unrighteousness in *Him*'.

<div align="right">P. S. A.</div>

These personal recollections may serve as a prelude to critical estimates of his scientific work, kindly contributed by the two scholars most competent to judge, Professor Stenton of Reading, and Dr. Best of Dublin:

THERE can be no doubt as to the importance of Plummer's work on Old English history. We owe to him the first modern critical text of the *Historia Ecclesiastica* of Bede, an edition of the Old English Chronicle which has greatly helped all later students, and a life of King Alfred in which for the first time historical and literary materials were combined to give the impression of a living personality. The whole of this work was marked by the same general qualities. Plummer was interested in individuals rather than in the development of Old English society or the details of early law, and it was in the illustration of character and environment that his learning was most happily

employed. The Introduction to the *Historia*, which is his most remarkable piece of continuous writing, is the portrait of a scholar rather than a critical estimate of his work.

His work on the *Historia Ecclesiastica* is his chief contribution to Old English studies. He established the chief groups of manuscripts, and carried through an elaborate series of collations. Although he took no account of an eighth-century manuscript of the History, then in the Imperial Library at St. Petersburg, it is unlikely that his text will be materially affected by future work. His editions of the Epistle to Archbishop Egbert and the Lives of the abbots of Wearmouth and Jarrow by Bede and an anonymous contemporary, which follow his text of the *Historia Ecclesiastica*, may fairly be called definitive. Their value only increases the regret that he did not add to them a critical text of Bede's lives of Cuthbert and the anonymous *Vita Cuthberti*.

In the Old English Chronicle Plummer was faced by problems of a different character. He was no longer dealing with the set composition of a single historian, nor even with the productions of a definite group of scholars. The Chronicle gave no opening for his faculty of tracing the operation of a single mind in a group of cognate works. He was interested in the relations of different versions to each other, and his tables of affiliations will be the basis of any future work in this field. But they are in no sense final. To some important materials, notably the Latin translation of the Chronicle by the ealdorman Aethelweard, Plummer gave little attention, and he declined to enter into the question of the sources which were available to the Alfredian chronicler. But it will be long before analysis has done its final work on the Chronicle, and Plummer showed for the first time the complexity of the problems which such analysis must attempt to solve.

It is probable that many of those who use Plummer's editions of the *Historia Ecclesiastica* and the Chronicle, value them even more for their notes than for their text. He was a generous annotator, with an extraordinary range of reading,

and some of the references which he used for the illustration of Bede's writing are a little disconcerting in their remoteness from the world of this ancient scholar. Nevertheless, it is hard to overestimate the service which his notes have rendered to those working in recent years on Old English history. He knew charters as well as chronicles, Irish and Icelandic as well as Old English literature. And the apposite illustration was never far from his mind.

His work on Old English history was virtually completed in 1902, when he published his Ford Lectures on the *Life and Times of Alfred the Great*. The more recent investigation of this period has run on other lines than those natural to him. He was not interested in Old English philology, and the student will not go to him for guidance in matters of chronology or of diplomatic. He confessed to impatience with the technicalities of Old English law, and his identifications of places mentioned by Bede or in the Chronicle are often untenable. But his work is that of a scholar to whom Old English history was always a humane study, and its essential distinction remains.

<div style="text-align: right">F. M. S.</div>

PLUMMER began his Celtic studies under the late Sir John Rhŷs; and later on he spent some summer vacations at Greifswald, working with Heinrich Zimmer, who was some months his junior. The personal instruction he received from these eminent masters is gratefully acknowledged in the preface to his *Vitae Sanctorum Hiberniae*. From the outset he would appear to have devoted himself to Irish hagiology, which was then to a large extent a neglected field. Accordingly, the first fruits of his Irish studies was an edition with translation of the Irish text on the 'Conversion of Loegaire and his Death', preserved in the Book of the Dun, which he had read in class with Rhŷs, and which appeared in 1884 (*Revue Celtique*, vi). This was followed a year later by some 'Notes on the Stowe Missal' (*Zeitschr. f. vergl. Sprachforschung*, xxvii. 441–8), in which he cleared up several obscure

passages in the Old-Irish tract on the Mass. For twenty years no further contribution to Celtic studies appeared over his name. He seemed to have dropped altogether out of the ranks. In this long interval, however, he was engaged in the preparation of his edition of Bede, and in those other Anglo-Saxon studies already referred to. These happily brought to completion, Plummer was free to devote himself to the task which was to occupy him for the remainder of his life, namely a Collectanea of the lives of Irish saints, both Latin and Irish.

It was a great and arduous undertaking, involving not only years of silent toil in the amassing of material, visits to libraries both at home and abroad, in the transcribing and collating of manuscripts, weighing and sifting their evidence, but in addition a mastery of medieval Irish, the want of which has proved a stumbling-block to so many writers on Irish history. Plummer read widely in Irish literature, both religious and secular, devoting himself particularly to the study of the vocabulary, which in the absence of those lexicographical aids such as other languages possess, constitutes the main difficulty in the study of Irish. The collection of slips which he formed for this purpose, ranging over the entire field of medieval Irish literature is a remarkable testimony to the sureness of his method and his patient industry. Few other scholars had so complete an apparatus at hand. This fine collection has now by the kindness of his executor passed to the Royal Irish Academy, where it will be a valuable aid in the production of the Irish Thesaurus at present in course of preparation.

Two critical studies entitled 'Some new light on the Brendan legend' and 'On two collections of Latin lives of Irish saints in the Bodleian Library' (*Zeitschr. f. Celt. Philol.* v, 1904–05); a translation of the *Cáin Eimíne Báin* (*Ériu* iv 1908); and an edition of the Irish *Betha Faranndin* (*Anecdota from Irish MSS.* iii, 1910), were the forerunners of his *Vitae Sanctorum Hiberniae*, 2 tom., Oxonii, 1910. Nothing quite comparable to these two volumes had appeared since

Colgan's *Acta Sanctorum Hiberniae* and *Trias Thaumaturga* in 1645-7, and Fleming's *Collectanea Sacra*, 1667. In the preface Plummer modestly expressed his satisfaction in the thought that he had done 'something towards carrying out the great design at which Colgan and his associates laboured with such pathetic fidelity amid the storms of the seventeenth century,' . . . 'striving amid poverty and persecution and exile, to save the remains of their country's antiquities from destruction'. The lives of no less than thirty-two saints are included, twelve of which had not before been published. They are edited from three manuscript collectanea in Dublin, Oxford, and Brussels, and with that accurate scholarship that one expected of the editor of Bede. In an introduction of nearly 200 pages Plummer treats of the manuscript sources from which the individual lives are derived; their character and mode of composition, their relation to one another, both Latin and Irish—a *Quellen-kritik* that had not before been attempted; an account of the social life of the people, monastic and liturgical practices, &c.; and finally, what was altogether new and perhaps venturesome, the heathen folk-lore and mythology in the lives of Celtic saints. It is precisely in this concluding section of his learned prolegomena that critics of the most opposite views have found least satisfaction, holding that he pushed too far the solar myth theories of Max Müller and his master Rhŷs. Still, it remains with its wealth of illustration a most valuable contribution to the folk-lore of ancient Ireland. In the copious glossaries and indexes not a few place-names are identified for the first time. His labour on the Latin lives was concluded by the *Vie et Miracles de S. Laurent, Archevêque de Dublin*, edited from the Cod. Kilkenniensis (*Analecta Bollandiana*, xxxiii, 1914).

Having disposed of the Latin lives, to which it may be said all his other Irish publications are supplementary or in great measure accessory, Plummer set to work on the Irish lives, for which he had been accumulating material

all along. The text was sent to the printer in 1914, and the manuscript of the entire work was completed down to the Preface by the end of the following year; but owing to the outbreak of the war and its after effects, the *Bethada Náem nErenn* or Lives of Irish Saints did not see the light until 1922. In the interval appeared the Irish text with translation of the 'Miracles of Senan' (*Zeitschr. f. Celt. Philol.* x, 1914). The two Irish volumes contain the lives of ten saints, in seventeen different texts, all save two hitherto unpublished, and corresponding with nine of the Latin lives, though quite different compositions: lives that were mere translations of the Latin having been omitted. They are edited mainly from O'Clery's collectanea preserved in the Royal Library in Brussels, and are accompanied by translations. As in the former volumes, the sources of the individual lives are discussed at length, and the whole is enriched with valuable notes and indexes.

In a volume entitled *Miscellanea Hagiographica*, published by the Société des Bollandistes in 1925, as No. 15 of the *Subsidia Hagiographica*, Plummer edited and translated the Irish lives of three saints, omitted from the *Bethada* as being lives of secondary importance, two of them 'not favourable specimens of Irish hagiography'. To these he appended *A Tentative Catalogue of Irish Hagiography*, a work by which he has laid all students under a deep obligation. The need of such a guide as a complement to D'Arbois de Jubainville's *Essai d'un Catalogue de la littérature épique de l'Irlande* had long been recognized. Plummer's work made no claim to completeness. It was based on the materials made for his own use during many years without any idea of publication. The actual compilation occupied him only three months. It is divided into six sections, and indicates the manuscript sources, with incipits and explicits, printed editions of both Latin and Irish lives, tracts of various kinds, hymns, historic poems, calendars, martyrologies, Irish lives of non-Irish saints, indexes of manuscripts, etc. A few months later his work on the Irish saints was fittingly brought to a close

by a volume of *Irish Litanies* (Henry Bradshaw Society, vol. lxii), upon which he had been at work since the beginning of 1915. It contains thirteen beautiful compositions, nine in prose and four in verse, all the products of private devotion, as he felt it necessary to warn his readers, and edited from various manuscripts with translations and notes.

While his Irish Lives were languishing in the press, Plummer turned his attention to the ancient Brehon Laws, of which the published edition and translation offered ample scope for critical study and emendation. He saw that only by a careful comparison of parallel passages could progress be made in this 'dark and tangled wood'. In his 'Notes on some passages in the Brehon Laws' (*Ériu*, viii–x), he succeeded in correcting the official translation in many places, and solved the meaning of a number of obscure legal phrases, upon the right interpretation of which whole groups of passages depended. In an illuminating paper 'On the fragmentary state of the text of the Brehon Laws (*Zeitschr. f. Celt. Philol.* xvii, 1927), which did not appear until after his death, he put forth the suggestion, supported by examples, that the chaos of Irish legal literature is largely to be explained by the fact that in much of it we have merely the debris of the oral teaching in Irish law schools, as might be found in various lecture notes of students, often taken down in a desperate hurry.

His study of the laws also led him in a short paper 'On the meaning of Ogam stones' (*Revue Celtique*, xl, 1923), to advance the view that these standing stones were not in every case set up as sepulchral monuments, but frequently as boundary stones, constituting title to the possession of lands.

Two short papers, published in 1925, are worthy of mention: 'Notes on some passages in the Thesaurus Palaeohibernicus of Stokes and Strachan' (*Revue Celtique*, xlii) and 'Addenda et Corrigenda to the Glossary of Du Cange' (*Bulletin Du Cange*, i).

Fellows of the Academy need not be reminded of his

charming contribution to these Proceedings on the 'Colophons and Marginalia of Irish scribes' (1926). The spirit in which he himself worked could not be better exemplified than in his account of the beautiful prayers with which it concludes.

R. I. B.

ARTHUR NAPIER *Bassano*

VI

ARTHUR SAMPSON NAPIER

1853–1916

ARTHUR SAMPSON NAPIER[1] was born on 30 August 1853, the eldest of the nine children of George William Napier of Merchistoun, Alderly Edge, Cheshire, a house named after the ancestral Edinburgh home of the Napiers of Merchiston, but not because of any established connection with them. His mother was the daughter of Sampson Bridgwood of Lightwood Lodge, near Longton, Staffordshire, china and earthenware manufacturer. George Napier was in the cotton-spinning firm of Napier and Goodair of Preston and Manchester, and died in 1884. He was a book-collector of some importance. That his son, throughout and beyond his boyhood, had a family home full of black-letter books may have been influential.[2] Napier was at school at Rugby (Arnold's house) and went from there in 1871 to Owens College, Manchester, with an Entrance Exhibition to read chemistry, a subject likely to be useful to one intended for business. A business career for him was still the intention when he left Owens College in 1873, with a first in the London University B.Sc.: Henry Roscoe wrote to him on 5 December to say he was sorry that the claims of business would prevent a promising pupil doing research.[3] In fact he was

[1] In attempting to give some facts about Napier fifty years after he died I have been much helped by letters and papers in the English Faculty Library (EFL), the Bodleian Library (BL), and the Oxford English Dictionary Archive (OEDA). These are no substitute for personal recollections. I have been fortunate to have had letters about Napier from three people who knew him well, although, it should be remembered, at a time when he was not as young as he once was and after the great years of *Old English Glosses* and the fight for the Honour School: from Kenneth Sisam, who came to Oxford as a Rhodes Scholar in 1910 and was Napier's assistant from January 1912; from Mrs. Somerset, formerly Miss Rubie Warner, who attended his lectures from 1905; and from Mr. Harold Napier who was twenty-six when his father died. Dr. Sisam sent me extensive notes in February and April 1966 and in July 1967. Mrs. Somerset wrote down her recollections for me in February 1966. I had letters from Mr. Harold Napier in May 1966 and later. I am very much in their debt. I owe special thanks also to Miss Margaret Weedon and her staff in the English Faculty Library, to Mr. R.W. Burchfield and his secretary, Mrs. Blackler, at 40 Walton Crescent, Oxford, the present headquarters of the Oxford English Dictionary, and to Mr. D.G. Vaisey, the Deputy Keeper of the University Archives.

[2] The books, 2396 lots, were sold at Sotheby's 22–29 March 1886. There is a good deal about them in the obituary of George Napier on the back page of the *Alderley and Wilmslow Advertiser*, 19 Dec. 1884 (copy in EFL).

[3] Letter in EFL.

awarded a science scholarship at Exeter College, Oxford, spent 1874–7 there reading chemistry, and got a first in the Final Honour School of Natural Science in 1877. At Manchester and Oxford he learned German—Hamann says in his testimonial that he taught him for four years—and he visited Germany and had a term of the academic year 1876/7 in Göttingen 'to pursue chemical experiments'. He also learned Norwegian and went for walks in Norway in vacation. At Oxford he went to Max Müller's lectures and to Earle's. As a result, instead of being in business, he was in the spring of 1878 a lector in the English department of the University of Berlin under the great Anglo-Saxon scholar, Julius Zupitza. In 1879 he married Mary, daughter of James Hervey, J.P., The Whins, Alderley Edge. In 1882 the dissertation on which he had been working under Zupitza was accepted by the University of Göttingen for the degree of Ph.D. Its publication brought him an immediate reputation in Germany and with Zupitza's backing he was made an 'ausserordentlicher Professor' of English at Göttingen. The first three of his five children were born in this German period, which lasted until the summer of 1885. In the spring of that year (7 March), the newly created 'Merton Professorship of English Language and Literature' at Oxford was advertised. Zupitza urged Napier to go in for it. Eighteen professors, all but three of them continental, one ex-professor (Stubbs), Furnivall, Hamann—formerly Taylorian Teacher of German at Oxford—, Augustus Jessopp, and four Fellows of Exeter College, Boase, Bywater, Franell and Tozer, wrote testimonials in his favour.[4] Probably Zupitza and Stubbs carried most weight. Jessopp put the matter conveniently in a few words: 'If the new Chair is intended to be a Chair of English Philology, first and foremost', then Napier's claims are preeminent. On 27 May the electors[5] were unanimous and on 10 June Napier wrote from Göttingen accepting the appointment.

EFL has much material from April, May, and June 1885. There are about 100 letters to Napier and drafts in his hand of letters he wrote to the authorities at Göttingen and at Oxford, and to his supporters, Furnivall and Zupitza. There are also drafts of what must have been difficult letters to Sweet. Sweet had written twice to Napier, 5 June and 9 June, and was to write again 15 June, in reply to the letter Napier wrote to him on 12 June. I quote from the letters of 9 June and 15 June because of what

[4] *Testimonials in Favour of Arthur S. Napier* (Göttingen, 1885), 32 + 2 pp., 8°.
[5] Two Oxford professors, Freeman (Modern History) and Max Müller (Comparative Philology), E.A. Bond (Librarian of the British Museum), E.W.B. Nicholson (Bodley's Librarian), and G.C. Brodrick (Warden of Merton College).

Sweet has to say about Napier and about himself: the former covers much the same ground as his letter to the *Academy* (I, 422) written on the previous day.

> (9 June) . . . I had the greatest respect for your character and your career, your accuracy and zeal, but was sorry to see you following the lead of Zupitza so blindly. I am certain that if you had been able to work with Sievers and Kluge instead of the Berlin clique, you would have had a far more independant and original development, and would have identified yourself with the party of progress. It also made a painful impression on me to see you ignoring the work of the English phonetic and modern language school, which is now spreading its influence all over Germany.
>
> When I knew you better, I saw that it would be a great gain if we could both work together at the same university. My idea was that I should take English generally, but concentrating myself more on the living language and its dialects, phonetics, syntax, and style, while you took Old English, text-criticism, Comparative Teutonic philology, etc. We should thus supplement each others defects. You are more accurate than I am, and have had a proper training in German methods, while I am wider and more original, though less accurate. If I had got the Merton prof., I could have guaranteed your succeeding Earle; we should then have been perfectly well suited.
>
> The Merton prof. was my last chance. You probably know that all my efforts to get a footing in England have failed hitherto. I had the Baltimore professorship offered me in America, and my name was sent up for the Berlin one (through Lepsius's intervention) before Zupitza got it. I refused both, because I was determined to stick to England. The next chance I get may come too late, as in a few years I shall have lost the necessary elasticity. This I regret because I am sure I could train up a school of workers who would develope a new science of language not a mere copy of Germany. I am quite unsettled. I may throw up English altogether . . .
>
> <div style="text-align:center">Yours in haste
Henry Sweet[6]</div>

> (15 June) . . . What I really regretted in my letter was the reference to Zupitza, which was altogether superfluous . . .
>
> Thank you for your expressions of sympathy. I am afraid I do not deserve them. I have myself to blame for not making friends at Oxford, and for my criticisms of and attacks on the institutions of the place. I am really no worse off than before. I am glad I went in for the professorship, for the result has opened my eyes to my own position. I am personally pleased that you have got it, and altho I think you have not QUITE earned so commanding a position, I hope and believe that a few years of the leisure which

[6] Both the original and Napier's copy of this letter are in EFL.

you are sure to enjoy will enable to complete your training and put yourself above all criticism.

Again congratulating you, and wishing you success, I remain

> Yours very truly,
> Henry Sweet

In his last sentence Sweet was not telling Napier anything he did not know. After being offered the chair and while hesitating whether to accept it he paid a brief visit to Oxford and jotted down the pros and cons on a sheet of Merton College writing paper now in EFL.[7]

> Contra
>
> die Lit. von Ch. ab nicht vertreten.
> Style of lecturing so different. What they want in Oxf. more brilliancy and originality. I am not *begabt* enough.
> Have settled down and have got into the German way of lecturing, have conquered my ground.
> My philological knowledge *not* good enough. Pro Time enough in Oxford to learn.
> My line really Anglo-Sax.
>
> Pro
>
> Never such another chance from pecuniary point of view. If I throw it up, I shall neither have a chance in Oxf. nor in England again and must make up my mind to live quietly there (?). When once settled more leisure.

In the rest of the present section I have included a few facts and dates from Napier's all but thirty years at Oxford. His professional activities, campaigning for English as an Honour School subject and organizing the School when it existed, lecturing, examining, supervising, giving a private class, helping scholars, young and old, in need of advice in his special field of competence—and writing are discussed in [III-X]. I have put writing last, because I think that that is where Napier would have put it. He was not a scholar with great schemes of research for ever distracted by professorial duties. His duties came first and research second.

Napier rented at first a house in Pullen's Lane, at the top of Headington Hill, named Torbrex. It was one of the first houses there. His youngest

[7] Evidence for this visit comes from the envelopes of several letters in EFL. Napier was expected at Dawlish, where his mother was living, on 3 June, according to a letter written by his grandfather, John Napier, on that day.

son, Harold, was born at Torbrex in 1890. In the same year he moved to Southfield House, Cowley, where his daughter, Hilda Mary, was born in 1891. In a letter written on 1 January 1892 Furnivall says that he was 'greatly taken' with Southfield. The final move was in 1892, to the slope below Torbrex, where a new house was built down the slope of the hill, so as to interfere as little as possible with the view of towers and spires from Torbrex. Sisam describes it as 'a big "Victorian" house with good lawns and gardens and ample service.'[8] From this house, as Mrs. Somerset recollects, Napier walked each lecture day to the examination schools in High Street. Summer holidays were on the Welsh coast, first at Nevin and later at Saundersfoot in Pembrokeshire: Mr. Harold Napier remembers the annual exodus with 'our domestic staff of 4' in a Great Western Railway saloon. Napier visited Vercelli in 1887, a 'busman's holiday'. He was in Tyrol with Joseph Wright one summer and in Norway for some weeks in 1891. He retained his membership of the Norwegian Tourist-Club until 1900 but Mr. Harold Napier does not remember his going to Norway.

Napier applied for the degree of D.Litt. Oxon. in 1901. The application was referred to Skeat and Murray and approved on 10 June. He was elected to the British Academy in 1904. He was given honorary degrees at Manchester and at Göttingen, and was a Corresponding member of the Göttingen Akademie der Wissenschaften and an Honorary member of the American Academy of Arts and Sciences. He was a member of the Philological Society from 1886 and its president in 1892.[9]

Furnivall wrote to Napier in 1896 asking about the health of his wife and children: 'no need to ask about you: you're tough and strong'. Farnell, who knew him well, is probably nearer the mark in saying that he was never robust. His ill health became obvious before the 1914–18 war and it seems likely that the comparative lack of achievement in the last ten years of his life was because his energy and capacity for work were not what they had been. The political situation did not help him. Mr. Harold Napier remembers that for some years before August 1914 'my father was very bitterly opposed to the Germans'. Farnell makes the same point, and so does Sisam, who tells me that after the war broke out 'he never seemed to be the same man'.

[8] It is now a Students' Residence of the College of Technology in Oxford.
[9] Other societies of which he was a member for longer or shorter periods are the Chaucer Society, the Deutsche Shakespeare-Gesellschaft, the Early English Text Society (he took over his father's subscription in 1884), the English Dialect Society, the Modern Language Association, the New Palaeographical Society, the Numismatic Society, the Samfund til udgivelse af gammel nordisk Litteratur, the Spenser Society, and the Yorkshire Dialect Society: the receipts of payments to these societies are in EFL.

Napier died on 10 May 1916. Immediately afterwards Joseph Wright organized 'The Napier Memorial Library Fund' to buy his working library 'for the benefit of undergraduates and registered women students reading for the English School, and of others interested in the subject'. The money was subscribed in a fortnight and the English Faculty Library is the happy possessor of a very fine basic collection of books on Teutonic philology and especially Old and Middle English. Many of them have side-notes in Napier's neat hand.

II. Personality

In one of his letters to me about Napier Sisam wrote: 'A few impressions. He was gentle in his manner, hating quarrels and controversy; very modest about his remarkably wide range of competence: science, Greek and Latin, French of all periods, Norse, especially Norwegian dialect; Germanic philology; and a complete mastery of written and spoken German. None of this was "on show".' In another he said, 'If I had to choose one word to describe his manners and temper I should choose "gentle".' Mrs. Somerset remembers him as a 'handsome well built man with no superfluous flesh' and as 'a shy man and much happier with few people'.

> After the 1914–18 war broke out and I went to Belfast I spent even more time in the Napiers' house during the vacations. We used to work from about 9.30 to 12 and then go for a walk and it was during those walks that I heard much of his early life ... He went among other lectures in various subjects to one by Max Müller (?) on Comparative Philology and realized this was to be his future work. He went every vacation to see Zupitza in Berlin ... He often told me he did not think examination papers were a real test of a person's ability and he would like it to have been possible to offer a thesis for the B.A. degree. He was very much averse to the D.Ph. degree ... He thought Doctors should be people of mature age who had had time to do work of real originality and able to put the books on the table for the Assessors.

She remembers his 'delicious cigars' and the smell of them in his study and the thrillers there in 'huge cupboards' underneath the open shelves—'he considered that books ought to be allowed to breathe'—; walks in Merton garden and, if it was the season, strawberries and cream at the Cadena—'I don't care if they are bad for rheumatism, they don't last long enough to do much harm'; excursions by hired car with his wife and friends to wellknown places of interest—'one realized then that his inter-

ests were really wider than one had supposed. His chief friend among the Dons was Mr. W.H. Stevenson of St. John's, and I remember when I said Place-Names always interested me he warned me that he only knew one man eligible to deal with them, and he was an historian as well as a good philologist, this was Mr. Stevenson.'

Of his contemporaries, Henry Bradley and, it seems, L.R. Farnell[10] were also Napier's close friends in Oxford and letters show that he was on very friendly terms with Skeat and Furnivall both of whom were older. On this subject Sisam wrote to me: '... besides Bradley, I think chiefly of W.H. Stevenson, who found Napier the ideal collaborator because he kept so closely to his own special field. Napier entertained external examiners at his Headington house ... From him I got an impression of Skeat, who could not be idle. He would sit in the evening knitting, with a text before him and a bag of slips which he made when anything he thought (worth) collection occurred in his reading. W.P. Ker whom he admired greatly, also used to stay with him, and again he was an ideal collaborator and co-examiner.'

Mrs. Somerset's anecdote about place-names draws attention to one of Napier's strongest characteristics, his refusal to go beyond his own province. This came from his training in Germany, where in Sisam's words the 'system of research was based on strict delimitation of fields of competence and a free collaboration among advanced scholars ... Napier applied this principle rigorously: he would not express judgements or opinions unless he felt specially qualified. It was not a question of whether or not he was interested, or even moderately competent. It was sometimes a question of etiquette—he would not intrude on the official province of some other scholar.'

Sisam continues: 'This has a bearing on the common belief that he cared nothing for literature. It is true that I never heard him, in lectures or classes, touch upon literary criticism (in the sense 'aesthetic criticism'). In classes, if a question of comparative literature came up, he would say 'You should ask W.P. Ker' ... If a question concerned the philosophy of literary criticism he would say 'That is rather Andrew Bradley's province'. On the other side, when he lectured on texts, he chose literary texts: *Beowulf*, *Gawain*, *Pearl* ... It was the same in his classes: he chose e.g. *Exodus*, *Andreas*, the less known Anglo-Saxon Elegiac pieces; in Middle English *Havelock*, etc.; and he distinguished sharply texts of purely linguistic interest, which, if my memory serves, he dealt with only in lectures on historical grammar.

[10] [Cf. the warm appreciations of Napier in L.R. Farnell, *An Oxonian Looks Back* (London, 1934), pp. 50–4.]

I am not saying that he was himself interested in aesthetic criticism: I think he distrusted it; certainly he did not think his own views on it had any special value or authority. He thought that his business in lectures was to explain the meaning of the text, and he left the "appreciation" to the students, or to their teachers on the literary side. You will remember that he had a high opinion of de Selincourt. I think he never opposed any improvement on the literary side of English.'

One can add de Selincourt's[11] and Gerould's to this weighty testimony. Neither was a philologist but both of them owed much to Napier. Gerould wrote of Napier in the preface to his *Saints' Legends*, with some exaggeration, perhaps—he was writing only two months after Napier died: 'To him I owe my first impulse to the study of saints' legends, and to him I had hoped to submit this volume in all humility. The field was his more than any other man's, just as a searching knowledge of the earlier periods of our literature in general was more completely his than any other scholar's.'[12] I do not know if this opinion can be reconciled with Raleigh's, that in Oxford in Napier's time there had been 'no competent teaching in the first eight centuries of English literature'.[13]

III. Campaigning for English as an Honour School Subject

Napier took no part in the paper war on the teaching of English in Universities which began in 1885,[14] but, inevitably, he was involved almost at once in university politics on the question of whether there should be a Final Honour School of Modern Languages: English was to be one branch of this. His career in Oxford, politically and administratively, is in four parts, because of the way things developed from 1885 to 1887, from 1887 to 1894, from 1894 to 1904, and from 1904 onwards. The events in the three crucial years were the rejection of the statute in favour of a School of Modern Languages on 1 Nov. 1887, the passing of the statute in favour of setting up a Final Honour School of English in June 1894, and Walter Raleigh's arrival as Professor of English Literature in 1904. The progress towards an Honour School and the early years of the School are the subject of several chapters in a recent book by D.J. Palmer,[15] in which Napier

[11] See p. 104.
[12] G.H. Gerould, *Saints' Legends* (1916), p. ix. The preface is dated 'Princeton, July, 1916'.
[13] Quoted by D.J. Palmer, *The Rise of English Studies* (1965), pp. 145–6.
[14] He followed it with the aid of cuttings (now in EFL) supplied by an agency, Romeike's.
[15] D.J. Palmer, *The Rise of English Studies* (1965). See especially pp. 95–140.

is a 'dim figure'.[16] Palmer only refers to him once in fact before 1894 in connection with the School, as a signatory to the memorial of 1891. This does not square with what contemporaries said of Napier. According to Farnell's obituary notice, 'he set himself whole-heartedly to the task of his life, the introduction and organization of the scientific study of English in Oxford. He knew our University well enough to realize that his sole chance of success was the creation of an Honours School ... with the help of powerful friends[17] he pulled it through at last.'[18] A writer (female, I think) in *The Friend* (8 December 1894, p. 799) makes the same point in announcing the establishment of the School, 'after a hard struggle maintained on the one side by the Professor of English Language and Literature, with an indomitable perseverance worthy of the cause and on the other with a prejudice and blindness . . .'.[19] Furnivall wrote a characteristic postcard to Napier on 20 June 1894, the day after the vote in Convocation: 'I congratulate you heartily. You've won the match off your own bat . . . What a splendid answer and rebuke you've given to the geese who hisst at your appointment.'[20] These opinions may be over simple, but they show at least that what one would think true *a priori* is likely to be so, that Napier was a leading figure in the creation of the School.

Fortunately there is material among Napier's papers in the English Faculty Library to show his part in the first years. Mr. Palmer did not have access to it. The Protagonists were Napier and Frederick York Powell, then lecturer in law at Christ Church, a man of wide interests. They were working on a scheme in March 1886, Napier's second term in Oxford.[21] It took form as a printed memorial of 'considerations in favour of establishing a final School of Modern Language and Literature', of which proof copies survive, corrected by Powell—in his invariable violet ink—and by Napier. Napier sent the memorial to probable well wishers on 2 November. Letters to him in reply from F. Armitage, H.R. Bramley, Ingram Bywater, Robinson Ellis, A.J. Evans, W.W. Jackson, W.P. Ker, W.M. Lindsay, R.L. Nettleship, Charles Plummer, R.L. Poole, D.G. Ritchie, Arthur Sidgwick, T.C. Snow, Whitley Stokes, and H.F. Tozer express willingness and (Jackson[22] and Plummer only) unwillingness to sign it. Six of the letters

[16] The words are Sisam's in a review of Palmer in *Review of English Studies* n.s. XVIII (1967), 231.
[17] For Napier's 'powerful friends', see below, n. 29.
[18] L.R. Farnell, obituary of Napier in the *Oxford Magazine*, 19 May 1916, p. 313.
[19] Cutting in EFL.
[20] Letter in EFL.
[21] Letter from Powell to Napier in EFL.
[22] Jackson approved, but felt that he could not sign as he was a member of Council.

arrived after 13 November when the memorial, with twenty-three signatures appended, was sent to the Hebdomadal Council. A committee of Council reported on it on 27 November: Napier made a copy of the report which was favourable on the main point. On 1 December Napier and Powell put out over their names a printed letter to the Provost of Oriel (D.B. Munro) on the subject of the proposed School: one of the fifteen copies in EFL is emended by Powell.[23] A committee on the school of Modern Languages, eight persons, Napier and Powell among them, was set up and reported on 12 February 1887. Napier and Powell issued a final paper 'in favour of establishing' a Final School of Modern Languages in April of this year. It bears no date, but the copy for the press in EFL is stamped 'Received at the University Press 21 April 1887'. This copy is in part in Napier's hand, in part in Powell's, and in part cuttings from the printed memorial of 2 November 1886, of which the whole is, in fact, a reworking. The statute for the School was introduced to Congregation by Monro on 3 May 1887, but in a final vote on 1 November it did not secure a majority: the voting was 92 for and 92 against.

The events from 1 Nov. 1887 to June 1894 are not so well represented in EFL. Henry Nettleship revived the rejected scheme in a pamphlet, *The Study of Modern European Languages and Literature*, written before 17 December 1887, when Churton Collins replied to it in the *Academy*. Napier revived it in a brief letter to the Hebdomadal Council written in May 1888, asking that a committee of Council be appointed to consider the whole question. It bore nine signatures, besides his own. EFL has Napier's draft and also four copies of the letter, all in his hand, signed by Earle, Mayhew, Max Müller and Henry Nettleship respectively: the others who signed were Lindsay, Macdonell, Murray, Powell, and Rhŷs. Jackson wrote to Napier on 5 June to say that council had deferred consideration of the letter until next term 'in the interests of obstruction'. After this there was no forward move for three years. In this interval Napier and his supporters in 1888 had a change of mind. In June 1891 all of them, except Murray, are among 108 members of Congregation who signed a memorial in favour of an Honour School of English.[24] Council considered it (Oct. 26) and asked for a 'fuller scheme'. Napier replied on 14 November with a 'rough outline of what in our opinion an Honour School of English Language and Literature might be': the chief point here is that Language and Literature

[23] To secure Monro's interest was important. A piece of paper in EFL, presumably from this period, bears a list of names in Napier's hand and against most of them either 'N' or 'FYP'. Against Monro's is 'call on together'.

[24] Printed by Palmer, *The Rise of English Studies*, pp. 107–8, and, with the signatures, in *Hebdomadal Council Papers*, vol. 29.

should be of equal weight.[25] Council came to a decision on 23 November: the memorialists were to be told that 'council do not find it expedient at present to propose a new honour school in the final examination but are willing to consider any proposal not involving the establishment of a new school'. In the end after two more years it came to a vote on a Scholarship or a School. Furnivall wrote to Napier 'I do hope that you'll get your Honour School in English'[26] a week before Congregation voted, 5 Dec. 1893, in favour of an Honour School rather than a Scholarship, and on the day itself he wrote, 'Hurrah! It is a splendid victory over those damd obstructionists, I congratulate you heartily on it. You've fought an uphill battle for so many years, that you deserve your triumph now. But you've only won the right to work harder than ever'.[27] The Statute for a School was submitted to Congregation on 1 May 1894. After the passing of amendments on 15 May, Skeat wrote from Cambridge (21 May). 'I am glad you are getting on. As Prof. Wright points out, you have a strong point. Yours is, definitely, an ENGLISH School: but we have only a Languages Tripos. The NAME makes a deal of difference, tho' the THING is much the same.'[28] From this time all there is in EFL is a suggested list of papers 'Drawn up by F.Y.P. and A.S.N. Jan. 1894'.[29]

From 1894/5 to 1903/4 was a time of waiting.[30] There was a Board of Studies, which Napier attended regularly and chaired usually. There were examinations and a few candidates for them, mainly women from the Association for the Education of Women in Oxford. There were a few B.Litt. students. But there was no Professor of English Literature and without one the School could not develop. A Professor was provided for by a Statute of 1894, but only when money to pay him with became available

[25] Printed in *Hebdomadal Council Papers*, vol. 30. The manuscript copy in EFL is partly in Napier's hand.
[26] BL, Eng. letters d. 79, f. 64.
[27] *Ibid*. f. 66.
[28] *Ibid*. ff. 211–12. Another interesting letter from Skeat about conditions in Cambridge was written on 6 December 1893 (*ibid*. ff. 204–5).
[29] In 1893 and 1894 and no doubt earlier support for the proposed English School came from 'The Club'. Napier was a member and so was Falconer Madan, later Bodley's Librarian. Letter-cards to Madan from the secretary of 'The Club', H.T. Gerrans, are in the Bodleian, Gough Adds. 4° Oxon. 599—a reference I owe to Mr. Eric Merry. They draw attention to matters of importance on the Agenda of Congregation, for example, 11 June 1894, 'Tuesday Congregation . . . Fears about English School. Please come *and bring friends*'. For 'The Club', see E.M. Wright, *The Life of Joseph Wright*, 2 vols. (1932), ii. 488 and the references given there.
[30] On these years, see Palmer, *The Rise of English Studies*, pp. 112–17.

on a vacancy in the Rawlinsonian Professorship of Anglo-Saxon.[31] Earle was 69 in 1894 and people hoped, no doubt, that the vacancy would be soon. Furnivall wrote to Napier when the Statute was being discussed, 4 June 1894, 'Can't somebody make Earle resign?', and a fortnight later, 'Earle ought at once to resign or die, and let your new scheme get to work.'[32] Meanwhile W.P. Ker, Professor of English Literature in University College, London, acted as consultant and Ernest de Selincourt lectured—for a pittance—on English literature. A letter from Ker to Napier in July 1897 expresses satisfaction with the results of the examination in that year: 'it has proved that the two sides can be balanced'.[33] Another letter from Ker written on 14 January 1898 makes suggestions of prescribed books in literature from Shakespeare to Coleridge. He ends with a postscript: 'I had a very fine time on Ben Cruachan on New Years Day—clean snow and blue sky—Jura and Mull very remarkable, and Colonsay far out. I admire that time of year.'[34]

Raleigh took up his post in October 1904. From now on what Palmer says is probably true enough, that 'Napier . . . allowed Raleigh, Firth, and Nichol Smith [who came as Goldsmith Reader in 1908] to take the initiative in planning the school'.[35] Since literature, not language, was mainly in question, it would have been presumptuous in him to do otherwise. The choice of David Nichol Smith and not de Selincourt as Reader was surely Raleigh's choice and not Napier's: Napier thought well of de Selincourt, but Raleigh had had Nichol Smith as his assistant in Glasgow.

IV. Lecturing

The development of lectures on English subjects in Oxford may be followed in the lecture lists published in the *Oxford University Gazette*. Until Napier's election the only lectures were those by the Rawlinson Professor. In the years immediately before Napier came, John Earle lectured on the *Heliand*, Ulfilas, The Saxon Chronicles, The Laws of Cnut, *Beowulf*, and in the Michaelmas term of 1881 on the 3rd edition of his *Beginner's Book*. These last were lectures on the English language, but they were very different lectures from those which Napier gave under the title 'History of

[31] *Oxford University Gazette*, 5 June 1894, p. 534.
[32] BL, Eng. letters, d. 79, f. 71; EFL. Earle died in 1903.
[33] Letter in EFL.
[34] Letter in EFL.
[35] Palmer, *The Rise of English Studies*, p. 144.

the English Language' in the Hilary Term of 1886. Napier's will have been revolutionary to an Oxford audience.[36]

The course on the History of the English Language developed gradually into two important sets of lectures, the longer on Historical English Grammar and the shorter on Historical English Syntax. A course with the former title was given first in 1893/4 and subsequently every other year in two or three of the terms, Michaelmas, Hilary and Trinity, and took up usually four hours a week—in the two-term arrangement—or three hours a week. The course on Historical English Syntax was given first with this title in 1898/9 (Michaelmas and Trinity Terms) and again in the Trinity terms of 1902, 1904, and 1906 and in the Hilary and Trinity terms of 1909, 1911, and 1913.

Napier lectured on 'Earliest English Literature' in Michaelmas Term 1885—they were his first advertised lectures —, on Sweet's *Reader* in 1894/5 (for beginners), on OE literature in 1899–1901, and on OE authors for several years from 1895 and last in 1902/3. *Beowulf* apart, this was the extent of his public lecturing on Old English. He gave more attention to Middle English texts. A course on Morris's *Specimens of Early English*[37]—and in 1906/7, 1909/10, and 1911/12 on Emerson's *Middle English Reader*, first published in 1905—runs right through from 1887/8 to 1913/14. Particular texts lectured on were *Havelok* (1895 only), *Sir Gawayne and the Green Knight* (in nine years from 1896/7 to 1910/11) and *Pearl* (1913 and 1914/15). *Beowulf* was Earle's preserve until he died in 1903. From 1904/5 onwards Napier lectured on it each alternate year, six times in all, the last three during two hours a week in each of the three terms of the year. Lectures on Chaucer, 'Life and Works' and 'Language', were advertised in 1895 only.

Lectures on OE dialects were advertised in nine years between 1895 and 1913; on Gothic for beginners in 1895, 1897, 1899, 1901, and 1905, on Gothic Grammar in 1903 and 1907, and on 'Comparative Gothic and Old English (Anglo-Saxon), with translations from selected passages of the Gothic and Old English Gospels' in 1886; on the history of English metre in 1892, and on OE and ME metre in 1908.

It will be seen from the dates that until 1895, that is to say until the Honour School was founded, Napier confined himself mainly to *Specimens* and 'Historical English Grammar'. Afterwards, and especially in 1895, there is much more variety. Gothic to which he attached importance[38]

[36] Wright, *The Life of Joseph Wright*, i. 169.
[37] Napier's annotated copy is in EFL: pt. 1, 2nd ed., 1887; pt. 2 (Morris and Skeat), 1873.
[38] See below, p. 106.

appears less than we might expect. Sisam tells me that Napier considered it to be Joseph Wright's province and 'he did not teach it, publicly or in class in my day'.

Unfortunately the sets of lectures on Grammar and Syntax no longer exist. Sisam says that 'they were excellent lectures and historically interesting'; the former 'a more or less complete text book', and the latter 'an admirably clear short summary'. Miss Wardale had the loan of them after Napier's death and returned them to his daughter, Lady Cash. After her death in 1964 they were destroyed through a misunderstanding of what they were. The sets on Chaucer, *Beowulf*, and *Pearl* are in EFL. These last consist of seventeen lectures, two of them introductory. The *Gawayne* lectures may be extant, but have not been found. For the rest what remains in EFL is mainly in note form.[39]

Napier advertised lectures at 12 noon first in 1894. From 1899 this became his invariable time of lecturing.[40]

There is much evidence that serious students found Napier's lectures excellent. Writing of 1898 or thereabouts Miss Lea (later Mrs. Joseph Wright) has a passage about them beginning 'The lectures I really enjoyed were Professor Napier's.'[41] Ernest de Selincourt wrote to Miss Napier on her father's death: '. . . I have often expressed the opinion before now that of all the teachers I studied under during six years as a student at Oxford [1888–94; 2nd in Lit. Hum., 1894], when I attended lectures from all the

[39] (a) For *Specimens* and Emerson, Napier's autograph notes on King Horn dated '4 May 1888', Moral Ode, dated 14 February 1890 (it was the fourth lecture of that term), Owl and Nightingale, dated 29 February 1893, Proverbs of Alfred, Juliana, Passion of Our Lord, Bestiary, Luue ron, Sinners Beware, Moral Ode, Ancren Riwle, Rauf Coilier and Layamon, all undated. (b) Cyclostyled sheets for distribution on Ancren Riwle, Ayenbite, Robert of Gloucester, Ormulum, OE dialects, OE verbal declensions, and a reading list for Historical English Grammar: these bear dates from 1904 to 1914 and, Sisam tells me, 'were distributed (or most of them) at the Historical English Grammar course'. (c) Mis Frances Warren's notes of Napier's lectures on *Specimens* and Sir Gawayne taken in 1897.

[40] Mrs. Somerset, writing of 1905 onwards, says: 'He always walked into the room exactly at five minutes past 12 and left at five minutes to 1; if by any chance he should forget the time the Undergraduates would begin to stamp and at once he shut up his papers and with "My apologies Gentlemen" he hurried from the room.' Sisam comments on this: 'In my time (1910–13) there was no stamping of feet and I recollect no occasion for it. Probably earlier there was an undergraduates' campaign for a proper interval to get to the next appointment.' From Michaelmas 1898 until the summer of 1914 Napier normally lectured on four days of the week, Monday, Tuesday, Thursday, and Friday. Before 1895 the number of lectures was two or three a week; in at least one term of each of the years 1895–8, 1901, 1902, and 1914 it was five; in Trinity term 1895 and Hilary term 1898 it was six. In 1894–8 lectures on OE authors and on OE for beginners were at 5 o'clock.

[41] Wright, *The Life of Joseph Wright*, i. 176.

best classical men as well, he had the finest powers of exposition and the most masterly method.'[42] Sisam writes: 'His lectures were of splendid quality and he revised them carefully for each delivery' and 'His public lectures were always well attended because they were abreast or ahead of the latest work in print. They were delivered clearly and plainly without any mannerism; and they were right on target—no digressions or excrescences, no sign of his own special interests at the time. When I came to Oxford [1910], with quite a good knowledge of the leading text-books, I was astonished at their uniform quality and balance. When lecturing on texts, he gave an edition; Introduction on the MSS, sources, date, metre, etc. Then literal translation in conveniently short pieces; then a full commentary—allusions, meanings of words, idioms, consideration of textual problems, etc.; but ... no aesthetic criticism. Yet I never heard anyone who listened carefully to his lectures complain of that as a deficiency—there was plenty to learn.'

Napier's forecast of his lectures on *Specimens* for the summer term of 1895 is extant in a letter to Miss Lea on April 22nd. 'I am sorry that I could not answer your letter at once, but the truth is that I had not quite made up my mind as to what form I would give my lectures on the ME. Specimens. I shall only be able to give a short grammatical introduction to a few of the pieces. I think my best plan will be to take *Ancren Riwle* first (devoting 1 1/2 to 2 lectures to it)—then perhaps *Layamon* (about 1 lecture). I might also point out the main points of difference in the Language of *Owl and Nightingale* and the *Moral Ode* (this of course very briefly). Then I think I shall take the East Midland Group beginning with *Orm*—then take *Genesis* and *Exodus* and then *King Horn*. That will be all I can get done this term. I shall have to take vol. II next term. Of course all I can do will be to give a very brief grammatical introduction. I don't expect I shall find time for much translation (if any)'.[43]

Napier had help with lecturing for the first time in the Hilary Term of 1905 when R.H. Carr, B.A. (1st in English, 1903) lectured on 'Old English Translation (Elementary) for Professor Napier' on Wednesday at 12 (fee 10/- for the course). In Hilary Term 1906 A.B. Gough (3rd in Lit. Hum., 1895) lectured for him on OE poetry. After this the succession was: A.O. Belfour (2nd in English, 1904), from Trinity 1907 to Michaelmas 1909; S.J. Crawford, from Michaelmas 1909 to Michaelmas 1911; Kenneth Sisam, from Hilary 1912. These assistants did an increasing amount of lecturing: Sisam lectured four or five times a week and in Hilary and Trinity Terms

[42] Letter in EFL.
[43] BL, Eng. letters d. 125, f. 196.

1914 as often as six times a week. In four terms during 1911 to 1913 Karl Jost was also lecturing once a week.

V. Examining

In reply to a question about Napier, Sisam wrote to me: 'One thing in your letter I should mention: the extraordinary time and pains he gave to examining. I was never good at distinguishing between the mediocre candidates, or found a sure way of dividing β from β-. Napier used every device of cross-checking to get a fair decision and the time he gave to a paper of no great merit impresses me still.' Even so, examining for the Final Honour School at Oxford cannot have been very arduous: the number of candidates was never above 30 before 1909 and often below 20. Napier was an examiner in 1896–8, 1902–4, 1907–9, 1912, and 1915. But Honour School examining was only a small part of the total amount of examining he did. As the university expert he was in demand wherever there were OE and ME papers to be set and at first he was called on to examine in German too. The collection in EFL of examination papers set by him is probably complete or nearly so. They show that Napier examined: in Cambridge, in German in 1886, 1887, 1889, and in English in 1890, 1891, 1892, 1897; in Oxford, for the Taylorian Scholarship in German, together with Max Müller, in 1887 and 1891; in Oxford, for the A.E.W., in 1889–92, 1894, and 1895;[44] in London, each year from 1899 to 1905; in Manchester, for Intermediate and Honours, in 1905 and 1906; in the Magdalen College Fellowship Examination in English in 1907;[45] in Oxford, for the Honour School of Modern Languages, in 1909, when a candidate took OE as a special subject; in Belfast in 1910.[46]

As a Cambridge examiner Napier replied to a circular sent out on 13 February 1889.[47] He made two main criticisms about the examination in English: 'I think it very important indeed that, as already suggested, Gothic should be required from all candidates of English ... there should

[44] There was no examination in 1893. On 4 June 1889 Joseph Wright wrote to Miss Lea: 'That the paper this year is being set and examined by a specialist in the subject, ought to be welcomed by *serious students* at any rate' (Wright, *The Life of Joseph Wright*, i. 186).

[45] G.S. Gordon was elected. He wrote to a friend before he knew the result: 'I can't have done anything that will strike—unless it be my amazing ingenious paper on Middle English. I should think Bradley and Napier will need a stimulant after it' (*Letters of George S. Gordon* (1943), p. 25).

[46] For the B.Litt. examining, see below, pp. 108–9.

[47] Copy in EFL.

be a paper on History of the Language (Historical English Grammar).'
Letters from Skeat to Napier about arrangements for examining in
Cambridge in 1891 have been preserved.[48] Examining in London, where
the co-examiner was Professor J.W. Hales or Professor C.H. Herford, must
have been a heavy task. EFL has no less than seventy-one different papers
for the five years 1900–1904 with Napier's name on them as examiner.
They are for M.A., for B.A. at Honours and Pass levels, for Intermediate
at Honours and Pass levels, and for Matriculation. For Matriculation
English was a compulsory subject and the number of candidates was very
large.[49] Napier set and examined part of the paper five times, but only
once under the new regulations in force from September 1902, which did
away with 'elementary questions on the History of the language and
literature'. Before that it was as well to know about Grimm's Law.

VI. Supervision

At the turn of the century very few people were candidates for the B.Litt.,
compared with nowadays. Between 1896 and 1911 thirteen men, most of
them from overseas, chose to do a subject in English Language or in OE
or ME (up to Chaucer), and were supervised, certainly or presumably, by
Napier.[50] In the following list, dates of admission are from the Minute
Book of the English Board, and titles of dissertations from the *Oxford
University Gazette*. The title is that of the dissertation actually examined, or,
if the candidate was not examined, the title proposed at the time of admission. R.S. Loomis (11) changed the subject of his dissertation. Probably all
the other subjects were suggested by the Professor: three authors have said
as much in print (4, 10, 12). All the seven candidates who put in a finished
dissertation gave satisfaction to the examiners: their work is described as
being—in the stock phrase—'of a high standard of merit'. Though stock,
it was no empty phrase, and especially not in the days before the higher
degree of D.Phil. was introduced.

[48] BL, Eng. letters d. 79, ff. 179–80, 185–90, 192–3.
[49] *University of London Historical Record 1836–1912*, gives the names of successful candidates
in the Intermediate and B.A. examinations (pp. 349–52, 383–6, 392–3). The University
Calendar has lists of matriculants: in June 1902 (when Napier was examining) there are
1337 names. I am grateful to Miss Joan Gibbs for references to these sources.
[50] The Minute Book of the English Board fails to specify the supervisor of the three candidates admitted in 1899. 'No supervisor was appointed' at the meeting when Crawford
was admitted.

Since Michaelmas Term 1953 B.Litt. theses have been deposited in the Bodleian Library. From 1928 to 1953 nearly all English theses were deposited in EFL: they too are now in the Bodleian. In Napier's time, however, there were no formal arrangements for deposit and, so far as I know, Gerould's (4) is the only one of the seven dissertations here in question which is to be found in Oxford now.[51]

1. 20 June 1896. Henry Cecil Kennedy Wyld, 'The Relation of Standard English to the Modern Dialects in their Treatment of the Gutturals'. Napier and Joseph Wright supervisors. Napier and Wright examiners, 1899: their report in *Oxford University Gazette*, 13 June 1899, p. 639.[52]

2. 1 Nov. 1899. Alfred Edward Armour, 'The Syntax of the English Verb'. Not examined.

3. 1 Nov. 1899. Samuel Swayze Seward, 'The English of the Twelfth Century'. Not examined.

4. 28 Nov. 1899. Gordon Hall Gerould, 'The North English Homily Collection, with a Study of the Tales contained Therein'. Napier, Wright, and W.H. Stevenson examiners, 1901. Their report in *Oxford University Gazette*, 18 June 1901, p. 718. The dissertation was printed at Lancaster, PA, in 1902.

5. 21 Nov. 1902. Edward Herbert Strong, 'The Manuscripts of the *Ancren Riwle*, including a Collation, a Discussion of their Mutual Relations, and an Account of their Grammatical Features'. Napier supervisor. J.A.H. Murray and Henry Bradley examiners: their report, unusually full, in *Oxford University Gazette*, 1 May 1906, pp. 532-3. Sisam tells me that it was when supervising Strong that Napier found the French version of the *Ancren Riwle* in Cotton Vitellius F. vii to be still in usable condition and not, as had been said, burnt. According to the *Gazette*, Strong copied it. Later J.A. Herbert copied it for Miss Allen and printed it in EETS 219 (1944).

6. 21 May 1903. Hardin Craig, 'A Grammar of the so-called Surtees Psalter . . . with the Question of Authorship and Notes on the Language, Dialect, etc'. Napier supervisor. Not examined.[53]

7. 18 March 1905. Theodore Erbe, 'An Edition of the Liber Festivalis of Johannes Mirkus, together with an Investigation into the Language and

[51] But see 7, 9, 10, 12 below, for printed work based on the dissertations.
[52] Wyld succeeded Napier at Oxford in 1920.
[53] Craig went back to Princeton in 1903. He had already produced *Two Coventry Corpus Christi Plays* for EETS, extra series 87 (1902).

Sources of the Work, and into the Relationship of the MSS'. Napier supervisor. Not examined. According to the Minute Book of the English Board, p. 51, Erbe had been working at his subject under Napier since Michaelmas Term 1903. Erbe's edition of the *Festial* was printed as EETS extra series 96 (1905), Part I, The Text. Part II was never published.

8. 19 May 1905. Frank William Cady, 'An Investigation into the Sources and Language of the Towneley Mysteries with a View to Determining the Possible Diversity of Authorship'. Napier and Murray supervisors. Napier, Murray and A.W. Pollard examiners, 1908; their report in *Oxford University Gazette*, 23 June 1908, p. 838. Papers by Cady on the *Towneley Mysteries* are in *PMLA*, xxiv (1909), 419–69, and in *JEGP*, x (1911), 572–84 and xi (1912), 244–62.

9. 15 Feb. 1907. Algernon Okey Belfour, 'An Edition of the Unpublished Twelfth-Century Homilies in MS. Bodley 343, together with an Investigation of their Language'. Napier and Bradley supervisors. Not examined. Belfour's edition of the homilies was printed as EETS 137 (1909), Part I: The Text. Part II was never published.[54]

10. 3 Dec. 1909. Samuel John Crawford, 'A New Edition of the Old English Translation of the Hexameron of Basil (usually ascribed to Ælfric)'. Napier and W.A. Craigie examiners, 1912: their report is in *Oxford University Gazette*, 1 April 1912, p. 578. Crawford's edition was published in 1920 as vol. x of the *Bibliothek der angelsächsischen Prosa*.[55]

11. 19 May 1911. Roger Sherman Loomis, 'Illustrations of the Romances in Mediæval English Art'. Napier and C.F. Bell supervisors. Bradley and Israel Gollancz examiners, 1913: their report in *Oxford University Gazette*, 6 Aug. 1913, p. 1083.

12. 3 Nov. 1911. Kenneth Sisam, 'An Edition of the Salisbury Psalter (Salisbury MS. 150), with Introduction and Critican Notes'. Napier supervisor. Craigie and Bradley examiners, 1915: their report in *Oxford University Gazette*, 23 June 1915, p. 767. The edition of the Psalter by K. Sisam and C. Sisam in EETS 242 (1959) is based ultimately on this dissertation: see there p. v.[56]

13. 3 Nov. 1911. Henry Alexander, 'The Middle English Romance of Sir Percyvelle'. Napier supervisor. Not examined.

[54] Belfour became Napier's assistant in the summer term of 1907.
[55] Crawford became Napier's assistant in Michaelmas Term 1909.
[56] Sisam became Napier's assistant in Hilary Term 1912.

VII. The Private Class

In the recollections of Napier which Mrs. Somerset wrote for me she says: '... in my second year [1906/7] he decided to have a special seminar for four or five students at his house every Wednesday afternoon. I was fortunate enough to be chosen by my Tutor for this very great privilege. We did advanced textual work outside our Schools work and he tried to instil into us his principles of textual criticism. "Before you start tampering with a text, remember the scribe was much more likely to be right than you are." His patience was marvellous. When one of us dared to suggest an emendation he would listen silently to the end and then having heard our reasons he would take them one by one and show whether it could be supported or not. He never poured scorn on our efforts so long as we did not make elementary mistakes.'

Sisam writes: 'For the few advanced students—I doubt if there were more than half a dozen at any time—he gave a weekly class at his house on Headington Hill. Here the basis was texts of which there was no readily available edition with commentary. We read a few lines at a time; Napier pointed out anything he thought interesting; and we could then ask questions or make suggestions. Both were examined with the greatest care. If the question was difficult, he would say "I shall take that next week"; and then all the literature that mattered would be collected for us and sifted. Our suggestions might be dismissed out of hand, or might be held over for a considered judgement; and like his master Zupitza, Napier excelled in judgement. I recall suggesting an emendation in *Emaré* for which I still have an affection. After the week's pause, Napier ruled that it was "too ingenious", and I have been prudent not to publish it. In these classes we learned textual criticism at a level which only later came in to "modern" English literature with the reform led by Pollard, Greg and McKerrow, all of whom, it is worth noting, had an interest in medieval English studies' (letter of 17 Feb. 1966). 'His private class was always kept at a high standard, and there one learned to pass from acquiring information to finding out things by the strictest methods' (letter of 18 July 1967); also, 'I still have a notebook he used for his private classes on OE verse (*Exodus, Daniel, Andreas*, etc.); but these are jottings, not written-out lectures ... He also gave a class on minor ME texts, but there were no notes for these.'

VIII. Advice to Young Scholars beginning Research and Teaching

This important and time-consuming activity usually leaves little trace beyond acknowledgements in books and articles. Fortunately, rather more than usual is known about the help Napier gave miss E.M. Lea (1863–1958: married Joseph Wright in 1896), whose preface to her grammar of the Northumbrian gloss to the Gospel of St. Mark acknowledges her debt to Napier 'for almost all the explanations here proffered of the difficult and obscure words in the text'.[57] She had a first meeting with Napier in the Bodleian on 6 Nov. 1890, 'quaking with shyness'—she had been to his lectures for three years 'but had never yet spoken to him'—and there were further meetings about the grammar in 1891.[58] Napier wrote to her about words in the gloss on 9 July 1891 and on 30 Sept. 1891.[59] Miss Lea lectured for the A.E.W. in 1893/4, 1894/5 and 1895/6 and 'almost every Sunday, and often on a week-day besides, I used to go to Professor Napier with a sheaf of "difficulties".'[60] Napier wrote to her to help clear up points in *Ancren Riwle*,[61] *King Horn*, *Ormulum*, and Laȝamon, and gave her some sheets of pencilled annotations on some seventeen passages of *Ancren Riwle*.[62] '. . . all my lecture note-books are full of the scholarly comments and explanations he gave me to eke out and emend my own material.'

IX. Advice as an Expert on the English Language

The great enterprise to which Napier gave much assistance was the Oxford English Dictionary. In the historical introduction (1933) he and Skeat are the two scholars in English named in a short list of seven persons 'who, especially in the earlier years of the work, freely gave the editors [Murray and Bradley][63] the benefit of their special knowledge in their respective fields': the others were Paul Meyer in Romanic Philology, Sievers in Germanic, Rhŷs in Celtic, Pollock in Law, and Maitland in History. Napier was helping in and before 1888. Some of his contributions

[57] *Anglia*, xvi (1893–4), 62. The grammar occupies pp. 64–206.
[58] Wright, *The Life of Joseph Wright*, i. 200, 207, 209.
[59] BL, Eng. letters d. 125, ff. 184–5, 187.
[60] Wright, *The Life of Joseph Wright*, i. 213.
[61] BL, Eng. letters d. 125, ff. 178–9, 181–2, 191–3.
[62] Ibid. ff. 205–7. Line references are to Morris's *Specimens*, no. IX.
[63] Murray edited A-D, H-K, O, P, T, between 1882 and 1909. Bradley edited E-G, L, M, between 1888 and 1908.

can be guessed at from the long run of postcards—and a few letters—from Murray preserved in BL and EFL. The postcards from Murray on dictionary business are fifty-three in number and all uniform in their size and buff colour. They run from 1889 to 1897 with a gap of nearly two years between 6 Nov. 1891 and 3 Oct. 1893. All are concerned with words beginning with the letters C (28.iii.89—6.xi.91), D (19.x.93—4[?].xii.96), and H (9.i.97—22.xi.97).[64] The only letters from Murray are later than this: 27.v.98, saying apropos of 'giddy' that quotations from Napier's *Old English Glosses* were now coming in; 2.iii.99 on 'gemænesse' and 'gemæte'; 22.i.01, on Orm's 'Iudiss-kenn' (cf. *OE* Judeish); 10.vii.05 ('I am at periwinkle').[65] Of Napier's replies there are, unfortunately, only three (all in OEDA), a postcard of 5.v.02 and two letters written in 1912, July 27 and September 5. The former has a nice postscript: 'I have to thank you for a delightful evening in Jesus—it was a real pleasure to have a long talk with Sievers, who seems as full of enthusiasm as ever. The way he recited OE verse, ON prose laws etc. according to his latest views of metrical intonation was simply marvellous.'

Henry Bradley will have had less need than Murray to question Napier. After 1896, when Bradley became an Oxford resident, there was no doubt frequent verbal consultation between them, as between equals. All that remains in writing from Bradley to Napier on dictionary business are two postcards on F words (9.iii.91, 19.ii.94).[66] From Napier to Bradley there is rather more, for Bradley sent Napier proof of the Dictionary and nine letters from Napier in reply survive in OEDA, the first two of them on 'each' (29.ii.88) and 'else' (11.xii.88), the third on six Ev-words, and the others on F, G, and L words (two each).

Apart from the Dictionary correspondence there are not many advice-seeking letters to Napier in BL and EFL. Skeat wrote three times (1893–4) about the pronunciation of ME *ai, ei*, on 15.xi.91 about the mysterious 'beautees' (or the like) in manuscripts of the Parson's Tale (858), and on 29.xi.04 about the etymology of 'wile'.[67] By ill luck the only correspondence we have both sides of—so far as I know—dates from only a few months before Napier died. Bradley wrote then, February 1916, about five textual emendations which he published shortly afterwards in *MLR*.[68] His letters are in EFL. Napier's answers about four of them are in OEDA. He approved the suggestion of 'þefeþorne' at *Leechdoms* ii.52/8, but of the pro-

[64] BL, Eng. letters d. 79, ff. 106–61.
[65] *Ibid.* ff. 166, 163, 167, and EFL.
[66] *Ibid.* ff. 1, 2.
[67] BL, Eng. letters d. 79, ff. 199–202, 197–8, 207–8, 183–4; EFL.
[68] *MLR*, xi (1916), 212–15.

posed changes in the Junius Manuscript he said only that Bradley might well be right, 'but is an emendation really necessary?'[69]

Napier's role as an adviser may be seen also in prefaces, for example M.R. James's to his *Descriptive Catalogue of the Manuscripts . . . of Corpus Christi College Cambridge* (1912), Plummer's to his edition of *Two of the Saxon Chronicles parallel* (1899) and Stevenson's to his edition of *Asser's Life of King Alfred* (1904).

X. Writing

Soon after he came to Oxford Napier was occupied with two major pieces of work, neither of which was ever published. One arose from his lecturing on the English language. Furnivall wrote on the last day of 1891, 'Finish your Historical English Grammar, to show them [*sc.* 'those cursed Oxford Dons' referred to nine lines above] how much is involved in the knowledge of English as you would have it known.'[70] Both the Grammar and the Syntax lectures were constantly revised and the latter was nearly, if not quite, in a fit state for publication at Napier's death. Sisam tells me that he urged Napier to publish it, 'but he flinched from what he said was the huge task of checking every detail'.[71] The other major work followed from the edition of the sermons attributed to Wulfstan (*Wulfstan. Sammlung der ihm zugreschriebenen Homilien nebst Untersuchungen über ihre Echtheit* [Berlin, 1883]). This edition had established Napier's reputation in Germany and rightly. It is a notable advance on anything which had been done before in this field and made possible the later work on Wulfstan by Jost, Miss Bethurum and Miss Whitelock. The further scheme was to edit all the unpublished Old English homilies. Napier wrote of it in a letter to Furnivall, of which the draft survives, undated, but in reply to a letter written by Furnivall on 24 October 1887.[72] Probably Furnivall wrote back to say that he would be glad to have the homilies as an EETS publication: at any rate his advertisement of 'texts preparing' bound up before EETS, extra series 49 (Guy of Warwick) and dated 1 Dec. 1887[73] states that 'Prof. Napier of Oxford has been good enough to promise that he will edit for the Society all the unprinted and other Anglo-Saxon Homilies which are

[69] Krapp, *Junius Manuscript*, does not adopt them; cf. his notes to *Genesis* 1704–5 and *Daniel* 645.
[70] BL, Eng. letters d. 79, f. 45.
[71] Sweet's *Historical English Grammar* was published in 1892.
[72] BL, Eng. letters d. 79, ff. 18–20.
[73] Mr. R.W. Burchfield kindly referred me to this volume of EETS.

not included in Thorpe's edition of Ælfric's prose, Dr. Morris's of the Blickling Homilies and Prof. Skeat's of Ælfric's Metrical Homilies'. Napier himself refers to the project in *Anglia*, x (1888), 156, and says that he intends to omit not only Thorpe's, Morris's and Skeat's, but also the homilies about to be published by Assmann and (from the Vercelli manuscript) by Wülker.[74] Through Furnivall's means Donald Kensington was employed in 1888 in copying homilies for Napier in the British Museum. Furnivall wrote on the 26th of July: 'Donald says he has at last sent you all your Homilies from B. Mus.'[75] Notes added to some of the copies now in EFL show that copyists employed by Napier were at work in Oxford and Cambridge at about the same time. In October 1888 Napier was checking their copies and adding the variant readings of Cambridge Univ. Libr. Ii. 4. 6 on the copy of one of the Faustina homilies. Napier could still say in 1894 that the homilies were in preparation for EETS,[76] four homilies in CCCC 162 were collated at as late a date as 25 November 1899, and the edition was still being announced by EETS in 1916. But long before 1916 Napier must have known that he would never get it done. Two of his B. Litt. students and Miss Rubie Warner (Mrs. Somerset) were set to work on homily manuscripts in the 1900s.[77] Napier himself published three homilies. For the rest the work does not seem to have got beyond the stage of copies and collations, and even these are, apparently, far from complete: for example, there are no copies in EFL from the important and difficult manuscript BM, Cotton Vitellius C. v.

In 1931 fifty-three copies made for or by Napier were transferred to Professor Pope, who arranged them in their present order and in due course sent them to the Early English Text Society: they are now in EFL.[78] Nos. 1–32 in this collection are copies of Pope's homilies II-XVI, XVIII-XXIII.[79] Napier himself copied only four homilies, no. 11 from Cleopatra B. xiii, no. 26 from Hatton 115, no. 32 from Hatton 114, and no. 47 from

[74] Assmann's are in *Bibliothek der angelsächsischen Prosa*, iii (1889). Wülker's were not published.
[75] BL, Eng. letters d. 79, f. 29. For Kensington, see also f. 23.
[76] See Napier's preface to *History of the Holy Rood-Tree . . . with Notes on the Orthography of the Ormulum and a Middle English Compassio Mariae*, EETS 103 (1894), p. 30.
[77] See above, p. 109.
[78] Certainly not all the homilies copied by or for Napier are in the EFL collection, not for instance those on SS Michael, Giles and Nicholas (CCCC 41, art. 17; CCCC 57, arts. 26, 34) of which Gerould had the use (*Saints' Legends* (1916), p. 126).
[79] *Homilies of Ælfric: a Supplementary Collection*, ed. J.C. Pope, 2 vols., EETS 259–60 (Oxford, 1967), i. 2.

Hatton 115, art. 31.[80] Some of his neat collations include a statement of what he had not attempted to do, for example on the first page of no. 29, 'coll. ASN (not regarding stops, nor word divisions)'. The expressions he used in collation are sometimes in German and sometimes in English.

The work Napier printed is nearly all of it occasional. The occasion might be a discovery which he had made or which someone else had made and brought to his notice, a recent acquisition by the British Museum or the Bodleian Library, or a point raised by someone in print. As Sisam has reminded me, two of Napier's principal and most remarkable works—*Old English Glosses, chiefly unpublished* (Oxford, 1900) and 'Contributions to OE Lexicography' (*TPS* (1903–6), 265–358)—are occasional too. They and other shorter lexicographical pieces came out at a time when printed evidence for words was of particular value to Murray's great Dictionary. In the 1890s and 1900s *OE Glosses* and 'Contributions' had more importance than the projected 'Homilies'.

In all his work Napier's exact knowledge and judgement are displayed in simple, direct sentences. He is plain and to the point, remembering always what Chaucer said of the Clerk and he himself of Zupitza, 'Noght o word spak he more than was nede', not that words are lacking when there *was* need. This is the charm and power of his writing, as evidently of his lecturing. Sisam called it 'mastery of exact methods' in 1923,[81] and in a recent letter to me he says, 'I think his distinctive quality was the finish he gave to every detail'. When I was a B. Litt. student in Oxford I thought no-one wrote on OE as well as Napier. I am more aware now how much the quality he gave to his work must have held him back. A 'finisher' goes slowly, and very slowly indeed if he is outside his field of special competence. It is no wonder that Napier did not get on with the editing of the homilies. He might have managed something in collaboration, but probably not. We can see now what had to be done to make a satisfactory edition. On a smaller piece of work his collaboration with Stevenson was a happy one (*The Crawford Collection of Early Charters and Documents now in the Bodleian Library*, ed. A.S. Napier and W.H. Stevenson (Oxford, 1905)).

Sisam writes to me that 'he was excessively cautious and fastidious about publishing'; also, 'He was almost exasperatingly thorough, collating texts on the MSS over and over again; correcting his proofs until—as he once complained to me—broken letters and other accidents to the type began to exceed the improvements'; also, 'His thoroughness inhibited him

[80] Hatton 115, art. 31 had been printed by Morris in 1868. It is one of fifteen copies, nos. 39–53, in a separate folder marked 'not to be included in my edition'.
[81] K. Sisam, *Fourteenth Century Verse and Prose* (Oxford, 1923), p. xliii.

in many ways ... Then again he was very modest about his own work. Bradley was a close friend, and though Bradley was as modest as he was brilliant, his first reaction was always to see some objection, even if, on full consideration, he was favourable. I more than once asked Napier to publish some emendation or interpretation. I got the answer that he had mentioned it to Bradley, who saw objections, and that was enough.'[82]

<div style="text-align: right">NEIL R. KER</div>

[82] [Ker appended to his article a complete list of Napier's publications, some seventy-nine entries, with brief descriptive annotations (pp. 174–81). As elsewhere in the present volume, and in order to save space, the list has been omitted here.]

JOSEPH WRIGHT

Lafayette

VII

JOSEPH WRIGHT
1855–1930

JOSEPH WRIGHT was born on 31 October, 1855, at Thackley, a village three miles north of Bradford. His grandfather James Wright, was a tenant farmer who combined the cultivation of about forty acres of land with the hand-loom weaving which was one of the staple industries of the district. Dufton Wright, the third of his five sons and the father of Joseph Wright, deserted weaving for quarrying which was the other local industry. 'My father', said Joseph Wright, 'was a cheerful, good-tempered chap, singing snatches of songs, very kind and friendly, never quarrelsome.... He was fond of poaching, and always kept a dog however badly-off we were, but he never wanted to work.' He found employment at the ironstone mines near Middlesborough in 1861, and left his wife and children to the charge of the parish, though he returned later, and died at home in 1866.

Fortunately his wife, Sarah Anne Atkinson, was a woman of strong will and untiring industry. She found a one-roomed cottage which would hold herself and her four children, and set to work to bring up her family by her own efforts. Joseph Wright, the second son, was a wage earner from the age of six. He began as a donkey-boy, carrying quarrymen's tools from the quarry to the blacksmith, for which he got eighteenpence a week from the smith, and a penny from each of the quarrymen. When he was seven his mother took him to Sir Titus Salt's mill at Saltaire, where he became a 'doffer', that is a boy whose duty was to remove full bobbins from the spindles of a weaving frame and replace them by empty ones. He earned at first one and sixpence, rose later to three and six per week, and earned a few pence more by odd jobs. As a half-timer he worked from 6 to 12.30 one week, and from 1.15 to 5.30 the next, and began his education at the factory school for

half-timers, where he learnt the alphabet, some arithmetic, and a few scraps of scripture or moral verse. When he was thirteen he left Salt's mill for a new one built by Wildman at Bingley. His wages rose to nine shillings a week, but the doffer's job was a blind alley, so his mother apprenticed him to wool-sorting which offered a better prospect. By skill as a sorter he came to earn between twenty and thirty shillings a week, for it was the best paid work in the mill, and it was piece-work. He handed his wages to his mother, and since his father died in 1866, and his elder brother had gone to sea, he became the main-stay of the family. In 1869 they moved from the one room hovel in which they had lived to a cottage with five rooms, and Wright was able to furnish it from his earnings. He was now, as he put it, the main-stay of the family. 'Father, husband, son, and companion' to his mother and 'plunged, when a mere child into the severest battles of life.' 'My mother and I', said Wright, 'struggled hard for the sake of my two brothers, who were then little children. We were determined that their lot should not be so hard as ours, so that we did manage to give them some schooling. . . . In fact, they could read and write long before I ever dreamt of such luxuries.'

About this time Wright began to educate himself. He heard men in the mill talking about the war between France and Germany: it excited his curiosity, and he learnt to read the newspapers. When he had taught himself reading and writing he attended a night-school, where he picked up some French, and later a little German. Later still he attended classes in Arithmetic, Euclid, and Algebra, at the Mechanics Institute at Bradford, though it meant a three mile walk each way twice a week. He took lessons in shorthand too, and in April 1875 obtained a certificate for his knowledge of Pitman's system.

Side by side with his thirst for knowledge his instinctive desire to teach developed itself. In 1873 he set up a class at his mother's house in the evenings; sometimes there were

a dozen boys in it, each paying twopence a week, and he added later a more advanced class for their seniors.

Wright's favourite studies at this time were mathematics, and languages. A temporary stoppage of the mill in February 1876 gave him a holiday. He had saved forty pounds, and he resolved to go to Germany. It was then that he left his home and his mother for the first time. 'We both knew how necessary it was for me to go; for my future development, I felt that I must go to that country of scholars, and I went.'

To economize his money, Wright walked from Antwerp to Heidelberg, and studied mathematics and German there for eleven weeks. When he returned he did not go back to the mill, but became a schoolmaster. From September 1876 to April 1879 he taught at Springfield School, Bradford, at a salary of £40 a year for five days every week, returning home for week-ends. During the same time he contrived to attend classes at the Yorkshire College of Science at Leeds, and prepared himself for the London University Matriculation. He passed that examination on July 24, 1878, and was placed in the First Division. He took English, French, German, and Latin, besides Mathematics and Chemistry.

In April 1879 Wright became a resident master at Grove School, Wrexham—a well-established Wesleyan School—and remained there about two years. He then spent a short time at Roubaix to improve his French, giving lessons in English and Mathematics to maintain himself. Next he was an under master at a school at Margate with a salary of £100 a year, but finding the boys lazy and the discipline bad, he quarrelled with the head master, and left in a few months.

1882 was the turning point in Wright's life. He passed the Intermediate examination for the London B.A. in that year, but resolved to go no further, and to complete his education by studying at a German university. Accordingly he matriculated at Heidelberg in the spring of 1882, intending

to study mathematics, but he was fascinated by the lectures of Professor Hermann Osthoff, and resolved to devote all his time and energy to Comparative Philology. He felt that his earlier studies had been a useful training for the new one. 'Everybody who would be a philologist', he said, 'must have done mathematics, or be capable of doing mathematics.' But philology was not entirely new to him. 'Long before I thought of going to study in Germany I had made myself intimately acquainted with the works of Grimm, Schleicher, and Curtius.'

His progress was rapid. In his examination for the degree of Ph.D., which he obtained *insigni cum laude* in the summer of 1885, his thesis was *The Qualitative and Quantitative Changes of the Indo-Germanic Vowel System in Greek.* The comparative philology of the Indo-Germanic languages, the grammar of the Germanic languages in detail, and Anglo-Saxon language and literature were his principal and secondary subjects.

In 1886 Wright matriculated at Leipzig in order to extend his knowledge of languages, phonetics, and German literature. Under Leskien, whom he regarded as 'the great light' of the university, he studied Lithuanian. 'From a linguistic point of view I love the Lithuanians more than any race under the sun' was his conclusion. He was also delighted with Zarncke's way of teaching. 'I shall learn from him as to the manner a seminar ought to be conducted.'

While he was at Heidelberg Wright eked out his savings by teaching mathematics at Neuenheim College—a boarding school for English boys in the suburb across the Neckar. But both at Heidelberg and Leipzig he found time to enjoy the social life of German Universities. He made many friends amongst his fellow-students, joined a club, and though he had never touched beer till he came to Germany, became as expert a judge of the various brews of Munich as he was of wool. He also went to the theatre occasionally, and took long walking tours with his friends in the vaca-

tions. Now he was able to earn money by his pen as well as by teaching, and he entered into a contract with the publishing firm of Julius Groos of Heidelberg to examine and revise educational books in four modern languages at a fixed annual salary. During his long connexion with the firm he supervised the issue of about thirty books. He also undertook to translate at so much per sheet the first volume of Professor Brugmann's *Grundriss der vergleichenden Grammatik der indogermanischen Sprachen*, under the supervision of its author. He had learnt to know Brugmann during a term spent at Freiberg in 1883, and was himself classed with the group known as Jung-grammatiker, who adopted the principles of Osthoff and Brugmann.

His translation of the 'Grundriss' appeared in the spring of 1888, some months after he had left Germany.

Wright spent the winter of 1887–8 in London. Max Müller, who had heard Wright's history in the north, and believed that poverty and hard work were the making of a scholar, got him to come to Oxford. 'You will soon be a made man, if you can keep your own counsel', he told him. One result of his support was that early in 1888 Wright was appointed lecturer to the Association for the Higher Education of Women in Oxford, to teach Gothic, Anglo-Saxon, and Old German. At Easter 1888 a more lucrative post followed. A. A. Macdonell, who since 1880 had been German Lecturer at the Taylor Institution, wished to get time to work at his *Sanskrit Dictionary*, and Wright acted as his deputy for the next four terms, at £50 per term. As he also did some teaching at the Girls' High School, and some examining for the Oxford Locals, Wright felt opulent. 'Since coming to Oxford', he told a friend in July 1888, 'I have spent £60 on books. How thankful and pleased I am to be in a position to purchase the necessary tools.' He proved himself such an efficient teacher that in June, 1890, when his employment as Macdonell's deputy ended, the Curators of the Taylorian created a special lectureship in Teutonic Philology for Wright's benefit. The salary was only £25

a term, but Wright said: 'It gave me the first real start in life, and that was the reason for my long devotion to the Taylor.'

During these years he began the publication of his primers. The Clarendon Press at first rejected his *Gothic Primer*, which did not appear till 1892, but it published his Primers of *Middle High German* and *Old High German* in 1888. He earned also a great reputation as a teacher. 'It would be impossible', declared the two secretaries of the Women's Association, 'to find a more thorough, clear, or methodical teacher, or one with more enthusiasm for his subject.' Wright attributed his success largely to the fact that he was self-taught. 'When I came to teach these things I was able to present the difficulties to my pupils in an entirely new way, because I knew exactly where my difficulties had been.' Before he had been three years in Oxford he knew every one interested either in English or in the science of languages, gained general respect by his character and his knowledge, and made some lifelong friends. He used to say later that Oxford was 'the most cosmopolitan University in the world'. . . . 'A man could make his way there if he had the will: it did not depend upon birth or social status, but upon work'.

Fortune provided the opportunity he needed. Mr. Sayce, who had been deputy to the Professor of Comparative Philology since 1876, resigned at the end of 1890, and Wright became a candidate for the post. 'I could not wish for a better Deputy', wrote Max Müller, while Murray, Napier, and other Oxford authorities reinforced by their personal evidence the eulogistic testimonials of German experts. Wright was elected in February 1891. The statutes required him to give twenty-four lectures a year, but during the ten years for which he held the post he never gave less than forty-two, besides a large amount of private instruction. He lectured now on the Comparative Grammar of the Indo-germanic languages in general, and also on Comparative Greek and Latin Grammar. At this time his intention

was to make 'a big Comparative Greek Grammar' his *magnum opus*, and he had already written out the phonology of the vowels for press. But this Greek Grammar would require many years for its completion, so Wright turned first to a lighter task. He was wont to say that he knew many languages, but that the only one of which he was really master was the dialect he had spoken for the first fifteen years of his life. Having learnt the first principles of linguistic science in Germany he proceeded to apply them to his native speech, and began to put together in 1886 his *Grammar of the Dialect of Windhill in the West Riding of Yorkshire*. The Dialect Society published the volume in 1892.

It contained a glossarial index, and a series of specimens in verse and prose phonetically rendered. Scholars welcomed it enthusiastically. One German professor declared that it was 'epoch-making in the history of English dialect research'; another said more simply that 'after a flood of dialect works of little value an Englishman had at last shown his countrymen how they ought to work in that field'.

One result of the publication of this book was to divert Wright's efforts still further from his big Greek Grammar. Ever since its foundation in 1873 the English Dialect Society had projected the production of a Dialect Dictionary. For some time past Wright had been pressed to take it in hand. The story of its origin is told by Professor Skeat— 'the father and real originator of the work'.

> After meeting with much success in the collection of dialectal words, by the help of the English Dialect Society, founded and for many years presided over by myself, the work came at last to an absolute standstill, owing to the impossibility of finding an editor capable of compiling a dictionary from the materials. It was soon perceived that no one but an accomplished phonetician could hope for any success in preparing such materials for the press, and in superintending the issue of the work in a final and intelligible form. After the work had thus been at a standstill for at least a couple of years ... I was so fortunate as to discover in Dr. Wright the only man capable of undertaking this task.

In June 1887 Skeat tentatively suggested the task to Wright, and in January 1889 Wright told his friend Holthausen that if he could get 'something permanent and worth having' in England he should settle down to dialect work, and edit the projected *Dialect Dictionary*. His appointment as Deputy-Professor gave him the required position, and in the summer of 1891 he took a house in Norham Road, Oxford, to hold himself and his materials. Twelve large cases weighing about a ton, and containing a million slips were sent him by the Dialect Society. On examination he judged that another million slips would be necessary. By circulars, public addresses, and the formation of Local Committees he got together 600 voluntary helpers, and accumulated the additional evidence needed. He also collected dialect books to the value of six hundred pounds, and in 1894 began to experiment in the printing of specimen pages.

No obstacle daunted Wright. 'The real pleasures of life', he once said, 'were derived from overcoming difficulties.' But there was one difficulty that seemed insuperable, and that was how to provide for the cost of publishing the *Dictionary*. At the end of 1889 the balance in the hands of the Dialect Society was only sixteen pounds. The Delegates of the Clarendon Press refused to publish the book: the *New English Dictionary* was too great a drain on their resources. The Cambridge Press also refused. Other publishers who were approached: John Murray, Black, and Frowde, all declined. The only expedient left was for the editor to publish the book by subscription at his own risk. The Delegates of the Clarendon Press were so afraid of responsibility that they would not allow their agents to collect subscriptions, lest they should seem committed thereby 'to some kind of guarantee with regard to the appearance of the work'. But fortunately they proved willing to let Wright a couple of rooms at a nominal rent, and he transferred the books and slips from his house to this workshop in the summer of 1895.

Wright took the responsibility of financing as well as editing the Dictionary. He put all the £2,000 he had saved into the enterprise, collected subscriptions himself, and applied for government aid. In March 1896 an interview with Mr. Balfour was arranged. By that time Wright had obtained 920 subscribers, and the application was supported by a strong memorial. Mr. Balfour was convinced; he made a grant of £600 from the Royal Bounty Fund, to be paid at the rate of £200 a year during the next three years, and promised that when that period ended he would consider the question of a pension. Wright performed his task with punctuality. The first instalment of the *Dictionary* came out on 1 July, 1896, followed at regular intervals by parts which increased in size as the work progressed. In July 1898 a Civil List Pension of £200 a year was granted to the editor. By that time the work had reached the Letter F. Z was published in February 1905. The *English Dialect Grammar* which came out in the following September was not merely an introduction, but an independent work, and in Wright's opinion, 'philologically far more important than the Dictionary'. The six volumes contained 5,000 pages, and included about 100,000 words, explained by some 500,000 quotations. The total cost of production was estimated to be £25,000.

Wright was wont to describe the *Dictionary* as 'the work by which I hope to be remembered'. Its production had occupied him from the fortieth to the fiftieth year of his life. At the end of those ten years he might have said as Chapman did when he completed his translation of Homer:

> The work which I was born to do is done.

It was undertaken at the right moment; delay for another generation would have made the task harder. 'Pure dialect speech', wrote Wright in 1895, 'is disappearing even in country districts, owing to the spread of education and to modern facilities for inter-communication.' Thirty years

later he found it almost impossible to collect reliable phonographic specimens of dialects.

In Yorkshire and in England generally it is very difficult to find people who can speak a dialect without being seriously mixed up with the so-called standard language. There are thousands of working people who speak their dialect properly so long as they are talking among themselves, but so soon as they come to speak with educated people, especially strangers, they become hopelessly mixed in their pronunciation.[1]

Wright was the fittest man for the undertaking. For the first fifteen years of his life he had spoken only his native dialect. To that advantage he added a scientific training in philology and phonetics which few Englishmen had acquired. He combined with this equipment all the qualities of character needed for a great enterprise; energy, foresight, courage, and singleness of purpose. Long and hard experience had developed his mastery of detail, and taught him to make the most of every hour and every penny. He had also the genial enthusiasm which secured the co-operation of other men, and skill to organize systematically the labour of his helpers and subordinates.

One of his collaborators was his wife. Miss E. M. Lea had been his pupil whilst she was a student at Lady Margaret Hall (1887–90). Under his supervision she produced a grammar of the Northumbrian Dialect, based on the Northumbrian version of the gospels, which was printed in *Anglia* in 1893. She was then appointed, by his recommendation, tutor in Old English and Middle English to the Association for the Education of Women in Oxford. Miss Lea became engaged to Wright on the day when the first part of the *Dictionary* appeared and they were married on 6 October, 1896, after the preparation of the second part had been completed. 'Had it not been for you', he told her, 'nothing in the world could have induced me to undertake what seemed an impossibility to everybody else.'

Mrs. Wright helped with the clerical work throughout,

[1] ii. 424, 12 Oct. 1926.

and acted as sub-editor of the text of the *Dictionary*. She took a still larger part in the production of the *Dialect Grammar*, and was specially thanked in its preface. Her name appears on the title-page of many of Wright's later grammars as part author. Separately Mrs. Wright published in 1913 *Rustic Speech and Folk Lore*.

Financially Wright was now a prosperous man. While the *Dictionary* was still in progress he had been elected to succeed Max Müller as professor of Comparative Philology (1901), and had thus an assured position in the University. However, it was some years before he obtained the full salary of the professorship. When the approaching completion of the *Dictionary* relieved him from the heavy responsibility he had assumed, he bought an acre of land in north Oxford, and built himself a house there. He called it 'Thackley', and roofed it with stone brought from a quarry near his old home. He purchased the building materials and hired the workmen, instead of employing a contractor, and saved a considerable sum by this plan, as he had done by undertaking the publication of the *Dictionary* himself. He adopted the same method in publishing the grammars he subsequently produced.

As Wright had now more time at his disposal, he was able to take a larger part in University affairs. He was a member of the Hebdomadal Council from 1908 to 1914, and vigorously supported Lord Curzon's projected reforms, but he went much farther than the Chancellor. His chief service was the preparation of a scheme for professorial pensions, and though the measure for that purpose introduced in 1913 failed to pass, the evidence he had collected proved of use ten years later.

Wright's view of the functions of professors was based on his observations in Germany. His theory is set forth in a memorandum written for the University Commission in 1920 and was exemplified by his practice.

A professor's most important duty was to teach others the subject he professed, and it was part of it to remedy the

defects of existing text-books by writing better ones. 'Continental professors', he told the Commission, 'attach very great importance to the provision of first-rate text books on their subject, but here it is generally thought to be beneath the dignity of a Professor to write such books, whereas it is in reality only a Professor who knows his subject from all points of view, who is in a proper position to do work of this kind.' As soon as he was free from the *Dictionary* he set to work to revise the primers for beginners which he had already written, and started a new series of grammars on a larger scale, and accordingly a second edition of the *Old High German Primer* appeared in June 1906, followed by a third in 1917. The *Gothic Primer* had reached its second edition in 1899: in 1910 it was converted into a *Gothic Grammar*, with the Gospel of St. Mark, and other selections from the Bible added.

The larger series of historical and comparative grammars began in 1907 with the *Historical German Grammar*, which was a substantial volume of over 300 pages. In 1908 appeared the *Old English Grammar* which reached a second edition in 1914, and a third in 1925. The third of the series was the *Comparative Grammar of Greek* which Wright began in 1892, and brought out at last in 1912.

Next came the question of professorial teaching. The statutes of the University usually defined the duties of a professor as the delivery of a certain number of lectures per annum computed according to the amount of his salary. Wright did not underestimate the importance of lectures. 'It used to take me a dreadful long time to write a good set of lectures', he once said; yet for many years he gave more than the number the statutes required. By itself, however, he thought lecturing an inadequate method of teaching, and held that professors should supplement it by holding classes and giving instruction for several hours a week.

It is in just this method of coming into direct contact with the men in classwork and in private intercourse that a professor can exercise that stimulating influence upon men which encourages

them to take a keen interest in their studies, and to aspire to a higher and wider standard of knowledge than is usually required for examination purposes. It is only in this way that men can be taught how to work for themselves in a scientific and scholarly manner, and to be in a position to pursue their studies further after they leave the University.

Wright practised this doctrine. He possessed a remarkable knowledge of the character and capacity of his students, and his correspondence shows that he continued to advise and help them in dealing with problems of teaching or research in their later career.

He held that another duty incumbent on a professor was 'to take a leading part in organizing the teaching of the subject connected with his chair', as professors did at all continental Universities and at the modern English Universities. In the older subjects which were directly connected with the inter-collegiate system of teaching it was not possible for professors to exert this influence unless they were given statutory powers for the purpose. In English and Modern Languages Wright could employ his zeal and skill. Though the statute establishing an English School had been passed in 1894, the University provided no adequate instruction in English Literature till the appointment of Sir Walter Raleigh as professor in 1904. A Committee was then formed which arranged systematic courses of lectures and classes, devised a plan for raising fees to pay for additional teachers, and established a special library for the use of English students. Wright was throughout one of the leading members of 'The English Committee'. In addition to that he organized in 1913 a special course for foreign students, which promised to become a great success till the war brought it to a premature end.

Wright's greatest service to the University was the organization of the School of Modern Languages. The statute creating that School was passed in 1903. More than half a century before that date Sir Robert Taylor's endowment had provided rooms for lectures, a fine library, and

a small staff of teachers, but neglect, hostility, and the narrowness of the examination system had for many years made the teaching mainly elementary and prevented the development of the study. Wright, who as professor was *ex officio* one of the Curators of the Taylorian, became almost at once their inspiring spirit, and was from 1909 to 1926 the Secretary of the Board. A bold and comprehensive policy was adopted, and consistently pursued by the Curators.

Between 1905 and 1914 two new professorships were founded, and several new lecturers added to the staff, elementary classes were supplemented by advanced teaching, some departmental libraries were created, and an efficient system of instruction in five modern languages was organized. The number of students was more than doubled, and to provide for the necessity of increased accommodation in the future four adjacent houses were purchased for the extension of the building; the funds needed for these purposes were derived from the Taylorian endowment, from lecture fees, from increased University grants, and from Sir Julius Wernher and other private benefactors. Wright himself subscribed very generously towards the purchase of the houses and the provision of new lectureships, and managed the finances of the study with great ability.

The war suspended the development both of the English and the Modern Language Schools. Male students were reduced to a handful, though there were still large classes of women, and the number of teachers was much diminished. No man worked harder during those years than Wright. Besides his own lecturing duties he undertook the work of Professor Napier[1] for the English School, did part of the teaching of German, and finally performed the ordinary duties of the clerk to the Taylorian Curators. He also published in 1917 a third, and much enlarged edition of his *Middle High German Primer*.

The revival of studies and the reorganization of the

[1] Professor Napier died on 10 May, 1916.

University after the war added to Wright's labours. He hoped to give evidence before the University Commission appointed in November 1919, and drew up two memoranda to submit to it, but he fell ill before the Commission met, and was unable to appear in support of them. Prolonged overwork and unwholesome diet during the later years of the war had destroyed Wright's robust health. Suddenly taken ill in January 1920 he spent nearly a couple of months in Leicester Infirmary, and underwent a serious operation in the following June. It was not till the autumn of 1921 that he was fit to resume his lectures, and another year passed before he could begin writing again. 'I am now naturally obliged to take care of myself', he wrote to a friend in 1924, 'but for a long time back I have been able to work solidly for 50 or 60 hours a week without being run down or feeling tired.' Three new grammars were published in rapid succession. The *Elementary Old English Grammar* and the *Elementary Middle English Grammar* appeared in 1923, and an *Elementary New English Grammar* in 1924. These, nominally designed for beginners, were something between the Primers and the larger Comparative grammars. He had in his mind a fourth book of the same type to be entitled *Historical English Grammar*. It was meant 'to combine the essential elements of the three previous books, leaving aside in each period of the language as far as possible all side issues and problematic questions, and concentrating on the sounds, inflexions, and native vocabulary which are the basis of living standard English'.

Wright resigned his professorship at the end of 1924, hoping that when he was able to devote himself to his own private work he could succeed in completing this *Historical English Grammar*, and add to it historical and philological grammars of other languages 'to serve as text-books for the younger generation of University students'. These schemes were frustrated by the steady decay of his health. The last book he was able to publish was the enlarged and revised edition of his *Middle English Grammar* which came out in

January 1928. In announcing its appearance to a friend, he said 'I have definitely given up all idea of ever writing a new book, or of finishing the one I was writing before my illness'.

The Latin grammar at which he had been busily working as far back as 1912, had been put aside during the War, and postponed again for the sake of the three English Grammars; it was now given up altogether, though much of it was written out in final manuscript for the printer. The epitome of the *Dialect Dictionary*, which he had prepared by Skeat's advice many years previously, was delayed owing to increased cost of printing, and remained also unpublished.[1]

There was one project Wright still hoped to carry out, and that was the extension of the Taylor Institution by building on the site of the houses bought for that purpose in 1909–10. As early as 1917 he began private applications to possible benefactors, and he issued in 1920 a public appeal for subscriptions. About £15,000 had been raised by 1923, of which he contributed over £2,000 himself. Since the war the number of students of Modern Languages had very greatly increased, while three new professorships and a number of scholarships had been endowed. More rooms for teachers, pupils, and books were needed. In May, 1927, Wright offered the University £10,000 in order to induce it to undertake the extension at once. The gift was subject to the condition that interest on the capital sum should be paid to himself and Mrs. Wright during their lives, but would have made it possible to build what was primarily essential. After more than a year's deliberation, Council proposed a decree for the acceptance of Wright's offer on 23 October, 1929, but it was rejected by a small majority in Congregation owing to the opposition of rival interests.

The failure of his scheme was a great blow to Wright. A few months later the Local Examinations Delegacy voted £10,000 from its surplus for the purpose of extending the Taylorian, and though building was still for some time

postponed, the extension was opened by the Prince of Wales on 9 November, 1932.

Unfortunately Wright did not live to see his desire fulfilled. He died on 27 February, 1930, leaving to the University of Leeds as a legacy the gift he had offered to Oxford. His portrait, painted by Ernest Moore in 1927, hangs in the Taylorian. It is reproduced in the *Life of Joseph Wright*, published by Mrs. Wright in 1932, which commemorates also their two children who died in childhood, and contains fragments of his autobiography. Wright's character is the key to his story. 'Necessity', he said, 'taught me at a very early age to trust myself.' The lesson was easy for a man of his temperament, and the result was lasting. 'I have never been depressed in my life', he told his friends. A large and generous simplicity inspired his actions. He combined the energy and courage of self-made men with a scholar's love of knowledge for its own sake, and having attained success, instinctively used position and gains for the advancement of his studies.

The value of the work he did was recognized by many honorary degrees and distinctions. He was created a D.C.L. of the University of Durham in 1898, and L.L.D. of Aberdeen in 1902 and of Leeds in 1904, a Litt.D. of Dublin in 1906, and a D.Litt. of Oxford in 1926. He was also an honorary member of the Royal Flemish Academy (1919), of the Utrecht Society (1926), of the Royal Society of Letters of Lund (1928) and of the Modern Language Association of America (1926). He had been elected a Fellow of the British Academy on 25 June, 1904, and to him it awarded in November 1925, its first Biennial Prize for English Studies. To our library he presented a copy of the *Dialect Dictionary* printed on hand-made paper when the Academy moved into its new rooms in Burlington Gardens in July, 1928.

<div style="text-align:right">C. H. FIRTH.</div>

W P KER

VIII
W. P. KER
1855-1923

WILLIAM PATON KER was born on the 30th August, 1855, the eldest son of William Ker, a merchant of Glasgow. He went from the Glasgow Academy to Glasgow University, and on to Balliol (1874-8), in the time of Jowett, with a Snell Exhibition.

The notes of his undergraduate days which follow have been written by his lifelong friend, Professor John MacCunn.

The love of books and the love of nature, two compelling passions which shaped decisively his whole plan of life, were already strong within him. He took to Oxford kindly from the first, and, as the years went on, fell more and more under the spell of her antiquity, her traditions, her beauty, her College life, her river, and not least that charm of her environment which *Thyrsis* and *The Scholar Gypsy* have revealed to the world.

Perhaps the greatest change that marked these years was the growth of that sociability which made him in all his after years so notably a man of friendships many and strong. Not that he was lacking in sociability when he came up. Far otherwise. Yet in temperament and in manner he was reserved, reticent (especially about himself), and of few words even in the company of his friends. But it was not shyness nor aloofness; nor were his silences unsympathetic. As all his later life proved, he had the instinct of good fellowship in most uncommon degree. Among the Scottish set in Balliol he very soon began to associate much more freely than any of the hyperboreans of his time with the southrons. Nor did his reticences and silences seem to stand in his way. His new acquaintances just dubbed him 'William the Silent', and made him thrice-welcome to their companionship and friendship.

This expansion of his friendly circle undoubtedly owed much to the river. From the first he took to rowing with gusto. He rowed in the Torpid, and won the Morrison Fours in 1875—an occasion on which he wrote to a friend owning up to a sense of 'the pride of life' in victory. He also, from the first years onwards, made many an outing with many a friend in exploration by water of the meadows of Thames and Cherwell. It was a pastime he kept up all his life.

These rowing days made a lasting impression—all the deeper perhaps because, excepting long tramps on the open road and off it, there was for him no rival sport to divide the allegiance. Some of the most valued and enduring friendships of his life were those with rowing men. Few things gave him more delight, when many years had gone by, than to go down to Oxford and launch again on the river with A. L. Smith or some other old comrade.

In those days there were few opportunities, outside College life, for undergraduates to cultivate the social affections. Ker has himself recorded the fact that throughout those years there were but two households that 'took him in'. But there were compensations. The College friendships throve all the better. And when Mr. Whibley recently paid to his memory the tribute that 'he never gave up to an imagined necessity of toil the hours which he might dedicate to talk and to his friends', he was but putting his finger on a characteristic which had a singularly rapid growth in the care-free sociabilities and friendships of College life.

Not that the 'toil' was any the worse for that—not much at any rate. When he was reading for Moderations, Paravicini was his tutor—'one of the best teachers I ever had', he calls him, looking back across many years—and under that quickening and exacting guidance he got his first class (as was generally supposed) with ease. An equally sure First in 'Greats' was prophesied by such as knew him best, dons included. Why not? Had he not already won distinction in philosophy under Edward Caird in Glasgow? Was not T. H. Green, for whom he had a profound respect, his tutor— 'generous as he always was even when I pained him with my futile essays'? Did he not already love his Plato? Was he not known in his own circle as a man who seemed to remember everything he read?

When the unexpected happened, and his name appeared in the respectable but sadly levelling second class, there was general astonishment, and of course conjecture enough as to the Why. Who can tell? But one might suggest that it was Literature and the love of it that at any rate helped to his transient discomfiture. For though he read steadily enough for the Schools, he did not bound his reading thereby. This was characteristic. He could walk on the beaten highway reasonably well, but he was not minded to be enslaved into never leaving it. Few things exasperated him more in later years than the suggestion that either he or his students should be barred from wandering adventurously, even far afield, when the spirit really prompted. Nor does it seem doubtful that this spirit was already in him in those two years when he was facing the

'Greats' curriculum. He once told a friend how T. H. Green, coming into his room, found a volume of Heine on the table and 'warned him against it'. Was this just an instance of Green's well-known aversion to cynics and satirists in general? Not so likely, on the whole, as that it was the dutiful reminder of a College tutor that the paths of Heine and his like did not lead to success in the Schools. And it is probable that he had been stealing many an hour for Dante which should have been given to Plato and Aristotle.

Mr. A. C. Bradley records: 'I was a young don at Balliol then. W.P. was as good at philosophy as at history: yet we used to say to one another, "It would be ridiculous for W. P. to miss his First, but can he write enough?"'

But this academic misadventure did not appreciably retard his career. He took it with equanimity, and the incident was swiftly made good by the Taylorian Scholarship (in the year of his Final Schools, 1878), by the assistantship to W. Y. Sellar, Professor of Humanity in Edinburgh (one of the most valued experiences of his life), and in November, 1879, by the All Souls Fellowship.

In 1883, at the age of twenty-eight, Ker was one of the young men appointed to professorships in the new University College of Cardiff. Six years later he was appointed to the Quain Chair of English in University College, London. Till his resignation of that chair in 1922 he spent most of the very long London terms at his house, 95 Gower Street. But at the end of each week 'he was always to be found at Oxford'.

Returning to London on Mondays, he gave every week an extraordinary number of lectures and classes—in the earlier years of his professorship as many as a dozen. It is to be wished that many of these courses of lectures could be printed. In substance and style they were quite different from those single public lectures on isolated topics by which alone he is widely known as a lecturer. His manner to his students has been described by Mr. B. I. Evans, one of the younger among them:

> We will always remember him as he lectured to us: the low voice with its slow, emphatic delivery: pausing at times while he stood, his hand outstretched even as if in pain. We remember how the eyes would sparkle and the whole face lighten in anticipation of a stroke of wit, and the voice would grow even thinner and quieter than in the main discourse; how he would read and quote frequently, while the sounds would rise and fall through a wide range of tones. We remember how he taught us that life and work were a game to be played well, and with attention to the rules and to the other players.

For long after each lecture Ker waited in his class room, and there was always a line of students who loved to come up, each for a few moments' talk.

About one-third of these thirty-three years of strenuous teaching had passed, when the University of London was reorganized. After that, as Chairman of the Modern Languages Board, and, later, of the English Board, Ker took the leading part in moulding English studies throughout the University of London. It was not always an easy task. He was inflexible in his hatred, on the one hand, of any officialdom which seemed likely to hamper the School, and, on the other hand, of any slackness on the part of his colleagues on the Committee. When he thought he detected either of these sins, he could be unusually (his victims may have thought unnecessarily) severe. A member of the Board who came late might be greeted with the words, 'Mr. —— has returned from his holiday.' The words look harmless: but those who watched the eyes and mouth of W. P. had a lesson in the meaning which harmless words may be made to convey.

But the building up of an Honours School of English was only one of his labours in London. He threw himself into the general work of the University, on the Senate, the Academic Council, and the Faculty, and on the Professorial Board of his College. He attended assiduously, spoke seldom, and then always very briefly, but with extraordinary effect. His conservatism was combined with a readiness for any development upon sound lines. During the difficult years of the reconstruction of the University of London he was, in the words of his most tried and experienced colleague, 'a tower of strength to us'. His eagerness for any new adventure was shown by the energy with which, even during the distractions of the war, he undertook the work of organizing the teaching of Scandinavian in London. After some Swedes had been dining with him, he writes: 'They are all very keen about getting Sweden better known over here, and I am hoping to be one of the instruments, under Providence.'

An early biographer of Sidney tells us that 'Such was the ubiquitariness of Sir Philip's mind that he could attend at the same time to all arts'. Ker could attend to all the literatures of Western Europe, and to the affairs of more than one University, with a thoroughness which made it difficult to believe that each of these interests was not first in his mind. He was ready to give help everywhere: particularly, perhaps, for old sake's sake to the Welsh colleges. 'I go to-day', he wrote on 12th May, 1922, 'to Aberystwyth, to give a lecture on Pope.

You may think this exorbitant, but it saves me a meeting of school governors at Bow' (Ker represented University College on the governing board of the Stepney and Bow schools for twenty-six years). At another time he apologized for not coming to lunch: 'I am sorry I am prevented. A committee springs up at 1.45 to-morrow, and chokes my party.' How many were his duties, and how seriously he took them, few knew till, after his death, friend spoke with friend about him, and found that he had been working in all sorts of unexpected ways.

The demands upon his time made by all these things grew, in the end, unbearable; and when he resigned his London chair in 1922, he wrote to a friend, 'it is only the intolerable agenda of committees'. The Directorship of Scandinavian studies in London, however, he retained to the last, for the thing dearest of all to him was the study of what Scandinavia had contributed to the world. Almost his last words to the Provost of University College were: 'I am anxious about Scandinavian studies; they must be kept going.' In a letter, amid other topics, he would suddenly break out with, 'Do not neglect the Danish tongue.'

What he himself felt about his teaching was expressed when, less than three months before his death, he said farewell to old friends and students who had met in University College to hand over his portrait to the College, and to give him the album containing their signatures:

> I ought, I know, to feel that all my past life is coming back in a vision, and that this present reality is somewhat unreal as compared with what is past—and I will not say that that is altogether different from my present state of feeling. At any rate, I think of the noble words of Goethe, and I see the meaning of them, though they do not express fully and entirely what is in my mind just now:
>
> > Was ich besitze seh' ich wie im Weiten,
> > Und was verschwand wird mir zu Wirklichkeiten.
>
> That is part of—that might be part of my story; but I am just as much impressed with the reality of the present occasion, with the sense that I have had a successful life in this College. . . . There is something poor, I know, in complete success, but I can't help it. There is nothing left me to wish for, nothing that I wish better in this theatre as I leave it. There, I have spoken my mind. It is not that I haven't many things to repent of: I do not believe that all my sentences have been full of life, any more than I think that they have all been grammatical. . . .
>
> I might go on with reminiscences, and with good advice. My good advice is that of the Abbey of Thelema, 'Do what you like'— and of course be sure that you know what you like. That advice

is supplemented with the note, that those who are well nurtured have in them the mind of honour that keeps them in the right way . . .

May I add the piece of advice not to forget Mr. Helweg's 'Danish Ballads'. These are my last words. Thank you.

There was something peculiarly happy in the application to Ker (by a friend writing three days after his death) of the words of Torfrida, 'Which of you knows all the tongues from Lapland to Provence?' It is not only that Ker 'knew every dialect of them all, and more beside', but that, with all his knowledge, he had the spirit of Hereward the Wake. We think of his words about the epic hero: 'A gentleman adventurer on board his own ship, following out his own ideas, carrying his men with him by his own power of mind and temper'; and then of his presidential address to a society of students and scholars: 'I have been chosen one of the captains of a band of adventurers, whose province is the Ocean of stories, the Fortunate Isles of Romance, kingdoms of wonders beyond the farthest part of the voyage of Argo.'

After giving his counsel to his old students, 'Do what you like,' he continued: 'That is my advice. I have followed it as well as I could since I began to attend to books.' He told his hearers how his preferences had first been for Italian, French, and Middle High German, and how it was on the advice of a Glasgow friend, William Gow, that he turned to the things with which he was later more directly concerned.

Ker was slow to publish. He was forty-two when *Epic and Romance* appeared in 1897. Till then, he had printed hardly anything except an essay on *The Philosophy of Art*, which appeared in *Essays in Philosophical Criticism* in 1883. It was not at once realized how great was the light which *Epic and Romance* threw on problems which had been puzzling scholars for many years. In 1900, Ker edited Dryden's Selected Prose (2 vols.), and from 1901 to 1903 Berners' Froissart, in six volumes, with a characteristic Introduction. In *The Dark Ages* (1904) and *English Literature: Medieval* (1912) he compressed into small volumes much of the result of his vast reading. In 1905 a number of his shorter writings were issued in a collected volume, *Essays on Medieval Literature*. Other lectures and essays were *Sturla the Historian* (Romanes Lecture at Oxford), 1906; *Tennyson* (Leslie Stephen Lecture at Cambridge), 1909; *On the Philosophy of History* (delivered to the Historical Society, University of Glasgow), 1909; *On the History of Ballads, 1100–1500* (Proceedings of the British Academy) 1910; *Thomas Warton*

(Warton Lecture, British Academy), 1911; *Jacob Grimm* (Philological Society), 1915; *Two Essays: Don Quixote—The Politics of Burns*, 1918; *Sir Walter Scott* (at the Sorbonne), 1919; on *Romance, The Teaching of English*, and *The Eighteenth Century* (three pamphlets for the English Association); *Browning* (in 'English Association Essays and Studies'). His lectures as Professor of Poetry were issued in 1923 (*The Art of Poetry—Seven Lectures, 1920–1922*). His contributions to periodicals are too numerous to record here, but mention must be made of the essay on *Imagination and Judgement* in the 'International Journal of Ethics', 1901.

[1] Connected as Ker was with five British universities, in which he studied or taught, Oxford was the centre of his life, the home of his hearthfire. He became a Fellow of All Souls at twenty-four. By successive re-elections, in which the College honoured both him and itself, he retained his Fellowship for forty-four years, until his death. Residence in the full sense was, for nearly the whole of that period, impracticable, for his regular work lay first at Edinburgh, then at Cardiff, and then for many years in London. But he managed to keep throughout in the closest touch not only with his own College, but with the University, and with those who worked it on the spot, with Oxford affairs, and controversies, and men. After he came to London, in 1889, there can hardly have been a week-end in term that he did not spend there, besides many other occasional interludes both in term and in vacation. He was a mainstay, an institution, in All Souls. He took his turn as Sub-Warden, held other College offices, and was always a respected and trusted counsellor. The austerity of his rooms, though no unfamiliar thing in a College, seemed like a shell or husk of his own personality, for his house in Gower Street had just the same quality—

> Halt sunt li pui e tenebrus e grant—

of cavernous darkness made visible by a candle or two and by the gleam of firelight, with a surge of books and papers flooding over tables and chairs and floor. It was not there that he expanded; nor was it at the dinner-table, where he would often sit in grim but appreciative silence. It was in the light and warmth of the smoking-room, between ten o'clock and twelve or one or later: where his bust now stands regarding, with something of his own austere geniality, the tide of life and talk, *fumum strepitumque*, that eddies round it still as it did round him so often for so many years.

[1] For the three pages which follow (to 'Oxford atmosphere', p. 422) I am indebted to Prof. J. W. Mackail.

His feeling for Oxford was less that of a son to his mother than of a subject to his queen. She was something august and inviolable. When called upon, at short notice, to give the Romanes lecture in 1906 he did not hesitate to accept, and did not cast about for any grandiose subject. He took for his theme the historian Sturla Thordsson. 'I have no need to defend my choice of a subject', he characteristically said. 'The University has published the *Sturlunga Saga*. The study of Icelandic began long ago in Oxford; an Icelandic Grammar was printed here in 1689.' But it is the opening sentences of the lecture which rang the note of the man himself to those who heard the words then, and may still do so to those who read them now:

> It is natural, when the task one has to perform carries along with it so much honour and so much responsibility, to begin with a sentence of apology and deprecation. Words of that sort are not always insincere, but there is seldom much good in them. I have been asked by the University of Oxford to give the Romanes lecture, and in acknowledgement I will take and apply to my own case the words of Dr. Johnson: 'It was not for me to bandy civilities with my sovereign'.

It was in a similar spirit that he began his Warton lecture on English Poetry to the British Academy, four years later, by a brilliant vindication of eighteenth-century Oxford, of 'those quiet generations', and of Thomas Warton himself, 'a college tutor all his life, and his method with his pupils was simply and openly to discourage their attendance at lectures'; ranking him among the 'adventurers, who used their leisure in a right academic way', and his work as 'an example of historical studies springing from a fresh and genuine love of the pursuit'. 'The marriage of wit and learning, of Mercury and Philology,' he goes on (and the words might be aptly said of himself), 'was not broken in those days'.

Feeling as he did about Oxford, his election to the Chair of Poetry in 1920 was probably regarded by him (though he did not speak much about such things) as the greatest distinction of his life. He might have held the Chair earlier had he chosen; one at least, if not more than one, of his predecessors only consented to be nominated on the distinct assurance that Ker declined to stand. 'This is the Siege Perilous', he observed in his inaugural lecture. In the last of the seven lectures given from that Chair which he prepared for publication, there are a couple of sentences about Matthew Arnold which sum the whole thing up. 'His praise of Oxford is well remembered, and keeps alive an Oxford still recognizable, in spite of the thin ends of wedges and the thick of unnecessary suburbs.

He claims, and has, our loyalty through the religion of the place, which none of us will blame as superstitious.'

A word may be said here of the Oxford Dante Society, founded by Edward Moore in 1876, and still in vigorous life. From the time when Ker was elected into it in 1894, he was one of its mainstays, and a regular attendant at its meetings. He contributed five papers, besides a number of shorter notes, to its proceedings. It was part of his genius to link up with the more circumscribed and concentrated field of the Greek and Latin classics, which was the inheritance of Oxford, the study of medieval letters, and particularly of Italian poetry; just as it was to link up with it likewise the study of Scandinavian and especially of Icelandic literature. It was a characteristic instance of this that when, at his suggestion and by means of his liberality, Sveinbjörn Egilsson's translation of the *Odyssey* into Icelandic was reprinted in 1912 at Copenhagen, he sent copies of it to some of his classical colleagues; and equally characteristic of him that in doing so he did not labour the point of the unity of humane studies, but only wrote a single phrase on the gift: 'Gleðileg Jól og Guð í garði!'

The 'religion of the place' permeated, as it might be put, three concentric spheres. There was his own College, for whose fabric hardly less than for the life which it contained and moulded and interpreted, he had the passion of a lover:

> Thy saints take pleasure in her stones,
> Her very dust to them is dear.

The green quadrangle into which his own rooms looked, between the flanking masses of the Chapel and of the Library, 'designed in the tradition of Wren for his own College', to the magnificent dome of the Radcliffe and the spire of St. Mary the Virgin, was for him at all times and seasons, by dawn or starlight, in the blaze of westering suns or in the grey drift of rain, a holy place, a perpetual miracle. Next, there was Oxford itself, as a whole, filled with the enchantments not only of the Middle Age, but of later ages as well; unexplored by him indeed in its detailed riches—Bulwarks Lane, that romantic and little-known fragment of the medieval city, was, not many years ago, still a thing to which he had to be introduced—but felt by him throughout with a keen and silent appreciation. And, lastly, there was the surrounding country, the country of *Thyrsis* and *The Scholar Gypsy*, with its rivers and hills and woods, its grey villages, and its flowers. The days on the upper or lower river, with A. L. Smith and other fellow-oarsmen, the Sunday walks by field-paths,—'I know these slopes, who knows them if not I?'—and the

luncheons at Bablockhythe or Beckley, or at some remote hamlet on Otmoor, were part of his inner life. He did not shoot or fish or ride, but he had 'the characteristic passion of the good and wise for walking', and would walk alone if—as was seldom the case—he found no company. One of his last letters, written from Oxford when, towards the end of June, 1923, he had come back from Italy to give what was his last lecture from the Chair of Poetry, speaks of 'the flowers in the lanes, meadow-sweet, wild roses and elder-blossom, and a green woodpecker in a copse'.

'He never gave up to an imagined necessity of toil the hours which he might dedicate to talk and to his friends.' The talk was often silent, and not less eloquent for that. The friends were made in nature as well as among men; and of both it may be said with equal truth that 'he never forgot a friend, living or dead'. That was the ethical side of his vast and almost flawless memory. It was part of his Oxford tradition, as he conceived and pursued it, to have this width and depth of permanent background. His physical and intellectual strength were both great. Both were closely packed. He reminded one sometimes of an oxygen-cylinder; what he let out from that immense reservoir of knowledge and insight was only, in the phrase of the Greek poet, $\pi\iota\kappa\rho\alpha\grave{\iota}\ \sigma\tau\rho\acute{\alpha}\gamma\gamma\epsilon\varsigma\ \dot{\alpha}\pi'\ \dot{\omega}\kappa\epsilon\alpha\nu o\hat{\upsilon}$. But no less was it part of that tradition to be cheerful, and helpful through cheerfulness. The aphorism of Spinoza, *Hilaritas excessum habere nequit, sed semper bona est*, was often on his lips. It was a strenuous habit of his own; and it flowered abundantly in the Oxford atmosphere.

Ker's feelings on public affairs were an essential part of him—one cannot imagine them otherwise. 'Nothing modern,' says Mr. Charles Whibley, 'affected him so deeply as did modern politics', and Mr. Whibley goes on to quote a characteristic letter written two days before Ker set out for his last journey to Italy:

> I went to Windsor Castle yesterday. . . . There are the flags of the disbanded Irish regiments, all together, looking very honourable, and each succeeding swarm of tourists is told what they are. I hope they will be remembered.

This side of Ker's character was much to the fore in the closing years of his life: during the war and after. It is reflected in the portrait of him by Mr. Wilson Steer at University College, London. The face is that of a man thinking deeply on some subject not altogether pleasing to him, but through which he sees further than his fellows. It is on record how, on the day of the Armistice, he sat

silent in his club, whilst his friends around him said 'this and that about the war, about the peace, and W. P. Ker said nothing. Then, in a lull, he murmured, "God is not mocked", and went his ways.'

The bust at All Souls College (by Mr. John Tweed) shows Ker in a more happy mood, and one which his friends will recognize as a more usual one. For, indeed, if any man ever carried out the Pauline precept, 'whatsoever things are of good report: if there be any virtue, if there be any praise, think on these things', it was W. P. Ker. An old student has written of him, 'his love of children, of dancing, rowing, climbing, of good wine' (for there also the Pauline advice was attended to), 'and of good fellowship, was the same thing as his love of books'. He loved animals too, and would gaze at them with a grave friendliness during his constant visits to the Zoo. It was this which made him such a guide and counsellor to the young. 'I have accustomed myself', one of them writes, 'to feel that I could not get on without him, and now I shall have to do it.'

Ker not only shared the 'passion of the good and wise for walking', but would admit only grudgingly the goodness and the wisdom of some in whom that passion was wanting: 'He is a good man: but he does not walk, and he does not drink: he is no good to me.' Dante, he thought, 'must have been good at walking tours'. He thought the more of Keats because of his long and difficult walk to the Ross of Mull. Every friend must have received, at some time, descriptions of the countryside in England, or Scotland, or Norway, or Switzerland, like some of the following:

Chequers in 1917.

I went out to look at the world on Saturday last, stirred up by the editor of *The Times,* who proposed a burst for freedom. We took train to Great Missenden, and walked over Chiltern Hills, past Hampden House to Chequers, where we were taken in to lunch, and looked at relics. It is the country that the Whigs came from, and there is a lot of Cromwell at Chequers. A place like a story book—a large Jacobean house looking down a long valley, and a hill behind it—and when you walk up to the top you find yourself on the edge of steep slopes, and a wide prospect over the Vale of Aylesbury and further. We walked to Princes Risborough, with a lift from a farmer in his pony cart, and got a train to Oxford—and slept in it most of the way. It was a fine day—misty in the morning and clearing later. Plenty of good natural rough going, through woods and up and down hill—the steep side to the West in the afternoon, and beautiful gallery paths—grass—leading along a down.

I went back to [Scott's] country at the end of the summer, and through the railway strike I was able to walk over the hill from

> Ashestiel on the Tweed to Selkirk, at sunset and after: a wonderful evening, like forty or fifty years ago, with the amusement of playing at being lost on the hill in the dark. Really it was quite dark enough when seeming plashes of pale water got up and ran away, being sheep all the time. (Halloween, 1919.)

To a friend at Molde:

> Molde is one of the places I know best in Norway, and one of the best places in the world. It was in the year 1887, I think, that I cut the hotel Sunday dinner, and walked up on to the moor till I saw the outer sea. I met with no enemy except a Mother Ptarmigan, who stood up and drummed with her wings while her little poults ran for shelter. I was misunderstood—I wished them no harm. In a later year I walked round by the road to the outer coast—there were roses a good part of the way. And later still, in 1904, I came in on board the North Cape steamer at 1 in the morning, when all was quiet, and all in the strange light of July thereabout. Pleasant to remember, and not at all 'distained' by what I have seen lately. (September, 1921.)

'What he had seen lately' had been his favourite haunts on either side of the Monte Rosa range above Zermatt, Valtournanche, and Macugnaga. During the war he had remained in England, doing confidential work for the Admiralty during his vacations, not without some envy of those who could qualify for more active service. An archaeological colleague, expert in Modern Greek, was serving with the navy in the Eastern Mediterranean, and had just been promoted Commander. 'If I had learnt bad Greek,' said Ker, sadly and slowly, 'instead of learning good Greek, I might have been a Commander.' With the peace, the passion for the mountains had returned, and in 1919 he recorded his joy at finding them again:

> I have been travelling on the 'Munt of Muntjeu' (Mundiúfjall), meaning the Alps. Walking by moonlight and most of the day after is worth while, and there is air to breathe. I will not write the sentimental journey, but I may say that the world looks very much as it used to do when I was in this country last—six years ago. Italy in the Alps is like Norway—the woods and hayfields among them, the high cows, and the cheeses. Macugnaga is the place for blaeberries: under Monte Rosa. I knew that before, but always in July, and was glad to find them still going well in August.

In 1921, at the age of sixty-five, he was doing, without apparent fatigue, strenuous climbs in swift succession, in a way which might have tried a young and very strong man. When, in 1922, he was at last free from the duties of his London Chair, he set off in the spirit of a released schoolboy. Here is a summary of a week's holiday, in

which bad weather did not stop him from climbing the Finsteraarhorn:

<div style="text-align: center;">Hotel Monte Rosa, Zermatt, 19 Aug., 1922.</div>

... Last week I was *out* for 7 days. No plans, and the weather diverting. What actually happened was

1. Stalden to Weissmies Hotel.

2. To Simplon: beaten down from Rossboden Pass by cloud: new way found over a grass pass resembling Cumberland.

3. To Eggishorn. We had meant Monte Leone, but the weather was against it: also preventing cross-country travel to Binn: so we walked down the Simplon road to Brieg.

4. A very fine day: Eggishorn to Aletsch glacier: Concordia hut: Grünhornlücke: Finsteraarhorn hut.

5. Guides at 3 called: the weather beastly, and went back to bed. N.B. it occurred to me that here was I, *the Professor on the Shelf*: the shelf of an Alpine Club hut, and wondering why. But at 6 Joseph Biner took me out into the cold windy world: over snow to the foot of rocks. I did not want to go farther, but he is a strong man. Afterwards he told me I had been so good to him that he couldn't let me off: and I am glad he took me on, for though the wind was horrible and the rocks cold, yet they were good rocks everywhere, shaking you, or rather not shaking but taking you, by the hand—being laid the right way. [A sketch of the rocks and the climber is inserted here.] And the top was sooner than I expected. That night we stayed at Concordia in great comfort—the best hotel I know for true rest.

6. Saturday morning—fine—back to Eggishorn Hotel. There Joseph left me to come home, and I stayed.

7. Sunday, 13th Aug. I did what no man has ever done—walked from the Eggishorn hotel down the Rhone valley through Brieg to Visp. I rested hours over breakfast at Moerell reading Dante, *Paradiso*, and some time at Brieg over tea: the last five miles into Visp in the cool of the evening. ... William Wordsworth is everywhere—he and Jones on the Simplon must have seen the waterfall where Joseph and I descended to find the high road. Going down to Brieg we took a bit of the old road, same as 1790.

In the previous month he had been with A. D. Godley, who describes his 'rare and singular temper which made him an ideal partner in any mountain expedition':

He idealized mountains; nothing in the whole business of mountaineering but seemed in a manner to him to have a kind of divine sanction; and the peasants who guided him ceased to be ordinary men, and became creatures divinely appointed to lead him into sacred places.

So, between England, Scotland, Italy, and the Alps he passed his first and last year of complete freedom, in the spirit of an explorer,

preparing for new things. It was about this time that he gave *nos manet oceanus* as his favourite motto.

In one of the earliest lectures he gave in London he had contrasted the perfect conclusion of the *Commedia*, in which Dante sees all the scattered leaves of the Universe, ingathered in the depths of the Eternal Light, with the apparently accidental ending of some great English poems, particularly of *Piers Plowman*; which ending, he maintained, is nevertheless also right and just. In his farewell to his students on May 2, 1923, he said, 'I never was very careful to find a peroration for my lectures. The conclusion in which nothing is concluded has always seemed to me the most admirable; and I am hoping to go on.'

The conclusion (in which nothing is concluded) came on the 17th July. He was at Macugnaga, which he loved best of all places in the Alps, and on the Pizzo Bianco, 'to him, its Holy of Holies'. He was walking up, with his three god-daughters and the guide, 'in the starlight and into the dawn: a most beautiful clear morning, with Monte Rosa above, lit by the sun'. 'I thought this was the most beautiful spot in the world,' he said, 'and now I know it.' The party had just started again after a short rest, with Ker as happy as ever, when he fell dead from heart failure, without pain or struggle.

He was buried in the little old churchyard of Macugnaga, among the guides, not far from the great lime tree which he loved.

<div style="text-align:right">R. W. CHAMBERS.</div>

SIR ISRAEL GOLLANCZ

IX
SIR ISRAEL GOLLANCZ [1]
1863-1930

ISRAEL GOLLANCZ, the first Secretary of the British Academy, was born in London on 13 July 1863, the son of the Rev. S. M. Gollancz. He was educated at the City of London School, University College, London, and Christ's College, Cambridge. At each of these places he came under the influence of a remarkable teacher, who fostered his natural taste for the study of English literature. At school it was Edwin Abbott, at University College Henry Morley, at Cambridge W. W. Skeat. For all these teachers his respect amounted to affection; I remember his anxiety that Abbott should be elected to the Academy, and by procuring from Mrs. Skeat the gift of her husband's working library he founded the Skeat Library at King's College, London, to which the Furnivall Library was subsequently added by a similar gift.

His life, which was full of enthusiasms, had two which predominated over all others—English literature and the British Academy. The story of his career (apart from its domestic side, of which this is not the place to speak) is the story of his contribution to these two causes. Even during his undergraduate days he belonged to a small club which studied poetry and read it aloud, and he founded and conducted the Christ's College Magazine. It was at this time that he formed that intimate acquaintance with Skeat and his family which had so much influence on his future career. After taking his degree at Cambridge in 1887, his life for twenty years was that of a student and teacher of English literature. He began as a lecturer at Cambridge, unofficially under the guidance of Skeat. From 1892 to 1895 he was

[1] In preparing this memoir, I have been much indebted to Lady Gollancz, who furnished papers and information, and Mr. A. W. Pollard, to whom practically the whole of the portion dealing with Gollancz's work as scholar and teacher is due.

Quain English Student and Lecturer at University College, London. From 1896 to 1906 he was University Lecturer in English at Cambridge. Throughout this period he also undertook much University Extension lecturing both for Cambridge and for London. In 1903 he was appointed Professor of English Language and Literature at King's College, London, a post which he held to the end of his life, being then on the eve of retirement under the age regulations.

During the twenty years which mark the first period of his life he had not only been teaching, but had actively devoted himself to strenuous editorial work. The first-fruits of this activity was his resuscitation in 1891 of the late fourteenth-century West Midland poem *Pearl*, which (with the three cognate pieces with which it has been preserved in Cotton MS. Nero A x in the British Museum) had been edited in 1864 by Richard Morris, but the estimation of which Gollancz considerably advanced. His edition of it had the special distinction of being adorned by a drawing by Holman Hunt and a quatrain by Tennyson, and was marked by a scholarship which was a great advance upon that of the previous edition. This was followed in 1892 by a good piece of Old English work, his edition of Cynewulf's *Christ*, and in 1893 by an Elizabethan venture, an edition of Lamb's *Specimens of the Elizabethan Dramatists*. To *Pearl* and the cognate West Midland poems Gollancz constantly recurred. A revised text of *Pearl* appeared in 1897, in 1918 a version of it reset in modern English (sold for the benefit of the British Red Cross Society), and in 1921 it was included (together with a text and translation of Boccaccio's *Olympia*) in a series of *Select Early English Poems*, of which six parts were issued between 1913 and 1923, while two more remained incomplete.

In 1895 he published for the Early English Text Society the first part of his edition (unhappily never completed, though never formally abandoned) of the Exeter Book of Anglo-Saxon poetry; but in the previous year he had em-

barked on an enterprise which played a great part in his life. This was the Temple edition of Shakespeare, which he undertook for Messrs. Dent, and which occupied the years 1894-6. This was not the first venture in the production of handy volumes of the best literature at a moderate price, for Henry Morley had shown the way with his threepenny *Cassell's National Library*; but it aimed at a far higher standard of scholarship and external attractiveness. After the completion of the Shakespeare, Gollancz and his publisher utilized the great popularity achieved by its combination of the results of the best scholarship of the day with a novel and very pretty format, by producing a long series of 'Temple Classics', which had a great success, and only came to an end in 1907 when Gollancz suggested that the share in the success due to the format was being rather excessively remunerated in comparison with that due to his scholarship. Gollancz's contributions to the series (apart from his work as editor) consisted of editions of Vaughan's *Silex Scintillans, Childe Harold, In Memoriam,* and *Maud.* He found another adventurous publisher, also skilled in book production, in Mr. Alexander Moring, for whom he edited 'The King's Classics' and 'The King's Library' in 1903-8, but as an editor the years 1891-6 were his *anni mirabiles,* and the impression which he made by them was academically acknowledged by two invitations to return as a teacher where he had been a pupil.

These invitations led to the appointments, mentioned above, in University College, London, and at Cambridge; and to these was added in 1903 his professorship at King's College. Here he succeeded a very fine scholar, John Wesley Hales (who also had graduated from Christ's College, Cambridge), but one who was at his best with a small class of rather exceptionally good students. Gollancz had proved his capacity for advanced editorial work and advanced teaching; but his distinctive gift was that of a scholarly popularizer, and at King's College, London, he saw his opportunity. In those barbarous days teachers in the London Colleges, with a few favoured exceptions, were paid

mainly or exclusively from the fees they earned, and the fees which had been earned in the year preceding the vacancy of this particular professorship had been grievously small. Gollancz, though not thinking it right to apply for the post so soon after the abolition of the religious test, intimated that he would accept it if it were offered to him, but would not compete if it were advertised. He was appointed, and in a very few years under the same system was earning the full equivalent of a modern professorial salary. One very important feature in this remarkable development was the three years' Diploma course in English Poetry and Drama, followed by a fourth year of more specialized work, including language, which Gollancz started mainly for evening students who were earning their living during the day, most of them as teachers. He brought to it a great enthusiasm which he passed over to his students, even in subjects like Anglo-Saxon poetry which most of them could only read in translations.

He was very far from limiting his interests to the earliest periods of English literature. His colleague, Prof. R. W. Chambers, notes as the most marked characteristic of his work, alike as scholar and as teacher, his conviction of the continuity running through the whole of English literature. For him the West Midland poets formed a link between the poetry before the Conquest and the achievements of Chaucer and Spenser from which our modern poetry springs. This argument was embodied in a pamphlet on *The Middle Ages in the Lineage of English Poetry*, printed in 1921.

In making the venture of exchanging his work at Cambridge, where he would doubtless have succeeded Skeat, for a risky Professorship in London, Gollancz was doubtless actuated by a well founded belief in his own capacity to make his new post a success. But he had a very strong motive for moving to London in his Secretaryship of the British Academy which, as will be described below, had come into existence in 1902. Before passing to this second

predominant interest in Gollancz's life, it will be in place to add a few words, derived from the evidence of those who knew him best, as to his methods and influence as a teacher.

On this subject the testimony of his pupils and colleagues is singularly unanimous. He never troubled himself greatly to give information which could be obtained from books which his students were likely to possess or to have access to, though on his own special subjects, such as West Midland poetry, his lectures were exceptionally instructive. His main business was not to give facts but to arouse interest and enthusiasm in his students. In this he was remarkably successful, partly because of his own obvious enthusiasm for whatever he was talking of, partly from his ability to take his students into his confidence, carrying them with him till they lost the oppressive feeling of their own ignorance. A charming story is told by one of his Cambridge students who before he came under Gollancz had written to point out to him what he considered some flaws in the *Temple Shakespeare.* On his first visit as a pupil to Gollancz's rooms, to his surprise and confusion his letter was produced, and his new teacher went through it with him in the friendliest possible way, pointing out where the criticisms were wrong, and where they were right cheerfully admitting it. 'I always liked him from that time onwards for treating a beginner so seriously' is the commentary which came with the reminiscence, and undoubtedly this willingness to treat beginners seriously was one main element in the good work which Gollancz got out of his students and in the affection with which they regarded him. Probably a very large majority of his students were themselves either already teachers or in process of becoming teachers, and Gollancz thought it abundantly worth while to give them of his best, even though to do this and to be an efficient Secretary to the British Academy involved some sacrifice of the editorial career on which he had started so brilliantly in the 'nineties. He remained a keen scholar, but good as was his scholarship his gifts as a popularizer and organizer were greater,

and his memorial is in the work of his students and the British Academy.

To this latter branch of Gollancz's career it is time to turn.

The last years of the nineteenth century saw the beginning of the movement that eventually led to the foundation of the British Academy, with which the remainder of Gollancz's life was intimately associated. As is recorded in the first volume of the Academy's *Proceedings*, its origin was due to the need for some body which could represent this country in the humanistic sciences in the International Association of Academies, as the Royal Society represented the natural sciences. The initiative was taken in the course of 1899 by the Royal Society, in consultation with certain selected leaders of humanistic studies; but in June 1901, after prolonged consideration, the Council of the Royal Society came to the conclusion that it was undesirable that the Society should either enlarge its scope so as to include the humanistic sciences, or should itself initiate the formation of a new body. The humanists were accordingly left to their own resources, though with the entire good will and sympathy of the scientists.

Meanwhile certain younger scholars had begun to take a hand in the project, with a view to doing some of the spade work for their seniors. Gollancz at Cambridge was in communication with Jebb, who was one of the leaders, and offered his services. It so happened that at the same time the present writer had been discussing the subject with Bywater and Maunde Thompson in London; and through Jebb and Thompson we were put in communication with one another, and encouraged to discuss possible solutions of the problem. I was then living at Harrow, and Gollancz had an engagement there in the instruction of the Jewish boys in the school on Sundays. Meetings were therefore easy, and more than one conversation took place in my house and garden. Gollancz, always fertile in ideas, had at first the idea that a certain literary society, then somewhat inactive,

which possessed a Royal Charter, should be persuaded to commit hara-kiri and allow its defunct body to be re-animated by members suitable to form the desired Academy. He even went so far as to secure the assent of the existing members of the society. This project, however, did not commend itself on fuller examination, and it was decided that the only satisfactory course was to found a new society altogether. The leaders concurred, and on 28 June 1901 a meeting was summoned by Maunde Thompson at the British Museum, at which a resolution embodying this decision was adopted, the persons present being constituted a provisional General Committee. A sub-committee was at the same time appointed to draft detailed proposals, and to this sub-committee Gollancz offered his services as Secretary. In this capacity he did an immense amount of spade-work, and was in constant communication with the leaders of the movement, notably Maunde Thompson, Jebb, A. W. Ward, Reay, and Ilbert. The sub-committee drew up a list of first members of the new Academy, omitting their own names. The General Committee on 19 November adopted their report and list of names, with the addition of the members of the sub-committee; and with them Gollancz, as Secretary, deservedly became one of the original Fellows of the body which thenceforth was known as the British Academy, and to which a Royal Charter of Incorporation was granted on 8 August 1902. Of these original Fellows only five now survive.

Henceforth the Academy held the first place in Gollancz's devotion, and divided his main activities with his duties as Professor at King's College. He devoted himself heart and soul to its interests, and was indefatigable in devising means of magnifying its importance and increasing its usefulness. The infant Academy laboured under considerable difficulties. It had no pecuniary resources beyond the subscriptions of its members. Its reputation was still to make, and there were not wanting persons, young and old, who, in spite of the indisputable eminence of its members in their

respective spheres, looked somewhat contemptuously on its claim to represent British scholarship. It was dependent for a place of meeting on the kindness of the Royal Society. Its members being scattered over the British Isles, it was not easy to gather them at meetings for the reading of papers. For all these disadvantages Gollancz sought a remedy. He persuaded his friends to endow lectures to be given under the auspices of the Academy, and thereby at once increased its funds for the encouragement of learning, and provided occasions and audiences for meetings. He also seized any opportunity that presented itself for bringing the Academy into the public eye. A notable early example of this was the celebration of the Milton Tercentenary in 1908. Poetry as such did not come within the scope of the Academy, which has always disclaimed the functions of an Academy of Literature; but literary history came within its province, and as no society then existed with better claims to take the lead, Gollancz seized the opportunity to procure from influential quarters an invitation to the Academy to discharge this national duty. The result was a banquet given by the Lord Mayor (Sir George Truscott), a musical service at Bow Church, a performance of *Samson Agonistes*, a memorable poem by George Meredith and a Commemorative Ode by Mr. Laurence Binyon, and a series of papers by Fellows of the Academy and others. The whole was organized by Gollancz, to whom the whole credit of an undertaking which greatly increased the prestige of the Academy was due.

In the same year was founded the Schweich Fund, by a munificent gift of £10,000 from a friend of Gollancz who desired to remain anonymous, the first of eight foundations, all but one of which were directly due to his initiative and influence, and which now form a predominant part of the public activities of the Academy. The two earliest of the endowed lectures, apart from those established by the Schweich Fund, were the Warton Lecture on English Literature and the Shakespeare Lecture, which thus represented two of Gollancz's main interests. Notable among

the others was the Raleigh Lecture on History, founded by Sir Charles (now Lord) Wakefield as the sequel to the Raleigh Tercentenary organized by Gollancz in 1919; and to Gollancz's friendship with the same munificent benefactor was due Lord Wakefield's splendid gift of the whole cost of fitting up the rooms in Burlington Gardens assigned to the Academy by the Government in 1927.[1]

In addition to these special benefactions which Gollancz was the means of securing for the Academy, the whole burden of organizing its business for nearly twenty-nine years fell upon him. As it happened that I was a member of Council, and permanently resident in London and therefore accessible, during nearly the whole of this period, I was brought into close association with him, and am perhaps in the best position to testify to the manner in which he spent himself in the Academy's service. He never missed a meeting of Council until the commencement of his final illness, and he retained in his hands the functions not only of Secretary but of Treasurer. He also superintended the issue of all the publications of the Academy. He was assisted by the devoted services of his sister, but his own labour was gratuitous; for until after the receipt of the Government Grant the Academy was not in a position to do more than make a small grant for secretarial assistance. All this work had to be done in such time as he could make available after discharging his duties as Professor at King's College; so that if publications were sometimes in arrear, and if the business of Council was not always methodically arranged, no one was inclined to be critical. The worst that could be said was that his zeal for the Academy was such that he could not bear to delegate any part of the duties of its management. His relations with all the successive Presidents under whom

[1] His zeal and skill in securing benefactions were not confined to the Academy. For King's College he obtained the Skeat and Furnivall libraries, already mentioned, and the Frida Mond Collection of Goethe books and relics. He also took a great part in bringing about the foundation and endowment of the chairs of Spanish and Portuguese.

he served were admirable; I remember particularly the testimony borne to his services by Lord Bryce when he handed over the Presidency to me. It was a special happiness to him to be associated subsequently with Lord Balfour in the negotiations which led to the gift by the Government of permanent quarters in Burlington Gardens, thus setting the seal on the status of the Academy, the establishment of which had been the goal of his efforts for a quarter of a century.

The completion in 1927 of the first twenty-five years of the Academy's life was celebrated by Gollancz by the production of a magnificent facsimile edition of the celebrated Caedmon Manuscript in the Bodleian, accompanied by a full introduction in which the many problems connected with the contents of the manuscript are studied and several original contributions are made towards their solution. It was an undertaking which at the time of the foundation of the Academy he had suggested as a suitable task for its energies, and he had been engaged on it intermittently for many years. It was a great gratification to him to be able to complete it for this occasion, and to dedicate it to the Academy. It thus serves as an embodiment in a worthy and beautiful form of his two great devotions to early English literature and to the Academy.

He did not take much share in the framing of regulations for the election of Fellows and their organization into Sections, a troublesome matter which occupied a good deal of time in the early years of the Academy's life, and in which Sir Courtenay Ilbert was the principal adviser; and the negotiations for the Government grant passed through other channels. But apart from these, it is difficult to think of any activity of the Academy in which he was not intimately concerned, if he was not the initiator of it. The Academy is not likely to forget the debt which it owes to its first Secretary.

The Knighthood which was conferred on him in 1919 was specifically in recognition of his services to the Academy, as well as of his distinction as a scholar.

Some important sections of his literary work still remain to be mentioned.

1. *The Early English Text Society.* With his Professorship at King's College and Secretaryship to the British Academy Gollancz was a very busy man, but in 1910 Dr. Furnivall, in the closing days of his life, nominated him as his successor in the Directorship of the Early English Text Society (to which Gollancz had, in addition to Part I of the Exeter Book, contributed in 1897 an edition of Hoccleve's Minor Poems from the Ashburnham Manuscript). The old man had ruled the Society as an autocrat for forty-six years, and though the names of members of a Committee were printed on its prospectuses it was said that it had only been allowed to meet once. Membership of the Committee was an honour conferred on some of the workers and helpers of the Society at the Director's pleasure. It is believed that some of these titular committee-men met after Furnivall's death and confirmed his nomination, and Gollancz managed the Society successfully for twenty years, not troubling the Committee to meet for any normal business, but occasionally summoning it when he needed help, or contemplated some use of the Society's funds a little out of the common. On one occasion, for instance, an interesting fifteenth-century manuscript, a miscellany of unedited English verse, had come into the market, and the Director was anxious to secure for the Early English Text Society the right of printing it. He arranged with a friendly bookseller to buy and hold it for the Society, and with the Keeper of Manuscripts at the British Museum that he would recommend the Trustees of the Museum to purchase it at a reduced price after it had been printed. To the members of the Committee Gollancz proposed that the publication should be connected with the name of Henry B. Wheatley, one of the founders of the Society and for many years its Hon. Treasurer, then recently dead, and that his friends should be asked to subscribe to it as a tribute to his memory. So the volume appeared, edited by Dr. Mabel Day, in 1917,

under the title 'The Wheatley Manuscript', its cost was somewhat reduced, and one of the Society's best friends was honoured; a characteristic example of Gollancz's deftness in combining several good objects so that each should be more easily attained.

The Wheatley Manuscript appeared during the War when the Society was reduced to great straits owing to the difficulties of communicating between England and the United States, from which it drew a considerable proportion of its subscriptions, and ultimately of a great increase in the cost of print and paper. The gift by the Carnegie Trustees of America of half the cost of its publications in two successive years saved its finances, and for the rest of his term Gollancz managed them so well that at the time of his death it had some three thousand pounds to its credit with its bankers. In the visit which Gollancz paid to the United States in 1923 he had procured its society new subscribers and recalled old ones, and his wisdom in abandoning the paper covers (which Furnivall throughout his Directorship insisted on retaining to save expense) in favour of substantial cloth had helped to increase the sales. An even greater asset to the Society than his good management of its publications was the cordiality with which he welcomed all students from a distance when they came to work in London. He interested himself in their researches, and every Saturday afternoon opened his house to all who cared to come.

2. *Shakespeare.* In addition to his 'Temple' Shakespeare Gollancz published studies on the history of the Hamlet Saga, and had a favourite theme for a lecture on the Merchant of Venice which, without ever writing it out for publication, he gave in a variety of forms, tracing the origin of the different strands in the play and trying to penetrate to an inner meaning, which has escaped its commentators.[1] In 1916, when the Great War prevented any full celebration of

[1] Three forms of this lecture were printed as an In Memoriam volume for private circulation after his death.

the Tercentenary of Shakespeare's death, he organized the publication of *A Book of Homage*, to which scholars and Shakespeare-lovers from the allied and neutral countries contributed, though few were able to give of their best. From 1908 onwards he was Honorary Secretary of the Shakespeare Memorial National Theatre. He also took an active part in organizing the celebration of a Shakespearian Day in schools, and founded a Shakespeare Association, which met to hear papers and at the outset interested itself in publishing reports of the growth of appreciation of Shakespeare, both in the theatre and in the study, in various countries. In 1923 he organized a further celebration, this time in commemoration of the publication of the First Folio in 1623, arranging for a very successful series of lectures by Sir Sidney Lee, Dr. Greg, Prof. Dover Wilson, and others at King's College, which were subsequently published for the Association by the Oxford University Press. He also moved the Stationers' Company to take part in the celebration, and so interested them that he was admitted to its freedom. Shortly after this he took part in a visit of a number of professors and students of English to the United States, and in the course of it frequently spoke of the Shakespeare Association which, having enlisted the help of Dr. Page, he had planned on an Anglo-American basis. Eventually an independent Shakespeare Association was formed in the United States, but the English society benefited considerably by the donations to it which resulted from Gollancz's visit. Under its auspices some excellent lectures were given, but he was so busy with other things that he never quite succeeded in equipping it with a practical plan of work. Yet he was keenly anxious for its success, so keenly that when his friends came together in the autumn after his death, the first step to which their loyalty to him prompted them was to work out a constitution for the Association and give it a new start with Mr. Harley Granville Barker as its president.

3. *Tokyo University Library*. After the disastrous earth-

quake at Tokyo in 1923, another piece of work was laid on Gollancz and gallantly carried through. On the suggestion of the Foreign Secretary (Lord Curzon), the British Academy undertook the formation of a Committee to raise funds and invite gifts of books, as a contribution from this country towards the restoration of the University Library, the greater part of which had been destroyed by the fire that followed the earthquake. The organizing of this work, like every other undertaking of the Academy, fell almost automatically upon Gollancz; and when, on the completion of this stage (resulting in a gift of about 20,000 volumes to our ally), His Majesty's Government procured from Parliament a grant of £25,000 for the extension of the gift and the formation of a representative collection of English literature in the restored Library, it was naturally to Gollancz that they entrusted the administration of the grant. He threw himself into it with enthusiasm, forming advisory committees for the several departments of learning, co-ordinating the lists furnished by the committees, taking endless pains to procure all the books which the Japanese authorities particularly wanted (more especially a copy of the Catalogue of the printed books in the British Museum, which for long seemed unattainable), and in the end obtaining the consent of the Government to a scheme which a friend had proposed to him, by which among the books sent to Tokyo was a series of examples of English printing from 1520 to our own times. For this (after the earlier years had been represented by facsimiles) one or more books printed in every decade were acquired to illustrate the history of English printing and book-building during four centuries. These books were exhibited at the Foreign Office before being sent off and a special catalogue was printed as a record of the collection.

 The fullness of the life which has thus been recorded speaks for itself; and it was vindicated by the glow of his own enthusiasm, by the circle of personal friendships that grew out of it, and by a happy home life. In 1910 he married

Alide Goldschmidt, who with a son and a daughter survives him. He continued in full activity and health till within a few months of his death. When he returned from his usual spring holiday in 1930, he was obviously a very sick man. At a great cost to himself he insisted on making all the usual arrangements for, and himself attending, the annual meeting of the Council for the election of Fellows on 21 May; but thereafter his illness made rapid progress, and on 23 June he died.

Distinctions which have not been already mentioned included the Fellowship of King's College (1917), Corresponding Membership of the Royal Spanish Academy (1919) and the Medieval Academy of America (1927), the Presidency of the Philological Society (1919-22), and the Leofric Lectureship in Old English at Exeter University College.

A fine bronze bust of him, the work of Mr. C. L. Hartwell, R.A., and the gift of Lord Wakefield, stands in the Council Chamber of the Academy, and a characteristic photograph hangs on the wall of the Lecture Room; but the whole Academy for the first thirty years of its existence is in a sense his memorial, and he would have desired no better one.

F. G. KENYON.

WILLIAM CRAIGIE

X

SIR WILLIAM CRAIGIE

1867–1957

WILLIAM ALEXANDER CRAIGIE was born in Dundee on the 13th of August 1867, the youngest son of James Craigie and Christina Gow. He was something of a linguist even before he went to school, for his parents spoke the local Scottish dialect and his maternal grandfather, who was Highland, taught him some Gaelic when he was only three or four. At the West End Academy he learned a second Scottish dialect from two of his teachers, who were Aberdonians; and his headmaster, George Clark, gave him a sound training in phonetics and shorthand, both of which were to stand him in good stead later on.

So lively was his interest in the Scottish language that he began studying the Scottish writers of the fourteenth and fifteenth centuries on his own, while he was still at school, noting in the margins of an abridged Jamieson dictionary the words and forms he came across which Jamieson had not recorded; and he continued to improve his knowledge of Gaelic by working at that language along with his eldest brother.

At the University of St. Andrews, where he went in 1883, the resources of the library enabled him to extend his reading of older Scottish literature, and during his last session there, 1887–8, he worked on a manuscript of Wyntoun's Chronicle of Scotland to such good purpose that he succeeded in making out how that work had been originally written. He had previously shown his amazing genius for solving problems in the Greek Class by providing an ingenious and convincing explanation of the order of the numbers in a passage towards the end of the Tenth Book of Plato's *Republic*, which was afterwards published in the edition of that work which Jowett and Campbell produced in 1894. Concurrently with his university studies he taught himself French by reading the *Revue des Deux Mondes* in the Dundee Public Library, learned German by attending evening classes in Dundee and, as the result of receiving a present of a small book of Norwegian songs from a friend, took up the study of Danish and Icelandic. Amid all these activities his university work was never neglected. 'Craigie took all the prizes', a contemporary, the late Dr. D. Lawson, once said to me 'but nobody bore him any grudge for that.'

He had other problems in his university days, which his unfailing tact and sense of fitness enabled him to take in his stride. Small of stature and slightly built and having the friendliest of dispositions he was easily persuaded by his less gifted classfellows to do their Latin proses for them, and when there was a long wait for their connexion at Leuchars junction—for they travelled daily from Dundee to St. Andrews by rail—he would often dictate four or five versions of the same passage to as many undergraduates; but he always took care to include in each version a few mistakes such as the person concerned might be expected to make. The net effect of this was that the work which his fellows handed in as their own was to all intents and purposes their own. When he got home he would do a correct version for himself.

In 1888 he came up to Balliol with a Guthrie Scholarship and, after only one term there, went on to Oriel as a Bible Clerk. He was glad to get away from Balliol: he did not like Jowett because of the way he had behaved to a friend of his. While up at Oxford he continued his Celtic studies by attending the lectures of Professor (afterwards Sir John) Rhŷs and, though there were no Scandinavian lectures in Oxford at the time owing to the illness and death of Gudbrand Vigfusson, he worked at the Scandinavian languages on his own; and he also began now to contribute articles to Scottish journals, especially *Scottish Notes and Queries*. His tutors were alarmed at the number and variety of his activities: they were sure he had too many irons in the fire; but they did not know their man. He got his First both in Classical Moderations (Mods) and in Literae Humaniores (Greats) without a hitch.

This satisfactory and unexpected result seems to have convinced the Provost and Fellows of Oriel College that his Scandinavian studies ought to be encouraged rather than discouraged for they now offered him the means of prosecuting these in Copenhagen; and he spent the winter of 1892–3 there. As was to be expected, he made good use of his time: he studied manuscripts in the Royal and University Libraries, making copies of the texts that interested him—among them that of *Skotlands Rímur*, of which he produced a critical edition in 1908—and he learned modern Icelandic by associating with Icelanders in Copenhagen, several of whom became his life-long friends. He also seems to have had an attack of home-sickness, as his verses *Autumn in Denmark* show; for amid all his new friends he missed the accents of his native tongue.

On his return to Scotland in 1893 he was appointed assistant

to the Professor of Latin at St. Andrews, and there he remained for the next four years. In the course of these he collaborated with Andrew Lang in an edition of Burns, supplied material from Scandinavian sources for Lang's *Fairy Books* and *Dreams and Ghosts*, and began producing books on his own account. His *Primer of Burns* and *Scandinavian Folk-Lore* belong to this period, and his own edition of Burns, which was to appear in two small volumes in 1898, was in hand.

In the summer of 1897 he married Jessie K. Hutchen of Dundee and was just on the point of leaving for his honeymoon in Denmark when he received an entirely unexpected invitation to join the staff of the *New English Dictionary*. It could not have come at a more awkward moment; but he did not take long to make up his mind: the honeymoon was postponed, and he set off for Oxford at once with his bride.

The explanation of this sudden summons came later: Charles Cannan, the then Secretary to the Delegates of the Clarendon Press, had decided that even with two editors, James Murray and Henry Bradley, the production of the *New English Dictionary* was not proceeding fast enough, and that a third should be found. On his way back from one of the meetings of Delegates at which this matter had been discussed he happened to meet D. H. Nagel of Trinity, and he told him of his preoccupation. 'I can tell you where you will find the man you want' said Nagel, naming Craigie. Nagel, who was a chemist, did not know Craigie personally, but he had heard of him from his father who was a schoolmaster in Dundee. Cannan went straight to the Provost of Oriel, who confirmed Nagel's opinion; and the invitation to Craigie was sent off without delay.

After working for two years with Bradley and a similar time with Murray, Craigie started on the letter Q in 1901 as an independent editor, with a fresh staff of assistants. He and his staff shared the ground floor of the Old Ashmolean with Bradley and his. Dictionary hours were long, some forty-two hours a week, and the work was hard, but he still found time and energy for his other studies. In 1905 he was appointed Lecturer in the Scandinavian languages at the Taylor Institution, and when the Chair of Anglo-Saxon was restored in 1915 he was elected Professor, and the scope of the duties of the chair was officially extended to enable him to continue lecturing on Old Icelandic. He resigned this chair in 1925 in order to take an English chair at the University of Chicago, but he continued his work on the *English Dictionary* until not only the dictionary itself

but the *Supplement* also was completed in 1933. His work for the main dictionary, which was completed in 1928, included the letters N, Q, R, V, and U, part of S (Si-Sq) and part of W (Wo-Wy). His main responsibility in Chicago was the *Dictionary of American English on Historical Principles*, and his work on this enabled him to supply additional American material for the *Supplement of the Oxford Dictionary*.

In March 1936 he retired from the Chicago Chair, but retirement for him meant no cessation, not even a slackening, of his labours. Though his colleague, Professor J. R. Hulbert, now took over the reins, he continued to work on the American Dictionary until its completion in 1944. But the main part of his time was now devoted to the task he had reserved for his old age, *The Dictionary of the Older Scottish Tongue*, which he had started in 1925. He made steady progress with this until the Second World War caused the printing of it to be suspended about the end of the letter D. The difficulties and hardships of the war years were aggravated in 1944 by the onset of Lady Craigie's last illness. For the next three years most of his time and energy were perforce expended on ordinary household tasks under circumstances too distressing to recall. It is doubtful if he fully realized the nature of his wife's illness, but even if he had, he was ill-fitted to cope with the situation. Yet he never complained.

After the death of Lady Craigie in 1947 one of his nephews (he had no children of his own) came, with his wife and family, to live at Ridgehurst, and this enabled Craigie again to give most of his time and attention to his literary and lexicographical work, but his whole situation had changed in the meantime. For reasons which will be given below the cessation of the printing soon involved a suspension of the editing of his Scottish Dictionary, and this had continued until Craigie realized that he would not live long enough to finish it. The result of this was a loss of interest in the whole undertaking and his accession to the wishes of his Icelandic friends that he should write a Supplement to Gudbrand Vigfusson's *Icelandic Dictionary* and edit a selection of Icelandic *Rímur*. Even the resumption of the printing of the Scottish Dictionary after the war failed to revive his old interest, in view of his age and his more recent commitments; and it was only when the Scottish Universities took steps to provide for the continuance of the work by finding him a capable assistant and successor that his old zeal for his Scottish Dictionary really came to life again.

That the initiative for this appropriate and prudent arrange-

ment was taken by Scotland and not by Craigie himself is well known to Sir William Hamilton Fyfe and Sir Hector Hetherington, who were the Vice-Chancellors of the Universities of Aberdeen and Glasgow, respectively, in 1947; and it is important that it should be generally known. Craigie himself wished it to be known, not because the concern of the men of learning of the land of his birth for this major contribution to Scottish studies was gratifying to him and becoming in them—both of which it undoubtedly was—but because his special obligation to the University of Chicago Press, which had generously borne the whole cost of the printing and publication of the Scottish Dictionary from the outset, precluded him from taking the initiative in any such arrangement, and his characteristic scrupulosity made him anxious to avoid even the appearance of having done so. (His many friends and admirers will be pleased to learn that the University of Chicago Press is continuing this generous support for his *Magnum Opus* now that it is being edited by his assistant and successor, Mr. A. J. Aitken, under the auspices of the Scottish Dictionaries Joint Council.)

The details of this arrangement, from the time it was first mooted to the transference of the materials and reference books to Edinburgh and the final handing over of the editorial responsibility, engaged Craigie's attention for several years, for he insisted on choosing his successor himself, and turned down a great many offers; and the whole episode together with its happy issue had a special importance for him personally, for his last ten years were on the whole lonely years. He missed the ready sympathy, admiration, love, and protective care of the one who had been his constant companion for fifty years, and though many friends still visited him from time to time, they could not fill the void. The only one who might have, and to some extent did alleviate his loneliness, was the late Dr. J. J. Munro; but Craigie always had a feeling that his was a cupboard love and he did not give him his confidence. His friends in Iceland never forgot him, as a constant stream of presentation copies of their many publications reminded him. But for the most part he was cut off from the scholarly world to which he properly belonged.

There was one other event of this period, however, which gave him genuine pleasure and satisfaction. That was when a group of his friends in Oxford honoured the occasion of his eighty-fifth birthday by presenting him with his portrait and a List of his Published Writings in the Library of Oriel College, in October 1952. The presence then of the Vice-Chancellor of his

original University, St. Andrews, the First Secretary of the Icelandic Legation, and the Director of the Frisian Academy, as well as the Vice-Chancellor of the University of Oxford, gave the ceremony an appropriate international character. Subscriptions for the portrait and the List of his Published Writings had been received from all over the world, over 100 from Iceland alone.

His *Sýnisbók Islenzkra Rímna* (Specimens of the Icelandic Metrical Romances) was published in three volumes in 1952 and the Supplement to the Icelandic Dictionary in the summer of 1957. He died on 2 September of the latter year, twenty days after his ninetieth birthday.

When Craigie joined the staff of the *New English Dictionary* in 1897, the form of that work and the methods used in its preparation had long been settled by Murray, and for the excellence of Murray's achievement Craigie's admiration was unbounded: 'Murray's system', he said, 'proved to be adequate to the end, standing the test of fifty years without requiring any essential modification.' According to Craigie, it was in fact Murray's introduction of what we now call 'the slip system' (which obviates both the labour and the errors of recopying) and the closeness with which the printer pressed on the heels of the editor, that made the production of the *New English Dictionary* at all possible—and no one who is in a position to express an opinion will disagree with him. (His own innovation on the slip system, made in his Scottish Dictionary, was not to prove a very happy one.) But though Murray supplied the mechanics of lexicography, Craigie brought to the work many assets of his own: among these were his unrivalled knowledge of other languages, his uncanny instinct for solving problems at sight, and his equability of temperament, which never knew dismay either at the magnitude of a task or the intractability of the material. To his staff he was a constant source of inspiration, not only by his own tireless industry and quiet enthusiasm, but by his generous appreciation of all that was good in their work. Though he revised everything that was prepared by his assistants, correcting what was wrong and improving anything that could be better expressed, he never changed a definition for the mere sake of changing: the justness and the restraint of his editing were always evident; and this encouraged everyone to give of their best.

His work was never limited to merely correcting or touching up what had previously been roughed out by others for he did a

great part of his articles from start to finish himself, and he was constantly active in the collection of fresh material. A vast amount of the quotations for his American Dictionary came from his own reading, and a still greater proportion of those collected for his Scottish Dictionary; and though he often got others to write or type the slips, scores of thousands were transcribed in his own clear hand.

Another great asset was his immunity to distractions. No interruption, whether it was caused by his university duties or by visitors seeking his advice or merely calling to see him, ever put him out of his stride. He was always readily accessible to everyone, and would give his attention to their affairs as if he himself had no other concerns for the moment. And after any such interruption he simply resumed where he had left off, without haste and without further loss of time. I once asked him whether noise did not impede his working—there happened to be a lot of noise going on at the time. He smiled and said 'not necessary noise'.

His actual output was consistently less than that of Bradley, simply because he refused to have a bigger staff than he could effectively supervise (and it may well have disappointed Cannan, for by 1906 he was casting about for a fourth editor). And his most important contribution to the *English Dictionary* was completely unnoticed, both at the time and afterwards, and even, I may add, by himself. Yet it was eminently characteristic of the man: at once unobtrusive and climacteric.

Much of Bradley's output was not seen by the editor himself until it was in first proof. Craigie, on the other hand, not only read every definition and every selected quotation with care, but he also read the rejected quotations, which were on the average twice as many as the selected, in case anything of value were being overlooked. Thus it was that he noticed one day that some quotations, which he had seen in the 'copy', were missing in the first proof; and he proceeded to find out what had happened to them. It was only then that he discovered that there was one man in the Dictionary Room whose business it was to ensure that all the 'copy' sent to the printer was right for scale. The scale originally agreed on was ten times that of the edition of Webster current in 1879—the 1869 Webster, if my memory is to be trusted. Having salvaged some of his own missing quotations and some of Bradley's which had met the same fate, he showed them to Bradley who, till that moment, had had no idea that this rigid scaling of the 'copy' was going on. It was as

obvious to Bradley as it was to Craigie that this Procrustean treatment of their work was intolerable, and from that day all adjusting of the scale ceased. The ultimate effect of this was that the second half of the dictionary expanded to seven volumes instead of the five that had been originally planned.

The Clarendon Press could not fail to notice the departure from the prescribed scale, but that they never learned the reason for it is shown by the late R. W. Chapman's mention of the matter on page 7 of his James Bryce Memorial Lecture, *Lexicography*, of 1948: 'He [Charles Cannan] remarked that the Dictionary "went wrong" when Henry Bradley fell into a *mud hole*. By this he meant that the Dictionary departed, at that juncture, from the scale laid down.' But it was near the beginning, not near the end, of the letter M that the departure began.

Worse was yet to come. The main part of U consists of the compounds of *Un-*. The final sorting of these was done by Mrs. Craigie: this was her 'war work' as she afterwards proudly recalled. All the compounds for which there was only one quotation were taken out and used by Craigie for the introductory article; the rest were all included in their alphabetical place. The result was that the scale, previously much more than ten times that of Webster, now soared to much more than twenty times. The publishers protested strongly, but Craigie stood his ground, and a compromise was eventually reached with the help of the printer. The departures from the style of the rest of the Dictionary which the Un- section shows are a permanent record of Craigie's refusal to allow a mechanical process of scaling to damage the quality of his work.

The stark simplicity of his plan for *Un-* was characteristic both of his work and of the man himself. He began his editing at a plain deal table, without even a drawer, and would have gone on using that indefinitely, had not one of his assistants decided that an editor ought to have a knee-hole desk, and presented him with one. But whether he worked at table or desk, he never allowed it to become untidy, keeping no more on it than the slips he was working at and a very small pile of unanswered letters. Everything else was carefully arranged and put tidily away in its proper place. Until well after his eighty-fifth year he preferred, when in his own study, to sit on a backless wooden seat; and he always used a steel pen, which he would clean with his pocket knife when it got clogged with dry ink.

In all the practical concerns of life he depended on the shrewd sense and judgement of his wife as implicitly as his friend, the

Sheriff of Reykjavík, trusted the judgement of his horse. She was more demonstratively Scotch than her husband, and loved to ask her Oxford butcher for a *gigot* of lamb. She found much satisfaction in entertaining his students and his many visitors and friends alike in Oxford, in Chicago, and at Watlington. She was his constant companion on all his travels, and is still remembered in Iceland for the strong protests she made when she was there in 1910 at the wastage which was then being permitted of the island's natural hot water. Ten years later it was being utilized for growing vegetables, fruit, flowers, and even vines. It was she who designed Ridgehurst, the home of their retirement on the Chilterns above Watlington, combining the interior arrangements of American houses with a Scandinavian exterior. But her influence extended to more than the external arrangements of his life. She was also mainly responsible for his leaving Oxford and going to Chicago in 1925, for she felt far more strongly than he ever did, or could, feel that Oxford had failed to give him the recognition which was his due.

It can hardly be denied that throughout his long life Craigie was constantly doing the work of two, if not of three, men. This capacity of his had alarmed his tutors at Oriel without cause. But other feelings were aroused when he combined his editorship of the *New English Dictionary* with his tenure of the Rawlinson and Bosworth Chair of Anglo-Saxon. Yet he discharged the duties of both these offices not only conscientiously but brilliantly. Of his teaching Professor C. L. Wrenn, the present occupant of the chair, writes (*The Times*, 9 Sept. 1957):

To have made one's first steps in the study of an Anglo-Saxon or an Old Norse text under Craigie, was to acquire almost imperceptibly the ambition to become a keen and exact puzzle-solver. In his small seminars . . . many were stimulated to lifelong interests. He would make each student produce a careful short paper on a given problem or text, and then, after only the kindliest criticism, give his own view in precise and clear language enlivened by an occasional very Scots reminiscence; and his summary presentation and solution of the question at issue invariably seemed right and final.

Of his lexicography the whole world can now judge. The cause of the breach with Oxford was that, when the university revised the stipends of professors round about 1920, account was taken of the salary which Craigie was receiving as editor and the stipend of his chair was left at £600 odd. Craigie himself blamed Joseph Wright for this decision, as Wright's influence was then

paramount in the English Faculty. To his wife it was as if the university had said 'your husband may do two jobs, if he so chooses, but he is only to get one salary'.

The List of his Published Writings provides conclusive evidence of this breach, even if we did not have his own account of it. *The Pronunciation of English* (1917), *A First English Book for Foreign Pupils* (1920), and *English Reading made Easy* (1922) were published by Oxford; *Easy Readings in Anglo-Saxon* (1923), *Specimens of Anglo-Saxon Prose* (1923–9), *Specimens of Anglo-Saxon Poetry* (1923–30), *Easy Readings in Danish* (1923), *Easy Readings in Old Icelandic* (1924), *An Advanced English Reader* (1924), *A First English Reader* (1927), and *Systematic Exercises in English Sounds and Spelling* (1927) are all published by Hutchen, Edinburgh—and Hutchen was, of course, his wife's maiden name. Craigie came to regret this change of publisher. Many years later, after his many S.P.E. Tracts (1937–46) had indicated his second thoughts, with reference to the Hutchen publications, he observed to me rather ruefully 'they were not published'. It was an unfortunate occurrence for all concerned mainly because of the loss involved to English, Anglo-Saxon, and Scandinavian Studies, for they form an excellent series of booklets, as full of life and interest as the teaching of their author. Those who knew Craigie best realize that in this episode he seemed to depart from his real character: the most discerning will be reminded, not that the Craigies were Scotch but that theirs had been a childless marriage.

By 1928 even the desire of his wife that his merits should be recognized was amply satisfied: he had been made an Hon.LL.D. of St. Andrews as early as 1907 and an Hon.D.Litt. of the University of Calcutta in 1921, when he lectured there in the course of his trip round the world; in 1925 Iceland made him a Knight of the Order of the Icelandic Falcon (and in 1930 a Knight Commander); but when the English Dictionary was completed in 1928, in one and the same month of June he received an Hon.D.Litt. from the University of Oxford, an Hon.Litt.D. from the University of Cambridge, and the culminating honour of Knight Bachelor; in the same year Oriel College made him an Honorary Fellow, and the Royal Society of Literature did likewise. Other honours and distinctions were to follow: in 1929 he was made an Hon.Litt.D. by the University of Michigan, in 1931 a Fellow of the British Academy, and in 1946 an Hon.D.Phil. of the University of Iceland. The range of his interests is shown by his having been President of the English Place-Name Society from 1936 to 1945, President of the Scottish

Text Society from 1937 onwards, and President of the Anglo-Norman Text Society from 1938 onwards. His support of the efforts of the Frisians to revive their language was recognized by making him an Hon. Member of the Frisian Academy when that was formed in 1938. For him a presidency was not a sinecure. For the Scottish Text Society he had done yeoman service: he edited *Bellenden's Translation of Livy* in two volumes (1901 and 1903) and between 1919 and 1925 he produced *The Maitland Folio Manuscript* in two volumes, the *Maitland Quarto Manuscript* in one volume and *The Asloan Manuscript* in two volumes, making seven S.T.S. volumes in all.

His proposals for Period Dictionaries had been communicated to the Philological Society on 4 April 1919, and published in the Society's *Transactions* in 1925. These included the *Dictionary of American English*, the *Older Scottish Dictionary* (down to 1700) and the *Modern Scottish Dictionary*. He had decided to do the *Older Scottish Dictionary* himself because, to quote his wife, 'he was sure that if he did not do it someone else would do it after he was dead, and do it so badly that he would turn in his grave'. Now, in 1925, he was being invited to Chicago to do the American English one. The late William Grant, who was then Convener of the Scottish Dialects Committee, decided that he would do the *Modern Scottish Dictionary*. He got in touch with Craigie and eventually spent two weeks with him at Ridgehurst to discuss the project. Grant's exuberance did not impress Mrs. Craigie: 'He might have learned something', she afterwards declared, 'but he did all the talking; my poor husband could hardly get a word in edgeways.' But Craigie did in fact tell Grant all he needed to know about Murray's wonderful 'slip system' and his own ill-fated innovation. (This was to use the same quotation slip three or four times instead of making three or four copies of the same passage. Thus a quotation like 'short cuts are often longest' would be given three headwords, CUT, LONG, and SHORT, would be sorted first under CUT, and as soon as that article was in type, would be taken out and resorted under LONG, and so on.) Grant rejected the slip system out of hand, thereby more than doubling the labour of producing the dictionary; but he did take over from Craigie some ideas for his forthcoming Appeal for Subscribers. He got his Appeal out before Craigie's was ready, and Craigie was profoundly shocked to find that Grant had coolly appropriated his title, *The Scottish National Dictionary*. Craigie's words, when he mentioned the incident later, were unusually severe: 'Grant stole my title,' he said, 'after all, Scotland was a nation

before 1700: it ceased to be one in 1707.' Craigie's own Appeal for what he now had to call *The Dictionary of the Older Scottish Tongue* was an abysmal failure. Out of some 500 Scottish, Caledonian, St. Andrews, and Burns Societies all over the world to which it was sent, only two took the trouble to reply; and they both expressed their regret that they did not see their way to subscribe. There the matter rested until the University of Chicago Press came to his rescue by undertaking the publication.

Whether the failure of this Appeal should be connected with his loss of admiration, and even respect, for Robert Burns it is difficult to say. What can be said is that it was from his comments on the complete lack of interest which the Scottish societies showed in his Dictionary that I first learned that his early interest and regard for Burns had been outgrown. Burns is probably a young man's poet. For Scott, on the other hand, Craigie's admiration endured.

Craigie's innovation on the 'slip system', mentioned above, originated in a desire to save time in the preparation of his material. He wanted to start the writing of articles at the earliest possible moment. At first sight the method seems to be suitable for a dictionary being done single-handed, with the printer pressing on the heels of the editor. But in the long run it saves no time at all; and the trouble with Craigie's Dictionary was that the printer ceased to press on his heels. Having reached the end of the letter D, Craigie could prepare E, without the collaboration of the printer, but when he reached F, some of his material would be locked up in the unprinted 'copy' for E, and when he came to G, still more of his quotations would be inaccessible in the 'copy' for both E and F. This was the situation that led him to suspend work on the Scottish Dictionary. Had it not been for this, it is not impossible that he might have lived to finish it, for he would have felt no temptation to undertake the Supplement to the *Icelandic Dictionary* or the Selection of *Rímur*. But there was something appropriate in his giving the last years of his life to the language and literature of Iceland.

His first contact with that country had been made during his stay in Denmark in the winter of 1892–3; his first visit to Iceland itself was made in 1905; his last in 1948. Between these dates he made several other visits to Iceland, Holland, Denmark, Norway, and Sweden. On all these visits he contrived to combine sightseeing with research work and lecturing, and the cultivation of old, and the making of new, friendships with the scholars of the country concerned. In 1921 he made a trip round the world,

lecturing in Romania, India, and the United States, and visiting China and Japan. He paid a second visit to Romania in 1929, returning via the Danube and the Rhine. It was on this occasion that his knowledge of Romanian enabled him to come to the rescue of the Englishman who had transported Prince Carol's baggage from London to Sinaia by a devious route (made necessary by the political situation), did not know a word of Romanian, and had lost his ticket on the way.

Notable among his many friendships was that with Dr. P. Sipma, the Frisian scholar. Craigie had taken up the study of Frisian seriously because of its kinship with English, and in 1909 he went to Veenwouden to see P. de Clercq. He met Sipma in de Clercq's house. The Frisian revival was then in full swing, and Craigie's enthusiasm for the movement was aroused. It was he who persuaded Sipma to write his *Phonology and Grammar of Modern West-Frisian* in English, and arranged for it to be published in Oxford by the Philological Society. His active interest and support contributed to the ultimate success of the movement, which was marked by the foundation of the Frisian Academy in 1938.

But for much the greater part of his long life Iceland was his spiritual home. There was a natural affinity between him and the scholars and poets of this northern island, which he had experienced when he first met Jón Stefánson, Valtýr Guðmundsson, Þorsteinn Erlingsson, and Finnur Jónsson in Copenhagen in 1892. Articles on, and translations from, Icelandic were among the earliest of his publications and it may be doubted whether he greatly regretted the conjunction of circumstances which diverted him from the *Scottish Dictionary* in the early years of the war to his latest contributions to Icelandic studies. His edition of *Skotlands Rímur* (Icelandic ballads on the Gowrie Conspiracy) in 1908 set a new standard for the editing of *Rímur* and has been the model for all subsequent editions. Many of the editors of these availed themselves of the advice and help which he always gave so gladly and so freely to all who ever consulted him. For though Iceland has produced many distinguished editors and scholars of her own, these have as a rule specialized in limited periods: Craigie's work has ranged over the whole six centuries of *Rímur*, and his supremacy in the whole field is generously acknowledged by all who know his work. He has written verses in different rímur metres himself, which his Icelandic friends pronounce technically perfect. He was largely responsible for the founding of the Rímur Society (*Rímnafjelag*) in 1947; and when

he gave his last address, *Nokkrar athuganir um rímur*, in Iceland in 1948, in his eighty-first year, his audience filled the largest hall in the university, and were kept spell-bound for an hour.

But the joy which he found in his intercourse with the people of Iceland was not wholly, perhaps not even mainly, due to a community of interest in their literature or to the appreciation which the Icelanders felt and showed for his services to Icelandic scholarship; it was based on something far deeper and much more elemental than that. In Iceland more than anywhere else Craigie found a life and a literature firmly rooted in nature and reality—for poetry is still a natural and vigorous growth there—and a capacity to recognize and appreciate genius which was as free from envy and affectation as his own. It was inevitable that such men should take him to their heart, and he them to his, with that spontaneity of love which no language can express, and which, indeed, needs no words for its expression.

The help and encouragement which he gave to other lexicographers and scholars was very great. Apart from the many who worked for him for longer or shorter periods, Geir T. Zoëga in Iceland, Dr. P. C. Schoonees in South Africa, and Dr. Wijeratne in Ceylon were all indebted to him. Many others got their ideas for research from his ever-fertile brain. Warrack not only got the original suggestion for his *Scots Dialect Dictionary* from Craigie, but as long as he was engaged on it he used to call at the Craigies' home at 15 Charlbury Road, Oxford, every Friday evening at eight o'clock with the week's queries and unsolved problems; and he never called in vain. The help Warrack received is fittingly acknowledged in the dedication and the preface of his dictionary; and many other prefaces bear grateful witness to Craigie's help and inspiration.

The latest and perhaps the most systematic utilization that was made of Craigie's learning and genius for solving problems and his constant willingness to help others was that made by the late Dr. J. J. Munro in the preparation of his edition of Shakespeare, which appeared in six volumes in 1958—*The London Shakespeare*. Munro went to live in Watlington for the sole object of being near Craigie, and during the ten years or so that he was engaged on this project there was a standing arrangement that he visited Craigie every Tuesday afternoon and Craigie visited him every Thursday afternoon, and at all these meetings he got Craigie to help him with his current problems of reading and interpretation. *The London Shakespeare* thus owes to Craigie a debt which the death of Munro, at a time when the Preface was still

unwritten, has apparently left unacknowledged, and the extent of which can never be properly assessed.

Craigie himself would wish this to be mentioned for he was not only punctilious in such matters himself, but he expected others to be so too. Other people have noticed this trait in his character, and it was brought home to me very convincingly in 1952. Magnus Maclean had inserted four of Craigie's verse translations of Gaelic songs in the 1904 edition of *The Literature of the Highlands*, without permission, and without a word of acknowledgement. Craigie seems to have done nothing about this at the time, but forty-eight years later, when the List of his Published Writings was being compiled, he specially asked that his authorship of these four songs should be vindicated. All that he then remembered about them was that he had published them in the *Scotsman* some time between 1897 and 1904. When he eventually read the entry 'Gaelic Jacobite Songs: 1901 *The Scotsman* 1 Feb.' in the printed List he said, 'Well, I'm glad we've got that cleared up.' That it had been cleared up was not so obvious to others, but Craigie was satisfied.

He had an exquisite sense of humour and an inexhaustible fund of amusing reminiscences and anecdotes, with which he would often delight his visitors and friends. He loved to quote the Dundee acquaintance of his youth who thought the moon was better than the sun 'because the moon shines at night when it is dark, and the sun only shines by day when it is light anyway'. He was very pleased with the now famous last quotation for the word *moron*, when he saw it in the first proof of the *Supplement to the Oxford English Dictionary*: 'I have always maintained,' he said, 'that there is far too little of this kind of thing in the dictionary.' It is interesting to record his own view of the kind of work to which he devoted so much of his life: 'It cannot be denied', he said, 'that dictionary work for most of the time is very dull and boring.' He had contrived to relieve the tedium by making a collection of amusing ambiguities, such as 'In Switzerland pines grow to a height of 7,000 feet' (culled from the ninth edition of the *Encyclopaedia Britannica*), which in his notebook had the heading 'Tall Trees' and a passage of Middle English, which I cannot now recall, but of which the substance was 'The thing went very well for a time, but of late somehow, we woth not how, it hath gone into reverse' under 'The Motor Car'.

It may be idle to speculate what a man with Craigie's gifts might have done, had he not been drawn into the dictionary pool. That event probably involved less of a change for him than

it had meant for Murray and Bradley. He would still have done his Scottish Dictionary—those additions in the margins of Jamieson assure us of that—but he would have had to do it without the advantage of knowing Murray's system. There would have been more editions of Scottish Writers, more translations of Gaelic songs. No man was ever more successful than Craigie in reproducing the metre and preserving the spirit of the original Gaelic. His felicity can be seen in one of the four songs mentioned above, A. Macdonald's *Call to the Highland Clans*:

> Gladsome tidings through the Highlands,
> Tumult wild arising;
> Hammers pounding, anvils sounding,
> Targets round devising

Equally adequate versions of the even more complicated Icelandic *Rímur* might have come from his pen. And we might have had more of his clear, elegant prose. The first sentence of his *Historical Introduction* to the English Dictionary has a sly humour which reminds us of Scott at his best: 'If there is any truth in the old Greek maxim that a large book is a great evil, English dictionaries have been steadily growing worse since their inception more than three centuries ago.'

He had many interesting affinities with Scott. Both had a strong and deep attachment to their native land; both had read the older Scottish writers with a lively interest; both devoured Froissart with peculiar delight; and both remembered ever after whatever they had once read, and could recollect it in all its detail the moment it became relevant. Both had a keen interest in the supernatural, and both contrived, though in different ways, to manage the business side of their affairs not for the best. Scott was more fortunate than Craigie: he had his children to comfort and sustain him in his misfortunes, and he was left in possession of his library; the hardships which fell to Craigie's lot eventually separated him from his, though it must have been the dearest of his possessions. The 'financial stringency' which compelled him to sell what he had always intended to bequeath cannot now be explained, for he told no one of his troubles. In this he lived up to the requirement of Burke 'that beings made for suffering should suffer well'. It should perhaps be added that the purchasers of his library, the Irish Folklore Commission and University College, Dublin, presented the Icelandic MSS. to the National Library of Iceland, for that was the kind of thing

Craigie himself would have done under happier circumstances.

He had affinities too with Gilbert Murray—affinities which will not be ignored by anyone interested in understanding what constitutes genius. It seems odd that two of the most outstanding men of their day in Oxford scarcely knew each other, though they had so much in common. Both had innumerable friends; both had a remarkable capacity for making strangers feel at ease; both gave the most sympathetic attention to the concern of others; both were incapable of inflicting pain or even embarrassing others; and both seem to have possessed telepathic powers, possibly because both had Celtic blood. Gilbert Murray's demonstrations of telepathy are well known; and it is clear that they involved access to the mind of other persons. It is certain that Craigie also had this power. We have the testimony of Bradley, recorded by Robert Bridges in his *Memoir*, that of all his friends who had got into the habit of finishing his sentences for him when Bradley seemed unable to do so himself, Craigie was the only one who always did it correctly. And though neither Murray nor Craigie would have called themselves Christians, there are many among those who knew them best who would not hesitate to call them both Saints.

It would be quite wrong to suggest that Craigie held any particular theory of telepathy or ESP, or of the supernatural in any other aspect. No man was ever more level-headed or matter-of-fact than he. He had no theories at all, not even about lexicography: he simply made dictionaries. He was extraordinarily free from what we call 'wishful thinking', and never jumped at conclusions but rather let the conclusions jump at him. But he had what can only be called the makings of a theory of the supernatural. Everyone who saw a lot of the Craigies must have been struck by the number of times his wife mentioned cases of receiving a letter from a friend they had not heard from, perhaps for years, but had been talking about on the previous day. On these occasions Craigie himself always confirmed his wife's statements with a zest that betrayed a very lively interest in these occurrences. Like other couples who remain in love with each other, he and his wife often found themselves thinking the same thoughts. He was greatly impressed too by his friend, the Sheriff of Reykjavík, who depended on the judgement of his horse in all his business dealings (for he was a business man as well as sheriff): 'If my horse takes to a man at once, I know I can trust that man; if my horse does not take to a man at once, I know he is not to be trusted; and my horse has never let me

down.' And with this practical utilization of horse sense he associated the custom of the Icelanders, when they went to rescue sheep buried in deep snow, of using another sheep rather than a dog to guide them. He believed, too, in wraiths, if not in ghosts; but again without having formed any definite theory. He quoted the phantom baker's van his uncle had seen as evidence against the theory of astral bodies. He told the story of the phantom knock he and his father had heard so often in his Dundee home, but simply as an interesting personal experience. And not many years before his death he saw a lady walking in his garden at Ridgehurst, who simply vanished, as the baker's van had, into thin air. When he told me about this experience, a few hours after it had happened, it was clear that he had been strangely thrilled by it; but again he told it simply as an isolated occurrence. If he had been pressed for his explanation, he would probably have said 'There are more things in heaven and earth, Horatio. . .' He shrank from the obvious inference that he himself had any special perceptive power.

Attempts have been made to describe the operations of his mind. Wrenn records that it was once said of him 'the facts seemed to run round and rattle in his head like dried peas, and then suddenly to form a convincing pattern.' But we can perhaps carry the explanation a little farther. To minds untrammelled with any illiberal ambition or distorting theory or restrictive creed, facts and ideas are not the hard, bald, dead things that they appear to normal self-centred worldly minds, but they are invested with a fringe of live and active associations which, like the bonds of chemical atoms, link them together in organic patterns by a natural process of combination, so that the solution of apparently complex and baffling problems is simply the natural uninhibited functioning of the intellect. So it was with Craigie; so it has doubtless been with many other men of genius. In all such men we tend to find that this disinterested love of knowledge is associated with a true humility and an unaffected love for their fellow men.

This was the secret of Craigie's extraordinary intellectual power, for if he had a genius for solving problems he had also a genius for inspiring friendship. To know Craigie was to admire and love him. If he ever aroused envy by his remarkable ability and learning, or a desire to exploit these by his simple trustful nature, the fault was not in him. Men in whom there is no guile have no effective defence against envy and exploitation, for resentment is incompatible with the free working of the mind.

Their bounties, like the rain of heaven, must fall alike on the just and on the unjust.

The same sweet reasonableness marked all his thoughts, words, and actions. He had a humble origin—his father was a gardener—but he never either boasted of that fact or felt it was something he should be ashamed of. He indulged in no speculations about a life after death. He took the simple view that it would be time to cross his bridges when he came to them. He felt no need for any future reward or punishment. Life for him was a full and rich experience by virtue of the intellectual energy he had at his command and the human love and sympathy which he shed around him. He taught us, not by words, for that was not his way, but by the sheer force of his example, that the love which vaunteth not itself (as distinct from its misnomer, sex, which merely degrades and stultifies) is the very staple of genius and the as yet undiscovered mechanism of telepathy. And by all who were worthy to be his friends he will long be remembered with love and gratitude for having shown them what a man may do and what a man may be; perhaps even what a man, without repining, may endure.

J. M. WYLLIE

Personal knowledge; D. C. Browning; A. M. Craigie; J. H. Delargy; the late J. J. Munro.

HECTOR MUNRO CHADWICK

XI

HECTOR MUNRO CHADWICK

1870–1947

BY a singular and appropriate coincidence the birthplace of this great Anglo-Saxon scholar is situated in a parish adjoining that of Thornhill, Yorkshire, where are preserved no less than four of the relatively few runic inscriptions found in this country, not to mention a number of sculptured stones dating from Anglo-Saxon times. Son of the Reverend Edward Chadwick, he saw the light on 22 October 1870 in the vicarage of Thornhill Lees.

His father belonged to a family which traced its descent from John Chadwick of Chadwick Hall, Rochdale, who flourished in the later years of Queen Elizabeth's reign, a family related by marriage to the Chadwicks of Healey Hall. James, the father of Edward, was one of a number of sons of John Chadwick (1756–1837), all of whom were members of the firm of John Chadwick & Sons, flannel manufacturers, Rochdale. There was a branch of this concern in Edinburgh and it was there that James was in business during the earlier part of his life and where he married Sarah Murray, daughter of George Murray and Margaret Munro. There is a tradition in the family that Margaret Munro was a sister of General Sir Hector Munro, hero of Buxar and Pondicherry, whose names were borne by the eminently unsoldierly subject of these pages. Actually the relationship of Margaret to the General is not clear. But she had a daughter, Christian, a somewhat uncommon name, borne also by Sir Hector's sister. The occurrence of the double pairs of names, Christian Munro and Hector Munro, in two families from the same region is hardly likely to be fortuitous, and the fact that the name Hector Munro appears more than once in the Chadwick's family tree shows it to have been a traditional one and suggests that the story of his relationship with the General is not ill-founded.

After spending a number of years in Edinburgh, James Chadwick moved south with his large family to the main office of the firm in Rochdale.

Edward, father of the Professor and the seventh of James Chadwick's eight sons, was not in the family business, though he had an interest in it. He came up to St. John's College, Cambridge, and eventually took orders. Not long after he was

appointed curate of St. George's, Hulme, Manchester, where he met his future wife, Sarah Bates. Both her father's and her mother's family were business people of some consideration in Oldham. Her cousin, Captain Chadwick,[1] took part in the charge of the Light Brigade and, on his return from the Crimea in 1855, was given a public banquet in Oldham. Sarah's father retired early from business, apparently for reasons of health, and went to Manchester where he took to farming at Old Trafford, a locality which has somewhat changed its character since those days. His wife died young and a sister of Captain Chadwick came to take care of the eight children. Sarah Anne was the only daughter. Her father died on the day fixed for her marriage with Edward Chadwick—it was said of a broken heart at the thought of losing her—and the wedding was postponed. Edward and Sarah spent the first years of their married life at Bluepits, where he was then curate in charge and where Edward, their eldest son, was born.

Not long after his birth they moved to Thornhill Lees, Yorkshire, where Edward Chadwick senior became a close friend of one of the Bibbys, of the Bibby Line of steamships, who built him a church in the growing suburb of which he became Vicar. It was here that their three remaining children were born: Dora, Murray, and last of all Hector Munro. Their father ended his career as Rural Dean of Dewsbury. Both his elder sons, Edward and Murray, took orders. Edward, who had been a mathematical scholar of Jesus College, Cambridge, eventually became Rector of the chief church at St. Albans. Murray was at Trinity College, Cambridge. His interests were not academic, but he was very musical and had a gift for painting. He ended his career as Vicar of Athelney—another family link with Anglo-Saxon England. The only sister, Dora, seems to have been educated at home, probably by the curates.

Hector was by far the youngest of the family and the link between him and his sister was very close. 'She brought me up', he used to say, 'and taught me letters and Latin.' Their father was not a scholar but he was constantly urging his children to work at their books. He used to tell Hector that if he did not learn his Latin, a bear would come and carry him off. One of Chadwick's earliest memories was peering for the bear through a window by the vicarage's front door.

In 1882–3 Hector attended Bradford Grammar School. Although even at that age he enjoyed his work, he did not like

[1] Unrelated to the Chadwicks of Rochdale.

school life and made a daily practice of feigning sickness in order to stay at home. The year 1884 he spent at his father's house, where he was taught by his sister and the curates. But next year he went as a day-boy to Wakefield Grammar School, where the great Bentley had been educated, and he continued to attend there until the summer of 1889. A. H. Webster, a contemporary of his at Wakefield, writes of him:[1]

> I only knew him for a few terms when I sat next to him in the 6th Classical. . . . He arrived just as school opened and left to catch his train as soon as afternoon school closed. Consequently he took no part in games and indeed showed little interest in them. He was very shy, but always approachable and willing to help any of us ordinary boys with any difficulty in our Latin; and often he could make clear some point that the best dictionary left obscure. His answer would always be given with a smile and without the least sign of condescension. . . . Of his personal appearance I well remember his hair was distinctly red, a colour usually associated with high temper. Chadwick was the mildest and quietest tempered boy imaginable. He might have been a passive resister and would have died at the stake with a smile on his face.

On reading this account of him as a boy, those who knew him in later life will realize that in many of its essential features Chadwick's character was already formed: the shyness, gentle manner, quiet tenacity, lack of condescension yet eagerness to help others in matters of learning. His lack of interest in games may be exaggerated. In his early graduate days he was so keen a player of lawn-tennis that the Fellows of his college used to tease him, warning him that he was in danger of becoming a man of one idea. Moreover, an account book, written in his hand and found among his papers, suggests that he was the treasurer of the school cricket club. Against this may be set the story of the visit to the vicarage of two young Harrovians. A discussion arose on the best way of spending a half-holiday. After the rival merits of different games had been duly weighed, the young Hector, who had hitherto abstained from comment, gravely observed, 'My favourite way of spending a half-holiday is fettling my sister's hen-coop.' Sub-ironic self-depreciation, so integral a part of his humour, was clearly manifest in his boyhood!

On leaving school in 1889 he obtained a Cave Exhibition at Clare College, Cambridge, which was destined to become his

[1] *The Savilian* (The Wakefield Grammar School Magazine), Easter Term, 1947, p. 7 f.

home for many years. During that summer vacation he made a short trip to Scotland, Ulster, North Wales, and the Isle of Man, where he visited Tynwald Hill. That autumn he took his Little-Go and entered upon his life at Cambridge.

It was in his undergraduate days that he first visited the Continent, in company with his brother, Edward. They stayed at a pension in Innsbrück, the scene of one of his favourite stories: how he first came to visit Italy. He was sitting next to a young lady at dinner. Suddenly she addressed him, just as he was being proferred a pink blancmange. (Chadwick, on principle, always pronounced foreign languages as if they were English—'a pink blank mănge'.)

I was startled by her speaking to me and the spoon slipped from my hand and the blank mange fell on to her lap. She was very nice about it. [Then, in darker tones] But she did not see the extent of the damage: we were sitting too close. It slid down the folds of her black silk dress like a glacier. I rushed to the smoking room where my brother and I had a council of war. There was only one thing for it: flight! And there was a train leaving for Verona early next morning.

His adventures on arriving there—his first glass of wine and subsequent attempts at counting the number of windows of the amphitheatre in an effort to steady himself—formed the close of a saga which loses much of its flavour to those who were not lucky enough to hear him tell it.

In 1890 he was elected to a scholarship at Clare and two years later he was placed in Class I, Division 3 in the first part of the Classical Tripos and took his B.A. Next year (1893) he obtained a First Class with distinction in Part II, Section E (Philology) of the same Tripos and was elected Fellow of his college. During the next year his first publication, 'The Origin of the Latin Perfect Formation in *-ui*', appeared in Bezzenberger's *Beiträge zur Kunde der indo-germanischen Sprachen*.

It was about this time, when visiting his brother, Murray, that he chanced upon Paul Du Chaillu's *Viking Age*. It was this book which first quickened in him an interest in northern studies. Although Du Chaillu was an amateur and his book, published in 1889, is in many respects out of date, the width of its scope may well have helped to inspire Chadwick with that breadth of outlook which so characterized his work both as a writer and a teacher—for Du Chaillu was concerned with early northern civilization as a whole, though he lacked Chadwick's training in philology.

In the summer of 1895, Chadwick attended Streitberg's

lectures at the University of Fribourg. On his return to Cambridge he began teaching for what was then Section B of the old Medieval and Modern Languages Tripos and devoted the rest of his time to research in northern studies. In 1899 three works of his were published: 'Ablaut problems in the Indo-Germanic Verb' in *Indo-germanische Forschungen*, xi, 'Studies in Old English' in *Transactions of the Cambridge Philological Society*, iv, and his first book, *The Cult of Othin*, published by the Cambridge University Press. His 'Studies in Old English' was an important monograph which threw light upon 'the distinctive . . . dialects and the chronological sequence of the sound-changes which marked the early history of the language'.

In *The Cult of Othin* he examined the evidence for that cult in the north and among the Teutonic peoples of the Continent and reached the conclusion that, in both regions it was, in all essential features, the same. The final chapter is devoted to the date of the introduction of the cult and to this end the evidence of literary sources, philology, inscriptions, and archaeology was brought to bear. On reading *The Cult of Othin*, the student of his works cannot fail to recognize how here, in his first book, Chadwick's method of dealing with evidence, the all-embracing nature of his approach, is already fully manifest. In the year which saw the publication of these three contributions he became an M.A. and his Fellowship at Clare was renewed. From 1899 until 1919 he undertook the whole teaching of Section B of the Medieval and Modern Languages Tripos. In 1900 his two important papers, 'The Oak and the Thunder-God' and 'The Ancient Teutonic Priesthood', appeared in the *Journal of the Anthropological Institute* and in *Folk-Lore*. Three years later he was appointed Librarian to his college, a position which he held until 1911. He used to tell with much relish how the library was once visited by a man with his wife, who, after they had been shown its treasures, thrust a surreptitious sixpence into Chadwick's hand with the words, 'Do a bit of reading myself: I am the trainer of the Norwich City Football Club.'

Studies on Anglo-Saxon Institutions appeared in 1905. Two years later he contributed chapter III, on 'Early National Poetry', to the first volume of the *Cambridge History of English Literature*, published by the Cambridge University Press. The same year (1907) also witnessed the publication of his book, *The Origins of the English Nation*. The writer wishes to thank Miss Dorothy Whitelock, Fellow of St. Hilda's College, Oxford, a distinguished authority on Anglo-Saxon history and a former pupil of

Chadwick's, for the following appreciation of the two books just mentioned.

In rather rapid succession, in 1905 and 1907, Professor Chadwick's two main contributions to Anglo-Saxon history appeared, and it may be of interest to recall what W. H. Stevenson said of the first of them, in a review that even in its detailed comment anticipated the verdict of later times. He writes: 'He shows full acquaintance with the materials, exact philological knowledge, great powers of combination, ingenuity in suggestion, and critical power, and he has in consequence placed many old problems in a new light.'[1] A considerable amount of *Studies on Anglo-Saxon Institutions* has become regarded as accepted fact, and underlies the work of subsequent scholars. His account of the social classes of Anglo-Saxon society has in all its main features held the day ever since, based as it is on a careful study of the monetary systems of the Anglo-Saxons, without which the full meaning could not be drawn from references to *wergeld, mund, borg* and other compensations. Not all the conclusions were new and revolutionary in 1905, but it seems fair to say that the various elements had never been fitted into so comprehensive a system, nor presented so as to win general acceptance. Authoritative, also, are the chapters on Anglo-Saxon officials, the earl, the sheriff and other reeves, and additions to previous knowledge occur in sections on the origin of our shires. His view that the hundred was not a primitive institution has been accepted, and his suggestion that there was a connection between the smallest jurisdictionary area and the royal manors has received corroboration from later research. He was least happy with the borough, and his hypothesis that the shire system was temporarily superseded by a system of administration centred on the boroughs has not proved acceptable. Professor Chadwick's hypotheses were not, however, built on air, but in order to account for some puzzling feature in the evidence, and in more than one instance where scholarship has rejected his explanation the puzzle still remains unsolved. Far from being content with unsubstantiated conjecture, he devised the whole method and arrangement of *Studies on Anglo-Saxon Institutions* as a protest against the writing of Anglo-Saxon history from pre-conceived ideas—of the popular nature of government &c.—with a disregard or a perversion of the evidence. This is why he works back from later and better-evidenced periods to the remoter past. Here and there the effect is somewhat disconcerting, but he was often wont to say to his pupils: 'We must begin with what is known.'

If, however, in this he was reacting from a manner of writing history of which Kemble had been the most brilliant exponent, he was in other respects very much in the line of descent from this great scholar, as appears more clearly from his book, *The Origin of the English Nation*. For he shared Kemble's versatility, and like him he believed in ignoring

[1] Review of *Studies on Anglo-Saxon Institutions*, Eng. Hist. Rev. xx (April 1905), 348.

no field of study that might yield even a fragment of evidence. In the stress he laid on archaeological evidence and on the sifting of later traditions he has had many successors, and the approach seems so natural to us now that it is well to note that the book was hailed by R. W. Chambers as remarkable for this very reason, and as 'a valuable example of the method which is now likely to lead us to the best results in the study of Old English philology and history'.[1] It was not to be expected that this book, like its predecessor, should be of primary importance for establishing fact; its main concern is with problems that can never receive a definitive answer. The evidence for answering them is fragmentary, contradictory and often capable of several interpretations. No two persons will agree entirely on the comparative importance of the various types of material. Professor Chadwick too confidently believed that they could be combined to give a definite answer, and in some places the reader's verdict is: 'Unproven.' But he is in a position to reach this verdict because the evidence has been fairly put before him. It would be a rash person who should attempt to consider matters such as the continental homeland of the English, the use of the names Saxon and Angle, the date of the invasion, without looking at the evidence assembled here.

In many branches progress has been made since *The Origin of the English Nation* was published; Professor Chadwick was fully aware that conclusions drawn from archaeological data must, in the unsatisfactory state of these studies, be considered tentative. The work of the English Place-Name Society has produced new material; and moreover he wrote before the appearance of Chambers' monumental edition of *Widsith*. It is remarkable how often Professor Chadwick's tentative conclusions have been shown to be in the right direction, and fruitful results have been forthcoming from approaches he suggested. To take only a few examples: he saw clearly the 'Jutish problem' and indicated that a study of Kentish land-tenure was necessary for its solution; he realized that further research into the vocabulary of Old English was the linguistic approach most likely to bear on the distinction between Angles and Saxons; by his interpretation of the element *ge* in place-names he glimpsed the importance of the ancient *regiones*, and by use of charter material he was able to add to what was then known of the kingdoms of the Heptarchy, thus beginning work on material used with such striking effect by Sir Frank Stenton.

It is difficult to assess just how far subsequent scholars' work in the many fields covered by these books derives direction and inspiration from them; but, it would certainly be a mistake to relegate either work to the category of influential books that have been superseded. The steady advance and logical unfolding of a complicated argument afford the reader a keen aesthetic pleasure. Both books are full of penetrating criticism on individual sources: the student of the Anglo-Saxon

[1] Review of *The Origin of the English Nation, Mod. Lang. Rev.* iv (1908–9), 262.

Chronicle cannot afford to ignore chapter 2 of *The Origin*; anyone interested in genealogies must read chapter 9. In either book it is possible to find tucked away in a foot-note a conclusion that one has reached only after painful toil. And as new evidence comes to light, even the more speculative portions should be re-read; it may be they will help us to place the new factor in its true place.

Chadwick was appointed in 1910 to a University Lectureship in Scandinavian, a position which he held for two years. But on the death of Skeat, to whom he was the obvious successor, he was elected to the Elrington and Bosworth Professorship of Anglo-Saxon in the University of Cambridge and held the chair from 1912 until he reached the retiring age twenty-nine years later.

The year which witnessed his election to this chair also saw the publication of *The Heroic Age*. This book won for him a wider circle of readers: for the main theme, a comparison of early Teutonic poetry and tradition with the Homeric poems, renders it of importance to classical, as well as Anglo-Saxon and northern studies. Moreover, the approach to Greek Heroic poetry was one hitherto unexplored. The book falls into three parts and the chapters are interspersed with a number of essays dealing with Slavonic and Celtic Heroic poetry and traditions and their background—themes which were later to be studied in greater detail in *The Growth of Literature*. In defining his use of the term 'Heroic', Chadwick writes: 'I am not clear that the essential conditions requisite for a Heroic Age need involve more than may be conveniently summed up in the phrase "Mars and The Muses".'[1] Although a state of war is not a necessary condition even for the formation of a Heroic story, the societies in which such stories and poems arose were essentially martial and the protagonists were drawn from the aristocracy and with few exceptions famed for their courage.

The opening chapters (I to VIII) deal with the early poetry and traditions of the Teutonic peoples and relate to the age of the Teutonic Migrations, a period for which a considerable amount of external information is available. The distribution of the stories, the inter-relationship of the various versions, the antiquity of the poems, and the conditions under which they arose are treated in detail, together with the different elements of which they were composed, history, myth, and fiction; and the relative importance of those elements is discussed. In the next six chapters Greek Heroic poetry is treated on generally

[1] *The Heroic Age*, p. 440.

similar lines, although for the period here involved little external information exists. In the final part a number of characteristics common to Heroic poetry and story are discussed, resemblances which he ascribes to resemblances 'in the ages to which they relate and to which they ultimately owe their origin. The comparative study of Heroic poetry therefore involves the comparative study of "Heroic Ages"; and the problems which it presents are essentially problems of anthropology.'[1]

He shows that the characteristics exhibited by Heroic societies are in no sense primitive: both virtues and defects are not those of infancy but adolescence—of a youth, not fully mature, who has outgrown the ideas and the control of his unsophisticated parents and who has acquired a knowledge which places him in a position of superiority to his surroundings. The external influence of a superior civilization—for instance, that of Rome upon the Teutonic peoples and the Welsh—often played a part in this process.

The chief characteristic both of the Teutonic and Greek Heroic Ages is an emancipation, a revolt—social, political, and religious—from the bonds of tribal law. In the social and political spheres this is seen in the weakening of the ties of kindred and the growth of the bond of personal allegiance, in the rise of irresponsible kingship resting, not on a national basis, but purely on military prestige. While in religion chthonic and tribal cults were subordinated to 'the worship of a number of universally recognized and highly anthropomorphic deities, together with the belief in a common and distant land of souls'[2]—changes which he ascribes to a weakening in the force of religion. These observations are almost all applicable to the Gaulish Heroic Age and he finds similar analogies in the Heroic Ages of the Cumbrian Welsh and the Christian Serbians, though, at most, only to a very slight extent in that of the Mohammedan Serbians.

This masterly book marks an epoch in the study of comparative literature, for in the anthropological approach to his subject Chadwick broke new ground. His former pupil, Dr. C. E. Wright, quoted by Dr. Telfer, Master of Selwyn, in his obituary of Chadwick in the *Cambridge Review*, writes of it as follows:

The Heroic Age was a synthesis of the results of his research in the two broad divisions of his work, the classical and the Anglo-Saxon (and Scandinavian); exhibiting a masterly handling of all the material then available. The line of his future studies was clearly foreshadowed in the emphasis he laid on the value of tradition, and in the Notes (as

[1] Loc. cit., p. viii. [2] Loc. cit., p. 442.

he modestly called them, though each was a masterly essay) on the Heroic poetry of the Slavonic and Celtic peoples. The long time-gap between this and *The Growth of Literature* is irrelevant. The latter was, one might say, inevitable and it was as carefully and consciously prepared for as Gibbon's *Decline and Fall*.[1]

Chadwick's election to the Professorship marks the beginning of a new phase in his academic career. Hitherto, his time had been divided between teaching and research; for the greater part of the next ten years it was almost entirely devoted to teaching, to university business and to the development of a School of studies. During this time he published nothing, apart from a short paper entitled 'Some German River-names', a philological study which has bearings on the early home of the Celtic peoples. It was his contribution to *Essays and Studies presented to William Ridgeway*, 1913, to whose inspiring personality Chadwick owed not a little in the earlier part of his career.

Chadwick accepted his new and heavy burden without regret. The silence of these years was a loss to scholarship rather than to him personally: he believed that his teaching and direction of research-students was of greater value than his written work.

Though fostered in the schools of Classical and linguistic studies, Chadwick's interests embraced a wider field. He held that the scope of his School should cover not only the study of language and literature but of history and civilization; by civilization he meant institutions, religion, and archaeology.

The student may specialize in whatever direction he wishes, provided that he knows the languages, but he must at least have an opportunity of getting a comprehensive picture of the period he is studying and of conditions which are of course very different from those of modern civilization. We believe that it is only by such training that we may render services to learning approximating to those of German and other continental scholars who have hitherto been responsible for the greater part of the advance made in these subjects.[2]

The achievement of these aims was not attained without opposition. The history of his School's development falls into three stages.

Section B of the old Medieval and Modern Languages Tripos

[1] *Cambridge Review*, 1 Feb. 1947, p. 248. In view of what Mrs. Chadwick has told me, I should hesitate to describe *The Heroic Age* as a conscious preparation for *The Growth of Literature*, the idea of which took shape much later (see below, p. 320 f).

[2] From a letter of Chadwick to the Vice-Chancellor, dated 2 Oct. 1926, printed in the *Cambridge University Reporter*, 1926–7, pp. 1069 ff.

came into being in 1894 and during the first year of its existence Sir Israel Gollancz and G. C. Macaulay taught for it; in 1895 they were joined by Chadwick who from 1899 onwards was solely responsible for the teaching. Skeat was then Elrington and Bosworth Professor, but his interests lay mainly in Middle English and he gave no teaching in Anglo-Saxon save for a paper in Section A (English) of the same Tripos. Section B was almost entirely limited to linguistic study and attracted but few students, though one of them was no less a person than Sir Allen Mawer. In 1907 regulations were passed of a tentative nature which widened the scope of the Section by the inclusion of a paper on Anglo-Saxon, Teutonic, and Viking Age history, tradition and mythology. But it was not until twelve years later, when the regulations drawn up by Chadwick and passed in 1917, came into force, that the scope of Section B was broadened and it became more or less the same section that it is to-day. Apart from the study of specified passages from Anglo-Saxon and Norse works the syllabus now included papers on the history, traditions, religion, literature, and archaeology—in short the general civilization—of the Anglo-Saxon, the continental Teutonic, the northern, and the Celtic peoples, and a paper on Early Britain. Philology became optional and, in its place, most of the students availed themselves of one or other of the alternative subjects. At first the teaching offered for Celtic studies was of a somewhat tentative nature. The death in 1920 of that eminent Celtic scholar, E. C. Quiggin, was a blow not only to Chadwick personally but to Celtic studies in Cambridge. Chadwick, who married in 1922, was at first aided by his wife who, for some years, taught the Irish language, while he himself undertook the teaching of Welsh and early Irish and Welsh history. It was not until the appointment of his old pupil, Kenneth Jackson (now Professor of Celtic at Edinburgh) that the staff was augmented by a lecturer in Celtic subjects.

But Chadwick's reforms were not limited to the broadening of his own Section: with the collaboration of his friends, Professor Sir Arthur Quiller-Couch and Doctor H. F. Stewart, he simultaneously set about remodelling Section A (English studies) and indeed transforming the whole of the old Medieval and Modern Languages Tripos into the new Modern and Medieval Languages Tripos in which English became a more or less independent course consisting of the two sections mentioned above.

All through 1916 and 1917, he was busy drafting new regulations and, although they have suffered change since then, it is safe to affirm that

both these Triposes (*Modern and Medieval Languages* and *English*) are his creation; and the students of the modern humanities are as deeply indebted to him as students of antiquity, though for different causes and in different degree. He kept studiously in the background, but even the remarks which opened the discussion in the Senate House were founded upon notes supplied by him.[1]

The reformers met with considerable opposition from several quarters, among them from the English Association. In a letter to Stewart Quiller-Couch wrote:

Trouble is that everybody thinks he knows enough English to tender advice upon it. If this goes on, one of these days I'll buy a Slavonic dictionary and a match-lock for Chadwick, and we'll raise trouble in the Balkans.[2]

But in spite of opposition, this conjunction of three so remarkable and yet such different personalities proved too strong and their reforms were carried and came into force.

The teaching for his new and much extended Section B rested almost entirely with Chadwick during the first years of its existence, and with it the supervising of an ever-increasing number of research-students. Apart from the aid already referred to which was given by his wife, his former pupils, Sir Cyril Fox, F.B.A., and F. L. Attenborough (Principal of University College, Leicester), gave some short courses between 1919 and 1926. But it was not until after the Royal Commission on the Universities, when the Faculty system came into being, that Chadwick acquired a permanent staff: two lecturers were appointed in 1926, one his old friend, Dame Bertha Phillpotts, D.B.E., who had recently resigned from being Mistress of Girton. The premature death of that rare and enchanting being in 1932 was felt keenly by her colleagues and robbed England of one of its outstanding Norse scholars. Further lecturers were appointed later and towards the close of his tenure of the chair Chadwick had four colleagues working with him in his department.

The addition of a purely literary second part to the English Tripos could only mean a decline in the number of Chadwick's pupils. For this, and for other reasons, in 1927 he moved with his Department into the Faculty of Archaeology and Anthropology, where it remains to-day.

Chadwick's lectures were informal. They were usually given

[1] From a letter of H. F. Stewart in the *Cambridge Review*, 2 Feb. 1947.

[2] F. Brittain, *Arthur Quiller-Couch*, p. 89. In one of the public discussions Quiller-Couch said that he and Stewart were the babes in the wood, but Chadwick was the wicked uncle.

in his college rooms, which looked out on the broad sweep of lawn at the back of King's and over the river. Gowns were not worn; he sat at the head of his dining table, his students, men and women, around him. Even in the earlier days of his career, when the position of women in the University was not officially recognized, he treated them with the same consideration as his men students, always convinced of the important part they could and did play in learning. Whether men or women, his students met with the kindliness and old-world courtesy which ever marked his bearing to his fellow humans and, more than that, they were treated as fellow scholars. For all his gentleness, his influence upon his pupils was a strong one. It was exerted unconsciously and sprang from his vitality and keen enjoyment in teaching. The breadth of approach, the instant grasp of essentials, the exhaustive handling of evidence which characterize his written work were equally manifest in Chadwick, the teacher. Yet his teaching had a rare quality, almost wholly lacking in his writings, a lightness of touch that made work appear amusing, an engrossing and delightful game. I doubt if he was really aware of this himself, yet it was a gift which played no little part in his hold upon the young.

But even more enriching than his lectures were his supervisions. When the present writer was an undergraduate, Chadwick would give long solitary sessions to his students. Once a week, at nine in the evening, one would repair to the small room lined with books to find 'Chadders' (as his students spoke of him) sitting in a rocking-chair, roasting his stockinged legs before a small gas fire. A vast jorum of tea was borne in, capped with a cosy of eider ducks' feathers, sent to him by an admirer in Iceland. A newcomer would be asked, 'How many cups do you take? Because the pot holds eight and I take seven.' And then, for close on three hours, he would impart the riches of his learning upon any problem which had been troubling one, mingling his observations with highly diverting anecdotes and occasionally falling off into a short but profound sleep. Few who had the privilege of these long evening sessions spent alone with him can fail to look back on them as the most formative experience in their education.

If one may venture to criticize so great a teacher, he erred at times by overestimating the capacity of a research student in suggesting subjects for him which were beyond his capability. Chadwick's modesty was perhaps responsible for this: he treated young post-graduates working under him as his intellectual peers.

Too often he has been described as 'a shy recluse'. Shy he certainly was; and the many claims on his time in themselves precluded his mixing in general society. Yet no one who knew him well could deny that he was essentially sociable: he delighted in the society of his chosen friends and of the young. It is true that if he had just cause to be disappointed in someone, he would dismiss him from his thoughts. Moreover, he was apt to regard criticism as hostility—but this only applied to criticism of his ideas on the development of his 'School', which did meet with opposition from the more conservative of his colleagues. Yet thanks to his tenacity, his persuasiveness and a sense of strategy not unworthy of the man whose names he bore, he overcame that opposition and, in his later years, he was able to look back on a band of men and women, former students of his, who had attained distinction in a wide field of subjects. At the time of his death some thirty of his pupils held university posts, not to speak of museum officials and librarians; while on his book-shelves he could number more than forty books written by those who had studied under him. As Miss Dorothy Whitelock has observed,

It was a remarkable achievement to add so enormously to knowledge by his own researches and to form so large a 'school' of workers, if that term can be applied to a body of archaeologists, anthropologists, Celticists as well as the Saxonists one would expect, linked together only by their reverence for a master to whose training they owe so much. It should be put on record that by his own writings and teaching he rescued English studies from a narrow pre-occupation with vowels and consonants.[1]

The final stage of Chadwick's academic career was a period in which, while continuing a still heavy programme of teaching, he turned his attention once again to written work. In a sense, this phase may be said to have begun with the return to Cambridge in 1919 of his former student, Miss Nora Kershaw, whom he married in 1922. It seemed to her more than a pity that his time was devoted solely to teaching, university business, and to directing the research of others, and she told him so. At first he was unwilling to begin writing again, for he felt that the work he was engaged in was of greater consequence. But she persisted in urging him to do so and eventually he agreed to write a book if she would collaborate with him.

It was their original intention to continue the line of research explored in *The Heroic Age* into the later Post-heroic period, and

[1] *The Savilian*, Easter Term, 1947, p. 6.

to undertake a comparative study of the literature, archaeology, and general civilization of the Viking Age with that of Greece in the time of Hesiod, Solon, Archilochus; in 1919 they began collecting literary, historical, and archaeological material to this end.

It was about this time that his collaborator chanced upon a passage in Layard's *Early Adventures in Persia, Susiana and Babylonia* in which he vividly describes the effect of poetry upon Mehemet Taki Khan and his followers—'men who knew no pity and who were ready to take human life upon the smallest provocation'.[1]

It tells of a scene in the Khan's camp: the minstrel seated by his chief, chanting in a loud voice from the *Shah Nameh* and how his listeners would shout and yell, draw their swords, and challenge imaginary foes, or weep as they listened to the moving tale of the Khorsam and his mistress. 'Such was probably the effect', wrote Layard, 'of the Homeric ballads when recited or sung of old in the camps of the Greeks, or when they marched to combat.' It was this passage which fired Mrs. Chadwick; and to it the great design embodied in *The Growth of Literature* owes its birth. Their original scheme was vastly extended: archaeology was abandoned and a comparison of advanced oral traditions—'oral literature' was their term for it—was embarked upon.

Though in a sense, as Dr. C. E. Wright has observed (see above, p. 315 f.), it was the logical, perhaps the inevitable, outcome of *The Heroic Age*, *The Growth of Literature* was a work far wider in range than the earlier book, for it embraces not only Teutonic and Greek Heroic poetry (the main themes of *The Heroic Age*) but the oral literature of many other peoples, ancient and modern: Heroic and Non-heroic poetry and saga, poetry and saga in relation to deities, antiquarian learning, gnomic, descriptive, and mantic poetry, poetry relating to unspecified individuals. Chapters are also devoted to Literature and Writing, Texts, Recitation, Composition, the Author, and Inspiration. Moreover, a number of essays and notes are included.

Volume I, which appeared in 1932, is concerned with the ancient oral literatures of Europe. Chadwick himself was responsible for its form, although nearly all the Irish material was collected by his wife who also contributed to other sections of the book. In Volume II (1936), Part I (on Russian oral literature) is her work; while he wrote the sections on Yugo-Slav oral poetry, early Indian and early Hebrew literature. Volume III

[1] Layard, op. cit., vol. I (1887), p. 488.

(1940) was mainly the work of Mrs. Chadwick who wrote the first three sections (oral literature of the Tartars, Polynesia, and some African peoples). The concluding section, a masterly summary of the whole of this vast material, is the work of Chadwick himself.

This book is concerned with a stage of human development when 'a man's memory was his library'. Its aim is 'to trace if possible the operation of any general principles in the growth of literature' and the method adopted is 'a comparative study of the literary *genres* found in various countries and languages and in different periods of history'.[1]

This necessarily brief account of Chadwick's life and work is no place to embark upon a detailed criticism of so extensive a work and an arbitrary selection of certain points for comment would throw any estimate of the book out of focus. There are details with which one may disagree and views here and there which perhaps a more exhaustive reading of the works of modern scholars might have modified. But it would be ungenerous, not to say foolish, to cavil at this. As the authors themselves admit, had they not concentrated on the primary sources, the book would never have been completed. Rather one should marvel at the courage of a man of his years venturing on so huge an enterprise with but a single collaborator, and at their accomplishment of the task within fifteen years, despite the great inroads which teaching made upon his time—for during the period in which they were at work upon the book, Chadwick was giving something in the neighbourhood of 120 to 150 lectures a year. Yet in spite of this, his writing in this book is more lucid and easier to assimilate than in any of his earlier works.

The approach to their formidable comparative study might be described as an anthropological one. It seems paradoxical that in a man who devoted so much of his life to the study of literature, the aesthetic sense should be lacking or at all events repressed. Yet, although the authors are more concerned with the classification of literature than with its aesthetic value, the book is of absorbing interest. Even those whose interests lie in the aesthetic sphere could hardly fail to admire his sure grasp of the essentials of a problem, the clarity of his argument and, in the final summary, the breadth of his vision.

Certain types of literature are formulated, described in detail, and their distribution and interaction studied. From this, main

[1] The quotations are from the preface to the first volume of *The Growth of Literature*.

drifts in the general history of oral literature are observed: among them the encroachment on and the final supersession of the Heroic by Non-heroic elements, the relative parts played by the minstrel and the seer, the historical and purely speculative elements, the differences between 'maritime' and 'continental' literatures. Among the most stimulating chapters are those dealing with the author and with inspiration. Not the least of the services rendered to learning by this great book lies in its estimation of the relative value of different types of tradition when used as historical evidence—those which have their roots in history and those which are merely the fruit of philosophical or antiquarian speculation. Chadwick's almost pentecostal knowledge of tongues stood him in good stead: nearly all the languages of the many literatures studied in this book were known to one or other of its authors. If the term epoch-making may be applied to so large a synthesis, and one which broke so much new ground, *The Growth of Literature* may well be so described, and it should take its place in English scholarship along with such works as Frazer's *Golden Bough.*

After their marriage in 1922, the Chadwicks set up house in an old paper-mill on the outskirts of Cambridge, close to the Norman 'Leper Chapel' which they took under their care. They had a roomy garden defended by a high wall, and one entered the front door after crossing a bridge over the old mill-stream. Mrs. Chadwick shared his love of animals and the house was peopled with dogs and cats named after various personages in *Beowulf* and in Norse mythology. There was an aviary in the garden, near which in summer they would sit and write; while along the mill-stream ducks and geese could be seen drifting. Mrs. Chadwick had a collection of harps, and on these favoured guests were sometimes regaled by 'The March of the Men of Harlech', played with one finger by the Professor.

One evening, when they were living at the paper-mills, the present writer had occasion to visit him upon business. On being asked how he was, Chadwick replied: 'I have been having a terrible stiff time. One of my in-laws has died. It's like that, do you see.' Still unsuspicious of his preternatural gravity, I murmured my sympathy. 'It has involved me in a lot of legal correspondence,' he continued. 'Only this morning I received a letter from the lawyers which explains why I have not been feeling as well as I should be. It appears that I am a good deal older than I thought—you'd better not mention this or they will have me out of my chair. It appears I am just over a hundred.'

Then, with a blink and a perceptible quickening of *tempo*: 'My father and mother were married in 1857 and, according to this letter, I was not only present at the wedding but must have been twenty-one at the time, since I witnessed the marriage settlement.' As in his treatment of evidence, so in his humour, the approach was original, while in the unfolding nothing of significance was left unexplored.

Soon after their marriage, Chadwick, who had hitherto viewed motoring with an almost superstitious apprehension, was induced by his wife to have a car. Mrs. Chadwick drove, and in it they would not only take students to see archaeological sites in the vicinity, but would make long tours together, visiting many early monuments in this country, Wales, Scotland, and Ireland. One of these trips led to their buying a house at Vowchurch in the Golden Valley on the borders of Herefordshire and Wales in which they spent a considerable part of their vacations. It was here that he began a work on *Early Wales and the Saxon Penetration of the West*. The book was laid aside in 1940: his sense of the past was too keen, his love of this country so strong, that he found it more than he could bear to write of an earlier invasion from the same quarter and by people of the same race as that which then threatened to engulf his native land. Only a few chapters were drafted, but the project had entailed a close field-survey of the Border and his tracing on foot many of the parish boundaries. As Dr. C. E. Wright observes:

> One feature of his genius, which all those who travelled with him over the country-side noted particularly, was his amazing eye for natural features and for their importance in determining the course of history—earthworks, barrows, camps, trackways and Roman roads were not just isolated objects of antiquarian interest, but essential elements in a great pattern.[1]

This gift is nowhere more apparent in his published writings than in his last book, *Early Scotland*.

When the war came in 1939, the Chadwicks, not without regret, moved from the paper-mills to Adams Road, which became his home for the rest of his life. Pleasant though it was, the new house never bore the imprint of his personality as clearly as did the old mill which they had quitted.

The Second World War deprived the University of many of its younger lecturers. The greater part of the teaching for his own department (*Anglo-Saxon and Kindred Studies*) fell once more

[1] *Cambridge Review*, 1946–7, p. 248, quoted in Dr. Telfer's obituary.

upon Chadwick. In 1941, on attaining the age limit, he retired from the chair, but at the request of the university authorities, continued teaching as head of the Department. This did not prevent him from continuing his own writing and research. His contribution, 'Who was he?' in the issue of *Antiquity* (xiv, 1940, 76–87) devoted to the find at Sutton Hoo, throws light on the early kings of East Anglia. To his mind Redwald was the most likely person for whom the great monument might have been made—a view somewhat at variance with the numismatic evidence which suggests a slightly later date.

A short book, *The Study of Anglo-Saxon*, appeared in 1941. Its main purpose was to indicate the scope which that study has to offer. Here, as in the Preface to volume I of *The Growth of Literature*, he argued that the interest and value of this subject is greatly increased by combining it with kindred studies (see above, p. 205). In the last chapter, after tracing the growth of Anglo-Saxon studies, he turned to the future and pleaded that they should not be treated merely as an adjunct to English or be limited solely to language and literature; they should be given, like Classics, full scope for their various interests and an independent position among the courses in Honours. Moreover, he believed that the principles which he advocated for his own subject should be extended to the study of foreign peoples, an idea which he had developed at greater length in *The Nationalities of Europe*.

Both in *The Study of Anglo-Saxon* and in an article 'Why compulsory Philology?', which appeared in *The Universities Quarterly* for 1946 (pp. 58–63), he states the case against the teaching of philology as a compulsory subject. The latter was written at the request of the National Union of Students which had passed a resolution against the teaching of compulsory philology for students of languages at the universities. Even those who disagree with Chadwick's view can hardly fail to be struck with the manner in which he, a man of seventy-five years, was still able to enter into the students' point of view. He held that philology appealed to a very small number and, while believing that students who were interested in the subject should have an opportunity of studying it, he regarded it as best suited for postgraduate work. This has led some to believe that he had grown to dislike philology. Nothing could be further from the truth: his last two books bear witness to his constant use of it as a favourite and delicate instrument.

The Nationalities of Europe appeared in 1945. This book, in a

sense, may be regarded as his war work. His purpose in writing it was

> to call attention to the need for more knowledge, not only of national movements—their characteristics and causes and the ideologies associated with them—but also, and more especially, for more knowledge of the nationalities themselves. I believe that the mistakes made by British policy in the past have been due in the main to ignorance of foreign peoples, including non-British peoples within the Empire.[1]

As a means of overcoming this ignorance, he suggests that a government-sponsored Institute of Imperial and Foreign Studies should be established to provide courses on the languages, history, records, and antiquities of the different countries—subjects which are essential to the true understanding of the culture of any nation. A scheme for this is outlined at the end of the book. The book itself is a general survey. He traces the different nationalities from their beginnings down to and including the Second World War. Much attention is given to the German philosophy of domination, to its origin, development, and disastrous consequences. The book reflects a mellow, progressive, yet realistic outlook. In the chapters on the formation of the linguistic map of Europe and the prehistoric foundations of claims to domination, Chadwick is in his own element; here his handling of the linguistic evidence is brilliant: for example, his arguments for locating the early home of the Celts in the north-west German–Netherlandic area, a region farther to the north than is admitted by many scholars. His interpretation of the archaeological evidence in the light of linguistic study, though at times unorthodox, is none the less arresting. While the book can hardly fail to elicit the interest of the general reader, for those entering upon a diplomatic career or the foreign branch of the civil service it should prove indispensable.

There remains but to mention his posthumous book, *Early Scotland: The Picts, the Scots and the Welsh of Southern Scotland*, published in 1949 by the Cambridge University Press. Here once again, as his wife writes in her admirable introduction,

> his chief contribution lies in synthesis. Linguistic problems, both philological and textual, were his special field.... But the writer of the present book was also keenly interested in the prehistory of Europe as a whole, and more especially in the archaeology of the British Isles. He realized that the historian and philologist must work in close co-operation with the field-worker, and he has not hesitated to make use of recent archaeological work where it could be seen to be relevant to the historical

[1] *The Nationalities of Europe*, p. vii.

records. It may perhaps be added ... that his studies were always closely bound up with his personal life. To work on the history of Scotland gave him keen personal pleasure. Descended from an old Highland family, he turned to Scotland whenever opportunity offered as to the home of his ancestors, and the work of his later years, both on Scotland and Wales, was inspired by an almost romantic love of the Celtic West.[1]

The book opens with two somewhat formidable chapters on 'The Kingdom of the Picts' and 'The Value of the Sources'. Not the least important contribution arising from them is his thesis that the *Chronicles of the Picts and Scots* were derived from two original chronicles based upon two independent oral traditions: in one the Gaelic element is deeply embedded; in the other the forms are in a language virtually identical with Welsh, a language which he calls 'Welsh-Pictish'. The significance of this emerges in the following chapters; while not denying the existence of pre-Celtic, even pre-Indo-European linguistic elements, of which we know nothing, Chadwick holds that both Gaelic and 'Welsh-Pictish' were spoken by the Picts. He holds no brief for the current view that the Gaelic language was introduced into Scotland at a relatively late date by the Dalriadic Scots from Ireland, rather he regards it as having first reached Scotland in the Late Bronze Age through a movement from the north-west German–Netherlandic area which he believes to have affected the whole of the British Isles.[2] In this he is in agreement with Mahr and Crawford, though not with the majority of archaeologists. 'Welsh-Pictish', he believes, reached Scotland later, with the La Tène invasion from overseas (Childe's Abernethy Complex). The new-comers were responsible, among other innovations, for the introduction of forts of the *murus gallicus* type; their primary areas of settlement were in the east-coast regions, whence they spread over a considerable part of Scotland. Although believing that the Gaelic element reasserted itself in certain areas, Chadwick claims that 'Welsh-Pictish' was spoken in Scotland for a thousand years and it has left numerous traces of itself in place-names over a large area of that country.

The distribution of the vitrified forts[3] on the one hand and of

[1] Loc. cit., p. xxvi. [2] Cf. too *The Nationalities of Europe*, p. 150.
[3] The vitrified forts are in reality *muri gallici* which have undergone the action of fire. Chadwick regards both as 'Welsh-Pictish' monuments and believes that the firing of the former was due to hostile action, since the *muri gallici* which have not undergone the action of fire only occur in the primary area of his 'Welsh-Pictish' settlement, i.e. in the East.

the brochs on the other lead him to believe them to be the monuments of two contemporary and hostile cultures.[1] But, as he himself admits, this view awaits the confirmation of further excavation. In the chapter on the Irish Picts the broch-builders are equated with the Fomorians of early Irish tradition who appear to have been Cruithni (here the 'Gaelic-Picts' of Scotland) or their dependants on the west coast and western isles of Scotland. Chapters follow on the Dalriadic Kingdom and the Kingdoms of the northern Britons, the latter being perhaps the most interesting part of this arresting book. Chapter VII was never finished, and as Mrs. Chadwick observes, perhaps the greatest loss was the section projected for it upon the earliest history of Christianity in Scotland, on which he held original and valuable views.

Three features in this book are striking: his interpretation of the evidence as seen against the background of physical geography, his estimate of the varying values of different types of tradition as historical evidence and his deductions based upon linguistic study, both philological and textual. But more striking still is the fact that, despite his advancing years, in this, his last book, his intellectual powers show no trace of crystallization; his imagination remained fresh and his brilliance in the handling of evidence undimmed.

Chadwick was a man who neither sought nor expected honours; recognition came to him. He received the following Honorary Degrees: D.Litt., Durham (1914); LL.D., St. Andrews (1919); D.Litt., Oxford (1943). He was elected Fellow of the British Academy in 1925 and Honorary Member of Sweden's *Kungliga Humanistika Vetenskapssamfundet*, Lund, in 1928; while in 1941 he became an Honorary Fellow of his own college, Clare.

On the election in 1945 of his old pupil and friend Bruce Dickins to the Elrington and Bosworth Professorship, he relinquished his teaching, satisfied that the electors had chosen a scholar of distinction to succeed him.

In the February of 1946 he fell ill and for a few days his life was in danger. But he recovered and soon resumed writing. During the summer and autumn of that year he was well enough to work in his garden. Up to the evening on which his last illness set in, he was wonderfully alert both mentally and physically, and when the blow fell, it fell suddenly. An operation became imperative and he was hurried to a nursing-home.

[1] For a recent but different view on the brochs see Sir Lindsay Scott, *Proceedings of the Prehistoric Society*, 1947, 1 ff.

Although at first he showed signs of making a recovery, complications set in. All through his last illness he was urging his doctor to let him go home, as he was anxious to finish his book on *Early Scotland*. But the strain proved too great and on the morning of 2 January 1947, the day on which they had decided to move him, he died in his sleep. He did not live to see the publication of the *Festschrift* which his former students had written in his honour, but he knew that it was in course of preparation under the editorship of Sir Cyril Fox and Professor Bruce Dickins.

It is fitting that many distinguished scholars, men and women, should thus testify to his genius as a teacher, for it was this sphere of his work which he himself set most store by. Some may believe that his services to learning might have been greater still had he limited his research purely to Anglo-Saxon studies— a view, perhaps, more narrow than just. His life's work was a harmonious, if unusual, development: from Classics he passed through a phase of philological research to the study of early history, literature, religion, archaeology, and tradition. Not the least of his many achievements was to reveal how 'the darkness of the Dark Ages' could be illumined by tradition when scientifically used and in his formulation and fearless application of a technique which, outside the range of purely classical scholarship, he did so much to extend and perfect. His views on archaeological matters may at times have been unorthodox, but they were always alive and provocative, while not infrequently they revealed deep insight. As a philologist his contribution lay in the realm of 'practical' rather than 'asterisk' philology. His power of synthesis, based as it was upon learning deep and wide, stood out like a beacon in this age of ever-increasing specialization.

His friends will always remember the stocky figure in shaggy green tweeds, the old Norfolk jacket, belt unbuttoned, out at elbows; the heavy boots yet delicate almost tripping gait; his inseparable companion a battered, wheezy pipe, swathed in adhesive tape. Nor will they forget the gentle voice, the comfortable north-country manner of speech, the fine cliff-like brow and the large brown eyes, kindly, yet to the end so piercingly bright.

The richness and rare variety of endowments, not only of the scholar but of the man—his faculty of at once penetrating to the core of things, his quiet yet inflexible tenacity, his gentleness, shyness, delicate courtesy, the humour, dry, ironic, yet not

unmingled with a sense of mischief and self-deprecating buffoonery—all these qualities combined to make him an utterly unique being and will keep his memory green to all who were fortunate enough to know him. For those who were not his written work and, it is to be hoped, the School which he laboured so unsparingly to found will remain his monument.

J. M. DE NAVARRO

R W CHAMBERS *Campbell's Press Studio*

XII

RAYMOND WILSON CHAMBERS
1874–1942

CHAMBERS was not among those professors who encourage writers of detective stories. 'I never read anything', he once told the present deponent, 'that I do not intend to remember.' It is true that he read *The Times* newspaper and the *Daily Telegraph* daily, and thoroughly. But it is also true that his memory of even this reading was enduring, impeccable, and disconcerting to political opponents. Not only was he, in fact, one of the most widely read of men, but his reading was entirely at his disposal at all times. He gave his whole mind to whatever he did, or read, and was tenacious and attentive. When we add to this habit and quality a deep love of truth and of literature, an ambition to excel in scholarship, and the influence and example of great masters, something remarkable was likely to come of it. Chambers himself would have said that Yorkshire blood gave him a good start.

He was born at Staxton, at the foot of the Yorkshire wolds, on 12th November 1874, but was soon brought to London, and to the Grocers' Company's School. Thence he proceeded, not yet seventeen years of age, to University College, London, which became his abiding place and his club for almost the whole of his life, with annexes in the British Museum, Bodley, or wherever else books were gathered together or scholars were to be met. There he studied under that unrivalled trio, W. P. Ker, A. E. Housman, and Arthur Platt, who gave to many a taste for the humanities even on the high and severe plane of scholarship, and to Chambers a lifelong passion. He never ceased from proclaiming his veneration for them, and in his riper years for Henry Morley, Ker's distinguished predecessor at University College. He took his Bachelor's degree in 1894.

'Life was not all easy', as another Yorkshireman complained some five hundred years before, for the brilliant young student. He knew privation and anxiety, with a father stricken with early paralysis, and with the need to earn a living without delay. His love of books led him to contemplate a career in librarianship, and upon graduation he was employed in the library of the Medico-Chirurgical Society under Sir J. Y. MacAlister, then in the Guildhall Library for a short time, whence he moved to the library of the Royal Agricultural Society under

his friend Sir Ernest Clarke. He was thus away from University College for five years.

But in 1899 he returned, when Ker appointed him to be Quain Student, in succession to Israel Gollancz and Gregory Foster, the latter becoming Assistant Professor, Secretary, and subsequently Provost of University College. In 1902 Chambers took his Master's degree, and in 1904 he was made Assistant Professor. In the meantime, in 1901, he had been appointed to be also Librarian of the sadly neglected College Library, a post which he held and exercised with energy and vision, together with his considerable teaching duties, for over twenty years. Dr. Offor, Brotherton Librarian in the University of Leeds, who began his career as his assistant in that year, has recorded 'Chambers' excitement when he unearthed, almost literally, a Coverdale Bible, a Nuremberg Chronicle, a first edition of Piers Plowman', from the long undisturbed dust of wired bookcases.[1] During his tenure of office the Library developed into one of the greatest of University collections of books, second in England only to those of Oxford and Cambridge, and admirably organized and equipped for the service of a community of scholars and students. In this work Chambers was most ably seconded by a remarkable group of assistants, Col. Newcombe, Dr. Offor, and Dr. Bonser, who all rose to the direction of a great academic library, and the present Librarian of the College, Mr. Wilks. The delegation of responsibility thus made possible freed him in great measure for the pursuit of English scholarship and for teaching. When he left this post in 1922, to succeed Ker as Quain Professor, he had thus already achieved what for many would have counted as a life's work.

Chambers's attachment to the College Library was, indeed, second only to his devotion to scholarship, and he was one of a notable group of scholar-librarians to whose work so much is owed by learning in England. The first important piece of work in which he showed his quality and his powers was done in collaboration and in the background, at an early age. Ker's edition of Berners's *Froissart* in the Tudor Translations, 1901–3, owed much more to Chambers than appears. A long account of the origin of the edition appeared in *The Times Literary Supplement* in a letter from Chambers, dated 8 December 1927, rebutting a statement that the text was a reprint of Utterson. The 'help' given by Chambers, as he there modestly described his share in the joint effort, was indeed important. His own

[1] *The Library Association Record*, June 1942.

more private account of the matter was that he was responsible for both text and annotations after Volume I. He often spoke of the high praise which W. E. Henley expressed for the Index, under Chambers's name, and of his intention, defeated by death, of making public acknowledgement of its excellence. 'You must see to it,' he told his pupil and colleague Miss Husbands, in a whimsical vein, 'that Henley's praise of my Index is mentioned in my obituary.' It is therefore duly recorded here. 'One of the great ones gone,' said Chambers, when Henley died in University College Hospital.

He never lost this interest in Tudor prose, which led later on to great results. But his main activity in this early period was in medieval studies. He was already busy with the text of *Piers Plowman*, with a view to an edition under preparation for the Early English Text Society, from 1909 onwards. But his chief effort was devoted to those Anglo-Saxon studies in which he soon distinguished himself by scholarly work of the highest order.

His first published book under his own name was his well-known and fundamental study of *Widsith*,[1] which appeared in 1912. Chambers's text and commentary upon *Widsith*, and his treatment in this volume of old Germanic heroic poetry and saga in general, established his reputation at once, and gave new life to Anglo-Saxon studies in England, according to competent opinion upon what one reviewer described as 'one of the finest works of Old English scholarship'. It was in recognition of this notable contribution to learning that the University of London conferred upon him the degree of D.Lit. in the same year.

Chambers then turned his attention to a new major task. In 1914 he published a first instalment of his labours upon *Beowulf*, his revision of A. J. Wyatt's edition of the poem. It was, in fact, a new edition in all respects, though it bore the names of both Wyatt and Chambers.

The Great War of 1914–18 interrupted his scholarly activities. But a humble duty well done ranked high in his mind and gave him great satisfaction. Physically unfit as he was to play the part he would have wished, he did what he could, manfully, as an orderly at a great base hospital in France. And the War Memorial Album, which recorded the part played in the War by students of the College, owed much to his pious, unwearied labours.

Beowulf had to wait. But in 1921 came his finest work in

[1] *Widsith: A Study in Old English Heroic Legend.*

this field, his *Introduction to Beowulf*,[1] concerning which the late Sir Allen Mawer wrote:

> The Introduction finally and definitely places its author in the front rank of the great English scholars who have handled the problems of Anglo-Saxon literature and at the same time removes the last vestige of reproach that might be brought against English scholars of letting themselves be outrivalled by scholars of German and Scandinavian nationality. (*Modern Language Review*, January 1923.)

Tribute was paid at the same time to the style and personality of a scholar who could give life, wit, and excitement to a book of severe learning.

The British Academy set the seal upon his reputation as a scholar by electing him to its Fellowship in 1927, and upon his work on *Beowulf* in particular by awarding him its Biennial Prize for English Studies in respect of that work in 1928.

Again, when Chambers published a revised edition of the *Introduction* in 1932, bringing his survey up to date, and adding a great deal of new matter, with a fuller, exhaustive bibliography, the greatest of his rivals as a *Beowulf* scholar, Professor Klaeber, wrote of Chambers's work as a landmark in scholarship and a humanizing of a recondite subject. All the resources of archaeological study and knowledge, and a close and intimate familiarity with Scandinavian history and literature, were here combined with mastery of Anglo-Saxon studies to produce a work of the highest authority and importance.

The following year, 1933, saw the completion of Chambers's last major piece of work in this field, the magnificent collotype facsimile edition of the *Exeter Book*, in which he collaborated with Professor Max Förster and Dr. Robin Flower. No less perfect work could have superseded Sir Israel Gollancz's earlier, but incomplete, edition in type-facsimile, with translation, of 1893.[2]

Here, then, was a second achievement that might have satisfied a man as his life's work.

It brought further recognition of Chambers's standing, both at home and abroad. The University of Durham conferred upon him in 1932 its Honorary Doctorate of Letters. The Modern Language Association of America, in 1930, made him an Honorary Member. In 1933 the Johns Hopkins Univer-

[1] *Beowulf. An Introduction to the Study of the Poem, with a Discussion of the Stories of Offa and Finn.*

[2] E.E.T.S., o.s. 104. It was completed by Professor W. S. Mackie of Capetown in a second volume of 1934.

sity honoured him with an invitation to deliver the Turnbull Lectures in Baltimore. In the same year the Philological Society, so closely associated with University College, chose him to be its President. And in 1935 the University of Cambridge also honoured him, when Trinity College elected him Clark Lecturer for that year.

A third great achievement, however, was yet to come, and in a different field. The starting-point was that early interest in Tudor prose which had been aroused by his study of Berners's *Froissart*. The result in the end was that Chambers, so long known in the world of scholarship by his work upon *Widsith* and upon *Beowulf*, attained a wider reputation as scholar and writer among general readers as the biographer of Thomas More, and among students of literature as the author also of a notable essay upon 'The Continuity of English Prose'.

The first-fruits of these deep interests, so long set aside in favour of Anglo-Saxon studies, were a remarkable lecture delivered before the British Academy in 1926, upon 'The Saga and the Myth of Sir Thomas More', and a solid and conclusive article in the *Modern Language Review* for October 1928 upon 'More's *History of Richard III*', vindicating the importance of this historical work and More's authorship of it. This study of More was set in the frame of wider studies in the development of English prose, which in their turn led to consideration of continuity in the development of English poetry. It is impossible to dissociate these studies in continuity from the conservative trend of Chambers's political and historical thought, which forbade him to accept the point of view so ably represented by his colleague Professor A. F. Pollard, concerning the true interpretation of the Reformation, or those views which attributed to the Norman Conquest the entry of England into the European comity of thought and culture. These wider studies furnished the material for the two notable series of lectures already referred to, the Turnbull Lectures of 1933 upon 'The Continuity of English Poetry', and the Clark Lectures of 1935-6 upon 'English Prose between Chaucer and Raleigh'. But the focus of all this interest was More.

A profoundly religious man himself, Chambers had long been drawn to More as an Englishman of heroic quality in his religion, as an unbending protagonist of religious freedom, against the tyranny of State compulsion under Henry VIII, and as a man whose private life was at all points consonant with his convictions. He never wearied, in his teaching, of press-

ing the claims of More to one of the highest places in the history of literature, as the father of modern English prose writing. And he saw in More not only the scholar, the judge, the writer, but also, and above all, the type and model of all that is best in the English people.

Chambers's enduring and close association with Professor A. W. Reed, whose life's work was devoted to this period of our history and literature, and to the editing of More's prose works, helped to concentrate and feed his interest in this great figure, as did also his contact with Catholic scholars, in particular Monsignor Philip Hallett. He collaborated with Dr. E. V. Hitchcock, his pupil, colleague, and close family friend, in her edition of Harpsfield's *Life of More* (1932), a prolegomenon to his own monograph, *Thomas More*, which appeared in 1935.

Chambers's long essay upon 'The Continuity of English Prose' formed part of the preface to Harpsfield's *Life*, and it was also issued separately. This was not merely a revolt in favour of More against Wyclif as the first great writer of modern English prose. It was a rejection of the concept that there was any breach of continuity in its development from Anglo-Saxon days through Middle English down to the essential fifteenth century, the fame of whose writers in devotional prose was fully vindicated by Chambers. The key to this continuity was to be found in proper attention to religious writings throughout this long period.

Apart from the literary and scholarly success of *Thomas More*, the book took its place with other devoted work, such as Monsignor Hallett's translation of Stapleton's Latin *Life of More*, in the movement which sought recognition of More's spiritual greatness. It was among Chambers's proudest memories that he received a letter of thanks from His Holiness Pope Pius XI, with an autographed photograph. I have it on the authority of Monsignor Hallett that Chambers's work helped on a cause that both he and Chambers had much at heart, the canonization of More and Fisher, which was accomplished on 19 May 1935. It is well to record that this was the work of a faithful son of the Church of England, who took pleasure in the reading of the Lessons and let nothing interfere with this duty in his parish church of Southgate during his long residence in North London.

When he heard of the canonization Chambers was in America on a second visit. In 1935 the Huntington Library in California had invited him to go again, with Professor A. W. Reed,

to study its Langland manuscripts. While there he gave a broadcast address, the only occasion I can trace when he did so, and the subject was Thomas More, on 6 July 1935.

It was not possible that Chambers should not also have 'attended to' Shakespeare, to use Ker's favourite phrase for literary studies. He had, in fact, much to say about Shakespeare. To this he was moved, in part at least, by his work upon More and by the attention directed to the now famous biographical play *Sir Thomas Moore* through the remarkable studies of Sir Edward Maunde Thompson, Professor A. W. Pollard, and Dr. W. W. Greg, which led to the attribution to Shakespeare of the 'Three Pages' of Addition D as his own holograph manuscript.

When that admirable book appeared, *Shakespeare's Hand in Sir Thomas More*, edited by Dr. Pollard, in 1923, it included an essay by Chambers, 'The Expression of Ideas in the Three Pages and in Shakespeare', upon relations between the thought and expression of Shakespeare in his known plays and in Addition D. To many readers this essay carried a conviction which even the most conclusive palaeographical arguments, or Professor Dover Wilson's acute analysis of the bibliographical parallels, failed to induce. He returned to the charge in 1931, with an article in the *Modern Language Review*, and again in 1937. The lecture then delivered in Manchester University was finally printed as the essay upon 'Shakespeare and the Play of More', a new and full survey, in *Man's Unconquerable Mind* (1939), a remarkable and widely read collection of essays and addresses.

Later studies took form in his British Academy Annual Shakespeare Lecture in 1937 upon '*Measure for Measure* and the Jacobean Shakespeare', and the inaugural Ker Memorial Lecture at Glasgow University in 1939 upon '*King Lear*'.

His last important public utterance was his 1941 British Academy Warton Lecture on 'Poets and their Critics: Langland and Milton', a counterblast to iconoclasts. The lecture concluded with words that give a clue to his fundamental attitude towards great poetry:

> Let us beware how we give consent to the breaking down of one stone from the walls with which the sacred poets have fortified the town of Mansoul.

Such a warning, resting upon unrivalled scholarship, a powerful and faithful intellect, and a lifetime spent in close and familiar

communion with high literature in many tongues, may well be a watchword against that kind of criticism which, uneasy in the company of the great, seeks to reduce their stature to a level where envy ceases.

Chambers's latter years were marked by further honours for a scholar who had now become a public figure. The University of Leeds conferred upon him its Honorary Litt.D. in 1936, at the opening ceremony of its great Brotherton Library. *Thomas More* won for him, in the same year, the James Tait Black Memorial Book Prize 'for the best biography or literary work of that nature'. In 1937 the Bavarian Academy of Science elected him to be a Corresponding Member. And in 1938, the year before the Second Great War, he undertook a new and great responsibility. He had long been closely associated with the work of the Early English Text Society, and now, upon the resignation of Alfred Pollard, soon to be followed by the lamented death of that great and beloved scholar, Chambers was chosen to succeed him as Honorary Director of the Society. The choice was indeed inevitable. But the war years brought with this office many anxieties and troubles, despite the constant counsel of Dr. Flower and the devotion of Dr. Mabel Day, Assistant Director and Secretary of the Society.

A further distinction conferred upon Chambers in 1937 was his election to the Council of the British Academy. There was never a man more appreciative of the honours that fell to his lot, as never was scholar more worthy of them. In particular, he cherished greatly his Fellowship of the Academy and the society he enjoyed in its meetings or on its Council. The British Academy was his favourite audience, and he gave of his best in a notable series of Academy lectures, from 'The Saga and the Myth of Sir Thomas More' in 1926 to 'Poets and their Critics' in 1941.

It might hardly seem likely that there was room in this crowded life of scholarship for any further major achievement. Yet what might have been Chambers's greatest piece of work, indeed, remained unfinished at his death, his work upon *Piers Plowman*. He had long been deeply engaged in this task. As far back as in April 1909 there appeared an important article by Chambers and J. H. G. Grattan on 'The Text of *Piers Plowman*. I. The A-Text', and a second from his own pen, upon 'The Authorship of *Piers Plowman*' in January 1910, both in the *Modern Language Review*. These were followed in 1911 by 'The Original Form of the A-Text of *Piers Plowman*', by

Chambers, in 1916 by 'The Text of *Piers Plowman*: Critical Methods', by Chambers and Grattan, and in 1919 by 'The Three Texts of *Piers Plowman* and their Grammatical Forms', by Chambers. He was drawn away by other interests, and little progress was made for some years thereafter. The present writer later on asked him to survey the problem and to lay out a plan of work towards the completion of the task, for the same journal. In January 1931 a notable long article appeared, upon 'The Text of *Piers Plowman*', by Chambers and Grattan. In the arduous task of collating the many manuscripts of the poem, he was helped in the earlier years by colleagues, Mrs. Blackman and Professor Grattan, and in later years by young scholars like Dr. Mitchell and Mr. Kane, who came to study under his direction. He returned from his visit to California with much added material for his proposed definitive edition of the text. The war interfered with the progress of the work, as with so many good matters, though in 1941 *Work in Progress in the Modern Humanities* recorded him as occupied with 'an investigation of the fifty-one manuscripts of *Piers Plowman*'. The mass of material left towards this end awaits an Elisha to his Elijah, if the work is to be completed. But two completed achievements remain.

First, the text of the A-version was already in proof for the Early English Text Society as early as in 1913, though not yet published. Second, the theory of multiple authorship has been massively and conclusively rebutted. There remains one poet and thinker, among the noblest in any language. These achievements are monument enough to a great Langland scholar, who also defended and vindicated the memorable work of Walter Skeat, the founder of Langland studies in this country, from all belittling attack.

Having said all this, much yet remains. The admirably complete bibliography of Chambers's writings, compiled by Miss Winifred Husbands and printed here as an appendix, gives proof not only of his enormous and varied activity in scholarship but also of his loyalty to his masters and his friends. It was, he said, mainly 'for the pleasure of working with Walter Seton' that he collaborated with that scholarly Secretary of the College, a perfervid Scot and a devoted Franciscan student, towards an edition of Bellenden's 1531 translation of Hector Boece, at the end of the last war. Upon Seton's death, Chambers continued, in collaboration with his colleague Dr. Edith Batho, in pious duty to Seton's memory. It was not until 1938

that the first volume appeared, in the Scottish Text Society's publications, edited by Chambers and Dr. Batho. The work was completed by his colleagues under his direction, and the second volume appeared in 1944, edited by Dr. Batho and Miss Husbands.

So also, upon the death of Ker, his executors asked Chambers to edit certain lectures delivered in University College and taken down *verbatim* by Dr. Hitchcock at Ker's request. The whole Department of English joined with Chambers in the task of editing the book, which went far beyond the mere checking of text, even to some measure of rewriting, where Ker's known preciseness was wanting in these impromptu deliveries. Ker's *Form and Style in English Poetry*, published in 1928, was a considerable addition to the comparatively slight memorials in print of Ker's vast scholarship and reading. Chambers had intended to edit also two further sets of lectures of Ker, similarly recorded by Miss Hitchcock, upon the 'Eighteenth Century' and the 'Romantic Age', together with Miss Husbands's excellent bibliography of his writings, and an enlarged version of Chambers's own *Memoir* of Ker, all of which remain unpublished as yet, in the possession of Chambers's executors, as are also Chambers's own Turnbull Lectures, carefully revised for press.

The loyalty of Chambers to Ker was the measure of his own colleagues' loyalty to him. He was an inspiring and active teacher all his life, and attracted his students to the highest standards of scholarship. In due course some of his pupils and Ker's came to be his colleagues and his helpers in many ways. He was the central figure in a busy and friendly hive of industry, in which interests and views were shared in the service of all. When, in 1928, a second Chair was created by generous endowment in the Department of English, to which the present writer, then Reader under Chambers, was elected, to be Joint Head of the Department with the Quain Professor, a lesser man might have thought his position diminished and might even have offered resistance to this aspect of the proposals. The Northcliffe Professor, it is true, inserted a secret clause into the unwritten regulations for the duumvirate, the clause providing privately for a casting vote invariably to lie with the Quain Professor. But the need never arose during thirteen years of the closest collaboration. It was typical of Chambers's generosity, as of his unfailing wit, that he dubbed the Professors the Two Kings of Brentford and delighted in elaborating the jest. He was happy in the affection and admiration of his nearest col-

leagues, as of the whole academic body of the College. There was added satisfaction in his relations with other scholars, not least in his friendship with men like W. W. Lawrence and Kemp Malone in the United States, or Max Förster in Munich, among many. He was a generous and voluminous letter-writer, and gave greatly of himself in his letters. In his later years he took even greater comfort from sharing thoughts with other men of note, as the shadows darkened upon the world in the fateful nineteen-thirties.

Chambers never married. In his early days he and his only sister, Miss Gertrude Chambers, devoted themselves to the needs of a paralysed father, and in later days to each other in an ideal relationship which gave the scholar the comfort and home-life he needed. There is little to record in his private life. He spent many holidays in Switzerland, with his sister, and was led by the example of W. P. Ker, an enthusiastic Alpinist, to a successful assault upon Monte Rosa. His work on *Beowulf* took him to Norway, where he learned to ski, and to Denmark. And the present writer learned of a visit to Italy from a postcard recording his pilgrimage to the tomb of Romeo and Juliet in Verona. His visits to Florence and Assisi were events of great significance to the lover of Dante and St. Francis. He was an indefatigable godfather, and in his relations with his god-children gave evidence of the kindly and serious earnestness and love with which he rejoiced in the hopeful excellence of the generations to come. We need not wonder, therefore, if, among the many activities associated with University College, St. Christopher's Working Boys' Club was especially a matter of concern to Chambers, its Secretary for many years. To it he gave much of his thought and his time. It was also one of the principal beneficiaries of his private, often secret, benevolence. It was a college beadle—and Chambers was popular with college servants, no mean judges of men—who recalled after Chambers's death festivities shared by him with the boys and young men of St. Pancras, a Christmas Treat in College, a Ramblers' Club on Saturdays, and the fortnight's camp at the seaside.

The war years filled the last chapter of Chambers's life. He had scarcely recovered from a grave operation which aged him, when the blow fell. The deep roots of his being, in University College and in London, were torn up when the College moved to Wales. Even the hospitality of Aberystwyth, or the presence of his friend Dr. Robin Flower with some part of the British

Museum Library housed in the National Library of Wales, could not fill the void. The grievous damage done to University College, the destruction of much of the great library which he had helped to build up as its Librarian for over twenty years, and the annihilation of Chelsea Old Church, in which More worshipped, scarred Chambers too, mentally and physically, though not spiritually. Upon the loss of my own library, Chambers sent me a book to encourage a fresh start, *The Whole Workes of W. Tyndall, Iohn Frith, and Doct. Barnes*, 1573. And on the fly-leaf he wrote:

> 'Our souls be not faint, though our bodies be weary'
> *Mortui resurgent.* October 18, 1940.

There was no wavering in his faith, nor diminution of his activity, during these troubled last years. He ended as he had begun, absorbed in scholarship and in University College. He retired from the Quain Chair in 1941, a Chair made great by Henry Morley and W. P. Ker, made yet greater by Chambers, and now a Siege Perilous but also an inspiration and a challenge for their successor. But he consented to continue as Special Lecturer. His last work of all was the preparation of a lecture upon the history and significance of the College, to be delivered to its scattered groups in Welsh centres, at Aberystwyth, Bangor, and Swansea.

> I have ended my teaching exactly as I should have wished. Two crowded lectures to students on the History of University College; the third stopped by my sudden illness the night before.

So he wrote to a friend from Swansea. The journey had brought on a fatal illness, and he died there a few days after this letter was written, on St. George's Day, 1942.

The history of criticism has hitherto been inclined to disqualify professors of literature from consideration, in favour of non-academic writers. But it would be a queer and incomprehensible survey of critical thought and writing which, in fifty years' time, were to leave out Saintsbury, Bradley, Ker, Elton, Chambers, and Grierson, if we may make a selection from among professors of critical stature within our own personal knowledge. The sweep and scope of Saintsbury's histories, or of Elton's great surveys; Bradley's masterpiece of critical exegesis upon one great theme; the essence of vast reading compressed into Ker's highly original and stimulating writings; the masterly and masterful approach of Grierson to seventeenth-century prose and poetry and to Donne in particu-

lar: none of these is the precise claim of Chambers to rank among the highest. But as absolute scholar, in a wide field of learning, he was perhaps unequalled among the professors of our day in English. His work upon *Beowulf* and *Piers Plowman* remains as the firm foundation upon which all further study must rest. It would, moreover, be difficult to deny the claim of his *Thomas More* to be considered among the greatest biographies in English, or the claim of 'The Continuity of English Prose' to a high place among critical essays of classical quality. In all his writings, the personal note, the all-pervading humour, the lively gusto, the vast allusiveness, the unswerving faith in what is best in the life and the art of man, the warm recognition of excellence in others, which mark them: all give a picture of the man and of his mind and heart which is for ever on record for future generations.

<div align="right">C. J. SISSON</div>

SIR ALLEN MAWER

XIII

SIR ALLEN MAWER

1879–1942

ALLEN MAWER was born at Bow on 8 May 1879. He was the elder son, and second of the five children, of George Henry Mawer and Clara Isabella Allen. His parents were people of strong religious feeling of a humane evangelical cast, which respected learning, and was entirely free from intolerance. It may be said that the whole character of Mawer's life was determined by the nature of his upbringing in childhood. The first stages of his education were undertaken by his father and mother, from whom he acquired an abiding love of literature and a sound elementary training in Greek and Latin grammar and in the details of history. He also acquired, though unconsciously, a sense of intellectual responsibility and a conviction that a life devoted to study was well spent.

His more regular instruction began at the age of ten, when he entered the Coopers' Company Grammar School. At the end of his first term he won a scholarship, with which event his education ceased to be a charge upon his parents. In 1897, after preparation by private study, he sat as an External candidate for the Honours Degree in English of London University, and obtained a First Class in the examination. In the autumn of 1898, as a graduate, he entered University College, London, where for the first time he came into association with a group of contemporaries engaged in the studies which attracted him. To the end of his life he was grateful to University College for this experience. In October 1901 he entered Gonville and Caius College, Cambridge, as a foundation scholar, and resided there for three years, obtaining what was then the unprecedented honour of a double mark of distinction in the English sections of the Medieval and Modern Languages Tripos. With the support of a Research Studentship awarded him by the College, he spent the next year on an inquiry into the history of the Scandinavian invasions of England. In October 1905, on the report of the experts who had examined his thesis on this subject, the College elected him to a Fellowship. A few weeks earlier he had been appointed Lecturer in English in the University of Sheffield, where he remained until his election in 1908 to the Joseph Cowen Professorship of Language and Literature in Armstrong College, Newcastle.

During the thirteen years of his professorship in Newcastle the future course of his life and work was in all essential respects decided. In 1909 he married Lettice, daughter of the Rev. C. Heath of Cheltenham, by whom he had four daughters, and a son who died in infancy. For much of this period his home was Steel Hall among the hills to the west of Newcastle. It was a happy choice, for it gave him abundant opportunity for the expeditions on foot or bicycle which were among his greatest pleasures, and a knowledge of country life and habits which he could have obtained in no other way. It was at Newcastle that he first acquired responsible experience of the details of university administration with which his later years were increasingly occupied. Before the end of his Newcastle professorship he was already marked out as a man to whom high academic office was bound to come.

But the most significant feature of this phase of his career was the gradual concentration of his studies upon the field of research offered by English place-names. The thesis by which he had obtained his fellowship had been in effect a preliminary sketch for a large-scale work on the effects of the Scandinavian settlements in England. It was to run on historical lines, and to show the colonies in their proper relation to the Scandinavian world from which they arose. The historical interest was always strong in Mawer, and was expressed in a number of publications which in the last resort go back to this large design. They include two chapters on early Scandinavian history in the *Cambridge Medieval History* (vol. iii, 1922), an admirable survey of early Scandinavian expeditions entitled *The Vikings* (Cambridge, 1913), and above all a remarkable article entitled 'The Redemption of the Five Boroughs' (*English Historical Review*, xxxviii, 1923), which showed that the distinction between Danes and Norwegians was an important political factor in tenth-century England. On the other hand, the idea of a general survey of Anglo-Scandinavian history gradually receded as the complexities of the field became plainer. In particular, it was clear that a systematic review of the evidence supplied by place-names would be an essential preliminary to the larger scheme, and that this review would in itself be more than enough to occupy a working lifetime. In order to obtain the roughest estimate of the strength of Scandinavian influence in different parts of England, it would be necessary to study the place-names of each district as a whole, and to take account of the innumerable English names which everywhere survived the age of Scandinavian immigration. For

historical reasons studies of this kind are most easily organized county by county, and in 1920 Mawer published the results of eight years' investigations in a volume on the Place-Names of Northumberland and Durham.

In the preface to this volume he laid down the principle that 'no single county can be dealt with satisfactorily apart from a survey of the field of English place-nomenclature as a whole'. He expressed the same idea more elaborately in a paper entitled *English Place-Name Study* which he read before this Academy in 1922. It was the main object of this paper to bring the conception of a national place-name survey within the range of practical discussion, and in this it was remarkably successful. Mawer, who had already been in communication with historians and philologists likely to be sympathetic, obtained both the formal and the financial support of the Academy for the projected survey. Within a year he had brought into being a society composed of interested persons, provided it with a constitution, and laid down the lines of its future activities. The head-quarters of the Society were fixed in the University of Liverpool, where Mawer in 1921 had become Baines Professor of the English Language. The publications of the Society began in 1924 with two preliminary volumes; one, a collection of essays by various hands, the other, a dictionary of the chief elements found in English place-names, which was intended to be used as a companion to the volumes issued by the Society on individual counties. Thenceforward until his death Mawer remained the Honorary Director and Secretary of the Society, sharing the management of its finances with a succession of Honorary Treasurers, but retaining the sole responsibility for the maintenance of its organization. Throughout this period he and the present writer acted together as General Editors of the volumes containing the Survey which it was the purpose of the Society to undertake. From the start it was Mawer's object to attract all scholars interested in place-names into co-operation with the scheme, for he was convinced that only so could a succession of annual volumes be maintained on the projected scale. Four of the eighteen county volumes which have so far been produced were the work of other hands. Dr. A. H. Smith was responsible for the volumes on the Place-Names of the North and East Ridings of Yorkshire, and Dr. P. H. Reany for those on Essex and Cambridgeshire.

Before the first county volumes could be compiled it was necessary to reach an important decision about the range of the

material which should be brought under review. There were a few counties where the bulk of the records needed for the Survey had already been published. But at a very early date in the history of the Survey it became evident that, if its aims were to be realized, manuscript sources must be used on a scale far larger than had ever been attempted before. This conclusion greatly increased the cost of producing the Survey, and it was at this point that the financial aid which the Academy has always afforded to its work was of the greatest value. For a few years the collection of forms from manuscripts was undertaken by unpaid workers, but the Academy's grant soon made it possible to engage professional assistance. In the years before the war the investigation of manuscript sources—a task covering private collections as well as records in public custody—was mainly in the hands of Mr. J. E. B. Gover, who had carried out the researches needed for the volumes on the Place-Names of Devon. From 1929 until the association was broken by the war Mr. Gover was Sub-Editor of the Survey. Mawer was thus freed from anxiety about the provision of the material needed for the Survey and enabled to concentrate upon the work of interpretation and local inquiry. Even so, the burden was heavy. Mawer always approached the linguistic problems raised by the Survey with the topographical situation in the background of his mind. He was keenly alert to the risk of advancing explanations which, though philologically possible, were contradicted by the nature of the ground. He was indefatigable in resort to persons who knew the country with which the Survey at the time was dealing, and he never missed an opportunity of testing interpretations by personal visits to sites.

Looking back across the eighteen years which Mawer devoted to the undertaking, one can see that its course began at a propitious moment. General interest in the subject was widespread; the fundamental principles of place-name study had been established earlier in the century, and a number of scholars were endeavouring to carry them into effect. Mawer's own volume on Northumberland and Durham and Professor Ekwall's *Place-Names of Lancashire* were illustrations of this tendency. Nevertheless, a survey which should cover in detail the place-names of all England was a formidable undertaking, and no one but a man of signal determination would have attempted it. For one thing, it entailed a vast correspondence. The Survey lacked the advantages, if it escaped the inconveniences, of an enterprise maintained by the Government. It was necessary to enlist the

support of a large number of subscribers before the scheme could go forward. The whole burden of this task fell on Mawer, although before long the future of the project was so far secured that he could engage secretarial help. He was always careful to keep in touch with interested persons. He was punctilious in answering the questions which they put to him by letter. He lectured to local societies in all parts of England, and he indicated the aims and illustrated the methods of the Survey in two short publications which had a wide circulation—*Place-Names and History* (1922) and *Problems of Place-Name Study* (1929). Amid academic responsibilities, which steadily became heavier as time went on, he took every occasion of explaining the work of the Society to those who might be interested in its results.

Mawer's attitude towards the central problems of place-name study may fairly be described as conservative. He followed the work of other scholars, foreign and English, with the closest attention, and was quick to appreciate the significance of their discoveries. He had the sincerest admiration for the intensive study devoted to English place-names in the Universities of Lund and Uppsala, and in particular, for the brilliant and massive achievement of Professor Ekwall, to whom the Place-Name Survey was indebted for invaluable assistance on detailed points of interpretation. Nevertheless, to the end of his life, Mawer himself retained an outlook on place-name study which was natural to one who had been a pupil of Skeat, and had come as a young man under the influence of Bradley, Stevenson, and other pioneer investigators. He was unwilling to introduce into the interpretation of place-names any *a priori* generalizations, such as the assumption that personal names are only compounded with terminations denoting sites of habitation. His own familiarity with the manner in which place-names arise to-day made him disinclined to accept interpretations which presupposed the currency of words unknown to the written language or to dialect. He disliked what he called 'dredging the etymological dictionary' for explanations of hard names which further evidence might simplify. On the vexed question of the extent to which unrecorded personal names are preserved in place-names, Mawer, again, stood in line with earlier English scholars. Like them he was always conscious of the inadequate range of the authorities from which knowledge of Old English personal nomenclature is mainly derived. He was impressed by the variety of the forms produced by different types of hypocoristic development, and was convinced that they are most imperfectly represented in the

heroic poems, the formal witness-lists, the historical writings, and the necrologies which are the basic materials for this study. His opinion was confirmed by the names of this class, previously unrecorded, which have come to light during the past thirty years. Here, as throughout his work, Mawer was unwilling to dogmatize. Few scholars as learned as he can have been readier to admit the limitations of the available evidence, or the necessity of keeping an open mind towards the possibility of an alternative explanation.

In 1929 the current of Mawer's activities was suddenly changed by his election as Provost of University College, London. It gave him unqualified pleasure to return in this way to the place where the nature of his career had been determined. He identified himself with the life of the College, and devoted his fullest energies to its interests. Those who followed the course of his Provostship within the College have elsewhere recorded their appreciation of his devotion to its fortunes, and their sense of the humanity with which he interpreted his official duties. One who was not thus placed can merely note that the well-being of the College was obviously Mawer's primary interest in his later years, and that there was no aspect of the College which did not at one time or another fill the centre of his thought. That, despite practical responsibilities so heavy and so gladly accepted, Mawer continued to the end the studies of his earlier life, proves at once the resilience of his personality and the depth of his regard for learning. However pressing the issues with which he was required to deal as Provost, he always swung back, when they were decided, to the familiar problems of place-name study. The accumulation of knowledge was resumed, and its results were put out year by year in volumes which increased in range and detail with the passage of time.

A twofold responsibility like this would have been a strain upon the strongest worker. Mawer possessed great physical energy and took little thought for its conservation. In reality he was less strong than was sometimes inferred from his appearance and his way of life. The action of his heart was irregular. In 1936 he had a serious heart attack while on a cycling holiday in France. In 1938 he lost consciousness for a considerable time at the end of a day in College. Some intermission of work was clearly becoming necessary when the outbreak of war brought a new series of duties upon him. The College was dispersed to various parts of England and Wales. For a time Mawer lived at Aberystwyth, to which place a large section of the College was

evacuated. An attempt to reunite the College in London was ended by serious damage to the fabric and the destruction of part of the library in September 1940. In November Mawer, with his administrative staff, removed to Stanstead Bury in the east of Hertfordshire. There, as formerly at Aberystwyth, Mawer exerted himself to the utmost in the task of holding together the scattered fragments of the College. He held himself ready at any time to travel for long distances with this object, and there can be no question that these journeys, often undertaken at night and in extreme discomfort, placed him under a strain to which his constitution was unequal. In addition to the activities which centred upon the College, Mawer was unremitting in his attendance at the various University committees of which he was a member. On 22 July 1942, without any warning of imminent danger, he collapsed and died while on his way from Stanstead Bury to a meeting of a committee in London.

The importance of Mawer's work received various forms of recognition. He was elected a Fellow of the British Academy in 1930. He received the honour of knighthood in 1937, and became an Honorary D.C.L. of the University of Durham in the same year. His reputation among those throughout the country who respond to the interest of its past was in some ways more significant. He was everywhere regarded as an unfailing source of information about place-names, and it would be hard to overestimate the value of the service to sound learning which he rendered by his replies to his innumerable correspondents. But he was more than a learned consultant in the background. He knew the face of England intimately, and the travels by which he came to this knowledge gave him many friends. He was among the best-known scholars of his generation, and the memory of his personal qualities—his humour and kindliness, his generosity and tolerance—will reinforce for years the influence of the books which bulk so largely in the record of his life.

For help in the preparation of this Memoir, I am indebted to Miss Millicent and Miss Irene Mawer, to Mr. E. L. Tanner, Secretary of University College, London, and to Miss Aileen Armstrong, now Secretary of the English Place-Name Society, who was closely associated with Sir Allen Mawer in the preparation of the volumes issued during his later years.

<div style="text-align: right;">F. M. Stenton</div>

SIR FRANK STENTON

XIV

SIR FRANK MERRY STENTON

1880—1967

FRANK MERRY STENTON came of a family long settled in the Archbishop of York's soke of Southwell.[1] A Nicholas Stenton was reeve of Southwell in the time of Philip and Mary. Most of the Stentons appear to have been substantial farmers in these early days, living in Westhorpe, Southwell, or Halam, but some were more humble. A Goody Stenton sold a hive in Halam in 1710 and two years before had received an umbrella which cost a shilling. When Rastall compiled his first History of Southwell he provided a very poor pedigree of the family from the Registers, and he found no one to mention earlier than Charles I's reign. But in the first surviving register of baptisms a number of a Richard Stenton's children are entered as baptized in the latter half of the sixteenth century. ... The entries appear to relate to a family already long established in Southwell. In 1787 Rastall described the Stentons as 'much the oldest family in the place and become, of late, one of the most opulent.' The opulence was acquired by Francis Stenton, who, after doing well in Southwell and the neighbourhood as a builder and architect, went to London and prospered there also. When he retired from active work he went back to Southwell and built himself a fine house backing on Westgate with stables across the road. The house still stands, has been modernized, and is now known as Stenton House. Francis's fortune passed to his son, another Richard Stenton, enabling him to undertake the office of High Sheriff of Nottinghamshire in 1788. He was the great-grandfather of Frank Merry Stenton. ...

The head of the family in the next generation was Captain Henry Stenton, Frank Merry's grandfather. Henry Stenton was appointed Adjutant in 1810 and commissioned as Major in 1813 and retired as Captain to live in Southwell. He had inherited both the Southwell house and other property there and the London property, but the necessity of paying his debts and providing for his sisters meant that the London property had to be sold. It was necessary for him to marry an heiress if possible,

[1] [In order to accommodate Lady Stenton's unusually long (108 pp.) obituary of her husband within the scope of the present volume, I have had to abbreviate it considerably. Omissions are marked by ellipses; and where I have omitted passages of several pages' length, I have given brief summaries of the omitted content within square brackets. Everything included within square brackets is editorial.]

for the chance of profitable employment in the army was remote. In 1814 he married Elizabeth Judson Cawdron [1772–1855], daughter of John and Mary Cawdron of Bawtry. . . . In 1815 she gave birth to Henry Cawdron, father of Frank Merry. [In 1837 Captain Stenton blew his brains out under a yew-tree at the bottom of the garden,] having first charged his son to get himself a trade or profession. Henry Cawdron duly qualified as a solicitor, taking his examination in London in January 1838 following his father's death. . . . As might be expected Henry Cawdron's career as a solicitor was not marked by any outstanding events, but was a steady record of a strongly conservative and virtuous member of the Church of England. He entered the old firm of solicitors which had always managed the Archbishop of York's affairs at Southwell, and in time became its head. He went around the various manors which made up the soke of Southwell, holding courts in the old way, although some of the courts leet in which business had become little more then a formality he closed because he wished to spare the Archbishop the expense of the necessary hospitality of the court. Frank always regarded that as a mistake on his father's part. Although Frank was not old enough when his father died to hear about his work in the ancient courts from his father's lips, he was able to talk to the man who for many years was his father's head clerk and went about the manors with him. . . . Frank's father became a leader in the little community of Southwell, prominent in furthering all good causes, such as the subscription list for the victims of the failure of Wild's Bank, or a mining disaster in the Nottingham and Derby coal pits. . . . Before he retired he had gone some way to restore the Stenton fortunes, for in those days the Southwell office had no rival for the legal business of the town and country around. He invested in land, mainly in Southwell itself, Westhorpe, and Halloughton, so that he became a farmer as well as a lawyer. He purchased South Hill House, its grounds, and the cottage adjacent to it . . .

In 1852, when Henry Cawdron was 36, he married Frances Cooke, sister of the Southwell surgeon and daughter of a man of the same profession. . . . She bore a son and a daughter and died at the age of 55 in 1873. . . . In 1879 Henry Cawdron retired, having provided for the future of the firm by taking in a young and reliable man as partner, A.T. Metcalfe, so that the firm became Stenton, Stenton and Metcalfe. . . . Henry Cawdron's retirement was followed at once by his marriage to a young woman of 30, Elizabeth Merry, described in her marriage certificate as daughter of Thomas Merry, Esq., gentleman, of the Watt Pitts, Honily, Warwickshire. They were married in London in July and set up house at Hope Cottage, Crown Hill, Upper Norwood, in order to be near the amenities of the Crystal Palace. . . . Despite the disparity in their ages

Henry and his wife were deeply in love and remained so during their brief married life of eight years. Their only child, Frank Merry, was born on 17 May 1880 at Hope Cottage. The birth was a difficult one and the doctor asked which he should save, mother or child, for he did not think that both could live. Henry unhesitatingly demanded that the doctor should preserve his wife, but fortunately both survived. It was fortunate, too, that Frank was born in London and not Southwell, for he was born with a club-foot and in 1880 the operation for club-foot was not performed as a matter of course, nor was it always successful. Frank was operated on before he was a year old in December 1880 and a sinew was cut so that his left ankle had to be supported with irons until he was 13 and his left leg and hip never properly developed. When overtired he always had a barely perceptible limp and when he hurt his right knee, as he did once late in life, he was hard put to get about at all.

From February 1885 until near her husband's death in 1887 Elizabeth Stenton kept up a full diary recording the daily routine of the little household; the weather, the health of the individual members, the meals she gave them, her husband's doings, Frank's daily lessons given by her. . . . Henry Cawdron began to go downhill in 1885 and Elizabeth was clearly anxious that a small child in the household should not be troublesome to her husband. . . . Frank was a delicate little boy, who tended to get what his mother described in her diary as 'weezy' if he went out in the damp or wind or cold, so that he had to have a fire in his bedroom and a steam kettle. A good deal of pressure was exerted on him to 'be a good little boy' . . . [but] it was hardly necessary to exhort Frank to quietness and virtue. . . .

In 1886 the lease of Hope Cottage was running out and the tenant of South Hill House . . . had inherited property in Scotland, so that the house was free for Mr. and Mrs. Stenton to go to. [Unfortunately Mr. Stenton, Frank's father, died on 6 March 1887.] It was a sad story which Mrs. Stenton told in [her] diary, but Frank's early years at Norwood were by no means uniformly gloomy. As an old man he remembered how much he enjoyed seeing trains at Norwood High Level station and travelling in them to London to visit Whiteley's shop. All his life pleasure in seeing trains and travelling in them persisted. [The early phase of young Frank's life, at Norwood and Southwell, is illustrated by various of his childish letters and diary entries, recorded *in extenso* by Lady Stenton; it is clear from these that he progressed in his lessons, in arithmetic, drawing, and Latin, as well as in violin and piano lessons; that he began collecting coins at an early age; and that he formed a friendship with one Frank Walker, a young man eight years older that Frank, and the son of an old friend of Mrs. Stenton.] South Hill was an isolated house, turning its back on Southwell

and the north. The hill was steep and people did not want to walk up it very often. There was no one in Southwell who collected coins, but it was fortunate that Mr. Metcalfe [Frank's father's former partner] was a good amateur geologist and a friend of Professor Swinnerton in Nottingham. Frank cannot have had, and perhaps did not want, many of the ordinary pleasures of childhood. Frank Walker's arrival was eagerly awaited, but he was an undergraduate, reading agriculture at Edinburgh. [But Frank Walker soon moved to the agriculture department in the Extension College at Reading, and] the great change in [the young Frank Stenton's] life, which made all the rest possible, was when Frank Walker persuaded his mother to let Frank join him in his Reading lodgings in 1897. It was a fortunate moment which brought Frank Walker to the nascent agriculture department in the Extension College at Reading. W.M. Childs, who had been at Toynbee Hall, had taken the post of History Lecturer at Reading in 1893 to teach pupil teachers and a young woman who wanted to enter for the Oxford Honour School of Modern History . . . There was when Frank first came to Reading no idea that he should read History. Music was what he hoped to give his life to . . .

II. Early Days at Reading, 1897–9

When Frank joined Frank Walker at Reading, neither he nor his mother can have had any conception of how fragile was the framework on which his future was being built. The late Dr W.M. Childs has set out in *Making a University* the many difficulties which beset those who were trying to attract students to Reading. In 1897 only an unworldly guardian and one who had no experience in launching young people on a career would have sent a promising boy, so ill prepared at school, down to Reading to be taught. There was a real danger then that if the college avoided complete collapse it would become a technical institution based on agriculture and dairying. Although the Extension College was set up under the aegis of Christ Church, Oxford, in 1893, it was not until W.G. de Burgh came to Reading in 1896 that any Greek or Latin was taught, and not until 1897, the year Frank found his way there, that Sir Walter Parratt undertook to direct a School of Music. [At this point in his career, Frank's] main interest was Music with Geology as his main academic subject. History and coins were a hobby. But as soon as Childs knew of his existence the scene changed. De Burgh—though he had very poor success with it—was put on to his Latin and Greek and Childs began to consider the future. [Nevertheless, for the length of his time at Reading, young Frank contin-

ued preparing himself for a career in music. There is no doubt that he had considerable gifts in this domain: he played Chopin's Third Ballade in a recital soon after his arrival in Reading, and during his time there composed a number of chamber and choral works, notably a trio in A minor for violin, viola and 'cello. It was on the promise of this work, presumably, that he passed, in September 1899, the Smalls (that is, the Oxford entrance examination), and was admitted to Keble College on 7 October of that year, and 'entered for First Mus. Bac.'] But music was not to be his vocation, merely a decoration to his life.

III. Undergraduate Years at Oxford, 1899–1902

The credit for turning Frank firmly towards History and away from Music and Geology must go to W.M. Childs. Frank said himself that he was always glad that Mr. Metcalfe and, indeed, his school had encouraged him towards Geology, as it was extraordinarily useful to a historian of the English countryside to know something of what lies beneath the surface. His close friendship with Frank Walker, an agriculturist too, and the fact that most of the small income which maintained his mother and himself came from the rent of the South Hill property turned his thoughts to the history of the Danelaw where he had been bred. He also came to realize that he must choose between Music and History which should be his life's work. He knew that he had not the physical strength to continue his early efforts to maintain both. His failure in the First Mus. Bac. ended his attempts to become a serious musician, but he still hired a piano during term time and won the friendship of many of his contemporaries by his willingness to play whenever he was asked. . . . He certainly made friends at Keble, but none have survived him. He assured me [Lady Stenton] that he went to every University sermon when he was in residence, whether the preacher was famous or not. He had had a good training in church attendance as his childhood's diary shows. He told me how one eminent ecclesiastic of advanced age and poor eyesight, having preached for some time, turned to the gallery and not observing that Frank was the only undergraduate present, thundered with outstretched arm: 'And now I address you young men on whose shoulders the government of this great empire will most surely rest. . . .' Stunned by the threat Frank could remember no more. When trouble broke out in South Africa Frank joined the volunteer batallion of the Oxfordshire Light Infantry in company with many of his fellow undergraduates. There seems to have been no sort of medical examination previous to enrolment or he would surely have been

ignominiously rejected. At the worst time in the 1914–18 war his services were refused on the grounds that he 'was totally and permanently unfit for any form of military service'. . . .

Not much has survived from the whole of Frank's undergraduate life at Oxford. By the time I came to know him well History occupied his thoughts and it was of the great men he had come to know there, of Firth, Poole, Stevenson, and Vinogradoff rather than of his contemporaries that he wanted to talk. It was as an undergraduate that he took to a bicycle and began to ride about the countryside looking at it with the eye of a budding historian. He was fortunate, as he often recalled in his later days, to have been able to do this before the petrol engine and the increasing population of the twentieth century had spoiled it. His bicycle and his piano gave him the entertainment he needed and he resisted the attempts of the rowing men of Keble to turn him into a cox. He was still in close touch with Frank Walker and soon found a few kindred spirits at Keble. One of them was a Welshman named Phillips, who also achieved a First and became headmaster of Brecon College. . . .

How many of the great historical figures working in Oxford Frank became at all friendly with while he was an undergraduate it is not easy to judge from the surviving evidence and the things Frank told me of his youth. The fact that he had come to Oxford immediately from Reading which owed its beginnings to the inspiration and help of Christ Church probably meant that some Oxford teachers were interested to see what the embryo institution at Reading could produce. Until 1903 Halford Mackinder, a Student of Christ Church, remained the nominal head of Reading, but could only afford time to visit it about twice a week. Childs, nominally assistant Principal, was really its head. He felt an almost paternal interest in Frank's future and welcomed him at Reading almost as warmly as did Frank Walker himself. Although Childs had deprecated too much music when Greek had to be mastered for Smalls, he did not hesitate to send Frank verses to be put to music for singing at the Reading Christmas Party, the Jantaculum, and Frank, however busy, always tried to oblige. This connection of Frank's with Reading may have been one reason for the kindness shown to Frank by York Powell, then Regius Professor of History at Oxford and one of the Christ Church men who had given their help to the development of Reading.

But Frank's interest in Scandinavian studies was of a different nature from York Powell's. Frank was not a romantic and always preferred evidence which really was contemporary to that which was written down several hundred years afterwards. Hence it was the gritty food of language and early law for which he yearned rather than the heady tales of Vikings

which were for him entertainment rather than intellectual sustenance. He was fortunate that after his country upbringing, which had included the freedom of a lawyer's office with a long tradition of managing the business of the soke of Southwell, he could choose 'Land Tenure' as his special subject in the Schools. This drew him to the study of Anglo-Saxon and the course of lectures given on that subject by A.S. Napier as well as to Paul Vinogradoff's seminar. Stevenson, who had in 1895 collaborated with Napier in producing what Frank was in *Anglo-Saxon England* to describe as 'a model edition of a small collection of charters in the *Crawford Collection of Early Charters and Documents*', welcomed Frank, not only as an aspiring Saxonist, but also as a fellow Nottinghamshire man and showed him great kindness and hospitality. If Stevenson was more anxious to talk of the local politics of Nottingham itself than Frank, as a Southwell man who rarely visited the country town, approved, he was ready to listen, awaiting the crumbs of wisdom which he knew would fall from time to time. Keble was, as Childs had warned him, not a specially intellectual college, hence it was perhaps natural that its tutors should fear that results in Schools might be endangered if men strayed ahead of the programme to follow their own intellectual interests. His tutor warned him not to attend R.L. Poole's lectures on Diplomatic, but he warned him in vain. Except for the first lecture, which was also attended by Samuel Hoare, later Chancellor of Reading University when Frank was Vice-Chancellor, Frank attended the whole course alone. In after years at Reading when the Chancellor and Vice-Chancellor were comparing notes on their youth, Lord Templewood confessed that he did not again go because he was afraid that Frank also would drop off. To C.H. Firth's lectures Frank went, both because of his lasting interest in the period and also because of the affection he immediately felt for the man, an affection which lasted their joint lives and was, I think, reciprocated.

In later life Frank had little interest in going abroad, but in these early years, perhaps under the influence of de Burgh, he seems to have spent a little time in France or Germany with his Reading friends each year in the summer. . . . The club as the travellers called themselves consisted, I believe, besides de Burgh, Frank, and Frank Walker, of Lady Jenkinson and her daughter Polly, who lived at Leamington and perhaps one or two Reading folk. Lady Jenkinson was the widow of a member of the Daimler firm. . . .

[Frank took his Schools in 1902; Lady Stenton here quotes two letters on the subject written by Frank to his mother. The letters indicate that Frank was confident that he had done well.]

Already before his viva Frank's future was being settled, although hardly as he would have chosen at the time, had the choice been his. Like most

other promising young historians he aimed at the All Souls Fellowship and with the encouragement of Firth, himself a Fellow of All Souls, and the support also of the Warden and tutors of his own College he entered for it, but did not get it, much to Firth's annoyance. There were at this time few opportunities for profitable employment which offered both a livelihood and training in research to those who wanted to make History or any other intellectual subject their life's work. Firth himself was fighting what seemed at the time like a losing battle against college tutors who were uninterested in encouraging young men to get the training necessary for the sound writing of history. . . . A previous generation of young scholars had found the *Dictionary of National Biography* a starting-point. At the turn of the century *The Victoria History of the Counties of England* was in its initial stages and those who were responsible for it, notably H.A. Doubleday and soon William Page, were on the look-out for historians, young or old, who could share in the work.

[At this point Lady Stenton quotes another letter of Frank to his mother, from which it is clear that, through the kindly intervention of J.H. Round, Doubleday invited young Frank to undertake the history of Nottinghamshire for *V.C.H.*, and to begin the work by producing a translation of the Domesday Book entry for that county, for which Frank would be paid £20–25.]

All his life Frank remembered Round's kindness with gratitude. He had gone to London with some trepidation, not lessened when he observed the top hat and frock-coat in which Round was clad. When asked to write a foreword to a reprint of *Feudal England* in 1964 Frank brought it to a conclusion by saying:

> And when regretting the acerbity which too often colours Round's style, it is no more than just to remember the generosity which he could show to younger men, such as the present writer, who were venturing into the fields where he was master, sixty years and more ago.

Congratulations upon Frank's First Class flowed in from Southwell, from Bleasby Vicarage, from Reading, and of course, from Frank Walker, now at Ridgmont in Bedfordshire, and from Oxford contemporaries [Lady Stenton here gives a synopsis of the letters in question]. All these and many more letters were preserved by Frank's proud mother who herself wrote, 'Words fail me when I try to write about the good news of the last two days . . . The news gave me greater pleasure than anything I had ever had before.' She urged him to have a holiday before he came home and ended 'Your delighted Mother.'

IV. Schoolmaster at Llandovery, 1904–8

Frank was not unduly depressed by his failure to get the All Souls Fellowship, and applied himself to Domesday Book under Round's direction. He returned to Oxford in October 1902, hoping to supplement his earnings from the *V.C.H.* by some journalism and by coaching for the Honours School of Modern History. As a coach he seems to have been successful. Men from his own and other colleges came to him and surviving letters show that he was successful both with good men and with the less intelligent. In 1904 one thanked him warmly for getting him a Fourth and a number acknowledged his help in getting their Firsts. How much he made by these labours I do not know, but when as an undergraduate I came to know him I gathered that he was often hard up as he was unwilling to accept or ask for any help from home. His diary for 1903 is blank, except for a note that he has finished a draft of the Nottinghamshire Domesday in January and begun on Rutland . . .

It was probably his work on Domesday Book which led to an invitation to take part in the Putnam scheme of volumes on the 'Heroes of the Nations', sturdy, well printed and produced volumes on great men of the past aimed at the general reader and the student, for they were modestly priced at five shillings each. The editor was H.W.C. Davis. Frank wrote the life of William the Conqueror for the series. It appeared in 1908 and was a remarkably mature book, which for a generation and more was the authoritative book on the Conqueror. It is well worth reading even today. The low price at which this series was sold meant that the authors were not richly rewarded for their labours. At this date publishers did not expect to pay royalties. For the life of William Frank received two cheques, each of £50. I can trace no more payments, although the book was several times reprinted.

The life of William the Conqueror was not produced until Frank had left Central Wales for Reading, but the work was all done and the book written while he was a schoolmaster. Schoolmasters are not given, nor do they expect, extra free time in consideration of their literary labours. In view of this, the book is surely a remarkable piece of work for a beginner. His own later labours have inevitably invalidated some of his pre-1908 conclusions and it always irritated him when reviewers and young writers pointed out that what he said in 1908 did not agree with what he wrote in *Anglo-Saxon England* or *English Feudalism* a generation later. A careful re-reading of *William the Conqueror* today shows the reader why it was that the young author of 1908 became the master of his subject a generation later.

Since the financial outlook was so poor at Oxford Frank applied for the lectureship in History advertised towards the end of 1903 at the College at

Newcastle attached to the University of Durham. He was strongly backed by Firth and his Keble tutors. H.A. Doubleday and William Page, as general editors of the *V.C.H.*, wrote a joint letter recording their appreciation of the work he had done for the 'Putnam History' and their hope of being able to offer him a post on the central staff . . . [But Frank was not offered the job, and stayed for the time being in Oxford.] The real advantage of staying at Oxford was that he was near his Reading friends and able to sit at the feet of scholars in Oxford, particularly Firth, Poole, Stevenson, and Vinogradoff. Their friendship was invaluable to the younger man and he never forgot what they had given him.

Frank had no particular wish to go to Newcastle and was so little regretful at not being appointed that he never even mentioned to me that he had ever applied for a post there. But he was not happy at earning so little money to supplement the resources of South Hill. Hence in mid November 1904 when the History master at Llandovery College in central Wales felt that he could endure it no longer, packed his bags and departed, Frank very willingly took his place. He sent his mother a picture postcard on the way and went straight innto the deserted class-room. Llandovery College played an important part in Frank's life although he was there for less than four years. . . . The years he spent at Llandovery made him a lifelong lover of Wales and its people. In the library he rejoiced to find a *Monasticon* and other books he needed for his own work. In Wales and the Marches he found castles which delighted him and were responsible for the Historical Association tract,[2] first printed in 1910 and reprinted twice since then. By a stream of picture postcards of Welsh castles, rivers, mountains, roads, and little country towns he tried to keep his mother in touch with his activities and show her something of the charm of the Principality. Among the tough boys of Llandovery College he gained great respect by his conquest of mountain tracks in the long bicycle rides he took at week-ends and whenever time allowed; by his work on William the Conqueror and Domesday Book which was going on all the time; and by his music of which the school made full use. His altogether unjustified reputation for toughness meant that he never had any difficulty in dealing with even the bearded footballers. . . .

The four years at Llandovery proved that Frank would never be deflected from his destiny as a historian. He was working hard all the time as a schoolmaster, writing and publishing serious Domesday Book articles on Derbyshire (1905), Nottinghamshire (1906), Leicestershire (1907). Each

[2] *The Development of the Castle in England and Wales*, Historical Association Leaflet no. 21 (1910).

involved difficult identifications of Domesday place-names. It was his obvious capacity in the matter of identifications which made Round so sure of him. As well as these considerable works he produced a number of articles, which, though short, were none the less important. The first article he chose to remember was, as he told his mother on a postcard, accepted by the editor of the *English Historical Review* soon after his arrival at Llandovery in November 1904: 'You will be pleased that Poole has accepted a short article of mine for the *Eng. Hist. Review.*' It was an important article and showed that Frank could already command the material necessary for the identification of place-names as well as that to trace manorial descents. It identified the place 'Godmundeslaech', where Æthelbald, king of the Mercians, issued his important immunity charter with the place of a similar name where Offa issued two charters and traced it down through the manorial descents of both parts to the seventeenth century when its name took on the modern form of Gumley. 'It was', he wrote, 'a place which admirably suits all the conditions for a meeting place of the Mercian witenagemot being situated roughly in the centre of that kingdom.' The speed with which the article appeared in the *Review* after the editor received it shows that it did not need elaborate editing as articles from the young all too often did. Frank's work was extraordinarily mature and finished. On 25 February 1905, a picture postcard of Llandovery told his mother, 'My Derbyshire Introduction sent off at 7.30 this evening. Most blissful relief.' That, too, was very soon in print. In his maturity Frank was never tempted to send off unpolished work to the press. That seems already to have been a characteristic of his youth. . . .

Two other short notes also appeared in 1905: 'The Death of Edward the Elder' and 'Inwara and Utwara', both in the now defunct journal *The Athenæum*, the former identified as 'Fearndune in the Province of the Mercians', where Edward the Elder died as Farndon in Cheshire north of Wrexham, and the latter explains the meaning of the phrase 'inwara and utwara' as 'all manner of charges laid upon a man's land by the authority of his lord and by the authority of the king.' These little articles, or notes, give the impression that Frank was aiming at clearing up a number of small, but important points before he began to write a consecutive history of the Anglo-Saxon period. It is, however, possible that he hardly realized that this is what he was doing, for he was slow to begin to write such a history and needed a good deal of persuasion. He began to lecture on the Anglo-Saxons in the session 1913–14 and allowed me to attend the lectures although I was not yet free of the Intermediate examination. After I had taken my final examination in 1916 I suggested that I should come again and take a verbatim copy so that he could use it as a working base for the book. . . .

In 1906 he published another brief note on a matter of Anglo-Saxon history in the now extinct *Academy*, 'Place-Names as Evidence of Female Ownership of Land in Anglo-Saxon Times'. This is a subject which he elaborated in one of his Presidential addresses to the Royal Historical Society and encouraged me to pursue into post-Conquest and even modern times. His diary for 1906 with its enigmatic notes shows him continually spending small sums on coins, mainly Saxon ones, and his mind ever turning to the Anglo-Saxons. 'Wigingamere', he notes, 'cannot be 'Wickmere.' He went from Matlock to see his friends at Reading early in 1906 and his mentors at Oxford before going back to Llandovery through Matlock again at the beginning of term. Childs at Reading was very conscious that the College was coming to a turning-point. It must either make up its mind to move forward towards university status or accept failure. The future turned on the question of whether he could raise money for the day-to-day expenses of salaries already due. He has himself told the story of the way in which George William and Alfred Palmer came to the rescue and by their example encouraged Leonard Sutton and other Reading businessmen to help. These were men whom I knew when I first came to Reading as a student. There were others who helped, but I did not know them all. At some time during this year Childs raised the question with Frank of whether he would care to come back as a Research Fellow in local history if he could raise a sum sufficient to support him. Firth was proposing that he might be able to get him an invitation to give a couple of lectures at Oxford. H.W.C. Davis had asked his help with the *Regesta Regum Anglo-Normannorum*. The future was opening out, but there was no possibility that success would be achieved without very hard work and it made no promise of riches. Every day he tried to write a page or two of *William the Conqueror*. He was lucky enough to buy a fine copy of *Orderic* for eleven shillings on 12 February. On 22 January he noted, 'Begin to see how to treat the Confessor's reign'. . . . On 4 February he noted that he had written twenty-six pages this term . . . he wrote out lists of places where Anglo-Saxon kings went to die or made notes about coins or place-names. One Sunday afternoon he spent checking figures relating to sokemen tenements and another day 'amused myself with Anglo-Saxon genealogies'. . . . Before the end of the term he had drafted the Domesday chapter under fourteen headings and the chapter remains today to show how carefully the headings were drafted and how exactly the draft was followed.

Before he went home for the Easter holidays in 1906 Frank noted in his diary what he wanted to talk over at Oxford: with Davis the Norman charters and the precise plan of *William*; with Stevenson the place-name

endings 'by' and 'berie'; and with Poole 'sokemen tenements' . . . At Easter week-end he took his mother to York and attended the morning and afternoon service in the cathedral with her. But it was clearly a working weekend, making up his mind about what happened at York in the crucial months of 1066. They went out to Tadcaster and Stamford Bridge. When they came back to South Hill on Tuesday he found the final proofs of the Introduction and Translation to the Nottinghamshire Domesday Book awaiting him. . . . Most of the [summer] holiday he spent at South Hill, as we used to do after we were married. One could not spend it at a more attractive place. Richards and Frank Walker each came for a holiday there too. Towards the end of August he had his usual visit to Oxford and Reading again, seeing his usual friends and in Oxford staying at his old lodgings. Before the end of the holidays he was able to send off the Leicestershire Domesday Introduction and by the beginning of November to copy into his Diary the scheme of chapters for *William* of which little remained to be done except the Introduction and Conclusion. The proof of the Leicestershire Introduction and Translation was coming in, and L.V.D. Owen was elected to the Keble scholarship. He must have felt that life was brighter when 'he heard from Childs and wrote a tentative acceptance'. Unhappily Childs was unable to get the grant for which he hoped and Frank after writing a definite acceptance to Childs had, after all, to stay at Llandovery still longer.

The diary for 1907 shows that Frank wanted very much to get away from Llandovery. He was not tired of Wales, but was tired of schoolmastering. He took to writing music more seriously again and took even more rides than before. Even Domesday Book seems to have become a burden. He wanted to move on to something else. During the spring term he finished Leicestershire and began on Rutland. He engaged himself to do Lincolnshire and Oxfordshire. In May he sent off the second 'Utwara' letter which was soon in print. In June he took his M.A. and on Friday, 19 July he 'resigned 2.10—2.20'. . . . The manuscript of *William* went off to Putnams in mid October, and Frank was anxiously looking for another post. The possibility of lectureships at Oxford excited him, but nothing came his way, though Vinogradoff promised to do his best to get the board to invite him to give a couple of lectures on some Danelaw topic. Frank planned a volume of Danelaw Studies, one of the many books he planned, but did not write. There were to be ten chapters: 1. The Types of Manorial Structure; 2. The Landholders T.R.E.; 3. The Position of the Sokemen in the Manorial Group; 4. Sokeland and Inland; 5. Carucates, Teamlands and Teams; 6. The Hundreds of the Danelaw; 7. The Wapentakes of the Danelaw; 8. Private Jurisdiction T.R.E.; 9. The Process

of Manorialization; 10. The Origin of Rutland. Although this book never appeared as he had planned it, most of these subjects are treated in one or other of his works, and treated with more authority than he could have dealt with them in 1907. As the term and year drew to an end the Warden raised the question of Frank's return to Llandovery in 1908 for a little longer, and, after consulting his mother, he agreed to do so.

As his third year in Wales drew on Frank began to feel that he must move or he would find himself at 70 pensionless, still teaching there.... For Frank it meant looking back to Reading where Childs was trying to raise a modest sum sufficient for him to invite Frank back there as a Research Fellow in Local History. The spring term of 1908 was Frank's last term at Llandovery. He was beginning to feel like his predecessor and with no certainty of another post he left the school at the end of that term. He had undertaken a substantial programme of *V.C.H.* work. As well as the Domesday articles he had in hand, he had agreed to write the articles on the social and economic history of Worcestershire and the city of Worcester. He noted on 9 March that he had 'sent Page the Rutland Introduction' and on 3 April he left Llandovery for good. During April he kept hard at work at the Lincolnshire Domesday Introduction until he left for Oxford on 30 April to stay at his old lodgings and finish the Introduction in Bodley. He finished the last paragraphs on 3 May and sent it off to Page the following day, at 6 p.m., noting that it 'amounted to 59pp. Virtually it has taken me just four weeks'. He was also writing for the *V.C.H.* the general history of Nottinghamshire. This considerable amount of work made him feel that he had been wise to leave Llandovery, but before much more work could be completed financial disaster had befallen the *V.C.H.* In December Frank had noted that he 'Had conversation with Page about *V.C.H.* finance.' At the same time, Page promised £25 on account of what the *History* owed him and £5 for his Rutland expenses. By this time Frank was safely back at Reading as Research Fellow in Local History. The arrangement was made in June, and he entered in his diary on 11 July that he was 'settled for two years'. His salary was to be £100, out of which he would have to pay for his rooms and battels at Wantage Hall, which had been given to the College by Lady Wantage as a memorial of her husband. It was opened formally by her in the winter term of 1908. The Domesday articles on Lincolnshire and Oxfordshire went into cold storage, as did the articles on Worcester and Worcestershire.

In 1922 the second Lord Hambleden bought the assets and rights of the *V.C.H.*, and authorized Page to continue as editor as best he could with the help of an annual allowance. Hambleden died in 1928 and his son maintained the subsidy until 1931 when the economic crisis made it diffi-

cult for him to do so. The surviving rights were therefore conveyed to Page who at once offered them to the University of London. The offer was accepted on 9 November 1932, the deed of gift being dated 15 February 1933. The Senate of the University then asked the Institute of Historical Research to appoint representatives to confer with the Finance and General Purposes Committee of the Senate on the financial future of the *History*. A.F. Pollard, Charles Johnson, and Frank were enlisted, but only Johnson and Frank attended the meeting on 8 June 1934.

Frank himself again wrote an Introduction to the Lincolnshire Domesday, but for the Lincoln Record Society, not the *V.C.H.* He also wrote the Huntingdon and Oxfordshire Introductions for the *History*, but by then he was established in the world and no longer needed payment for his work. Despite what had seemed a serious misfortune for a young man he was able to carry on, for he had saved something of his Llandovery salary; Firth arranged the much-talked-of Oxford lectures in 1909, which were printed in 1910 as *Types of Manorial Structure in the Northern Danelaw*; his first £50 for *William* came on 12 November 1908 and the second in the following year. He was still able to hire a piano for his rooms in Wantage Hall.

V. Research Fellow in Local History, 1908–12

Frank did not realize that when he returned to Reading in 1908 he had found his life's work. He looked no further than his two-year fellowship. Page was suggesting that he should take on the Domesday articles of Wiltshire and Gloucestershire as well as Worcestershire and Nottinghamshire for the *V.C.H.* His first work as a local historian was to be a tract on Berkshire place-names and he was looking ahead to the early history of the Abbey of Abingdon, which was to follow it up. He was also writing *Types of Manorial Structure in the Northern Danelaw* to serve as lectures at Oxford for Vinogradoff. These two lectures do not make easy reading. They were written under Vinogradoff's influence and aimed at satisfying his technical precision, but even Frank could hardly have made them a simple story. There is all-too-little pre-Conquest evidence to build on in the Danelaw, but Frank made the most of what he could find and the fragments of early post-Conquest evidence. They led him on to *Danelaw Charters*. His tract on the 'Development of the Castle in England and Wales' was also on the stocks and was delivered first as a lecture on 18 February 1909. Firth was giving him good advice to become a Fellow of the Royal Historical Society, to keep up his numismatic interests, and to do a paper on Abingdon in the Civil War. . . .

In May 1910 news came of a resumption of work in some counties for the *V.C.H.*, together with a cheque for £35 on account of what was owed him. On 24 June he handed in to Childs the manuscript of his *Place-Names of Berkshire*. . . . To him, place-names were always one type of the materials from which our knowledge of English history should be drawn rather than things to be studied for their own sake. Nor did he ever expect final answers from them to difficult questions. The day after he handed the Berkshire place-names to Childs he sent off the castles work to Tout to be printed as a Historical Association tract. It came out in the same year and contains a great deal of enjoyable work, for all the castles mentioned in it had been visited by the author. The place-name book did not appear until 1911, for the correction of proofs was a much more elaborate work. . . .

Things were looking up a little, for Childs had managed to get the £100 for Frank's fellowship for a third year. Page wrote to him in December 1910 asking him to write 20,000 words on Worcester City and 25,000 on the Social and Economic History of that county. Frank put in a full requisition for the work done on Nottinghamshire. Although no more money was apparently available for the fourth year of the fellowship, a Council minute decided that 'Mr. Stenton's services must be retained in the best interests of the College'. Frank was informed that his stipend would be £200 and his title that of Lecturer, £100 to be in virtue of the fellowship and £100 in virtue of his evening class and other lectures, about seven or eight a week. Childs himself had not been enjoying an easy passage during these years. Each year income had run far short of expenditure and the deficit was getting worse. . . .

Childs and de Burgh were both concerned to find something which would bring in a little money for Frank during 1910 and 1911. They did not want to lose him from Reading any more than he wanted to go. He had always enjoyed the lively society of Reading from the time he went there as a boy in 1897. . . . His diary for 1910 contains in the early pages a list of *Possibilities*: Victoria History, Pitman's series, Oxford Extension, Special Course, Rothley, Place-Names, Abingdon, Danelaw. One possibility which he did not note here was the Historical Manuscripts Commission. In July he called at the Public Record Office and 'saw Roberts and Maxwell Lyte and agreed to do the Staunton papers at a guinea a day of seven hours'. When he was at home for the summer 1910 he came to know George Staunton of Staunton and his family. He stayed with them both in 1910 and 1911 in Kessingland and Clare as well as their lovely old house at Staunton . . . The Staunton papers supplied him with £12. 12*s*. at the end of the year and also with a paper for the *English Historical Review* on the

Staunton manumissions. At the end of the year £10 also came in from coaching the Egyptians at Reading and £40 for his W.E.A. class. . . .

The more cheerful impression given by the diary of 1911 may be due to Frank's realization that as the College moved towards university status more security of tenure could be expected. The last thing he wanted was to go elsewhere, an attitude he never abandoned. P.N. Ure was appointed to a chair of Classics and Ancient History in that year so that de Burgh was free to become Professor of Philosophy. A chair in Modern History was advertised for the next year. But Frank took nothing for granted and had a careful application printed at the Oxford Press, his Oxford friends being pressed in to provide testimonials. Firth, Poole, Haverfield, and Vinogradoff made an impressive company. It was gratifying when the appointment was made without calling any other candidate than Frank for interview. The letters which Frank received and his mother preserved on this occasion from Childs and de Burgh show that they held him in as much affection as he in return held Reading. Childs wrote:

> I am heartily glad that the affair is ended and ended well. You won on your merits. I am very delighted about it, though it makes me feel aged to see one of my own pupils placed in authority over me . . . I must not close without thanking you most heartily for the admirable way in which you ran the meeting. The success was due to you more than anyone else.

De Burgh wrote from 2 Southern Hill where he lived until he retired in 1934:

> The recommendation of the committee was unanimous and decisive. They did not feel it requisite to interview any other candidate. They came to their decision solely on the merit of your published work and on the value of your testimonials and record. Had they allowed feelings of personal regard and confidence to enter into their consideration, their verdict would, if possible, have been still more emphatic.

[Frank Stenton began his career as Professor of Modern History at Reading in the autumn term, 1912.]

VI. Professor at Reading University College, 1912–26

The year when Frank became the Professor of Modern History at Reading saw the death of a great historical figure of the past, Frederic Seebohm. For the *University College Reading Review* Frank wrote an account of this scholar's work and his place among the historians of the nineteenth century, which not only carries conviction but also shows an almost

prophetic understanding of the trends which the study of Anglo-Saxon origins would follow as the result of the work which Vinogradoff, Maitland, and Round had been doing in recent years. He could write as he did because he had already gone so far himself towards reaching the conclusions he adumbrates. His essay on Seebohm, which marks the first year of his professorship, should be read with his last Presidential address to the Royal Historical Society which was delivered in 1945 and discusses the writing of English History between 1895 and 1920. Behind Frank's work on Old English society and in particular on the society of the Danelaw lies the inbred knowledge of a family which has lived and worked on the land for generations and seen families rise and fall as chance and individual ability has led them.... It is true to say that Frank's own work as a teacher and writer of history would have been less effective had he not enjoyed a personal conversance with a country background in the heart of the Danelaw shires; if he could not have himself claimed to own strips of land in an ancient open-field village.

The Early History of the Abbey of Abingdon appeared in 1913, a work which he had proposed as filling the requirements of his Fellowship in Local History. Not that Frank thought of it as definitely local history or regarded local history as a special and perhaps subsidiary form of history. The history of a land and people is composed of the history of all its parts. In his diary for 1909 he wrote on 11 November, 'began Abingdon', but there are hints of the foreworks of Abingdon long before. On the 7 October is the cryptic note 'Abingdon < Malmesbury'. As far back as 1906 in March he copied into his diary the statement of Æthelweard that when the ealdorman of Berkshire was killed in 871 in the fighting round Reading with the Danes his body was 'privately withdrawn and carried into the province of the Mercians to a place called Northweorthige, but Derby in the language of the Danes'. When he read this passage in his study at Bank House, Llandovery, he must have had that flush of excitement which comes when one finds something which throws new light on a period of history. Here again, too, is evidence that already in 1906 his mind was set on the Anglo-Saxons. This little book on Abingdon, which was greeted with applause by those best qualified to judge, made a real contribution to early English history. In concluding the tract he writes that: 'In the previous pages stress has been laid especially upon those details which bring the early monastery of Abingdon into touch with the general condition of the country.' That a Mercian was ealdorman of Berkshire in 871 showed that Berkshire was indeed a border county fluctuating in allegiance between Wessex and Mercia in accordance with the power of kings. By a critical examination of the surviving documents of the abbey Frank concludes

that Abingdon in origin differed not at all from the many *monasteriola* which studded the shires of Wessex in the eighth and ninth centuries. Its importance under Æthelwold [abbot, 954–63] as a school of monks tended to hide its insignificance in earlier times. The monks of the Norman age applied themselves to the invention of details in the history of their house of which the authentic memory had perished and thus obscured the true story of their origins. 'It remains possible to recover a faint outline of the history, and the facts that are thus suggested have their significance in relation to the general condition of the country in the age which lies behind the middle of the tenth century.'

R.L. Poole, writing to thank him for the book, said: 'The charter work is quite first rate and shows how much can be learned from records by those who are capable of treating them critically and bringing them into connexion with local and territorial history.' He went on to urge Frank to undertake a new edition of the Abingdon Chronicle. . . .

[Lady Stenton here gives a brief account of her impressions of University College, Reading, where she had gone as a student in 1912, and had attended Frank's classes: she recalls that there were some thirty-odd students who attended his lectures on English History; she also recalls his insistence on research as a necessary adjunct to teaching.] His strong belief that universities should exist to extend the frontiers of knowledge not only by teaching the young, but by research faithfully pursued by university teachers, made him insist in later days, as his influence in the University grew, that every lecturer should have at least one day completely free of teaching each week for the prosecution of his own studies. Sabbatical terms or years were completely impossible at Reading throughout his days as professor and he never had one in his life. After the exacting duties of a schoolmaster in a boarding-school in central Wales, the slightly shorter term at Reading, the slightly less full working day, and the nearness to the great repositories of the Public Record Office, the British Museum, and the Bodleian Library helped him to continue to do what, like R.L. Poole, he regarded as his real work. . . .

His activities in the Museum and Public Record Office in these years fell into two divisions, the discovery and collection of twelfth-century charters relating to the Danelaw and the investigation of English records of the Tudor and Stuart periods, towards which he was drawn as a result of the records of those times preserved at Southwell minster and in the strong room at his father's old office. . . .

Unfortunately no diaries survive for the next few years, nor have any letters to or from his mother survived, but a stream of picture postcards sent to her throw a good deal of light on his doings. He was engaged in

collecting the charters in the British Museum, the Public Record Office, and Bodley which eventually appeared in 1920 as *Documents Illustrative of the Social and Economic History of the Danelaw*, commonly referred to as *Danelaw Charters*. The Preface to the volume gives no information about when Sir Paul Vinogradoff, as editor of the new British Academy series of Records of the Social and Economic History of England and Wales, invited Frank to contribute to it a volume to illustrate the society of the northern Danelaw, but he had for some years been urging him to concentrate on the Danelaw and I think that Frank must have begun the collection as soon as he was established in Reading. [But progress was slower than Frank might haved wished.] Sir Israel Gollancz, as Secretary of the British Academy, several times spoke of the heavy strain on the resources of the Academy caused by the slow progress of *Danelaw Charters* during the years of the First World War.

The outbreak of war in 1914 had soon drained men from the College [the buildings of which, in addition, were used for war needs. Frank was not accepted for military service, and was obliged to live in improvised and temporary lodgings.] Meanwhile, in 1916, Frank started me off on my researches. The London degree was taken in November those days and I bought a season ticket so that I could do the papers and also go to the British Museum on the one free day and the Saturday afternoon in the examination week. Frank was himself copying charters of the Danelaw counties and he optimistically set me to copy the twelfth-century charters of all the non-Danish shires. Frank was also making a collection of grants of land made by and to men with native names. He also collected personal names of native English and Scandinavian origin, taking enough of the document in which the names occurred to enable us to know something of the status of the individual. He also continued his file of slips recording place-names which were derived from personal names, a file which was of the greatest value when the English Place-Name Society was established. He was still adding to this file late in life. But the big book that he meant to write about personal names was never written.

In 1916 Frank and Canon Foster of Timberland made each other's acquaintance and soon became firm friends. Frank must have initiated the correspondence by joining the Lincoln Record Society in 1915. [Here follows a long account of the muniments of Lincoln Cathedral, of Canon Foster's energies in bringing these into print through the agency of the Lincoln Record Society, and the assistance which Frank was able to give to Canon Foster.] Frank was [meanwhile] clearing up outstanding matters before beginning his book on the Anglo-Saxons. He enjoyed reviewing Thurlow Leeds on *The Archaeology of the Saxon Settlement*. . . . He had also in

1915 written a pamphlet on Norman London, which before he died he twice revised and enlarged. In 1917 he printed 'An Early Inquest Relating to St. Peter's Derby' and in the next year 'Sokemen and the Village Waste', both in the *English Historical Review*. The outstanding article which he wrote in 1918 was 'The Supremacy of the Mercian Kings'. It settled a central problem of Anglo-Saxon history and cleared the way for his attack on a large-scale account of the Saxon age. . . .

Meanwhile Mrs. Stenton [Frank's mother] was far from well. [As she lay dying during the summer of 1918, Frank stayed with her in South Hill.] He was finishing his Introduction to *Danelaw Charters* and as he wrote to me in August he was also 'trying to write down a plausible outline of the settlement of Wessex. But this is a luxury and I do not divert myself from the Introduction. I keep up my page a day. I am now cleaning up the Hundreds section' [His mother died at the beginning of the university term that autumn.]

On 8 November 1919 Frank and I were married and set up a modest household in the back half of a seventeenth-century farmhouse, called Lunds Farm, at Woodley with a daily help. Our home was South Hill . . . [Here Lady Stenton includes several pages of description of the Stentons' domestic arrangements, as well as a detailed report of Canon Foster's continuing work on Lincoln muniments, and the work on the Lincoln Domesday being undertaken by Canon Longley. To all these enterprises Frank Stenton offered unfailing assistance, insofar as they overlapped to a significant degree with his own work on *Danelaw Charters*.]

Danelaw Charters, the Introduction of which makes easy and pleasant reading, gives a full account of villages and towns and the methods of landholding in the Danelaw derived from a large collection of original charters. It was the last big piece of work which Frank had begun before we were married. I only saw at close hand the last stages of its preparation. Of the transcripts of Gilbertine Charters, which came out in 1922, I saw every stage except the actual copying of the charters, which had been done in odd times at the Public Record Office after Frank had left Llandovery for Reading in 1908. I even did some of the translations, but the Index was again done at Timberland under Canon Foster's eye if not by his hand. In later years Frank said that he ought not to have used late medieval transcripts as the foundation of his arguments about the history of the development of the medieval private charter. But since the copies were good, generally slavishly accurate, and it was high time that someone made the effort to place the development of the private grant of land in the perspective of history, there was no reason against using them in this way. No one had attempted to do anything of the kind since Madox had

published his *Formulare Anglicanum* in 1702. The Gilbertine charters were particularly suitable for the attempt because they were a homogeneous collection from a part of the country which Frank knew well, which was in the forefront of advance and where freedom was in the air. The Introduction was sent off to Canon Foster on 1 February 1922. In the same year Frank had also produced an article on 'St Benet of Holme and the Norman Conquest' and a review of J. Armitage Robinson's *Somerset Historical Essays*, both for the *English Historical Review*.

[Lady Stenton now returns to Canon Foster and the Lincoln Record Society, and treats in detail the various people who worked in collaboration with Canon Foster's projects. Such work is seen by Lady Stenton in the context of the establishment of various local Record Offices, and to be related to the work of the Pipe Roll Society, to which she devoted a good deal of her own scholarly energy. This long intermission, which bears only tangentially on Frank Stenton's work, is concluded by several more pages of description of the Stentons' domestic arrangements.]

In 1924 and 1925 life began to be very full. The first volume of the English Place-Name Society appeared in 1924 and in it Frank wrote two chapters, 'The English Element in English Place-Names' and 'Personal Names in Place-Names'. Both were based on the collections we had been making through the years. The Director of the Society had no intention of losing members by allowing publication to get behind, so that the material for volume 2 was at once taken in hand; for this volume Frank wrote the historical Introduction. The time was also coming round for the production of volumes of essays in honour of the great scholars of Frank's youth. He was delighted to set out his own opinion about an Anglo-Saxon problem in a volume presented to Professor Tout in 1925; 'The South-western Element in the Old English Chronicle' was a subject he had long turned over in his mind. All his life he retained his interest in 'Wessex beyond Selwood' and lectured on it when he was asked to be President for a year of the Somerset Archaeological Society in 1959. Unfortunately he did not write out the lecture. Before Frank wrote the article in the Tout volume no one had challenged, or apparently thought of challenging, Plummer's suggestion that the 'annals which led up to the full development of historical writing under Alfred' were kept at Winchester. The fact that in the last years of the Old English state Winchester had become the largest town south of the Thames is no evidence for its importance in earlier times. The many references to people and events which concern the south-west of England, the few references to Winchester, or the bishops of Winchester, suggested to Frank that it may well be possible that the early annals were written by or for a lay noble of the south-western shires.

[There follows a long paragraph on the visitors whom the Stentons entertained during their summer residence in South Hill.]

Frank's publications in 1926 were prepared for the press in the previous year and illustrate both how he yearned to get on with the Anglo-Saxons and still felt a sense of responsibility towards Domesday Book and the *V.C.H.* His work on the Domesday Survey of Huntingdonshire appeared in that year, for the *V.C.H.* was now saved from extinction by the action of Lord Hambledon, although dependent on the courage of Dr. Page and his faith that so good a cause would not fail for lack of support. Professor Ekwall of Lund and Professor Zachrisson of Uppsala, both members of the first Council of the English Place-Name Society, jointly invited Frank and me to visit their universities in 1925 to enable Frank to lecture on some aspects of his work on the English Danelaw. We enjoyed a holiday of between five and six weeks in Scandinavia, acquiring with the help of Professor Ekwall a number of important books, mainly in Lund. The outcome of Frank's lectures was the printing in the *Bulletin* of the Royal Society of Lund in 1926 of a small pamphlet entitled 'The Free Peasantry of the Norther Danelaw', founded on his collections of charters granted by men and women of native descent in the shires drawn by the West-Saxon kings round the armies of the Five Boroughs. For us the Scandinavian visit was an adventure, as we generally spent our vacations at South Hill working. Finally, the lecture which he delivered in January 1926 to the Royal Historical Society on 'The Foundations of English History' shows how firmly, though unobtrusively, he had been through all these years laying the foundations of his own knowledge of the literary sources on which his work on Anglo-Saxon England would be based.

[This section is concluded by an account of how University College, Reading, was granted a charter to become the University of Reading in 1926.]

VII. Professor at Reading University, 1926–46

To us the year 1926 always seemed one of the turning-points in our lives. We had made up our minds when we returned from Sweden in the autumn of 1925 that we must find a home in Reading. . . . [The Stentons purchased an eighteenth-century farm house, Whitley House Farm, with 22 acres of land in the vicinity of Reading; Lady Stenton describes in some detail the nature of the land, and especially of the gander and ducks which they raised on it.]

The year 1926 was also notable in the annals of our lives because my husband was in that year elected a Fellow of the British Academy, an honour which brought new friendships and the invitation to deliver the Raleigh Lecture. He chose to give it on 'The Danes in England', a subject central to the history of the period where his interests lay. His Domesday studies on his own county of Nottingham, on Derbyshire, Lincolnshire, Leicestershire, and Rutland had started him on the serious study of the Anglo-Saxon period. The Raleigh Lecture gave him the opportunity of setting out the conclusions to which much thought and avid reading, encouraged by Sir Paul Vinogradoff, had led him. His collections of cards containing evidence about men and women who, in the charters and other documents of the twelfth and thirteenth centuries, were still bearing names of native English or Scandinavian origin were invaluable material for this study, as were the slips which noted place-names derived from personal names of native origin. The Academy Lectures were sometimes at this date delivered in the rooms of the Society of Antiquaries. Frank was a lecturer who always automatically got on terms with his audience and even if he had his lecture written out seemed to deliver it extemporarily. He rarely had his lectures written out in full, so that many have been lost or have left only a few notes behind. I have a vivid memory of this lecture. I sat with his old friend Stephen Ward in the front row and we shared the dust Frank in excitement banged out of the black cushion on which lecturers laid their notes.

The year 1927 and the seventieth birthday of R.L. Poole gave Frank the opportunity of writing another satisfying article on an Anglo-Saxon subject which he had been turning over in his mind since Llandovery days, when he noted in his diary 'amused myself with Anglo-Saxon genealogies'. In the article entitled 'Lindsey and its Kings' he showed that, obscure as is the history of Lindsey, it was a kingdom the boundaries of which were clearly marked, ruled by its ancient line of kings until late in the eighth century. The kings of Lindsey could trace their descent from Woden and could still use the title *rex* to a time when Alcuin is remarking that scarcely anyone survives who comes of the ancient royal lines of the English peoples. Despite their royal and God-descended line the kings of Lindsey had never been strong enough or rich enough to attract young warriors from neighbouring kingdoms, which alone could make it possible for an Anglo-Saxon king to make his power felt outside his own kingdom. When R.L. Poole acknowledged the receipt of the volume in a gracefully worded printed letter, he added in his own hand, 'I have read your paper twice with special interest. It is most illuminating.'

The invitation to give the Ford Lectures in the University of Oxford came to Frank in 1927 and was momentarily embarrassing. He did not want to give them on an Anglo-Saxon subject for he was not ready to write at length on the Anglo-Saxons. He wanted to deal with individual problems before attacking the period as a whole. He came to the conclusion that he had better for a time turn his back on the Anglo-Saxons and give the Ford Lectures on a twelfth-century subject. He therefore planned a series of lectures on the feudal society of the immediate post-Conquest period, based on Domesday Book and the charters we had steadily been collecting since he returned to Reading from his Welsh school and since I had taken my degree in 1916. In this subject he could count on the help of many friends. Canon Foster could make available to him the great collections at Lincoln as he had already done. It was through the good offices of the Canon that Frank and other scholars interested in family history had come to know of the book prepared under Sir William Dugdale's eyes and known as *Sir Christopher Hatton's Book of Seals*. Its owner, the thirteenth Earl of Winchilsea, had allowed the Canon to borrow this most valuable collection and it had joined the Cartularies of Lincoln cathedral in the safe at Timberland. In 1927 the fourteenth Earl, on succeeding his father, placed his manuscript collections, including the *Book of Seals*, in the care of the Northamptonshire Record Office, now firmly established by Miss Wake, for the use of scholars. Mr. (now Sir Charles) Clay's collections for Yorkshire and his knowledge of Yorkshire families were all at Frank's service, as was Mr. Lewis Loyd's vast knowledge of feudal genealogy. Round's death before the lectures were delivered gave Frank the opportunity of assessing the debt which all who are interested in feudal history owe to that irascible, but often generous scholar. Henry II's demand in 1166 from his tenants-in-chief for information about the knights whom they had enfeoffed provided a convenient date for the end of the lectures and also a title for the book founded on them, *The First Century of English Feudalism*.[3]

The Ford Lectures were an attempt, as Frank himself points out in his Preface to the second edition, 'to get behind the abstract conception of feudalism to the actual relations between the king, his barons and their men in the aristocratic society imposed by war on the ancient Old English state'. He wanted to show feudal society, particularly lay feudal society, in action. He deliberately excluded from his discussion the organization of the great ecclesiastical baronies. Much more had been written about them. But inevitably his search for documents which would reveal feudal

[3] *The First Century of English Feudalism, 1066–1166* (Oxford, 1932, 2nd ed. 1961). pp. viii + 312. Mr. Sisam suggested this title.

society to the historian provided him also with much evidence, sometimes unexpected evidence, about other aspects of feudal relationships, notably about the place of the church and its ministers in relation to the king and his ministers. Many bishops were ministers both of church and state. They administered ecclesiastical law, but were also, as royal judges, bound to administer the law of the land. When he was invited to lecture at Cambridge in 1927, he took the opportunity to illustrate some of the varying interests which the vast number of documents put out by the chanceries of English bishops may provide. He called his lecture *Acta Episcoporum*,[4] a title which has since been taken as the usual description of documents issued in the names of English bishops. Since Frank gave this lecture other scholars have taken up the challenge and turned their pupils on to this field of work. A notable early contribution was made by Miss Kathleen Major's *Acta Stephani Langton Cantuariensis Archiepiscopi* in 1950, based on her B. Litt. thesis of 1931, of which Frank had been the examiner. Our close friendship with Miss Major dates from this B. Litt. examination, when we spent the week-end with the Galbraiths and Miss Major came to tea.

The enthusiasm of Sir Paul Vinogradoff had initiated the British Academy series of Records of the Social and Economic History of England and Wales of which *Danelaw Charters* was vol. V.[5] Before his death in 1925 he had already planned several other volumes which were slowly proceeding in the years which followed. Professor Tout succeeded Sir Paul as Director and Frank was one of the four scholars who were added to the committee in over-all charge of the enterprise. When Professor Tout died in October 1929 Frank succeeded him as Director, and in the first introductory note written by him in 1932 to Professor Douglas's volume of *Feudal Documents from the Abbey of Bury St. Edmunds* set out the arguments for concentrating on printing monastic cartularies in future volumes of the series. Unfortunately only one more volume, edited by Miss B.A. Lees, *Records of the Templars in England in the Twelfth Century: the Inquest of 1185 with Illustrative Charters and Documents*, appeared before the war (in 1935). This volume was so large that it ate up all the money that could be spared from the then limited finances of the Academy for this series, and my husband's vision of a series of Cartularies faded into a nebulous future.

Frank's long preoccupation with the charters of the early feudal period did not in any way turn the strong undercurrent of his thoughts from the

[4] Published in the *Cambridge Historical Journal*, iii (1929), 1–14.
[5] *Documents Illustrative of the Social and Economic History of the Danelaw*, Oxford University Press for the British Academy, 1920. pp. cxliv + 554.

Anglo-Saxons. In any time he had to spare from day-to-day duties and professional preoccupations such as lecturing, teaching, examining, and writing encyclopedia articles, he was slowly and painfully beginning to draft the early chapters of what ultimately became *Anglo-Saxon England*. This meant that an invitation to write an article for a Festschrift volume for an old friend or to give a casual lecture generally produced an article or lecture on the Anglo-Saxon period. In 1933 Professor Tait's Festschrift produced one of his best articles, 'Medeshamstede and its Colonies'. This could only have been written by one who had brooded long and profitably on recalcitrant material. Frank knew very well that it would be useless to rush into writing the history of the Anglo-Saxon kingdom. He had the patience of the great scholar who was ready to allow his subconscious mind to work on material long collected and stored there. His prodigious memory made this possible. This article is founded on a sifting of the material collected by the twelfth-century monks of Peterborough in their search for the early history of their house among the sad relics left from the devastation of the Danish wars, on careful examination of seventh- and eighth-century charters to determine how much genuine evidence might lie concealed among them, on the grateful acceptance of the archaeological evidence provided by A.W. Clapham, which shows that the remains of the early church at Breedon-on-the-Hill in Leicestershire coincide with the date claimed in the twelfth century for the settlement of a colony of monks there from Medeshamstede in the seventh century. Hugh Candidus, the twelfth-century monk of Peterborough responsible for attempting to write of the early history of this house, knew that Medehamstede was a monastery from which other monastic houses were founded. I remember very clearly Frank's excitement when he noticed the similarity between the long privilege running in the name of Pope Constantine in favour of the monasteries at places which must be Bermondsey and Woking and the privilege issued by Pope John VII for the house of Farfa and preserved in the Register of that house. Bermondsey and Woking were two of the monasteries which Hugh Candidus claimed as colonies from Medeshamstede, the pre-Danish monastery which was the predecessor of his own Peterborough. Stubbs had not ventured to claim authenticity for Constantine's privilege, but the Farfa privilege appeared to Frank to be on 'unimpeachable authenticity' and supported the slightly later document.

When 'Medeshamstede and its Colonies' appeared in the Tait volume, Frank had already signed the contract with the Clarendon Press undertaking to write the Anglo-Saxon volume for the Oxford History which Professor (now Sir George) Clark was planning. He wrote to Frank on 26

September 1929, sending a formal invitation to take part in the enterprise and also a personal letter assuring him that he would make every effort to enable Frank to fit his plans for the volume which he was known to have begun into the new series. Frank was slow to answer for he never liked to be tied down to a time-table, nor were his own plans clearly formed. Sir George's next letter is dated 30 October 1929 and shows great consideration for Frank's susceptibilities and a persuasive tact which was evidently irresistible. He was very willing to allow Frank to begin where he liked and A.L. Poole, who was to write the third volume, was very ready to leave Domesday Book to Frank. Frank's only worry was whether he would be able to compress all he wanted to say into the space the Delegates of the Press felt it possible to allow. Nor were they ready at this time to accept as many footnotes as Frank would have liked to put in. It was a time when there was a strong feeling among reviewers against footnotes. Nevertheless, I should record the generous sympathy of all the officers of the Press to a slow-moving author, the helpful attitude of the Secretary, Mr. Sisam, and the general editor of the series, who may well have feared as the years passed, that Frank would never get the volume finished, but would tire of his seemingly endless task. The last of the little bundle of letters from Sir George Clark which I possess is dated 5 November 1929 and from its terms it is clear that Frank has agreed to write the volume:

> Thank you very much for your most welcome letter. I have carefully considered everything you say, and am in no doubt at all that a volume such as you suggest, from the starting point of the formed kingdoms to the death of William, would be the best possible thing for the series, in which it would be the second volume.

From this time forward this household revolved round *Anglo-Saxon England*. It was always there awaiting attention. Its plan was under constant discussion. The wording of every paragraph was continually revised. Frank was a perfectionist, who took endless trouble with every part. Occasionally, as in what he wrote about King Alfred, or the end of his account of the Normans, an interior excitement seemed to move his pen so that he produced a passage which was not only history, but literature, and hass been so recognized by his readers. I shall never forget going into his room to borrow a book one summer morning in 1939 and finding him walking about and very excited. He gave me the paragraph to read which ends:

> The Normans who entered into the English inheritance were a harsh and violent race. They were the closest of all the western peoples to the barbarian strain in the continental order. They had produced little in art or

learning, and nothing in literature, that could be set beside the work of Englishmen. But politically, they were the masters of their world.

The first stage of the long task was finished. We took the copy over to the Clarendon Press on 9 September 1942 and an advance copy of the book reached Whitley Park Farm on 19 October 1943.[6]

[At this point Lady Stenton inserts some discussion concerning the death of the Stentons' housekeeper and the concomitant domestic arrangements; the early years of the University of Reading following the receipt of its charter; and arrangements for the administration of the Lincoln Record Society following the death of Canon Foster in 1935.]

Frank was invited to give the Creighton Lecture in London University in 1936 and chose to give it on a subject which had long fascinated him, 'The Road System of Medieval England'. For many years he had kept a notebook into which he entered any information he noticed in his reading about English roads. When he planned this lecture he asked me to consult Mr. Stamp, Deputy Keeper of the Public Records, about possible material to be found in the Record Office. Mr. Stamp helped me to look for journeys along English roads which could be timed and dated. We found a surprising number, so that the lecture was assured of success. In the same year Frank was invited to lecture on St. Frideswide by Christ Church, an invitation somewhat embarrassing because, as he said, the only certain thing known about the lady is that nothing certain is known. Nevertheless, he managed to fill out a very entertaining hour's lecture. Two papers were wanted by the Historical Monuments Commission in these years, one on 'Pre-Conquest Westmorland' and the other on 'Pre-Conquest Herefordshire'; about the latter Frank felt that there was not a lot more to say than there was about St. Frideswide.

In 1937 Frank was elected President of the Royal Historical Society, an office normally held for four years. Owing to the war Frank held office for eight years and in consequence had to deliver twice the number of Presidential addresses usually given. All of them were well attended and safely delivered without the interference of bombs, although bombs could sometimes be heard in the distance. Five addresses were on the 'Historical Bearing of Place-Name Studies' and three on other aspects of early English history. Frank's well-furnished mind meant that this gave him no difficulty. The last one dealt with the writing of 'Early English History 1895–1920' and concluded that 'for fifty years early English history has increased in range and interest with each successive decade of research.

[6] A second edition appeared in 1947 [and a third addition, with some bibliographical addenda by Dorothy Whitelock, in 1971].

The end of this enlargement is not yet'. The part that he had himself played in this enlargement was already a leading one, but he did not touch on it.

Frank wrote the last of his many studies of Domesday Book for the *V.C.H.* in 1939 when he wrote another account of Oxfordshire rather than let the editor print his youthful exercise on that county. When war broke out we were both so busy that we had no time to worry. O.G.S. Crawford came to stay with us early in the war and made me promise to type out another copy of the newly finished *Anglo-Saxon England* in case the unique copy were bombed. The Clarendon Press soon set it up, but printed so few copies that it went out of print at once. As Frank found a number of changes he wished to make, the Press set up a new edition in 1947 and we took the greatest trouble so that the pagination should not be changed. At Reading the later war years were troubled by the knowledge that Sir Franklin Sibly, who like Canon Foster, had always worked too hard, was failing and Frank had to be ready to take his place at Council or Senate at short notice. When on the advice of his doctor Sibly retired in 1946, Frank was invited to follow him as Vice-Chancellor. Sir Allen Mawer had died in 1942 and Frank had taken on his work as Director of the English Place-Name Society. Frank did not want to succeed either Mawer or Sibly and could not cope with the work of both of them. Bruce Dickins agreed to take over the English Place-Name Society and Frank became its President. Reading University could not be so easily handed over. Frank was a first-rate administrator, although he did not, like his predecessor, enjoy that type of work. He was also an extremely good public speaker, whether as the giver of a learned lecture or an after-dinner speech. He also had the sympathy with others and the wisdom and patience which a Vice-Chancellor needs. Moreover, as he was 66, he could not have a longer session as Vice-Chancellor than four years. By statute he would be bound to retire at 70. The fact that he would not be leaving Reading, but would be serving the institution he had served so long was a final argument making for the acceptance of the invitation. At no period of his life would he have accepted such an office in any other place than Reading.

VIII. Vice-Chancellor of Reading University, 1946–50

Frank's last years of active employment were in complete contrast to those which had gone before. No longer was writing his main occupation. Nor could he work continuously at home. Every day he spent at the University, generally lunching meagrely in Senior Common Room. The vacations

were no longer times of blessed surcease from university cares. It became difficult to get any time at all for a holiday. It was a time of loosening purse-strings and Vice-Chancellor and Bursar sat together day after day devising new wage-scales and salary-scales. In 1948 Frank received the honour of knighthood, to his pleasure, as a historian, not as a Vice-Chancellor. Congratulations came from many of his old Llandovery pupils as well as old Reading students. His friends at the University had his portrait painted by William Dring, who painted also a smaller one for me. In the same year he was chosen a Trustee of the National Portrait Gallery, an office he held until 1965, when he was nearly 85, a good many years after the normal period of tenure. His wide reading, particularly his knowledge of the seventeenth, eighteenth, and nineteenth centuries, and his tenacious memory made him a useful member of that body. He was Vice-President during his last few years on it. It gave him pleasure to be able to convince his fellow trustees that coins could often provide excellent portraits of kings and queens of whom there are no other likenesses. He came to know a number of numismatists as friends and was able to be of some use to them by seeing that the British Academy included numismatic periodicals with other learned journals as sharers of the money granted to help with the higher publishing costs of post-war years. It gave him pleasure, too, to help win the support of the Academy for the *Sylloge of Coins of the British Isles*, and to become its Chairman and provide in his friend Professor Dorothy Whitelock a member of the committee who could take his place when he could hold it no longer.

One further result of Frank's Vice-Chancellorship in a period when scholars could look for larger non-recurrent grants than any of us could remember before was that Frank himself was able to acquire a share in this bounty for a subject very near his heart, the purchase of coins to add to his own collection, which he gave to the University to form a teaching collection for the History School. As it happened the years which followed were particularly fortunate for those who were interested in collecting Anglo-Saxon coins. There came on the market many which much interested Frank. The late Mr. Albert Baldwin was extremely helpful in advising him in the purchase, at a moderate price, of a representative Anglo-Saxon collection. Messrs. Spink also purchased the Duke of Argyll's coins and Frank was able to buy from them many silver pennies from a representative number of mints. Frank's duties as Vice-Chancellor, which meant also the spending of time on extra-university affairs, prevented him taking full advantage of the opportunities which arose in connection with the coins, but despite these handicaps his efforts have secured for Reading University some very interesting pieces. He himself

found considerable enjoyment in making a catalogue of the coins after his retirement.

The outstanding events of my husband's Vice-Chancellorship of Reading University were the acqusition of Whiteknight's Park in 1946 and Shinfield Grange in 1949. [Lady Stenton here spends a number of pages describing the negotiations entailed in the acquisition of these lands for the University; she also mentions Sir Frank's presidency of two local bodies, the Berkshire Archaeological Society and the Berkshire Association of Parish Councils.]

Frank retired from the Vice-Chancellorship in 1950 at the age of 70 and both his Historical friends and his University friends did their best to show their affection by the warmth of their leave-taking. His old friend, Austin Poole, son of R.L. Poole, to whom Frank owed so much at Oxford, was at that time President of St. John's College and Chairman of the Delegates of the Clarendon Press. He suggested that the Historical world should give him as a 'Festschrift' an edition of *Sir Christopher Hatton's Book of Seals*. Ever since Canon Foster had first shown it to him Frank had wanted to see it in print and in 1936 Mr. Lewis C. Loyd had agreed to edit it for the Northamptonshire Record Society in whose custody the book had been placed by the fourteenth Earl of Winchilsea in 1927. Six years of war all spent at his desk in the Treasury Solicitor's Office had broken Mr. Loyd's health so that he was unable to do the work. Frank had offered to help and so had I, but when Frank became Vice-Chancellor he could not and the project had lapsed. Moreover, Mr. H.S. Kingsford, who had offered to write the heraldic descriptions of the seals, had died, having done about half the number. When Mr. A.L. Poole revived the suggestion of publishing the book, Mr. (now Sir) Charles Clay offered to describe the rest of the seals and to help by reading the proofs. That left me with the preparation for the press, writing the Introduction, and doing the indexes. The volume would obviously be a very expensive one and time was short. The Clarendon Press produced a time-table for me and agreed that if I kept to the time-table they would bring out the book in time for Frank's birthday. It could only be done with the help of the subscriptions of Frank's friends and a grant from the Northamptonshire Record Society, of which Frank was a Vice-President. It was presented to him at a most enjoyable dinner-party held in the Senior Common Room at Reading and presided over by Austin Poole. The leave-taking by the University was equally warm and Frank never forgot the kindness of the several groups who organized gifts and parties to mark the occasion. . . .

IX. Retirement, 1950–67

The first task which Frank took up in the fifties was the organization of the History of Parliament. He had been consulted by the trustees of the fund raised for the purpose by Colonel Lord Wedgwood as long ago as 1942. Lord Wedgwood's enthusiasm had enabled him to raise among his friends sufficient money to provide two large and indigestible volumes covering the years 1489–1500, which had been met by serious criticism from the historical world. It was to some extent, perhaps, unfair criticism. The faults were there certainly, and to do these two large and costly volumes was an expensive way to avoid them in future. Nevertheless, Frank always felt that the Wedgwood volumes were a pioneer effort in a difficult field and should be regarded as teaching future workers both what mistakes they must avoid and at what they should aim. In 1943 Lord Wedgwood died and two only of his research staff remained in employment. About £2,500 of the fund raised remained, which was being used up at about £70 a month. Frank suggested that work might go on slowly during the war under a historian interested in Parliamentary history and advised by a committee of eminent historians interested in the same subject, but he found it impossible to suggest a name. Nor was there enough money to pay a scholar to accept the work. Frank himself became a trustee, but there was little that he could do beyond agreeing to supervise the researchers until they were called up. The most effective thing he could do was to talk to a possible future editorial committee, Professor (now Sir Goronwy) Edwards, Professor (later Sir Lewis) Namier, Professor (now Sir John) Neale, and the late Professor Plucknett, to stimulate them to think about what might be done in more propitious days. When in 1948 the trustees formally consulted Namier he suggested that £100,000 would be needed to provide an effective establishment for the work and that the Institute of Historical Research might provide a home for the History. Frank agreed to prepare a detailed scheme for the History and in 1949 his proposals were agreed in principle and he began negotiations with the Treasury.

In November a formal joint meeting between the trustees and the Chancellor of the Excequer took place and the latter agreed to put a proposal for a grant before the Prime Minister who would consult the leaders of the two parties in opposition, the Conservatives and the Liberals. Final agreement was reached in January 1951 on a government grant of £15,000 a year for twenty years and the supervision of the History was entrusted to an editorial committee who were to prepare and carry out the plan. Frank suggested Professors Edwards, Namier, Neale, and Plucknett for the committee and was himself asked to become chairman. He

therefore resigned his trusteeship and took up the task of chairman. The Institute of Historical Research agreed to provide accommodation.

From that time the History of Parliament became one of Frank's problems, often a tedious one. It needed an exercise of patience, for he had always found it easier to do a job himself rather than watch someone else doing it more slowly than he would have done. Some of the sections into which the committee agreed to divide the History were no trouble. Professor Namier and his assistants forged ahead like a train and it was obvious that their three volumes would appear in a reasonable time. That Sir Lewis died too soon to see the completion of his work was a tragedy, but Mr. John Brook was able to finish it. The expansion of the universities and colleges and the increase of university salaries drained researchers from the History to better-paid and pensionable work. The committee was fortunate in securing the services of Mr. E.L.C. Mullins as secretary who proved extremely competent. Before he retired from the chairmanship of the editorial board Frank had the pleasure of seeing Sir Lewis's volumes appear. The last meeting of the board at which he presided was held at Whitley Park Farm in the summer of 1965. . . .

From university administration and the History of Parliament alike Frank turned in relief to the Anglo-Saxons, their coins, their solemn charters, and their works upon the ground. Professor Wormald invited him to give three lectures on the solemn charter in the department of Palaeography in the University of London. This he did with enjoyment in March 1954. They were published a year later as *The Latin Charters of the Anglo-Saxon Period*, perhaps an austere title for what were fascinating lectures, as an appreciative audience testified by their faithful attendance and considerable applause. As always Frank's felicitous choice of words held those who heard him and the printed book has been reviewed in terms of the highest praise. . . .

For many years about this time we regularly stayed for a week at least within the reach of Offa's dyke. We used to drive to a point whence we could walk along it and try to follow it in places where the indifference of farmers had gradually worn it down so that the line was not easy to trace with assurance. We used to take with us the reports which Sir Cyril Fox had published of his work on the dyke betwen 1926 and 1934. I have happy memories of windy and sunny days when we clambered up the hills near the Three Shepherds, and looked down on the ruins of Sir Samuel Romilly's house, a house which we heard a local lady in the hotel say one day had belonged to 'such an unlucky family'. After Frank retired we took the History Honours Class there with us one year, I think 1953. Sometimes we stayed at Oswestry, more often at Presteigne; once at Sedbury Park.

When the British Academy determined to reprint Sir Cyril's reports as a book, Frank was delighted to be asked to write a Foreword to it which he did during 1954. The very beautiful book was issued in 1955 and Frank's Foreword greatly pleased Sir Cyril. Frank showed in it, arguing from Felix's *Life of St. Guthlac*, that in the reign of King Cenred between 705 and 709 the Welsh were carrying out a series of devastating raids over Mercia and that King Æthelbald's reign (716–57), when the king of the Mercians can claim for himself the title of king not only of the Mercians but of all the southern English, was the time when Wat's dyke, the first of the great Mercian defence works against the Welsh, was made. . . .

One piece of work which Frank did in his retirement was, like coins, very much a return to the interests of his youth. Dr. Bela Horowitz, the founder of the Phaidon Press, planned and raised the funds to print a sumptuous facsimile edition of the Bayeux Tapestry and invited Frank to edit the book and write about the historical background to the work. That Professor Wormald would take part in it gave Frank great pleasure and greater still to find that his view of the English origin of the tapestry was also held by him. An advance copy came in the early autumn of 1957. That Dr. Horowitz died in America before the volume came out was a matter of sorrow to all connected with it.

Frank's main intellectual interest through his last years was in building up a collection of coins which could be used to illustrate the whole sweep of English history. He was, of course, primarily interested in Anglo-Saxon coins, which are a main source of information for the period, but the amount of history which he could extract from the coins which he had collected as a boy was surprising.[7] When a little more money meant rarer items and even an occasional gold coin he was delighted. He greatly enjoyed dropping into Messrs. Baldwin for a chat with the late Mr. Albert Baldwin and the purchase of a coin or two after what was often a rather tedious meeting and bringing home the coins to show me after supper. When he was very ill he asked his night nurse for his coins, meaning his coin catalogue which he wished to look at. Mr. Blunt and Mr. Dolley wanted him to do a Sylloge volume of the Reading Saxon coins, but it was too late. It would, however, give him pleasure to realize that such a volume is being done now in his memory. He was pleased to realize that he could still spot a die-duplicate even in his middle eighties. Fortunately neither his sight nor his mind failed him as the end of life drew near.

[7] I may perhaps note that his first published work was an account of English copper farthings from the time of Charles II in 1672, which he published in the school magazine when he was in the sixth form.

Mr. Dolley planned a Festschrift for Frank when he reached the age of 80 based on and entitled *Anglo-Saxon Coins*. He had hoped to be able to present it at the British Numismatic Conference in the summer of 1960, but it was not ready. It was published in the following summer and greeted by reviewers with warm praise both of Frank and the book. Dr. Nowell Myres described Frank as having contributed more to Anglo-Saxon studies of every kind than any other living scholar and the book as

> the most important and valuable Festschrift in the Anglo-Saxon period that has appeared in this country for many years. It is true that by limiting its subject-matter to problems connected with the coinage, its sponsors have deliberately ignored the wide range of related subjects in which Sir Frank showed his mastery, and also the claims of his pupils and friends to share in paying tribute to his inspiring leadership.[8]

Although he had found it difficult to get the sort of academic post he desired in early life, once he was established at Reading recognition was not long delayed. His single-minded devotion to learning was his most obvious characteristic and election to the British Academy came early in days when it was generally slow in coming. He was early elected to the Council and served on it for nine years until he resigned so that a younger man could take his place. He won recognition also from learned societies in other lands. He was elected a Corresponding Member of the Académie des Inscriptions et Belles Lettres in the Institut de France (1947), and Honorary Member of the Royal Flemish Academy for Language and Literature (1949), a Corresponding Member of the Monumenta Germaniae Historica (1955). The Universities of Oxford (1936), Leeds (1939), Manchester (1944), Nottingham (1951), Reading (1951) conferred on him an Honorary D.Litt.; the University of Cambridge (1947) an Honorary Litt.D.; the University of London an Honorary D.Lit. (1951), the University of Sheffield (1948) an Hon. Ll.D. In America he was elected a Fellow of the Mediaeval Academy of America. But more important were his friendships and the many people who loved him.

The longest life is never long enough for all the devoted scholar plans to do. Nor does the young man ever believe that his strength will fail and, as the years pass, he will not have to energy to work as he did in former days. Most scholars must be conscious of the books they have planned but which, as life draws near its end, they realize that they will never write. Frank's collection of personal names, both Old English and Old Scandinavian, will never be made into a book, nor will his collection of

[8] *Antiquaries Journal* xliii (1963), 153–5.

personal names compounded in place-names. They have been used in many of his own and other peoples' writings, but on cards they will remain. Similarly the book to be called 'The Unity of England', of which he had set out the chapters in his well-worn notebook and had discussed with Mr. Sisam, will now never be written. Nor will the Reading Cartularies, of which in odd times, between meetings in London, he had copied almost the whole, ever be published by him. The years as Vice-Chancellor have much to answer for. They drained him of his energy and although he seemed to recover his old vigour he no longer had the excited sense of urgency which carried him through the earlier years and made him so much fun to work with. To the end he could give sound advice on matters of scholarship and was interested in the work that I and his friends were doing. Moreover, his affection for Reading, which goes back to his boyhood and Reading's origins and kept him here all his working life, despite offers from other places which might have seemed to some men more attractive, was such that he never regretted abandoning so much to take his turn at the labours of its Vice-Chancellor.

DORIS M. STENTON

SIR IFOR WILLIAMS

J Russell & Sons

XV

SIR IFOR WILLIAMS

1881-1965

IFOR WILLIAMS was born at Pendinas, Tre-garth, near Bangor, Caernarvonshire, on 16 April 1881, the fourth of the six children of John Williams, a quarryman, and his wife Jane. His maternal grandfather, Hugh Derfel Hughes (1816–90), a farm labourer who came from Llandderfel, Merioneth, to work at the Penrhyn Slate Quarry, Bethesda, was a man of remarkable attainments:[1] at his best a considerable poet, he had a lively interest in antiquities, geology, and botany. On this side of the family there was a long tradition of literary activity. Hugh Derfel's uncle, Dafydd Hughes (1792–1862), was a fascinating character who found the transition from the eighteenth to the nineteenth century a somewhat unsettling experience. A country tailor, he forsook the merry company of his fellow poets at their *eisteddfodau* to take up the cause of religion and total abstinence. He constructed his own printing press in the 1840s.[2] A volume of poems by him, *Eos Ial* (1839), reveals a competent skill in handling the classical Welsh metres, and his undoubted gift as a writer of carols is seen in the *carol plygain* (a carol for Christmas morning) 'Ar gyfer heddiw'r bore / 'N faban bach'. Portions of Hugh Derfel's account of his father and himself (written when he was twenty-nine) have survived and parts of it were published by Ifor Williams. The grandson comments:

> He gives a simple description of the hard life of an ordinary countryman in that age—poverty, illness, suffering, the lack of all kinds of advantages—a bitter chronicle: and unconsciously he also makes plain both the virtue of the religion of the Methodists of the period to its possessor, and also the beginning of that delight in learning, literature and poetry which grew into an abundant crop throughout Wales. 'The old man' is here, and 'the new man' also.[3]

[1] Ifor Williams wrote the article on Hugh Derfel Hughes for the *Dictionary of Welsh Biography* (1959).

[2] For Hugh Derfel's description of his uncle, see *Y Tyddynnwr*, i (1923), 307–9. Bob Owen, 'Dafydd Hughes (Eos Ial)', *Transactions of the Honourable Society of Cymmrodorion*, 1940, 156–79, gives biographical details and an account of the works printed by Dafydd Hughes.

[3] *Y Traethodydd*, ci (1946), 174–83. For 'the old man' and 'the new man', see Ephesians 4: 22, 24.

Hugh Derfel, according to Ifor Williams, 'was a serious man: rarely did he smile. I never heard him make a remark in jest—being my grandfather had probably sobered him.' Of the other grandfather, who came from Anglesey, he wrote:

> He was neither a poet nor a writer nor an antiquarian. But he was at all times wonderfully fond of fun. He was a good one for telling a story. He and an old gamekeeper, known as Wil Cip, would exchange stories for hours. An entertaining, amusing old man, bubbling with innocent mischief, who delighted in teasing children.[1]

At Pendinas, which takes its name from the adjoining early Iron Age hill fort, the family was part of what was essentially a rural, closely knit Welsh-speaking community of quarrymen and small farmers, predominantly nonconformist in religion and radical in politics. It was a society which nurtured a profound respect for learning and strove amid hardship to secure the benefits of higher education for its children.

Ifor Williams received primary education in the church schools at Gelli, Tre-garth, and Llandygái: the instruction was entirely in English. His father died in 1893, aged forty-five. The following year Ifor Williams was awarded a scholarship at Friars School, Bangor. After four terms he had a serious accident which affected his spine. There followed six years of crippling illness during which he read everything that came to his hands—'from "Penny Dreadfuls" to Thomas Charles's biblical dictionary [*Geiriadur Ysgrythyrol* (1805)]'.[2] It was during these painful and often despondent years, he once remarked, that he learned the hardest lesson of his life—submission. By September 1901 he had recovered sufficiently to enter the school at Clynnog, Caernarvonshire, where candidates for the Calvinistic Methodist (Presbyterian) ministry were given grammar school education. There he passed the London University matriculation examination and won an open scholarship at the University College of North Wales, Bangor, where he began his studies in October 1902. He read for an Honours degree in Greek under W. Rhys Roberts and T. Hudson Williams, and was placed in the Second Class in 1905. He then proceeded to take the Honours examination in Welsh under John Morris-Jones and was placed in the First Class. During 1906–7 he was Scholar-Assistant to Morris-Jones and working for the degree of M.A. His subject for research was 'Y Gododdin', the series of poems attributed to the sixth-century Aneirin: it tells of the ineffective attempt, about

[1] *Meddwn i* (1946), 39. [2] *Y Cymro*, 4 Feb. 1965.

A.D. 600, by the war-band of Mynyddawg Mwynfawr from Manaw Gododdin to regain Catraeth from the Angles of Deira and Bernicia. This was a formidable task for a young graduate to undertake but it gave ample scope for the exercise of those qualities which made Ifor Williams a supreme scholar. He was awarded the degree of M.A. in 1907 and was appointed Assistant Lecturer in Welsh. In 1919 he was promoted to be Independent Lecturer; a Professorship of Welsh Literature was created for him in 1920 and on the death of Sir John Morris-Jones in 1929 he became Professor of Welsh Language and Literature and head of the department. He retired from his chair in 1947 with the title of Emeritus Professor.

The lack of adequate annotated editions of early and medieval Welsh texts was a serious problem for university teachers at the beginning of this century. For example, at Bangor, the members of the Honours class in 1905–6 had to copy the text of the *Black Book of Carmarthen* from the College library copy of W. F. Skene's *Four Ancient Books of Wales* (1868)—J. Gwenogvryn Evans's collotype facsimile had been published in 1888 but his 'diplomatic' transcript did not appear until 1907. Students had to bear this burden of transcribing texts of the early poetry from Skene's edition for many years. In Ifor Williams's words, they lacked 'the essential tools'. He therefore began to produce them. Since there was no complete and reliable dictionary of the Welsh language 'on historical principles', he started to compile that vast collection of lexicographical slips, based on wide and careful reading of manuscripts, printed texts, and documents, which became an indispensable instrument of his work for over half a century and was counted among the *mirabilia Britanniae* by his colleagues and pupils.

The next few years soon brought a rewarding harvest. First an edition of *Breuddwyd Maxen* in 1908: the introduction in Welsh and the grammatical notes in English. The 'Bangor Welsh Manuscripts Society' was founded in 1907. Volumes iii and iv were published as one volume in 1909 (each of the Society's volumes was limited to 200 copies privately printed): *Casgliad o waith Ieuan Deulwyn o wahanol ysgrifyfrau* by Ifor Williams. This was an edition of fifty-one poems by the fifteenth-century poet Ieuan Deulwyn, based on a collation of thirty-two manuscripts. It was Ifor Williams's first experience of preparing a critical text. The introduction and notes show his firm confidence when dealing with historical and genealogical material. In 1910 he brought out his edition of *Lludd a Llefelys* on

the same pattern as *Breuddwyd Maxen*, and contributed an introduction and additional notes to a short anthology of passages from the works of the court poets of the Welsh princes compiled by Arthur Hughes: *Gemau'r Gogynfeirdd*.

Towards the end of 1910 the efforts of the Welsh societies of the three University Colleges succeeded in establishing a quarterly journal, and in March 1911 the first number of *Y Beirniad* appeared, with John Morris-Jones as editor. Ifor Williams was among the original contributors with a series of five articles on 'Y Gododdin' in which he laid down the guidelines of the arguments which he sustained at greater length and with more detail in *Canu Aneirin* (1938).

As an undergraduate he had copied many of the poems of Dafydd ap Gwilym in the reprint of the 1789 edition prepared by Robert Ellis (Cynddelw) in 1873. He now turned to the life and works of this fourteenth-century poet, one of the greatest poets of the Middle Ages by any standards, and in February 1914, in a lecture to the Honourable Society of Cymmrodorion in London, he gave the substance of his discoveries. 'Dafydd ap Gwilym a'r Glêr' (*Transactions of the Honourable Society of Cymmrodorion*, 1913–14, 83–204) established new facts about the poet's family and connexions: these emerged from Ifor Williams's thorough and discerning analysis of documentary sources and of the poems themselves. It also examined the wider European context of Dafydd ap Gwilym's work: in medieval Latin verse and in the forms of the French courtly lyric. This major contribution has justly been assessed by later scholars as an *article remarquable*[1] which 'inaugurated a new era' in the study of the poet.[2]

Work among the great manuscript collections for his edition of Ieuan Deulwyn's poems had revealed to him the vast quantity of unpublished sources awaiting to be transcribed and edited for the use of students of Welsh literature. A group of enthusiastic young scholars was formed to bring out, with Ifor Williams as general editor, *Cyfres y Cywyddau*: a series of annotated editions of poems by the great masters of the *cywydd* form of Welsh verse. The first volume was published in 1914: *Cywyddau Dafydd ap Gwilym a'i gyfoeswyr*, edited by Ifor Williams and Thomas Roberts of Llanuwchllyn. The cost of the volume was undertaken by Ifor Williams from the meagre resources of

[1] Th. M. Chotzen, *Recherches sur la Poésie de Dafydd ab Gwilym* (1927), viii.
[2] Rachel Bromwich, *Transactions of the Honourable Society of Cymmrodorion*, 1964, 9; *Tradition and Innovation in the poetry of Dafydd ap Gwilym* (1967), 6.

an assistant lecturer's salary. He was responsible for the text of sixty-four *cywyddau* by Dafydd ap Gwilym, together with a lengthy introduction, using the material of his Cymmrodorion lecture, and notes. Dr. Thomas Parry describes Ifor Williams's edition as 'the first attempt to restore the text of Dafydd ap Gwilym's *cywyddau* according to the standards of modern scholarship' and he adds that it has been 'beyond value and has shown how to do justice to the poet'.[1]

The war of 1914–18 disrupted the *Cywyddau* series. Another collaborator, Thomas Roberts of Borth-y-gest, had been preparing an edition of the poems of Dafydd Nanmor (*c.* 1420–90). He died of wounds on 11 October 1918. His will was drawn up on the battlefield and he left his transcripts of Dafydd Nanmor's poems to Ifor Williams for use as he 'thought fit in the preparation of the *Cywyddau* series'. *The poetical works of Dafydd Nanmor* (1923), carefully revised by Ifor Williams, who performed this moving act of *pietas* with delicate care, is a noble testimony to the ideals and industry of this group of young scholars.

Plans for the *Cywyddau* series were resumed with *Cywyddau Iolo Goch ac eraill, 1350–1450* (1925), edited by Henry Lewis, Thomas Roberts (Llanuwchllyn), and Ifor Williams. The general editor took a conspicuous share of the work and his preface indicates how he and his colleagues approached their tasks:

For many reasons, the introductions are historical rather than literary. One must seek to establish the dates of a poet before beginning on a serious discussion of his literary connexions, and a fair judgement on his poetic inspiration cannot be given until his authentic verse is first established.

What came to be a standard pattern had taken shape. The editing of the works of the *cywyddwyr* was now taken up by other scholars, teachers, and pupils, and during the last half-century an extensive amount of medieval Welsh poetry has been edited according to the standards which Ifor Williams had adopted. His last contribution to this area of Welsh studies was an edition of the works of Guto'r Glyn, collected by John Llywelyn Williams: *Gwaith Guto'r Glyn* (1939).

The study of Dafydd ap Gwilym's family associations led to two important articles on the fourteenth-century bardic grammar or metrical treatise attributed to Einion Offeiriad: 'Dosbarth Einion Offeiriad', *Y Beirniad*, v (1915), 129–34, and 'Awdl i Rys ap Gruffudd gan Einion Offeiriad: Dosbarth

[1] *Gwaith Dafydd ap Gwilym* (1952), ix.

Einion ar ramadeg a'i ddyled i Donatus', *Y Cymmrodor*, xxvi (1916), 115-46. It was a great pleasure to him twenty-five years later to be able to identify Einion with *Eygnon Yfferat* who is named in Ministers' Accounts for Cardigan, 1352-3—*Bulletin of the Board of Celtic Studies*, x (1940), 242. His grasp of some fundamental problems in medieval Welsh metrics may be seen in a review in *Y Cymmrodor*, xlii (1931), especially 289-307.

One of the momentous consequences of the Report of the Royal Commission on the University of Wales (under Lord Haldane's chairmanship) in 1918 was the establishing of the Board of Celtic Studies which held its first meeting in January 1919. It was mainly as a result of Ifor Williams's importunate and, to some of his seniors, obstinate pleading that the Board's *Bulletin* was founded. He was appointed editor of the Language and Literature section, a position which he held until 1948 (from 1937 he was also general editor in succession to Sir John Edward Lloyd). His optimism and confidence were both justified and rewarded. Towards the end of his period as editor he remarked that he was prouder of the *Bulletin* and of the co-operation of Welsh scholars in maintaining it than of any other project with which he had been concerned.[1] Volume One, part one, came out in October 1921; more than half of the Language and Literature section consisted of lexicographical and textual notes by the editor; part three, November 1922, contained his discussion of 'Gwyllon, Geilt, Ŵyll' in which he drew attention to some of the similarities between the Myrddin Wyllt and Suibne Geilt legends. From 1921 until 1944 (intermittently afterwards until 1958 when they ceased) his eagerly awaited contributions were regular features of each volume. It was in the *Bulletin* that he published the results of some of his most important researches. His lexical and semantic notes, textual analyses, examination of questions in Welsh literature and history, together with many annotated transcripts of unpublished material, reveal the phenomenal span of his scholarship and his wide-ranging mind. They also disclose the developing pattern of his major activities from 1920 onwards.

The preface to *Breuddwyd Maxen* in 1908 announced his intention to publish similar editions of each of the Four Branches of the *Mabinogi*. This was fulfilled in 1930 with *Pedeir Keinc y Mabinogi*. Here he established the meanings of *mabinogi* ('boyhood', 'a story about boyhood', then simply 'story'), examined the orthographical and linguistic problems with masterly detail,

[1] *Y Cymro*, 17 Oct. 1947.

and argued convincingly that the Four Branches were brought together about the year 1060. Further, he perceived a point of vital significance for its bearing upon his later study of the poetry associated with Llywarch Hen: the verse passages (*englynion*) in the text belonged to a more primitive stage in the development of the story and, because of their metrical structure, they had generally preserved their archaic forms despite the many changes in the prose narrative. In 1930 (*Bulletin*, v. 115–29) he also published a text of 'Trystan ac Esyllt' from manuscripts of a late date (1550 onwards). The interest of this text was similar, for he showed that although the prose links are obviously late and confused the *englynion* derive from a much earlier period and seem to have been part of a long 'Arthurian' tale in prose and verse.

He then brought his whole attention to bear on the complex series of *englynion* which had been ascribed to Llywarch Hen. The preliminary results of his investigation were announced during a course of public lectures at Bangor early in 1932 and were later expanded in his Sir John Rhŷs Memorial Lecture to the British Academy (read on 1 February 1933). His thesis was that the *englynion* were not composed by the sixth-century Llywarch Hen—one of the 'Men of the North'—but that they

are the verse elements in a cycle of stories, tales, sagas, told in pre-Norman times in north-east Wales, in the eastern part of Powys bordering on England, opposite to, and perhaps including portions of Shropshire and Herefordshire. The prose setting has disappeared: the verse has survived in twelfth-century and fourteenth-century manuscripts, a few stanzas even in eighteenth-century copies of earlier manuscripts now lost.

From these verse fragments he shaped the substance and context of two sagas composed in the middle of the ninth century concerning Llywarch Hen and Heledd. *Canu Llywarch Hen* (1935) gives a critical edition of these texts with detailed notes. The introduction again shows the precision with which Ifor Williams handled historical and genealogical evidence; it also gives a clear outline of the development of early Welsh saga and a sensitive analysis of the metrical techniques. Twenty years later he traced the development of the saga which, from about the ninth century, had grown out of the legendary traditions about Taliesin: *Chwedl Taliesin* (1957).

At the end of his British Academy Lecture in 1933 he observed that

Aneirin and Taliesin remain, and we still have before us the hard task of establishing, or disproving, the authenticity of the Urien and Gododdin poems.

The 'hard task' was to answer the question 'How old is Welsh poetry?' In his early work on 'Y Gododdin' he had recognized that about one-fifth of the stanzas written in a second hand in the thirteenth-century manuscript retained orthographical features identical with those of the Old Welsh glosses and therefore pointed towards an exemplar dating from probably the ninth century. Subsequently, as a preliminary to a deeper investigation of the problem he began a close study of all the Old Welsh written sources. The results were published in a number of illuminating articles in the *Bulletin*: 'The *Computus* Fragment'—Cambridge University Library MS. Add. 4543 (B iii, 245–72); 'Glosau Rhydychen'—the Old Welsh glosses in Bodley MS. Auct. F. 4. 32 and Bodley MS. 572 (B v, 1–8); 'Glosau Rhydychen: Mesurau a Phwysau'—Old Welsh glosses on the section *Incipiunt pauca excerpta de mensuris calculi*, Bodley MS. Auct. F. 4. 32, fol. 23 (B v, 226–48); the 'Juvencus' *englynion* and glosses in Cambridge University Library MS. Ff. 4. 42 (B vi, 101–10, 115–18, 205–24); 'An Old Welsh verse', in C.C.C. Cambr. MS. 199 (*National Library of Wales Journal*, ii. 69–75). Closely connected were the study (uncompleted) of the *Vocabularium Cornicum* in BM. Cotton. Vesp. A xxiv—the Old Cornish version of a Latin–Old English glossary compiled by Ælfric (B xi, 1–12, 92–100) and the notes on twenty-seven ninth-century Old Breton glosses in Venice Marciana MS. Zanetti Lat. 349—Orosius, *Historia adversus Paganos*—and three in Gotha Landesbibliothek M Br. I. 147—Isidore, *Etymologiae* (*Zeitschrift für celtische Philologie*, xxi. 291–306).

By these investigations he both solved many crucial linguistic problems and defined the criteria for dating Old Welsh. He had a remarkable ability to elucidate the complexities of computistic tables and this is nicely demonstrated in his analysis of the *Computus* fragment, the Oxford glosses on *de mensuris calculi* and the Nennian 'cycle' (B vii, 383–7).

Another group of articles threw light on the crucial significance for the problem of the authenticity of Aneirin and Taliesin of various poems which, although preserved in late manuscripts, unquestionably belong to a much earlier period. The outstanding examples are 'Moliant Cadwallon', in honour of Cadwallon, king of Gwynedd, who died near Hexham in 634, which survives in an eighteenth-century manuscript but shows evidence of written transmission from at least the twelfth century and possibly dates from the seventh century (B vii, 23–26, 29–32); and 'Marwnad Cynddylan', an elegy on Cynddylan, ruler of

Powys in the seventh century and brother of Heledd (B vi, 134-41).

He realized that the evidence of the inscriptions on the early Christian monuments of Wales and the forms recorded in British–Latin sources had to be reassessed. Of his many contributions to the study of the epigraphic material special mention must be made of the account of the Trescawen stone and the examination of 'the personal names in the early inscriptions of Anglesey'—both published in the Royal Commission's *Inventory of the Ancient Monuments in Anglesey* (1937), cix–cxvii—and also of his Presidential Address to the Cambrian Archaeological Association on the Towyn inscribed stone—'in all probability, the words carved on [it] are the earliest examples *on stone* of the Welsh language', *Archaeologia Cambrensis*, c. 161–72. He used the personal names in the inscriptions as 'test-material for the study of the development of Welsh from Brythonic or British, the language of the ancient Britons'. His answer to the question 'When did British become Welsh?' was given in a lecture to the Cambrian Archaeological Association at Bangor in 1937, later published in the *Transactions of the Anglesey Antiquarian Society*, 1939, 27–39:

> British became Welsh when the unaccented medial syllables, and the unaccented terminations were dropped; the medial consonants during this process underwent regular changes or mutations....Both the dropping of the unaccented vowels and the various mutations of consonants were gradual processes, and several centuries passed away before the orthography was adapted to the changed pronunciation. When, however, these changes had taken place in the living speech, British may be said to have become Welsh.

These changes had occurred by the middle of the sixth century.

The full maturity of Ifor Williams's scholarship, the massive strength of his learning, and the stimulating yet disciplined vigour of his ideas are all to be found in *Canu Aneirin* (1938). Accepting the eighth-century testimony of Nennius that Aneirin and Taliesin composed poetry at the end of the sixth century, two questions had to be faced and answered 'in cold blood' (as he put it): 'what certainty is there that a single line of Aneirin's work has survived from the sixth century to the thirteenth?', and had 'Brittonic become Welsh long before Aneirin's day, because no one could compose so skilfully in a newly-born language'? The evidence for a ninth-century written version was clear; the methods for dating Old Welsh

sources were now more precise. Obvious extraneous accretions had to be eliminated—for example, a poem on the death of Domnall Brecc, king of Dál Riada, who was killed in 642; a song to a young child (it was Ifor Williams's perceptive eye which recognized this gem); a floating fragment from the Llywarch Hen saga; anachronistic references to Aneirin. There were also later extensions to the poem. The next step was to establish a context and date for the military event at Catraeth which provided the occasion for composing a series of elegiac stanzas to celebrate the heroism of a number of warriors from north Britain—and probably from other British kingdoms.

The historical evidence was sifted with judicious thoroughness. Place-name identifications were submitted to linguistic tests—for example, the identification of Catraeth with the neighbourhood of Catterick Bridge in Yorkshire. He argued convincingly that the battle of Catraeth was fought some time between 590 and 617—that is, before Edwin became king of Northumbria. He analysed the military vocabulary and the terms which indicate the religious and social nexus of the poems. The ultimate question, however, was 'how old is the verse?' The linguistic and metrical data were patiently assessed in a way which shows Ifor Williams's brilliant co-ordination of linguistic techniques and his penetrating discernment of earlier patterns. His analysis of the alliterative structure is an excellent example of this. The linguistic evidence pointed to a stage shortly after the changes by which British had become Welsh, and it was now possible to show that substantial sections of the 'Gododdin' could have been composed by Aneirin. Beneath the layers caused by confusion and corruption during oral and written transmission—so Ifor Williams firmly believed—'the substance is here'. On historical and linguistic grounds, circumstantial though much of the evidence must be, his conclusion, based on a cool evaluation of all the relevant evidence, a unique knowledge of the language in all its stages, and an unprecedented understanding of the nature of the problem, was that 'we can now with considerable degrees of confidence begin to believe that the body of the poem is the authentic work of Aneirin Gwawdrydd, Mechteyrn Beirdd ("Aneirin of the Flowing Verse, High King of the Bards")'.[1] There can be no fundamental disagreement with this conclusion. In the lengthy notes to the

[1] For a précis of the introduction to *Canu Aneirin* see Colin A. Gresham, *Antiquity*, xvi (1942), 237-57. Kenneth Jackson discusses the work in a review article, ibid. xiii (1939), 25-32.

text he deploys the entire force of his knowledge of the language, and the vast resources of his lexical collection are used to the full. Here, as in his 'lexicographical notes' in the *Bulletin* and in the notes to *Pedeir Keinc y Mabinogi* and *Canu Llywarch Hen*, he considers every form known to him of a particular word, examines its range of meanings and its various cognates, weighs the evidence and proposes an answer—or a choice of answers. Thus did he solve most of the extremely difficult linguistic problems in the text and also provide material and suggestions for other scholars. *Canu Aneirin* has become the constant and inspiring companion of every student of early Welsh poetry.

Peniarth MS. 2—'The Book of Taliesin'—written in the late thirteenth or early fourteenth century is, in Ifor Williams's words, 'a pretty mixed bag'. In 1916 (*Y Beirniad*, vi. 129–37, 203–14) he had reviewed at length J. Gwenogvryn Evans's *Facsimile and Text* of the manuscript and his *Poems from the Book of Taliesin*. The latter was certainly a mixed bag, and Evans's misguided, carefree excursions into the territory of linguistic and historical criticism prompted John Morris-Jones (not altogether without Ifor Williams's ready assistance) to write a magisterial review which appeared as volume xxviii of *Y Cymmrodor* (1918). This book-length review of 290 pages, which dealt with the basic problems, had far-reaching influence on the study of the early poetry. But there was still much to be done with the 'Taliesin' collection. Over the years Ifor Williams sorted its contents, both in matter and chronology, discussed fifty of the fifty-seven poems, and, as usual, made many discoveries. He published detailed studies of some individual poems which, though old, were not by Taliesin. 'Moliant Dinbych Penfro' is a poem composed *circa* 875 in praise of Tenby (*Transactions of the Honourable Society of Cymmrodorion*, 1940, 66–83). Again, 'an early Anglesey poem' was shown to be a tenth-century elegy on Aeddon, an Anglesey chieftain (*Transactions of the Anglesey Antiquarian Society*, 1941, 23–30; 1941, 19). In *Armes Prydein* (1955) he established that this long poem of political 'prophecy' and propaganda was composed *circa* 900 during Athelstan's reign—certainly before the Battle of Brunanburh. His reconstruction of the 'Taliesin legend' has already been mentioned. What, then, of the poems by the sixth-century Taliesin? The outcome of Ifor Williams's thorough inquiries was a firm assurance that the 'hard core' of Taliesin's poetry is preserved in twelve historical poems to sixth-century British rulers: one to Cynan of Powys, whose son Selyf was killed at the Battle of Chester; two to Gwallawg, ruler of Elmet;

the others to Urien Rheged and his son Owain in north Britain. An edition of these twelve poems, *Canu Taliesin*, appeared in 1960, shortly before the editor's seventy-ninth birthday. His scholarly treatment of the poems and their background was as masterly as ever and the notes as usual were full of information and fresh ideas. At one stage he had planned two 'large' books on Taliesin; unfortunately he was unable to achieve this and his full-scale edition of 'Chwedl Taliesin' was never finished.

He revealed fresh perspectives in the study of early Welsh tales and legends. 'Hen Chwedlau' (*Transactions of the Honourable Society of Cymmrodorion*, 1946–7, 28–58) gives a general summary of his thoughts on the methods of the professional story-tellers (*cyfarwyddiaid*) and illustrates how Nennius's account of Vortigern is derived partly from popular oral tradition and partly from a lost *Vita Germani*. And almost everywhere in the fields of medieval and modern Welsh literary studies he either opened or indicated new paths of investigation. In articles, transcripts, and books his range extended from an edition of Welsh versions of twenty-one fables by Odo of Cheriton—*Chwedlau Odo* (1926)—to the writings of William Salesbury and his contemporaries.

He made many contributions to place-name studies and enjoyed solving onomastic problems. In September 1942, however, when he was feeling the strain of war almost intolerable, he wrote:

> I spent three weeks of hard unbroken labour on the Ravennas for Crawford. I had had his slips for years and had done one-third of them. An appeal came for the lot to be returned. I therefore applied myself to doing them and became completely lost in the task. There was no time to accomplish any feats, but I did my best. I was completely exhausted by today when I finished the last slip, and packed the lot for the post.

His comments on the individual names, 'often amounting to a wholly new contribution', were incorporated into 'The British Section of the Ravenna Cosmography' by I. A. Richmond and O. G. S. Crawford, *Archaeologia*, xciii (1949,) 21–50. *Enwau Lleoedd* (1945) brings together within its sixty packed pages a wealth of place-name learning presented with the author's rare gift for lucid exposition.

It was natural, perhaps, for a grandson of the author of *Hynafiaethau Llandegai a Llanllechid* (1866)—a description of the antiquities of those two parishes—to take a keen interest in archaeology. At Pendinas, too, he had lived on the threshold of prehistory. But Ifor Williams found for himself that archaeology,

history, and philology must be used together for a real understanding of the early periods. Shortly before 1914 he was enthusiastically excavating some round huts at Cororion, not far from Pendinas. The results were never published but the note 'information from excavator' appended to the report on these huts in the Royal Commission's Caernarvonshire *Inventory*, i (1956), 107-8, No. (346), indicates that he had not forgotten what he had been doing over forty years earlier. He always found pleasure in conducting groups of undergraduates to such sites as Tre'rceiri and Din Lligwy: for one with his experience of hill-walking along the Ogwen Valley and around Tre-garth climbing up the craggy slopes of Tre'rceiri was easy. To watch the careful probings of his fingers on an inscribed stone was like seeing a detective examining a vital piece of evidence. For many years he was Honorary Curator of the Museum of Welsh Antiquities at the University College of North Wales, and with R. Humphrey Davies he kept jealous guard over its contents.

'You cannot fully understand the spoken Welsh of Anglesey today', he remarked in 1938, 'without going back to Antiquity.'[1] This was an expression of his deep and lively awareness of the unbroken continuity of the language and its literature. He had, of course, a perfect knowledge and control of the spoken language: it was his mother tongue. In his linguistic notes on early and medieval texts he often illustrates a point by quoting words and phrases drawn from the speech of his own community at Tregarth or from that of some other region. This interest in *llafar gwlad* was long-standing. At the Caernarvon National Eisteddfod in 1906 he was awarded a prize for an essay on the spoken Welsh of Caernarvonshire. Throughout his life he collected, recorded, explained, and cherished innumerable examples of the spoken language's resourceful resilience. The simple dignity of his spoken Welsh was a delight to the ear and it did not suffer when transposed to the printed page. A translation from Norwegian of Ibsen's *A Doll's House—Ty Dol* (1926)—brought the freshness and suppleness of speech rhythms to stage dialogue. *Cymraeg Byw* (1960), the B.B.C. Welsh Lecture delivered on St. David's Day (1960) gives the essence of his reflections and ideas on the opportunities and problems which challenge the Welsh language in the contemporary world. Almost to the end of his days he was actively at work finding or creating 'natural' Welsh equivalents for modern technical terms.

Ifor Williams believed that he had a duty to share the fruits

[1] *Transactions of the Honourable Society of Cymmrodorion*, 1938, 52.

of his scholarship with those who had not received higher education and to remove any *medium parietem maceriae* which might be set up between the academic world and those outside it. Admiration of Hugh Derfel's efforts to educate himself, his own mother's struggle to give four of her six children a college education, and the enlightened zeal for learning among the quarrymen in whose society he lived until his marriage in 1913 —all these were powerful influences. Moreover, he firmly believed that Providence had entrusted every person with a special gift—*dawn arbennig*: this was 'something to be grateful for, and a burden of responsibility'.[1] This deep awareness of duty and responsibility can be quickly sensed in his writings. It was also the primary reason why he travelled far and wide to lecture to literary societies, both large and small.

In 1922 he joined with Robert Richards in editing a new journal, *Y Tyddynnwr*. Its aim was to explain 'in Welsh to the workers of Wales' important matters in philosophy, economics, history, and science, subjects which, unlike theology, had not yet come to be familiarly treated in Welsh. Only four numbers were published.

He was one of the editors of *Geiriadur Beiblaidd*, a dictionary of the Bible which came out in fifteen parts during 1924–5. In 1939 he became one of the three editors of *Y Traethodydd*, a quarterly started in 1845 'for religion, theology, philosophy and literature'. He served for twenty-five years—until 1964— and wrote regularly for it until 1958. For many years he was chairman of the Executive Committee responsible for the publications of the Calvinistic Methodist (Presbyterian) Church of Wales. When he went to the Preparatory School at Clynnog in 1901 his intention was to enter the ministry of this church. Until the early 1930s he frequently undertook preaching engagements and his name appeared on the presbytery's list of 'recognized preachers' up to his death. His sermons and addresses were models of simple and memorable exegesis based on a solid foundation of biblical scholarship. Theology never lost its hold on him nor was he ever in doubt about the certainty of his faith.

In the pulpit, on a public platform, or when sitting among his Final Honours class (who were invariably among the first to share with him the excitement of his discoveries) his manner was completely relaxed and unassuming. His conversational style (he disliked the 'prepared lecture'), the constant touches

[1] *I ddifyrru'r amser* (1959), 66—from a talk given in 1948.

of gentle humour, and the charm of his speech were irresistibly effective. He had inherited his Anglesey grandfather's gift for 'telling a story' and his lectures, in College and outside, had a quality of their own. As a broadcaster he was outstandingly successful. Many of his talks have been published, together with other essays: they all bear witness to his distinction as a writer.[1]

Soon after his appointment as Assistant Lecturer at Bangor he sought and obtained Morris-Jones's permission to give his lectures in Welsh—English was the common medium of instruction in all the departments of Welsh in the University then and for a considerable time after. There were many difficulties, some of them inherent in the social attitudes of those years. Not the least of them, however, was the lack of established grammatical terms in Welsh: the notes to *Breuddwyd Maxen* and *Lludd a Llefelys* express the dilemma. But Ifor Williams was not easily discouraged once he had made a decision and the difficulties were overcome, with the result that—in his own words— 'Welsh gradually became a medium of learning, as is right and proper'.[2] His conviction that it was 'right and proper' was the reason why almost all his scholarly writing was in Welsh. He remained unmoved by the appeals of critics and admirers that he should make his fundamentally important works more accessible to a wider circle of the academic world by writing in English. 'The Poems of Llywarch Hên', the Dublin *Lectures on Early Welsh Poetry* (1944), and a short article on 'The earliest poetry', *Welsh Review* vi (1947), 238–43, give excellent outlines of some of his researches and conclusions. They also prove that he was as lucid and attractive a writer in English as in Welsh.

There were many strands in the strong fibre of his character. Perseverance and patience, self-discipline, tempered by the affliction of his youth, and an assured sense of vocation—all these could easily be discerned. The spinal injury had left its mark and it took many years for him not to be painfully sensitive of its physical effect, especially when he had to appear before a strange audience. Yet he could never be an academic recluse. His enthusiasm was contagious, whether he was giving an account of his latest pursuit in scholarship or describing his exertions as a gardener. It was exhilarating to be taught by him and to feel the virtue of his sheer delight in learning. His energy was boundless, and his powers of recovery were

[1] *Meddwn i* (1946); *I ddifyrru'r amser* (1959).
[2] *Y Cymro*, 17 Oct. 1947.

astonishing. The stubby pencil in the waistcoat pocket and the small notebook—or an old envelope or any scrap of paper—were always at hand to jot down questions or facts or ideas that came to him when travelling or during the restless hours of the night. 'The fun is in discovering', he once said. 'There is no pleasure in writing it.' However, when the demand was pressing, as it often was, he would write as one inspired. *Canu Aneirin* appeared in the early summer of 1938. The preface is dated 13 April 1938. Yet, on 17 November 1937 he wrote:

As for myself—labouring tirelessly on the *Gododdin*—when I have an opportunity. Page proof—up to p. 150; galleys up to l. 1000. Not a word of the Introduction written so far—too many other calls. But I must get down to it in spite of everything.

When the book appeared a few months later, there were 93 pages of introduction, 57 pages of text, 329 pages of notes and 23 pages of indices. During 1943–4, not long after delivering his lectures on early Welsh poetry at the Dublin Institute for Advanced Studies in March 1943, he suffered from severe exhaustion. In April 1944 he described the previous nine months as 'an empty period'; this was 'the miserable state of I. W. with the whole Taliesin in front of him'. Nevertheless, he managed to prepare the Dublin lectures for the press. By May 1945: 'the war in Europe has come to an end, and we are in the middle of the "aftermath"—and prospects of confusion for yet awhile, I'm afraid.' He had again been 'for months without being able to sit at the table to write a word', but

I am now getting better: in January I scribbled a book for *Pobun* on *Enwau Lleoedd*.... In February I sent a dozen of my B.B.C. talks [to the publisher]. Then in March I put into shape a little book on *Armes Prydain* for the University Press. That is beginning to be printed at Cardiff—though I have not yet had grace to shape an introduction. I have a good deal to say.

He had retired from his chair in 1947 and at the end of 1948 he was again in good spirits although he had not 'yet got down to my work in the study',

but the kettle is beginning to sing. A sign: I read the Gogynfeirdd right through once again. Then to my draft of the Taliesin—and I broke my heart. I had completely forgotten my own attempts! But things will gradually come back to the memory. There is an enormous task in front of me.

He now became advisory editor for the University of Wales *Dictionary of the Welsh Language* (he had been a member of the

editorial board from the start) and he continued to advise and contribute almost to the end.

The inspiration, encouragement, and support of his wife was beyond measure. His marriage in 1913 to Myfanwy Jones of Cae Glas, Pontlyfni, Clynnog, brought him all the happiness and succour he could have wished for. At Y Wenllys, Menai Bridge, and at Hafod Lwyd, Pontlyfni, she created a safe refuge to which he could return to work undisturbed, and a home where they and their two children, Gwenno and Gwynn, always gave a warm welcome to a large and devoted circle of friends and pupils.

No account or examination of Ifor Williams's monumental achievement would be complete without calling to mind part of a *confessio fidei* which he once made:

> To work prudently one must plan beforehand. Nevertheless, on the foundation stone of every scheme it is well to inscribe a portion of St. James 4[15] ['If the Lord will, we shall live, and do this, or that']. Afterwards, let the craftsman proceed gladly, confidently and hopefully to construct the building... Faith is that force in a man's soul which can turn a dream into a programme—and realize it.[1]

He had certainly planned carefully and he lived to see the greater part of his programme realized, although he used to say that he would like 'to re-edit all [his books] since fresh light is constantly breaking upon us as we struggle forward'.

He had a magnificent head on a broad-set body—but for his early accident he might have attained the fullness of stature of Hugh Derfel and the Pendinas men; as it happened he was like his Anglesey grandfather, 'short and broad'. His eyes were kind and sympathetic with a shrewdness that often laid bare the innermost heart.

By temperament and inclination he was reluctant to accept official responsibilities but he took on a large number as opportunities of dutiful service. His achievement and contribution both to scholarship and to Welsh life were widely and gratefully recognized, and he received many honours. From 1941 to 1958 he was Chairman of the Board of Celtic Studies, University of Wales. In 1932 he was Sir John Rhŷs Memorial Lecturer at the British Academy, and in 1933 became D.Litt. (Wales). In 1938 he was awarded the Cymmrodorion Medal 'for distinguished services to Wales' and elected a Fellow of the British Academy. He was made a Fellow of the Society of

[1] *I ddifyrru'r amser*, 54.

Antiquaries in 1939. In 1943 he was appointed a member of the Royal Commission on Ancient Monuments in Wales and Monmouthshire (he resigned in 1963) and of the Board of Ancient Monuments for Wales—later becoming Chairman of the Board. From 1939 to 1954 he was President of the Anglesey Antiquarian Society, Patron from 1954 to 1957, and Vice-President from 1957 until his death. He was knighted in 1947. In 1949 he was elected President of the Cambrian Archaeological Association and in the same year he received the degree of LL.D. *honoris causa* from the University of Wales. He was Gregynog Lecturer at the University College of Wales, Aberystwyth, in April 1950, and O'Donnell Lecturer in the University of Wales during 1955–6. He also served on the Court of Governors of the National Library of Wales and of the National Museum of Wales.

In the last years of his life failing eyesight troubled him and his energies were gradually diminishing. He died on 4 November 1965, less than a year after the death of Lady Williams. His unique contribution and unceasing devotion to scholarship will always be acknowledged with humble gratitude by all students of Welsh language and literature and will be a source of inspiration for many generations.

<div style="text-align: right">I. Ll. FOSTER</div>

[The quotations from Sir Ifor's writings (except those on pp. 367 and 369) are in each case translated from the original in Welsh; the quotations from his correspondence are translated from his personal letters to the writer.

No complete bibliography of his writings has so far been published but it is understood that one is being prepared. Thomas Parry, *Mynegai i weithiau Ifor Williams* (1939), gives a most useful index to the linguistic notes published by Ifor Williams in books and articles up to June 1938. Thomas Jones's valuable study in *Gwŷr Llên* (1948), 243–67, gives an excellent account of the man and scholar. Ifor Williams wrote a short account of his career in *Y Cymro*, 17 October 1947. Reminiscences and appreciations by friends and former pupils were published in *Y Traethodydd*, cxx (1965), 2–4; cxxi (1966), 49–70; *Y Genhinen*, xvi (1965–6), 9–13; *Y Dyfodol*, 10 December 1965.]

ROBIN FLOWER

XVI

ROBIN ERNEST WILLIAM FLOWER

1881–1946

ROBIN ERNEST WILLIAM FLOWER was born at Meanwood, Yorkshire, on 16 October 1881. On both sides he came of mixed Anglo-Irish parentage. The Flowers were originally English settlers in Northern Ireland, but Flower's immediate forebears had lived in England (Yorkshire). His mother, Jane Lynch, came of an old Galway family, but she was living at Meanwood Hill Top, Leeds, when she met her future husband, Marmaduke Flower, and her mother was a Yorkshire woman. Marmaduke Clement William Flower, Robin's father, was the son of the Rev. William Balmbro' Flower, a well-known writer and a learned patristic scholar, the translator into English of the *Sermons* of St. Bernard of Clairvaux, works of St. Cyprian, Theophilus, Bishop of Antioch, and Thomas á Kempis. He also made some translations from the German. Besides these learned works he published several original tales and a volume of *Classical Tales and Legends*; and he was the editor of *The Churchman's Companion*. He was the son of Marmaduke Flower of Leeds, and was educated at Leeds Grammar School, which he entered on 29 July 1833 at the age of thirteen. He was at one time classical master of Christ's Hospital, and also held a chaplaincy at Baden Baden. Eventually, in April 1868, he was appointed by the Duke of Buckingham and Chandos Colonial Chaplain at Labuan at a salary of £350, and he left England on 16 May from Southampton. He occupied this position, however, but a very short time: on 29 July 1868 a letter was sent from Government House, Labuan, to inform his wife of his death, the result of an accident while mounting his horse. The writer, who speaks highly of his character, states that he was at the time 'engaged in further translations of St. Bernard'.

Scholarly traditions were thus part of Robin Flower's inheritance, but it was no doubt from his grandfather rather than his father that he derived his bent for learning, though some of his aesthetic equipment may have come to him from the latter. Marmaduke Flower had a varied and extraordinary career, as far removed from the scholar's life as one can well conceive. 'Educated', according to the *Gentleman's Journal* of 15 March 1898, 'at Heidelberg, under the famous Dr. Guspie, finishing

later on at St. Andrew's College, Chardstock, Dorset', he ran away from the latter establishment (as the *Gentleman's Journal* does *not* inform its readers), went to sea, and was at various times a soldier in the American Civil War (in which he fought on the Confederate side), a sailor, a midshipman, and a gold-digger in Australia. His career in the army of the South ended with his desertion, when he and a companion jumped from a troop-train into a river. According to Robin's school-friend, the Rev. Dr. J. A. Findlay, to whom I am much indebted for information about Flower's early life and ancestry, 'one of the Hamiltons— I am not sure whether it was Lord Claud or his brother—used to hold him down forcibly under water at school, and he had perforce to learn how to breathe [? hold his breath] under water'. This accomplishment now stood him in good stead: whereas his companion had to come to the surface and was shot, he managed to stay underneath long enough to make his escape, tramped through the States to New York, and eventually reached Canada. He was in the Navy when he received news of his father's sudden death. Making his way to Leeds, where he gathered that his relatives were living, he slept the first night in a barn on the outskirts of the city, and was there arrested by the police and taken to jail. He was recognized next morning by one of the magistrates as a relative of the Vicar of Leeds, and was set free, though his family disowned him. At this point, already a man of some maturity, he suddenly decided to become a landscape-painter, and about the same time married his landlady's daughter. It was not long before a picture by him of the Seven Arches in Meanwood Woods was hung on the line at the Royal Academy. He acquired a considerable reputation as a landscape-painter, but Sir Hubert Herkomer, under whom he began to study in October 1886, advised him to take up portraiture. In an interesting letter, dated 27 July 1889, Herkomer counsels him to avoid photography and gives some sensible advice, very profitable to an artist in the early stages of his career. The instruction fell on fruitful soil and Marmaduke Flower was before long the leading portrait-painter in Leeds. Nor was his well-deserved reputation merely local. A letter from Bishop Mitchinson, Master of Pembroke College, Oxford, testifies to the excellence of a portrait of himself which Flower had painted, as also one of his predecessor, Dr. Price.[1] He seems in fact to

[1] The two portraits mentioned above and another still hang in the College; see Mrs. R. Lane Poole's *Catalogue of Portraits in . . . Oxford*, vol. iii, pp. 252, 254.

have been highly esteemed by the College authorities, and it was mainly his father's connexion with Pembroke which led Robin to try for a scholarship there.

Marmaduke Flower had not very long been a pupil of Herkomer when the latter chose him to be assistant in his school at Bushey. There he made himself invaluable. In a letter of condolence to his widow after his death Herkomer writes of him, on 1 October 1910, as 'my most loyal student, one who *never* failed me, who helped more than all the others to uphold the right tone in my colony of students'.

Thus we have some of the ingredients which went to make up Flower's temperament and mental outfit: a home near the Yorkshire moorlands and a strain of Yorkshire blood, with all which that means of grit and sturdy independence, an Irish ancestry working in him to inspire the nostalgic patriotism which in the exile of mixed origin is often more potent than in the native-born, a tradition of scholarship derived from his grandfather, and a mixture of adventurous adaptability and sensitiveness to beauty which he had from his father. With such antecedents it is easy to understand the direction which his genius took.

Flower's grandfather had, as already said, been a pupil of Leeds Grammar School, and it was in any case natural enough that Robin, living as he did at Headingley, should be sent there. He entered the school in the third term of the year 1894 at the age of twelve. His school-friend, Dr. Findlay, gives a vivid picture of him as a schoolboy.

> We had [he says] to cross Woodhouse Moor on our mile's walk—or rather run—to morning school. I was always in danger of being late, but could not help noticing that there was another boy toiling along behind. He was a noticeable object, because he appeared to be trying to read and run at the same time. His pockets always bulged with cheap magazines, mostly of the 'Halfpenny Marvel' and 'Pluck' type. After a while, we took to running together, and in this way a close friendship was begun which lasted for five years. Neither of us was much interested in playing games, and the consequence was that we were to some extent separated from the general life of the school. . . . During the five years between our first meeting and the time when I left school, we were never apart. Even when he got a bicycle, he would push it by my side; when he did ride it, he became known to all the policemen on the route for his habit of trying to read and steer his way through the traffic at the same time. When a very pious lady staying at my home kept getting us into corners and enquiring about the condition of our souls, in desperation we entered into a solemn compact that we would never be good, signing the deed in our own

blood; he charged me in after years with having broken my plighted word, while he had remained faithful to the letter of the bond. At that time he would read anything in print, but I watched him rise from 'Pluck' to 'Chums'—the 'Boys' Own Paper' we regarded as too edifying for our tastes—on to Swinburne, Shelley, and Keats. Several times his pockets were searched by irate masters, and their contents confiscated, while the class gazed in wonder at the quantity of reading matter which could be extracted from them. Alternate evenings we would spend in each other's habitations, and each would see the other home, the process of going to and fro often lasting until we were in danger of being locked out. We went walking-tours together in the Yorkshire dales, and on one occasion for some reason or another we had arranged to go to our starting-point separately. I went, as arranged, to Pateley Bridge in Nidderdale—a railway journey of about 30 miles—only to find no Robin there. I returned home to find he had gone to Apperley Bridge in Airedale by mistake!

Flower's friends will see from this description that in his case the child was indeed father to the man—even in the matter of the mistake over his appointment at Pateley Bridge. And more than one of them will be inclined to say 'ditto' to Dr. Findlay's concluding words: 'Certainly my friendship with Robin Flower made all the difference to my school life; I think it is true to say that, during those years, we had no secrets from one another, and it is quite impossible to put into words what he was to me.'

Flower was at first on the modern side of the school, from which he transferred later to the classical. He won while at school a number of prizes; those for history and literature were much in his way of business, but friends acquainted with his views in later life may be amused to learn that the Hook Theological prize was also awarded to him. He was for a time Honorary Secretary to the Literary and Debating Society, and he appears to have contributed to the school magazine; for example, a very Tennysonian (and, for a schoolboy, remarkably good) poem on 'The Death of Theocritus', which contains several lines characteristic of his style in his earlier poems, can hardly be by any other hand than his. His progress after his transfer to the classical side was so rapid that in little over two years from his first beginning Greek and more advanced Latin he won, in 1899, an open classical scholarship at Pembroke. He had previously passed the Higher Certificate examination with distinction in Latin and had been awarded the school exhibition.

He went up to Oxford in 1900, just before his nineteenth birthday. He seems thoroughly to have enjoyed his life there,

and one can imagine that his reading was discursive and miscellaneous; but, even if we allow for his power of rapid assimilation and his amazingly retentive memory, he can hardly have won a good first in Classical Moderations (in 1902) without working hard at the prescribed subjects of study. A letter to his mother, which bears no date but was obviously written early in the summer term following the examination, and which I quote without altering its characteristic punctuation, or lack of it, gives an amusing account of his reception by the College authorities:

I am feeling quite cheerful again under the influence of spring Oxford. The weather is simply divine absolutely redolent of punts and straw hats and tennis and all else the heart of man can set his desire upon. I met the Master as I went to chapel this morning. He greeted me affectionately 'It is a case of "see the conquering hero comes"' he said 'I congratulate you with all my heart Mr. Flower. Not that we did not expect it, but it was none the less pleasant for that.' He seemed ready to weep on my neck. The Dean congratulated me after chapel.... My interview with Benjy was rather curious. [In this affectionate diminutive Oxford men of the period will recognize a very 'fruity' scholar of the old school, to whose lectures on Virgil the present writer for one looks back with gratitude as an ineffaceable experience.] He received me joyously. 'I was very pleased to see you among the firsts, Mr. Flower.' I muttered my acknowledgements 'Of course the College will give you a prize of £5 in books. . . .' I thanked him, and then asked if he could find how I did in Mods. He answered 'Do you feel any safer or more comfortable on a railway journey if you have looked into the firebox of the engine before starting'. I was crushed. Then he suddenly said 'By the way how is your father?' 'O he is quite well' I answered 'Will you send him my compliments and say how glad I am he has so good a son' I bowed and mumbled thanks, and said Good Morning.

This extract shows that Flower, despite his indifference as a schoolboy to games, was not insensible of the delights other than intellectual which Oxford has to offer. I never saw him on the river, but from later experience I can imagine the sort of tennis he played. He put into it the same furious energy which he expended on a problem of scholarship. His strokes were sometimes erratic, and he was never a player of outstanding excellence, but a drive which landed in the right place was apt to be unplayable. So, too, in ping-pong, to which in later life he was much addicted: standing firm-set, almost crouching, the upper part of his body inclined decidedly forward, holding his racket with a short grip, his eyes flashing with excitement, his hair all

disordered, he jabbed at the ball in quick, fierce strokes, which sent it flying across the table at an almost agonized speed. He was not an elegant player but very deadly as an opponent. He was moreover a keen and tireless walker. And already in his Oxford days he was a poet, immature indeed but with a genuine inspiration, a strong feeling for the beauty of words, and a true lyrical gift.

It was at Oxford that he made the acquaintance of the late Canon Streeter, then Dean of Pembroke, who was later to be his brother-in-law. Shortly after he had taken 'Mods.' a sister of Streeter's, who wished to become an art student, was discussing the project with her brother in his rooms when Streeter, seeing Flower in the quad and remembering his father's work for the College, exclaimed: 'Let's ask Flower about it.' As a result of the advice then given she became a student in Herkomer's school at Bushey.

Flower followed up his first in 'Mods.' by winning in 1904 a first in 'Greats'. With such a record he could reasonably hope for success in the Civil Service examination, and for this he accordingly sat. But destiny had not designed him for a post in an administrative office. The acquisition in two years of enough Greek to win a classical scholarship must have entailed immense effort, and whatever diversions he may have allowed himself at Oxford he had obviously not spared himself. He was never one who did things by halves; whatever task he undertook he was apt to pursue with a concentrated intensity which called on the last ounce of his mental and physical strength. He had clearly overtaxed his constitution, and during the examination he collapsed and had to be carried out of the room. An almost complete loss of memory was a serious warning, and medical advice enjoined a prolonged period of rest. This he took in the Orkneys but later went to Cologne, apparently with a view to the possibility of becoming a candidate for a post in the British Museum. His first attempt was, however, for one in the Victoria and Albert Museum. Perhaps he had not yet fully regained his powers; at all events he was unsuccessful, and it is interesting to record that his victorious competitor was Sir Eric Maclagan. His next enterprise was more prosperous: he sat for the British Museum examination and was appointed a Second Class Assistant in the Department of Manuscripts, where he took up his duties on 10 September 1906.

I was his senior by three years and a few months. Being much of an age and with a great deal in common, we were soon fast

friends. We were both of mixed blood, he English-Irish, I English-Welsh, both born and brought up outside the country of our most intimate love, both keenly interested in all things Celtic, both Oxford men, both classics, both enthusiastic lovers of poetry. Flower may well have nursed for years the ambition to learn Irish, but I fancy it was the discovery that I was already studying Welsh which gave him the final impulse. Like myself he was at that time in what I may perhaps call the Ossianic or romantic phase of Celtic enthusiasm. Later he was to show up with decision and fine critical acumen the falsity of the Ossianic landscape, writing 'The one great English poet whose style suffered the infection of Ossian is William Blake, for Macpherson must take a great part of the responsibility for the change from the piercing intensity of the lyrics to the muffled rhetoric of the prophetic books';[1] but in 1905 he was still under the illusion of the 'Celtic Twilight'. I treasure a copy of Fiona Macleod's *The Sin-Eater* given me by him in the early days of our friendship, with a dedicatory poem beginning

> Because a dream is in our blood
> And in our hearts a strange desire
> Of roses of no earthly bud
> And flames of not an earthly fire
>
> We find no rest in this closed world
> But send our vagrant thoughts astray
> Where on the walls of darkness hurled
> Die the last onsets of the day.

We dreamed in those days of many things to which the hard logic of fact denied fulfilment, among others of a joint catalogue of the Welsh manuscripts in the British Museum. Never before, in all probability, we reflected, had the Department had simultaneously two Assistants, one of whom specialized in the Celtic languages while the other had some knowledge of Welsh; it was improbable that such a chance would occur again; now was the time to produce a comprehensive and up-to-date catalogue of the manuscript resources which the Museum possessed for Welsh studies. But my Greek papyri and Flower's Irish catalogue, with the many miscellaneous tasks which the work of the Department entailed, and, later, increasing administrative responsibilities, made it impossible even to broach the scheme.

Flower, as I remember him in those days (and years, if they

[1] *Byron and Ossian* (Byron Foundation Lecture), Nottingham, 1928.

mellowed, did not essentially change him) was of a singularly vivid and arresting personality. He had a quite extraordinary power of concentration and was able to extract the essence of a book or an article in about a fifth of the time required by others; indeed he appeared to possess the knack of getting all he required from it by a glance at the cover and a hasty skimming of the pages. He began from the first the practice of wandering about the Department and taking down from the shelves any manuscript which caught his attention. So rapidly could he assimilate its contents and so marvellous was his memory that before he had been more than a year or two in the Department he knew infinitely more about the collections than most of us could ever claim to do. He probably spent in these divagations much time which should have gone to the routine duties of the moment, but the speed with which he worked was such that he produced as satisfactory results as some who stuck more closely to their allotted tasks, and the knowledge he acquired was of incalculable service to his colleagues and to inquiring members of the public. He was no doubt helped by his self-confidence. This was in fact probably not as great as it appeared superficially, and certainly in scholarship he observed a praiseworthy caution, but in talk his opinions were positive and emphatic. His drastic dismissal of any opinion which did not commend itself to him and a self-centredness which was his chief (I think one might say, his only serious) fault at times gave pain, leaving in some people an impression that he was lacking in sympathy and kindness. But this was to do him a grave injustice. He mentioned to me on one occasion that he was spending many of his evenings in reading aloud to an elderly artist who was dying of consumption. The remark was dropped casually apropos of something else, but the act was characteristic. All his life he was the soul of kindness, ready to do a service to anyone who required it, freely spending time and money and effort in helping the many friends and acquaintances, and not infrequently even perfect strangers, who appealed to him. With his forcefulness of manner, and even at times an apparent ruthlessness, went a real moral sensitiveness and a high standard of integrity, alike in scholarship and in personal conduct; and his exceptional mental gifts did not exclude a certain naïveté, even an ingenuous simplicity, of character.

There was no subject within the Department's scope in which he did not take some interest and acquire at least a modicum of relevant knowledge, and his private reading was extensive and

omnivorous, ranging from solid volumes of scholarship and remote by-ways of literature to the lightest and most ephemeral contemporary fiction. The ardour of his quest for knowledge was matched by the enthusiasm with which he both read and wrote poetry.

For a short time after joining the staff of the Museum he lived at Highgate, in rooms overlooking Waterlow Park, later with his parents at Bushey; but eventually he settled with a fellow poet, Vivian Locke Ellis, in quarters in Whitcomb Street, where he lived until his marriage. A visit to their rather bohemian establishment was an enjoyable and stimulating experience. Between them they planned and, with the collaboration of several friends, eventually launched in 1910 a literary periodical called *The Open Window*. Shortlived, as is the way of such ventures, it survived at least to reach the end of volume ii. The daintily produced little volumes, adorned with good pictures by artists of distinction, are a precious memorial of this friendship; the list of contributors includes such names (besides those of the two promoters) as E. M. Forster, De la Mare, John Drinkwater, St. John Lucas, James Stephens, Lord Dunsany, W. H. Davies (who took over Flower's lodgings with Locke Ellis when Flower vacated them on his marriage), Hugh de Selincourt, Jack Yeats, Maxwell Armfield, and Claude Shepperson. The second volume includes a fine verse rendering by Flower of an early Irish poem, 'Tempest on the Sea', ascribed to Ruman mac Colmáin, an early fruit of his Irish studies. 'The Poems of John of Dorsington, Chantry Priest of Stratford-on-Avon', in vol. i, a group of three charming lyrics in the medieval manner, may have puzzled some readers of the magazine, who perhaps thought them a modernizing by Flower of poems in Middle English. They are in fact the sole relics (I cannot recall whether any others were written) of a projected *jeu d'esprit* about which he had spoken enthusiastically to me some time before. It was his intention to write a number of these poems and, if I remember rightly, to furnish them with a 'spoof' introduction and commentary as the work of an imaginary cleric of Stratford. But like so many other schemes this never found fulfilment, and the three lyrics published in *The Open Window* alone survive to recall the jest. Whether it would have deceived any reader, or was seriously intended to do so, I rather doubt.

In 1911 Flower married Miss Ida Mary Streeter, the late Canon Streeter's youngest sister, whom, as related above, he had first met at Oxford. They settled at first in Chelsea, removing

later to Coulsdon, afterwards to Croydon, and eventually to Southgate, where they were living at the time of Flower's death. It was a singularly happy union, not the less happy or the less complete because they kept their separate identities and each was in a sense curiously detached—'two distincts, division none' as a friend remarked, happily applying to them a line from *The Phoenix and the Turtle*. The understanding and self-forgetting singleness of mind with which his wife helped and seconded him throughout their married life can never be forgotten by his friends. Readers of his poems will be familiar with the beautiful series of ten Shakespearian sonnets, the Patmorean lyrics (themselves sonnets of an irregular pattern) called 'Beauty', the four-line poetic epigrams, and other poems inspired by his love for his wife. The ten sonnets were all written, if I remember rightly, within a week, and the intense concentration which this necessitated left Flower for a time quite exhausted.

Flower had not been long at the Museum before he resolved to learn Irish. At first he took private lessons in his spare time, and so good was the progress he made that he ventured to broach to the then Keeper, Sir George Warner, a project which I fancy had been in his mind from the first: that he should complete the catalogue of Irish manuscripts commenced by Standish Hayes O'Grady in 1886 but never finished. A large portion of it, amounting to 706 pages, had been printed, and some copies had been bound for use in the Department, but it had not seemed advisable to publish a mere fragment. The proposal to continue this work, after an Irish scholar of such distinction as O'Grady, was a bold one when we consider that Flower was still a beginner in the language and that Old Irish at least, which it would obviously be necessary to acquire, is by common consent the most difficult of the Indo-European tongues; but Warner knew his man, and Flower's confidence in his own powers was justified. The plan was submitted to the Trustees and approved by them. Flower rightly felt that if he was to do justice to his task he must have the best instruction available, and he suggested that he should be given facilities for this at Dublin. A report submitted by Warner to the Trustees on 11 June 1910 asked on his behalf for three weeks' special leave for the purpose of attending lectures by Professor Marstrander in Dublin on 'The Old and Middle Irish language and literature' and also of making himself acquainted with the Irish manuscripts in the Royal Irish Academy. Special leave was granted, as recorded in a minute of 8 October 1910, and the Treasury made a grant of £15

towards Flower's expenses. A report submitted on 12 November following states that he had attended lectures on Irish and had taken 'lessons in the modern spoken language and also worked at MSS.'.

During his stay at Dublin Flower made several enduring friendships. One of these was with his teacher, Marstrander, who was later to stand godfather to his eldest daughter. His choice of godparents is indeed a guide to some of his friendships: Kuno Meyer, then Professor at Liverpool, whose acquaintance he made not long after taking up the study of Irish, was godfather to his second daughter, and among the godparents of his third daughter were two for whom he always entertained a quite special regard, Professor W. P. Ker and Mrs. J. R. Green. For Ker's scholarship and personality he had an admiration hardly this side of idolatry, and he was profoundly influenced by Ker's views on literary history. To Mrs. Green he owed much encouragement in his Irish studies and an affectionate kindness which never failed him. Whether it was in Dublin or in London that he first met her I cannot say; but one friend first met in the former city was the Austrian Celticist, Dr. Pokorny, a fellow pupil in Marstrander's class.

It was Marstrander who suggested a visit to the Great Blasket as the best means of acquiring fluency in spoken Irish. Flower acted on this advice, and thus formed the close ties with that remote and storm-beaten island which meant so much to him and which he put to such excellent use. His translation of Tomás Ó Crohan's autobiography published as *The Islandman* (Talbot Press, Dublin and Cork, 1934), a real masterpiece of sympathetic interpretation, and his original work, *The Western Island* (Clarendon Press, 1944), which he was fortunately able to see through the press after he had already been incapacitated by the illness to which he eventually succumbed, are permanent memorials of his association with the island, and will preserve the record of a singularly interesting popular culture long after the standardization of modern life has destroyed it. He paid frequent visits to the Blaskets, often spending his summer vacation there, and collected from Ó Crohan and others a great mass of stories, traditions, and island memories. Some of these materials he wrote down himself; others were recorded on a dictaphone, which on one of his visits was transported across the unquiet strait, along with himself, a goat, and an internal-combustion engine committed to his charge, in one of the flimsy coracles which are the chief means of communication between island and

mainland. Residence in the Great Blasket must indeed have entailed some measure of hardship, but Flower was never fastidious, and he lived cheerfully and happily in the house of the 'king' of the island under conditions from which some scholars might have shrunk, sharing the king's kitchen with poultry and other domestic fauna, exchanging experiences and reflections on the mysteries of life with the villagers, and taking down from their lips whatever of traditional lore they had to impart. He would roam the island, watching the islanders at work in their barren fields, chatting to them as they took an al fresco meal or smoked beside their hauled-up coracles, would accompany them on their fishing expeditions, and, if any of them ever ventured so far afield as to visit London, would greet them with a never-failing hospitality. More than once his visits entailed actual peril. On one occasion, when the sea was so stormy that the boatmen declared it impossible to put out from Dunquin, Flower stood on shore discussing the possibilities with the little crowd which had gathered while his wife sat waiting in the coracle, when, turning to the beach, he saw that the boatmen, suddenly changing their minds, had started without him; and he had to wait on land, not knowing whether the frail craft would ever reach the island. On another, when he was spending his vacation with his family on the Blasket and had arranged to be back at the Museum on a Monday morning so that I could leave for my own holiday that afternoon, so violent a storm broke out that he was unable to embark till the Saturday and then on a sea of such turbulence that the coracle could not make the harbour at Dunquin, and Flower and his family were landed at the foot of the cliff, hauled up the face of it, and so, transported thence in a manure-cart which was going to Dingle, caught the train by the skin of their teeth. Flower, leaving his wife ill at Dublin, arrived at the Museum on Monday afternoon when I had quite abandoned hope of seeing him.

Hardships and perils notwithstanding, his visits to the Blaskets were of immense service to Flower's studies. They had a direct bearing on a subject which always attracted his particular attention and in regard to which he owed much to Ker's books, the popular transmission of traditional literature and legend, for he was able to see, and to record from personal observation, this phase of culture, long outgrown for most people in England, still actively going on. His charming talk *How a Folk Tale is Told*, broadcast from Cardiff in the B.B.C.'s Welsh service on 3 September 1941, showed how much the experience had meant to

him. He profited also linguistically, acquiring a proficiency in spoken Irish which he could hardly have attained otherwise. His knowledge of the language and literature was of course greatly increased by his work in preparation for the catalogue of Irish Manuscripts, by constant study at home, by correspondence with Irish scholars in the British Isles or abroad, and not least (for to teach a subject is as good a way as any of mastering it) by his appointment to be Honorary Lecturer in Celtic at University College, London. Simultaneously he was acquiring additional qualifications for his task. The Department of Manuscripts has never had a staff large enough to allow of its individual members becoming pure specialists, and Flower's interests were in any case too wide and various for an excessive specialization. His hand can be recognized in many descriptions scattered about the *Catalogue of Additions*, for which he described manuscripts of the most diverse kinds, medieval and modern, and in various languages. He continued his practice of dipping into any volume which attracted his attention, and wandered down many by-paths of scholarship, acquiring in time an intimate acquaintance with several branches of medieval studies. He was, too, a tireless reader of English literature, with a particular interest in certain authors and periods, Swift and Goldsmith, for example, and the Elizabethan period. He managed also, without much formal study, to pick up a considerable knowledge of Anglo-Saxon; and his interest in Middle English led him to join the Early English Text Society, and to become later a member of its Committee, and eventually its Acting Director. All these interests were apt to entice him away from strictly Irish studies, and in a letter of 6 December 1911 Kuno Meyer, apropos of some work Flower was then doing on 'those Mexican hieroglyphics', wrote to him, 'I hope you will soon return to your Irish work, which is so much more important'; but they certainly widened his perspective and gave him a background to which he could relate his view of Irish literature. He was, moreover, continuing to write poetry with growing metrical mastery and a greater maturity of thought and feeling. He wrote a good deal in forms reminiscent of Patmore's *Unknown Eros*, and he was so far influenced by the prevailing enthusiasm for *vers libre* as to experiment with looser metrical patterns, though without losing his rhythmical ease or sacrificing the articulate structure of his verse; the slackness and slovenliness of some contemporaries aroused his outspoken indignation. A reference may be made here to the charming little volumes of verse privately printed for

several years and circulated 'among his private friends' in lieu of Christmas cards.

When the time came to begin the actual preparation of his catalogue he was thus equipped with qualifications rarely, if ever, combined in a single scholar before. I do not know when he formed his design, which he certainly nursed from quite early in his career, of writing a history of Irish literature, but it was intimately connected with the plan of the catalogue. O'Grady's lively and highly individual style in his portion could not be followed by Flower. Tolerated perforce in a distinguished outsider, so personal a tone was unsuitable to an official work produced by a member of the Department. Yet the knowledge acquired in the course of the work could, in a general introduction, be gathered together, co-ordinated, and built up into a coherent sketch of Irish literary development during the period covered by the catalogue, which, owing to the special conditions prevailing in Ireland, meant in effect the main course of Irish literature. This, then, was Flower's programme: first to continue and complete in volume ii the description of individual manuscripts begun by O'Grady in the first volume; then, in a third volume, to give detailed indexes to the whole work, preceded by a general introduction, in which he would not only deal with the formation of the collection and the migrations of the volumes composing it, but sketch the literary tradition of Ireland as illustrated by surviving manuscripts, the activities of the scribal families, and the development of the various schools; then, at a later date, perhaps after his retirement, to use this material, no longer in the coldly impersonal style of an official catalogue, but with all the literary skill at his command, for a really comprehensive history of Irish literature.

As already said, he had peculiar qualifications for the task. His philological equipment, while it might fall below that of many Celtic scholars (for, though a good linguist, he was not a grammarian *par métier* and had no early grounding in comparative etymology), was at least adequate, and he had by now studied Irish literature widely. He had acquired a fair working knowledge of Welsh and rather more than a nodding acquaintance with Welsh literature. He was far from singular among Celtic scholars in having received an excellent classical education, but was more exceptional in his wide-ranging knowledge of medieval studies. He was an expert palaeographer, with a natural flair for the characteristics of a hand (a very important asset in this branch of scholarship) and considerable experience

in dealing with manuscripts. His knowledge of English literature was extensive and intimate, and he had read many of the leading continental authors. He was an outstandingly good literary critic, rather exacting perhaps in his standards and not without his prejudices (he had in general little inclination to religious and mystical literature, and he once told me he had never in his life felt any need of a religious belief), but he was too honest and too sensitive to literary merit not to respond to excellence in any sphere. Thus he could bring to his Irish studies not merely the enthusiasm of the scholar but the appreciation of the poet, while on the other hand he never allowed his love of Ireland to deflect his judgement and lead him into making extravagant claims for a literature of whose great merits he was none the less sensitively aware. He was essentially a poet, who, although not as well known as his merits deserved, had won an assured place among the writers of the day. Æ wrote to him on 10 January 1924: 'I like all the verses indeed I like all your verses which I have read and it is a pity you do not write more. But I know how difficult it is to make a space in the soul for the delicate flower of poetry to grow, so many other plants the useful cabbages and potatoes of thought come insisting for room based on their utilitarian value.' In his volume *Hymenaea*, published in 1918, the sequence of ten sonnets, 'The Dead', with its subtle and haunting rhythmical movement, and such poems, in Patmore's manner, as 'In the Train', 'The Vigil of Saint Venus', and 'In Church' show how far he had advanced in technical mastery, while 'The Hedge-Schoolmaster to his Love', which begins, 'O dearest of dear ones, O sweeter than sweetness', a poem which might easily be a happy rendering of a modern Irish or a seventeenth-century Welsh lyric, illustrates the extent to which he had absorbed the spirit of Celtic poetry. His translations from the Irish are indeed masterly, and will certainly be a permanent contribution to the none too abundant store of satisfactory English renderings from the Celtic literatures. Lastly, he was the master of an admirable prose style, lively, interesting, picturesque, and with a happy gift of phrase. He seemed indeed to have been chosen and prepared by destiny to produce the first really adequate and revealing survey of the Irish literary achievement.

The *Catalogue of Irish Manuscripts in the British Museum*, vol. i by O'Grady, vol. ii by Flower, was published in 1926, and its appearance was universally hailed as a major event in Celtic studies. One distinguished Irish scholar wrote to Flower (3 June 1926): 'I congratulate you most heartily on the achievement of

so splendid a piece of work. It surpasses all my expectations, high though they were. It is a veritable encyclopaedia, such as I thought no one man could accomplish.' Another wrote: 'You have like O'Grady, only in another direction, given us far more than we had any right to expect in a Catalogue. You have founded a solid basis for the future historian of Irish literature to build upon—tracing the sources for him of the various tracts you describe, and the centres of learning from which they have emanated.' Flower's volume had a Preface explaining the genesis and nature of the catalogue and giving an account of O'Grady's career. Flower here sets forth the principles followed by him in his part of the work: 'In this present volume an attempt is made, subject to the necessary limitations of the material and the cataloguer, to study the literature in its growth, to delimit its different classes, periods and districts, and, in particular, to isolate the foreign influences by the method of determining the sources of translated texts. . . . The descriptions of manuscripts have been so arranged as to illustrate, so far as the material allows, the history of the literature in its different periods and schools and kinds.'

These extracts indicate very fairly the special importance of Flower's work. Celtic scholars in general had tended, not unnaturally, to deal with Irish literature piecemeal: to select for their editorial activities particular texts or groups of texts which interested them, to copy these from the best available manuscripts, collating with any others that were accessible, and so to treat the works concerned in isolation. Few, if any, had conceived the idea of studying a whole manuscript as a corpus of literature, still less of analysing the contents of many manuscripts; of asking where each was written and in what circumstances, how it came to contain just those texts and no others, what was its relation to other similar manuscripts, and what light the answers to such questions might throw on the development of Irish literature in general. This was Flower's undertaking, and he was helped in it by his palaeographical training and by the medieval knowledge which enabled him to relate Irish literature to that of the contemporary world of which, however remote and detached Ireland might be, it yet formed a part. Thus he identified the external sources of several texts which had passed as original Irish works.

He was already at work on volume iii. The manuscripts described in volumes i and ii he had indexed while describing them, but the slips had still to be thrown together, arranged, and

revised. This task he took up shortly after he had finished the preparation of volume ii. The slips did not require an inordinate time to arrange roughly; the revision was a much longer task, which occupied him at intervals during the rest of his official life and was never quite completed. There was also the Introduction to be written. This he also began without delay, and when he had finished what was intended to be the first portion, giving the history of the various groups of Irish manuscripts which, passing one by one into the possession of the Trustees, made up the Museum collection, it was decided to send to the printers so much as had been already written. Proofs began to arrive in 1929, and eventually all this portion was printed and will in due course appear in volume iii. But the rest of the Introduction, that preliminary survey of the literary schools and the activities of successive scribes which was, as it were, to pave the way for the projected history of Irish literature, was never even begun. There were too many calls on Flower's time. An attempt was indeed made, by relieving him of some administrative tasks, to set him free for his main work; but the multiplicity of his interests and the very energy which drove him constantly to fresh undertakings nullified any advantage thus obtained. He could never resist the attraction of a new interest; everything he came across in his daily work had its threat to the steady pursuit of his Irish studies and was liable to send him off hotfoot on some novel trail. The schemes he conceived were innumerable, and though some were of no more than a moment's conception others led him into lengthy researches. The autographs of Oliver Goldsmith, the bibliography of Swift, the letters of Horace Walpole, alleged Shakespeare autographs, the literary activity of the Anglo-Welsh border under the early Plantagenets, particularly the importance of Worcester as a literary centre, the historical and antiquarian movement in Elizabethan England, Anglo-Saxon studies—these were among the interests which, successively or concurrently, occupied his attention. Visitors came to consult him on many problems, and he was never sparing of the time he gave them; sometimes he would be closeted the greater part of a day with some caller. Outside, too, he was more and more involved in responsibilities which claimed his energies. He continued his work as Honorary Lecturer in Celtic at University College; he was on the Council of the Irish Texts Society, whose Chairman he became, and the Council of the Irish Genealogical Society; and in 1931 he joined the Committee of the Early English Text Society, with whose work thenceforward he grew ever more

closely associated, until in 1940 he became Honorary Acting Director of the Society.

Distracted among these many calls on his time, Flower at last realized, as his friends had done already, that he was unlikely to achieve his full design, at least while he remained at the Museum. He was often worried, I am sure, by the difficulty of doing justice to his various interests, and in the later years of his official life I had at times the feeling that the readiness with which his mind gave access to new projects was itself an unconscious flight from a problem growing insoluble; it was easier to plan a new undertaking than to resume an old one too long neglected. His method of work constantly overtaxed a constitution always highly strung and not too robust. He rarely finished a task until the last possible moment, flinging himself on to it at the eleventh hour in a perfect fury of energy. I remember on one occasion, when he was to deliver an important lecture in the first half of the following week, his telling me on Saturday that he had not yet begun to write it. He spent all Sunday and most of the following night at the typewriter, and was back at the Museum on Monday morning exhausted but triumphant. It was a costly method of procedure and he was often urged to change it, but he always said, doubtless with truth, that this was the only way in which he *could* work; and certainly some of his best prose was written under high pressure.

In 1927 Flower gave at the British Academy the Sir John Rhŷs Memorial Lecture, taking for his subject *Ireland and Medieval Europe*. In a note to this lecture, which might be described as a sort of *praeludium* to his history of Irish literature, he states that 'a discussion of the development of the Irish manuscript tradition . . . will form part of the Introduction to the forthcoming third volume of the *Catalogue of Irish MSS. in the British Museum*'. He still entertained, then, the design of including in that work some at least of his conclusions on the growth of Irish literature, but by about 1930 he had finally abandoned the idea, and had decided to confine his Introduction to the portion already written and to reserve what he had to say on the larger subject for the days of his retirement. He did, however, sketch the main lines of the development in 1935, when he was invited to give the Lowell Lectures at Harvard University. This visit to the United States, in which he was accompanied by one of his daughters, was a strenuous, not to say a hectic, time, but he enjoyed it whole-heartedly. He was not only Lowell Lecturer at Harvard but Woodward Lecturer at Yale and W. Vaughan

Moody Lecturer at Chicago, and he gave single lectures elsewhere. The Lowell Lectures were concerned chiefly with the Blaskets, though they included one on Irish poetry. Others, in which he dealt with Irish literary history, lively, excellently designed, full of colour and literary charm, and containing within their limited space a vast amount of information, furnish a vivid idea of what his history would have been like had he lived to write it. After his breakdown in health he was strongly urged to publish them as they were. He was, reasonably enough, reluctant to do this, since he felt that a fuller documentation and justification of the sometimes novel and unorthodox theories categorically stated in them ought to be given; but as the conviction grew that he would never again be fit for the continuous and concentrated effort which this would require, he became more favourably disposed to the project; and it is very satisfactory to know that the lectures will in fact be published by the Clarendon Press. In them, in the John Rhŷs Lecture already referred to, in various scattered articles and lectures (some of which it is hoped to issue in a volume of his papers), and above all in volume ii of the Irish catalogue, a contribution of lasting value has been made to Irish studies.

Some of the other studies already alluded to also issued in valuable publications. His Gollancz Memorial Lecture given in 1934 on *Laurence Nowell and the Discovery of England in Tudor Times* illustrates his interest in the antiquarian movement of the Elizabethan period. This was a subject which increasingly attracted him, and on which he designed further work. It was stimulated by his official duties in connexion with the projected new catalogue of the Cottonian manuscripts; those containing the correspondence of Cotton and his contemporaries were among the volumes which he asked to be allowed to describe himself. Two articles contributed to the *National Library of Wales Journal* in 1941 and 1943 respectively (see the Bibliography) are further signs of this interest. He conceived also a special interest in Sir John Price as a collector of manuscripts, and intended to write an article on him. He emphasized in his work on these sixteenth-century scholars the characteristic bent of their studies and the difference between them and later bibliophiles, such, for example, as the Earl of Arundel or Robert Harley, Earl of Oxford. The Elizabethan antiquaries were not miscellaneous collectors; their acquisitions of manuscripts sprang in the main from their interest in British history, and the character of the collections they formed was determined by that bias.

Flower's interest in Anglo-Saxon studies was shown by his collaboration with R. W. Chambers and Max Förster in editing (in 1933) the facsimile of the Exeter Book of early English poetry, to which he contributed a chapter (vii) on the script, besides sharing with Chambers the task of transcribing the damaged portions of the manuscript (chapter vi), and, in 1941, by the edition (with Hugh Smith) for the Early English Text Society of a facsimile of the Parker Chronicle and Laws (Corpus Christi College, Cambridge, MS. 173). His Giff Edwards Memorial Lecture, *Lost Manuscripts*, published in the *Transactions* of the Royal Society of Literature for 1940, gives a fascinating account of the search for and discovery of various notable manuscripts, and an article contributed to the *National Library of Wales Journal* in 1940 on 'A Metrical Life of St. Wulfstan of Worcester' was in intention an earnest of more extensive studies on Worcester as a literary centre. Lastly, he found in Exeter Cathedral Library MS. 3514 an important 'Cronica de Wallia', closely related in parts to the text of the Welsh *Brut y Tywysogion* contained in Peniarth MS. 20. He decided to edit this as part of a new edition of the *Annales Cambriae* and invited Dr. Thomas Jones of the University College of Wales, Aberystwyth, to collaborate with him in the task. Unfortunately his breakdown in 1942 made it necessary to abandon the project; but Dr. Jones has since published the 'Cronica' and other texts from the same manuscript in *The Bulletin of the Board of Celtic Studies*, xii. 26-44.

As Flower's work grew more widely known honours came to him from various quarters. He was elected in 1934 a Fellow of the British Academy, and other distinctions which he received from time to time were Membership of the Royal Irish Academy, Fellowship of the Royal Historical Society, Corresponding Fellowship of the Mediaeval Academy of America, and the honorary degrees of D.Litt.Celt. from the National University of Ireland and D.Litt. from Trinity College, Dublin.

During the years 1937-9, as the shadow of war darkened over Europe, arrangements were made for removing to places of greater security elsewhere the most important of the British Museum's collections. It was decided that Keepers should remain in London and that Deputy Keepers (or the senior Deputy Keeper in Departments which had more than one) should take charge of the material removed. Flower was designated as custodian of the manuscripts selected for removal to the National Library of Wales; and on Wednesday, 23 August 1939, when word came that packing was to be commenced, he left

London for Aberystwyth. According to the arrangements previously made he would have been in charge merely of the Western manuscripts from his own Department, but owing to circumstances which prevented the Senior Deputy Keeper of Printed Books from going to Aberystwyth Flower was senior among the officers established there, and on him consequently devolved the general responsibility for all the Museum collections housed in the National Library. This entailed a great deal of administrative detail, often of a kind vexatious to a man of Flower's temperament, who had little taste for administration. It is likely that his constitution was already impaired by the energy and diversity of his activities, and the mental strain caused to him by various worries incidental to his position—worries of which some temperaments would have taken little heed—undoubtedly tried him greatly. A slow but steady decline in his health and his capacity for coping with his responsibilities was observable—though by colleagues not daily in touch with him hardly observed—during the years he spent at Aberystwyth. Yet his brain continued active and enterprising. He found new interests in the manuscripts of the National Library, formed new projects of future work, and undertook to deliver the Ford Lectures at Oxford, though he had subsequently to withdraw from this commitment. In the autumn of 1942, while lecturing for University College, London, then centred at Aberystwyth, on *The English Tradition of Research*, he collapsed and had to be helped out of the hall. It was a serious warning, and he wisely suspended all unnecessary work for the time being. Heart trouble was suggested, but an examination by a heart specialist in London during April 1943 revealed nothing very seriously wrong. His relief was great and I suspect that for a time he did not spare himself as much as he should have done. But his health was now giving those round him real cause for alarm. On 18 October 1943 he and his wife returned to London for a short holiday, and during the following night he was taken alarmingly ill. Not quite a stroke, said the doctor who examined him, but apparently as near to it as made little difference. He rallied and gradually grew better. At first he suffered from an almost complete loss of memory; the most familiar names and words would escape him, and for a time he could not read at all; he could, he said, recognize the letters but lacked the power to put them together. Months passed, with a slow improvement; he could once more read (though not for long or with much concentration) and write letters. He even wrote the charming

preface to *The Western Island*, a book written before his illness, whose publication gave him great pleasure. But slight attacks kept throwing him back, and it gradually became clear to him, as to others, that his effective working days were done. A letter from an old acquaintance written to him on 15 February 1945 shows that he was still able and willing to put his knowledge and his judgement at the service of others: 'It is like the person who wrote the letter of twenty years ago to be so ready to explain the points I raised, to offer to trace those verbs, and to hold out the chance of a copy of your translation of Tomás' book.' The last time I saw him was not long after Christmas 1945. He was, outwardly, much like his old self, but he spoke despondingly of his prospects; he feared that some new attack might destroy his power to think coherently. Fortunately he was spared that calamity, and on 16 January 1946, after only a few hours' illness, he died.

It is often said of a notable man after his death that he was himself more remarkable than anything he did. This is certainly true of Flower: his vivid and forceful personality, his brilliant talk, ranging over many themes and spiced with a humour never malicious, his gift of anecdote and the delightful lilt with which he would tell an Irish story, his fresh and critical judgement, and his gift of friendship will linger in the memory of his friends but must be lost when those who knew him are dead. Yet in his writings much of the man himself will live, and his contributions to scholarship are real and lasting.

[The writer is much indebted to Mrs. Flower and her family for details used in the above Memoir, and to the Rev. Dr. J. A. Findlay, Flower's brother-in-law, for reminiscences of Flower's early life and information about his ancestry; also to Mr. T. C. Skeat for consulting on his behalf in the British Museum some publications not available in the National Library of Wales. The bibliography printed below, included because so many of Flower's contributions to scholarship were made in the form of isolated articles, was compiled almost entirely by members of his family. It does not aim at absolute completeness, omitting some minor reviews and brief notes and not recording re-publications of poems in anthologies, &c., but it is believed that it includes all publications of any importance.]

H. I. BELL.

KENNETH SISAM

XVII

KENNETH SISAM
1887–1971

KENNETH SISAM was born on 2 September 1887 and died on 26 August 1971. In writing something about his life in New Zealand (1887–1910), at Oxford University (1910–17), in London (1917–23), at the Clarendon Press (1923–48), and in Scilly (1948–71) I have had a great deal of help, above all from his daughter, Miss Celia Sisam. I would like to thank her and also the following: Mr. Hugh Sisam; the abbot of Downside and Dom Daniel Rees, O.S.B., for allowing me to use the letters Sisam wrote to Edmund Bishop in the years 1911–17; Mr. D. M. Davin, for giving me access to files of Press correspondence and for much other help; Professor Dorothy Whitelock, for the loan of letters Sisam wrote to her; Lady Welch, who was with him in the Ministry of Food (1917–20); Mrs. Figgis, who, as Miss Bone, was with him there and at the Press (1920–4); Dr. Nigel Abercrombie, Professor J. A. W. Bennett, Mr. R. W. Burchfield, Mr. E. H. Cordeaux, Mr. R. E. Coxon, Dr. Roger Highfield, Mr. Raymond Page, Mr. David Vaisey, Miss Margaret Weedon.

Sisam's paternal grandfather, Thomas, farmed the lands of Arrow Mill, near Alcester. His father, Alfred John, left Warwickshire for the North Island of New Zealand in 1863, together with two brothers. In New Zealand he got married and had eight children, four daughters and four sons, of whom Kenneth was by seven years the youngest. His wife was Maria Knights and, to judge from photographs, the sons Leonard, Walter, and Kenneth, derived their distinctive looks from her. Kenneth was born at Opotiki on the Bay of Plenty. In about 1890 the family moved to the then very small settlement of Whakatane some forty miles further east along the coast, where Alfred Sisam was police constable and clerk of the court and two of his daughters successively had charge of the post office. Mrs. Sisam died there in 1894 at the age of 48. By this time the country, still essentially wild after the Maori wars, was being tamed and settled in sections. Alfred Sisam obtained one of forty-four sections balloted for in 1896 at Opouriao, about twelve miles inland from Whakatane, and Leonard and Walter went to work it. Kenneth joined them when he was 11,

'to be broken of the idle habits of the sea-coast villages', or so he said in a letter to Edmund Bishop, 23 December 1916: he remembered the house as 'a kind of wooden box' with almost no furniture. His is the story of the boy from the backblocks with few tangible advantages who ends by winning the highest honours: the five books at the farm were Josephus' history of the Jews, a volume of eighteenth-century plays,[1] Prescott's *History of Peru*, a translation of Hugo, *Les Misérables*, and an encyclopedia of the horse and its diseases. His first school was Whakatane primary and his second Opouriao South primary, a one-master school. In 1900 Kenneth won a scholarship to Auckland Grammar School. In 1906 another scholarship took him to University College, Auckland, where he took his B.A. in 1908 in English, Latin, French, Mathematics, Jurisprudence, and Constitutional History, and his M.A. in 1910 in English and Latin, with first-class honours. The electors to the Rhodes Scholarship decided that Sisam had the best claims of four good candidates to be New Zealand's Rhodes Scholar for 1910. In October of that year he matriculated at Merton College, Oxford.

Stories of the young Sisam in New Zealand are preserved in the memories of his children and his colleagues at the Press. His custom of not having any lunch to speak of was formed, so he said, when he walked to the Opouriao school: he usually gave his lunch to a hungry dog at the first creek he came to. The habits of Press authors with their manuscripts put him in mind of his uncle's dog who went to sleep in the bush, instead of bringing the cattle home. Te Kooti, the Maori leader, who died in 1893, gave him plum cake. Going up to Auckland in the first years of the twentieth century was quite an undertaking, and the two-day journey by horse track to the railhead at Rotorua was in part through peculiarly wild and barren country, devastated by recent volcanic eruptions. Frequent returns home for holidays were out of the question. Sisam boarded in Auckland with a Mrs. Farquhar and there he met her niece, Naomi Gibbons.

Printed accounts of him when he won his Rhodes Scholarship are in Auckland papers. The University College Students Association said that 'During the whole of his course Mr. Sisam has shown himself to be a man of untiring energy, not only in

[1] Now in the English Faculty Library, Oxford, of Sisam's gift in 1915. The first play in the volume is a 1772 edition of Richard Cumberland's *The Fashionable Lover*.

his studies, but in furthering a scheme for the benefit of the college. He is a student in the finest sense, combining unusual accuracy and sense of detail with great breadth of view, a wise caution with high originality.' It referred also to his prowess in cricket, rugby football, and hockey, and added that 'He is also thoroughly used to swimming, rowing, and the management of boats at sea.' Miss Sisam tells me that the scheme for the benefit of the college was to acquire more land on which to build and that the authorities turned it down—unwisely, they thought later; also that he was a slow leg-break bowler and opening bat. Cricket and rugby football were abiding interests; also boats.

These were exciting days for anyone with a leaning to English language—and for that matter English literature: L–R and the first half of S of the *Oxford English Dictionary* appeared in fascicules during 1901 to 1910. Perhaps the Dictionary started Sisam off, but his interest in English was promoted, it is said, by a plot at the Grammar School to do down a classmate who was first in everything. Sisam was told to get ahead of him in English and did so. Probably he began Old English when he first went to University College, Auckland: his name and the date 'March 5th 1906' are in his copy of the seventh edition (1898) of Sweet's *Anglo-Saxon Reader*. In his second year, he acquired, 20 December 1907, Bülbring's *Altenglisches Elementarbuch: I, Lautlehre*. The large and curly 'K. Sisam' in these books and in a Horace dated by him 'March 20th 1906' is very different from the later Sisam signature on letters: in books he wrote his name only when he was young. Egerton who held the chair of English at Auckland considered him 'in many respects the best and most promising student' he had ever had. P. S. Ardern (1884–1964) was not teaching at University College when Sisam was there, but it seems likely that they met.[1]

After 1910 Sisam returned to New Zealand only once, but he continued to take much interest in it and to keep up with his relatives in North Island. As a background to his whole life the experiences of the first twenty-three years were of great importance. In the words of another New Zealander, D. M. Davin, he derived from them 'versatility in emergency, a power of improvisation, a fundamentally practical approach, a relish for simple solutions, and a skill in finding them'.

[1] On Ardern's high quality as scholar and teacher see the memoirs by J. A. W. Bennett, James Bertram, and H. W. Orsman in *Comment, New Zealand Quarterly Review*, 21 (1964), 11–13.

At Oxford Sisam was allocated to Merton College, perhaps because it was the college of Professor A. S. Napier. In 1910 Napier was fifty-seven and almost, if not quite, at the height of his powers. He looked for a worthy B.Litt. subject for Sisam and suggested that he should work on one of the still-unpublished Latin psalters with an interlinear Anglo-Saxon gloss. 'An Edition of the Salisbury Psalter (Salisbury MS. 150) with Introduction and Critical Notes', supervised by Napier, was announced in the *Oxford University Gazette*, 3 November 1911. The choice of subject had an unexpected consequence. In September 1911 Sisam wrote to the chief liturgical scholar in England, Edmund Bishop, to ask him if he would agree that the Salisbury manuscript had its origin at Sherborne. It was not the sort of letter to please Bishop, who wrote after five weeks to say, in a sentence of rare complication, that the conclusion was faulty.[1] Sisam replied at once (23 October) and this second letter showed Bishop the real quality of his young correspondent. Sisam said 'I should like to be able to point to some place from which it *might* have come.' Bishop interlined 'quite the right spirit' above '*might*'. The exchange of letters ceased in February 1912, by which time Sisam had his answer, that Shaftesbury, not Sherborne, was the likely first home of the Salisbury psalter. It began again when Sisam wrote to Bishop early in 1913 and continued until Bishop's death in February 1917 at the age of 71.

A glimpse of Sisam as a Merton undergraduate is in Hubert Phillips's *Journey to Nowhere*, published in 1960. Phillips went up to Merton at the same time as Sisam, but, like most other undergraduates, he was four years his junior. Phillips remembered him as level-headed and 'a valuable friend to me, and to many others'. When he went to Sisam's book-spread room, '"Sit you down" was his invariable greeting. "You can move the books off that chair."' There were many besides work-books: 'novels; plays; essays; belles lettres; criticism'. On many matters, 'Sisam blinking rapidly ... laid down the law with a firmness and a finality that Dr. Johnson himself could hardly have bettered.' Mr. R. E. Coxon, another Merton contemporary, assures me that the law was laid down only to a small circle of friends: 'To the outer world I should have thought he appeared almost diffident and retiring.'

The years 1913-16 are illuminated by Sisam's letters to Bishop. They are particularly interesting, to me at least, for the

[1] Nigel Abercrombie, *The Life and Work of Edmund Bishop*, p. 428.

evidence they provide of his early love for palaeography. They suggest that, but for illness, he might have become a Traube or a Lowe. Wanley was an inspiration. Writing to Bishop on 13 June 1914, the day after his first visit to the library of Corpus Christi College, Cambridge, he says 'it reminded me of dear old Wanley's letter—I copied all that there were in Bodley once when time seemed less precious than it does now—Take 'em all together and they'll appear to be a most noble parcel of books.' Palaeography comes into the letters again and again: 10 February 1914, 'Shades of Traube! How we limp behind the great ones. My own impression of English script of late 9th–11th centuries is that its contractions don't matter a pin'; 2 April 1914, 'My interest in the Pontifical is purely palaeographical' (a hard saying to Bishop who had no special interest in palaeography and wanted to make Sisam into a liturgiologist) and 'I am very interested in any handwriting of that time, and should like to work through it all from about 900–1100. A Herculean task of course'; 14 July 1914, 'Bosworth Psalter [Bishop and Gasquet, *The Bosworth Psalter*, 1908] . . . has been, or, I should say, will be when people see, an extraordinary help in the subject for which it wasn't written—palæography'; 17 February 1915, on 'a certain way of finishing the 3' in the Vercelli manuscript of Old English poetry 'which I remember very clearly in the Worcester charters of 969 and 984, but elsewhere *almost* nowhere'; 16 November 1915, 'the real life of script which is *form*'; 22 October 1916, 'When I look at the facsimile [of the Heliand] all the duct, which is the real life of a script after all, is un-English, Netherlandish (it is more likely therefore to be written by an Old Saxon in England)'. Sisam's ticket allowing him to use the manuscript room in the British Museum is dated 5 July 1911. The letters refer to visits there in January 1912, in July and December 1914, and in January 1915. Three surviving notebooks from this time are concerned mostly with letterforms. Of the Athelstan charter of 930 among the Crawford charters in the Bodleian, Sisam noted 'reminds strongly of Junius 27, but much rougher in form . . . a roughness and delicacy I can't catch'; of the Eadwi charter in the same collection, 'reminds of a charter of the date in vol. iv of B. M. Facs. but more lively and better'; of Cotton Domitian vii, f. 47v, 'a very interesting half page in bold archaic insular'; of Royal 8 C. iii, 'interesting as presenting a number of good hands *c.* 1000'.

Trouble with health and eyes are first mentioned in letters written early in 1913. For some reason, a robust athletic young

man was changing, after a few years in Oxford, into a more or less permanent invalid—or so it must have seemed to the victim in 1916. A photograph (1913 or 1914 ?) shows a very different person from the Auckland graduate of 1910. In June 1914 Sisam told Bishop that 'an appendicitis operation nearly two years ago was only the beginning of a series of well meaning blunders which have reduced me—I hope only temporarily—to the state of a cripple'. He also blamed the climate: 1 May 1915, 'When I first came to England . . . I used to wonder at the feebleness of the English physique but now I just marvel that they have the strength to stand their climate.' The winter was 'a desolate time for us who were born "in the sun"' (30 January 1914). After a holiday in Cornwall, he resolved not to attempt another in England and was in Lugano at the end of March 1914. In July he was going to Switzerland again 'to see whether their excellent climate and hotels can "give new wheels to our disordered clocks"'.

Probably overwork was the main trouble. His letters show him at his B.Litt. thesis, exploring Anglo-Saxon manuscripts far beyond the requirements of the thesis, and (24 June 1914) with projects in mind 'enough to last me 20 years': the prayers in Arundel 155 and the Durham Ritual were at the top of the list. They also show him teaching. From 1905 onwards Napier had had a succession of young assistants to help him. S. J. Crawford, the assistant in Sisam's first four terms, was no longer available in Hilary term 1912, and Sisam was 'pressed into the service to fill a gap in the Old English lectures' (letter to E. B., 28 February 1912). He gave lectures or classes five or six times a week for fourteen terms and set himself a high standard: Professor Tolkien has told me how fortunate he considers he was to have been able to go to Sisam's lectures. Sisam told Bishop he was 'quite disheartened with the amount of teaching . . . which has fallen on my shoulders' (30 January 1914), that he had 'not had time this month to go near Bodley' (31 January 1914), that 'my work in term is perniciously heavy' (9 June 1914), that he was 'overwhelmed in the mere drudge work of teaching for three or four disconnected hours every day' (17 February 1915), that he was '"curled up"—mere tiredness' (27 February 1915). When Napier died in May 1916 Sisam was in charge of the teaching of English language and no doubt he had been virtually in charge for a year or two.

1915 was an important year in his life. He no longer had money from his Rhodes Scholarship, but only as a Mark

Quested Exhibitioner at Merton (1915–17) and from teaching, and it did not amount to much. He married Naomi Gibbons in January. In the summer he sent in his thesis: it was approved on 18 June and reported upon by the examiners, Craigie and Bradley, in the *Oxford University Gazette* (23 June, p. 767). His health seems to have improved temporarily, although it was at this time, as he told me in a letter, that his eyes failed him for close work. He did his first piece of paid work, other than as a lecturer, by producing for the Clarendon Press in three weeks a revision of Skeat's edition of *Havelok*, a text and edition he knew well, as he had lectured on it for the last nine terms. At that time (letters to Bishop, 14 and 20 June) his thoughts were on leaving Oxford: he badly needed a better job. In July, however, he told Bishop that he had 'decided to stay here at least one more year'. In November and December he was able to report two new events. One was his employment as a member of Henry Bradley's staff on the Oxford English Dictionary. According to family tradition he worked particularly on STER-words and STEWARD, part of the fascicule 'Stead–Stillatim' published in June 1916. 'I was inveigled into the big Dictionary and have never seen daylight since . . . I go there in such parts of the day as are not occupied with teaching with a kind of roving commission to fill gaps and very trying it is getting hold of all the technique of a vast work—how each author is to be quoted, what editions, etc. etc. What phrases to use to express complete ignorance, partial ignorance, and so on' (9 November 1915). The other event was an interview with Charles Cannan: 'I am glad to say that, health permitting, I shall be stationed here for a while. The Secretary of the Press, who is the real manager of its affairs, very kindly sent for me and told me he would do anything he could to keep me here for the present, and offered me a sufficient retaining fee in return for putting half my time at their disposal. This was very good of him, as he is a complete stranger' (24 December). A little more can be learned from a letter to Napier written in March 1916: 'I have arranged with the Press for doing the MS. work on AS. poetry in the following year, which will give me more chance to recuperate than I could ever hope for at the Dictionary, as I shall be able to get away from Oxford in the second winter term, always the most trying'. The arrangement helped him to decide not to accept an offer in March 1916 to go to America as Carleton Brown's successor at Bryn Mawr.

The Hilary and Trinity terms of 1916 were bad ones for

Sisam, even though the amount of teaching had declined, as a result of the war. On 1 April he told Bishop that he had been 'very poorly indeed for a long time', and that he had found the Dictionary too trying for his health,[1] also, that the writing of his letter had been delayed two days 'due to an urgent call to correct some troublesome proofs. I am rather a good technical reader'. On 8 May he was 'teaching from a couch' and confined absolutely to his room. The Press added to their good deeds by sending up 'Sir William Osler, who diagnoses the trouble as internal nervous affection, the result of run down, and in no way dangerous, or likely to be permanent, though taking long to cure' (12 May). On 28 May the word 'overwork' occurs for the first time, I think, in the letters to Bishop. At this time he had two new cares, business arising from Napier's death and the proofs of Bishop's *Liturgica Historica*, which began to come from the Clarendon Press early in May and continued until the end of the year. Sisam's part in seeing *Liturgica Historica* through the press is set out by Nigel Abercrombie in *The Life and Work of Edmund Bishop*, and his name is on the title-page as joint editor with Dom Hugh Conolly. The letters to Bishop from 17 May onwards are concerned with the proofs. At the end of Trinity term the vice-chancellor asked him if he would take on Napier's teaching for the academic year 1916–17 at a salary of £250. His answer must have been 'Yes, if I am well enough', otherwise there would have been no need for him to write again in September to say that he was not well enough to do the teaching in the Michaelmas term. The next news is in a letter from Cannan in July 1917: 'It is a great comfort that you report yourself to be getting stronger . . . Bradley and Craigie will be delighted to see you back at the Dictionary.' The great improvement in health came that summer, helped by some kind of electrical treatment, as Miss Sisam tells me, and perhaps by dieting: the rigorous diet he kept to in Oxford and Scilly, much milk, but little fruit or green vegetables, may have been started at this time. He and Naomi moved to London and he began work at the Ministry of Food early in November. There, Lady Welch remembers 'his fast striding-out athletic springing walk' down the long Ministry corridors. She noticed 'no signs whatever of ill health' and only learned of his illness much later from Naomi.

From this time Sisam was a part-time scholar. The decision to give up the 'cult of vellum', envisaged two years earlier (to

[1] Dr. R. W. Burchfield kindly tells me that the payments to Sisam for his work on the Dictionary were £31.10s. 0d. in 1915 and £25 in 1916.

Bishop, 20 June 1915), must have been unpleasant, but he knew that he did not have the strength of body or the eyes to do what he would have liked to do and he may have realized already that what he had learned as an Oxford lecturer and a reader in libraries could be put to good use in the end. The thirty-two years during which he worked in offices must be passed over briefly here. In Whitehall he found that he was someone whom colleagues liked working with and for and that he was good at administration and the running of an office—he kept office hours and liked others to keep them. Lady Welch wrote to me: 'At the M. of F. we would at tea time be a group of five or six; he would be the initiator and the centre of happy talk. . . . He was outgiving in all his ways.' He became Director of Bacon Contracts in August 1919. Three years later the Delegates of the Clarendon Press offered him a job as assistant to John Johnson who was himself Assistant Secretary to the Delegates. No doubt they had an eye to the future. They had come to know of Sisam's quality in the three years before he went to London and through the reports on books offered for publication which he had been writing for them in spare time in London. Johnson wrote in support in 1922: 'The best of Sisam's reports is that behind their severity they are constructive.... It is just that kind of severity by which the learned press would be most benefited.' Sisam admired the civil service, but he cannot have had much hesitation about accepting a post in an institution which he thought of as 'alert and unconventional' and 'a kind of island of good sense in the quagmire of loose thinking' (to Bishop, 7 January 1917). The appointment was made by the Delegates in October 1922. 15 October was his last day in Whitehall. He and Naomi went then on their first and last holiday in New Zealand. It was a shorter holiday than they had hoped for. In the spring he was back in London, giving witness in an arbitration over bacon contracts between the British Government and firms in Canada. His secretary, Mrs. Figgis, who was present, tells me that he was a formidably effective witness.

Sisam began work at the Press on 1 June 1923 and remained there for twenty-six years. A good view of him in this busy and happy period of his life is in Mr. Peter Spicer's memoir in *The Record*, which sums him up in the words 'Fundamentally, for all his mental powers, he was a simple man, with a countryman's values derived from his boyhood in New Zealand. That was the secret of his common touch, which enabled him to win and keep the affection, as well as the respect, of so many'. At first he

cannot have felt quite settled and satisfied, or he would not have been a candidate for the Rawlinson and Bosworth professorship of Anglo-Saxon in 1925. But from 1925 onwards, as Assistant Secretary, after Johnson became Printer, and as Secretary to the Delegates of the Press, after R. W. Chapman retired in 1942, he was in a position to use his skill for business and administration by overseeing the production of scholarly books. He is remembered at the Press for three things in particular: his instinctive know-how about book production which enabled the Press to become publishers of important series of scientific books in and after 1930 when they brought out Dirac's *Principles of Quantum Mechanics*; his interest on the arts side in making knowledge accessible through maintaining and adding to the number of good reference books, the Oxford Companions, the Oxford Dictionaries, and the Oxford Books of Verse; and his championship of refugee scholars, if they had something of real value to offer: as he said in a letter 'We are bound to limit that particular form of help to books which are not themselves a burden on the publisher.' I would like to mention Paul Maas (1880–1964) in particular here. Sisam wrote about him on 11 March 1940, 'Professor Maas for whom we have already a real affection' and 'I have to think over the problem of keeping Maas gainfully employed.' He wrote to Maas on 6 November 1940 that he had been reading Housman's introduction to Manilius and found it distasteful: 'I should have prescribed for him a daily reading in the life of some great scholar who was also not wrapped up in himself, e.g. Mabillon.' But Maas did not accept this as valid criticism of Housman. Miss Sisam tells me that 'He used to have tea with us every Tuesday, without fail; except that every fourth Tuesday he went to the Murrays instead.'

The files of correspondence at the Press show the amount of trouble Sisam took with his authors. That he was not always successful goes without saying: there are valuable books in existence which the Press hoped to publish and did not publish for one reason or another. As an officer he disallowed expressions of thanks for the help and encouragement he gave. People writing after 1948 have been glad to take the opportunity of saying what they felt: thus, Rudolf Pfeiffer in his *Callimachus* (1949), 'exstitit patronus vigoris et caritatis plenus Delegatorum nuper Secretarius Kenneth Sisam, qui cunctanti mihi persuasit, ut Callimachi non solum "Fragmenta", sed quae supersunt omnia ederem'; Fritz Schulz in his *Classical Roman Law* (1951), that Sisam 'suggested the book and greatly contributed to

making it a reality'; Mrs. Heseltine in her and Sir Paul Harvey's long-delayed *Oxford Companion to French Literature* (1959), that Harvey 'could not indefinitely withstand the persuasive enthusiasm of Mr. Kenneth Sisam'; Eugene Vinaver's long passage in the preface to his *Malory* (1970). Eilert Ekwall wrote to Sisam in February 1960, when a new edition of his *Oxford Dictionary of Place-Names* was planned, 'It should not be forgotten that the idea for the book was yours; if you had not made the suggestion it would hardly have been written.'

Sisam's work as a publisher was interrupted on two occasions, once briefly in 1926 when Whitehall borrowed him back to help keep down grocery prices at the time of the general strike, and again for a longer time in 1930, when he served as secretary of the Bodleian Commission. The Commissioners had a busy time of it. They were in Rome from 8 to 17 April, visited libraries in Germany, Switzerland, Denmark, and Sweden from 9 to 25 July, and saw thirty-nine libraries in the eastern United States, the Middle West and Canada in forty days' travelling between 5 September and 1 November. Their 150-page report, *Library Provision in Oxford*, was printed in 1931.

His work in London and Oxford left Sisam very little time for English language and literature. One of the few letters of the London period I have seen is to John Johnson in July 1920 telling him that he could not prepare Napier's English Historical Syntax for the Press: 'I cannot help feeling some amusement at the belief that I am a gentleman of leisure.' He did, however, manage one important piece of work immediately after the war, with his wife's help. It had its origin in a letter from Charles Cannan, 31 October 1918. The result, *Fourteenth Century English Verse and Prose*, an anthology of texts, with notes and a 33-page introduction, was published by the Clarendon Press in 1921. J. R. R. Tolkien contributed a glossary, at first printed separately and later combined in one volume. More than 60,000 copies have been sold. Sisam's introduction, the most widely read of his writings, is an admirable example of the 'haute popularisation' which he encouraged later in others. For half a century it has been a stimulating guide to Middle English literature. Probably the amount of work in Whitehall declined and Sisam was able to be a little more in libraries in 1922. He used British Museum and Oxford manuscripts for a paper and a review printed in 1923. The envelope of a letter to him from Max Förster survives, with postmark 26 June 1922 and address '17 St. Michael's Street, Oxford'.

After the Sisams moved to Oxford in 1923 the new house, Yatsden, built for them on Boars Hill, the new garden there, and two young children—Hugh was born in 1923 and Celia in 1926—were time-consuming. Work at the Press had absolute precedence over writing and holidays were for recreation; except in 1935 and during the war, they were always, after 1931, spent in Scilly which he said reminded him of New Zealand. Sisam refused to give the series of Ford's lectures at Oxford 1940–1: 'conditions in this strange war, as they affect the Press, are occupying all my mind'. But he felt able to give two single public lectures, the Sir Israel Gollancz Memorial Lecture in 1933 and a lecture on Humfrey Wanley at Oxford in 1935. In 1929 he gave the Society for Pure English a paper on word-division. The Society was the creation of Robert Bridges, whom Sisam had first met when he was staying on Boars Hill in 1915. He was on its standing committee from 1923 and wound up its affairs in 1948. He was a regular Sunday visitor at Chilswell in the last years of Bridges's life and Bridges made him his literary executor. The longest piece he wrote in the Press period, on Ælfric's Catholic Homilies and in particular the Bodleian copy of the Homilies, appeared in successive numbers of the *Review of English Studies* in the three years from 1930 to 1932. It commends 'the irregular study of Old English manuscripts' and 'foraging among manuscripts' and concludes 'The manuscripts at least have still plenty to offer.' These words influenced the present writer.

In London Sisam got to know two people who remained his friends as long as they lived and whose scholarly work influenced him. One was Robin Flower (1881–1946) at the British Museum. Mr. Davin tells me that when Flower visited Oxford Sisam scrubbed all his appointments: there was the mere pleasure of being with him and 'he knew that he would learn more in a day's talk with Robin Flower than he would learn in a month's talk with anyone else'. The other friend was Dom André Wilmart (1876–1941). He was in France for most of the war, but came to London in 1917 and was there, working for the Mission Militaire Française attached to the War Office, until January 1919. Sisam knew his work through Bishop, whose disciple he was. It is probable that they saw much of one another in the last year of the war.

Sisam was elected to the British Academy in 1941, when his sponsors were Allen Mawer, R. W. Chambers, Flower, and William Craigie. The recommendation mentions Sisam's skill

in palaeography, so perhaps Flower wrote it. In the year of his retirement from the Press he was given an honorary degree by Reading University and became a Grand Knight of the Icelandic Falcon.

Sisam was just sixty-two when he left Oxford for Scilly. From then on Middle Carn was his home. Except in the first year or two he hardly ever left St. Mary's and was never further east on the mainland than Cornwall. Efforts to get him to Oxford and Cambridge did not succeed. In a letter to Dorothy Whitelock in February 1953 he said: 'The Press is always urging me to make the journey; but I feel my infirmities: the minimum of Oxford hospitality would be too much after years on milk diet here; and besides, I am like the ass who knows his stall, easily worried by change.' The white house he had had built for him in 1937 he named after the carn which rises immediately behind it. It stands on the east side of Old Town Bay, facing south-west across the bay, and is separated from a shore of low rocks only by a narrow strip of garden and a narrow road unused by cars beyond the house. Middle Carn fish is gutted among the shore rocks, but for his boat Sisam had to go nearly to Old Town: the 200 yards was about the extent of his walking. His abiding pleasure was to go out in his boat whenever possible from boat-launching day at Easter to boat-hauling-up day in October and to take what he could from the sea, mainly pollock and mackerel. He wrote to Miss Whitelock on boat-launching day, 24 April 1951: 'We are like those little beach sandhoppers, which the high tides of summer throw into wild excitement; and I doubt I shall do much more work for a long time.' Mrs. Sisam died in March 1958 and from this time Celia, with a job at Oxford, kept house for her father in vacation time. In summer visitors came, his friends from the Press and Celia's friends: in early October 1958 Celia and D. M. Davin were with him 'and my incompetent housekeeping takes up all my time on such pleasant occasions' (letter to D. W., 6 October). In winter one may suspect that he was lonely from 1958 onwards, but if he was he made up for it. There was talk with Old Town friends and especially Mr. Roland Gibson, his nearest neighbour, Mr. Alfred Jenkins, who looked after his boat, and Mrs. Arthur Sherris, who helped him in the house and on whom, more than anyone else, he depended in his latter years: also with the workmen who came to do repairs to house and boat and figure in the letters as a cause of distraction. He had his garden and the

wireless and books and a succession of beloved black cats: the cat the Sisams brought with them from Oxford figures delightfully in a letter to Miss Whitelock, 4 March 1951: 'The rough and noisy journey down, and the horror of emerging on a bare sea-coast . . . caused something like a nervous break-down at first. In this time, he comforted himself by treating me to all the conversation of a cat family, and it is very curious . . . he watches tyrannically to see that I never get up late in the morning.' He had also his interest in the people, the history, and the stories of Scilly. His voice—and his laugh—can still be heard telling some of the stories in recordings made by Mr. R. M. Baxter. He contributed nine pieces to *The Scillonian* between 1949 and 1962, four of them appreciations of Old Town people, Richard Phillips, Israel Pender, Frank Phillips, and Edgar Ashford. Richard Phillips who died aged 92 in 1950, interested him particularly: 'he could hardly read, but had a fine sense of the distinction between what he had witnessed and what he had heard tell. I doubt if an educated man could ever attain it' (to D. W., 16 July 1950). He liked people to get their rights and was used as a sort of poor man's lawyer in Scilly. Some Scillonians supposed that he was a retired lawyer.

Finally, there was his continuing interest in Old English literature. The hour for writing was early in the day. Not much of it was done after 9.30. Dislike of the physical process is a recurrent theme in letters: 'I hate writing with a pen.' Pencil was better. He did not type and said he had been spoilt for writing by his good secretaries in London and Oxford. He thought of his hand as an illegible scrawl, but wrongly. It is quick scholarly writing, with more or less of an upward slope and remained essentially clear to the last. Papers intended for printing were sent to Mrs. Bull, his former secretary at the Press, or, if short, to Celia.

In discussing the scholarly work Sisam did in Scilly a distinction should be made between the first eleven years and the last twelve. In the first period there was always something on hand and especially four things, the papers, old and new, which went to make up *Studies in the History of Old English Literature*, the long paper 'Anglo-Saxon Genealogies', the long paper combating Sherman Kuhn's ideas about the Vespasian Psalter, and *The Salisbury Psalter*. *Studies*—'most of them are concerned with problems of textual transmission'—consists of five papers and parts of two reviews published in journals between 1916 and 1946, a first printing of the lecture on Wanley, and six other

pieces. In the newly written pieces there are some passages which refer to manuscript readings and problems: for them Sisam either had his old notes to go on (pp. 110, 125) or had to get his information at second hand (pp. 143, 146). *Studies* was assembled and got into shape mostly in 1950 and 1951. He was working on 'Seasons of Fasting', the last piece to be written, in February 1952. When it was finished with he turned to the, as he said, 'crazy' subject of Anglo-Saxon genealogies, begun before he left Oxford, taken up again in January 1949, when he was settled in at Middle Carn, and put aside soon afterwards in favour of *Studies*. It was a main occupation of 1952 and the first half of 1953. In 1952 a new subject for work appeared as a result of Miss Whitelock's suggestion that he should refer in the *Studies* reprint of 'Cynewulf and his Poetry' to what Professor Kuhn had written about the Vespasian Psalter. Sisam resisted this—'*littera impressa manet*'—(to D. W., 1 March 1952), but the suggestion bore fruit in the end in 'Canterbury, Lichfield, and the Vespasian Psalter', published in 1956: he was working on it in 1954 when he wrote to me (in May) about the date of the added word *nostro* in Tiberius C. ii. The last major task was the Salisbury Psalter. The time had come when his daughter could give him substantial help with the work he had begun as a B.Litt. student and had given up in 1915. In June 1954 he told me in a letter that 'Celia is—or is supposed to be—immersed in Salisbury Psalter 150 which was too long for me. But I hope she will see it through at last. My part will be to counsel her against perfectionism and other bars to publication.' His part was a good deal more than that. On 12th October 1958 he was in a position to write to Dorothy Whitelock: 'As you know, Celia and I have done with the Salisbury Psalter—a very narrow and technical piece of work. . . . We do throw some light on the behaviour of scribes in good scriptoria . . . and on the number of MSS. of a common text that must be reckoned with. I think the tendency is to bring obviously related MSS. too closely together.'

Two principal pieces of work come into the final period of Sisam's life. The letter from which I have just quoted continues 'Next we propose to work on an *Oxford Book of English Verse 1100–1500*, to which my contribution will be little more than experience.' The *Oxford Book* came out in 1970. Miss Sisam tells me that the translations of Layamon and the Gawain poet are her father's and that he revised texts, glosses, and preface and 'confirmed the selection. . . . He was the arbiter, whenever there was a difficulty.' In March 1961 Sisam told Dorothy Whitelock

that he was not doing anything at the moment, 'But from time to time I think about *Beowulf*.' His thoughts took printed form in *The Structure of Beowulf*, 'too short for a booklet, too long for an article' (to D. W., 4 August 1963), which appeared as a small book in 1965. His last published work, written when he was close on 80, was a review for *RES*. There was no failure at this time of his skill in clear exposition, as I know from the letters and long notes he sent me in 1966 and 1967. At least two pages I wrote then about his old teacher, Napier, are direct quotations of what he sent to me.

Sisam had been a fellow of Merton College when he was Secretary to the Delegates. In 1964 he was made an honorary fellow. His election as a Foreign Member of the Finnish Societas Scientiarum Fennica in 1970 gave him pleasure in the last year of his life.

In a letter to me on 24 June 1953 Sisam said of Dorothy Everett, 'She had good judgement as well as learning, and judgement is among the rarer gifts.' As a rule, he too judged rightly. It was part of his strength as a man of affairs. For example, when war broke out, he saw that the Press ought to lay in as large a stock of paper as possible: paper would never again be as cheap as it was in 1939. In his writing he often made telling points about simple things which other people had misjudged or passed over without reflecting on the difficulties. Was it likely that the early kings in Anglo-Saxon England named their sons so as to produce a 'perfect verse pedigree' ('Genealogies', pp. 300–1); or that King Athelstan specified a *ram* as the monthly food of a pauper (*Studies*, p. 240); or that abbot Brihtnoth of Ely was murdered by having heated sword-thongs thrust into his bowels: 'It is not easy to realize this process' (*Medium Ævum*, xxii. 24)? Are there not easy explanations for the use of the words 'gepalmtwigoda' and 'stefn' (*Medium Ævum*, xiii. 34; *RES* N.S. xiii. 282)? Many of his papers are arguments for views which he held strongly or thought very probably right: that certain texts in Lambard's *Archaionomia* are not authentic (*Studies*, pp. 232–58); that there is no reason to suppose that the Vespasian Psalter and other manuscripts associated with it by Professor Kuhn come from Lichfield (*RES* N.S. vii); that the Anglo-Saxon genealogies are not primitive documents, but fabrications made probably in the late eighth century ('Genealogies'); that the Beowulf manuscript is a collection of marvellous stories, a 'Liber Monstrorum', put together deliber-

ately in the second half of the tenth century (*Studies*, pp. 65–96); that the Vercelli book was taken to Italy in the first half of the eleventh century (*Studies*, pp. 113–18); that Anglo-Saxon poetry was not accurately transmitted (*Studies*, pp. 29–34); that VI Æthelred is Wulfstan's 'exposition of the laws in V Æthelred and L for parish priests in the diocese of York' soon after V Æthelred was issued in 1008 (*Studies*, pp. 278–87).

Sisam's opinions about some things, the importance of manuscripts, perfectionism, proof correcting, have been touched upon already. I add here some passages, mostly from letters to Dorothy Whitelock. 'I work mostly by thinking of possibilities and later testing them' (to N. R. K., 31 May 1932). 'I think editors should edit, and not produce inferior "photographs" of MSS.' (to D. W., 4 February 1950, on manuscript punctuation). On a subject on which you are not an expert, 'don't quote with approval or back the opinions of others . . . I was taught the lesson painfully by Edmund Bishop' (to D. W., 13 September 1954, on the work of a younger scholar). Translations 'invaluable, whether or not one knows medieval Latin' and 'Translation helps one to cover a lot of ground easily' (to D. W., 28 January and 9 March 1955, apropos of her *English Historical Documents*). 'I was never a good note-taker and never looked forward to the day I couldn't see a Bodleian MS.' (to N. R. K., 20 July 1955). 'I like some textual problems that have no more practical usefulness than a problem in pure mathematics' (to D. W., 12 October 1958, about the introduction to the Salisbury Psalter). 'Often we must be content with probabilities' (to D. W., 11 July 1960: this was something he had from Edmund Bishop). 'I feel myself drawn to the factual and obvious things that don't make for novelty' (to D. W., 4 July 1963, when he was thinking about Beowulf). 'On *Beowulf* I am deliberately controversial. I think we must have speculations to make any broad advance, and they are the better if they are clearly stated as opinions or inferences from assumptions' (to D. W., 9 May 1965, on *The Structure of Beowulf*). Passages in his *Medium Ævum* review of the edition of *Salomon and Saturn* by Robert Menner (of whom he had a high opinion) help us to appreciate how he became, as B. J. Timmer said in a letter to him, 1 June 1956, 'a past-master in working out and presenting . . . a long sustained argument'. He found in the edition some signs of 'the modern fault of sprawling over all the fields of scholarship that border on Old English Studies', 'an inclination to follow interest beyond the limits of relevance, and a reluctance to sharpen the edges of

hypotheses and to press them home until it can be seen whether they fit together cleanly'. He noted that 'scholars like Sweet, Sievers, Zupitza and Napier who defined with professional strictness the field in which they were expert, had the advantage, I think, in rigorous and penetrative methods'; Napier had learned about *fach* from the Germans and Sisam had learned from Napier. And he put in a plea for 'more rigorous methods, more concentration, more pruning of those unsuccessful investigations which are so profitable to the investigator himself'.

NEIL KER

BRUCE DICKINS

XVIII

BRUCE DICKINS
1889–1978

THOSE of us who knew Bruce Dickins only in his later years, when his professional excitement in his own field had rather worn away, remember him as a Grand Old Man of early English studies; as a Cambridge character, gruff but loveable; a man of lively and wide-ranging mind, proud of a fine memory; a lover of the old and familiar, whose stories were of the past but who gladly made new acquaintances and was eager to hear their discoveries and promote their interests. His temper was disciplinarian, but he made easy contact with the undergraduates of his college, and when they returned to Cambridge in later life they remembered him with affection. A haunter of bookshops and libraries, he often deserted them for college and university playing fields. In his day he was a sportsman of modest talents, yet he admired athletic prowess in others. A loyal and pious churchman, his Christian charity sometimes faltered when he assessed his contemporaries and juniors. His figure was unmistakeable; burly, energetic, and ill-clad in an outfit for all seasons, he cycled with ponderous dignity through the Cambridge streets or progressed with a peculiar rolling gait, like the bear that many people thought him. Careless of many of the formalities of social life, he was meticulous in others, and criticized severely those who fell below his standards. Though he was often outspoken, in some subjects —notably in his family and private life—he was far more reticent than most men. For us, then, it is hard to get behind the man we knew in the enjoyment of his *otium cum dignitate* to find the working scholar of his prime. In writing this memoir I have been fortunate to have the help of a large number of colleagues, pupils, and friends of his who have shared with me their experiences of Bruce Dickins, and I have also had a short account that Dickins composed about his early life, full of the terse self-irony so typical of his writing as well as some of the regretful melancholy of his last years.

Dickins was born in Nottingham on 26 October 1889. His parents were of farming stock, and as a boy he spent a good deal of his time with grandparents in South Lincolnshire. From there he derived country lore of a popular kind, as well as the countryman's deep distrust of the amenities of rural life. Seen

from his last years his childhood was an unhappy one. Thence perhaps came his reluctance to speak of his family, and also perhaps his lifelong uncertainty in his achievement, which he revealed only to his close friends. He was a pupil at Nottingham High School, beginning as a classic and then, when he realized he would never get an open award at Oxford or Cambridge on the strength of his Latin and Greek, moving to history. Both studies fed his later work. It was as a historian that he won his exhibition at Magdalene College, Cambridge, in 1909. He was disappointed with the first part of his History Tripos, and the great H. M. Chadwick had no trouble in getting him to move to Section B of the Medieval and Modern Languages Tripos, to read Anglo-Saxon and related languages and literatures. Despite sickness and bereavement in his final year, his First with Distinction came, almost as a matter of course, in 1913.

In his eighties Dickins drew a picture of his undergraduate days. He saw himself as a poor, shabby, and graceless provincial entering a dazzling new world, but by his circumstances being unable to take much part in it. He spoke warmly of Magdalene, and particularly of the friendship and kindness of A. C. Benson and Stephen Gaselee; but he had to subsist on the small income from his scholarships and his meagre savings. He did without what he could not afford, took refuge in his work, reading and attending lectures far beyond the calls of his subject, and finished without a penny of debt; but the feeling of poverty lasted through his life.

On his graduation the college generously gave him, from its modest funds, a research studentship of £100 and this, together with a Nottinghamshire County Council award of £45, put him in comparative affluence, and allowed him to begin his first important piece of research, a comparative study of a group of poems in early Germanic languages. In 1914 he was offered a Cassel Studentship and planned to spend a year at the University of Heidelberg, but the Kaiser and Mr Asquith thwarted his plans. Not at first taken for military service he worked for the War Office in postal censorship, and there gained a deal of practice in foreign languages and a sound distrust of the administrative skills of the public service. In July 1917 he was at last accepted for the war, and in September was drafted to France where he served, as he himself said 'without distinction', seeing 'very little action and a good deal of discomfort', until January 1919. Perhaps at this time began his interest in the life and history of the British Army that

enriched his writings and his conversation many years after. On demobilization he came back to Magdalene which elected him to a Donaldson Bye-Fellowship. This gave him a stipend of £100 a year, but without rooms, halls, or commons. It was generous for a poor college, but not enough to live on at that expensive time, and Dickins determined to leave Cambridge. He used to tell how he applied for an assistant keepership in the British Museum; the museum delayed too long and he received its offer only after he had accepted a lectureship in the University of Edinburgh. It is a good tale, for Dickins would have been an excellent departmental keeper; for the biographer it is salutary to learn that the British Museum has no record of the application or offer. Edinburgh certainly took its opportunity and appointed him to an engagement that let him finish his teaching by March, and so complete his tenure of his fellowship by spending the summers of 1920 and 1921 in the libraries of Cambridge.

Dickins served Edinburgh University as lecturer and reader until 1931. His Cambridge reading and Edinburgh teaching, covering as both did an immense spread of topics, gave him the massive solidity of learning characteristic of the later man. At Edinburgh he taught the whole of the medieval and language syllabus of the English department, and years afterwards would chuckle over the number of teachers Edinburgh now employed to do what he had done alone. He introduced Old Norse to the syllabus, and developed his knowledge of Middle Scots, publishing notes on detailed readings in the texts as well as an edition of Henryson's *Testament of Cresseid*. The Edinburgh atmosphere he found stimulating (though he was sceptical about some lauded aspects of Scottish education as well as the Scots claim to a sense of humour), and contributions to the *University of Edinburgh Journal* show his respect for colleagues in various fields. He married here his able and great-hearted wife Mollie, daughter of Professor H. J. C. (later Sir Herbert) Grierson. There were two children of the union, a son William whose early death in Uganda was a bitter distress to him, and a daughter Jane who was his joy throughout his life and his solace in his last years. The work at Edinburgh was full and tiring, and towards the end of his stay he was eager to leave. In 1930 he applied for the Chair of English Language at Liverpool to which, however, J. H. G. Grattan was elected. His application for the Chair of English Language at Leeds in 1931 succeeded.

Now began a great period in Dickins's scholarly life. He came to a department that already claimed distinction in the study of early English. F. W. Moorman, J. R. R. Tolkien, and E. V. Gordon had held the chair, R. M. Wilson and A. S. C. Ross (both of whom were to become professors) were junior staff members, and his co-professor in English Literature was F. P. Wilson. Dickins found the grimy but vigorous West Riding atmosphere exciting, and always spoke enthusiastically of the life of town and gown in Leeds, of the variety of urban life and the comradeship of eminent fellow-academics. With R. M. Wilson and Ross he founded *Leeds Studies in English and Kindred Languages*, which, in its six volumes issued between 1932 and 1937, set standards of meticulous and elegant scholarship. Its founders subsidized the journal, and ploughed back the profits into a series of texts and monographs, while exchange periodicals went to the University (Brotherton) Library. A flourishing research school produced work on a surprising range of subjects, with Dickins supervising dissertations on different aspects of the English language, Old, Middle, and Modern, and on Old and Middle English literature and place-names. University and society year-books and journals show him in vigorous action which must have made him an inspiring colleague and mentor, setting an example in his own work for the Leeds Literary and Philosophical Society, the Yorkshire Dialect Society, the Yorkshire Society for Celtic Studies, as well as national bodies like the Viking Society for Northern Research whose president he was in 1938–9. The Second World War added to his duties, reducing the number of his colleagues and engaging him in local defence.

Dickins's old teacher, H. M. Chadwick, retired from the Elrington and Bosworth Chair of Anglo-Saxon at Cambridge in 1941, but the wartime state of the university stopped the post being filled. The chair was not advertised until 1945, when his friends persuaded Dickins to apply for it—reluctantly, he afterwards claimed. He was elected, and took possession on 1 January 1946. Corpus Christi College, whose magnificent library makes it a gathering-point for medieval studies, chose him to be a professorial fellow, and he grew devoted to a college whose solid churchmanship and sound conservatism (now no more) so suited his disposition. He identified himself with its interests and its members, became an expert on its history and architecture, and for many years displayed and cared for its splendid collection of silver, on which he spoke with authority.

He was an urgent supporter of its athletic teams, and would often stalk the touch-line exhorting them on; indeed in his late seventies he would still referee soccer matches when the prescribed official failed. Though a married man he kept in college during term, thinking that only thus could he properly serve it, and it became one of the two foci of his intellectual life, the other being the University Library. On High Table he was a vigorous diner and an energetic raconteur, though over the years his stories gained an oral-formulaic spareness that was disconcerting to those who had not heard them before. His range of learning made him a court of appeal and sometimes a centre of controversy. One of the more amiable foibles of the fellows of Corpus Christi is to keep a book in which are preserved, out of context, the memorable and often outrageous sayings made unsuspectingly on High Table or in Combination Room. On one occasion a colleague had been so rash as to disagree with Dickins on a point of fact well outside the Professor of Anglo-Saxon's usual territory. It was checked. Dickins was right. His laconic comment is recorded for posterity, 'It is never wise to assume that I am ignorant of anything.'

College life became important to Dickins since his tenure of the Cambridge chair was not as happy as his time at Leeds, and he often spoke of his regret that he ever left the North of England. He had private griefs, and his son's death on an adventurous expedition in Uganda cut at his heart. In public life he often felt he failed. *The Times* obituarist speaks of him as endearingly maladroit in university politics, and this, I think, is true. Himself forthright in speech and thought, he did not appreciate guile in others, or understand why a clear argument, clearly expressed, might not convince all men of goodwill. But politics is the Art of the Plausible, and Cambridge's favourite treatise on the academic branch of that art is F. M. Cornford's *Microcosmographia Academica*. In consequence, Dickins did not have that influence on his colleagues that his talents and good sense deserved. One field in which he sadly admitted his failure affected the subject he professed. In Cambridge he found himself responsible for Old English within the Faculty of Archaeology and Anthropology, a state largely the creation of his predecessor Chadwick. Dickins was sympathetic to the aims of archaeology, but his background was quite different from Chadwick's and for many years his experience had been in the whole range of English teaching, from the earliest records to his own day. The Cambridge set-up cut him off from the later

fields and their literatures. So throughout this part of his career one of the country's most distinguished Middle English scholars had no part in teaching or examining Middle English. He felt his rightful place and that of his department was in the English Faculty, and fought and spoke for that on several occasions, but he did not mount a planned campaign and it was left to his more adroit successor, Dorothy Whitelock, to bring Anglo-Saxon back into Cambridge English.

For all that these too were years of achievement. With Sir Cyril Fox he edited the Chadwick memorial volume, *The Early Cultures of North-West Europe* (Cambridge, 1950), contributing his felicitously named article, 'The Beheaded Manumission in the Exeter Book'. With R. M. Wilson he compiled an anthology, *Early Middle English Texts* (Cambridge, 1951) which became a standard undergraduate reader. He instituted a series of Occasional Papers of the Department of Anglo-Saxon, one of which was his own 'The Genealogical Preface to the Anglo-Saxon Chronicle'. At this period too he brought out, as Honorary Director of the English Place-Name Survey, the three-volume *The Place-Names of Cumberland* (Cambridge, 1950–2), and supervised the preparation of the two succeeding volumes devoted to Oxfordshire. He continued the inspirer and support of many learned societies, as the Cambridge Bibliographical Society, the Medieval Group, the Cambridge Antiquarian Society, and the John Mason Neale Society, serving several of these in formal capacity. He retired from his chair in 1957, and two years later was deeply pleased when, on his seventieth birthday, his friends and pupils presented him with a *festschrift*, paying just tribute to 'the wide knowledge and exact scholarship . . . which he has always placed so unselfishly at the disposal of others'.

In the Corpus Christi, Cambridge, library readers' book for 1913–14—just before the first Great War halted scholarship and ended an era—the last three signatures are Bruce Dickins, Kenneth Sisam, and A. S. Napier. To his name Dickins, still at that time writing an easily legible hand, added 'To study runes'. He had already touched on the subject in his short memoir of the eighteenth-century Bristol bookman Amos Simon Cottle. In collaboration with his Clare colleague M. D. Forbes Dickins quickly wrote two articles on the great monuments of Ruthwell and Bewcastle, challenging the eccentric views the American philologist A. S. Cook had expressed on their dates. Shortly afterwards appeared his first extended work, *Runic and Heroic Poems of the Old Teutonic Peoples* (Cambridge, 1915),

providing annotated texts of the English, Norwegian, and Icelandic rune poems, as well as of a group of heroic poems in Old English and Old High German. Thereafter and for many years, runes were part of Dickins's life. When he moved to Edinburgh he planned a runic corpus with his senior colleague Professor G. Baldwin Brown, Dickins to supply the philology, Baldwin Brown the art history. They signed a contract with the Cambridge University Press in 1920, and began a vigorous pattern of journeys, recording, describing, and measuring. A mountain of notes survives, but the book was never completed. Baldwin Brown died in 1932, and Dickins did not push on with it. A second big project began in autumn 1936 with a course of lectures on runes at University College, London. Again, part of the text survives, and Dickins intended to prepare the series for book form. Again a Great War intervened and blocked the plan. What remains publicly of Dickins's rune work is his edition (with A. S. C. Ross) of *The Dream of the Rood* (London, 1934, several times reprinted), and a group of notes and short articles on individual aspects and inscriptions. Runes are notorious for attracting the crank, for appealing to the lover of fantasy rather than of fact. Dickins responded with shrewd common sense. In 1932 he published a practical system of transliteration for English runes, practical because, in those far-off pre-xerox days, an ordinary typewriter could reproduce it with only slight adaptation. He cut through the nonsense that the learned had built round a group of Anglo-Saxon ring legends by pointing out how they resembled the gibberish of certain Old English written charms. And he commented, always sensibly if not always definitively, on a variety of runic monuments, Norse and English: on the Maeshowe runes and those from Pennington and Conishead, the 'epa' coin legends (where his identification of Epa as the seventh-century East Anglian king Eorpwald found no favour with numismatists) and the inscriptions of the Sandwich stone, St Cuthbert's coffin and, again with A. S. C. Ross, the Alnmouth cross, as well as a couple of monuments less clearly runic. Dickins's work on runes was always distinguished. For my taste it was too kindly; though critical, not incisive enough. As an example, he explained the Sandwich text most ingeniously, linking this difficult inscription with the equally difficult recorded Kentish name form *Theabul*, but he did not question, as some later investigators have done, the long-accepted reading of the characters.

It is a fact that *Runic and Heroic Poems* was too ambitious a

work for a man as inexperienced as Dickins was in 1915. At that stage he needed tauter supervision by a mature scholar, as well as much more time to develop the complex subject he faced. Among the reviews of the book was an icy one by Allen Mawer, then Professor of English at King's College, Newcastle-upon-Tyne. While admitting Dickins's erudition, vigour in translation, and innovative use of archaeological evidence, Mawer attacked the book's technical imperfections, its errors and unacknowledged emendations, mistakes or omissions in the notes, and inconsistencies in arranging the materials. Dickins learnt from this review, for thereafter his work showed him careful to avoid the weaknesses Mawer seized on; but he was deeply hurt by the criticism. Though in later life he admitted its justice, yet he added that, in consequence, he had vowed never to write another book. And he never did, save in collaboration. Perhaps this was a later rationalization, and the real effect of Mawer's comments was to push Dickins in the direction his talents and delights inclined to, towards the small enclosed problem and the careful and detailed citing of evidence, in which he could exploit 'the curious and intriguing byways of his knowledge'.

The result was that Dickins did not develop into the sort of scholar so often celebrated in the Academy's memoirs—H. M. Chadwick and R. W. Chambers stand out within his own field. They were famed, and swiftly recognized, for a relatively few great works that shaped anew early English studies. Dickins published freely, but as a miniaturist. 'Where somebody else would have written a book, he wrote an article. Where another would have produced an article, he composed a note.' Typical of his work during the next decade are the notes he sent to *The Times Literary Supplement*. He would take a disputed or obscure reading, often in a little-known text, and disclose the inadequacy of existing explanations. Then would come his alternative, and this he would support on evidence that few others would have come upon since it derived from his pleasure in out-of-the-way browsing. His exposition was always sensible and often revealing. For this type of writing he developed a crisp, laconic style and a no-nonsense tone, wasting no space on otiose words or observations.

Another typical Dickins study was the short monograph in which he put out the *editio princeps* of the Middle English alliterative poem, *The Conflict of Wit & Will*. This had all the qualities to attract him. It was obscure. It was fragmentary,

surviving only by chance—on parchment slips used to mend a rare printed book, a York Missal of *c.* 1507 in the Cambridge University Library. The text had no great literary merit, but considerable interest as recording a theme that the editor could trace from the early thirteenth-century tract *Sawles Warde* through a sequence of little-known writings down to the seventeenth century. The poem survived in a single hand which, if not exceedingly difficult, was tricky and obscure at times. The story needed piecing together, and the text needed supplementation, often from parallel phrasing in other Middle English poems. There were occasional corrections to suggest, and ample opportunity for lexical and semantic examination of unusual words.

Dickins's notes for this edition are extant, and his time-table of work shows how swiftly his mind responded to a challenge, and also perhaps how reluctantly he directed his thoughts towards publication. In the *Cambridge Review* for 3 May 1929 H. R. Creswick, then the Cambridge assistant under-librarian, announced the gift of the missal, with the comment, 'Among the fragments used to repair the edges of the leaves ... are also several pieces of a Scottish alliterative composition which has not yet been identified.' Dickins, then in Edinburgh, sprang instantly upon this unknown Middle Scots poem. By 7 May Creswick was already writing back to him to define the text more precisely (it was 'Northern' rather than 'Scottish') and to offer rotographs of the fragments. By 21 October Dickins had produced provisional transcripts for Creswick's comment, as well as an introduction. He then took a long time to complete the job, partly I suppose because his production was slowed down by his move to the Leeds chair. He had to check details of the readings of this difficult manuscript, and made five visits altogether to examine it. He was dissatisfied with the introduction and recast it completely, remodelling the literary commentary and cutting out a detailed phonological examination of the dialect. It seems a lot of effort to put into an undistinguished piece of Middle English verse. Maybe Dickins thought so too, for the work languished until 1937 when he published it, alongside R. M. Wilson's edition of *Sawles Warde*, as a monograph of the Leeds School of English Language.

This central period of Dickins's scholarly life is full of good things, and several of his papers stand out as classics of their kind. 'The Cult of S. Olave in the British Isles', *Saga-Book of the Viking Society* (1939), xii, 53–80, shows something of his formidable

range and curiosity. Briefly he traced the cult of Norway's patron saint from the battlefield of Stiklestad, through Adam of Bremen's history to the Scandinavian writers of the later Middle Ages, and then linked it to the British Isles by reference to the *Anglo-Saxon Chronicle* and early charters, citing service books, church dedications, martyr and relic lists, place-names, feast-days, seals, manuscript illuminations, church screen paintings, sculptures, painted glass, and even St Olave's Dock on the south bank of the Thames and St Olave's Railway Station in Suffolk, as evidence of the saintly royal bandit's impact on these islands. For the delightful 'Yorkshire Hobs', *Transactions of the Yorkshire Dialect Society* (1942), vii, 9–23, he gutted a mass of popular writings, medieval and modern, using his skills in philology, place-names, and textual criticism to illustrate north-country beliefs in the good-natured goblin who helped farmers and tradesmen with their toil. In 'The Day of Byrhtnoth's Death and Other Obits from a Twelfth-century Ely Kalendar', *Leeds Studies in English* (1937), vi, 14–24, he gave a precise demonstration of how to probe a text to make it give up its disguised historical information. 'J. M. Kemble and Old English Scholarship', the Sir Israel Gollancz Memorial Lecture for 1938, shows Dickins as biographer. He draws together the threads of family, political, social and scholarly history, and passes a shrewd critical judgment on Kemble's lasting contribution to Anglo-Saxon studies. And in 'English Names and Old English Heathenism', *Essays and Studies by Members of the English Association* (1933), xix, 148–60, which *The Times* obituarist chose as his model paper, Dickins wrote a seminal study on the pagan religion of the Anglo-Saxons as the place-names record it.

Toponymics was a field that Dickins made peculiarly his own. The English Place-Name Society's first volume appeared, in two parts, in 1924. Dickins gave it a masterly review in *Modern Language Review* (1926), xxi. Though he had as yet written little on place-names, his comments revealed that he had read and thought deeply about them. He welcomed the project generously, but corrected and added to the second part of the volume in a group of notes that showed him ranging from Bede to Leland, from the cross at Oswestry to the gravelly beaches of Shetland; in short, which stressed how widely the place-name scholar must wander looking for his raw material. As a result the directors of the survey attached him closely to the project, wisely thinking it better that he should correct the

proofs from within than attack the books from without. Volume III of the series *Bedfordshire & Huntingdonshire*, published in 1926, is the first to acknowledge Dickins's contributions. From then until his death he served the society devotedly. He acted as Honorary Director in the difficult years 1946–51, and it was his determination that saw the three volumes of *Cumberland* through the press, with a typically wry introductory comment that 'the General Editor declines to take more than a modest share of the responsibility for the delay in publication'. The county is a difficult one, its early history only sporadically recorded. Dickins's introduction is a classic demonstration of how the name-scholar, with a close knowledge of the geographical, administrative, and ecclesiastical regions of the county and broad skills in philology and literature, can supplement the sparse information that historical writers give.

But this formal period of service is only a small part of the debt the society owes to Dickins. Right to the end of his life he read through the draft or proof entries of the county volumes, producing new examples from a well-stocked memory, and noting with hawklike eye any typographical solecisms. Most of these volumes show how his alert and flexible mind enriched the approach to the meaning and background of place-names. For instance, the Derbyshire volumes of his devoted friend and pupil Kenneth Cameron show Dickins deploying his knowledge of rare and specialized words, as in *Conjoint Lane* (*congeon*, 'dwarf, imbecile'), *Malmanyates* (*molman*, 'one who held land for which he paid rent in commutation of servile customs') and *Kaffehouse Croft* (*caff-house*, 'a compartment connected with a corn-threshing machine for receiving the chaff'); his recognition of well-known words in unusual meanings, as in *Deaf Hazzle Meadow* (*deaf hazel*, 'hazel that produces nuts without kernels'); his freedom in drawing examples from rarely read and early texts, as in *Bear Stake* (cf. *Lamentacio Sancti Anselmi*, l. 173); the way in which his work in one field overflowed into another, as in *Blakemoncros* (cf. the *Blæcmann* runic crosses of Maughold, Isle of Man). He would compare two place-names in the same neighbourhood to cast light on both, as in *Kempshill Farm* and *Marvel Stones*—did ME *kempe*, 'champion', in the first imply that the second were traditionally associated with some stupendous feat of strength? He would try out suggestions for new meanings—does the element *sceacol* in *Shallcross* (*Schakelcros*) *Manor* imply a wheelhead cross? For the West Riding volumes he used his Leeds experience of local dialect words and minor

street names. For the Lake Counties he pointed out how the toponymist can benefit from reading the Lake Poets; for the hunting counties how significant could be the works of the hunting essayists and novelists.

From his early years Dickins expressed his passion for books in a compulsive collecting. His first library was comprehensive. A provincial scholar, writing to ask him to check an abstruse reference in Cambridge University Library, would get a prompt reply because the book was on Dickins's own shelves. In its final state he housed his collection in his college rooms, to the terror of the fellow who kept beneath him and who feared the floor would not sustain the weight. When he moved out on retirement, his small flat had not space for such a library, and he had to sell it. At once he started again, and some claim to have seen him looming over David's book-stall in Cambridge market place, buying back volumes he had sold. In course of time this second library had to go, and Dickins set to a third time. When he left his flat to go to live with his daughter, Dickins generously let many of his books go to college and faculty libraries and to the shelves of his friends. Those housed in his presses were only a small part. Books were everywhere, piled in heaps on the floor and filling wardrobes and chests of drawers. It was more than a love of books, it was an infatuation, and the range was extraordinary, for everything in humane learning interested him.

The same is true of his knowledge, matched by his immense memory that allowed him to call up his information when it was asked for. 'Tell me, Bruce, which was Patrick Brontë's college in Cambridge?' A pause of about a second as his brow wrinkled, then, 'John's'; another pause, 'He was a sizar, I think.' And of course he was. This is an example from his eighties, when Dickins's memory remained unaffected by age. Right through his life he was able to use in this way the material he collected in his voracious reading, and this gave a distinctive flavour to his compositions. Not only could he illustrate the obscure from a little-known, often distant, source of light; he would also broaden his treatment—and delight his readers—by a recondite reference. A point in a Middle Scots text would gain from a knowledge of heraldry, or of Scots legal terminology, or of the introduction to Speght's *Chaucer*, or of Donne's *The Second Anniversary*.

Outstanding was the quality of Dickins's prose. His earliest publications show the beginnings of the sharp, clear written style that matched his directness of speech. From his manu-

scripts—when they can be read—it looks as though this way of writing came naturally to him, and that he had no need to recast and slim down his wording to achieve that spare effect. He was master of the throw-away phrase and the well-turned summary sentence. Of an early librarian of Corpus Christi, Cambridge, 'a Scot by origin and a drill-sergeant by temperament'; of a nineteenth-century Kingsman, 'he wore his hair too long and was critical of all authority'; of an idealist in politics, 'in Spain, striving to re-establish the constitution in a country where constitutions have never been robust'; of a fervent spiritualist who arranged to meet his family at a specified place after his death, 'They kept the appointment; he did not.'

Dickins was not, I think, a good lecturer for he did not project his generous and warm personality beyond the rostrum. His style was too dry, and he seemed determined to give his hearers not just the text of his paper but the footnotes and detailed bibliography as well. In teaching classes of students he was, as several of his pupils have painfully assured me, quite uncompromising. He expected a readier understanding and a greater original knowledge than some of them—and this includes men who later achieved repute as scholars—could bring to his classes. In consequence many of his pupils did not get from him as much as he should have given them. In fact it was as a supervisor, official or self-elected, that he was most successful in introducing the young to the essence of scholarship. Here his breadth of learning, supported by a massive bibliographical technique, made its impression. The beginner had first to convince Dickins that he was a conscientious and eager worker; once he had done it, Dickins became a ready and tireless helper, following up references and seeking out new and unexpected sources of information. And not only the novices; scholars of great experience and distinction came to him for help and advice. It has been said that, had he published nothing himself, the number of books whose introductions acknowledge his assistance would justify his reputation as a scholar. Here too the range is astounding: an edition of the itineraries of William of Worcester, a book on medieval graffiti, a history of the Cambridge University Press, an edition of Bede's *Ecclesiastical History*, a translation of *Orkneyinga saga*, a dictionary of English rock terms, a version of the *Anglo-Saxon Chronicle*, a history of the Cambridge University OTC; and the line stretches out almost to the crack of doom.

Late in his life the scholarly world recognized publicly

Dickins's excellence. The Universities of Edinburgh and Manchester gave him honorary doctorates. He was self-deprecating over such honours complaining that he would have to buy new clothes for the ceremonies, but his secret delight was unbounded and not so secret as to lie hidden from his friends. In 1955 the British Academy awarded him the Sir Israel Gollancz Memorial Prize for his work in early English. In 1959 he was elected a Fellow of the Academy, and here his reaction was even more ambiguous. Though he accepted the honour he did not see why it should have been so long delayed, until well after his retirement and so, he felt, after the time in which he had vigour to pursue his own researches or assist those of younger men. To those of us outside the Academy, who cannot know how scrupulously its Fellows scrutinize those who might be thought worthy to join them, it is certainly hard to see why Dickins, acceptable in 1959, was not just as acceptable five years before, for he published nothing in the years between impressive enough to tip the balance.

The last two decades of his life show Dickins working freely in two fields. There are his many short articles on local and family history (which he often linked to the history of the army, navy, or the universities), and more important, his work in bibliography. He used to say he had taken up these studies because it would be discourteous to remain in Cambridge and embarrass his successor in the Elrington and Bosworth Chair by continuing in Anglo-Saxon, but this too was a rationalization. Both themes have roots in Dickins's past. His later historical and biographical studies were the natural successors of his earliest published writings on Magdalene worthies and of his British Academy lecture on John Mitchell Kemble. His bibliography developed from his love of scholarly detail and his passion for books and antiquity. As early as 1947, shortly after his return to Cambridge, he had arranged in the college library an exhibition of early books printed in Anglo-Saxon types, its catalogue replete with bibliographical minutiae and esoteric lore. Thereafter he printed a series of notes, often in the publications of the Cambridge Bibliographical Society which he helped to found, over which he presided from 1951 to 1958, and whose transactions he edited. His eminence in the field led the University to elect him Sandars Reader in Bibliography for 1968–9. This he welcomed as an honour and a recognition, but regretted it had come so late, in his 'eightieth year and subject to the frustrating infirmities of age, when one

knows perfectly well what ought to be done and lacks the power to do it'. For over twenty years he had worked regularly in the Parker Library of Corpus Christi College, and come to know its collections as few could. Many of its volumes show his annotations and cross-references. For his Sandars lectures he planned a set of three papers describing how the various groups of manuscripts and printed books came together in the library, and he set to amassing materials for this elaborate study. They proved too much for him. Having scoured widely for evidence, he found his slackening energies could not cope with sifting and presenting it, and at one time, despairing, he determined to give up the lectures altogether. His friends encouraged him, and as a last resort persuaded him to reduce his programme to a single paper, which was given on 25 April 1969 and printed as 'The Making of the Parker Library', *Transactions of the Cambridge Bibliographical Society* (1972), vi, 19–34. It surveyed Corpus Christi's earliest recorded books, and then defined Matthew Parker's collections and the circumstances whereby they came to the college, how the Elizabethan fellows built a library to hold them, and later librarians set about cataloguing them. The lecture has all of Dickins's old precision of detail and clarity of phrase and structure, but it was to be his swan-song. Though he published occasionally thereafter he felt too tired and discouraged to continue his own work. His memory, however, remained unimpaired by age, and his love of books lasted to the end. The last time I saw him I handed to him a new book on a topic I thought might interest him, but his attention was held by the printing. He scrutinized the opening page minutely. 'A very neat title-page that', he remarked. Then he pushed his glasses up to his forehead and peered at it for a time. 'The central device a shade too heavily inked perhaps. But otherwise you can hardly fault it.'

He still found an interest in his younger colleagues and friends and was ready to help and advise, but he gradually withdrew more and more into himself. During his wife's last long illness and after her death he lamented that he lingered so long in a world whose changes he deplored. For his last year he gave up his own home and was welcomed into that of his daughter who lived at Hilton, some miles outside Cambridge. He showed little of the insistent self-centredness that so often afflicts the old, and he changed his way of life so as not to intrude on that of the family he lived with. His modesty and his reluctance to impose on others' kindness meant that he came less and less

frequently into town, though his college and university friends were always glad to receive him. It was at Hilton that he died peacefully and with characteristically little fuss on 4 January 1978.

It was a long life, spent in the pursuit of humane learning. Looking over it and working through his writings I feel a mingling of admiration and regret. Admiration at the talent, and regret that the achievement did not quite match up to it. The interests were so broad and the scholarship so exact that they should have been brought together in a major work. This—apart perhaps from his contribution to name studies—Dickins was not capable of doing, and the full result of his enthusiastic devotion is probably best displayed in the works he encouraged. A younger Cambridge colleague of his has summed him up admirably, and the impression is one I have received from many of Dickins's friends: 'a kind, generous, learned man disguising himself as a disgruntled bull; not happy, I think, but undoubtedly helping where help was most needed.' It is no ignoble epitaph.

<div align="right">R. I. PAGE</div>

FLORENCE ELIZABETH HARMER

XIX

FLORENCE ELIZABETH HARMER

1890–1967

FLORENCE ELIZABETH HARMER was born at Mitcham, Surrey, on 14 May 1890, the elder daughter of Horace Alfred Harmer and Harriett Frances Butler. Her father, who was engaged in the export trade with South Africa and Rhodesia, soon brought his family to Stamford Hill, North London, and there Florence spent her childhood. She attended the City of London School for Girls, from which she went to Girton College in 1908 with a college scholarship. She read for the Medieval and Modern Language Tripos—in those days a separate English Tripos did not exist—and was placed in the First Class both in 'Mays' in 1910 and in the Tripos in 1911. Simultaneously, since this was before a Cambridge Tripos gave to a woman even the title of a degree, she took an external London B.A. Honours degree, obtaining a Second Class. She studied French as well as English, and she never lost her interest in French language and literature, and always enjoyed visiting France. The English syllabus included papers in Old and Middle English, and Florence stayed on a fourth year at college to take what was known as Section B, which consisted of more advanced Old English, and of Old Norse. In this examination also, in 1912, she obtained a First Class. During this final year she worked with a group of very keen students, most of whom made a name later in Anglo-Saxon or Norse studies; they included Nora Kershaw (later Mrs. Chadwick), Margaret Ashdown, Daisy Keatch (later Mrs. Martin Clarke), and Bruce Dickins. From him I gather that, though it was not until 6 October 1912 that Professor Walter Skeat died, to be succeeded as Elrington and Bosworth Professor of Anglo-Saxon by H. M. Chadwick on 26 November, most of the study of Old English and Old Norse was done under the latter; but I believe that Florence Harmer also attended classes given by Dr. Anna C. Paues, my own former teacher, a distinguished philologist and an excellent teacher.

Florence, though little given to reminiscence, always seemed to look back with pleasure on her Cambridge days, and to maintain an affection for Girton College. It is reported that she was rather reserved and shy at that time, mainly interested in her

work, but she did take a prominent part in running what was called 'The Yellow Back Library', which aimed at providing a supply of novels and other light reading. Throughout her life she never lost this interest in contemporary literature. The quality of her work was recognized by the college with the award of prizes in 1910 and 1912, and of a fourth-year Higgins Scholarship in 1911; and in 1912 she was awarded a college research studentship, which enabled her to stay on in Cambridge and begin to work under Professor Chadwick's supervision on the charters which she published in 1914 with the title *Select English Historical Documents of the Ninth and Tenth Centuries*.

This subject was suggested by Professor Chadwick, who already in Professor Skeat's time had begun to widen the scope of Anglo-Saxon studies in Cambridge from too exclusive a preoccupation with philology and with literary texts so as to include historical studies. He had realized that one of the big gaps in Anglo-Saxon studies was the lack of good editions of the vernacular charters, and Florence Harmer was the first of his students whom he set to the task of supplying this need.

Few charters of the pre-Conquest period, Latin or Old English, had been edited with an apparatus adequate for their criticism and interpretation. The great exception was the edition by A. S. Napier and W. H. Stevenson of *The Crawford Collection of Early Charters and Documents*, in 1895; only three vernacular documents were included in this. This book supplied later editors with an excellent model, and it would be hard to give higher praise to any edition than the comment of a reviewer of Florence Harmer's book, that she maintained the standards of Napier and Stevenson. Her edition consists of twenty-three documents of considerable variety, and includes some of very great interest, such as the wills of King Alfred and King Eadred; the agreement of Ethelred of Mercia and Æthelflæd with Werferth, Bishop of Worcester, about the fortification of Worcester; a remarkable letter to Edward the Elder which sheds light on King Alfred's legal decisions and on his reputation; and some accounts of litigation which are important for social as well as legal history. She provided accurate texts and sound translations; working through all surviving charter and chronicle material, she was able to date more accurately some of the texts; she provided for the first time a number of correct identifications of place-names, at a time when little reliable work on this subject was available,

and when it was usually necessary to collect the forms of the names and trace the history of the estates in order to establish their identity; and she was able to go beyond the dictionaries in her interpretation of some words. As reviewers pointed out, the notes were a valuable part of the book, for they showed a remarkable range of both historical and linguistic knowledge; many of these notes are still the best brief accounts on a number of topics. Her book has stood the test of time so well that when I included several of the same texts in my *English Historical Documents* in 1955, or in my revision of *Sweet's Reader* in 1967, I found that the long intervening period had added remarkably little; and when one remembers that she was working without the help of important contributions published by scholars such as J. Armitage Robinson and F. M. Stenton after 1914, one grasps more fully the extent of her achievement. The value of the book was immediately realized—by Dr. A. C. Paues, among others, writing in the *Girton Review*—and it was praised for its learning, accuracy, and good judgement. W. J. Sedgefield, however, noted with disapproval that her notes were 'frequently hesitating and inconclusive'—not altogether without reason, for she tended to put queries after identifications which were undoubtedly correct, and at times to state the views of other scholars without letting it be seen where she stood herself. It is hardly a vice to refrain from over-confident statement, especially in a young scholar; yet Professor Sedgefield had put his finger on a characteristic which she never completely outgrew, a caution and over-modesty which sometimes led her to express her views too tentatively and to claim less than her evidence warranted. This same modesty, an essential part of her character, made her, in later years at any rate, reluctant to initiate a line of action, though she could be a stout supporter of others whose views she shared.

This book was produced within two years. Between 1914 and her taking up of a lecturership in English Language and Literature in the University of Manchester in the Lent term of 1920, she taught English and French in various schools, from 1914 to 1917 at the Central Secondary School, Sheffield, from October to December 1917 at the King Edward VI High School for Girls, Birmingham, and from January 1918 to December 1920 at the Streatham Hill High School. One may surmise that she took those positions while waiting for an opportunity to do academic work. She appears never to have spoken to her later friends about these years of school teaching, but that means

little, for she very rarely spoke about herself at any period, not merely because of a modest reticence, but also because she was always so keenly interested in the present, and had such a lot of other things to talk about, that there was no time for personal reminiscence. I have come across two brief, mainly descriptive, reviews by her in the *Modern Language Review* during these years, one on A. R. Benham, *English Literature from Widsith to the Death of Chaucer*, in 1917, and one on Hubert Ord, *London shown by Shakespeare, and other Shakespearian Studies*, in 1918.

The whole of her academic teaching career was in Manchester, from 1920 until her retirement in 1957. She was made a Senior Lecturer in 1949 and a Reader in 1955. In 1964 the University of Manchester paid tribute to her services and to the honour which the distinction of her work had brought to it by awarding her an Honorary Doctorate of Letters.

Former students tell me that she was an excellent teacher, sound and stimulating, who lectured well, with great clarity and straight reasoning. She expected them to work. One of them writes of 'her galloping energy', and adds: 'However hard we tried, we could never keep pace with her, but her energy caused us to make greater efforts, week by week. She set us an objective, even though we could not reach it, and she made us desire to reach it.' Some of her students stood in awe of her, but all respected her integrity and fairness, and she aroused the affection of those who came to know her best. Her students were aware that her own work engaged much of her interest, often taking her away from Manchester, and that she had little time for trivialities, but they never felt neglected. She was warmly interested in them as persons, a stout defender of their interests, ready to help and advise in cases of trouble.

It is likely that, like many of us, she had to give most of her time in her first two or three years as a lecturer in deepening her knowledge of the subjects she had to teach. In 1923, however, she consented to take over the task of completing an edition which had been begun by E. Classen, which appeared in 1926 in their joint names as *An Anglo-Saxon Chronicle from British Museum, Cotton MS., Tiberius B. IV*. This work had been planned in accordance with a scheme devised by W. P. Ker, to produce 'a simple plain text with a minimum of notes, apparatus and preliminary matter, but with such help to the student as a short introduction and a careful glossary could give'. It is implicit in T. F. Tout's preliminary note that Florence Harmer

was not in full sympathy with this plan, and she confirmed this to me in later years. In this she was right. This version of the Chronicle, usually cited as 'D', deserved a much fuller treatment, and an edition without extensive notes to bring out the peculiar features of this version could be only of limited value. Had she been allowed to supply the desirable apparatus, she would doubtless have seen that this version supplied the key to the advance of the study of the Chronicle beyond where it had been left by Plummer. She had seen the lines on which further investigations should proceed, for years later, when I was working on these problems, she spoke with some appreciation of an article by Sir Henry Howorth in *Archaeological Journal*, lxix (1912), which, though not acceptable in its entirety, had realized Plummer's failure to pay adequate attention to the possibility of conflation of versions of the text. She was herself inclined to dismiss Classen's and her edition as of small account; but in this she was unfair to it. Since it supplies an accurate text of an important manuscript, some sensible emendations of corruptions, a good glossary, and a reliable list of place-name identifications, it is a useful book, as was recognized by the few persons who reviewed it.

Perhaps it should not be regretted that she was prevented from handling this text as she would have wished, for this might have deflected her from her scheme to produce a corpus of Anglo-Saxon writs, which was to be her major contribution to learning. Lady Stenton tells me that she came to Reading on 26 June 1926 to discuss this project with Sir Frank. She probably talked it over with Professor Chadwick about this time, on a visit to Cambridge, when through the good offices of Mrs. Chadwick I first made her acquaintance. She was very kind to me as a shy young research student, though I recollect that she put some searching questions about my work on Anglo-Saxon wills, which was then in progress.

To collect all the extant Anglo-Saxon writs and publish them in an adequate edition was a very big undertaking, and it involved much travel in search of all the surviving copies. She was single-minded in applying almost all the time she could spare from her teaching work to this task, very rarely letting herself be deflected from it by publishing articles or by writing reviews. In 1936 she published in the *English Historical Review*, li, 'Three Westminster Writs of Edward the Confessor'. These writs had never been printed before, and contained matters of interest, such as the mention of a 'churchwright', Teinfrith; he

was presumably connected with the building of Westminster Abbey, and she argues convincingly for the continental origin of his name. In the careful notes which she supplies, and in the acumen and sound sense with which she examines the problems of authenticity and of the relationship of these writs to other Westminster documents, we get a foretaste of the quality which distinguishes her later big work on writs.

In her early work, *Select English Historical Documents*, the choice of texts had meant that she was not brought face to face with the problem of authenticity to any great extent. Whether or not she was aware of Sir Frank Stenton's dictum in *Folk-Lore*, xvi (1905): 'It is a pretty safe rule that a land-book should be regarded as spurious until it has been proved to be genuine', she was careful to note any discrepancies in the indications of date in those Latin charters to which she referred and to record that a text was starred by Kemble or suspected by W. H. Stevenson; but she did not add views of her own either in confirmation or in refutal of these suspicions. But by 1936 she was much more concerned with the establishment of authenticity, and, of course, was familiar with the various works in which Sir Frank Stenton had illustrated the proper methods of dealing with charter material. In 1938 she made an important contribution to the study of Anglo-Saxon diplomatic in an amusing article in the *Bulletin of the John Rylands Library*, called 'Anglo-Saxon Charters and the Historian', which was occasioned by the fear that some false statements in J. E. A. Joliffe's *Constitutional History of Medieval England* (1937), based on mistranslation of vernacular texts or on uncritical acceptance of dubious documents, should receive a wide currency. Yet the article is more than a demonstration of individual errors and mis-statements, for it begins with a valuable, lucid exposition of the criteria for assessing the authenticity of vernacular documents, which had far too often been taken for granted. She makes clear the degree of familiarity with the Old English language, especially with the usages of charter Old English, and with the later developments of the language, that is necessary before linguistic criteria can safely be applied, and she illustrates the importance of studying what was 'common form' in the royal secretariat. Not long after this article she criticized A. J. Robertson's *Anglo-Saxon Charters* both in the *Girton Review* (1939) and in the *Bulletin of the Institute of Historical Research* (1940-1) for its failure to pay due attention to the question of the authenticity of the charters edited or referred to in the notes. She admitted,

however, that 'the editing of Anglo-Saxon charters is a task of great difficulty and complexity', and expressed appreciation of the many good qualities of Miss Robertson's edition.

She contributed an article to the volume of studies which was begun in 1945 in honour of Professor Chadwick by a group of his former students and, after his death in January 1947, dedicated to his memory and published in 1950 as *The Early Cultures of North-West Europe*, edited by Sir Cyril Fox and Bruce Dickins. This article, '*Chipping* and *Market*: a lexicographical investigation', is in part a by-product of her preoccupation with the problem of authenticity of alleged pre-Conquest documents, for some claims regarding the use of these terms in Old English had been based on dubious texts. With characteristic modesty, she says that her main concern is with terminology, but it is obvious that with equally characteristic thoroughness she has studied all the English and continental evidence relating to markets, fairs, tolls, and trade in general, and has brought together a lot of information of value to the economic historian.

As her presidential address to the Viking Society for Northern Research she spoke on 'The English Contribution to the Epistolary Usages of Early Scandinavian Kings', and this was published in the *Saga-Book* of the society, 1949–50. Like the article just mentioned, this shows the tremendous thoroughness and range with which she investigated any subject even remotely connected with the writs. Once again, her claims are modest; she says: 'I have merely attempted to provide a basis for further investigation and study.' But what she has provided is a detailed account of the use of seals in western Europe and of the devices, especially that of the ruler enthroned in majesty, employed on seals used in England and Scandinavia, as well as an important discussion of the influence of English diplomatic practices on Scandinavia, seen on a background of the general history of the relations between these countries. She argues with probability that the earliest known Danish royal seal, that of King Cnut the Saint, is descended from a lost seal of Cnut the Great. The interest of this study goes beyond that of English diplomatic, though it is of importance for this.

These articles gave an indication of the great range and depth of the work she was all this time putting into her edition of the writs. She was not free to give undisturbed attention to this. In addition to her lecturing, teaching, and examining in Manchester—not to mention the additional strains and labours of the war years—she was in demand as an external examiner in

other universities, including London (1948–52); and she was generous in giving time to answering the queries of research workers who consulted her. She became more and more involved in various learned societies. She was elected a Fellow of the Royal Historical Society in 1939, and used to come up to London to some of its meetings; she was regular in her attendance at the annual meeting of the English Place-Name Society, which she had joined as early as 1924, almost at its inception; after her election to the Society of Antiquaries in 1948 she was fairly frequently present at its meetings; she served on the Council of the Philological Society from 1942 to 1951, and was President of the Viking Society for Northern Research from 1948 to 1951. She greatly appreciated the contacts with other scholars which these visits to London gave her, but they were a drain on her time. Another cause of delay in the appearance of her book on writs was her meticulous conscientiousness, which caused her to check and re-check, and to reconsider conclusions previously arrived at. She continued this process even when the work was in proof; in her zeal for absolute accuracy she was ready to alter in a way that seemed to me reckless, sometimes for very minor gain. One had to convince her that the value of a suggested alteration was questionable, before she would let what she had written stand. This meant that the book took some time in going through the press.

Though some of us waited with impatience, when *Anglo-Saxon Writs* appeared in 1952, the wisdom of her refusal to be hurried was manifest. This book was, as Professor F. Mossé says, 'une véritable édition monumentale'. Sir Frank Stenton refers to it in his *Latin Charters of the Anglo-Saxon Period* as 'an edition which from whatever standpoint it may be regarded is a model of its kind'. Several reviewers used the word 'definitive'. The book gives a completely reliable text and translation of a set of documents of immense importance for assessing the quality of the administration of the later Saxon kings. Dr. H. M. Cam wrote in the *Girton Review* that previously 'no full-scale attempt had been made to set the Anglo-Saxon writ firmly in its place among the instruments of English government'. Yet it is far more than a definitive edition: it is an important contribution to the science of diplomatic, and its introduction, in addition to containing a skilful treatment of the problems of authenticity, and accounts of the history of the writ, of its relation to the diploma, of the methods and personnel of the royal secretariat, and of judicial and financial rights conferred

by writs, includes an excellent study of the intellectual background of the later Anglo-Saxon period. The book is also a positive storehouse of precise information on all manner of topics, both in the sections introducing the writs of individual religious houses and in the notes, while the list of Biographical Notes is a piece of exact scholarship of which the usefulness cannot be overvalued. Perhaps only those who have worked long on the sources of this period can fully appreciate the vast amount of labour that lies behind these succinct little biographies. It is therefore not only the authoritative work on writs; it is an indispensable reference book for the historian, linguist, literary historian, and diplomatic scholar.

This work brought her well-deserved recognition: she was awarded the degree of Doctor of Letters in the University of Cambridge in 1953; she was elected a Fellow of the British Academy in 1955 and awarded its Sir Israel Gollancz Prize in 1957; she was appointed a Reader in the University of Manchester in 1955; and she was made an Honorary Fellow of Girton College in 1957.

Apart from reviews, she published only one piece of work after *Anglo-Saxon Writs*, namely an article in the volume of studies presented to Bruce Dickins on his seventieth birthday, *The Anglo-Saxons: Studies in some Aspects of their History and Culture*, edited by Peter Clemoes, in 1959. In this article, 'A Bromfield and a Coventry Writ of King Edward the Confessor', she edits two writs which had escaped her net earlier, handling them with the mastery and the grasp of all relevant material which we had come to expect from her. The Bromfield writ, the only surviving writ relating to Shropshire, gives interesting information on an Anglo-Saxon 'minster' of secular canons, but its text is corrupt, and no one else could have emended it so successfully; the Coventry writ, of which she had only known a Latin version previously, is shown by this vernacular version to be, as she had surmised, genuine, and it lends itself for comparison with the forged charters of this house discussed in the *Bulletin of the Institute of Historical Research*, xxvii (1954), by Miss Joan C. Lancaster, who called Dr. Harmer's attention to this modernized version of an Old English writ.

Though she published no other studies after 1952, she was by no means idle. She held her Readership in Manchester until 1957 and continued to act as external examiner, even after her retirement, when she examined for the University of Bristol from 1959 to 1960, and for that of Cambridge in 1962. She also

continued to attend the meetings and functions of the British Academy and of various societies. From 1960 to 1963 she was a member of the Council of the Royal Historical Society and of its Library and Publications Committee, and from 1963 to 1966 she served on the Committee of the Ecclesiastical History Society, of which in 1961 she had become a foundation member. During all this time she was an active reviewer.

As long as she was engaged on the writs, she rarely accepted books for review, but between 1952 and 1957, the year of her retirement, she reviewed a dozen books, and, after this time, twenty-two. Taken as a whole, they make a useful contribution to Anglo-Saxon studies. She was fair-minded, quick to recognize quality and express appreciation. She never wrote to display erudition or cleverness, and they are often short. But she was very conscientious in examining closely the work under review, not taking its accuracy for granted, and her judgement was shrewd. She could see when some insecurely based idea was becoming accepted owing merely to repetition, as when she warns against the view that the West Riding was part of Mercia in the time of Penda and after, or that William the Conqueror's writs written in English must of necessity be dated early in his reign. A very valuable feature in many of her reviews is an admirable, succinct account of previous work on the subject, so as to put the new work in its proper setting. While unstinting in praise of sound additions to knowledge, she was careful to ensure that previous writers should not be robbed of credit due to them. Few persons were so well equipped to perform this service over so wide a range of subjects; she reviewed works on general Anglo-Saxon history, on Chronicle studies, on Anglo-Latin authors, on numismatics, on runes, on place-names, on manuscripts, and, of course, on charters.

Though I only came to know Florence Harmer really well after about 1942, my impressions of her personality have received confirmation from several persons who knew her also in her earlier days. She struck one as essentially a stable person, with firm convictions and strong loyalties, but free from dogmatism. She was a churchwoman, who supported her parish church at Withington and later at Pinner. She was devoted to her family, deriving great pleasure and support from their society throughout her life. One of her nephews has told me that she was a wonderful aunt, able to enter into their interests at all stages; he recalled childhood treats, travels with her in France later on, patient help with the mysteries of Latin and

German, and continued interest in their careers and in their families. She was a social and warm-hearted person, though undemonstrative. Some of her students have written to me about her keen personal interest in them, her tactful understanding of their social and other problems, and her generosity with time, encouragement, and practical help; and several colleagues have expressed similar appreciation of her readiness to help them in work and other matters, and especially of her kindness to younger members and her gentleness with those lacking in self-confidence. She often made newcomers to the University of Manchester feel welcome; for many years—until rationing made it difficult—colleagues tended to congregate over mid-morning tea in her room, which thus provided a much-needed centre for departmental intercourse. She was a staunch friend to many people; one could always rely on her for sympathy and understanding, for sound advice and honest criticism. She was generous with financial help to friends or students in any difficulty, and a close friend has told me that she denied herself many things in order to help others.

Sound common sense, and a trenchant sense of humour, helped to make her excellent company, at least among those with whom she felt at ease. Yet she could be formidable, for she had a sharp eye for foibles and an astringent tongue, and had little patience with persons she thought arrogant or affected. She was a modest person, reticent about her own achievements and concerns, and any expression of appreciation seemed to cause her surprise as well as pleasure. A certain element of self-distrust showed itself in an over-anxiety in matters of administration, and may have helped to create her dislike of this.

To those who knew her well, one of the most striking things about her was her zest, a robustness both of mind and body, an infectious enjoyment of the good things of life. She had a wide range of interests. She was a voracious reader of modern literature, newspapers, and journals, and she took delight in art and all beautiful objects, though she did not collect such things. She was a keen traveller, having begun to visit Belgium, Switzerland, and Germany in early days with her family, and later going abroad almost every year, especially to Italy, her favourite country. She travelled much in Britain also, and a friend who sometimes accompanied her speaks of the amazing amount of information she had of art and architecture, antiquities, country houses and their families, and of wild flowers. This intellectual vitality was accompanied almost to the end of her

life by remarkable physical vigour and strength. In her early days at Manchester she was fond of dancing, badminton, and tennis. She was a keen gardener and a tireless walker. Even when she was nearing seventy she would refuse my offer of a taxi and set off from Newnham to the station, cheerfully carrying a suitcase and an armful of books, declaring: 'But I like to walk through Cambridge.' In fact, I can most easily visualize her as laden with books or parcels or luggage and seeming unhampered by them, and one of her Manchester friends describes her arrival in the war years, carrying great packets of paper, huge tomes, her typewriter, and a generous contribution to the weekly rations. I used to wonder at the energy which brought her from Manchester to London, leaving at some very early hour, and returning the same evening; even the discomforts of war-time travel did not prevent her from making this journey, sometimes to pay a lecturer the compliment of hearing his (or her) lecture.

She gave the impression of having made a serene life for herself in retirement, taking pleasure in her house and garden at Pinner, where she was not far from her sister's home, and making new contacts among her neighbours. She was conveniently near the station, and greatly enjoyed being able to get up to London easily, to meet her friends, to attend meetings and lectures, to visit exhibitions, and to combine these activities with shopping. Cambridge now was easy of access, and she came many times, sometimes to attend functions as an Honorary Fellow of Girton. Her time was adequately filled with her reviewing, her reading, and her dealing with the queries of those who consulted her, without her letting these activities cause any undue sense of strain or urgency. It was not until late in 1965 that her health began to fail. Several of us were concerned to see her look so ill at the January meetings of the British Academy in 1966, though she made light of it herself. On 11 November 1966 she went into hospital, and though after a few weeks she was able to return home for a few months, during which she still wrote letters to me on scholarly and other matters, the convalescence was only apparent, and she died on 5 August 1967.

Anglo-Saxon Writs will long keep her memory alive among all interested in the Anglo-Saxon period. Her death leaves a great gap in these studies, as well as in the lives of the many persons who miss her warm and generous personality.

<div align="right">DOROTHY WHITELOCK</div>

NORA KERSHAW CHADWICK *Elliott & Fry*

XX

NORA KERSHAW CHADWICK

1891–1972

NORA KERSHAW was born at Great Lever near Bolton, Lancashire, on 28 January 1891, elder daughter of James Kershaw, cotton manufacturer and mill-owner, and his wife Emma Clara Booth. Her father, though over age for military service in 1914, volunteered to go to France with a Y.M.C.A. canteen unit, and was killed in an accident there. Her mother remarried, a Dr. Martin, and they settled at Houghton near St. Ives, within easy distance of Cambridge, whence Nora and her husband were able to visit them frequently. A younger daughter, Mabel, became a Catholic and a Carmelite Sister, eventually at the convent at Waterbeach, where again it was easy for the sisters to keep in contact.[1] Nora died at the Hope Nursing-home in Cambridge on 24 April 1972.

She was educated at Stoneycroft School near Southport, and went up to Cambridge in 1910 to read English at Newnham, and there she became a pupil of her future husband. She took a Class II in part 1 of the old Mediaeval and Modern Languages Tripos (English and Old English) in 1913, and a Class I in part 2 (English Literature) in 1914. She graduated M.A. in 1923. On the completion of her course at Newnham she was appointed Temporary Lecturer in English Language, and Assistant Lecturer in English Literature, at St. Andrews, where she carried a heavy load of teaching throughout the War. It was during this period that she taught herself Russian. After the War, having inherited money, she was able to retire from St. Andrews and go to live as a private individual in Cambridge, to work at Anglo-Saxon and Old Norse studies. In 1922 she married Hector Munro Chadwick, F.B.A., Elrington and Bosworth Professor of Anglo-Saxon in the University of Cambridge,[2] with whom she had made a tour in Italy the previous year, chaperoned by their friend Miss Enid Welsford of Newnham. The couple went to live at the old Paper Mills at Barnwell on the Newmarket road beyond the Leper Chapel, where they had a large house and garden barricaded by a high wall.

[1] N.K.C. put her knowledge of the Carmelite order, thus acquired, to effective use in her *Poetry and Prophecy* (Cambridge, 1942, reprinted 1952), pp. 65 ff.

[2] See his obituary by Mr. J. M. de Navarro in *Proc. Brit. Acad.* xxxiii, 307 ff.

Generations of students who cycled out there to lectures or visits will remember the fortress-like character of this wall with its little, inconspicuous postern gate, the plank bridge across the mill-lade to the front door, and the succession of 'fierce' dogs with intimidating Germanic mythological names like Loki, past which it was necessary to make one's way. Later the Chadwicks bought the Old Rectory at Vowchurch in the beautiful Golden Valley in the Marcher country of Herefordshire close to the Black Mountains in Wales, and here they would spend periods in the vacations. Indeed it was one of the numerous ways in which N.K.C. was so good for H.M.C. that she persuaded him to take wide-ranging expeditions by car to visit historical and archaeological sites, which he would never have done on his own ('Archaeologising, ye see, Master, archaeologising', as the famous Chadwick story about their courting tells); and a whole pack of postcards from her, despatched from various parts of the British Isles and Europe, attests in every one how each of these trips 'is doing Hector so much good'. She believed firmly in the importance of actually seeing and understanding the sites or regions she was studying. This enthusiasm continued all her life. She was constantly travelling to Wales and Ireland, and occasionally to Brittany, and at the age of 78 she tried unsuccessfully to persuade a colleague to journey across Russia by Trans-Siberian Railway, an ambition of hers from early days. Soon after the beginning of the Second World War the Chadwicks moved in from Barnwell to Cambridge, to a big house with a charming shady garden alongside the Binn Brook at 1 Adams Road, where Professor Chadwick's sister came to live with them. After his death in 1947, Nora Chadwick continued there, sharing the house with women research students, for some years, until the place became too large for her and she moved to a flat at Causewayside in Sheeps' Green. She remained there till not long before her death.

After her marriage she began the official connection with Newnham which lasted to the end of her life. In 1923-38, and again in 1953-65 she was an Associate of the college; in 1941-6 Associate Fellow;[1] and in 1941-4 Sarah Smithson Research Fellow. On her retirement in 1958 she was elected an Honorary Fellow, an uncommon distinction. She acted as Director of

[1] The Associates of Newnham are a self-electing body of graduates, distinguished in their own fields, who act as 'friends' of the College and nominate Associate Fellows for election to the Governing Body. They serve for a term of years and may be re-elected.

Studies in Anglo-Saxon and Celtic Studies for Newnham, 1950-9, and for Girton, 1951-62. For a time she was responsible for admissions in her subjects at Newnham, Girton, and New Hall, interviewing applicants, and showing a kindly interest and sympathetic understanding of their hesitations. She was University Lecturer in the Early History and Culture of the British Isles from 1950 until she retired, when she was succeeded by Dr. Kathleen Hughes. She was elected to the Fellowship of the British Academy in 1956, and appointed C.B.E. in 1961. Her honorary doctorates were D.Litt. (Wales) 1958, D.Litt. Celt. (Ireland) 1959, and LLD. (St. Andrews) 1963. She gave the O'Donnell Lecture at Edinburgh University in 1959, in the University of Wales in 1960, and at Oxford in 1961; the Riddell Memorial Lecture at Durham University in 1960; and the British Academy Rhŷs Lecture in 1965. She was a Fellow of the Society of Antiquaries, of the Royal Anthropological Institute, and of the Royal Asiatic Society.

Nora Kershaw Chadwick's first[1] serious publications[2] dealt with the literature of the Norse and the Anglo-Saxons. *Stories and Ballads of the Far Past* (Cambridge University Press), published in 1921, is a collection of translations from Icelandic and Faroese, with an introduction and notes; and *Anglo-Saxon and Norse Poems* (also C.U.P., 1922) was a very useful series of editions and translations, with notes, and short introductions on the manuscript sources. The poems are The Wanderer, The Seafarer, The Wife's Complaint, The Husband's Message, The Ruin, The Battle of Brunanburh; and in Norse, The Hrafnsmál, The Battle of Hafsfjord, The Eiríksmál, The Darraðarljóð, The Sonatorrek, and The Battle of the Goths and Huns. These two books reflect her interest at the time in the early poetry of the Germanic peoples, and her purpose was to make easily accessible to students what were then mostly relatively inaccessible short poems of very great interest. The second book contains much sound work, and, as she says in the Preface, was 'heavily indebted for criticism and help throughout' to Professor Chadwick.

[1] Her very first article was a short one on 'The Art of Anton Chekhov' in *The Englishwoman*, xxxiii (1917), 147-63.

[2] References, or exact ones, are often not given in the following account of her published work, and there are omissions. This is because a complete bibliography is available in Dr. Isabel Henderson's 'A List of the Published Writings of Hector Munro Chadwick and of his wife Nora Kershaw Chadwick, presented to Nora Kershaw Chadwick on her eightieth birthday' (printed by Will and Sebastian Carter, Cambridge, 1971). This pamphlet contains also the citations for her honorary degrees in the Universities of Wales and St. Andrews, and a drawing of her by Brian Hope-Taylor.

The Chadwicks' interests were soon to extend themselves towards the Celtic field, and the first published manifestation of this was her *An Early Irish Reader* (C.U.P., 1927). This is an edition and translation, with introduction, notes, and glossary, of the Old Irish 'Story of Mac Dathó's Pig'. It was meant, in the Chadwick tradition, not only to serve as an introduction to the Old Irish language for students but also to give them a first-hand acquaintance with one of the most extraordinary and fascinating heroic prose sagas of its literature. I must have been one of the earlier students in the famous Chadwickian 'Section B' (on which see below) who cut his first Celtic teeth on this edition. It received, however, some rather unfavourable reviews, including one celebrated 'stinker', and she did not ever follow this up with other editions of Celtic texts; doubtless wisely.

The Chadwicks' great plan for their collaboration *The Growth of Literature* (three volumes; C.U.P., 1932, 1936, 1940) must already have been in the air. Essentially, this monumental work is an extension of H. M. Chadwick's *The Heroic Age*, being an attempt to arrive at general principles governing the character and growth of various types of literature (not merely heroic) among various peoples at an early stage of civilization, and to show that there is a correlation between the nature of the social and political circumstances of such societies and that of the literature they produce, so that striking general similarities are everywhere to be found. A full account has already been given in H.M.C.'s obituary in these pages,[1] but a further word should be said about N.K.C.'s part in it. In the first place it is likely she did much to persuade H.M.C. to undertake such a task at all;[2] its boldness of conception and sweep is more typical of her than of him. Then, in Vol. I she appears to have done most of the collection of the Irish material; in Vol. II the Russian sections were her work, and in Vol. III the central Asiatic, Polynesian, and some of the African. As a whole these volumes had a rather mixed reception, and some reviewers expressed reservations and scepticism, notably about the Hebrew parts. However that may be, Vol. I, about which, unlike the other volumes, I have some claim to speak, was to me, as a young research student, one of the most exciting books I had ever read, and I still strongly recommend it to pupils as an illuminating comparative study of early Irish and Welsh

[1] *Proc. Brit. Acad.*, xxxiii, 320 ff.
[2] Cf. op. cit., p. 320.

literature. With reference to N.K.C.'s contributions to Vols. II and III, the Russian and Polynesian sections were highly praised by authorities on these subjects (some of her conclusions had already appeared in her book *Russian Heroic Poetry*, C.U.P., 1932; reprinted 1950). Her first-hand knowledge of Russian was used with great effect, and the Polynesian chapters (for which she had to rely on translations), which constituted the first extended sketch of Polynesian literature, were welcomed by, for instance, the editor of the *Journal of the Polynesian Society*.[1] The account of African literature was relatively somewhat sketchy, due to the lack of available material, and in this and other respects the intervening years, and the work of scholars such as Bowra and Hatto, have, of course, made a considerable difference. One of the virtues of this colossal enterprise is the way in which a mass of information was collected, much of it by N.K.C., from many little-known and frequently rather inaccessible sources. The whole undertaking naturally had the effect of colouring her approach to literature for a long time. For instance her work on Asiatic shamanism led her to a special study of the connection between poetry, prophecy, trance, and 'inspiration' in early and later literatures and societies, as may be seen for instance in her little book *Poetry and Prophecy* (1942; see above); and sometimes to discover shamans and shamanism where some scholars might have thought they were not there.

But although early literatures in general, including poetic inspiration, continued to attract her for virtually the rest of her life,[2] her interests were already shifting towards the history of the British Isles in the Dark Ages, and increasingly to that of the Celtic peoples in particular. Her husband had, of course, always been a historian even more than a student of literature, and in his earlier career a philologist, and the synthesis of these subjects constituted the essence of 'Chadwickianism', as described below. So, she was already writing about 'The Celtic Background of Anglo-Saxon England' in 1946 (*Transactions of the Yorkshire Society for Celtic Studies*, 1940–6, pp. 13 ff.). This is a sketch chiefly of some aspects of what is known about the intellectual and Christian religious life in late Roman and

[1] March, 1940; pp. 168 ff.
[2] e.g. 'The Borderland of the Spirit World in Early Literature' (*Trivium*, ii (1967), 17–36); 'Dreams in Early European Literature' (in *Celtic Studies, Essays in Memory of Angus Matheson*, ed. J. Carney and D. Greene, London, 1968).

fifth-century Britain, and it is interesting to note that already she was emphasizing the importance of contemporary Gaul both as a source of information on it and as forming a close parallel to it, almost (in her view) a unity with it. She returned to this theme in a much more thoroughgoing fashion nearly a decade later in her *Poetry and Letters in Early Christian Gaul* (London, 1955), one of her best and most original works. Meanwhile, her publications between these two dates dealt predominantly with Celtic history and literature, though two or three articles were still concerned with Norse, whether with or without Celtic parallels (e.g. 'Norse Ghosts', 1946; 'Thorgerthr Hölgabrúthr and the *trolla thing*', 1950), and remarkably the article on 'Negro Literature' in Cassell's *Encyclopaedia of Literature*, i. 379. Moreover, she found time to publish a book on *The Beginnings of Russian History* (C.U.P., 1946; reprinted 1966).[1] Apart from her 'The Celtic Background' just mentioned, her first real excursion into Celtic history was her edition of her husband's *Early Scotland* (C.U.P., 1949). This is presented in detail in the Introduction as virtually the printing, with the minimum of necessary editorial adaptation, of an unpublished book by H.M.C.; but the careful, and critical, reader will wonder sometimes whether the process did not entail rather more modification and expansion than she herself was consciously aware, and even sometimes whether H.M.C. would have been wholly in agreement with these parts of the book.

With the year 1950 her publications on Celtic history entered into full spate, and continued so until her death. In 1950–3 she wrote on the sources for the legend of St. Ninian; on 'The Celtic West'; on 'The Story of Macbeth' (a continuation of a study published in 1949), and on 'The Lost Literature of Celtic Scotland'. In 1954 there appeared the first of her three collaborative volumes edited by herself, *Studies in Early British History* (C.U.P.; reprinted 1959). The second was *Studies in the Early British Church* (C.U.P., 1958), and the third *Celt and Saxon: Studies in the Early British Border* (C.U.P., 1963). The intention was to gather a number of scholars more or less closely identified (in one or two cases distinctly 'less') with the Chadwickian school, and persuade them to contribute articles respectively on early Britain between the end of the Roman period and the establishment of the Anglo-Saxon kingdoms; specifically on the history of the Celtic Church and Latin learning and intellectual

[1] And compare her article 'The Russian Giant Svyatogor and the Norse Útgartha-Loki', in *Folklore*, lxxv in 1964.

life in the Dark Ages; and on the early relations between the Britons and the Anglo-Saxons in the same period. N.K.C.'s own contributions, apart from the Introductions (long ones in the case of the second and third books), were as follows. In the first book, her lengthy article takes up again and elaborates on the theme of 'Intellectual Contacts between Britain and Gaul in the Fifth Century', which brings together and discusses fruitfully a good deal of disparate material, much of it very interesting and useful. Three chapters, 'The End of Roman Britain', 'Vortigern', and 'The Foundation of the Early British Kingdoms', are from her husband's *Nachlass* (how far 'edited' by N.K.C. is unclear), to which she herself added two Appendices. In *Studies in the Early British Church* she has two long chapters. One, 'Early Culture and Learning in North Wales' is, in spite of its title, chiefly a valuable critical discussion of the native historical sources for the period, notably the *Annales Cambriae*, in which the influence of H.M.C. seems evident. The other, 'Intellectual Life in West Wales in the Last Days of the Celtic Church', is a thoughtful, original, and illuminating study of the Welsh school of learning at St. David's, particularly in the time of bishop Sulien and his sons in the late eleventh century, and the *Lives* of St. David and other propaganda arising there. In *Celt and Saxon* she provided no less than four contributions in addition to the Introduction: 'The Conversion of Northumbria', 'The Battle of Chester', 'Bede, St. Colmán, and the Irish Abbey of Mayo', and 'The Celtic Background of Early Anglo-Saxon England'.[1]

Returning to the period of the first of the above three volumes, chiefly after her retirement in 1958, her publications over the next six years were all articles in journals and collaborative works, apart from the *Poetry and Letters in Early Christian Gaul*. They ranged from 'The Monsters in Beowulf', in the Bruce Dickins festschrift, 1959, and 'Literary Tradition in the Old Norse and Celtic World' (1955), to 'Pictish and Celtic Marriage' (1958), 'The Name Pict' (1958), 'The Welsh Dynasties in the Dark Ages' (1959), and a double return to the story of Mac Dathó's Pig (1958, 1959). But in 1961 she brought out her Riddell Memorial Lecture, delivered at the University of Durham the previous year, *The Age of the Saints in the Early Celtic Church*. Three chapters respectively on the fifth, sixth, and seventh centuries ('The Continental and Eastern Background',

[1] Given as the O'Donnell Lecture at Oxford in 1961. The identity with the title of the article published in 1946 (above) appears to be a coincidence.

'The Age of the Saints', and 'The Celtic Church and the Roman Order'), sufficiently indicate their contents. This is a clear and useful summary of her views, and the first chapter is of particular interest for its treatment of the 'background' as defined. A rather unfortunate article 'Bretwalda, Gwledig, Vortigern' in the *Bulletin of the Board of Celtic Studies* the same year was followed by the appearance of her lecture 'The Vikings and the Western World' in 1962, in the *Proceedings of the International Congress of Celtic Studies* held in Dublin, 6–10 July 1959 —a subject which was, of course, very close to her interests. This is largely a straightforward summary of the historical situation.

In the remaining years of her life her published work falls into three groups. First some rather slight or popular articles on Celtic history ('St. Columba', pp. 3–17 of *St. Columba: Fourteenth Centenary, 563–1963*, Glasgow, 1963; the article 'Dalriada' in the *Encyclopaedia Britannica*, 1964; and one or two others). Then, two more thorough works on the history of Brittany, and a little book on the druids. In her British Academy Rhŷs Lecture 'The Colonization of Brittany from Celtic Britain', *Proc. Brit. Acad.*, li, 1965, 235 ff., and in *Early Brittany* (University of Wales, 1969), she extended her Celtic studies to a fresh region of 'the Celtic realms'. Her interest in Brittany reached back indeed a good way, and included at least one visit there, but she had not hitherto published anything considerable on its history. These bear witness to her usual industry and wide reading, but in spite of many interesting and valuable features it is clear that they are not the work of a master of the subject, and the treatment of it is not infrequently somewhat superficial and with too many inaccuracies. As distinct from the lecture, the book, which in the first four of its eight chapters ('Prehistoric Armorica', 'Gaulish Armorica', 'The Roman Conquest', and 'The Barbarian Invasions') deals with subjects more or less outside her real fields of expertise, is in any case by way of being a semi-popular production, aimed at a much less 'professional' audience than the Rhŷs Lecture. *The Druids* (Cardiff, 1966) is a slight work of some 120 pages, partly a collection of the facts and partly speculations about them; notably a theory, to which she obstinately clung, that the druids were not priests. The third group, published between 1963 and 1970, consists of three frankly popularizing works (of which parts of two were written by other scholars),[1] containing some remarkable lapses, and internal evidence, as well as external, suggests that they were

[1] The remarks made above do not apply to these parts, of course.

put together under self-inflicted pressure—a point discussed below. One of them in particular had a great success, and was translated into various foreign languages, including, I believe, Japanese. A last book, *Wales and the Men of the North*, to be published by the University of Wales Press, has been announced but up to the time of writing has not yet appeared.

When we look at Nora Chadwick's *œuvre* as a whole, it is very evident how greatly its nature was dictated by her personality. She was a woman of strong character, of tremendous mental vigour and quite unflagging capacity for hard-work, of abounding generosity, of a kind of still patience, of fierce and single-minded enthusiasms, and of passionate devotion to the subjects that interested her. These developed, as we have seen, by and large from Germanic literature to early literatures in general (notably Russian), then in particular to the early literatures and history of the British Isles, and finally to those of the Celtic peoples. It was an aspect of her breadth of mind that she always emphasized the unity of the Celtic world and the necessity for knowing as much as possible about it all—Ireland, Scotland, Wales, Cornwall, Brittany, and Gaul. She came to regard herself as a propagandist for Celtic studies (hence in part the popularizing works), and it was the prime hope and object of her later years that a Chair of Celtic might be established in Cambridge University. In fact the notable growth of public interest in Celtic of recent years must owe much to her.

The ability to work hard and concentratedly is seen perhaps above all in *The Growth of Literature*, to which she contributed so much of the labour of gathering material from innumerable obscure sources; but it never deserted her, and even in old age, when she could scarcely keep on her feet, she haunted the University Library, under the kindly care of her niece Dorothy Chadwick. The generosity and enthusiasm manifested themselves not only in this but also in the constant flow of ideas, theories, and speculations. These last were sometimes rather a trial to her friends, since though she would submit typescripts to them for criticism, or consult them personally and listen patiently, the theories which they had doubted or the obvious errors of fact which they thought they had corrected would eventually appear in print rather too often wholly and stubbornly unchanged, particularly in her latter years. I remember once protesting mildly about what I thought an inattention to accuracy and an undue tendency to speculation, and her reply was that she admitted this, but that time would winnow out the bad and

leave more permanently behind anything that was good grain. This was not an attitude with which I had much sympathy (so much harm has been done to Celtic studies by the apparently permanent acceptance of mere chaff as sound wheat), but I did recognise that it was, to her, a completely valid justification. Unfortunately, she was no philologist, especially in the Celtic languages, in which she had had no real training, and this lack was a constant and serious drawback to her work in Celtic history and literature. If her husband had been a man of her own age and had lived as long as she did, their lifelong collaboration would have been perfect, since what she needed was firm criticism and discipline; her tireless energy and mental activity, her abounding spate of ideas, would have complemented and been complemented by his learning and specially by his accuracy, sound judgement, and scholarly scepticism. Where this did indeed happen, in her early works and above all, of course, in *The Growth of Literature*, the combination was very impressive, and her own part in such collaboration of the greatest value. After H.M.C.'s death in 1947 she became rather like a boat adrift for lack of a steersman; but none the less her best later work, published between 1955 and 1958 ('Intellectual Contacts between Britain and Gaul in the Fifth Century', *Poetry and Letters in Early Christian Gaul*, 'Early Culture and Learning in North Wales', and 'Intellectual Life in West Wales in the Last Days of the Celtic Church'), shows her at the height of her powers, with her labour, enthusiasm, and fruitful insights forming their happiest synthesis. In this connection we must remember that she was sixty-seven in 1958, when she retired. The final phase of her writings, between about 1961 when she was seventy and her death in 1972, shows a decline, which would indeed not have been surprising in anyone but becomes more than wholly intelligible when one knows that somewhere in the latter part of this period she must have suffered the first of a series of minor strokes, as her mother and sister apparently did before her, the last repetition of which eventually rendered her unfit to live alone. She struggled pluckily against this, probably realizing what it meant, and refused for a long time to acknowledge that she ought not to remain on her own. This final period was that of the popular works mentioned above, when her friends sometimes wished that she would at last take a well-earned rest; but she was obsessed by the passion to further the subject that she loved, by the knowledge that she still had much to say,

and by the compelling need to say it. It was a case of Keats's
> When I have fears that I may cease to be
> Before my pen has gleaned my teeming brain . . .

But it was more; she hoped these books would bring in money which, when added to her own fortune and willed to the University, would make possible the realization of her dream of fostering the study of Celtic at Cambridge. In judging her latest writings it is right, then, to remember all this.

One of her aims in life was to propagate and defend the 'Chadwickian' ideal as it was expressed in Section B of the Archaeology and Anthropology Tripos. This ideal is defined in Mr. de Navarro's obituary of H.M.C. as 'not only the study of language and literature but of history and civilisation; by civilisation he meant institutions, religion and archaeology'. Eventually it came to express itself, in N.K.C.'s time, as the investigation of the total range of history and literatures of the British Isles in the period between the Roman and Norman conquests. This might be thought to be a tall order; and although in the early days most of Chadwick's colleagues perhaps agreed that it was reasonable to study both Anglo-Saxon and Old Norse language, literature, and history together, no doubt virtually all would have jibbed at the idea of including contemporary Celtic in this, while the addition of the archaeology of these peoples must have seemed chimerical—and as for Stone Age, Bronze Age, Iron Age, and provincial Roman archaeology, they very likely thought he had taken leave of his senses. Yet, superficial or not, the Chadwicks' pupils all testify to the intellectual excitement of this course. After the then comparatively narrow range of the Classical Tripos, in which, having specialized in comparative philology, not in 'Literature', I came away wholly ignorant of, for example, Classical manuscripts and palaeography, Section B was a most thrilling and liberating experience. Four new languages and literatures, all belonging to the British Isles, opened up their treasures, together with the history and archaeology of their speakers. As for the rest, the pre-Roman and Roman archaeology of Britain has remained, I am sure, with all 'Chadwickians' as an abiding lifelong interest. I well remember, forty years since, the excitement of cycling the dark and windy miles down the Newmarket Road to the Paper Mills, penetrating the inner fortress, crossing the bridge, negotiating the 'savage' dogs, and listening entranced for an hour while 'Chadders' gave his evening lectures on Early Britain and 'Mrs. Chadders' sat at the epidiascope

projecting pictures of Bronze Age leaf swords or palstaves and Iron Age enamelled horse harness on the screen, silent but radiating an extraordinary sense of powerful restfulness, if one may use such an oxymoron. Indeed, to describe her appearance at this time can only be done in clichés, which—like many others—are none the less true for being clichés; her large, quiet eyes really *were* a cornflower-blue, her piled hair which she wore in Edwardian fashion really *was* the colour of ripe corn. The same excitement extended to the reading of works like *The Growth of Literature*, the excitement of finding likenesses in and connections between subjects where none had been thought of before. The idea was, of course, originally H.M.C.'s, as his *The Heroic Age* had already shown, but its later development must have owed a good deal not only to N.K.C.'s encouragement, but also to her wide range, breadth of interests, enthusiasm, imaginative awareness of *different* types of evidence, and ability to see significant likenesses. She belonged to an older and ampler age than the modern one of specialization; each kind has its virtues and its faults, and it does not become the narrow specialist to condemn the wide synthesist (however irritating he may find him) for his faults without also making allowance for his virtues.

Indeed, one of the most successful of her contributions to learning, perhaps *the* most, was her zeal and success as a teacher. She had the gift, so effective with the young, of a capacity to arouse interest and eagerness. Here her generous heart had full play; her pupils were made to feel that they really mattered, that they really were somebody. In the case of those who were in fact nobody this might have had dangerous results in leading them to think *too* well of themselves, though there seems to be no reason to think it actually did so. Of course, all her geese were swans to her, and this might occasionally lead to some disappointments where in the judgement of others the swans were, after all, only geese (though they themselves were probably well aware that this was so); but it is not wholly disagreeable to be *thought* a swan, and the consequence was that she brought out in everyone the best that was there.[1] Her habit of treating

[1] Pupils of hers are widely scattered in British universities and similar institutions, notably the Lecturer in Celtic at Cambridge. But Scotland seems particularly favoured; here they include not only the heads of the three Scottish university departments of Celtic and one of the Lecturers in Scottish History at Edinburgh University, but also the Director of the School of Scottish Studies (Edinburgh University), the Editor of the Scottish National Dictionary (Edinburgh), and the Keeper of the Country Life section of the National Museum of Antiquities, Edinburgh.

her pupils as equals intellectually as well as otherwise was charming but could be disconcerting; unintentionally it made great demands on them, but the response justified this. The Cambridge Celtic Group which she organized brought distinguished Celtic scholars from outside Cambridge to talk to her pupils, and this too made them feel that they 'belonged' in a common enterprise of learning. In her relations with young scholars her kindness, warmth, interest, support, and encouragement were endless, and so too was her patience (this last quality, which could sometimes express itself as obstinacy, was in general a kind of massive, imperturbable quietness). An aspect of this was the generous way in which she would take her pupils to congresses or summer schools, or on holidays which were exciting voyages of archaeological and historical discovery, to far parts of the British Isles.

Her capacity for rousing affection and loyalty showed itself in the faithful service of the two sisters, Mrs. Steven and Mrs. Plumb, who were her domestic help for about forty years until her death. It was made strikingly manifest moreover at the luncheon party to celebrate the centenary of the birth of H. M. Chadwick, organized by Dr. Glyn Daniel and Eleanor Megaw, at St. John's College on 17 October 1970. Here some forty-five former Chadwick pupils and twenty friends and colleagues gathered to honour them both. The toast to H.M.C. was proposed by Professor Dorothy Whitelock, and that to N.K.C. by Professor Bruce Dickins. The party was indeed in celebration of his centenary, but in effect it naturally developed into an expression of this same universal loyalty and affection in which the company held his widow. She was greatly moved by this, and it must have been to her a happy lightening in the clouds which had already begun to close around her.

<div style="text-align: right;">KENNETH JACKSON</div>

Note: I wish to acknowledge my gratitude to the following for their ready help without which this memoir could scarcely have been written: Miss Dorothy Chadwick, Dr. Glyn Daniel, Professor Bruce Dickins, Dr. Isabel Henderson, Dr. Kathleen Hughes, Mrs. Eleanor Megaw, Miss Jean B. Mitchell, Dr. Harold Taylor, and Professor Dorothy Whitelock.

THOMAS KENDRICK

Walter Stoneman

XXI

Thomas Downing Kendrick
1895–1979

IN attempting this portrait of Tom Kendrick and his life and work I am conscious of my own limitations. It is a formidable challenge to do justice, in short space, to so complex, creative, witty, intellectually brilliant, versatile and private a man. I shall do my best, with the generous help of others who knew him, and

> Prune my ambition to the lowly prayer,
> That I may plough the furrow of my tale
> Straight, through the life and loyalties I knew.
> [After V. Sackville West, *The Land*]

Thomas Downing Kendrick, Director and Principal Librarian of the British Museum, was born in Birmingham on 1 April 1895 and died at Dorchester on 2 November 1979. He entered the Museum as an Assistant in the Department of British and Medieval Antiquities under Ormonde Dalton in 1922 and thereafter his whole professional life was spent in the Museum's service. He became Keeper of British and Medieval Antiquities in 1938, in succession to Reginald Smith. He was elected a Fellow of the Academy in 1941. He was appointed Director and Principal Librarian in 1950, and created KCB in 1951. He retired, earlier than he need have done, in 1958 at the age of 63. A natural writer, he continued scholarly work after his retirement, producing five further books to add to an already formidable output. Kendrick's range of interests within the antiquarian field was quite exceptional, but his major contributions were in the field of Anglo-Saxon art and in the history of antiquarian thought.

Kendrick's father, Thomas Henry Kendrick, a manufacturer of bedsteads, died when Tom was seven, in 1902. Tom was the eldest child and had a younger brother, William. His mother, Frances or Fanny Susan Downing,

married again, in 1905, a clergyman, Prebendary Sowter, who thus acquired two stepchildren. By him she had a daughter, Molly, Kendrick's half-sister, reputed to be jolly. They all got on well as a family. Fanny Downing's home was Stourton Hall, nr Stourbridge, but they were *nouveau riche*, not 'county'. Kendrick was born at Island House, Holyhead Road, Handsworth. His stepfather had a parish in Aston, so Tom continued to live in Birmingham, though not for long. He was a lifelong supporter of Aston Villa, he used to go and see them play at Villa Park, and spoke of having been brought up within a sound of the ground. Tom's stepfather was high church, Anglican, and said to have been a very fine and popular preacher, and Tom enjoyed helping with services and taking part in all the normal activities of a busy town vicarage. To the end of his life Tom had a genuine admiration and sympathy for the good hard-working parish priest. Later the family moved to The Old Rectory, Madresfield, near Malvern, which was Tom's home at the time of his going to Oxford and of his applicaton, at the age of 26, in 1921, to join the British Museum, in 1922.

Before going on to Charterhouse, Tom attended a prep school in North Wales, in or near Llandudno. Probably the best source about his early growth is his late novel *Great Love for Icarus*[1] with its portrait of a bright and sensitive boy on holiday in the family holiday home in North Wales (his grandmother's house). His was a comfortably placed upper-middle-class family, as it would have been described in those days. The state and comfort in which his grandmother (if we can follow *Icarus*, which does not claim to be autobiographical but certainly is) presided over her table in her home in Llandudno in 1906 must reflect this background of comfort and privilege which clearly influenced Tom profoundly and helped to form his tastes. Kendrick left Charterhouse from the fifth form and was admitted to Oriel College, Oxford, to read medicine. He passed his science preliminaries in his first year.

When war broke out he immediately joined the Warwickshire Regiment, in which he became a Captain. While fighting in France he was severely wounded in a hand and a leg.[2] His wife Helen once spoke to Hugh Hencken[3] of innumerable unsuccessful operations on his injured knee. As a result Tom walked in a halting fashion all his life, though this seemed in no way to hinder his mobility. He could not bend the knee and had to sit with his right leg stretched out under the table, when possible resting on a

[1] Methuen, 1962.

[2] The belief, even among close colleagues, that Tom had lost a leg (e.g. Basil Gray in *Burlington Magazine*, March 1980, and notably, Diana Bonakis Webster, *Hawkseye*, 1991, pp. 167–8), is incorrect.

[3] Later Professor of Archaeology at Harvard, the Director of the Peabody Museum of Archaeology and Ethnology.

cushion. In general, Kendrick never spoke of his war experiences; Hugh Hencken once remarked on a photograph of Tom in officer's uniform, presumably that of a Captain in the Warwickshire Regiment: Tom's comment was 'I had nothing else to do'. On another occasion he told Hencken that the British soldiers had no defence at all against poison gas and could only pool their urine, dip clothes and handkerchiefs in this and cover their mouths and noses. 'Hugh how would you feel if your mouth and nose was covered with someone else's excretions?'

Tom would never travel on the London Underground. He was afraid that he would become agitated—presumably by memories of being trapped and buried in the trenches, or seeing it happen to his friends and his men. He lost many of his friends and 'could never bear to talk about that time'.[4] Like many of his generation, he went to war a boy, and returned a man, lucky to have survived.

Back at Oxford in 1919 Tom continued with his science course, reading Honours Chemistry for two terms, but (as he told the Civil Service Commissioners in his British Museum job application), found standing at laboratory work-benches too much of a strain for his injured leg, and in the Trinity Term he switched over to the school of Social Anthropology. It was thus his war injury that led to the crucial decision of his life, and determined his subsequent career. At Oriel Tom was elected Secretary of the Junior Common Room in 1918, and the *Oriel Record* records that he coxed the Oriel boat in the Inter Collegiate Fours of the October term 1918, 'when the crew consisted entirely of wounded or invalided officers'.

There is no evidence that he had at this stage, any special interest in antiquarian matters though one source states[5] that he was already interested in the Lisbon earthquake while a boy at Charterhouse.[6]

In the Social Anthropology school Kendrick came under the influence of R. R. Marett, the Reader in Anthropology, and of Henry Balfour, Director of the Pitt Rivers Museum. He was awarded a Diploma with distinction. He took his BA and MA in December 1920 in the Trinity Term, and then, under Marett's guidance and prompting (so far as choice of subject was concerned), began research for a B.Sc. on '*The Megaliths of the Channel Islands and their bearing on the History of Culture*'. The latter part of his title suggests an instinct to place and interpret as well as to record.

[4] Katharine Kendrick, *Memoranda*.
[5] Daily Telegraph, 8 November 1959 in a feature on Kendrick's retirement.
[6] See also p. 468 below.

At Oxford, in the Anthropology School, Kendrick impressed. Marett wrote of him 'no student of these subjects who has ever passed through my hands is better qualified, in my opinion, to fill [a post on the staff of the British Museum] with credit'. 'Mr Kendrick's work for the Oxford Diploma in Anthropology was in the view of his teachers of first-rate quality and the award of Distinction but confirmed this impression ... his strong points I think are an extensive and accurate grasp of facts and a very cool and critical use of evidence': 'He also has a very good English style, quite plain, but forcible and lucid'. Marett was himself a Jerseyman and well able to assess the research subject he had suggested to Kendrick. Balfour wrote of Kendrick in similar terms, stressing the searching nature of the Diploma examination and the very wide field, Physical Anthropology, Comparative Technology, Prehistoric Archaeology and Comparative Sociology covered by the course. He spoke also of Tom's courtesy and geniality and added 'I very much regretted when his time at Oxford came to an end'.

Already 27 when he joined the Department of British and Medieval Antiquities Kendrick soon made his academic mark. His first publication was *The Axe Age* (Methuen, 1925). Kendrick had hoped to provide a detailed account of the tombs of the Channel Islands and their contents; but it could not be kept abreast of fresh discoveries, and had to be abandoned in that form. *The Axe Age* was the by-product of his Catalogue for the archaeology of Guernsey, and of the card indexes he had prepared for that and for Jersey.[8] The habit of card indexing Tom evolved for his Channel Islands work bore much fruit throughout his career. It was the hard, efficient core behind the surface nonchalence.

The Axe Age suffered by comparison with two influential works both referred to in Kendrick's footnotes, although his work for *The Axe Age* was done, it seems, before they appeared—these were Childe's *Dawn of European Civilisation* and O. G. S. Crawford's *Long Barrows of the Cotswolds*; and there followed three years later Childe's massive *The Danube in Prehistory*. As against Childe's European synthesis, *The Axe Age* delivered an essay based on a discussion of the Western Seaboard and the Megalithic problem only, and nothing about Central Europe. Instead of the Danube you have Easter Island. The 1920s, however, were a formative period for English Neolithic studies and *The Axe Age* was soon out of date in terms of

[8] I am grateful to G. de G. Sieveking, FSA for his comments, on which this account is based or from which it is directly taken.

British prehistory, while in the pan-European perspective it never recovered from comparison with Childe's work: Kendrick's sketch of the local succession was still of interest so far as French and Channel Island prehistory were concerned, and it was read and continued to be of value to the specialist as a source of ideas. In some ways it was remarkably prescient. For example, he proposed that Megalithic tombs had been independently invented in NW Europe (at three centres, p. 105) instead of continuing to bring them from the Eastern or Central Mediterranean, as Childe, Piggott and Daniel continued to do until well after the 1940–5 war.

Kendrick's next work was *The Druids*, (1927) subtitled 'A Study in Keltic Prehistory'. It appeared before his *Archaeology of the Channel Islands*, vol. 1, The Bailiwick of Guernsey (1928) (end product of the B.Sc. thesis he had embarked upon at Oxford in 1920) but the two were connected. His Channel Islands survey had been largely concerned with megalithic monuments, including tombs and their contents. It was the widespread notion that the Druids had built and used the megaliths, the Druid/Megalith link, that led Kendrick into a subject which he found engrossing. He was struck by 'the extraordinary and pervasive popularity of the Druids in the popular imagination', and the fact that it came about largely through the supposed Druid/Megalith connection. *The Druids* was prefaced with a frontpiece of John Aubrey (1626–94) who first tentatively suggested a connection between the Druids and Stonehenge. Tom wanted to get to the bottom of the whole business. His objective was to provide a complete and well-documented summary of the whole of the pertinent material on which a study of this subject should properly be based.

He disposed of the idea that there could be genuine folk memory behind the supposed connection, and he exonerated that ready source of myth, the 12th-century Geoffrey of Monmouth (p. 420 below), separating the Druid/Megalith link from Merlin and Arthurian legend. He then set out the varied evidence needed if a sound picture of the Druids was to be arrived at. Stuart Piggott, who many years later wrote the book which was to supersede Kendrick's, commenting on the three different types of evidence that have to be contended with—archaeology, classical texts, and the development of later notions about the Druids, originating in antiquarian speculations of the 18th and 19th centuries—wrote in his Introduction:–

> This tripartite nature of the evidence obviously calls for a most careful handling of the sources ... But it did not deter Sir Thomas Kendrick who, fifty years ago, wrote the only general account of the problem which has deserved serious attention since that date, and more than that, has stood up quite remarkably well to over a generation's work in the fast-moving subject of prehistory ... I think, however, there is room for a new treatment of that whole complex of problems which then engaged Kendrick's brilliant mind,

and if my book shows my indebtedness to his on every page, I hope I may perhaps in the end be thought to have added, here and there, a useful, or even sometimes a percipient footnote to *The Druids* of 1927.[9]

Kendrick dealt with all this disparate material extremely effectively, but his particular contribution was to add in, up to date for his time and with proper weight, the archaeological evidence that shed light on the Celtic peoples amongst whom Druidism arose and flourishd.

In the following year, 1928, there appeared *The Archaeology of the Channel Islands, Vol. I*, the Bailiwick of Guernsey. A handsome book, illustrated with 131 attractive drawings and engravings and 20 plates, it is concerned wholly (apart from the faintest whiff of Gallo-Roman) with prehistory. Tom presented his work in two parts, the first, *Introduction*, discussed the different categories of material: prehistoric sculptures and engravings of Guernsey; stone and early metal tools; megalithic tombs and stone cists and their ritual features and grave furniture, mostly pottery.

Part II, called *Descriptive*, dealt with each parish in turn, and with the outlying islands of the Bailiwick (Alderney, Sark and Herm), and included all types of features—a buried dug-out canoe, miscellaneous undatable earthworks, a promontory fort and so on. As one might expect it was a thorough and competent piece of work, the culmination of the B.Sc. thesis, on to which R. R. Marett had first put him in 1920. Marett's suggestion had reaped a rich harvest. This, and the Vol. II (Jersey) written by Jacquetta Hawkes on the basis of Kendrick's indexes, are a permanent contribution to the history of the Islands.

Two years later, in 1930 (reprinted 1968), Kendrick published another major work, his highly regarded *A History of the Vikings*. It represents a change of direction. Kendrick was to return to prehistory in *The Archaeology of England and Wales* (with C. F. C. Hawkes) in 1932, but now we see him entering a new field.

It seems that he was drawn by another major and popular cause where archaeology and literary sources (the Sagas) and the comments of literate onlookers or victims, were interwoven. He set out, as he had with the Druids, to assemble and review the evidence. Here, however, instead of casual and often obscure literary references, myth and speculation, he had an epic and coherent story to tell.

In the Introduction he set forth what he sought to achieve:

[9] S. Piggott, *The Druids*, Thames and Hudson (1968).

> There is no substantial book in English exclusively devoted to the Vikings and setting forth the whole of their activities not only in the west and the far north but in the east and south east as well.

Kendrick knew that he had chosen to write at a time when the scene was changing very rapidly.

> I shall fail in my duty to the reader if I do not warn him that even now large slices of this history are being industriously shovelled into the melting pot by my learned colleagues and friends.

It was not, he said, for him to write the definitive version of the Vikings, untrammelled by too many footnotes, that he would like to see.

> I want merely to be the forerunner of some luckier author of the future and I have done my best for him by trying to set down the complete narrative, as it is at present understood, in a severely plain and useful form.

A History of the Vikings is a well-planned piece of work, written in the author's relaxed, chatty style, with visual aids and footnotes—there is a short bibliography. The book shows him in command of the literature that had been produced on the subject between about 1925 and 1930. Henry Loyn has written of it:[10]

> Kendrick got the proportions and the context right. He knew that it was matter for Russia, the 'civilisation of the waterways' (as he called it) Iceland, Greenland and North America, as well as for Western Europe. He gave proper attention to the Celtic world as well as to the Germanic. He knew what the archaeologists were doing and he knew how treacherous saga accounts could be. He told his story well. In other words he wrote a good book direct to his own terms of reference and thoroughly deserved his success.

Kendrick did not make much impact in the study of the neolithic/bronze age, but he was, nevertheless, a competent prehistorian who, in the six years before Christopher Hawkes joined the Department, understudied Reginald Smith in those fields. It was he who wrote the first eight chapters of *Archaeology in England and Wales, 1914–1931* covering the periods from 'pre-palaeolithic man' up to and including the Middle Bronze Age, as well as Chapter XII (the Anglo-Saxon Period). The two authors worked independently; 'the most we can do is to say that we vaguely endorse, and in my case admiringly, each other's contributions', as Kendrick put it.

[10] Personal communication.

Archaeology in England and Wales, 1914–1931 (Methuen, 1932) is an enlarged version of a paper commissioned by Dr Gerhard Bersu, of the Römisch-Germanische Kommission of the German Archaeological Institute, and was first published in German; it was commissioned by Bersu to provide a survey of what had been happening in archaeology in England and Wales since 1914 for the information and use of members of the First International Congress of the International Union of Prehistoric and Protohistoric Sciences, held in London in 1932. It was a clear and readable account of progress in archaeology in England and Wales since 1914, and remained for a good many years an extremely useful work of reference.

In 1932, with *The Axe Age*, *The Druids*, *The Archaeology of the Channel Islands*, *Archaeology in England and Wales, 1914–1931* (Kendrick & Hawkes) behind him, he was a well-known and established figure in the profession. He was asked to give one of the four tails-and-white-tie evening public lectures in connection with the First International Congress of Prehistoric and Protohistoric Sciences (another of these by Cyril Fox became his famous *Personality of Britain*). Tom dazzled his audience with a brilliant colour slide of a splendid Anglo-Saxon jewel, the Kingston brooch, and gaily put forward highly subversive ideas about the date and origins of Kentish jewellery. He maintained that the best were made not by Saxons or Jutes but by Britons. In 1932 he was chosen as President of the Archaeology Section of the South Eastern Union of Scientific Societies, which later became the British Association. In this capacity, at their meeting in Reading, he gave another highly original paper, on the nearby Taplow Barrow (the richest Anglo-Saxon burial before Sutton Hoo), an essay in style-analysis in which he put forward his ideas on Animal Ornament in Style 1 and Style 2, introducing his Helmet style and Ribbon Style concepts, based on his analysis of the drinking horns.[11] He was already well advanced with the ideas which were to build up to his two major books on Anglo-Saxon art.

Tom tried in the Museum to do what he could to brighten the displays in the galleries and, with Reginald Smith's approval,[12] to index the collections in various ways; he began a Categories Index, which gave the locations of the specimens, one of several moves in the direction of opening up the collections for use and making the place more inviting.

[11] 'The Art and Archaeology of the Early Anglo-Saxon', *Transactions of the South-Eastern Union of Scientific Societies, 1934.*

[12] Reginald Smith, FSA, had become Keeper on the retirement of Dalton.

Most important perhaps was his welcome to outsiders—foreign scholars, specialists, and students. One of these was the young Stuart Piggott, who had already begun working on the Druids, and wrote to Kendrick for his approval. Piggott had found Reginald Smith, 'a dead hand and dry as dust', 'a fusser over minutiae'. Kendrick, and Hawkes who had recently joined Tom, 'were like two naughty boys', and Kendrick was gay and outrageous. Instead of thinking archaeology was awful, Piggott suddenly found that it could be exciting and fun. Kendrick, he said, 'had a rinsing effect'. Hugh Hencken,[13] then a young American research student at Cambridge, tells how he met Kendrick in 1936. O. G. S. Crawford, who had advised him to turn to the archaeology of the Scilly Isles and Cornwall, suggested that he go to the Office of the British and Medieval Department at the British Museum:

> There I found Reginald Smith, who was extremely uninviting. But at the same time I also met Tom, who made me extremely welcome, and gave me a vast amount of material and advice.

Kendrick describes how he and Reginald Smith eventually became friends[14] and Smith was not ungenerous. When in 1936 a Deputy Keepership became available (Tom did not get it—it related to the Antiquities Departments in general), Smith as Keeper wrote to the Trustees:

> throughout his fourteen years of service he has shown great industry and ingenuity with the arrangement of the exhibits and has revolutionised the indexing system with a view to rendering every object in the Department accessible without delay ... His cordial relations with the staff have been eminently useful in organising the galleries and studies and his extensive acquaintance with archaeologists at home and abroad is an important asset, as much due to personal qualities, as to professional reputation.[15]

When, in 1933, surprisingly late, Kendrick was put up for election as a Fellow of the Society of Antiquaries, his supporters included most of the great and good in British archaeology.[16]

[13] Later Professor of Archaeology at Harvard, and Director of the Peabody Museum of Archaeology and Ethnology.

[14] 'In the 20s', in *Prehistoric and Roman Studies*, edited by G. de G. Sieveking, pp. 2–8 (British Museum, 1971)—a priceless contribution extracted from Tom by the editor.

[15] BM Archives, Report p. 2067 of 23 April 1936.

[16] 12 January 1933, when he was 38; signatories were the initiator W. J. Hemp (a good mark for a snobbish figure recently stigmatized by Stuart Piggott as 'pretentious, ignorant and incompetent'—*Proceedings of the British Academy,* **74** (1988), p. 355), Reginald Smith (who had evidently not initiated it), Sir Charles Peers, Sir Alfred Clapham, Sir Frederic Kenyon, O. G. S. Crawford, Alexander Keiller (twice!), E. T. Leeds, Sir George Hill, Miles Burkitt, Henry Balfour, Christopher Hawkes, Charles D. Drew, H. St George Gray, Sir John L. Myres, and J. M. de Navarro.

Kendrick saw that a major gap in the basic documents for his projected art history or history of Anglo-Saxon style, was the very considerable body known to exist of unrecorded and unpublished stone crosses and sculptural fragments. And he set about rectifying it. A body of helpers had to be recruited to cover the wide dispersal of material all over the country. The excitement of it all and the companionship of workers, young and old, appealed to Kendrick who hugely enjoyed himself.

Among Kendrick's helpers was Ernst Kitzinger, later Professor of the History of Art at Harvard and Director of Dumbarton Oaks, and I am indebted to his recollections and correspondence for the substance of this account.

A call was sent out for helpers—people with cameras who could search out and record new sculptured fragments or known items, often in remote and difficult places. One appeal was carried in *Antiquity* (March 1936, p. 3); there were others in amateur photographers' magazines. There was quite a lively response, but only six or eight of the volunteers became suppliers of usable photographs on a continuing basis. Two of these helpers were Miss Mercie Lack and Miss Barbara Wagstaff, school mistresses with a photographic hobby. It was through their connection with Kendrick that they were allowed by C. W. Phillips to take responsibility in 1939 for the photographic recording of the Sutton Hoo ship—a basic record of this unique document, of which they took nearly 500 negatives (The Sutton Hoo Ship-burial, vol. 1, p. 142) and an 8mm film. Professor Lawrence Stone, who later wrote the Pelican History of Art volume on *English Medieval Gothic Sculpture*, then a boy at Charterhouse, was another who answered the appeal. Two who were to exercise a considerable influence on Kendrick's life whom he met through the Saxon Sculpture project were the artist John Piper and his wife Myfanwy. The Pipers had been invited to write a book on pre-Conquest or Norman sculpture, and had already spent much time on photographing Romanesque sculpture at Kilpek and elsewhere, and Saxon sculpture. Their prospective publishers, oddly enough, however, wanted a *Corpus* of the material, which, Mrs Piper commented to me, 'would have been boring'. Perhaps Alfred Clapham, or indeed Kendrick himself, may have persuaded the publishers that this was what was needed. The publishers referred the Pipers to Kendrick for advice: he visited their home, and returned there often. They became very good friends. The Pipers introduced Kendrick to John Betjeman, with whom he hit it off at once. These three were all kindred spirits and shared Kendrick's general antiquarian interest. When in 1950 Tom published *British Antiquity* it was dedicated:

> 'Ad Jo. Piperum necnon Jo. Betjehominem Lelandi discipulos'

For the collection of the photographs of Saxon crosses standard cards were prepared, and information was filed with the photographs by counties in the British and Medieval Department. Kendrick published an account of the material in *Journal of the British Archaeological Association*, 1941. After the war, when the team had been dispersed, indeed decimated, the assemblage remained in being and we (including Tom) kept it up to date as best we could, and it was kept available to all enquirers. Kendrick would have been here first to welcome enthusiastically the five volumes of *The Corpus of Anglo-Saxon Sculpture* now appearing under the auspices of the Academy.

For a good many years Kendrick had been building up to his two important volumes, *Anglo-Saxon Art to A.D. 900* (1938) and *Late Saxon and Viking Art*, (1949) which were together intended to give a complete account of the foundations of medieval style. While not concerned with architecture, they surveyed the background to Anglo-Saxon style in Romano-British and prehistoric Iron Age art; then, the pagan period Anglo-Saxon development; and then, from the introduction of Christianity and with it of Mediterranean influences, gave a thorough survey not only of the metalwork but of manuscript decoration and illustration and of sculpture.

In *Kendrick and Hawkes* (1932) Kendrick had surveyed the field of Anglo-Saxon and Viking period progress since 1914–31 in a lively and balanced way. He now produced a series of brilliantly original papers on 'Anglo-Saxon Animal Ornament; (*I.P.E.K.*)[17] 'Polychrome Jewellery in Kent', and 'British Hanging Bowls' (*Antiquity*, 1932, 1933). He saw everything with fresh eyes. A study of St Cuthbert's pectoral cross appeared in 1937 (*Antiquaries Journal*). *I.P.E.K.* was published in Berlin. Kendrick was making his unorthodox views known in Continental circles where the orthodox opinions were entrenched.

Into Kendrick's books on Anglo-Saxon Art, and this is their distinction, under scholarly control, went the element of style analysis and aesthetic judgement. Perhaps largely through the influence of his colleague and collaborator in the Saxon sculpture project, Elizabeth Senior, Kendrick became aware and absorbed something of the Continental school of art history. Elizabeth was one of the very early students from the new Courtauld Institute, who, before that, had studied for a year in Munich,

[17] *Jahrbuch für praehistorische und ethographische Kunst*, **9** (1934), 66ff. (Berlin).

and was now Assistant Keeper in the Department of Prints and Drawings. She introduced Kendrick to Freyhan at the Warburg Institute, where he also met Fritz Saxl[18]—Kitzinger himself, temporarily employed through Kendrick's agency at the Museum, a refugee from Hitler's Germany, had just finishd his doctoral thesis and was also a fully trained Continental art historian. Kendrick's contribution was to take the Continental attitude to style as something which tells you something more than just date or period, but is itself a part of, or kind of, history and is a historical fact (if it can be defined) and graft this approach on to the traditional British archaeological approach to the material and to style and art history.

A guiding theme runs through the book; his perception of the strength and persistence of the barbarian tradition, the non-classical element in Anglo-Saxon art, and the meeting, a mixture of accommodation and repulsion, of this barbaric tradition of the native art of the Celtic and Germanic north—non-representational, vigorous, decorative, based on animal ornament and on the exploitation or transformation of Roman derived themes or ideas—with the narrative and representational art, and architectural ornament, of the classical world. Ending at the Saxon church at Bradford-on-Avon, Kendrick summed up the theme of his first volume:

> My last picture in this book [of one of the Saxon angels above the chancel arch at Bradford-on-Avon] leads us back therefore to that barbaric ornament which has provided the main subject of our survey. I think that it is right that this should be so, for in the long struggle between the naturalistic and the geometric forms of aesthetic expression that has provided our central theme the instinctive urging of the barbaric northerner to make use of vividly patterned spreads of inorganic decoration has continually triumphed over the rare and timid experiments in organic art. Deep in the hearts of the people the inextinguishable spirit that had inspired early British art endured as a perpetual source of cunning intervention and gross travesty that came into operation whenever opportunity occurred for the classical forms to be changed into native idiom.

It was not till many years after, in 1949, that the sequel, *Late Saxon and Viking Art*, was published. The war had intervened, George Zarnecki[19] speaks of it as a very remarkable achievement, based as it was on pre-war scholarship; it is a fine combination of historical assessment and stylistic analysis, written by a master inspired by his subject.

On the sculptural side Tom 'made some brilliant observations as well as

[18] Here I am grateful for the comments of Ernst Kitzinger.
[19] G. Zarnecki, personal communication.

many errors', i.e. some of his datings and assessments are now seen to be wrong.

In the manuscripts miniatures and decoration are often found in sensitive preservation, and much of the original aesthetic effect can be got from them. The sculptural record on the other hand is more worn, illegible, fragmented; and on a monumental scale. George Zarnecki regards the chapter on manuscript painting as the best in the book. Here Kendrick was helped by his close contact with Francis Wormald, his British Museum colleague.

He made also an important contribution in defining and demonstrating the part played by the Scandinavian styles, the result of Viking activity and settlement and especially the 'Urnes style'.

To me Kendrick's greatest service was perhaps to bring together, in his 96 black and white plates, for the first time in the span of a book for general use, a wealth of unfamiliar illustrative material supplemented by sensitive notes on colour and a commentary that conveyed their aesthetic impact and closely integrated the pictures with the text.

In writing of *Late Saxon and Viking Art* George Zarnecki has commented on Kendrick's prose (e.g. talking about the acanthus leaves on the Bury Gospels)

> ... though formally and symmetrically posed and unmistakeably English in character, can nevertheless be described as storm beaten in as much as they lean crazily across each other at violently inclined angles.

adding 'I wish I could write like that.'[20]

What must be stressed is the novelty of such masterly writing, and of such an approach to the art of the period, in relation to all that had gone before.

Not many of Tom's personal letters (I am not thinking of official correspondence) are known to survive, but he was a sparkling, witty correspondent. One recipient, close to Tom's heart, writes of his letters:

> They were wonderful—and just think what there must have been to and from so many great characters—Lethbridge, Betjeman, Wheeler, the Pipers, etc. My own view was always that Tom lived a much fuller and more articulate life on paper, and so funny.

[20] Personal communication.

The same correspondent speaks of her own contacts with Tom when she was growing up—'a state of permanent childlike nonsense', which Tom kept up with her children in turn—'he was brilliant with children'.

Tom's widow, Katharine, also wrote 'He was marvellous with children, no child was ever shy with him, and they found him highly amusing and entertaining'.

Kendrick was certainly no *dong with a luminous nose*. He was charming and personable, but some analogy with Lear is there—the writing of nonsense, wild comic cartoons, scraps of verse, and the gift to communicate with and captivate the child. With them it seems his Lear-like shyness was shed, allowing a part of his true self to find expression.

Some of Tom's best letters were written on his journeys to photograph Saxon sculpture, from hotels in strange places—letters to his co-workers. There were *jeux d'esprit*, also, like the mock correspondence penned in the Savile Club between the legendary Sir Charles Hercules Read (whose tired-looking portrait by Augustus John hangs prominently in the Athenaeum) and Sir Lawrence Alma-Tadema, about the Roman bronze head from Saxmundham. Tom had the habit also of coining rhymes when he felt moved to. As a postgraduate student at Oxford he and his friend Louis Clarke attended a lecture on Petra at the Ashmolean. As they were coming out, Tom stopped on the steps and exclaimed:

> The dating, 'half as old as Time'
> You must reject *in toto*.
> It represents that *horrid* crime,
> *Ignotum per ignoto*.

As Director, Kendrick had agreed to write a preface to the costly colour-facsimile edition of the Museum's great treasure, the Lindisfarne Gospels. A very large part of the fat commentary volume was taken up with the exhaustive analysis of the 10th century interlinear Anglo-Saxon gloss by Professor A. S. C. Ross.[21] The work had been going on for years as a kind of fatigue on to which Ross's students were put. Every occurrence of every word is meticulously recorded. The entry for 'he', for example takes up 13 columns of small type on the very large pages. When Tom sent the proofs back to Julian Brown, then a young Assistant Keeper engaged, in his palaeographical commentary, on his first important publication, a note was pinned on, without comment.

[21] Index Verborum Glossematicus, 1–176 (separately paginated) by A. S. C. Ross & E. G. Stanley, in *Codex Lindisfarnensis* (Kendrick *et al.*), Urs Graf Verlag, Olten and Lausanne, Commentary Volume 1960.

31:xii:59

There was a Professor called Ross
Whose class was put onto a gloss.
 For thirty long years
 Those youths were in tears —
But it had no effect on their boss.

It is not surprising that under Kendrick a profound change came over the official correspondence. When I joined I was given some of his letters as an example. Our replies to the public grew cordial, informal, friendly and to the point.

In 1940 Kendrick was elected to the Secretaryship of the Society of Antiquaries,[22] first held by William Stukeley. This office he greatly valued and enjoyed, for he loved the Society, its history and traditions, and was working with people he liked and admired over the whole broad range of antiquarian studies. He served with three Presidents, Sir Alfred Clapham, Sir Cyril Fox and Sir James Mann. Initially he had to contend with the wartime situation. The Society's paintings and manuscripts and great numbers of the more valuable books were packed and sent for safety to the houses of Fellows and friends in the country. The Subject and Author Catalogues were removed to the Aldwych Tube, where the British Museum were storing the Elgin Marbles, the newly-discovered Sutton Hoo finds, the Lindisfarne Gospels and such treasures. Kendrick, with the help of Philip Corder, the Acting Librarian, and one of Kendrick's protégés, the Czech refugee scholar, Dr Edith Stiassny, supervized this operation. At the British Museum Tom had organized a wartime exhibition; now, single-handed, he organized an exhibition in the Library of early illustrations of British archaeology, which was a great success within the Society. The wartime anniversary addresses of the President show the Society's fortunes and notable initiatives in the war years, during which the Council continued to meet, to consider current problems and look to the future. In 1945, the second of a new series, Occasional Papers, was published— *Presidents of the Society of Antiquaries*—short biographies (brief lives) of those who held the office from Peter le Neve (elected 1717) to Lord Dillon (whose term ended in 1904). It appeared anonymously, but was written by Kendrick. He resigned the Secretaryship (in which I succeeded him) in 1950, on his appointment as Director of the Museum.

[22] J. Evans, *A History of the Society of Antiquaries*, (OUP, 1956), pp. 424, ff.

As Keeper (he had succeeded Reginald Smith in 1938) Kendrick set about the cleaning of the collections. The historic series of Iron Age bronzes from Stanwick,[23] in N. Yorkshire, alas, were over-cleaned and stripped, revealing light engraved designs, but destroying the patina (the work is of course done in the Research Laboratory, but the curatorial staff remain responsible): but a great success was the cleaning of the Department's splendid Roman and Early Christian silver; and bright colours and mirrors were introduced into the displays.

Kendrick established close links with the Research Laboratory, whose reputation under Harold Plenderleith was unrivalled, and helped to enlist their skills in the cause of important antiquities from outside the Museum. Perhaps in response to a request for advice from Kit Battiscombe, the Chapter Clerk at Durham, where the Dean and Chapter had embarked upon a publication of St Cuthbert's relics, (Tom had already published a study of the pectoral cross)[24] or at least with his active support, the relics of St Cuthbert were brought to London *en masse*, and studied afresh from all points of view, while being cleaned and restored at the V & A (textiles) and in the BM. Kitzinger had earlier published the wooden reliquary coffin of 698, which had been wrongly put together, with new half-scale drawings. *The Relics of St. Cuthbert* volume, published by the Dean and Chapter and edited by C. F. Battiscombe, followed, incorporating the new results. Kendrick's Hon. D. Litt. from Durham shortly after arose, one suspects, in no small degree from this. In 1938, St Manchan's shrine was brought over from Dublin, and when study and restoration were completed, a paper on it all was read at the Antiquaries by Kendrick and Elizabeth Senior, and published in *Archaeologia*.[25]

It was on the occasion of the arranging of the marvellous exhibition of the cream of all Departments in the Edward VII gallery after the war[26] that, as John Brailsford describes in his biographical account,[27] there occurred a revealing incident. Brailsford, who had only just joined the Department, was arranging prehistoric exhibits on the top shelf of a surround case between two bays when he dropped a bronze axe. The glass shelf shattered and smashed into the exhibits below with an almightly crash. Kendrick, who was working opposite on the other side of the

[23] Referred to by Kendrick in his Museums Association address, see pp. 417–18 below.
[24] *Antiquaries Journal*.
[25] *Archaeologia*, **86**, p. 105: the paper was read 28 Nov. 938, not 1935, as in Joan Evans, op. cit., p. 422.
[26] Referred to by Martin Robertson in his Memoir of Bernard Ashmole (*Proceedings of the British Academy*, **75** (1989), pp. 322–3. It was the only gallery then fit for use.
[27] See acknowledgements below.

gallery, never even turned round. I will vouch for this, because I was there.

Two major events of Tom's Keepership, one before and one after the war, were the discoveries of the Mildenhall Treasure of Roman silver, and the Sutton Hoo ship-burial. Kendrick, more than anyone, was in 1939 thrilled by the Sutton Hoo discovery, central to his field of Anglo-Saxon art and archaeology. Two splendid photographs taken by O. G. S. Crawford of Kendrick visiting the excavation on a great day, with Sir John Forsdyke, can be seen in the Museum's publication of 1986.[28] Charles Phillips, the excavator, recalls how on an earlier visit he met Kendrick at Woodbridge station, and the dramatic moment when he drew him into the waiting room, and produced from his pocket one of the perfect small gold and garnet buckles and the scale of the discovery became clear to him.[29] Tom attended the Coroners Inquest and sat with Mrs Pretty, and no doubt charmed her. Taking Stuart Piggott's arm at the end, Tom whispered 'I think I've got it, I think I've got it'.[30] Tom put on an exhibition in the Front Hall of the Museum of such things as were in exhibitable state, with graphics, and I recall blown-up photos of the excavation; but almost immediately the finds had to be taken to a place of safety. Tom organized, with admirable expedition, a preliminary publication of the discovery, in the *British Museum Quarterly* issue on Sutton Hoo (1939) and in *Antiquity* (1940), contributing his own assessment of the gold jewellery and of the large hanging-bowl. He got Ernst Kitzinger to contribute a classic account of the Byzantine silver.

In many ways the war seemed to mark a watershed in Kendrick's life and career. He had lost interest in his (much delayed) *Late Saxon and Viking Art*. He seemed to turn his back on what had gone before and on old friends. I think that his active mind, always probing forwards into new areas of enquiry and fresh lines of thought, had become engrossed with the antiquarian themes the history of ideas and human credulity, that led shortly to some of his best work.

Kendrick's appointment as Director and Principal Librarian in 1950 came at a moment that was not propitious for the development of new

[28] *The Sutton Hoo Ship-burial*, by A. C. Evans (BM Publications, 1986), Plates 1 and 2.
[29] C. W. Phillips in *Recent Archaeological Excavations in Britain*, ed. R. L. S. Bruce-Mitford, pp. 159–60.
[30] Personal communication. Actually the story was not so simple. Many strange things happened before Mrs Pretty, who had a strong interest in spiritualism, got in touch with her late husband, who came down on the side of the BM.

schemes or for radical action, even if Tom had been that sort of Director. It coincided with the outbreak of the Korean War.

The frustration of the staff of the Museum was most deeply felt at the slow rehabilitation of the building and the lack of money to invest in new displays—a matter close to Kendrick's heart—and for purchases—equally important in his eyes. Bentley Bridgewater, the Museum's Secretary, worked closely with Kendrick as Director, and was indeed his right-hand man in the running of the office and preparation of business for the Trustees, and was privy to much of what went on.

According to Bridgewater, Kendrick went to his new post as Director 'full of bright ideas and clear vision' but soon found that he could not get the money to implement them. There was in the office at this time a very small back-up staff. The Director's Office had not embarked upon the monstrous growth it later assumed. The view was, and Kendrick embodied it, that it was indecent to ask for more staff in the Office for administration when the Departments (the heart and soul of the Museum) had such obvious and radical needs. Kendrick had no doubt where his priorities lay. With him, the Office came last. He was greatly distressed when, under R. A. Butler's cuts, he was forced to close the upper floor of the Museum on alternate days. Then there was the inability to restore war damage, which had been severe.

It was a quarter of a century—in my own time as Keeper—before the burnt out galleries at the head of the great staircase, which had housed the prehistoric collections, were rebuilt. The same was true of the Greek Vase rooms and other parts of the building. Peter Brown, who was the Museum's Assistant Secretary and was later to become the Librarian of Trinity College, Dublin, wrote that the Korean War was 'a great thing in Kendrick's Directorship'—'the terrifying economies—staff cuts and ceilings or expenditure capping, leading to the closures of the Upper Floor Galleries'. This 'knocked Kendrick sideways—his morale went down—his terrific *élan* went'. Brown writes that Kendrick 'had a marvellous capacity for sizing up a situation in one'. 'He did not have the kind of practical intelligence for administrative action characteristic of his predecessors, Kenyon, Hill and Forsdyke,' (or indeed his successor Sir Frank Francis) 'but he had intuitive intelligence—he used the telling phrase to penetrate to the heart of the matter'.

Sir David Wilson has given me this impression of Tom as Director:[31]

> he managed the affairs of the Museum in the reconstruction period with great skill. He fought the Treasury to reopen the galleries on a full time basis. He

[31] Personal communication.

set a new standard of guide book and book production, and did a great deal to prepare the way for his successor to take on this burden (of carrying through the major reconstruction work) ... When I have come across papers written by Kendrick or notes of action taken by him, I am deeply impressed by his ability to deal, not only with the standard academic world, but also with Whitehall.

As one of his Keepers, I knew that I could count on a courteous reception whenever I went to discuss something with the Director, and was always confident that he knew exactly what the issues were and that he would bring to bear upon them a judgement based upon a thorough understanding of what mattered, and of the Keeper's point of view. He was on the same wave-length as all of the 14 Keepers that he represented; he took a great interest in what was going on and—though not, as Director, any longer himself responsible for any part of the collections—was often to be seen in the Galleries. It was immensely encouraging to members of staff, often junior Assistant Keepers, to be stopped by the Director and told—'I do like your new arrangement in the 12th century bay'—or to be congratulated warmly on a new acquisition just put on display, and told how splendid it looks.

In 1951, as Director and Principal Librarian, Tom was asked to give a paper to the Museum's Association Conference at Belfast. He no doubt chose the theme 'The British Museum and British Antiquities'[32] himself, for it was a subject that he knew all about, and one which chimed with his own interest in the history of antiquarian thought. The result was a hilarious survey of the laggard way in which the Museum's Trustees awoke to a realization of the value and potential of their own national archaeology. There was also a splendid depiction of the ideal Museum of National Antiquities of Ruritanea, round which Tom was being taken on a conducted tour which passed via the new Room of Romano-Ruritanean Antiquities, 'surpassing all that has gone before'.

> It is artfully contrived to represent in successive stages, the interiors of a forum, a temple, baths, a villa and a fort. Mosaic pavements spread out on the floor; the Roman fountain, which sprouts, though itself obviously bogus, undeniably genuine water into a little Roman garden where is to be found one of the most fascinating exhibits in this great Museum, a living colony of edible snails. It is all beyond praise, and continues to be splendid in all the

[32] Museums Journal, **51**, No. 6 (Sept. 1951), 139–49, subsequently reprinted in Antiquity, **38** (1954), 132–42.

> rooms representing succeeding periods. 'By Jove' my friends say to me as we progress,' you must be green with envy'!
> Why I am looking green is my own business. It happens that I should myself prefer the national antiquities of Ruritania to be housed in a dark, draughty and entirely unsuitable old castle, with plenty of spiral staircases ...

Kendrick understood perfectly well the new techniques and ideas which he himself as Keeper had, within the limits of the possible, prior to the rebuilding of the Department's galleries, sought to introduce. But he was not one to prostitute the museum to the needs of tourism, or compromise its essential health, strength and functions for the general cause of education at large.

The real interest of his Museums Association Paper is to me its exposure, in his peroration, of his love for the collections and of the depth of his convictions on the issues he was addressing.

In his peroration, worth quoting in full, he proclaimed his personal *credo* against the setting up, advocated by some, of a Museum of National Antiquities, devoted solely to our national archaeology.

> It is not by a priggishly virtuous discipline that we (the BM) resist nationalist self-glory. It is because we are—unless we lose all sense of proportion—prevented by our own great collections from indulging in such stupidity.
>
> After all, even the most distinguished British antiquities would look remarkably silly if we promoted them to take the honoured place of the pediment sculptures of the Parthenon.[33] It is a very important thing that the great museums of London share with many other museums the duty reflecting in a microcosm God's total creation. Both branches of the British Museum, the Science Museum, The Geological Museum, the Victoria & Albert Museum, and the National Gallery, have, put together, a cumulative purpose that ascends to the Heavens and descends to the depths of the sea; that comprehends in intention the stars on high and the innermost core of the earth, and the full story of man in this world, of his multifarious handiwork, noble and ignoble, everywhere. Our united song is Psalm 104, and not Psalm 105.
>
> In the British Museum we are not concerned with comment upon the felicity of the chosen. We say 'Man goeth forth to his work and to his labour: until the evening', and we mean Palaeolithic man, Mesolithic man, Neolithic man, the ancient Assyrians and Egyptians, the Greeks and the Romans, the Teuton and the Celt, man in Europe, man in Asia, man in Africa, man in America, man everywhere. Sir Hans Sloane said of his collection that it was 'tending in many ways to the manifestation of the glory of God'. Its purpose is summarized by the psalmist: 'O Lord how manifold are thy works: in wisdom hast Thou made them all. The earth is full of thy riches.' This principle is still our principle. To anyone who thinks we do not sufficiently

[33] This was before Suton Hoo came along. It might just have got by.

exalt the antiquities of the British Isles, I can answer only by repeating the words that I treasure and that serve as our governing text:

> 'Behold, the nations are as a drop in a bucket, and are counted as the small dust of the balance; behold he taketh up the isles as a very little thing.'

Kendrick was heavily involved in the plans for a new site for the British Museum skilfully designed to occupy the area opposite the Museum and between it and Oxford Street, but preserving Hawksmoor's neo-classical church of St George. Great Russell Street was to go over this part of its length. I recall that he had a difficult time at the public enquiry, when the scheme was violently opposed by the Camden Council. More happily he presided over two centenaries, the bicentenary of the Museum's foundation, a glittering party, graced by the presence of the Queen and the Duke of Edinburgh, and the centenary of the Reading Room. By the end of his Directorship the fine new offices of the Dept. of Coins and Medals had been opened and the Room of Greek and Roman Life, which had been totally destroyed, was almost ready for opening.

When Tom retired, after the tribulations of his 'eight lean years' he was able to write to Stuart Piggott.

> I am glad to say I hand over in a mood of optimism as the worst of the economic oppression is over and the prospects, at least as regards staff and money, are now quite comfortable for 59/60. Frank Francis can now start planning the Library in quite a cheerful mood.[34]

But Tom did not enjoy his time as Director.[35] Latterly he contrived to spend a good deal of time in the library. Bentley Bridgewater had to run him to earth there to get his signature. And when he left, in spite of coaxing from all sides, Tom absolutely declined to have his portrait painted to hang in the boardroom, where the likenesses of Founders and Directors by leading artists of the day are traditionally hung.

British Antiquity, appeared in 1950, shortly after Kendrick had become Director.

In the Preface he tells us that 'the book is based on notes I have made under the heading "Britain" while studying some general varieties of antiquarian thought in Europe'. The British chapter, covering the period from the late 15th to early 17th century, seemed interesting enough to stand as a story by itself, being in the main concerned with 16th-century

[34] Kendrick to Stuart Piggott, 3.2.59.
[35] Katharine Kendrick, *Memoranda*.

England and the transition there from medieval to modern antiquarian thought. The British or English essay, from the greater work contemplated, thus fortunately got written, though the major work hinted at, of European scope, never materialized. Fortunately, because *British Antiquity* is one of Kendrick's best and most highly regarded achievements.

His theme was to trace antiquarian thought in Tudor and Elizabethan England and to show how antiquarian thinking and method gradually emerged, with considerable travail, from blind acceptance of the fictitious version of British origins and history invented by the 12th-century chronicler Geoffrey of Monmouth, and propagated in his *Historia Regum Britanniae*, which Kendrick calls 'this brilliant book that became one of the principal successes of European secular literature in the Middle Ages'. Finally, the new learning triumphed over the medievalist view, and 'with Geoffrey disposed of the way was clear for original work based on the first-hand examination of documentary and archaeological evidence'.[36] Tom traces the growth of the Geoffrey of Monmouth story (by which the British people were of Trojan origin, descendants of the Trojan immigrant Brutus) and follows this with biographical portraits of two genuine antiquaries of the 15th century, John Rous (1411–91), artist and scholar and maker of the heraldic Rouse Roll, and William of Worcester (1415–82). He then provided in 20 pages, the first full length study of one of our greatest antiquaries, John Leland (d. 1552) (a fount of biographical information, often cited in the DNB; topographer and recorder of the libraries of Britain.

Kendrick traces 'The battle over the British History' and 'The eclipse of the British History' at the hands of Elizabethan scholars, writers and men of letters, and the development of original topographical studies culminating in Camden's great *Britannia*.

No single coherent account had previously been written of this evolution, or revolution, in the approach to the past in Tudor and Elizabethan times, that led on to the antiquarian scholarship of the 19th century and to modern archaeology. For this reason, if for no other, *British Antiquity* is a most notable achievement.

Tom's next book, *The Lisbon Earthquake* is another remarkable work. The earthquake occurred on 1 November 1755. It was calamity that reverberated through European literature and on down the years, a shattering disaster to a rich and famous city. About 15,000, including a

[36] Stuart Piggott, *Antiquaries Journal*, **30** (1950), pp. 96, 97.

good many of the English community, were killed, and the horrors of the earthquake itself were made worse by the Tagus pouring over its banks and a terrible fire that burnt out the whole centre of the town. Was this God's vengeance on the sins of the inhabitants? Or a warning to the pride of mankind at large?

Kendrick follows events minute by minute, quoting contemporary accounts and eye-witness reports, and describes the measures taken to deal with the damage and disorder and the reactions of Europe's men of science. But the heart of the book is the effect that the disaster had upon the minds of men and especially on the philosophers of the Age of Reason; as Tom put it in his introduction, 'the book is mainly concerned with the related themes of 18th century earthquake theology' ('there is no divine visitation which is likely to have so general an influence upon sinners as an earthquake' John Wesley wrote in 1777), 'and the end of optimism'. There was a kind of watershed, a reversal in the climate of thinking, in the middle of the century, and the Lisbon earthquake was the catalyst.

> Blest eighteenth century! propitious clime!
> Enchanted island in the sea of time![37]

had become the *siècle infame*, *siècle atroce* of P-D Edouchard le Brun.[38] Voltaire's poem *Sur le désastre de Lisbon* was followed up by *Candide*.

Kendrick shows a great range of reading and marvellous control over a wealth of material. He begins and ends the book with chapters about London—first in 1750, where before the Lisbon disaster minor quakes had stirred the dovecotes—and after, in 1755–6.

Tom's writing of the book, he says, arose out of his own small collection of earthquake pamphlets and sermons. It may also have been stimulated by his friend Louis Clarke's[39] possession of a MS copy of Voltaire's poem *Sur le Désastre de Lisbon* and of an autograph letter in Voltaire's hand discussing it.[40]

The book followed closely upon the heels of *British Antiquity*. Kendrick was by now a perceived master of the genre, writing with ease and authority.

[37] James Laver, *Ladies Mistakes*.
[38] *The Lisbon Earthquake*, p. 141.
[39] L. C. G. Clarke, Curator of the University Museum of Archaeology and Ethnology, Cambridge (1922–37); Director of the Fitzwilliam Museum, Cambridge, (1937–46). The point was noted by Basil Gray, *Burlington Magazine*, March 1980 (see acknowledgements below).
[40] See also p. 448 above, where it is indicated that his interest in the Lisbon earthquake went back to his schooldays.

Tom married in 1922 Helen Kiek, who had been a fellow student at Oxford and was the daughter of Louis Holland Kiek, a merchant banker. She was an excellent pianist and a kind and friendly hostess. They had one daughter, Frances (Mrs Atkin). Helen died in 1955, and Tom married in 1957 Katharine Elizabeth Wrigley, who, with her family, were old friends of the Kendricks. Her father, for whom Tom had a great affection, had been Kendrick's senior Officer, and Katharine could speak warmly from experience of Helen's 'kindness and hospitality'. Katharine was to outlive Tom by only six months.

Kendrick was a Life Trustee of the Sir John Soane's Museum, an institution, if one can call it such, much after his own heart; he received honorary degrees from Durham, Oxford and Dublin and was made an Honorary Fellow of Oriel College in 1952, though no one recalls his having taken advantage of it. He was a Foreign Member of the Swedish Academy of Letters, History and Antiquity, and he was also an Honorary Fellow of the Royal Institute of British Architects. He was made KBE in 1952.

Tom's retirement, at Organford Farm, near Poole, in Dorset, where he gardened and wrote, was productive and happy. His infectious enjoyment of whatever interested him was undimmed, so far as his temperament allowed. I think he had his despondencies and could be difficult to live with, but his winning enjoyment of whatever interested him was undimmed. Working steadily, in addition to *Icarus* and his 'aberration' (as a young publisher's reader felt) *The Creeper in the Second Quad*, he wrote three more Spanish studies. *St James in Spain* and *Mary of Agreda*, which were duly published, and *Philip IV of Spain* completed but rejected. Space does not allow for discussion of these books here, but *Icarus* seems to me of biographical importance, apart from its literary merits, and *St James in Spain* is a notable achievement.

Kendrick's high spirits never deserted him, as his correspondence showed. In 1962 I wrote to thank him for a copy of the newly published *Icarus* which had in fact been sent by Peter Wait of Methuen's without Tom's knowledge. Tom's disclaimer ended:

> If anyone asks you why I have started reviewing books (on subjects about which I know nothing) in the Daily Telegraph, the answer is that they ring up and start whining at me during Z-Cars or Coronation Street. I just give in.

Writing to Stuart Piggott in 1967, thanking him for the gift of a copy of his new *The Druids*, Tom urged Stuart to go in for the Directorship of the British Museum, now falling vacant again:

> The post is a precious prize. Practically no responsibilities. Just occasionally signing a letter or two that someone, who can write better letters than you can, has written for you. Honey-sweet relations with the dear, friendly Trustees, and turtle-cooing with the Staff Side at Whitley Councils. Above all, abundant opportunity to get on with your own work and no need to hide it under the blotting-paper when you have callers. Any library-book brought to you within minutes. You can even have the Rosetta Stone wheeled in. And, of course, at the end a reasonable expectancy of a life-peerage and the Garter. It's worth it, Stuart.

Tom became blind in his last years, but his mind remained sharp and clear as a bell, his wit unimpaired. But his death was not untimely. He was terrified of outliving Katharine who was known to have cancer. John Mitchell (of East Anglia University, son of Tom's old friend Charles Mitchell, the art historian) recalls a visit with a friend, not long before Tom's death, when though blind and physically dramatically wasted, Tom received them with extreme courtesy and discussed horses, a subject of great interest with him, with the knowledgeable guest. There was an extraordinary atmosphere of joy, even hilarity.

Tom supported his local church when able-bodied in the earlier part of his retirement, and Katharine was a pillar of it. What epitaph can one find for this great quicksilver-minded scholarly and witty man, with his voracious interest in all of life, and his gifts of empathy and expression? Perhaps, a sentence from his last and sparkling speech, in November 1971, as the guest of honour at a dinner that followed a one-day conference on Iron Age Art in Dorchester:

> All my life I have been taking trains to the wrong destinations, but oh, my dears, how enchanting have been the views out of the window.

RUPERT BRUCE-MITFORD

Note. In preparing this memoir I am greatly indebted to Professors Ernst Kitzinger and Stuart Piggott for their reminiscences and for access to Kendrick letters. Gale Seiveking has advised me on Kendrick as prehistorian and I have quoted his comments freely. J. W. Brailsford, my late colleague, the first Keeper of Prehistoric and Romano-British Antiquities, who greatly admired Kendrick, himself essayed a biographical account. Ill health prevented its adequate completion. I have had the benefit of access to his typescript.[41] Others to whom I owe much have been Kendrick's daughter Frances, Mrs Atkin; Bentley Bridgewater, Secretary of the Museum during Kendrick's Directorship, Peter Brown, the Assistant Secretary, afterwards the Librarian of Trinity College,

Dublin, and the staff of the Society of Antiquaries Library and the Society's Secretary General, Hugh Chapman. Mr and Mrs John Piper; Miss Armide Oppé, former Secretary to the Royal Commission on Museums and Art galleries and Mrs Sally Mellersh. Professor Henry Loyn and Sir David Wilson have given me the benefit of their views on Kendrick's *A History of the Vikings*, and in the latter's case on aspects of Kendrick's Directorship. I am especially grateful to the British Museum Archivist, Mrs Janet Wallace, who provided me with the photograph that accompanies this Memoir, and to her assistant Christopher Date. They have provided copies of some of the papers relating to Kendrick's Museum career. Also I am grateful for the help of the Archivist of Oriel College, Oxford, Mrs Elizabeth Boardman and of the present Secretary of the British Museum, George Morris. The late Professor Hugh Hencken and his wife, Thalassa, helped with their personal recollections. Peter Wait, of Methuen's, who was concerned with the publication of all Kendrick's books, and has given me information about Kendrick and his unpublished novel.

Others who have helped me to get a picture of Kendrick's life following his retirement have been Miss Brenda Inkster (Bampton) a friend of his second wife Katharine, and John Mitchell (University of East Anglia), and his father, the art historian Charles Mitchell, who knew Kendrick very well before and during the war. I am grateful also to our late Fellow Basil Gray for his recollections and comments and for the use I have made of his obituary of Kendrick (*Burlington Magazine*, March 1980).

[41] Deposited in the Library of the Society of Antiquaries.

DOROTHY WHITELOCK *Elliott & Fry*

XXII

DOROTHY WHITELOCK

1901–1982

DOROTHY WHITELOCK was born in Leeds on 11 November 1901, the feast of St Martin, a date in which she later delighted. 'I am so glad', she wrote in 1980 in one of the last letters to her publishers, 'to have St. Martin as a patron; St. Dorothy was only one of those virgin saints, whereas Martin did things.' The comment is a key to the character of this industrious, thoughtful Yorkshirewoman who did so much to mould Old English Studies in the mid-twentieth century. She was brought up in Yorkshire in a family deeply rooted in the shire and all its traditions. Her father died when she was only 2, leaving the family with considerable financial struggle. Dorothy who was the youngest of his six children always spoke warmly of the way her mother coped with the situation, so that if there was not plenty there was not want and the children as far as was possible were given the education that would open up their proper chances in life. For Dorothy that meant the academic life and she remembered later in life saying at a very early age, to the surprise of her family, that she wished one day to go to university. She was an excellent pupil at a very good school, Leeds High School, where she was given her essential grounding in language and literature. At the age of 18 she was awarded a place at Newnham, but sensibly spent a year at Leeds University before going up to Cambridge in October 1921, where she elected to read the relatively new Section B of the English Tripos under the direction of Professor H. M. Chadwick. It is not now easy to reconstruct the Cambridge of those days. The gulf between ex-servicemen and those straight from school was wider than after 1945 and the womens' colleges were small and regarded with suspicion by some and with open hostility by others. The majority, however, recognized their worth and welcomed the presence of able women undergraduates and of distinguished women scholars among the senior academics. Dorothy was one of only four students of her year to be reading English B, which involved much Anglo-Saxon and Old Norse and a certain amount of archaeology and wider historical study. Mrs Kathleen Ede (née Bond) who was a contemporary and who remained a firm friend throughout her life writes 'from the

beginning it was clear that she was a real scholar, far in advance of the rest of us. I believe she had a year at Leeds University before coming to Cambridge and she was certainly a more mature student. She had no use for research or teaching that was not genuine and honest; she was always appreciative of real scholarship.' The Dorothy Whitelock that we came to know later emerges full grown from this comment. She was small, elegant, frail-looking and to some extent frail, subject from time to time to attacks of migraine, but capable of long hours of work. She was no games player, not even a cyclist, but was a great walker who came to know Cambridge well from her secure base at Newnham with its gardens and opportunity for intellectual discussion. For she had and maintained a great capacity for friendship, though cautious in judgement and shrewd in her assessment of people. In proper Yorkshire fashion she did not suffer fools gladly, but willingly gave many the benefit of the doubt to a quite astonishing degree. The greatest intellectual influence on her at this stage was undoubtedly Professor Chadwick who was her principal teacher for English B. Amused by his eccentricities Dorothy revered him and, together with others of her generation, advanced knowledge along lines of thought and investigation that had been opened by him, notably in his early studies on Anglo-Saxon institutions. If in later years she sometimes felt that both Nora and Hector Chadwick had strayed too far along Celtic paths (among others), she never lost her respect and affection for them as scholars and friends. Cyril Fox, new to Cambridge, and full of the excitement of recent archaeological discovery, was another powerful influence and so, too, was Anna Paues, a fine and to all account formidable teacher of philology and phonetics. No one was surprised when Dorothy achieved a first class in this difficult Section of the Tripos. She was not as much at home in English A which she took as her Part II but even so enjoyed much of it and especially the lectures of G. G. Coulton, Stanley Bennett, and I. A. Richards. Among her tutors she remembered best Mrs Joan Bennett. Encouraged by Chadwick she moved into full-time research, holding the Marion Kennedy studentship at Newnham, 1924-6, the Cambridge University Studentship at the University of Uppsala, 1927-9, and the Allen Studentship of Cambridge in 1929-30. Anna Paues was instrumental in persuading her to take the Uppsala Fellowship, a considerable achievement, for Dorothy always travelled as little as possible, partly because she found travel a physical strain and partly because she hated to be away too long from her books and good libraries. The grant of the Allen

Studentship was particularly meritorious and she appears to have been the first woman to hold that prestigious award. The fruits of all this labour, six years exceedingly hard work, were twofold. She acquired a mastery of the technical side of one of the disciplines she was to make her own, a refined control of the Old Norse she had studied as an undergraduate, good modern Swedish, and basic skills in diplomatic. She also discovered, although this was not immediately apparent to all, a gift for social history of the most advanced type. In 1930 she published her first book, *Anglo-Saxon Wills*, a work which provides in method and content one of the best guides to the study of late Anglo-Saxon society. Accuracy and precision in the language disciplines is matched by an acute awareness of what the evidence can tell us of the realities of social life, the transmission of land and property, rules of inheritance, the tenacity of kindred ties and obligations. The observant eye of Marc Bloch in an early number of the *Annales d'Histoire Économique et Sociale* noted the value of her contribution and lamented the absence on the French side of the Channel of a comparable edition of these important *donations à cause de mort*.

There was, however, no immediate follow-up. Whether things would have been different if at this stage she had been appointed to a Cambridge rather than to an Oxford post is hard to say. Probably not, as the pressing need at both universities in the 1930s was for conscientious teaching in the language discipline, and it is possible that Cambridge would have been even more difficult than Oxford for a teacher of Dorothy Whitelock's temperament and interests. As it was she was appointed to a post at St Hilda's, where she made her home for more than a quarter of a century.

It is clear from what her friends say and from what she herself did not say that her early years at Oxford were hard. English was a popular school and this meant an immense weight of tutorial work, particularly in a college as small as St Hilda's with its 100 or so students and only six tutorial Fellows. Dorothy herself was a lecturer without rights or tenure for her first six years and was not appointed Tutor until 1936 and Fellow in 1937. There were natural compensations. During these years she acquired full confidence in her subject and in her ability to teach it. She made many permanent friends among her pupils who came increasingly to appreciate the young scholar, at first sight somewhat austere, who would recognize their problems in what to most was an extremely difficult element in the English syllabus, all the more terrifying because it was compulsory. She was good with the high-fliers who came her way but won a solid reputation for her sympathetic

handling of those to whom the language of *Beowulf* threatened to be the monster that destroyed all hopes of success and pleasure in the English School. She did not, however, fit easily herself into a School where, though the language interest was strong, there rested an uneasy suspicion of the Chadwickian historical and archaeological approach. Dr Kenneth Sisam became and remained a good friend and so did Professor and Mrs Stenton (as they then were) at Reading. Among the historians Sir Maurice Powicke provided kind support. She delighted in the companionship of Dr Kathleen Major whom she later served as Vice-Principal, and of Dame Helen Gardner with whom she worked closely from 1941–56. As Mrs Wallace-Hadrill writes in a personal letter which recalls the teaching in the English School, 'there were indeed giants in those days'. Dame Helen herself reminds us in a memoir of Dorothy written for St Hilda's of the comic side to what was essentially a very balanced academic existence, never quite at home with cigarette smoking, never quite at home as a dog-lover: yet dutifully conforming to both addictions. She also tells a revealing story of Dorothy the disciplinarian as Vice-Principal for once (and she was the kindest of persons) refusing mediation on behalf of one defaulter: 'She has told lie after lie', said Dorothy, 'and they were not even good lies!' Involvement in teaching and college affairs was intense. She was awarded a Leverhulme Fellowship in 1939 but war made leave impossible, so that for the first fifteen years of her career she taught full-time and at full stretch. In such circumstances it is no surprise that her productive work ceased in the early years, though markers to future progress appeared in a note on Wulfstan in 1937 and then in 1939 in her splendid edition of the *Sermo Lupi ad Anglos*, which established her reputation firmly as one of the leading authorities on the later Anglo-Saxon period. The war years proved busy both in teaching and administration. She became president of the Viking Society for Northern Research (1940–1) and editor of the *Saga-Book*. Her essay in that journal in 1941 on the conversion of the Danelaw deepened knowledge not only of the conversion itself but of the whole process of Scandinavian settlement in England. In a paper on 'Wulfstan and the so-called Laws of Edward and Guthrum' (*EHR*, 1941) she made a significant correction to the work of Felix Liebermann, a scholar whom she held in the greatest respect. An article in the *Transactions of the Royal Historical Society* (1942) on Wulfstan as homilist and statesman rounded off one aspect of her Wulfstan studies and prepared the ground for her analysis of Wulfstan's contribution to the Laws of Cnut which

was published in *EHR* (1948), with a confirmatory note added in 1955 in which she argued against some of Karl Jost's ideas. Publication in *EHR* brought her into close touch with the editor, Professor Goronwy Edwards, who remained a firm friend; and her reputation grew in the historical field as much if not more than in the literary. She had been a Fellow of the Royal Historical Society from as far back as 1930 and was elected to its Council (1945-8). She became a Fellow of the Society of Antiquaries in 1945. She was well poised to emerge as one of the leading figures in the post-war scholarly world. When the key post in Anglo-Saxon studies at Oxford fell vacant in 1945 on Tolkien's translation to the Merton chair she was a powerful candidate. Stenton and Sisam both supported her, but the election fell in fact on C. L. Wrenn. The admitted disappointment left no enduring mark and the first decade after the war proved one of the most productive periods in a very productive career. Her literary expertise, sharpened by intense tutoring over many years, was shown in a paper on 'Anglo-Saxon Poetry and the Historian', and an acute and penetrating analysis of the 'Seafarer', in which she placed the poem fairly and squarely in the context of Christian attitudes to penitential exile. She made permanent contributions to *Beowulf* studies in a set of three lectures given at London University and published under the title *The Audience of Beowulf* in 1951. Her cautious but firm statement of case for an eighth-century origin to the poem still wins wide acceptance. It was now, too, that her full stature as a historian became apparent. Penguin publishers had the good sense to ask her to contribute a volume on the Anglo-Saxon period to their very influential *Social History of England*. The result was a book not only good in its own right but also important as an example of how very intractable and scrappy basic material could be used fairly to recreate the sense of a living society in the past. Complementary to Stenton's *Anglo-Saxon England* (regarded by Dorothy Whitelock as one of the great books of the century), it probes the social structures of early England with a series of original observations relating to family life, kindred organization and the realities of human life, marriage, wills, and disposition of property, always based on evidence. 'I like facts', she wrote in one of her later letters, and the reader of her social history always has the comforting feeling that no general statement is made without serious factual support. Two years later in 1954 the full weight of her scholarship was experienced with the production of the facsimile volume of the Peterborough Chronicle in an early fascicle of the series *Early English Manuscripts in Facsimile* (Copenhagen,

1954), and in the following year appeared her masterly collection of documents in the first volume of *English Historical Documents*, over a thousand pages of ripe scholarship, including not only a mass of reliable translation from Latin and Anglo-Saxon but also shrewd comments on diplomatic connected with the manuscript sources, and excellent bibliographical information. For many, particularly for those with little command of Anglo-Saxon, the book opened up the whole period to serious investigation. Recognition now came thick and fast. She had already proceeded to the degree of Litt.D. at Cambridge in 1950. In 1956 she was elected a Fellow of the British Academy and in the following year she became, on the retirement of Professor Bruce Dickins, Elrington and Bosworth Professor at her home university of Cambridge, coupled with a professorial fellowship at her old college at Newnham. St Hilda's in deep appreciation of her services as a teacher and as Vice-Principal (1950-6) elected her to an honorary fellowship, a distinction which gave her great pleasure.

Inaugural lectures are sometimes revealing and so it proved to be with Dorothy Whitelock who chose as her theme 'Changing Currents in Anglo-Saxon Studies'. Her correspondence shows that she worried a great deal over the framing of her arguments in this lecture, though the main message is clear enough. She aimed at something approaching a totality of approach with her personal emphasis now heavily on the historical side. It is significant that when she talked to the local press at Cambridge about her appointment she described herself as an 'Anglo-Saxon historian', and welcomed her election for the prospect it gave her of more time for work in that field. Indeed the first paper she published after her succession to the chair, appropriately in a volume produced as a tribute to her predecessor, is one of the most historical of all her writings, an analysis of the way in which the late Old English kings intruded southerners into high office in Northumbria in their attempts to create a true kingdom of England. Historical interests remained strong throughout her tenure of the chair. She brought up to date Stevenson's edition of *Asser's Life of Alfred* in 1959 and then spent much time and energy defending the authenticity of Asser against attack. Some of her weakness as well as her strength came out in the course of this controversy. Scholarship was serious business and she could not understand (condone is almost the right word) the lightness of touch with which Professor Galbraith, for example, whose work she respected greatly in other fields, could launch an onslaught against Asser on grounds that she saw as inadequate and indeed

which she ultimately demonstrated were inadequate. She hated the waste of time involved in controversy, though she was formidable in argument, particularly if she sensed what she took to be ill-considered attacks on the views of people she trusted and respected, such as Sir Frank Stenton, Florence Harmer, or—one should perhaps add—Bede, Asser, or King Alfred! To grapple with the evidence and to try to make sense of it was time-consuming enough. This sometimes made her too wary of those who acted almost by instinct against so-called 'received opinion' and too sceptical of the intuitive. Her work on the Chronicle reached its culmination in her revised translation based on the sections in the first two volumes of *English Historical Documents* (by Dorothy herself and by Miss Susie Tucker), which appeared in 1961 and which remains a standard reliable version. She continued her studies of the tenth- and eleventh-century reformation with an important introduction to E. O. Blake's edition of the *Liber Eliensis* for the Camden Society (1962), a revised edition of her *Sermo Lupi* (1963), and a series of essays in Festschriften to F. P. Magoun (1965), Stefan Einarsson (1968), and—after her retirement—to H. D. Meritt (1970). Her contribution, the major contribution, to the splendid edition of *The Will of Aethelgifu* for the Roxburghe Club (1968) brings out at its best her mature perception as a social historian of the realities of tenth-century rural life on the great estates of an Anglo-Saxon princess. She delighted in her discovery of an unfree priest in the Home Counties and rejoiced at the humanity of Aethelgifu with her attitude to manumission and strong preference for freeing the young. Her remarkable scholarly energies were not directed exclusively to her historical studies. She published in 1967 a revised version of Sweet's *Anglo-Saxon Reader*, providing it with an up-to-date glossary, modifying the selections and making it a much more humane introduction to the language and civilization than its somewhat austere forerunners. She continued her active support of numismatic studies (a paper in the tribute to Sir Frank Stenton in 1961 and membership of the Sylloge committee of the British Academy), of the Viking Society, of the English Place-Name Society, and of the new Society for Medieval Archaeology, of which she was Vice-President for its first six years (1957–63). Underlying all this activity, cognate with the Asser controversy, there developed one main line of investigation, a deep and abiding interest in the work of King Alfred. Her brilliant Gollancz Memorial lecture for the Academy on the 'Old English Bede' (published in 1962) showed that there could be no certainty that the work was King Alfred's, though there

remained a probability that it was undertaken at his instigation by West Mercian scholars and that its popular impact should be considered in traditional fashion as part of the king's educational programme. An important general statement in *Continuations and Beginnings* (ed. E. G. Stanley, 1966) on the prose of Alfred's reign laid down the canon of orthodoxy for modern views of Alfred's achievements in that field. Her essay on 'William of Malmesbury and the Works of King Alfred' in the Festschrift to G. N. Garmonsway (1968) probed deep into later medieval sources for genuine information about the West Saxon king. In a multitude of other ways, occasional lecturing (never popular lecturing in the ordinary sense: 'there is no point in lecturing unless you have something new to say' was her somewhat austere comment), in maintaining a tremendous flow of learned correspondence, in encouraging the young, and in placing a brake on the enthusiasms of some who had the good sense to consult her, she provided leadership in Anglo-Saxon studies for a host of scholars throughout the world. The slightest serious query would often provoke an answer many pages long, not always in the most decipherable of handwriting, full of exact references, a labour which must have involved many hours of patient toil. She would attempt to disarm attacks of conscience which would then regularly overtake her questioners by saying that she had been meaning for some time to look at the evidence again or that she was glad of an opportunity to look at this or that text, but we all knew that the help she gave was the product of a truly generous nature. National recognition came in 1964 with the award of a CBE in the birthday honours. She also took very seriously indeed the more mundane tasks associated with the headship of department, and the Anglo-Saxon Tripos developed under her firm guidance into a most attractive and vigorous school, which drew to it students whose initial degrees had been taken elsewhere, as well as purely Cambridge students. She was helped in this greatly by the colleagues grouped around her, by the fine scholar Peter Hunter Blair at the height of his powers as an interpreter of Bede and of Northumbrian history, and by the two younger men who succeeded to her chair in turn, Dr Peter Clemoes in Anglo-Saxon and Dr Raymond Page in Scandinavian studies. Mrs Chadwick gave support on the Celtic side initially until she was succeeded by Kathleen Hughes. Kathleen became one of Dorothy's closest and dearest friends, whose academic achievements and teaching skill she greatly admired. Her illness and ultimate early death (in 1977) proved a lasting grief. In the mid-sixties this formidable team of creative

scholars provided as fine a training ground for young undergraduates or graduates as was to be found anywhere in the world: and Dorothy was the acknowledged leader, advising, steering through difficulties, anxious about standards but also about people, playing a full and active part in the inevitable round of college and university politics, rejoicing greatly when she could achieve her ends by what she called 'small administrative changes'. Towards the end of her tenure she realized increasingly that the rightful place for the Tripos was in its ancient home under the general protection of the English School; and her achievement of that end proved painless, a masterpiece in the art of the possible in university politics.

She retired in 1969, received the general accolade of friends and fellow-scholars in a Festschrift edited by her successor, Peter Clemoes and by Kathleen Hughes, and then entered into a further decade of fruitful scholarship. Faced with the task of moving out of college after close on fifty years as a resident student and scholar she sensibly joined forces with her widowed sister, Mrs Phyllis Priestley, and set up house in what became a real home in Cambridge; and 30 Thornton Close became an address to which scholars from all over the world came to enjoy hospitality and discussion and friendship. Her last years in the chair had been clouded by the death of good friends, notably her brother-in-law George Priestley and, in October 1967, Sir Frank Stenton. Sir Frank had been a constant source of encouragement and support from her earliest days and she felt the loss deeply. She wrote a memoir of him for the *English Historical Review*, though in a revealing comment in a private letter to Mr Christopher Blunt she told of her feelings of inadequacy: 'I am after all', she wrote, 'not a real historian and it requires someone with a better range than mine to describe the greatest historian since Maitland.' She admired Sir Frank not only for his scholarship but for his behaviour and relied heavily on his good judgement on anything she had written. Working closely with Lady Stenton she helped to publish his surviving papers and also to complete a revision of his great standard book on *Anglo-Saxon England* in 1971. She also succeeded to two of his key offices, the chairmanship of the Sylloge Committee which she held from 1967 to 1978 and the presidency of the English Place-Name Society which she held from 1967 to 1979. In both these offices she proved an energetic and constructive guide. Her own output continued to be significant, adding greatly to general knowledge of the East Anglian situation, and of Bury St Edmunds; and building up a realistic picture of the society that

grew up in the Danelaw. Of the honours that came to her in her later years she rejoiced especially in the honorary fellowship granted to her by her own college at Newnham, and at the honorary doctorate awarded to her by Leeds University. She continued to act as a supporter and adviser of many learned societies, and was greatly respected in the British Academy itself. For Anglo-Saxon studies generally, as her successor, Professor Clemoes, has testified, she remained a great source of strength at Cambridge, never interfering but always available for consultation whether on points of detail or of policy. In what were to prove sadly the last years of her life she still had three major academic projects in mind. She brought out in 1979 an impressive revision of her volume of *English Historical Documents*, unaltered in main structure but full of important minor emendments and extra bibliographical guides that brought it fully up to date. Working with Professor Christopher Brooke and Martin Brett she played a vital part in producing the important *Councils and Synods*, for which she had responsibility for the whole period before 1066. Professor Brooke comments that she was 'a marvellous collaborator: steady and punctual and totally uncomplaining' and adds that the example she gave, though the useful if partly mechanical labour inevitably diverted her from more creative work, still rests in his mind as 'an example of scholarship freely given out of pure conscience' with indeed a heroic quality to it. She read the proofs, but only just, and was too ill to appreciate the book when it was finally published in 1980. The third of her projects, the *Life of Alfred*, remains in manuscript but is being prepared for publication by her friends and fellow scholars, Janet Bately and Simon Keynes. Her last years were afflicted by illness. A stroke in late 1980 was followed by a more severe attack in June 1981, from which she never really recovered. She was greatly supported by her friends, and above all by her sister Phyllis, but the illness inevitably gained ground and she died on 14 August 1982 at the age of 80.

Dorothy Whitelock's academic and literary achievements were great but she should also be remembered as a person who exemplified in her attitudes to scholarship her own personal tenets. She was open about her own likes and dislikes. Professor Clemoes reminded us that St Augustine of Hippo and Lord Beeching, responsible for closing the branch line to her beloved Robin Hood's Bay, were not among her favourite people. She had strong views about the Normans and was known to bridle at the suggestion that William the Conqueror had any *right* to the throne of England. Respect for evidence was the main key to her attitudes

and to her integrity. Her personal letters to fellow-scholars are full of phrases such as 'It does not quite say that.' Humility in the face of the evidence was also constantly present: 'I may be stupid [she never was!] but I cannot quite see . . .' She tempered her use of the historical imagination of which she had plenty with a good down-to-earth realism. Bede, Alfred, Edgar, Dunstan, and Wulfstan were great men but they must not be made to act as no man would have acted. She asked the right questions. Could Bede have written this note about men who were still remembered in his native Northumbria? Was it reasonable to suppose that Alfred would have made his agreement with Guthrum without some thought for the future of the Christians in East Anglia? Her fury was roused at any attempt to distort, even worse to conceal, evidence which did not square with facile preconceived general ideas. A deep distrust of anything that smacked of the irrational sometimes caused her to miss the wheat in the chaff as more romantic scholars tried to tease meaning out of records, particularly poetic records relating to the Anglo-Saxon or the Viking past. Good Yorkshire common sense was tempered by a delicious sense of humour that could be directed against herself as well as against others. She explained part of her fondness for St Martin by the fact that he gave half his only cloak to a beggar: but it is not too fanciful to recognize the nice reserve in the implication that at least he had the good sense to keep the other half himself. The quizzical look on her face as she reflected on the absurdities of some interpretations of the past or on some misreading of the evidence was the perfect reflection of her sense of proportion, as she balanced the importance of the scholarly effort with the frailty of the human scholar. Unostentatiously religious, a loyal member of the Church of England, she had friends attached to many different communions or to none. Teaching meant much to her. She expressed irritation when people, knowing the weight of her teaching load, asked her how she found time for her own work. She considered teaching her students as much her own work as her research or her writing. From all generations, from St Hilda's and from Newnham, her students paint a steady and consistent picture. They chuckle at her absorption in her work, her apparent imperviousness to the cold of the hard winter of 1947, her splendid and in the right context devastating assumption that they were as learned as she. They also recognize their good fortune in having as a tutor one who took their work seriously yet humanely and who was herself one of the leading scholars of the age.

<div style="text-align: right">HENRY LOYN</div>

FRANCIS WORMALD

XXIII

FRANCIS WORMALD

1904–1972

FRANCIS WORMALD was born at Dewsbury in the West Riding of Yorkshire on 1 June 1904, a few minutes after his twin John. They were the first surviving children of Thomas Marmaduke Wormald, J.P., and his wife Frances Walker-Brook. Their father was chairman of Wormalds and Walker Ltd., blanket manufacturers at the Dewsbury Mill, and their mother's family owned a woollen mill at Huddersfield.

'The surname has its chief habitat in W. Rid. Yorks where I find the personal name Wormbald at an early period'.[1] One John Wormald became a clerk in Child and Company's bank in Fleet Street in 1763 and then a partner from 1786 until shortly before his death at his house at Gomersal in 1797. Another John Wormald, nephew of the first, joined the partnership in the following year and died in 1835; and two more John Wormalds continued the line of partners in Child's until the early years of this century. Thomas Wormald (1802–73), son of the second John, achieved distinction as a teacher and practitioner of surgery: John Abernethy's last apprentice in 1818; Assistant Surgeon and Demonstrator in Anatomy and eventually, 1861, Surgeon to St. Bartholomew's Hospital; Surgeon to the Foundling Hospital 1843–64; President of the Royal College of Surgeons 1865. Though born at Pentonville, he was educated at Batley Grammar School and by the Rector of Birstal; and though he had a house in Hertfordshire, he too died at Gomersal, during a visit.[2] John Wormald, one of his eight children, entered the woollen trade as a result of his marriage into the Haig-Cooke family; and Francis's father was his only son by this marriage. After his first wife's death in a carriage accident, this John married again and eventually moved away from Ravens Lodge at Dewsbury to Denton Park, an estate a few miles east of Ilkley, between the north bank of the Wharfe and Denton Moor. The five sons of this second marriage all followed their half-brother to Harrow and three of them, unlike him, went on to Cambridge. Two of them became cavalry officers, one a maltster at Wakefield, and the other two directors of the family business at Dewsbury.

[1] C.W. Bardsley, *A Dictionary of English and Welsh Surnames* (London, 1901), p. 821.
[2] F.G.H. Price, *The Marygold by Temple Bar* (London, 1902), pp. 31–5; *DNB*, vol. lxiii, pp. 30–1.

Francis and John were born in the mill house at Dewsbury; but their twin sisters Ellen and Ann were born, some five years later, at Field Head, a Georgian house at Mirfield, half way between Dewsbury and Huddersfield, which 'Marmi' had bought from his father-in-law. There was at least as much fighting as usual within each pair of twins, and when the boys and girls were able to go for walks together they went in two separate pairs: Ann was adopted by John and Ellen by Francis. John would not buy sweets on their walks, but Francis would; and both his sisters remember that his kindness to them did not end with childhood. Their father discouraged friends outside the family and the children had to entertain themselves. Francis alone enjoyed being with grown-ups, finding among other things that you got a better tea in the drawing room. Their games were home-made and Francis usually devised them. 'The Tibetan house game', which ended with all four in a pile of furniture, presumably derived from a book, *The Case of the Stolen Grand Lama*, which he remembered with pleasure all his life. A peculiar version of croquet played with one hoop, one mallet and one ball, in which Francis took the leading part of the Mother Superior, was inspired by the behaviour of nuns as witnessed from the summer house during a holiday at Scarborough. In a Sunday game Francis climbed on to a pulpit-like chair and preached eloquent sermons against the morals of his sisters. In another, he would show them 'how sailors beat their wives'. He sometimes went with his father to watch Huddersfield playing at home but his only conventional game was croquet, which he played all his life with venom and great skill. His father's sport was shooting, and in August the family used to migrate to the north of Scotland. His uncle John, then of Spofforth Hall between Wetherby and Harrogate, published *How to Improve a Stock of Partridges*, 1912, 2nd edn., 1914. Francis went shooting once and is reputed to have shot a snipe with his first cartridge and a brace of pheasants with the next two; but he disappointed his father's hopes of another good shot in the family by refusing to go out again on the grounds that shooting hurt his hands, which were in fact slightly abnormal. John was asthmatic in childhood, but became the athlete of the family; and a friend who knew them both said that while John suggested some stronger fabric, Francis suggested porcelain. After running to see a fire Francis once had an attack of croup, for which his mother called him Puffing Billy; and he was 'Puff' to his family thereafter. His general health was good as a child, but he was not above claiming illness in order to avoid going where he disliked: once—so that he could stay at home and catch sight of a *divorcé* for whom his father had the misfortune to be trustee.

Francis's mother died in her forties in 1920, her death being partly attributable to the former state of the leaden water-pipes at Field Head.

She was a very lively, energetic woman and, unlike her husband, she was not in the least shy; and she was an Anglo-Catholic. Field Head, where she had grown up, was opposite the gates of Hall Croft, the house to which the incipient Community of the Resurrection moved from Radley in 1898. She kept open house for the Community, especially at tea-time on Sundays; and Francis was attached to them all, but particularly to Walter Howard Frere, who as Superior from 1902 to 1913 and again from 1916 to 1922, when he was appointed Bishop of Truro, presided over the transformation of the Community of the small, private society founded by Bishop Gore into a fully fledged religious order. Hall Croft had been built by one of Marmaduke Wormald's uncles; but it was Francis Wormald's mother who had become a great friend of the Community on their arrival in 1898. She was a generous benefactor to the training college for ordinands, the College of the Resurrection, which Frere inspired and created; and in 1903 she laid its foundation stone. She was a good pianist and used to accompany Frere, whose love of secular singing is said to have outrun his accomplishment. Many of Francis's friends believed that Frere was his godfather. He was not, but the mistake is doubtless significant. Francis was deeply interested in the liturgy by the time he reached Eton; and there are phrases in E.K. Talbot's account of Frere at Mirfield which suggest that Francis found in Frere an intellectual and spiritual exemplar: 'Frere would touch a subject with swift and pointed comment and with an economy of words . . . He was incapable of wasting time . . . his swift readiness to help, the pungency and gaiety of his spirit . . . the lightness with which he carried his learning . . . his religious fidelity, and penetrating all, his selflessness—these were the gifts which were the secret of his authority. . .'.[3] Francis's father disapproved of the Community as 'socialists'—many of the early members were indeed committed to Christian Socialism, and they had entertained Keir Hardie voluntarily and Mrs. Pankhurst willy-nilly; and when he decided that the Anglo-Catholic incumbent of Christ Church, Battyeford, was another 'socialist', his family had to give up a church which had meant a great deal to them, and to the Community in its early days, in favour of the parish church of Mirfield. The latter was a three-mile walk from Field Head; and on the three miles back Francis used to argue the case for Anglo-Catholicism against his father.

Francis kept all his life one or two pieces of porcelain which he had acquired as a child. He spent hours in cottages round Mirfield angling for things he liked; and once, when he ran out of money at an auction room, he stood by the auctioneer urging others to bid for the lots he approved of.

[3] In C.R. Phillips *et al.*, *Walter Howard Frere* (London, 1947), pp. 44, 50 and 60.

When his maternal grandmother died, the children were told they could each take something from her house. Francis came back across the fields with either a bass bag or a toy wheelbarrow (the tradition is divided) well filled with objects which he had 'saved'. Finished collector that he was, he then went to work on his sisters: one of them parted with her share in return for some wooden animals from Interlaken; the other sensed that Francis's interest was a good reason for holding on. Books were another passion, and his regular disappearances during family visits to Huddersfield cause no anxiety, since it was known in advance that he would be safe in one of the second-hand bookshops.

The children's education was started by a governess who came out from Huddersfield. The girls would never have gone to school if one of their godmothers had not insisted on it after their mother's death. Francis and John were sent at the usual age to Stanmore Park, a preparatory school which was presumably meant to prepare them for Harrow. When the time came, however, their father decided that Harrow had gone down since his own day and sent them to Eton. They entered Chitty's house in 1918. After Eton and Cambridge, John went back to the north and in due course succeeded his father as chairman of Wormalds and Walker. He enjoyed wearing old clothes and talking to his work people in their own dialect over beer in the pubs and clubs of Dewsbury. He died in 1956, leaving a widow and two daughters, and his more or less sudden death was a severe shock to Francis. Their father had continued to work at the mill until his death at the age of seventy-nine in 1939, when his daughter had left Field Head for a house they had inherited in Devon. The idea of retiring to Yorkshire struck Francis as absurd—'What wóuld one dó if one wanted to look something úp in Mígne?'; but in moments of tension he spoke with the voice of the West Riding—the opening words of his first lecture to the British Academy were: 'I'll have that light out for a start'.

There is no evidence that the teaching at Eton contributed anything to the intellectual development of the rather eccentric Francis who entered the school with a ready-made vocation for two subjects which most of his contemporaries had never even heard of. Indeed, he did no Latin during his last two years in the school; and in the 1930s he advised his sister Ann to do as he had once done and follow the lessons in church in the Vulgate. A teen-age liturgist would have interested M.R. James; but although Collegers like Roger Mynors saw much of the Provost, Oppidans like Francis and Neil Ker saw very little of him; and whatever influence there may have been was aparently exercised at a distance. Francis had already decided for himself, after a sight of the illuminated manuscripts in the British Museum, that he wished to work there in the appropriate depart-

ment; and when he left the Museum he told a friend that for as long as he had been there he had felt like a boy who had grown up to *be* an engine driver.

Neither John nor Francis was at all 'brilliant' at Eton, and both had to be coached in mathematics for their entrance to Magdalene College, Cambridge in 1922. What Francis did get from Eton and then from Cambridge were friends, many of whom are now remembered as typically, and a few as notoriously, symptomatic of the social and intellectual life of England in the 1920s. His Cambridge nickname of 'Auntie' seems to imply in the users not only affection but a certain respect and a certain sense of incongruity. Much of his life in Cambridge revolved round acting, and his remarkable talent for comic parts earned him at least one description as 'the best-known undergraduate in the university'. It could very probably have earned him a living. Introduced to the learned person in the British Museum with whom she had been corresponding about calendars, Dorothy Whitelock was astonished to find that he was the pink-faced young man whom she had seen in *The Duchess of Malfi* at Cambridge; and when she asked him, some years later, whether he had been in the Marlow Society, he replied, 'Are you remembering my brilliant performance as Cariola?'. Francis was awarded a second class in the History Tripos in 1925 and proceeded Litt.D. in 1950. He went to palaeography lectures given by Sir Ellis Minns, who later wrote to him: 'I have always felt that I ought to have been more usseful to you. But of course I had to give my first attention to the Classics.' Sir Owen Morshead, Pepys Librarian at Magdalene, met Francis as an undergraduate and 'marvelled at the depth of his knowledge even then'. Later on, his reply to a question often took the form of 'Have you read Wilmart's paper on the library of Clairvaux?', or 'Have you looked at Royal 2.A.XX?'; and one suspects that these brief and pointed hints sometimes led one to retrace, for days and even months, paths which he had formerly discovered for himself.

In the interval after the Tripos Francis worked for a short time in the Pepys Library; but the long-awaited chance to compete for a vacancy in the Department of Manuscripts at the British Museum came conveniently soon. He was appointed an Assistant Keeper in 1927. Julius Gilson, who had been Keeper of Manuscripts since 1911, died suddenly in 1928 and was succeeded by Harold Idris Bell. Francis's first publication was apparently a note on a documentary papyrus[4] written at Bell's suggestion. This inoculation with papyrus dust did not take; but Francis was recognized during the 1930s as the Department's expert on Byzantine illuminated

[4] [A complete list of Francis Wormald's publications is found in *PBA* lxi (1975), 556–8.]

manuscripts, in which he always took a deep interest, although he was never widely read in Byzantine texts. Latin illuminated manuscrips were the preserve of Eric Millar. In A.J. Collins, who had entered the Department in 1919, Francis had a senior colleague who was also interested in liturgical manuscripts. Nobody was entirely excused from contributing miscellaneous descriptions to the five-yearly *Catalogue of Additions to the Manuscripts in the British Museum*. Francis did his share and always thought it right that a scholar should turn his hand to anything within reason. He himself learned some Portuguese so as to deal with a group of papers relating to India in the sixteenth and seventeenth centuries, and he was proud of his work on the Francis Papers for the light it had thrown on the Letters of Junius.[5]

The five senior members of the Department had entered it before 1914—Harold Idris Bell, Robin Flower, G.T. Hales, Herbert Milne, and Eric Millar. Milne, who was probably Francis's closet friend in the Department, remembered that a colleague who was killed in the First World War always used to greet visitors to his desk in the Working Room with the words, 'Is it official?'; and in the 1930s the Assistant Keepers still worked very much in watertight compartments. Theodore Skeat, who joined the Department in 1931, only got to know Francis well years later, when Francis was a Trustee and he himself was Keeper. There were those in the Working Room who thought Francis had too many outside interests. He had no sooner reached the Museum than he began to make closer friends outside the Department than in it, notably with Willie King, then of Ceramics and Ethnography, and with Roger Hinks, of Greek and Roman, both of whom were as unlike the average member of the Manuscripts Department as they could possibly be. This trio lunched together in Soho two or three times a week—excellent lunches costing something like 3*s*. 6*d*. each—and were the nucleus of a slightly larger interdepartmental group of which Thomas Kendrick, of British and Medieval, and Basil Gray, of Oriental Antiquities, were leading members. Gray, whom the trio rescued from the less congenial society of Printed Books, to which he originally belonged, remembers that all three were consistently witty, and that while two of them could be cruel as well, Francis's wit was never malicious. Francis learned much from each of these friends. King was an expert on porcelain; Gray already knew about an extremely wide range of Oriental art; Hinks's knowledge of European art extended to the Middle Ages and Renaissance; Kendrick was the lead-

[5] The Francis Papers are Add. MSS. 40756–65 and those relating to the Portuguese in India and Ceylon are Add. MSS. 41996Q and 42056.

ing authority on the arts in Anglo-Saxon England, and he and Francis used to swap knowledge about sculpture and metalwork for knowledge about manuscripts in the neutral territory of the first-floor landing which separated the working rooms of their two departments.

To these friends within the Museum Francis soon added an eminent circle of friends from abroad. To some he was introduced by Millar; others he collected for himself when on duty in the Students' Room; and he in turn took pains to introduce them to his younger friends of twenty and thirty years later. The following names must suffice as a small sample: Marie-Thérèse d'Alverny, Bernhard Bischoff, Paul Grosjean S.J., Wilhelm Koehler, Millard Meiss, Dorothy Miner, Carl Nordenfalk, Erwin Panofsky, Jean Porcher, Margaret Rickert, Meyer Schapiro, Kurt Weitzmann. All were entertained at his flat in Mecklenburgh Square (with housekeeper), as well as advised and amused. A number of them remember him with affection as not only their best but their first English friend; and when he died many of them felt that they had lost the leading member of their circle. The welcome they had received from Francis at the Museum encouraged his friends Jean Porcher and Marie-Thérèse d'Alverny to put relations between the Cabinet des Manuscrits and its readers on a new footing, when they took charge after 1945. Francis naturally made many friends among manuscript scholars: Sir Sydney Cockerell, E.A. Lowe, Sir Roger Mynors, James Wardrop, Neil Ker, Richard Hunt. And he was always just as willing, partly because he liked doing it and partly on principle, to help beginners and amateurs. He thus acquired a large number of regular and devoted 'clients', from some of whom he learned much himself and through all of whom he acquired useful experience in the arts of teaching.

In January 1934 the Warburg Institute, having withdrawn in good time and in good order from its original home in Hamburg, opened its new doors at Thames House on Millbank. At its head was Fritz Saxl, and his colleagues included Otto Kurz, Hans Meier, Edgar Wind, and Rudolf Wittkower. They were joined before long by Hugo Buchthal and Ernst Gombrich. With Buchthal and with Otto Pächt, who was in Oxford, Francis was later to collaborate closely in books on illuminated manuscripts. To begin with, some of the Warburg's staff could lecture only in German, and the building of a linguistic bridge was one of various ways in which the Institute's English friends were able to help it. In 1934–5 the courses given in English included one by Roger Hinks on 'Allegorical representations in ancient art' and one by Robin Flower on 'Methods of research in medieval manuscripts'. On 12, 19, and 26 February 1936 Francis gave classes, which had probably been postponed because of his

illness, on 'English medieval calendars as liturgical documents'; he belonged to the 'Medieval Group' which was personally rather than formally attached to the Institute and met there under the chairmanship of Beryl Smalley; he gave valued help with the Warburg *Journal* in its early days; and by 1937 he was one of the Institute's most frequent visitors. In fact, he and Hinks played a major part in acclimatizing the Institute in London. In return, Francis came under the influence of Saxl, whom he loved and revered thereafter. Carl Nordenfalk, who knew them both in the 1930s, has written: 'Were anyone to be called his teacher, or rather mentor, it was Fritz Saxl whose unique talents as a Socratic midwife provided Wormald's scholarship with an essential injection of self-confidence and creative spirit.' Francis in any case saw the past in terms of the actions, thoughts, and feelings of individual men and women rather than in terms of mass movements and abstractions; and Wittkower once spoke of 'Saxl's constant desire to penetrate the human significance of images . . . he had a single historical purpose—to see the spirit of man working in the images he made to express himself'. The mixture of these two complementary attitudes ensured that in his work on illuminated manuscripts Francis transcended the tradition of acute but none too imaginative connoisseurship which he had inherited from English scholars like Sir George Warner, Sir Sydney Cockerell, Eric Millar, and even—though he was a good deal more humane than the others—M.R. James.

Two other groups of scholars with whom Francis was already much involved in the 1930s were the Henry Bradshaw Society and the Society of Antiquaries. Elected to the Council of the H.B.S. in 1931, he served as Assistant Secretary 1936–8, as Chairman 1938–45, as Secretary 1945–50, and as Chairman again from 1954 until his death. His first major work, on calendars, was published by the Society in 1934. At the Antiquaries he was elected a Fellow in 1935 and he served on the Council 1938–9. He first important paper on illuminated manuscripts was delivered to the Society on 30 January 1941. It was about then that Alfred Clapham, the President, told the Secretary, Mortimer Wheeler, that he expected Francis to become President in due course.

In 1935 Francis married Honoria Mary Rosamund Yeo, who was a cousin on her mother's side. She was one of the four children of Gerald Yeo, barrister at law, of Aldsworth House at Emsworth in Hampshire, and his wife Mabel Leighton. Honoria was reading Medicine and had just taken her first M.B. at University College when Francis went to have a medical examination for life insurance. To their utter amazement he was found to have 'Bright's disease' and given only a few months to live. The condition, which must have been well on the way to becoming acute, soon

subsided into latency, to return only in 1970 and in the end to take his life. Some of his friends knew of this serious illness, but few of them knew the diagnosis. From 1935 onwards he lived and worked under a suspended sentence which might have been executed from one month to the next; but he did so with undiminished energy and liveliness and made no concessions to it of any kind. Francis and Honoria themselves simply ignored the danger and got on with their life together as if nothing had happened. They were a singularly unanimous husband and wife who shared each other's interests and shared a common Faith. Their friends were innumerable; some were academic and some were not; but the Wormalds' unforgettable gift for hospitality was equally at the disposal of both kinds, and they knew how to impart style and gaiety even to supper-parties given among the steely book-shelves of the Institute of Historical Research. From 1935 to 1941 they lived in Francis's flat in Mecklenburgh Square and soon acquired the habit, when at home, of taking it in turns to snooze after dinner: particularly disconcerting to any new friend who was the only guest. But they both rose early—Francis sometimes started work before six o'clock.

The removal of manuscripts and printed books from the Museum to the National Library of Wales at Aberystwyth began on 24 August 1939, and three weeks later many of the staff began to disperse into Departments in the Civil Service. Francis went to the Ministry of Home Security, where his work included the making of Civil Defence training films. He became a member of St. Paul's Watch, the band of volunteers who undertook the hazardous task of protecting St. Paul's Cathedral from fire. Honoria, who had joined the Red Cross, had the misfortune to lose her brother, Edmund Leighton Yeo, in an accident in wartime London. The flat in Mecklenburgh Square was given up and for much of the war years they lived for alternate weeks with friends in Essex and in Hertfordshire, except for odd nights in London. In 1941 they took a small flat in Beatty House, Dolphin Square, in Grosvenor Road, Pimlico; and Francis joined the Reform Club, to whose lunches he was devoted after the war.

When Francis returned to the Department of Manuscripts after the war, his double reputation as a liturgist and art historian was securely established, and only an accident could have prevented him from succeeding to the Keepership soon after 1960. Millar had followed Bell as Keeper in 1944 and was himself followed by Collins in 1947, when the full responsibility for work on illuminated manuscripts devolved on Francis for the first time. He also played a major part in the training of the new Assistant Keepers who joined the Department after the war: they remember him as an unfailing source of instruction and inspiration alike. He was

as earnest, and as little pompous, in his belief in the importance of the Museum's work after his resignation as he had been in the 1930s; and in both periods he took good care to see that new recruits to the Department understood his own revised, ecumenical version of a fine but often grimly parochial Victorian and Edwardian tradition. With his wide interests and sympathies, his loving respect for the Museum and its work, and his capacity for business he would have made a great Director; but the chance never came.

There had existed in the University of London since 1936 a Board of Studies in Palaeography charged with planning for a Chair of Palaeography, to be established in place of the Readership in Greek and Latin Palaeography at King's College which had been temporarily suspended in the previous year. The financial support for the Chair was eventually granted in 1949. The appointment was the subject of some brisk fighting on and off the Board, the details of which are probably not recoverable. For one thing, the Board itself included powerful representatives of the British Museum and of the Public Record Office: book-hand men *versus* charter-hand men. For another, it included the Head of the English Department at University College and the Head of the History Department at King's College: not only U.C.L. *versus* K.C.L. but philology *versus* history. The latter conflict had already attended E.A. Lowe's appointment as Lecturer in Palaeography at Oxford in 1913.[6] To the dismay of University College, the Chair was advertised as a post in the History or the English Department at King's College. King's had in fact conferred Readerships in Palaeography on Hubert Hall in 1920 and on Claude Jenkins in 1925, and a Readership in Diplomatic on Hilary Jenkinson in 1926. In the end, Sir Harold Idris Bell was deputed to suggest a name; and in spite of deep reluctance to leave the Museum, Francis eventually accepted the responsibility for which his former Keeper had singled him out. He was already teaching at the Institute of Historical Research in the Michaelmas term of 1949; but he formally took up his appointment at King's, as head of an independent, one-man Department, on 1 January 1950. In the Michaelmas term of that year he delivered an unpublished inaugural lecture on 'Manuscripts of Lives of English Saints'. He was given the front room on the first floor at 33 Surrey Street and made good use of it as a study, but his teaching was mostly done for and at the Institute of Historical Research. During his decade at King's Francis

[6] In Traube's words, 'Die Paläographie will lesen lehren'; but of the 2,247 pages of main text in Giry's and Bresslau's manuals of diplomatic only fifty-five (2.44 per cent) are about handwriting.

travelled widely, to work in libraries and museums, to visit the many great national and international exhibitions which were held during the 1950s, and to lecture both at home and abroad. In 1965–6 he and Honoria spent two terms at the Institute for Advanced Study in Princeton, New Jersey, where they were much in the company of their great friends Erwin and Dora Panofsky. His teaching at King's brought Francis into closer contact with the Department of English than with other departments and his reputation for pointed criticism would have caused less apprehension if he had been better known in the College. His greatest personal attachment was to the Theological Department, in which he had many friends, who saw to it that he was elected in 1954 to the appropriate governing body, the Council, of which he remained a greatly valued member for the rest of his life.

In the University at large Francis served on many boards and committees. He was chairman of the Board of Studies in Palaeography 1951–62 and was particularly interested in the work of the Athlone Press Board of Management, the University Library Committee, and—naturally—the Committee of Management of the Warburg Institute, where he served on the Finance and Establishment Sub-Committee and as Trustee of the Saxl Fund. The Warburg had become a Senate Institute in the University of London in 1944. At the University Library he and Jack Pafford, the Goldsmiths' Librarian, created the Palaeography Room, for which new quarters were opened in 1956. They realized that the University Library already possessed a formidable stock of palaeographical works which, to be effective, only needed to be brought together on open shelves, and that if the Schools and Institutes could be persuaded not to compete for funds, it would be reasonable for the University Library to undertake the costly business of keeping up with the new publications. The result of their energy and diplomacy is a specialized reading room which is a serious contender for the title of the most comprehensive and accessible library of Latin and vernacular palaeography in the world,[7] and which served as an exemplar both for the reorganization of the whole University Library as a series of open access subject libraries and for the rationalizing activities of the University's new Library Resources Co-ordinating Committee.

[7] See *University of London Library: The Palaeography Collection*, 2 vols. (Boston, MA, 1968), edited by Joan Gibbs, who has been responsible since 1956 for acquisitions, cataloguing, and service to readers, and with whom Francis and his successor have worked in the closest collaboration.

By 1960 his historical colleagues in the University at large thought so highly of Francis that they invited him to become Director of the Institute of Historical Research in succession to Sir Goronwy Edwards. The Institute acts as a centre for most of the postgraduate teaching and research done under the aegis of the huge intercollegiate school of History in the University of London, and as a London base for a large population of students and teachers from other British and foreign universities. Although he complained a little, later on, about the amount of time he had to spend reading other people's work, Francis welcomed the appointment because it brought him into daily touch with a large and various body of students and with a group of colleagues working at the *Victoria History of the Counties of England* and similar enterprises, much as he himself had worked in the Department of Manuscripts. His continuous personal interest in staff and students alike was warmly appreciated; and Honoria participated enthusiastically in a joint campaign to make the Institute look as agreeable as the architecture of the Senate House permitted, and to devise lively and amusing variations on the social occasions to which it gave rise. The catholicity of Francis's training in the Museum and of his experience at the Antiquaries—he believed that Fellows should not confine their attendance to papers in which they had a personal interest— served him well at the Institute; he could interest himself in any subject that came up and his intelligence and common sense enabled him to contribute usefully to almost any discussion. He supported with more enthusiasm than mere fairness to the modernists required of him the Institute's projects for a third section, 1541–1857, of the new Le Neve, *Fasti Ecclesiae Anglicanae*, and for lists of *Office Holders in Modern Britain*, from 1660. For eleven years he served as Honorary Secretary and then Chairman of the British National Committee of Historians. The Director of the I.H.R. is required to take at least one seminar, and Francis continued to give his introductory class on English handwriting down to the sixteenth century, and an 'advanced class', as he liked to call it, for postgraduates and colleagues particularly concerned with manuscripts. The latter's one collective enterprise was an edition of the fourteenth-century catalogue of the Augustinian priory of Lanthony, as yet unpublished. As a rule, the class discussed topics which had arisen in the course of their own researches or of Francis's, and his part was invariably to guide, not to control, the course of a meeting. Its members agree that the 'advanced class' served as a particularly good framework for his kind of teaching.

Francis's directorship of the Institute, from which he retired in 1968, was an unqualified success, academically and administratively; but it was hard work, and the sequel suggests that although he showed

no sign of flagging at the time, his work may have been taking an unsuspected toll of his physical reserves. His output of papers was undiminished; and on top of everything else he was now engaged in a round of committee work whose full extent was unknown to anybody but Honoria and his secretary at the Institute, Cynthia Hawker. It is already too late to give an exhaustive account of it; but not to record what *is* known would be to do less than justice to responsibilities which some public servants would think of as a full-time job. Francis's three most particular concerns will be left to the end; and it must be remembered that all the activities listed here were added to the administration of the Institute and to full participation in the elaborate gavotte of committees in which the existence of the federal University of London finds expression. Most but not all of the bodies referred to enlisted his services between 1950 and 1960 and retained them until his death. In the public sector her served on the Royal Commission on Historical Monuments (England) and the National Monuments Record Committee; on the Advisory Council on Public Records; on the Advisory Committee on the Export of Works of Art; on the Advisory Committee of the Victoria and Albert Museum; as a Trustee of the London Museum and the Museum of London; on the Council of the British School at Rome; on the Wall-paintings Sub-committee of the Council for Places of Worship. In the field of charities he served on the Executive Committee and then on the General Council of the Friends of the National Libraries; on the Advisory Panel of the National Art-Collections Fund; as a Trustee of the William Blake Trust; on the Council of the Marc Fitch Fund; as Chairman of the Twenty-Seven Foundation Awards Committee; on the U.K. and British Commonwealth Branch of the Calouste Gulbenkian Foundation. As Secretaries of the Pilgrim Trust, Lord Kilmaine and Sir Edward Ford were in the habit of consulting Francis on all aspects of medieval art, on manuscripts and public records, and on historical monuments; and he played an important part in two of the Trust's major enterprises. As a means of dealing systematically with the steady stream of requests that was reaching them from the Council for the Care of Churches (as it was then known) for grants for the treatment of wall-paintings, the Trust set up a Wall-paintings Committee to survey all the surviving paintings and draw up an order of priority which would take account both of quality and of the urgency of treatment. Of this Committee, chaired by Lord Bridges, Francis was an invaluable member. In 1967 the Trust appointed him a Trustee of the York Glaziers' Trust, the body which, on completion of the post-war reinstatement of the stained

glass in York Minster, converted the Minster Glass Workshop into a national glass repair shop: the work dove-tailed into his chief responsibility at the British Academy.

Learned societies in which he played an active part included the British Records Association, the Canterbury and York Society, the Royal Archaeological Institute, the Royal Historical Society (Honorary Vice-President in the centenary year, 1967), the Winchester Excavations Committee. He was elected to the Roxburghe Club and its Printing Committee in 1953, and after Eric Millar's death in 1966 he took his place as the Club's authority on illuminated manuscripts. The volume which he intended to present to the Club was a facsimile of his own leaves of twelfth- or thirteenth-century Italian drawings of illuminated initials, now in the Fitzwilliam Museum.[8] Another member of the Club is completing the introduction which Francis left unfinished. To the Dilettanti Society, another grand and very English institution, he was elected in 1966. For the Walpole Society he did work for which his fellow members were deeply grateful as a member of the Council 1937–42 and 1946–50 and of the Executive and Editorial Sub-Committee 1946–50, and in particular as Chairman of the Council 1958–62 and 1966–70. He was made an Honorary Vice-President in 1970. His long connection with the Henry Bradshaw Society has been recorded above.

Francis gave his first lecture to the British Academy on 14 June 1944, and was elected a Fellow in 1948. He belonged to Sections 2 (Medieval History), 10 (Archaeology), and 11 (History of Art), of the last of which he was Chairman from 1959 to 1967. He was on the Council 1960–3, and on the Advisory Committee 1961–2; and he was a Vice-President in 1960–1. He joined the Medieval Latin Dictionary Committee in 1967 and was an original member of the following: the Sylloge of British Coins Committee (1956), the Corpus Vitrearum Medii Aevi Committee (1961), the Anglo-Saxon Charters Committee (1966) and the Repertory of the Sources of Medieval History Committee (1971). Of the Corpus Vitrearum Committee he was Chairman from the beginning until 1970, and dramatic account of its work has been written by the then Secretary, Sir Mortimer Wheeler.[9] Francis also represented the Academy at the annual meetings of the Union Académique Internationale in 1964 and in 1965. The beginnings of his career as an Antiquary have been described above. After service on the Council and various committees he became a Vice-President

[8] [Julian Brown supplied a list of manuscripts owned by Wormald as an appendix to his obituary, pp. 558–9 (not reprinted here).]

[9] *The British Academy 1949–1968* (London, 1970), pp. 108–16.

1956–60, Director 1964–6, President 1965–70, and an Honorary Vice-President from 1970. His time as Director was curtailed by the sudden death in office as President of Sir Ian Richmond. Francis loved the Antiquaries as he loved that other eighteenth-century institution the British Museum, and he was a very generous friend and adviser to its library. As in Bloomsbury, so in Piccadilly, his standards were very high. Dame Joan Evans's prediction that from him as President 'the members will receive kindness, if without sentimentality' was precise. In his Anniversary Address for 1972 Nowell Myres ended an admiring and affectionate tribute with words that Francis's friends and colleagues wholeheartedly endorse: 'He was never one to seek the limelight, and he never received the public recognition which his distinction deserved.' Francis was a member for over twenty years of the Cocked Hats, one of the two dining clubs to which some Fellows belong as an excuse for conviviality and as a means of watching the development of the Society from the wings. The flavour of his presidency can be recaptured from his Anniversary Addresses. Each of them included a report on some research of his own, as if to say that for a scholar administrative responsibility was no excuse for neglecting his real work. The party with which on 12 October 1967 the Society celebrated the 250th Anniversary of its continuous existence is described in the Address of 1968. Francis admits that 'there were excellent things to eat and plenty of champagne', but not that he and Honoria had somehow communicated to everyone in the densely crowded Library the very sense of happiness and well-being that they communicated to guests in their own home. It was through the Antiquaries that Francis was, after all, finally able to return to the Museum. When the Executive had to appoint a Trustee in 1967, their President made it quite clear he wanted the appointment for himself. He was the first old Servant to the Trustees of the British Museum to become a Trustee himself, and he was to be succeeded by another in Derek Allen. Although he could be surprisingly diffident at meetings of the Board, he was an excellent adviser on all aspects of acquisitions, having been a collector himself for nearly sixty years; and to Theodore Skeat, who was then Keeper of Manuscripts, 'it was indeed an inestimable benefit to be able to discuss the problems of the Department with someone who had such intimate knowledge of them'.

Of Francis's many honours the chief was the C.B.E., conferred on him in the Birthday Honours of 1969 'for services to palaeography'. He received an Honorary Doctorate from the University of York in 1969, and a month before his death he had accepted the offer of a Doctorate of Law of the University of Cambridge. He was elected an Honorary Fellow of

Magdalene College, Cambridge, in 1961 and was a Fellow of King's College London in 1964. He was 'membre adhérent' of the Society of Bollandists (1960); Honorary Fellow for Life of the Pierpont Morgan Library (1960); Corresponding Fellow of the German Archaeological Institute (1960); Honorary Foreign Correspondent of the National Society of Antiquaries of France (1964).

To anybody whose health is overtly or covertly precarious the moment of retirement can be dangerous. Francis's retirement began in effect after his last Anniversary Address to the Antiquaries on 23 April 1970. Three months later he was already showing signs of illness; and in September he underwent emergency treatment for kidney-failure in St. Thomas's Hospital. When he went home, the specialists were anything but hopeful, but his own doctor thought otherwise; and in spite of a strict regime and diminished energy, he was able to go on working for more than a year. Among other things, he completed—with the help and encouragement of its publisher, Mrs. Elly Miller—his posthumous book on the Winchester Psalter. In December 1972 he had to return to St. Thomas's, but at Christmas he was at home again and writing to friends. Francis was taken back to St. Thomas's on 10 January and died there in the early hours of 11 January 1973. The funeral was private and no memorial service was held; but at 7.00 p.m. on 20 January a very large congregation of all ages, sorts, and conditions met in the fine Victorian church of St. Stephen's, Rochester Row, which had been the Wormalds' parish church since their move to Dolphin Square, for a celebration of Holy Communion 'in thanksgiving for the life of Francis Wormald'. Nothing else would have been appropriate. The Archbishop of Canterbury, a friend who had been devoted to Francis since their time at Magdalene together, postponed a journey abroad and came to give the Blessing. Other friends had crossed the Channel to be there.

II

Francis Wormald published some sixty books and articles on what seems at first sight to be a confusing variety of subjects. Closer examination shows that two main interests inspired all his work: about one-third of it was devoted to the liturgy, and above all to calendars; the rest was more or less equally divided between English illuminated manuscripts of the tenth, eleventh, and twelfth centuries, and illuminated manuscripts of the thirteenth and fourteenth centuries, with iconography. Only a quarter of his publication appeared before 1950; but that quarter established his reputa-

tion and remains the most impressive part of his work. Excepting his three books on calendars, he never wrote anything longer than an average paper in *Archaeologia*. He liked to be brief, and he wrote in the same *sermo humilis* in which he lectured—lucid, direct, unaffected. His lectures were always clear and sharp and he exacted attention with a minimum of artifice; but the written version, without the support of his strongly stressed intonation, sometimes lapsed into flatness: he sincerely admired the ease and elegance of Bell's writing. . . .

Palaeography in the strict sense of the close study of handwriting was for Francis only a means to other ends. He was perfectly satisfied with the simple terminology of the Palaeographical and New Palaeographical Societies; and even in the period which he knew best he never gave to handwriting the kind of attention which Neil Ker has given to the Anglo-Saxon minuscule or Alan Bishop to the English Caroline minuscule. One of his first publications was the indices to the second series of the New Palaeographical Society's facsimiles. After that, he only wrote notes on Insular script in Latin manuscripts of the late tenth century and on the inscriptions in the Bayeux Tapestry, and longer discussions of handwriting in the Latin Kingdom of Jerusalen and of the scripts of the St. Albans Psalter.

Francis's first major work was an edition of nineteen of the twenty-two liturgical calendars which survive from pre-Conquest England. Notes and indices were to follow in a second volume, which was never completed. The mere texts of the calendars were a remarkable achievement in themselves. Even more impressive were his texts of the post-Conquest calendars from English Benedictine houses, of which he published eighteen in two volumes: they involved not only the recording of additions and alterations to the basic manuscript but the collation of any earlier and later manuscripts from the same house. The simplicity to which he was able to reduce records of changing liturgical practice over as much as four centuries is astonishing; and the post-Conquest volumes include explanatory notes on the distinctive usages of each house. The materials for a third post-Conquest volume are in the hands of the Henry Bradshaw Society, which intends to attach it to a reprint of the three published volumes. Calendars discussed in separate papers included examples from Holyrood Abbey, Launceston Priory, a Carmelite house in England, and Glastonbury Abbey. The calendar of the Winchester Psalter is dealt with in his own book; and he contributed important commentaries to Buchthal's book on illumination in the Latin Kingdom, to the Warburg Institute's edition of the St. Albans Psalter, and to the colloquium on the *Liber floridus*. Three other papers were an explanation of the liturgical

aspect of the Sherborne Cartulary, dedicated to the memory of Saxl, and accounts of two manuscripts in his own collection: the twelfth-century Pontifical of Apamea, of which—to his great pleasure—he was the first to write since Dom Martène in the seventeenth century, and a late fourteenth-centujry Processional with diagrams, unique in a manuscript, from St. Giles's Hospital at Norwich. Francis kept the letters of thanks which he received for copies of the H.B.S. volumes on calendars; and no wonder. Victor Leroquais, 1935: 'Je n'ai pas besoin de vous dire avec quel bonheur le vieux collectionneur de calendriers que je suis a acceuilli cette belle publication si soignée et si solide.' Paul Grosjean, 1939: 'Votre ouvrage me semble vraiment parfait, surtout les notes et remarques, qui sont admirables.' Fritz Saxl, 1935: 'It must be a wonderful feeling having laid the solid basis of a great structure and to have years of quiet work before you to erect it.' Sir Sydney Cockerell, 1935: 'I see that you are busy on another volume. After that I hope that you will leave liturgical publications to specialists created for the purpose and devote yourself to the artistic matters for which you (but not they) are specially qualified.' Saxl's vision of a lifelong *travail de moine* on one subject was not fulfilled; Cockerell evidently knew that Francis was already at work, in a programme which included weekly visits to the Bodleian, on a second structure. It was to outgrow the first and led Francis to postpone the completion of his work on calendars until the retirement of which he was in the end deprived. The final touches might well have been given in a new version of the Warburg classes of 1936 on calendars as liturgical documents. As it is, the best way to understand liturgical calendars is to follow Francis step by step through his editions and commentaries.

The earliest public expressions of Francis's concern with illuminated manuscripts seem to have been the competent eight-page introduction on Queen Mary's Psalter in an *edition de luxe* of the Psalms, in the Authorized Version, illustrated by coloured plates from that manuscript, and his membership of the committee of the five who organized an exhibition of Gothic art for the Burlington Fine Arts Club in 1936.[10] Since the days of John Ruskin and William Morris, illuminated manuscripts had inspired the devotion of collectors like Yates Thompson, Dyson Perrins, and Chester Beatty, and of scholars like Sir George Warner, M.R. James, Sir Sydney Cockerell, and Eric Millar. Cockerell and Millar were collectors themselves. The standard of connoisseurship was extremely high, and the results of their combined research and experience were mainly recorded

[10] See Burlington Fine Arts Club, *Catalogue of an Exhibition of Gothic Art in Europe (c. 1200—c. 1500)* (London, 1936).

in the catalogues of the three great collections named above, and in the introductions to the facsimiles published by the Roxburghe Club from about 1900 onwards. Warner, James, Cockerell, and Millar were between them responsible for most of these publications. In the catalogue of the great exhibition held by the Burlington Fine Arts Club in 1908, which drew on the collection of J.P. Morgan as well as on English collections and libraries other than the British Museum and the Bodleian, Cockerell had produced a survey of knowledge at that date.[11] Francis entered the Museum in the year between the publication of the first and second volumes of Millar's *catalogue raisonné* of English illuminated manuscripts from *c.* 1000 to *c.* 1500.[12] The first part of a six-volume successor to Millar, called 'A Survey of Manuscripts illuminated in the British Isles', appeared only in 1975, although the medieval volumes of the 'Oxford History of English Art', published in the 1950s, and Margaret Rickert's fine book of 1954,[13] which was dedicated to Francis, marked an intermediate stage already deeply in debt to Francis's own researches. 'In manuscript illumination the course of present studies has been redirected by Professor Francis Wormald in a series of brilliant and stimulating articles.'[14] When Francis entered this field, Millar's work was so new, and relations between the two colleagues in the Museum were so close,[15] that there could have been no question of writing or even planning a new *summa*. The only continuous account of English illumination that Francis ever produced was a lecture on continental influences given in 1965; but his papers only have to be read in the right order for it to be obvious that each of them has its place in what could have been a grand design. As it is, the collected edition of them which will no doubt appear as soon as the present economic crisis is over, will be exempt from the *longueurs* which even the best-written surveys cannot avoid; and here too his readers will have the pleasure of following his researches step by step, in their first and freshest form.[16] Francis's true subject was what Traube called *kunstgeschichtliche Paläographie*, the study of illuminated manuscripts as manuscripts and not simply as collections of

[11] Burlington Fine Arts Club, *Exhibition of Illuminated Manuscripts* (London, 1908).

[12] E.G. Millar, *English Illuminated Manuscripts from the Xth to the XIIIth Century* and *English Illuminated Manuscripts of the XIVth and XVth Centuries* (Paris and Brussels, 1926 and 1928).

[13] Margaret Rickert, *Painting in Britain: the Middle Ages* (Harmondsworth, 1954; 2nd edn., 1965).

[14] T.S.R. Boase, *English Art 1100–1216* (Oxford, 1953), p. vi.

[15] Millar gave some leaves of a Missal, now B.L. Add. MS. 57530, to Francis in about 1929.

[16] [The work in question is *Francis Wormald: Collected Writings, I. Medieval Art from the Sixth to the Twelfth Centuries*, ed. J.J.G. Alexander, T.J. Brown and J. Gibbs (London, 1984). No further volumes were published.]

miniatures. He had a strong sense of the individual and complex personalities of the books he worked on, combined with a general sense of history, and an understanding of the history of art in particular, which was a world away from the attitude of his predecessors. No wonder that in 1941, after the first of the three great lectures in which the quality of this side of Francis's work was made apparent, Saxl should have written to him as follows: 'I really think that this lecture marks the beginning of a better history of English miniature in the future, and I was glad to hear that Pächt is of exactly the same opinion.'

The first-hand knowledge of manuscripts on which those three lectures were based must have been acquired before the war, and their delivery as well as their publication may well have been delayed by its outbreak. In the January 1941 lecture to the Antiquaries Francis presented the history of the decorated initial in England from the revival of book production under Alfred to the generation after the Conquest, that difficult period in which native Anglo-Saxon and imported Norman, but under strong Anglo-Saxon influence, can be difficult to distinguish. The development of the initials is important for the whole history of Late Saxon art; and Sir Thomas Kendrick's first acknowledgements in his pioneering book are to 'Francis Wormald, who has instructed me in the matter of manuscripts', to Saxl, and to Clapham.[17] The second lecture, given for the British Archaeological Association in May 1943, was an exposition of the stages by which Anglo-Norman illumination of *circa* 1100 evolved to the point at which late Romanesque was entering the difficult period—another difficult period!—during which it was gradually transformed into early Gothic. The main conclusions can be regarded as definitive. The third lecture, given to the British Academy in June 1944, discussed a theme which linked the first with the second and carried over into the fourteenth century, namely the long survival in English illumination of elements which had been typical of it in the Late Saxon period, the most important of which was a passion for pattern and line, both for their own sakes and as a means of heightening the expressive quality of a miniature. This continuity in art is compared with the continuity which R.W. Chambers found in the development of English prose on either side of the Conquest;[18] and the attitude of the miniature-painters to the scenes they depict, and especially to the Crucifixion, is compared to passages from devotional works in

[17] T.D. Kendrick, *Late Saxon and Viking Art* (London, 1949), p. vii.
[18] 'The Continuity of English Prose from Alfred to More', in *Nicholas Harpsfield: The Life and Death of Thomas More*, ed. R.W. Chambers and E.V. Hitchcock, Early English Text Society o.s. clxxxvi (Oxford, 1932), pp. xc-c.

Middle English, in which Francis was well read and which he used effectively on other occasions. To Romanesque art—a subject round which art historians swarmed like wasps round a jam pot in the twenty years after 1945—Francis returned only in the last year of his life, to write his book on the Winchester Psalter, in which he was able for the first time to enjoy the luxury of lavish illustration. The text achieves its dual aim, of revealing the personality of the book and of placing it in its artistic context, with typical brevity and modesty. Still in the twelfth century, Francis contributed important liturgical and palaeographical sections to Buchthal's study of illumination in the Kingdom of Jerusalem; and he did the same, *plus* a general description, for the Warburg Institute's publication of the St. Albans Psalter at Hildesheim, of which he was general editor, holding the ring between the two men of decided views, Otto Pächt and Reginald Dodwell, who described the miniatures and the historiated initials respectively. Another twelfth-century subject to which Francis devoted much attention was the encyclopedic work which Lambert of Saint-Omer completed *circa* 1120 under the title of *Liber floridus*. In 1962 he gave a seminar on it at the Warburg Institute with Harry Bober and Hanns Swarzenski, and they were hoping to collaborate in an Institute publication on the same lines as the book on the St. Albans Psalter; but their interest in the Ghent manuscript led in the end to a colloquium at Ghent in September 1967, at which Francis described the calendar, and to the publication of a facsimile in 1968,[19] in the course of which the original scheme had to be dropped, to the great regret of Francis and his two original collaborators. He characteristically gave his copy of the facsimile to the Institute, which could not have afforded it. An editorial enterprise of a rather different kind, shared with his former colleague in the Department of Manuscripts, Cyril Wright, was the publication of a set of lectures on the early history of libraries in England, to which Francis himself contributed one on monastic libraries.

From 1950 onwards Francis wrote another dozen important studies of Late Saxon illumination. This total includes a lecture published as a pamphlet on the Utrecht Psalter, and the expanded version of his Sandars Lectures at Cambridge in 1948, which were on the miniatures in the sixth-century Gospel book at Corpus Christi College which is known—with a reasonable possibility of truth—as 'St. Augustine's Gospels'. The Gospels were at Canterbury from at least the eighth century, the Psalter from at least the end of the tenth century; and their significance as sources of style and iconography in England is immense. The most important of

[19] *Lamberti Liber Floridus*, ed. A. Derolez (Ghent, 1968).

the books did for the unique Late Saxon technique of outline drawing, often in various colours, what his lecture of 1941 had done for the Late Saxon initials. The essay in which he explains the various phases of style and their different Carolingian sources is as clear as it is brief. It is followed by a catalogue of the fifty-nine manuscripts illustrated in the technique which, although the two longest entries occupy no more than a page, conveys a mass of strictly relevant detail. Since manuscripts with drawings far outnumber contemporary English manuscripts with miniatures in body colour, this little book is of much greater weight than the title suggests. Ten years later Francis wrote a miniature monograph of thirteen pages on the superb set of full-page drawings—the oldest known example of a method of illustration used all over Europe in later centuries—in a mid-eleventh-century Psalter now recognized as written by a scribe who worked for the Old Minster at Winchester.[20] Of similar length and importance is the book on the Benedictional of St. Æthelwold, to be read with a paper on a fragmentary Gospel Lectionary. Both manuscripts are from the Old Minster and both were, as we now know, written by the same hand.[21] A very short paper delivered in 1961 is particularly important for its criticism of the received dating of King Edgar's charter for the New Minster at Winchester. In his essay on the style and design of the Bayeux Tapestry, Francis used contemporary manuscripts to explain a difficult, because unique, work of art in another medium. His next-to-last, and one of his best, papers in this field was on illumination between King Alfred and St. Æthelwold, in which he used new material to show that the period from Alfred to Æthelstan actively prepared the way for 'the much more spectacular changes ... which are rightly associated with the reforms of St. Dunstan and St. Æthelwold'. The essay on English illumination of the tenth and eleventh centuries published posthumously in France, with its splendid illustrations, heightens one's regrets that the book with which he hoped to complete this side of his work remained unwritten. In 1970 he decided to take the Winchester Psalter first, knowing that it would not take very long to finish.

English calendars and English illumination from Alfred to Henry III were Francis's two great intellectual passions. The remaining one-third of his work is less concentrated and must be dealt with here in fewer words. Its quality is as high as the quality of the rest, and in it he makes more frequent use of his knowledge of media other than illumination. It was almost as great as his knowledge of books, and it was always at the disposal

[20] T.A.M. Bishop, *English Caroline Minuscule* (Oxford, 1971), p. 23.
[21] Ibid., p. 10.

of colleagues and students; but his belief that a writer should stick to his last meant that it was never paraded in print; and its extent can only be guessed at by anyone who never heard Francis in a discussion after a paper at the Antiquaries. Here too three comparatively early papers give the best idea of his achievement. To take them in 'historical' order, the first links the most important remains of English wall- and panel-painting with contemporary illlumination and it is based on a lecture to the Academy in 1949. In the second, he formed round the Fitzwarin Psalter in Paris, of the third quarter of the fourteenth century, a group of illuminated manuscripts close to the Bohun group, published by James and Millar, and to others whose Italianate aspects were discussed by Pächt in the same number of the Warburg and Courtauld *Journal*.[22] Another subject on which Francis and Otto Pächt worked harmoniously side by side was that of Normandy and England in the generation after the Conquest.[23] This is as good a place as any to say that with Pächt and with another distinguished refugee scholar in the field of illuminated manuscripts, Hugo Buchthal, Francis collaborated on terms of mutual confidence and affection which meant a great deal to them during their years in England. The third important paper in this section was on that battlefield of learning, the Wilton Diptych. To an outsider Francis would seem to have ignored some of his predecessors in a rather pointed way; and the explanation may perhaps be that much of his work was done some time before it was published. Using manuscripts again, Francis vindicates the claim of the panels to be English, but shows that both the naturalism of the white hart on the reverse and the whole iconography of the obverse have close parallels in Lombard manuscripts of *circa* 1400. The iconographical comparison with a memorial miniature of Gian Galeazzo Visconti (d. 1402) makes complete sense of the obverse, for the first time. The iconography of the throne of Solomon was the subject of Francis's paper in the Panofsky Festschrift, which gave particular pleasure to the recipient; and in the Festschrift for Hermann Schnitzler he uncovered the sources of the illustrations—amateur in style but conscientious in iconography—in a fifteenth-century collection of devotional texts in Middle English compiled in some Carthusian house in the North of England. Two important classes of manuscripts were reviewed in papers on illustrated lives of saints and on the major subject of illustrations of the Bible.

[22] O. Pächt, 'A Giottesque Episode in English Medieval Art', *Journal of the Warburg and Courtauld Institutes*, vi (1943), pp. 51–70.
[23] Idem, 'Hugo Pictor', *Bodleian Library Record*, iii (1950), pp. 96–103.

Numerous though they are, Francis's publications on liturgical and illuminated manuscripts still cannot convey the combination of wide interests with excellent memory that made him an all but infallible source of information and stimulation. When he retired from the Institute of Historical Research he left peremptory instructions that nobody should be allowed to edit a Festschrift for him. The choice of contributors would have been very difficult: a list of books dedicated to him or containing major acknowledgements would be a long one. His skill as a general practitioner, acquired in the Museum and carefully maintained ever afterwards, shows up well in his work for the Fitzwilliam Museum at Cambridge, which made him Honorary Keeper of Manuscripts in 1950. With the Librarian, Phyllis Giles, he produced a handlist of additions and the catalogue of the exhibition of illuminated manuscripts which commemorated the death of the Museum's founder. His reviews of the Copenhagen/Stockhold exhibition organized by Nordenfalk and of his own exhibition at the Fitzwilliam display the same versatility. So do his book reviews, which are mostly of books on illuminated manuscripts. He produced between seventy-five and a hundred of them, almost all after 1950 and usually for the *Burlington Magazine* or the *Times Literary Supplement*; and however concise they were, he generally managed to contribute some new piece of knowledge of his own finding.

The reviews, and a brisk exchange of offprints, contributed greatly to the excellent private library which Francis began to need after he left the Museum. After his death, Honoria and her co-executors in compliance with his wishes gave the collection of about 1,000 offprints to the Warburg Institute, and the books—about 1,800 titles, overwhelmingly on illumination and art history—to the University of York, where they form the nucleus of the Wormald Library, kept as a special collection at the Centre for Medieval Studies in King's Manor. To this the Warburg Institute added such offprints as it already possessed and photocopies of the rest. With the books are the remains of the incoming side of Francis's huge correspondence, comprising about 1,000 items. Letters which he decided to keep were inserted in appropriate volumes in his library, and most of the latters date, like most of the books, from the years after 1950. The few photographs in his *Nachlass* are also at York; but his notebooks, the contents of which have almost invariably been used in publications, are in the Palaeography Room of the University of London Library.[24] Francis's own collection of twenty manuscripts, many of which shared a drawer with his shirts, was also given away by the executors in accordance with his verbal

[24] U.L.L., MS. 809, *circa* 1925–1971 (twelve boxes).

instructions to Honoria. The mere list of them is ample evidence of their interest.[25] Francis presented other manuscripts and fragments of manuscripts to the British Museum and to the Fitzwilliam Museum, at least, during his lifetime.

Francis may have been denied the opportunity to put the roofs on his two structures, but his unfailing interest and his daily hard work raised them both very high, and their incompleteness enhances their power to stimulate: what we have prompts us to wonder about what was still to come. He was well aware of his own place in the history of his two subjects. In his assessment of Frere as a liturgist, Dom Gregory Dix places him not with the Mabillons and the Wilmarts, 'to whom one turns . . . for their *aperçus*, their general judgements', but with the Martènes and the Brightmans, 'to whom their successors turn naturally for texts and "information"'.[26] Francis, of course, had his insights—a case in point is his grasp of the importance of relics in the story depicted on the Bayeux Tapestry; but it is with Frere and his like that he will be gratefully remembered. Francis paid two tributes to Eric Millar, one in his first Anniversary Address to the Antiquaries and one in the commemorative volume issued by the British Museum, in both of which he praises him as a scholarly connoisseur, not as an art historian. His own task was to go over the same ground and consider from new, more 'historical' points of view, seeing the wood for the trees.

If, since about 1950, it has been possible to take this attitude to English illumination for granted and to ask for more, it is because Francis showed the way, in association with others—mostly from abroad—whose idea of art history took them beyond the placid admiration of beautiful things to the critical analysis of style and iconography. Francis's last public act as President of the Antiquaries was to present the Gold Medal to his friend Serarpie der Nersessian, as a result of whose work on Armenian illumination 'a completely new culture has been brought before us of a diverse and fascinating richness'. A few moments before, he had said: 'In the study of illuminated manuscripts there have been signs of change which in my opinion are changes for the better . . . a good deal of new ground is being broken. There are two very recent books which illustrate this . . . Mont Saint-Michel and Saint-Martial are the subjects . . . the first is by Jonathan Alexander of the Bodleian Library at Oxford[27] and the second about

[25] [Listed by Julian Brown as an appendix to his obituary, pp. 558–9 (not reprinted here)].
[26] Phillips *et al.*, *Walter Howard Frere*, p. 146.
[27] J.J.G. Alexander, *Norman Illumination at Mont Saint-Michel 966–1100* (Oxford, 1970).

Saint-Martial is by Madame Gaborit-Chopin of the Louvre.[28] . . . In these two books new facts have been brought to light not only for the history of art but also for the history of medieval civilization. There are a number of abbeys needing the same careful treatment.' What was new here was the exhaustive study of all aspects of a sharply defined body of material from a particular scriptorium. Jonathan Alexander's research was supervised by Otto Pächt. Francis mentions as earlier examples of the *genre* Dodwell's work on the two great Canterbury scriptoria[29] and Elizabeth Parker McLachlan's on Bury St. Edmunds,[30] but without saying that he himself had been the supervisor. A similar project which he supervised and approved of was Marie Montpetit's on the eleventh- to twelfth-century manuscripts of Rheims.[31] Francis's own work on English illuminated manuscripts is the colonnade through which the subject passed from the Victorian Gothic mansion designed by Ruskin and Morris and finished by Millar to the new, more functional building for which Francis himself acted as consultant.

III

Long though it has had to be, this account of Francis Wormald's life and works has done less than justice to their complexity, and none at all to the complexity of his character. The complexities, however, rested on simple foundations. He was born with many advantages, and the consequences of his portion of ill luck were so long delayed, and he achieved so much in the interval, that it is easy to overlook them; but he died with both his great scholarly projects unfinished. He was deeply modest and nobody could have been less 'ambitious'; but he loved hard work, and he thought it his duty to do his best in everything. Like Lord Curzon, another north-countryman who was still recognizable as such at the end of a metropoli-

[28] D. Gaborit-Chopin, *La Décoration des manuscrits à Saint-Martial de Limoges et en Limousin du IXe au XIIe siècle* (Paris, 1969).

[29] C.R. Dodwell, *The Canterbury School of Illumination 1066–1200* (Cambridge, 1954).

[30] Elizabeth Parker, 'The Scriptorium of Bury St. Edmunds in the Twelfth Century', Ph.D. thesis of the University of London, 1965; 'A Twelfth-Century Cycle of New Testament Drawings from Bury St. Edmunds Abbey', *Proceedings of the Suffolk Institute of Archaeology*, xxxi (1968–9), pp. 263–302; 'The Pembroke College New Testament and a Group of Unusual English Evangelist-Symbols. In memoriam Francis Wormald', *Gesta*, xiv (1975), pp. 3–18.

[31] Margery Marie Farquar, 'A Catalogue of Illuminated Manuscripts of the Romanesque Period from Rheims, 1050–1130', Ph.D. thesis of the University of London, 1968.

tan career, Francis saw himself as a self-made man. He had not been born into the academic purple. If he wore his learning very lightly on the surface, he was deeply serious about the subjects of it; and if he was a fox in the variety of his publications, he was very much a hedgehog in the intensity and durability of the two intellectual passions which inspired them.

Hard work and seriousness were the twin bases of his success in public life. Their immediate expressions were shrewdness and common sense; and they gave him an authority which could be formidable. He hated injustice and arrogance; complacency and thoughtlessness he despised; and when he rebuked them, he did it shortly and sometimes sharply—the more so because a very real diffidence had to be overcome before he could express his disapproval. Although they admit that he sometimes gave way to the waspishness of exasperation when among friends, Francis's contemporaries failed to understand how younger people could find him in the least frightening; but it took time to realize that if one did get bitten, it was only for what one had done or left undone, not for what one was or was not. If, as occasionally happened, he did entertain an antipathy, he was careful to control it. Since he had much to give, to be out of favour with Francis could be wounding. He himself was always much relieved to find that an adverse opinion could be revised; and he would take great pains to cancel out his previous censure by emphasizing his new-found approval.

When Francis died his friends and colleagues felt that they had lost a wholly dependable leader whom they loved and respected. Hard work and integrity alone would not have given him such influence. Once disagreement was out of the way, he was invariably considerate and kind, seeing people as individuals, whoever they were and whatever his relationship with them might be. The essence of this kindness and consideration was Francis's personal interest in anybody he met; and it made him friends wherever he went. Although he concealed the fact with the utmost care, he habitually used his considerable private means to make timely and often substantial gifts to institutions and individuals, outside the academic world as much as within it. His benefactions to the Society of Antiquaries, the Warburg Institute, and the Fitzwilliam Museum—mostly but not all to their libraries—have been publicly acknowledged and so can be mentioned here. Another aspect of his kindness—and one that is remembered with particular gratitude by many—was the way in which he befriended as well as taught students and young colleagues on the threshold of their careers, showing a discreetly but seriously paternal concern for their lives as well as for their work.

The friend who wrote a brief obituary of Francis in *Le Monde* of 18 January 1972 called him 'une personalité dont le charme, le sérieux et la

parfaite gentillesse était connus dans le monde entier'. The words are as exact as they are lapidary. Seriousness and kindness are more easily described than charm and grace; but the attempt must be made. Anyone who knew Francis as a boy or as a young man agrees that he never changed. The original, extravagantly playful child whose foibles and virtues evidently determined the quality of life in the nursery at Field Head simply went on with whatever he had always meant to do. Childish enthusiasm turned into adult realism—if Francis felt like the boy who grew up to *be* an engine driver, the important words are 'grew up'; but the lively imagination and the high spirits of his childhood also survived, as a sense of humour that not even the most serious occasions could overbear and as a capacity to make other people burn more brightly than usual [. . .].

Years afterwards he returned to London after a visit to Cambridge and reported: 'I díned at Kíng's last night. They were like a lot of núns without the cónsolations of relígion.' It was remarks like these, delivered with an intonation combining the manner of the 1920s with something trenchant that he and his sisters apparently inherited from their father, that made Francis 'amusing' in the best sense of a word that used to mean a great deal. He knew how to entertain, and he loved doing it, each 'act' being brief and pointed. Although he was quite short in stature, 5′ 10″, and on the stout side, Francis's physical presence was impossible to overlook. His movements and gestures were like his speech, brisk and pointed; and his manner was always precisely adapted to the occasion, whether dignified or informal. He radiated an impression not indeed of great strength but of great energy—his strength, perhaps, was being used at a deeper level, in the maintenance of his health. He was loved by his friends not only for the gaiety of his conversation, but for his power to give them a sense of security.

This is an obituary of Francis, and readers of it who never had the good fortune to know him and Honoria together may fail to understand that what he achieved was achieved with her, and that he participated to the full in her own very active life. Since his death, she has devoted much time and energy to objects which were dear to him; and to their friends the thought of him is inseparable from the thought of her. To those friends, the obvious expression of husband and wife's unanimity was their joint genius for entertaining, whether at home or in official surroundings. They conspired to convey to each of their guests a feeling of ease somehow united with the sense that he or she was an indispensable element in the success of the occasion. Hard work in the kitchen, which Francis enjoyed just as much as Honoria did, was followed by a close but unob-

trusive watch on the progress of each guest through the evening. After the attaching and keeping of their very numerous friends, two other activities in which they loved to collaborate were collecting and travelling. Francis collected porcelain all his life and had some excellent pieces; and their joint efforts were mostly devoted to furniture and *objets de vertu* for their spacious flat on the top floors of two adjacent houses in Warwick Square, from which they looked out into the tops of magnificent plane trees. Higher up still, Honoria made a garden in tubs on the roof, which bears remarkable testimony to her skill as a gardener and to the cleanness of Pimlico air. Francis was an accomplished traveller, in whom an essential gift was highly developed: in whatever city of Europe, he could find the best meal at the cheapest price. Conferences and exhibitions were always reunions of their international circle founded before the war, with the addition of new members who had joined it since, notably Marie-Madeleine Gauthier and Florentine Mütherich.

Of those who became friends of Francis and Honoria through Francis's work, only the oldest and most intimate could convey with adequacy the character of two other circles of friends who were as important to them both as the academic circle. The circle of relations, family friends, school friends, Cambridge friends was large, and devoted; and a few of its members, like Sir Charles Clay, who used to go to tea at Field Head when Francis was a child, or Sir Trenchard Cox, who was at Eton with him, belonged to the other circle as well. Again, the Wormalds played an energetic part in the life of their parish church, St. Stephen's, Rochester Row; and in that circle 'the Professor' was cherished by many friends who neither knew nor cared what it was that he professed. Christian worship and Christian devotion were not only the grounds of Francis's intellectual passions, but the grounds of his life. One good answer to 'What was Francis Wormald like?' is to say that with his baldness, his round steel-rimmed spectacles, his generally dark clothes, and his very quiet but very intent manner of going about his work, he was extremely like a learned Benedictine. There was one moment when he certainly felt like one, comparing his own fate in having to exchange his Assisstant Keepership in the British Museum for a Chair in London University to the fate of a monk who had to exchange the discipline of the cloister for the exposed responsibilities of a bishopric. It is impossible to believe that a man for whom life in the world was the occasion of giving and receiving so much enjoyment, and who possessed such a mastery of so many sides of the world's business, can ever have thought of growing up to *be* a monk; indeed, he chose his exact place in the world deliberately and decisively at a very early age. And yet, when he quoted a literary text to illustrate some point of

iconography it was generally from his wide reading of devotional literature in Middle English, and he was always deeply interested in the English mystics. ('What do you méan, it's "only a bít of papist theólogy?" For all yóu know, it may be an únknown treatise by Father Augústine Báker. Let me sée it!') Francis was too much of a moralist and far too little of a sentimentalist to be invariably mild; but his natural goodness was profound and he supported it by his observance of 'rellygyoun of the herte, that is of the Abbey of the Holy Goost, [where] all tho that mow nout been in bodylyche relygyoun mow been in gostly.' Francis's life was what Marie-Thérèse d'Alverny has called it: 'une existence sage, laborieuse et féconde.'

JULIAN BROWN

NEIL RIPLEY KER

XXIV
Neil Ripley Ker
1908–1982

NEIL RIPLEY KER was born in Brompton, London, on 28 May 1908, the only child of Robert Macneil Ker and Lucy Winifred Strickland-Constable. He was educated at home by his mother until he was ten, and then for two years at a preparatory school in Reigate before going to Eton. He was there at the same time as Francis Wormald and Roger Mynors, although each in a different house and year and so did not know them there. And only once, in his last year, was he entertained to dinner by the Provost, M. R. James, whom he greatly admired but whose work as a medievalist he was then unaware of. He went quite often to the College Library in the hour or two a week it was open to the boys and did not remember seeing any manuscript books on exhibition, only documents, but with the printed books 'we could just browse on the shelves, which was heaven'.[1]

In 1927 he entered Magdalen College, Oxford, to read Philosophy, Politics and Economics with the idea of a career in the Foreign Office, but, on the advice of C. S. Lewis, changed to English Language and Literature, in which he obtained a second-class degree in 1931. His interest in manuscripts had already begun as an undergraduate (when he is said to have chosen to read Old and Middle English texts in that form): 'The Laudian collection was my first love in Bodley. I can still remember browsing through the catalogue and the Summary Catalogue addenda about 1929–30 (?) and the sort of romantic aura there was about "Jesuits of Würzburg", that especially for some reason'.[2] And in 1929–30 he had attended the classes of E. A. Lowe

© The British Academy 1993.
[1] Letter to T. J. Brown, 29 July 1972, from Professor Brown's papers in the Department of Palaeography, King's College, London, made available to me by Miss S. Dormer; quoted by kind permission of Mrs Jean Ker, like subsequent extracts from his correspondence.
[2] Letter to R. W. Hunt, 10 June 1974, from Hunt papers, Bodleian Library, Oxford, made available by Dr B. Barker-Benfield.

in palaeography.[3] His B. Litt., 1933, guided by Kenneth Sisam, and influenced by his belief that study of the manuscripts offered new prospects for Anglo-Saxon studies, was on the additions and alterations in Bodley MSS 340 and 342 of Aelfric's homilies. Having failed to get a Research Fellowship at Magdalen in 1934 and spent some time at the family home near Glasgow and looking at (and being allowed to foliate) manuscripts in the University Library there, he was asked in 1935 by the Oxford English Faculty to give regular lectures on Anglo-Saxon manuscripts.[4] By 1937 he had begun the comprehensive catalogue of ones containing Old English which was to be published eventually in 1957, dedicated to Sisam, whose long encouragement he specially acknowledged.[5] In 1938–9 he made three tours of continental libraries for the purpose (in the course of which he met Berhard Bischoff in Brussels) and had intended to go to the U.S.A. for the same purpose in September 1939, but was prevented by the war, not getting there till 1968–9.[6]

Meanwhile he had become involved, together with R. W. Hunt, J. R. Liddell and R. A. B. Mynors, in the scheme of publishing lists of all books known to survive from medieval British institutional libraries, and of their catalogues, got off the ground by C. R. Cheney in November 1937. Ker already had, like the others (whose relationships in this matter have been well described by Sir Richard Southern),[7] a collection of such identifications and had also 'been through a good many sale catalogues'. Initially it appears he provided somewhat fewer entries (3–400) than each of the other three (Cheney 6–700), Mynors most of all (1200), but when the latter declined the general editorship and he and Cheney were taken for war service in 1940, Ker rather reluctantly accepted the responsibility.[8] When however Cheney wrote to him in 1941 approving the draft preface and suggesting the title *Medieval Libraries of Great Britain* he said that it was the unanimous opinion of the collaborators that Ker's name alone, under which it has since been known, should stand on the title-page: 'you have done so much more actual research than any others of us and you have had most of the burden

[3] Record reported by Professor R. J. Dean via Dr M. B. Parkes, from Lowe papers, Pierpont Morgan Library, New York.

[4] Letters to R. W. Hunt, 28 October 1934, 5 November 1934, 5 June 1935, 29 October 1935.

[5] See also his memoir of Sisam, *P. B. A.* 58 (1972), 409–28, esp. 413–14, 420.

[6] Letters to R. W. Hunt, 1937–9.

[7] Memoir of R. W. Hunt, *P. B. A.* 67 (1981), 371–97.

[8] Letters from C. R. Cheney to R. W. Hunt, 12, 18 November 1937, Hunt papers; letters from Hunt to Cheney, 14, 30 November 1937, presumably passed by Cheney to Ker, in box on origins of *MLGB* assembled by the latter, Ker papers, Bodleian Library, made available by Professor A. G. Watson.

of the final editing'.[9] And although they and others went on to contribute corrigenda and addenda for the master file of cards, housed in the Bodleian Library, it was under Ker's prime care and it was by him that the second edition in 1964 was greatly enlarged, including now the extant holdings of cathedral and college libraries, and a digest and index of persons connected with the medieval acquisitions (as desired by Cheney in 1940); he also prepared most of the supplement, completed by Andrew Watson, which came out posthumously in 1987. Nevertheless he was unhappy as late as 1974 'about the card index . . . being called Mr Ker's', and particularly about Cheney's original share not having been made clear enough in the later edition.[10] It was this work of a very happy convergence of interests and talents in Oxford in the 1930s and a remarkably rapid compilation steered to press by Cheney (as Literary Director of the Royal Historical Society) that has not unjustly made Ker's name most widely known, long envied and more recently emulated in other parts of Europe.[11] With future supplements and no doubt eventual reissues, if the studies it condenses continue to flourish, it will always be an indispensable guide to the evidence for intellectual and artistic history, when used in the ways he indicated.

In 1941 he had been formally appointed Lecturer in Palaeography and although in 1942 he was registered as a conscientious objector and directed to full-time work as a porter at the Radcliffe Infirmary (which he enjoyed except for night duty), he was nevertheless able to get on with a few of his own studies, publishing a number of notes and articles on various subjects, and even hoped to do his lecturing 'if I have any pupils', though he also helped to prepare other pacifists for their tribunals.[12] During the war years he was also able to visit some provincial libraries, such as Worcester Cathedral,[13] Ushaw College and Downside Abbey, and to 'spend what spare time I have' on descriptions of the Magdalen medieval manuscripts, where he gradually developed his methods and criteria: 'I've learnt that all manuscripts need looking at in the way that Lowe has looked at the oldest manuscripts, with due attention to the pricking, ruling, etc., and that a small book needs to be written on the subject'.[14] Though he himself regrettably never carried out the last notion, apart from making an

[9] Cheney to Ker, 1 April 1941, Ker papers.
[10] Ker to Hunt, 14 April 1974, Hunt papers.
[11] E.g. E. Van Balberghe *et al.*, 'Medieval Libraries of Belgium', *Scriptorium* 26 (1972), 348–57; 27 (1973), 102–6; 28 (1974), 103–9; S. Krämer, *Handschriftenerbe des Deutschen Mittelalters*, Mittelalterliche Bibliothekskataloge Deutschlands und der Schweiz, Ergänzungsband I, 2 vols (Munich, 1989).
[12] Ker to Hunt, 4 October 1942, 2 July 1943, Hunt papers.
[13] Ker to Hunt, 15 February 1941: at Worcester 'I saw about 180 manuscripts in three days'.
[14] Ker to Hunt, 16 January 1944, and list July 1944.

unpublished list of periods of changing practices, from the beginning of the twelfth century to the fifteenth, which he must have used in his teaching, the introduction to his *Catalogue of Manuscripts containing Anglo-Saxon* (1957) has a masterly account for its centuries, many such observations occur in *English Manuscripts in the Century after the Norman Conquest* (1960), some are found in the introduction to *Medieval Manuscripts in British Libraries*, volume 1 (1969), and many are indicated in the facsimiles and editions to which he contributed palaeographical matter, as well as in individual articles, notably that on above and below top line (1960), the findings of which have recently been freshly and more extensively vindicated.[15]

It was also during the war that he followed up Mr James Fairhurst's discovery, amongst the remains of John Selden's and Sir Matthew Hales's collections, of Patrick Young's, James I's librarian's, catalogues of the manuscripts of five cathedral libraries, of which Ker edited three, enabling him to identify additional items from their medieval collections and to trace the occasions and agents of losses; and the whole area of early post-medieval ownership of manuscripts was one (led by M. R. James) which he developed in showing the value of, in specific cases, such as those now at Antwerp, Thomas Allen's, Sir John Prise's and others.

In 1945 he was elected a Fellow of Magdalen and in 1946 he succeeded Lowe and Denholm-Young as Reader in Palaeography. Besides manuscripts of the Anglo-Saxon period he normally gave classes on writing in England from 1100 to the sixteenth century and on the description of manuscript books, leaving other Latin topics to Richard Hunt as a part-time lecturer besides being Keeper of Western Manuscripts in the Bodleian Library. Ker's modesty of manner meant that as a teacher he was most effective by example, and as much through influence on people who had never sat in his classes but who asked him about particular manuscripts or read with attention what he wrote.[16] When questioned he was usually reluctant to risk generalisation, except by way of report on his own experience, but what emerged from his acute and systematic observations has frequently more than narrow applicability.

His interest and expertise were not primarily in script, despite his very sharp eye and memory for its details, but in the ensemble of evidence about the making and history of medieval manuscript books, effectually

[15] M. Palma, 'Modifiche di alcuni aspetti materiali della produzione libraria latina nei secoli XII e XIII', *Scrittura e Civiltà* 12 (1988), 119–33. The comments by Jacques Lemaire, *Introduction à la codicologie* (Louvain-la-Neuve, 1989), pp. 164–5, concerning earlier and later occurrences, miss the limits of Ker's observations.

[16] The present writer cannot speak at first hand of his official teaching, only of a single seminar and a lecture (that published on cathedral libraries), which was very well received.

codicology, before the word was invented or imported.[17] Nonetheless in the field of pure palaeography he made without fuss specific advances ranging from the late ninth to the fifteenth century, and was adept in demonstrating crucial scribal identities in diverse conditions (e.g. Aldred, 1943, and William of Malmesbury, 1944). His establishment of the term 'anglicana' (with medieval precedent) for the traditional English cursive script of the thirteenth to fifteenth centuries, after a period when he had used the ambiguous 'chancery' for it (in private notes), was affected by growing awareness of the continental discussions of nomenclature, through the Comité International de Paléographie, of which he became a member;[18] yet, like his complementary naming of the competing late fourteenth- and fifteenth-century 'secretary' script (from its Tudor descendant), it was chiefly from the wish to characterise more distinctly the types and mixtures of writing he found in the late medieval books he wanted to catalogue.[19] Similarly, he decided it was desirable, in order to avoid ambiguity, to refine his form of stating broadly mid-century dates from that (s. xiii) in the first edition (1941) to that (s. xiii med.) in the second (1964) of *Medieval Libraries*.[20]

During the war, as a result of his work for *Medieval Libraries*, he had got to know the book-collector J. P. R. Lyell, who at his death in 1949 left 100 of his medieval manuscripts to the Bodleian Library and an endowment for an annual Readership in Bibliography at Oxford, of which in 1952–3 Ker was the first holder. The first lecture, by the donor's wish, was on Lyell's collection (published in the introduction to the catalogue of the Lyell manuscripts by Albinia de la Mare in 1971), and the remainder appeared as *English Manuscripts in the Century after the Norman Conquest* (1960). This was perhaps his most discursive work; hearers and readers may, like the present writer, have wished that it had been longer, revealing even more of his perceptions and reflections about books produced in that era.

His intimate knowledge of Oxford libraries, and that not simply of material in Oxford, was shown in an innovatory work, *Pastedowns in Oxford Bindings* (1954), which both identifies over two thousand fragments of medieval manuscripts (some of copies recorded in early catalogues),

[17] The French term is said to have been introduced by A. Dain, *Les Manuscrits* (Paris, 1949), in a more restricted sense than its later usage; the first instance in English in the Supplement (1972) to the Oxford English Dictionary is of 1953.

[18] G. Battelli *et al.*, *Nomenclature des écritures livresques du 9e au 16e siècle* (Paris, 1954).

[19] *Medieval Manuscripts in British Libraries*, I (Oxford, 1969), xi–xii, II (1977), vi; elaborated by M. B. Parkes in an Oxford B. Litt. thesis and *English Cursive Book Hands* (Oxford, 1969), pp. xiv–xxiv.

[20] This of course could hardly apply to datings he had not reviewed in the interval and, out of step, the older form is used in *MMBL*, I (1969), vii, much of the work for which however had been done in the earlier 1960s; for the revised form see II (1977), vii, III (1983), vii.

utilised by Oxford binders in the sixteenth and early seventeenth centuries, and dates and groups the tools they used and the colleges they worked for, with ample indexes; it was soon followed by the Sandars Lectures at Cambridge in 1955 on 'Oxford College Libraries in the Sixteenth Century' (not published till 1959) and an exhibition with a catalogue, 1956, on Oxford College Libraries in 1556; later came *Records of All Souls College Library* (1971) and posthumously 'The Provision of Books' in the History of the University, volume III, on the sixteenth century (1986). He was intended to contribute the parallel chapter to volume II, on the middle ages, a task taken over by M. B. Parkes after his death, but he already had drawn up, as a piece of the ordered documentation on which all his work is based, a chronological list of cautions, notes of book pledges in loan chests, incorporating contributions from Graham Pollard (with whom over the years he exchanged much other information on the university book-trade), which should be published eventually.[21] He also left notes on early sixteenth-century Cambridge bindings which have manuscript pastedowns. The results of his regular rubbing of early English blind-stamped bindings wherever he came across them, and any evidence of their provenance, had long been communicated to J. B. Oldham, and names of graduate book-owners to A. B. Emden, to the benefit of their respective publications.[22] And the significance of other binding details (such as marks of chaining) in relation to provenance is just one of the aspects he drew attention to in a number of articles and catalogues.

The *Catalogue of Manuscripts containing Anglo-Saxon* (1957), and a *Supplement* (1976) reissued with it (1990), definitively replaced the corresponding portion of the survey by Humfrey Wanley in the *Catalogus Librorum Septentrionalium* (1705), for which Ker had great esteem, but added many more items, describing most of them minutely at first hand, with full notice of previous discussions and editions, and relating them to each other, contemporary charters (excluded from the catalogue) and wholly Latin codices. One may now overlook how greatly this stout volume, with its packed introduction and elaborate index, transformed the palaeography and codicology of the field and promoted further research.[23]

From a very early stage in his career Ker seems to have resolved to see all the medieval manuscript books in British repositories outside the major centres, and any printed books which could have evidence of

[21] Bodleian Library, Ker papers.

[22] J. B. Oldham, *English Blind-Stamped Bindings* (Cambridge, 1952); *Blind Panels of English Binders* (1958); A. B. Emden, *A Biographical Register of the University of Oxford to A. D. 1500*, 3 vols (Oxford, 1957); *1501–40* (1974); *Cambridge* (1963).

[23] Evidence may be seen in the Supplement (1976) and the annual bibliography of *Anglo-Saxon England*.

fifteenth- or sixteenth-century British ownership, including early bindings, which meant constant journeying throughout his life. From this as a by-product came much of the information in the influential report on *The Parochial Libraries of the Church of England* (1959). By 1960 he was already engaged on cataloguing in London libraries for his last and largest enterprise, *Medieval Manuscripts in British Libraries*, intended to deal with all institutional collections not yet adequately described in print, with the exception of the British Library, the Bodleian, Cambridge University Library and a few others for which separate catalogues were known to be in preparation. The first volume, for London, appeared in 1969, the year after he took early retirement from Oxford in order to concentrate on this work. The second volume, Abbotsford – Keele, came out in 1977; in 1982, when he had completed all but the introduction of the third, Lampeter – Oxford, he anticipated that the remainder might take a further five years. Volume 3, then in proof, finished by his literary executor Andrew Watson, appeared in 1983, and volume 4, Paisley – York, for which Ker's drafts were all checked with the manuscripts and augmented, and descriptions for Parkminster and some in other places done *ab initio*, by A. J. Piper, has been published in 1992. Although adopted by the Manuscripts Sub-Committee of the Standing Conference of National and University Libraries, it was done entirely at Ker's own initiative and largely at his expense, including heavy subsidies for the printing of the first two volumes, though the Committee obtained British Library and Academy grants towards the third and fourth. Indexing of this huge assemblage of information still remains to be done, an urgent need of users all over the world, for the contents are as much European in origin as British, and deserves to be done as well as the compiler himself would have done it or seen it done. As Julian Brown said in a moving memorial address, Ker's bent, from his first publications, as a schoolboy, of churchyard gravestones, was to catalogue, as faithfully as possible, what he saw, while he showed in it fresh patterns of significance. It would be more difficult to draw these out of the miscellaneous matter of his last great work than from the coherent categories of his other catalogues, but he certainly would have been able to point to instructive instances of contrasting practices in different places and centuries, and varieties of format in relation to custom and function, in his quiet way.

In a work of such a wide reach, carried out over twenty years and in diverse conditions, published in instalments, there will be inevitably some inconsistencies, unconscious and conscious, as he learned more and adapted his methods, and possibly some failures to cite relevant literature, although Ker went back everywhere to check and fill out his first descriptions, in the light of researches he had to pursue elsewhere:

'I am bad at getting to the point where I don't need to see a described manuscript again'.[24] Many of the manuscripts included were of foreign origin, some of types with which previously he had not many dealings, and with texts or annotations in difficult hands and spellings, but he usually knew when and where to get help with them. Despite his remarkable visual memory, and his meticulous description of the details of the hierarchy of decoration, he explicitly limited his listing of illustration,[25] and generally avoided giving stylistic judgements related to region and period of origin, unless cited from another authority. This was presumably deliberate in an area where, surprisingly, he did not feel confident of his own assessment or realise the sorts of help enquirers want. More understandably he eschewed venturing on watermark identification before the techniques had been more fully developed. And over his whole career he concentrated on manuscript books, not documents (significantly having declined F. M. Powicke's suggestion of succeeding Cheney as Reader in Diplomatic in 1945), though he did not hesitate to discuss their contents and forms if apposite, and to use telling evidence from the content of archives.

His correspondence grew as his publications and the range of his expertise became gradually known throughout the world, and his readiness to reply rapidly and helpfully. Indeed he frequently took the initiative: as Sir Richard Southern writes, 'he remembered what everyone was doing and sent abrupt little notes about any discoveries he had made that would help; I imagine he did this for scores of people'.[26] There was however nothing abrupt in the following-up and continuing relationships. One looked forward keenly to what one would learn from his letters and visits. Acknowledgments to him appear in innumerable prefaces, introductions and footnotes. More than one obituarist remembered his Sunday mornings devoted to letter-writing and remarked on his personal approachability by young students and foreign scholars. His usual informality of dress and manner went with the happy division of his time and attention between lecture room, libraries and study on the one hand, and family and outdoor activities on the other. On a visit of more than a night to a place with manuscripts he would try to fit in afternoon or evening walks as he did at home, and he travelled with very simple luggage, though often burdened with annotated copies of crucial books. As an undergraduate he had been President of the University Mountaineering Club and he continued to resort to Switzerland and Scotland (where there were family homes), eventually retiring to the latter, and by a sad aptness it was on a walk there with his

[24] Letter to T. J. Brown, 21 July 1973, Brown papers, Department of Palaeography, King's College, London.
[25] *MMBL*, I, xii–xiii; cf. M. R. James's lengthy lists.
[26] Letter to present writer, 8 January 1991.

wife, looking for bilberries, that he had his fatal fall, on 23 August 1982, in the midst of undiminished activity of mind and hand.

He had a remarkable capacity for switching from and back to unperturbed concentration on a task, to produce systematic and accurate, if at first sight untidy, notes, transcripts or typing. Although disinclined to some forms of sociability and academic life, he rarely betrayed it, was extremely unwilling to criticise other people, and took a due share of college responsibilities. He was Librarian of Magdalen, succeeding C. T. Onions, from 1956 to 1968, but already active in cataloguing its manuscripts and assisting enquirers, and he was Vice-President in 1962-3, playing his part in college business and entertaining guests at High Table then, as at other times, very conscientiously and kindlily. He was a Curator of the Bodleian Library from 1949, and a member of the Standing Committee from 1960 (meeting fortnightly), until 1968, a length of service reflecting the value of his interest and support, as a long and constant reader, college librarian and frequent benefactor. It was not only the Bodleian but also other libraries and archives outside Oxford to which he gave books and documents and offered timely sums towards purchases thought particularly suitable, and through Bodley he helped institutions lacking their own facilities to get manuscripts and bindings repaired. He also served in the 1960s and 1970s on the Sub-Committee on Manuscripts of SCONUL, which besides making representations on such questions as export controls and arranging training seminars and conferences, took on the sponsorship of *Medieval Manuscripts in British Libraries* and the catalogues of dated manuscripts in Britain for the Comité International de Paléographie, of which the other British members sat on the Sub-Committee, under the chairmanship of Richard Hunt. Ker himself became the first chairman of the British Academy's Corpus of British Medieval Library Catalogues when it was eventually established in 1979, forty-eight years after the first notion of it was voiced by Roger Mynors, though the first volume did not appear until after both their deaths, in 1990. He was a Vice-President of the Bibliographical Society from 1966 till his death but declined the Presidency when it was his turn because of his removal to Scotland and wish to concentrate on *MMBL*. It was a handsome gift of money from him in 1977 that helped to revive the union catalogue of printed books up to 1700 in the cathedral libraries of England and Wales begun by Miss M. S. G. Hands in 1944, of which the first volume was published in 1984 and the second may appear in 1993.

The distinction of his work was recognised by his election as Fellow of the British Academy, 1958, a Corresponding Fellow of the Mediaeval Academy of America, 1971, and of the Bavarian Academy in 1977, conferment of honorary doctorates at Reading, 1964, Leiden, 1972,

and Cambridge, 1975, the Israel Gollancz Memorial Prize of the British Academy, 1959, the Gold Medal of the Bibliographical Society, 1975, and the C.B.E., 1979. Friends and pupils presented him with a Festschrift in 1978[27] and after his death an appeal (to which besides friends and pupils his family contributed generously) has provided a permanent endowment for a Memorial Fund administered by the British Academy giving grants annually to assist research, travel and publication concerning medieval manuscripts, especially ones connected with the British Isles.

In 1938 he married his second cousin, Jean Frances, daughter of Brigadier Charles Bannatyne Findlay; she survives him, with a son and three daughters. Many British and foreign scholars enjoyed their hospitality in Oxford, at Kirtlington, in Edinburgh and Perthshire, and other kindnesses.

It is not easy to write a wholly fresh memoir after a lapse of nine years, since a number of admirable obituaries appeared then which cannot now be bettered in expressing the professional and personal characteristics of the subject, one of which may most appropriately be quoted: 'It is no exaggeration to say that in the field of medieval manuscripts he was the greatest scholar that Britain has ever produced. His output matched that of M. R. James in volume and far surpassed it in authoritative precision'.[28]

There can be few scholars who have done more enduring work and merited more gratitude.

A. I. DOYLE
Fellow of the British Academy

[27] *Medieval Scribes, Manuscripts and Libraries*, ed. M. B. Parkes & A. G. Watson (London, 1978): includes a list of his publications pp. 371–9; supplement in the selection of his essays, *Books, Collectors and Libraries: Studies in the Medieval Heritage*, ed. A. G. Watson (London, 1985), pp. xiii–xiv.

[28] [B. Barker-Benfield] *Bodleian Library Record*, vol. 11, no. 2, May 1983, pp. 64–5; in fairness it may be noted that though the list of M. R. James's publications on manuscripts is shorter than Ker's, he must have catalogued at least twice as many books, and he published more than as much again on other subjects. The other obituaries I have seen are: [G. R. C. Davis] *The Times*, 25 August 1982; T. J. Brown, Address at memorial service, 13 November 1982, edition of 300 copies, Glendale (California), May 1983, also (with errors) in *Magdalen College Record*, 1983, pp. 35–40; P. Robinson, *Mediaeval English Studies Newsletter* (Tokyo), no. 7, December 1982, pp. 1–2; [A. I. Doyle] *The Library*, 6th series, vol. 5, no. 1, March 1983, pp. 171–3; C. R. Cheney, *Archives*, vol. 16, no. 9, April 1983, pp. 86–7; R. J. Dean, P. J. Meyvaert, J. C. Pope, R. H. Rouse, *Speculum*, vol. 58, no. 3, July 1983, pp. 870–2; H. Gneuss, *Jahrbuch der Bayerischen Akademie der Wissenschaften*, 1983; T. Webber, *Dictionary of National Biography 1981–85* (Oxford, 1990), pp. 221–2. Besides friends mentioned here and in notes above my thanks are also owing to Dr G. L. Harriss and several others I have consulted.

GABRIEL TURVILLE-PETRE *Merlin Turville-Petre*

XXV

GABRIEL TURVILLE-PETRE

1908–1978

GABRIEL TURVILLE-PETRE was born on 25 March 1908.[1] He was educated at Ampleforth and Christ Church, Oxford. He was appointed to the newly founded Vigfússon Readership in Ancient Icelandic Literature and Antiquities at Oxford in 1941, but spent the war years in the Foreign Office and did not take up the post until 1946. He was given the title of Professor in the field of his readership in 1953, and elected Student of Christ Church in 1964. He retired in 1975. During the last ten years of his life cancer of lung and lower jaw enfeebled his body but not his mind; until it set both at rest on 17 February 1978.

Other appointments he held were those of Lektor in English at the University of Iceland, 1936-8 (for the latter part of that time he was British pro-consul in Reykjavík as well); Honorary Lecturer in Modern Icelandic, University of Leeds, 1935-50; Visiting Professor, University of Melbourne, 1965; Honorary Research Fellow, University College London, 1975-8. He was General Editor with Sigurður Nordal of the four volumes of saga texts and translations put out by Nelson in their series called Icelandic Texts (1959-65). A number of Icelandic and Scandinavian academies elected him to membership, and the University of Iceland made him dr phil. h.c. in 1961, and the University of Uppsala fil. dr h.c. in 1977. The President of Iceland appointed him Officer of the Order of the Falcon in 1956, Commander in 1963.

Turville-Petre was closely associated with the Viking Society for Northern Research, to whose Council he was first elected in 1936. In 1939 he became Joint Honorary Secretary and Joint Editor of the *Saga-Book*; he gave up the latter post in 1963 but held the former until his death. He published numerous papers, reviews, translations, and editions for the Society, and was also General Editor of its text and monograph series inaugurated in 1953. The Society made him one of its twelve Honorary Life

[1] In preparing this paper I have gratefully benefited from the good advice of Mrs J. E. Turville-Petre and Mr A. R. Taylor. It may be noted that a full bibliography of Turville-Petre's writings is expected to appear in *Saga-Book*, xx 2 (1979).

Members in 1956. In 1972 it presented him with *Nine Norse Studies*, a selection of papers by him written between 1940 and 1962. And in 1976 the Society instituted an annual Turville-Petre Prize for award in Oxford to a student distinguished in 'Northern Research'.

A *Festschrift* was in preparation for his seventieth birthday under the editorship of an international panel led by Mrs Ursula Dronke, his successor in the Vigfússon Readership. It is now (March 1979) in course of publication as a memorial volume by Odense University Press.

At Oxford Turville-Petre read English and was particularly interested in philological and medieval subjects, a natural extension of his boyhood discovery of Iceland and its early literature. His first visit to Iceland was made as an undergraduate, and between taking his degree in 1931 and his lectureship in Reykjavík, he pursued Icelandic and Norse studies on several more visits to the country. He also spent some time in Germany and Scandinavia, where he met the most accomplished and influential scholars in the Norse field and became the firm friend of many of them. In these years he laid the foundations of his sovereign understanding of both classical Icelandic and the modern language—the latter he commanded in speech and writing to the admiration of Icelanders and the envy of foreigners. Probably his most important teacher was Þórbergur Þórðarson (1888–1974), famous as an extraordinarily versatile writer, lively, humorous, and idiosyncratic; but Turville-Petre also spent long periods in the countryside, particularly on farms in the north and remote east of Iceland, learning all the time. By 1933 he had also begun the study of Irish, to which he later added Welsh; and his reading in the early literature in these languages was to give him a range of reference of decisive importance for his subsequent contributions to the study of Norse mythology and poetics. Perhaps it might be added that it is no drawback for a medievalist to be brought up in a traditional Catholic family and school. A familiarity with scripture, liturgy, saints' lives, a sympathy for great churchmen of the calm and liberal kind, and a certain horror of 'enthusiasm', can be detected in his writings. Such moulding would obviously fit him for the appreciation of many aspects of early western Christian culture and its assimilation in the converted countries of the North. In a peculiar way it may also have fitted him for the appreciation of many aspects of the character and experience of the Icelanders, among whom

some of the coolest and sharpest intelligences have, still at the present day, a serious, deep-rooted interest in the paranormal and supernatural, without any trace of *Schwärmerei* whatsoever.

There is no doubt that he was the ideal candidate for the Vigfússon Readership in 1941, and he had demonstrated his qualifications in a number of papers which had proved his clear-headed ability in manuscript and text comparison and his notable interest in pagan religion. These largely stemmed from his graduate work on an edition of *Víga-Glúms saga*, which was published in 1940 as the first of the Oxford English Monograph series. That edition set the highest standards for future contributions to saga studies in the world outside Iceland, with its emphatic intention to serve 'the student of literature and cultural history as well as of linguistics'. The range of book-learning in many languages, the perspicuity and honesty of the comment, the feel for the story and characters, and the personal familiarity with the topography—learnt from trudging the sites and riding the valleys and passes—gave it unusual distinction. It also brought to the notice of English academics more cogently than had been done hitherto the new approaches to Icelandic saga literature developed especially by Björn Magnússon Ólsen and his successor at the University of Iceland, Sigurður Nordal. In *Víga-Glúms saga* Turville-Petre detected a theme and motives that appear archaic—belief in fate, competition between cult of Freyr and cult of Óðinn—but these are partly obscured in the story we know. Turville-Petre regarded this as the work of an artist who had 'genuine historical sources', some written, some oral (and we have no means of determining the form of the latter). Using criteria of composition, language, style, and literary influence, members of the 'Icelandic school' assigned sagas to places in an organic system. They argued that saga-writing began about 1200 with a comparatively unsophisticated narrative like *Heiðarvíga saga*, flowered about 1250 with the consummate, deliberate artistry of *Laxdœla saga*, and declined slowly thereafter, with the best-known of sagas, *Njáls saga*, written about 1280, a masterpiece on the edge 'between ripeness and overripeness', as Nordal has put it. Following this method, Turville-Petre dates *Víga-Glúms saga* to *c.*1230–40—the original text of it, that is, for Turville-Petre was able to show, ingeniously and persuasively, that that oldest text had first been expanded by interpolation and then compressed by stylistic recasting and minor excision to give us the only complete medieval version we possess, in the codex *Möðruvallabók*, written about 1350.

These conclusions stand without serious challenge, though scholars have recently been doubting the aptness of the organic analogy in the progress of saga literature, not least because it ignores the artistic levels that may have been achieved in oral story-telling. There are evident problems in attempting to talk in comparative terms about the original work of an artist which we know only in a recension that was at least twice edited in the century or more between date of composition and date of codex.

The edition was thus a contribution of decided merit to international Norse scholarship and much more than a textbook of local interest. But in some respects it was of special significance for scholarship this side of the North Sea because of its discussion of recent Scandinavian research then not well known here (Koht's 'new' chronology of late ninth-century Norwegian events, for example) and because of some criticism of *Origines Islandicæ*, the monumental source-book put together by York Powell on the basis of Guðbrandur Vigfússon's materials but published long after the latter's death and a year after York Powell's own—a work that should be kept away from anyone unable to undertake an independent check of what it offers.

That it was high time that some ray of light pierced the complacent ignorance about Icelandic studies in which many British scholars were content to linger was shown to the full by an article which C. L. Wrenn, then Professor of English at King's College, London, published in *History* in 1941.[1] His main subject was the famous Cynewulf-Cyneheard passage *s.a.* 755 in the *Parker Chronicle* as illustrative of Old English 'saga', but he introduced it with some inept comment on the wartime political situation of the Icelanders with the end of the union with Denmark in sight and with some extraordinary misinformation about Icelandic literacy in the early middle ages, claiming that writing did not become common there until late in the thirteenth century. That this was at least 150 years wide of the mark was shown in a crushing rejoinder which Turville-Petre published in the same journal in 1942.[2] In a dozen pages of 'Notes on the intellectual history of the Icelanders' he presented the facts of the Icelanders' conversion in A.D. 1000, the comparatively rapid organization of the Icelandic Church, the pursuit of education abroad, the development of native schools and monasteries, the vast amount of translation and adaptation, from about 1100 onwards, of foreign ecclesiastic and other

[1] 'A Saga of the Anglo-Saxons', *History*, xxv (1941), 208–15.
[2] *History*, xxvii (1942), 111–23.

literature and learning, the independent contribution of twelfth-century Icelandic scholars in grammar and computus, in the preservation and practice of native poetry, and in vernacular and Latin history writing. All this intellectual activity preceded the writing of sagas, which belonged essentially to the thirteenth century, and it totally belied the analogy of a fixed oral tradition in a primitive pre-literate Germanic society which Wrenn had wished to draw. There could be no reply to this. In retrospect one may even feel grateful to Wrenn for provoking the publication of Turville-Petre's paper, for it gave students an admirably concise and expert guide to the background of medieval Icelandic literature of a kind nowhere else available.

But controversy was not Turville-Petre's way in general. It was in keeping that when he read work submitted to him he did not correct by re-writing or annotating at length: a question mark in the margin was his usual way of suggesting that fresh consideration or better learning was needed. He had little patience with people he counted charlatans (and he could be amusingly malicious about them); but to the genuine, thinking enthusiast, academic or amateur (as many members of the Viking Society would testify), he responded with the greatest tolerance and kindness. He was a good teacher, particularly successful as a supervisor of the graduate scholars who in the last twenty years of his tenure in Oxford came to him from all over the world. Pupils of his are now in university posts in nine or ten different countries. He ended a paper given in Sweden in 1969 by saying of Australia, 'I think the future of Icelandic studies in the English-speaking world lies there.'[1] He visited Australia three times in his last years, and found the eager alertness of his Melbourne classes particularly stimulating. If his prophecy proves true—and I hope it does not—it will be largely because of his influence.

In 1942 Turville-Petre also published with E. S. Olszewska (Mrs A. S. C. Ross) a translation of an early Icelandic life of Guðmundr Arason, bishop of Hólar (1203–37),[2] with a perceptive introduction on early Christianity in Iceland and the personal and political complexities that made Guðmund's episcopate so disastrous. It is clear that Turville-Petre found Guðmund's contemporary of Skálholt, the aristocratic, cultivated, and moderate Bishop Páll Jónsson, the more admirable

[1] *Proceedings of the Sixth Viking Congress, Uppsala ... Bonäs ... 1969*, edited by Peter Foote and Dag Strömbäck (1971), 114.

[2] *The Life of Gudmund the Good, Bishop of Holar* (Viking Society, 1942).

character and perhaps in essence the more genuine Icelander, a judgement reflected in his views in other fields of Icelandic study.

In 1944 he published an essay on Gísli Súrsson and his poetry,[1] a theme which gave him an opportunity to engage the diverse predilections already apparent in earlier work: scaldic poetry, its nature, quality and dating, dreams and dream symbols (a lifelong interest on which he was to publish some valuable papers), the mingling of pagan and Christian concepts, valkyries and fetches and angels, good and bad (other papers written about the same time confirm his wide reading in international folklore). When he reprinted his paper on *Gísla saga* in *Nine Norse Studies*, he added a note on work published on that text in the intervening thirty years, and then typically proceeded to solve a crux as much by applying his knowledge of ornithology (another lifelong enthusiasm) as his knowledge of philology. It had been universally assumed that a word *læmingr* in a verse in the saga had given rise to a misunderstanding in the prose story—the writer apparently took it to be a bird and this everybody agreed was impossible. Turville-Petre showed that there was no misunderstanding and that the author of the prose was right to describe a bird identifiable as the red-throated diver (*colymbus stellatus*) for which a word **læmingr* is appropriate and natural (cf. English *loom*, and perhaps *loon*, from ON *lómr*).

In 1951 Turville-Petre published *The Heroic Age of Scandinavia* in Hutchinson's University Library, a succinct and clear account of Scandinavia in the Migration Age and Viking Age, its legends and history. Naturally the archaeology available was all pre-war, and some chapters now need revision. What is of abiding interest is the author's considered opinion on the significance of medieval Icelandic literature as a source of information about much earlier times. His approach is sensible and supple, judiciously pragmatic, rather than the wholesale rejection fashionable among Scandinavian historians, though he fully understands that a composite picture created from an eclectic use of sources without reference to age, genre, and literary history is unacceptable. He especially stresses that poems and stories are not merely valuable for what they may record of the past but are themselves cultural witnesses of independent worth and influence. He has no difficulty in persuading the reader

[1] 'Gísli Súrsson and his Poetry', *Modern Language Review*, xxxix (1944), 374–91.

that the legends and cult of St Óláfr, for example, have had far more significance in the course of Norwegian history than the actual fifteen years of the king's reign. This survey of legendary history and the poetry associated with it helped him to provide authoritative comment on *Hervarar saga ok Heiðreks konungs*, one of the most peculiar and in parts most archaic of the so-called *fornaldarsögur*, which he published with Christopher Tolkien in 1956.[1]

With these works and with a couple of important papers on twelfth-century religious literature—on an early vernacular life of the Blessed Virgin (1947) and the Norwegian-Icelandic dedication homily (1949)[2]—he was now prepared to make his major contribution to our understanding of early Icelandic civilization in *Origins of Icelandic Literature*, published by the Clarendon Press in 1953 (second edition 1967). The book may be said to have been there *in nuce* in his response to Wrenn in 1942, but his varied special studies in the intervening ten years, not least a thorough reading of the great corpus of medieval Icelandic religious literature, much of it of twelfth-century origin, gave his work weight and wisdom on an altogether different scale. With good cause it has proved the most influential of all his writings.

In the first paragraph of *Origins* Turville-Petre says that the Icelanders in their 'poor, isolated island', the last permanent settlement of the Vikings, not only preserved ancient tradition but devised new literary forms—'and the literature of Iceland thus became the richest and most varied of medieval Europe'. It is this mystery with which his book is concerned. He reviews the settlement in the decades around 900, and is inclined to believe that Celtic elements in the population contributed certain 'intellectual and imaginative qualities' to the native breed. He describes the mythological and heroic poetry of the Eddaic kind, and rightly maintains that a knowledge of these poems is essential for an understanding of the medieval Icelandic mentality. In discussing scaldic poetry he finds that the kennings, which are especially distinctive, have an essentially 'pictorial' (perhaps 'imagistic' would be a better word) base,

[1] *Hervarar saga ok Heiðreks* with notes and glossary by G. Turville-Petre, introduction by Christopher Tolkien (Viking Society Text Series, ii, 1956, reprinted 1976).
[2] 'The Old Norse Homily on the Assumption and the *Maríu Saga*', *Mediaeval Studies*, ix (1947), 131–40; 'The Old Norse Homily on the Dedication', ibid., xi (1949), 206–18. Both papers are reprinted, the latter with a postscript, in *Nine Norse Studies* (1972).

but stresses that their allusive nature requires an audience trained in mythology and heroic legend to appreciate them. In discussing the complex metres of the scalds, he refers to the possibility of Irish influence on the development of *dróttkvætt*, the favourite form.

He goes on to discuss the conversion of the Icelanders to Christianity in the year 1000 (or more probably 999). He argues that, since the Icelanders were already an uprooted people who had only recently devised their own form of self-government and social organization, the new religion did not entail a great social or cultural revolution: chieftains under the pagan dispensation remained chieftains under the Christian dispensation. There was no brutal severance with the past and though the gradual spiritual alteration affected the Icelanders' attitude toward their ancestral paganism, it did not lead to radical, intolerant rejection of their early culture. In treating the progress of Christianity in the eleventh century, he stresses the importance of the English connection and of the longstanding tradition of vernacular literature among the Anglo-Saxons and Irish (concomitant North German influence is probably unduly neglected). He gives an account of the earliest known writers, Sæmundr Sigfússon (1056–1133) and Ari Þorgilsson (1067–1148), paying special attention to the latter's connection with the famous *Landnámabók*, Book of Settlements, on the ancestors and descendants of the first prominent settlers in Iceland and the land they took into ownership. We know this in extant or reconstructed thirteenth-century versions but Ari is reliably said to have played some part in recording such information. If matter in *Landnámabók* can be traced to a recording by Ari, it will carry impressive weight, for from his known work Ari appears as a scrupulous historian. But if matter in *Landnámabók* depends on what was in oral circulation in the thirteenth century, it can hardly be taken seriously as a historical source. For historians who were not abreast of recent years' discussion of these problems—much of it in Icelandic—this was and is a particularly useful and well-judged exposition.

In a chapter called 'The school of Hólar and early religious prose' he considers the division of Iceland into two dioceses at the outset of the twelfth century, and the work and monastic foundations of the northern bishops. He discusses with easy familiarity the homilies, saints' lives, apocryphal stories, and doctrinal lore that were translated and adapted, often in a far from slavish way, in this early period. His lifelong experience

could build new bridges between the Icelandic texts and the English and continental sources; and from his middle-ground vantage point he could make a reasoned assessment of the significance of the early religious writings for the whole development of the extraordinary literary art of medieval Iceland. He summed it up: 'In a word, the learned literature did not teach the Icelanders what to think or what to say, but it taught them how to say it' (p. 142). The truth of this axiom has now been generally accepted—though it remains an article of faith for proof of which wholly satisfactory tests have not yet been devised. In recent years some saga-scholars have displayed more enthusiasm for structural and formulaic studies and have resurrected the theory of oral 'saga-like' stories which they believe existed in a form sufficiently fixed in the pre-literate age to have decisive influence on the composition of the classical saga-literature. Like members of the Icelandic school in general Turville-Petre tended to discount oral story-telling—not because it did not exist and was a source for saga-writers, but because it is irrecoverable. (It is a rare lapse of Turville-Petre's customary rigour that he frequently prefixes the phrase 'oral tales' with the rather misleading adjective 'formless'—by which he means that he believes we cannot know what they were like but assumes they were shifting.)

Having discussed the remarkable poetry of the early Christian period, he turns to the historical literature of the late twelfth century—native Icelandic hagiography and ecclesiastical history, along with the earliest lives of the Christian kings of Norway, Óláfr Tryggvason, apostle of Norway and Iceland, and St Óláfr Haraldsson. He effectively, but perhaps too unreservedly, contrasts the literary manner that flourished in the northern diocese of Hólar with that of Skálholt in the south, passing with some relief from the 'breathless hagiography' of the Benedictine Gunnlaugr Leifsson in the one to the calmer church chronicles composed by cathedral clergy in the other. In his conclusion on the genesis of the so-called 'oldest saga of St Óláfr' he is able to draw the main strands of his book together in a neat and sturdy knot. The material came from poetry and many kinds of story—the scaldic verse and the anecdotes that went with it were part of the secular heritage and provided the work's basis in history; the king's preeminence as martyr, miracle-worker, and *rex perpetuus Norvegiae* depended chiefly on what was cultivated, remembered, and recorded among churchmen; folktale and wondertale elements

were variously of Norse origin or migratory, clerical or lay. The native traditions were cast, however, in a foreign form adapted from European biography and hagiography.[1] The result was a new and productive vernacular literary mode: under the influence of hagiography there developed the saga of the royal saint; that gave rise to the Kings' Sagas that preceded Snorri's classic works; and Kings' Sagas prompted the first composition of Sagas of Icelanders.

Turville-Petre added an 'epilogue' on the classical saga literature, more at the desire of the publisher than because he thought the book needed it. He reviewed the Kings' Sagas and related texts that were written before Snorri composed his *Óláfs saga helga* and *Heimskringla*. Attribution to Snorri of *Egils saga Skallagrímssonar* (which now seems generally accepted) led him to brief discussion of a dozen of the more important Sagas of Icelanders. He says many sound things, but criticism of individual sagas in literary terms was not a prime interest—he has left us little beyond his important comment on *Víga-Glúms saga* and *Gísla saga* and a short introduction he wrote for a reprint of Dasent's translation of *Njáls saga*. On the whole, he thought, like others of us, that it was for the alert student to discover literary qualities for himself. It is typical enough that in this last chapter of *Origins* he puts twenty lines of *Morkinskinna* against forty lines from *Heimskringla*, with only half a sentence of precedent comment.

Turville-Petre's most ambitious and substantial undertaking was his *Myth and Religion of the North*, published by Weidenfeld and Nicolson in 1964 in their History of Religion series. His papers on the cult of Freyr (1936) and on the cult of Óðinn in Iceland (1958), on Thurstable (1962), and on the *landdísir* (1963),[2] and a number of reviews, had all shown his deep interest in Norse paganism. These contributions, typically combining solid learning and imaginative insight, were all on special subjects. Now it was necessary to provide a compre-

[1] For an important textual difficulty see however Jonna Louis-Jensen in *Opuscula* IV (Bibliotheca Arnamagnæana, xxx, 1970), 59–60.

[2] 'The Cult of Freyr in the Evening of Paganism', *Proceedings of Leeds Philosophical and Literary Society*, iii (1935), 317–33; 'Um Óðinsdyrkan á Íslandi', *Studia Islandica*, xvii (1958), 5–25 (in English in *Nine Norse Studies*, 1972); 'Thurstable', *English and Medieval Studies presented to J. R. R. Tolkien*, edited by N. Davis and C. L. Wrenn (1962), 241–9 (reprinted in *Nine Norse Studies*, 1972); 'A Note on the *Landdísir*', *Early English and Norse Studies presented to Hugh Smith*, edited by A. Brown and P. Foote (1963), 196–201.

hensive survey of the sources and the major divinities, to sort out the significance of the scraps of information that tell of warring divine tribes, the gods' constant struggle with monstrous powers, and their final doom, and to discuss such diverse topics as ancestor worship and reincarnation, chthonic spirits, godless men, heroes and demi-gods, berserks, cult buildings, disposal of the dead, and more besides. As a handbook full of reliable information (though marred by all too many printing errors) about what the sources tell us—including judiciously appropriate reference to English, Celtic, Baltic, and continental Germanic material—and with much fruitful discussion and skilful synthesis, it is an authoritative work unrivalled by anything else in English. But dissension over the trustworthiness of some of his sources and over the validity of his source-criticism is likely to live for some time yet.

The position was that many earlier scholars had decided that the mythological stories told by Snorri Sturluson in his *Edda*, and on a smaller scale in *Ynglinga saga*, both written about 1220, were largely literary invention and that he knew little more about Norse paganism than we did. It was as a source of arguments against this judgement that Turville-Petre found the writings of Professor Georges Dumézil particularly interesting and stimulating. The great *comparatist* in the field of Indo-European religious studies had begun writing about Norse mythology in the thirties, and Turville-Petre had to come to grips with these and later contributions and with Dumézil's central theory of the 'tripartite' structure of Indo-European society reflected in the functions of the divine hierarchies recognized in worship. He published a sympathetic account of three of Dumézil's books in *Saga-Book*, xiv, 1–2 (1953–5), invited him to lecture in Oxford in 1956, and wrote an article on 'Professor Dumézil and the literature of Iceland' in *Hommages à Georges Dumézil* (1960). In these essays and in *Myth and Religion* he makes little of the 'tripartite' theory, though he reports it faithfully where he finds it appropriate. His detachment is in notable contrast to the wholehearted application of Dumézil's scheme by Jan de Vries in the second edition of his valuable *Altgermanische Religionsgeschichte* (1956–7). Turville-Petre's lack of commitment stemmed partly from modesty in the face of the Indo-European dimension, and partly from caution dictated by the fact that the theory, whatever its Indo-European validity, does not always helpfully fit or explain the state of Viking Age religion and society as we can observe it in our

best sources. Turville-Petre's own research itself tended to support the view that some important features of Norse religion were decidedly late and local in character. Óðinn may have been an archaic divinity, for example, but his cult appears to have been unknown or insignificant in Western Scandinavia until made prominent by aggressive warlords, typified by Haraldr hárfagri, in the ninth century.

Turville-Petre frankly acknowledges that his main debt of gratitude to Dumézil is because his learned and ingenious comparative studies demonstrate the credibility of Snorri's stories. For Dumézil had shown that in a number of cases where scholars could point to no original or analogue in the Norse or Germanic world and had decided to ignore what Snorri said, some parallel in classical or Hindu or other system of myth suggested that Snorri's account must be derived from an antique source authentically preserved. Turville-Petre is of course fully aware that Snorri had a Christian viewpoint, was a learned euhemerist and a not wholly reverent humorist; but making allowance for all this, he insists that Snorri's accounts must and can be taken seriously. He makes the ancient poetry the first foundation-stone of his study and Snorri the second. Besides these he beds a third also conventionally regarded as of dubious reliability. Turville-Petre points out that tales of the *fornaldarsaga* kind often contain matter attributable to pre-Christian legend and religion. We know such texts, and the poetry some of them contain, only in versions from the late thirteenth century and after. But it was on such stories that Saxo Grammaticus in Denmark, writing before and about 1200, based the early books of his great *Gesta Danorum*, largely, it is believed, on the authority of Icelandic informants. Turville-Petre consequently turns as readily to Saxo as to Snorri in his search for pieces to complete the puzzle: Saxo gives, for example, a remarkable account of Baldr and endows him with characteristics quite different from those he possesses in West Norse tradition, while for the story of Haddingus Saxo is virtually our sole source.

The methodological importance of these approaches has yet to be accepted and assimilated. As Turville-Petre is the first to point out, they represent not so much a novelty as a return to the attitudes of nineteenth-century philologists and historians of religion. They certainly make Norse sources more fun to deal with, but few scholars combine the precise understanding of the Icelandic sources with the sane but imaginatively sympathetic breadth of vision of Turville-Petre, and without the

two it is not easy to give full and serious consideration to the sum and scheme of his interpretations. What we need perhaps is a series of slimmer volumes each devoted to one of the many topics he tackled with such boldness and insight. The studies that are required are unfortunately not much in vogue at present, when younger scholars seem chiefly concerned with manuscript minutiae or are happily blinkered by methods of source-criticism that are valid for documentary history but less appropriate for study of a transitional period between non-literate and literate cultural stages.

In virtually all his work Turville-Petre had been engaged with scaldic poetry, the verse which in many ways is the most characteristic and challenging product of early Norse culture, analysing the verse of individual poets in his studies of *Víga-Glúms saga* and *Gísla saga*, examining its distinctive nature and early history in *Origins*, and assessing its value as a source of mythological and historical information, not least in *Myth and Religion*. In *Origins* he referred to the possibility of Celtic influence on the genesis of the chief scaldic metre, *dróttkvætt*, and in 1954 he published an important paper in Icelandic on the subject[1] (in English in *Ériu*, xxii, 1971, reprinted in *Nine Norse Studies*, 1972). Here he skilfully examined the evidence and found striking similarities between the Norse and Celtic forms, although final proof of connection was not forthcoming. In the last years of his life he turned more and more to this fascinating field, and it was a great stimulus to him to discover that students in Oxford and perhaps even more in Melbourne enjoyed wrestling with the intricacies of scaldic verse and did not find the apparent a-naturalism of diction and syntax a stumbling-block to its appreciation as poetry. He remarks that 'the names of two British poets, whom students admired, came up repeatedly in comparison. These poets were Dylan Thomas and, much more frequently, Gerard Manley Hopkins.'[2] In several essays he reflected on the rewards of the study of scaldic poetry, on the reality of its aesthetic appeal, and on the relationship between verses and the prose narratives in which they are preserved. In the Dorothea Coke Memorial Lecture which he gave in University College London in 1966[3] he presented

[1] 'Um dróttkvæði og írskan kveðskap', *Skírnir*, cxxviii (1954), 31–55.

[2] *Proceedings of the Sixth Viking Congress, Uppsala . . . Bonäs . . . 1969*, edited by Peter Foote and Dag Strömbäck (1971), 109.

[3] *Haraldr the Hard-ruler and his Poets* (The Dorothea Coke Memorial Lecture in Northern Studies . . . 1966; 1968).

remarkable portraits of King Haraldr harðráði, who seems to have been as famous among the Icelanders as a critic and practitioner of scaldic poetry as he was among the Norwegians as a warlike adventurer of harsh breed, and the chief Icelandic poets of his retinue, who like others of their kin before and after them acted as the memorialists of Norway's pre-literate history. In another paper discussing what the poets tell of St Óláf's exploits in England, Turville-Petre shrewdly observes that, while the scalds throw 'little if any' light on the history of England, 'the history of England does throw some light on the poetry of the scalds',[1] and the corroboration offered encourages us to have faith in its transmission.

It was natural that Turville-Petre should think of making a textbook and anthology of scaldic verse; and it was a cause of much thankfulness to those of us concerned with Norse studies in the English-speaking world that he succeeded in doing so. His *Scaldic Poetry* was published by the Clarendon Press in 1976. In an 80-page introduction he selects precisely the right subjects to dwell on and writes with an easy mastery. He now comes down more firmly than before in favour of the idea that Celtic verse-forms must have exercised a vital influence on the genesis of *dróttkvætt*—at least he sees no plausible explanation of the syllable-counting of the scalds and their rule of fixed cadence save in the comparable features of Irish metres. If the introduction reflects his superior understanding, born of long experience and cultivation, the 100-page anthology may be said with equal justice to reflect his superior taste. He devotes a quarter of it to the poetry attributed to Egill Skallagrímsson and includes a new edition of the whole of his *Sonatorrek*, a great poem and a great monument which, despite textual obscurities, is not intrinsically difficult. He otherwise provides an excellent choice of verse from twenty-two poets, well calculated to intrigue the student without baffling him—Turville-Petre does not shrink from introducing stanzas with textual and interpretative difficulties, but their educative value is obvious. He provides a close English translation of each verse and a commentary, but commendably refrains from re-writing the words of the original in a prose order, as is commonly done even in Icelandic editions. He prefaces his selections with biographical sketches, where he naturally draws on saga-texts, assuming—perhaps rashly—that the reader is aware of the problems and uncertainties of such

[1] *Bibliography of Old Norse–Icelandic Studies, 1969*, edited by Hans Bekker-Nielsen (1970), 12.

story-telling. His verdicts on the poets as poets are memorable, deeply considered and by no means conventional.

It was probably a matter of taste and confirmed predilection that the anthology only covered the classical period from the beginnings of scaldic verse to the time of Haraldr harðráði, that is, only the first two of the art's five centuries of history. From Harald's time onwards scaldic verse chiefly developed in Icelandic isolation, and Turville-Petre did not much care for the post-classical, despite his enjoyment of the elaborate diction of some poets of the 'scaldic renaissance' in the twelfth century, Einarr Skúlason and Gamli kanóki in particular. He cared much less for the *rímur*, the branch of Icelandic poetry which in diction was the chief inheritor of the scaldic tradition and which flourished from the fourteenth century to the end of the nineteenth—not because of subject-matter, where he could stand a good deal of vulgarity, but because he found the rhythms trivial and the kennings hollow. He did not take much pleasure in the overwrought sentiment and underwrought form of ballads either. His standards were formed and maintained by poets like tenth-century Egill, craggy and passionate, loyal and tender, a great hater of a Norwegian king, and eleventh-century Þjóðólfr, brave and querulous, proud and touchy, a devoted follower of a Norwegian king—but both as poets dedicated to their art, uncorrupt and dignified in their craft.

All of Turville-Petre's books are major contributions to the world's general knowledge of Norse culture and classical Icelandic literature. They and his other writings also contain independent observations and theories of a kind that will always draw specialist scholars back to them, to weigh and check, reject, modify, confirm—chiefly, I believe, to confirm.

<div style="text-align: right;">PETER FOOTE</div>

KENNETH JACKSON *Walter Bird*

XXVI
Kenneth Hurlstone Jackson
1909-1991

PROFESSOR KENNETH HURLSTONE JACKSON, Hon. Fellow of St John's College, Cambridge, died on 20 February 1991. He had held the Chair of Celtic Languages, Literatures, History and Antiquities at the University of Edinburgh from 1950 until his retirement in 1979, and could have claimed to be a world authority on most of the varied subjects that the Chair, the most ambitiously named in the British Isles, called upon him to profess. It is certain that no previous holder of the Chair, distinguished as several of them were, could have made such a claim, and it is doubtful whether any future holder will make any pretence to it. Indeed, with the increasing extension and proliferation of the branches subsumed under the name 'Celtic Studies', it may very well be impossible in the future for any one to claim distinction in as many branches as Professor Jackson could. His achievements inspired unqualified admiration among colleagues of his own age and reverential awe in those who aspire to succeed them.

He was born on 1 November 1909 at Melville, Lavender Vale, Beddington, Surrey, the son of Alan Stuart Jackson and Lucy Jane Hurlstone. Alan Stuart Jackson came from a south London family, many of whose members had been in the past clergymen and latterly civil servants: he himself had gone into 'the City' on leaving school and became the head of a very conservative stockbroking firm. The Hurlstones are represented in the DNB by two artists, Richard Hurlstone (*fl.* 1768-80) who was great uncle to the other, Frederick Yeates Hurlstone (1800-69). F.Y. Hurlstone was elected President of the Society of British Artists in 1835 and again in 1840, retaining the office until his death. He married a fellow artist, Miss Jane Coral, by whom he had two sons, one of whom was also an artist. Lucy Jane Hurlstone, Professor Jackson's mother, had a brother, William Yeates Hurlstone, a composer of promise who died aged 30 from the effects

© The British Academy 1993.

of bronchitic asthma just after being appointed Professor of Harmony and Counterpoint at the Royal College of Music in London.

Professor Jackson inherited an interest in art: his sister who was older, was trained at the London College of Art, but he did not develop that interest. He also inherited or developed during his childhood a propensity for asthma and this meant that he was unable to attend the local primary school (Hill Crest, Wallington)—the family had moved by that time to Trelawn, 1 Sandy Lane South, Wallington—regularly during the winter and had frequent spells in bed. This meant that he received much of his early education from his mother who passed on to him her family's interest in music, art and literature. Naturally he was encouraged to read and he read extensively. His reading prompted him to write and apparently he compiled an illustrated 'book' on heraldry. He was also urged to go out in fine weather and to explore on foot and by bicycle the surrounding countryside and this he did to good effect with a small Brownie camera—apparently some exercise books have survived in which snapshots of local landmarks have been pasted with careful annotations in fading ink. Exploring the surrounding country remained one of his interests throughout his later life. As his friends can testify, he explored the Cambridge, the Bangor and the Dublin countryside as he was later to explore the Harvard, the Bermuda and the Edinburgh countryside. In *Who's Who* he gives his recreation as 'walking'. He continued to cycle well into his Edinburgh years. It is on record that he 'coxed' for one of the rowing boats at Cambridge during Lent Term 1930. In his younger days he also played some tennis. But 'walking' was his passion and preferably walking, or if that was too much, travelling to an archaeological site. It is not surprising that his son Alastar is a historian.

Jackson attended, albeit irregularly, Hillcrest School, Wallington, from May 1916 to December 1919. He then attended the County School, Surrey, from January 1920 to July 1920. He does not seem to have been happy there and he was transferred in September to Whitgift Grammar School, Croydon, where he remained until July 1928. As the name implies, Whitgift Grammar School had been founded in 1596 by Archbishop Whitgift and true to the tradition of the best grammar schools it gave Jackson a thorough grounding in the Classics. He must have been an excellent pupil for in June 1928 he was elected a scholar of St John's College, Cambridge, where he had a most distinguished career. He was placed in the First Class not only in the Classical Tripos, Part 1 (1930), but also, and with special merit, in the Classical Tripos, Part II (1931) when he graduated BA and was named 'Senior Classic'. In the meantime he had won the Sir William Brown Medals for Greek Ode and Latin Epigram in 1930 and for the Greek Ode in 1931.

In view of his achievements in Greek and Latin verse we are not surprised to find him writing poetry in his native language. A few of his poems were published in *The Eagle*, but he probably wrote more. We venture to say this because the best, 'Two Partings', is a kind of love-poem addressed, we assume, to the young lady whom he had met through mutual friends in Cambridge and whom he was to marry in 1936, Janet Dall Galloway of Hillside, Kinross, Scotland. Another poem, 'Mount Caburn', reflects the author's interest in prehistory. Two prose articles are of special note. 'A Forgotten Painter' is on the Belgian artist, Antoine Joseph Wiertz, and is written with the authority of one who has studied painting and can compare the work of one artist with that of another. 'The Cambridge Cottage' which includes an illustration, testifies to the fact that its author, true to the habit formed in childhood, had explored Cambridgeshire. There are also translations which reflect the author's wide-range of interests, e.g., 'Coming Night. From the Rig-Veda'. Of particular interest to us are the 'Irish Translations', 'The Drowning of Coning Mac Aedan' (*c.*720 AD), and 'Autumn Song' (*c.*850 AD) in *The Eagle*, June, 1931.

In his Classical Tripos, Part II, Jackson specialized in Comparative Philology and we would have expected him to proceed with Classical Studies and Comparative Philology. Instead of that he switched over to Celtic Studies. When asked the reason he would answer that he thought at the time that the Classics were overworked: the implications of the discovery of Hittite, etc., had not been realized, although it is interesting to note that Pedersen turned his back on Celtic to devote attention to Hittite, Tocharian, etc. Jackson never attended the lectures of A.E. Housman. The textual work done by the latter, brilliant though it was, held no attractions for him. More congenial was the work done by his tutor M.P. Charlesworth, not so much on the history of the Roman Empire as on the history of Roman Britain. One can readily believe that he eagerly joined and enjoyed immensely the visits to Roman sites organised by Charlesworth.

There must have been other reasons for the switch to Celtic Studies. On one occasion he remarked on his discovery that Old Irish *sechitir* corresponded exactly to the Latin *sequuntur*, thereby illuminating for him at one stroke the Indo-European character of Old Irish. On the same occasion he said that he must have been about nine years old when he read Alfred Nutt's *Cuchullain. The Irish Achilles* (1900) and Eleanor Hull's two books, *The Cuchulinn Saga in Irish Literature* (1899) and *Cuchullain. The Hound of Ulster* (1909), to find them all enthralling, 'marvellous stuff'.

The importance and the influence of H.M. Chadwick at Cambridge

during Jackson's years as a graduand no doubt had more than a little to do with the switch from Classical Studies to the Archaeological and Anthropological Tripos, Section B, to study Anglo-Saxon, Norse and Celtic. It will be recalled that Chadwick had succeeded W.W. Skeat in the Elrington and Bosworth Chair of Anglo-Saxon in 1912 and that he was fond of reminding his students of the founder's wish that the subject should not be Anglo-Saxon only but 'the languages cognate therewith together with the antiquities and history of the Anglo-Saxons'. In pursuit of this ideal, Chadwick had transferred English studies from the school of modern languages, and at the same time had reshaped the study of the origins and the background of English literature so as to make philological scholarship serve the knowledge of history and civilization. In 1927 he had transferred his department to the new Faculty of Archaeology and Anthropology where his group of studies, like the Classics, could constitute an independent discipline. Eventually it came, in Jackson's words, to be 'an investigation of the total range of history and literatures of the British Isles in the period between the Roman and Norman Conquests.'

All this was very much to Jackson's taste as a scholar. Naturally, he went for the languages, but one paper in Archaeology was compulsory, and he attended the lectures on anthropology as well. Some will recall that a few of Jackson's earliest papers were published in the anthropological journal *Man*.

Jackson has written of the course:

> the Chadwicks' pupils all testify to the intellectual excitement of this course. After the then comparatively narrow range of the Classical Tripos, in which, having specialized in comparative philology, not in 'Literature', I came away wholly ignorant of, for example, Classical manuscripts and palaeography, Section B was a most thrilling and liberating experience. Four new languages and literatures, together with the history and the archaeology of their speakers. As for the rest, the pre-Roman and Roman archaeology of Britain has remained, I am sure, with all 'Chadwickians' as an abiding life long interest.

He proceeds:

> I well remember, forty years since, the excitement of cycling the dark and windy miles down the Newmarket Road to the Paper Mills, penetrating the inner fortress, crossing the bridge, negotiating the 'savage' dogs and listening entranced for an hour while 'Chadders' gave his evening lectures on Early Britain and 'Mrs Chadders' sat at the epidiascope projecting pictures of Bronze Age leaf swords . . . The same excitement extended to the reading of works like the *Growth of Literature*, the excitement of finding likenesses and connections between subjects where none had been thought of before.

Needless to say, Jackson was placed in the First Class, with special

distinction, in the Archaeological and Anthropological Tripos, Section B, and was awarded the Allen Research Student Scholarship for 1933 and 1934.

Notwithstanding his enthusiasm for the course Jackson must have been aware from the beginning of its weakness for he seems to have taken steps to compensate for it. The weakness was in the teaching of the languages involved. Chadwick had apparently taught himself German as a schoolboy on the eight mile journey to school at Wakefield and back every day and he expected his pupils to teach themselves the four languages required for the course. When Jackson went to him for a reading list he was told that he would probably find Welsh easier than Irish and he rather dumbfounded him when he returned to say that he found Irish easier than Welsh, not surprisingly, if the experience of others is taken into account. Apparently some help was given by the Department in Old Irish. Mrs Chadwick prepared *An Early Irish Reader* (C.U.P., 1927), an edition and translation, with introduction, notes and glossary, of the Old Irish 'Story of Mac Dathó's Pig'. It was savagely reviewed by Professor Osborn Bergin, but, as he himself informs us, Jackson 'must have been one of the earlier students in the famous Chadwickian "Section B" . . . who cut his first Celtic teeth on this edition.'

However, he was not to be handicapped by the deficiencies of the Department. He has described how he read Wade-Evans, *Welsh Medieval Law*, with the help of a Modern Welsh-English Dictionary (?Spurrells) where the obsolete words were marked with a dagger. If he had not been convinced before, the experience must have convinced him that he had to go to places where Welsh and Irish were spoken languages. He spent a month in Ireland and a month in Wales in the Summer of 1932. Pontargothi in the old Carmarthenshire was the place where he spent the month in Wales, and it was there that he collected the 'Coracle Fishing Terms' which he published in the *Bulletin of the Board of Celtic Studies*, vol. VI, part iv (May, 1933). He had spent the previous month in the Great Blasket. Although the first two stories he published ('*Dhá Scéal ón mBlascaod*') in *Béaloideas*, IV, iii (1933) were taken down from the lips of Peig Sayers in June 1933, he had started recording her tales the previous year, as his note appended to *Scéala on mBlascaod*, published in *Béaloideas*, VIII, explains:

> The foregoing stories and poems were collected between the years 1932 and 1937 on the Great Blasket Island, Kerry. With the exception of nos 18, 20, and 35, they are all from Peig Sayers, the Blasket *seanchaidhe* who has become famous recently through her autobiography *Peig* . . . It was originally planned by Dr. Flower and myself to publish the present material jointly with his own famous collection of her stories recorded on

the ediphone, as the complete *Tales of Peig Sayers*; but as pressure of other work is likely to prevent Dr Flower's part in this being ready for some time to come, it has been decided to bring out my stories separately.

Jackson acknowledged his debt to Robin Flower in the interview he gave to Patrick Sims-Williams and some of the latter's students: Flower, he said, had made it much easier for him to learn Irish. Flower lived at Croydon where Jackson was then living and they may have come to know each other as neighbours or through M. P. Charlesworth or through the British Museum where Flower was deputy keeper of MSS as well as being honorary Lecturer in Irish at the University College of London. Flower's connection with the Great Blasket is too well-known to be more than mentioned here and we can take it for granted that it was he who introduced Jackson to the Great Blasket Island and its people. In the interview already referred to, Jackson described how he and Flower went once to the island together but in separate coracles, dipping and rising with the strong Atlantic waves, Flower sitting up with the inevitable cigarette dangling from his mouth, himself crouching back and held tightly by the powerful arms of the island's schoolmistress, so tightly indeed that he woke up next morning with aching ribs. However, he seems to have coped well with the primitive conditions on the island and to have established excellent rapport with Peig Sayers, then quite old. There is a charming photograph of the old Gaeltacht lady and the young Cambridge graduate in Bo Almqvist, *Viking Ale* (1991).

Flower must have had a far greater command of the Irish language at that time than Jackson, but it is both significant and revealing that whereas the former recorded Peig's stories on an ediphone, the latter took them down orally in a modification of the International Phonetic Script, and indeed recommended the use of phonetic script not only as a means of recording tales but also as a means of learning the language. He used to take down the 'chatter' of the Blasket women whom he found much more talkative and articulate than the men, and then checked what he had written by reading it back to them. This must have been most effective, for, as he admits, it gave the impression that he knew more Irish than he did. The tales he took down from Peig he afterwards published in a simplified Irish orthography based on the traditional spelling but adapted to the dialect. He must have had complete confidence in this method for he took down and published in much the same way Gaelic stories later in Nova Scotia and later still in Harris, Scotland. The results justified the method, but Jackson must have had a very good ear and very good training if not an innate aptitude for this effective use of the International Phonetic Script.

The *Scéalta ón mBlascaod* included Romantic Tales and Adventures, Anecdotes, Moral Tales, Saints and Miracles, and tales of the Supernatural, and it is worth emphasizing that Jackson never lost interest in folktales and

folklore. He lectured on them while he was at Harvard and also published on them, his most substantial contribution being perhaps *The International Popular Tale and Early Welsh Tradition* (1961).

To resume our account of Jackson's academic career. He spent his first year as Allen Research Student in Bangor at the University College of North Wales attending the lectures of Professor Ifor Williams on early Welsh poetry and those of his assistant Thomas Parry on the Mabinogion and Dafydd ap Gwilym. It was an exciting time to be at Bangor University College. Ifor Williams was preparing his edition of *Canu Llywarch Hen* (1935). Jackson was quick to see its importance and rendered English scholars a service by writing an article on it, 'The Poems of Llywarch the Aged', in *Antiquity* IX (1935). He was to render a similar service when he wrote on Ifor Williams' *Canu Aneirin* in 'The Gododdin of Aneirin' in *Antiquity* XIII (1939). But in addition to attending lectures Jackson was pursuing research with Ifor Williams' assistance on a subject suggested to him by H. M. and N. K. Chadwick, Celtic Nature Poetry, and succeeded in publishing the results of his research work at Bangor and Dublin in the two volumes which appeared in 1935, *Early Welsh Gnomic Poems* and *Studies in Early Celtic Nature Poetry*.

It was rumoured that Jackson went first to Bangor rather than to Dublin because of the savage review by Bergin on N. K. Chadwick's *An Early Irish Reader*. However, as a classics scholar, he must have been welcomed by Bergin with open arms, for, as I well remember, Bergin used to preface his course on Old Irish with the remark that to study the subject successfully one should have at least a sound knowledge of Greek and Latin and ideally some Sanskrit as well. And I should not be at all surprised that Jackson for this reason got from Bergin, if not more, at least as much as any of his other students, for in the introduction to his edition of *Cath Maige Léna*, he acknowledges his debt: 'I wish to record here my best thanks to Professor Osborn Bergin who read the whole book partly in MS and partly in proof, for his generosity in giving me the benefit of his great learning and for his invaluable help in correcting the many errors which were made'.

As one who, like Jackson, studied at the feet of Ifor Williams and Bergin, I should like to endorse Jackson's judgment that they were both great scholars and to add that had they lived to see Jackson's achievements they would have derived great satisfaction from them.

After the second year as Allen Research Student in Dublin Jackson returned to Cambridge where he was elected Fellow of St John's College and appointed first assistant, and then full Lecturer in Celtic in the Faculty of Archaeology and Anthropology.

In December 1938 he was appointed Lecturer in Celtic in the University of Glasgow but for some reason did not take up the appointment. The

following year, however, he was made Lecturer in Celtic at Harvard where he was soon promoted to be Associate Professor 1940–8 and finally Professor (1949–50).

He seems to have been almost as much at home in Cambridge, Mass., as in Cambridge, England. He found the students there tremendously enthusiastic and intellectually curious although not very well prepared by their previous education. His best attended course was that on the International Folk Tale. In the more linguistic courses students found his demands rather exacting and the majority withdrew after the first few classes. Eric P. Hamp, perhaps his best known student, although not among the earliest, found it impossible to read all the texts prescribed by him, especially in conjunction with all those prescribed by Joshua Whatmough, and when he telephoned Jackson to say so, the only reply was a laconic 'Oh! that is very unfortunate!' On the other hand, the company of some of the staff was most congenial. F. N. Robinson, the well-known editor of Chaucer's work and the not less well-known author of 'Satirists and Enchanters in early Irish Literature', used to hold 'Celtic Conferences' regularly.

World War II supervened and Jackson was sent to do war service in the British Imperial Censorship, Bermuda, in the 'Uncommon Languages' section (1942–4) and in the U.S. Censorship (1944). His knowledge of the Celtic languages was not greatly exercised: only one letter in Welsh appeared, and that written by a Patagonian, but his knowledge of the Romance Languages was extended to include Rumanian, and he was asked to learn Yiddish, only to find that there were already four persons in the section who knew the language. (Oliver Padel has written that Jackson qualified as a censor in 23 languages, and once said that he had learnt Japanese in three weeks.) True to the habit formed in childhood, Jackson explored the countryside thoroughly, but he must have been glad to return fully to the academic work he had managed to continue in his spare time.

His appointment to a full professorship at Harvard in 1949 was soon (1950) followed by appointment to the Chair of Celtic in Edinburgh. In those days, as in these, it was unusual for a scholar to relinquish a Chair at Harvard for another, and Jackson's decision to leave excited some curiosity among the local journalists, but he guarded his privacy with his usual tenacity, as we can gather from the comment by one Frank Oliver, the *Daily Record* Correspondent in Washington: 'Since coming to America, [Professor Jackson] has wrapped himself completely in his work at Harvard and has consistently shunned all publicity.'

Jackson had taken an interest in Scottish Gaelic before his appointment to the Edinburgh Chair. He had published notes on the Gaelic of Port

Hood, Nova Scotia, and tales from Port Hood, in *Scottish Gaelic Studies*, but the appointment meant that he had to take a far deeper interest.

Naturally he introduced changes in the Department. His successor in the Chair, William Gillies tells us that in the early 1950s,

> There was little demand for the teaching of Gaelic to learners at University level. Gradually that pattern was to change, and from the late 1960's demand was such that Kenneth and Willie Matheson . . . took two steps which transformed the numbers and the consistency of the student body when they introduced 'Celtic, Type II', one of the first intensive beginners' courses in a modern language at Edinburgh; and, for postgraduates, the M.Litt. in Celtic Studies, which was shrewdly designed to give access to Celtic to the increasing numbers of home and overseas students who had solid grounding in some allied subject but had not been able to take Celtic as their primary degree. This transformation brought Kenneth great satisfaction, despite the greatly increased workload—a satisfaction, which he retained until his last days as he followed the successful careers of his ex-students, many of whom also became fast friends.

If as an outsider I may add a gloss on Professor Gillies' remarks, it was characteristic of Jackson that he shouldered the extra-workload for the most part himself. I cannot believe that there were many departments in the University of Edinburgh that, like the Celtic Department, did not take advantage of the extra money available during the 60s to increase the number of staff appreciably.

Naturally Jackson took part in the activities of those societies which dealt with the wider aspects of Celtic, e.g. the International Congress of Celtic Studies of which he was President from 1975 to 1984, the English Place-Name Society of which he was Vice-President from 1973 to 1979 and Honorary President from 1980 to 1985, and the Council for Name Studies in Great Britain and Ireland. His enthusiasm for the study of place-names was intense; until recently the volumes of the English Place-Name Society were offered to him for comment before publication and the Celtic material in such volumes as those on Cheshire place-names benefited greatly from his detailed criticism.

As a life-long student of Roman and Pre-Roman Britain Jackson was naturally appointed one of H. M. Commissioners for Ancient Monuments for Scotland and served from 1963 to 1985.

More immediately connected with his Chair was his work for the Linguistic Survey of Scotland. This was initiated under the late Professor Myles Dillon during the session 1949–50 when he was at the University of Edinburgh. Jackson took over in 1950 and began collecting material, with the help of a questionnaire to elicit phonological and morphological data. By 1959 all areas other than the Outer Hebrides had been covered and

by 1963, 192 points had been researched. In 1960 Magne Oftedal (Oslo) was appointed co-editor of publications, and Jackson undertook to write a history of the dialects. Oftedal who resigned in 1969 was succeeded by Máirtín Ó Murchú who resigned in 1970 to be succeeded in turn by D. Clement. Jackson did not give up his work on the Survey until his retirement from the Edinburgh Chair, and, as was said at the time, after making a greater contribution than any one until then to the Survey. His Sir John Rhŷs Memorial Lecture, *Common Gaelic: the Evolution of the Gaelic Languages* (1951), may be said to have cleared the way for the Survey and his *Contributions to the Study of Manx Phonology* (1955), no.2 in the Monograph Series of the Linguistic Survey of Scotland, was an indirect contribution. His paper on 'The Pictish Language' in F. T. Wainwright, ed., *The Problem of the Picts*, can also be reckoned as a contribution to our knowledge of the linguistic history of Scotland.

But it is an indication of the extent of Jackson's contributions to scholarship that he, followed by us, regarded all these publications as *parerga*. His first *magnum opus*, *Language and History in Early Britain*, appeared in 1953. He had planned it as early as 1944 as a work which would describe the development of Brittonic Celtic into the later languages, Cumbrian, Welsh, Cornish and Breton, and would ascribe dates to the various stages in the development, and which would, by correlating these changes with the changes in Anglo-Saxon and Irish, give an overall picture of the language and history of early Britain. The linguistic changes in Brittonic Celtic which had produced Welsh, Cornish and Breton were broadly known thanks to Pedersen's monumental *Vergleichende Grammatik der keltischen Sprachen* but these changes had to be more minutely identified, analysed, and described in their various stages in the light of more recent knowledge, and, above all, they had to be dated with the help of facts which were not easily accessible even after the most thorough research. With characteristic perspicacity, Jackson had seen the relevance of Mac Neill's articles on the Latin loanwords in Irish and had become aware of the crucial importance of the evidence of place-names. It must have come as a considerable shock to him to find that another scholar had been working on that evidence and had already published an epoch-making volume. That scholar was Max Förster and his volume was *Die Flussname Themse und seine Sippe. Studien zur Anglisieriung keltische-Eigennamen und zur Lautchronologie des Altbritischen*, 1942. Unfortunately, owing to wartime circumstances it was not until 1947 that Jackson was able to obtain a copy. By that time his own researches were far advanced and his preliminary conclusion already formulated. He realised that in some matters Förster had anticipated his own results, in others they differed fundamentally in their conclusions, while yet in others he had answered questions which Forster had ignored.

Jackson called Förster's work 'monumental' and it is a shame that it has not received the attention that it deserves, but on the other hand it must be said that Jackson took a wider field to research than Förster and carried his research much further. One has to agree with every word of D. A. Binchy's tribute to the volume:

> *Language and History in Early Britain* is one of the most important contributions to Celtic scholarship that have appeared in our time. Its main purpose is to trace the historical phonology of the British dialects of Celtic from Roman times down to the twelfth century. A formidable task, indeed, owing to the scanty and scattered nature of the evidence, but one to which Professor Jackson brings unique qualifications. Almost every page illustrates his wide and accurate knowledge not only of all the Celtic languages but of Vulgar Latin and Anglo-Sazon, a combination which no other scholar has hitherto possessed. When one finds allied to all this a profound historical sense and a highly developed critical faculty, it is safe to conclude that the book supersedes all previous contributions to the subject and will long remain the standard work of reference.

Although several *parerga* were to appear before Jackson's second *magnum opus*, *A Historical Phonology of Breton* (1967),—in addition to those already named one should mention *The Oldest Irish Tradition. A Window on the Iron Age* (1964)—it must have been started immediately after the first had been completed. In a way it was an offshoot of the first, the second volume, as it were, based on the foundations laid in the first, but the more one studies it, the more one realizes that it was much more difficult to write, and although the author does not make much of the difficulties, he touches upon them. Primitive Breton is virtually unrecorded. For the earlier period of Middle Breton, down to the middle of the 15th century, our information consists almost solely of names in cartularies and such documents. There is controversy as to when Middle Breton became Modern Breton. And the most important source for our knowledge of the Breton dialects, Le Roux's great *Atlas linguistique de la Basse Bretagne* in six parts, 1924, 1927, 1937, 1943, 1953, 1963, excellent though it is for the study of present day dialects, should be used sparingly and with the greatest caution as a basis for speculation about their history in the past. However, in spite of these and other difficulties, Jackson succeeded in achieving what he set out to do, in producing,

> a consistent and methodical framework in which all the chief historical problems are raised and discussed; and within the scope of which it may be possible for future research to lead to criticisms, additions, substractions, adaptations, removals of error, and other improvements in the course of time, until by the collaboration of many scholars a fairly definitive and generally agreed picture is finally agreed. Nothing like an overall treatment

of Breton phonology throughout its history has been tempted before, and it seems evident that such a work is needed and that the time is now ripe for a first essay in this direction.

Jackson had two other *magna opera* in mind, a 'Historical Grammar of Irish' and an edition of the 'Vision of Mac Conglinne', and when he retired from his Chair in 1979, having published in the meantime *The Gododdin* (1969) and *The Gaelic Notes in the Book of Deer*, it seemed that he could finish both works. Indeed, when he was presented with a second *Festschrift* in the form of volumes XIV/XV of *Studia Celtica* (1979/80)—the first was composed of articles written by former pupils and presented to him in a bound typescript volume to mark the completion of his 25 years' tenure of the Chair of Celtic at Edinburgh—both he and his friends were looking forward with confidence to their completion. Unfortunately ill-health supervened—he suffered a stroke in 1984—and in the event he was only able to publish *Aislinge Meic Conglinne* (1990) with the help of friends, in particular Professor Brian Ó Cuív, at the Dublin Institute for Advanced Studies. The Appendix on the language of the text is an excellent introduction to Middle Irish, and the Glossary, far from being a mere vocabulary, is a concordance of the language and the key to the whole. It fully deserves to be called Jackson's third *magnum opus*.

It goes without saying that Jackson's amazing achievements compelled international recognition. In addition to being a D.Litt. of the University of Cambridge he had honorary doctorates conferred upon him by the National University of Ireland, the University of Wales and the University of Haute Bretagne. He was made a Fellow of the British Academy in 1957, and Honorary Member of the Royal Irish Academy in 1965. He was appointed CBE in 1985.

Faced with such prodigious achievements in scholarship and publications, one would like to find an explanation in extraordinary energy, tremendous industry, exclusive application to work or such. No doubt Jackson had both energy and industry but his working life was very much like that of other scholars. He used to work on his research in the mornings; he lectured or went for walks in the afternoons and he spent the evenings in reading scholarly books and journals with an occasional dip into a detective story. He was always available to his two children, Alastar and Stephanie, and delighted not only in telling them stories from his vast knowledge of folklore but also in taking them with Janet his wife to visit places of historical interest. Janet and he loved to entertain friends and students and many recall with gratitude their generous hospitality. No; energy, industry, application to work do not provide a satisfactory explanation. Jackson must have had quite exceptional ability, a brain of unusual power and a strong character to make the best use of it.

He was never less than a demanding teacher. A perfectionist himself he could be harshly critical of incompetence while at the same time deeply appreciative of excellent work by a student or by a colleague.

There was an old-fashioned aspect to his character and behaviour. One student wishes me to stress that he treated his women students with the chivalry of a world long-dead.

In his memorable address at the funeral service, Gordon Donaldson, H. M. Historiographer in Scotland, said that he knew Jackson almost exclusively as a friend, that he had known little of his scholarly achievements until then, but that he had been always impressed by his modesty, his courtesy, his kindness and his generosity. He concluded his remarks: 'Kenneth Jackson of course leaves the work he has done. But, what is dearer to his friends, with the fever of life over and his work done, he goes, as Ecclesiasts has it, to his long home, but he leaves in his friends' minds memories that will endure.'

Great scholar as he was, one of the greatest ever among Celtic scholars, Professor Kenneth Jackson would have appreciated that tribute. *Suaimhneas síorai dá anam.*

J. E. CAERWYN WILLIAMS
Fellow of the British Academy

Note. I gratefully acknowledge the help given me in the preparation of this Memoir by Professor Jackson's widow, Mrs Janet Jackson, her son, Alastar, his former pupils, Miss Margaret Bird, Dr Kay Muhr, Dr A. T. E. Matonis, Professor William Gillies and Dr Oliver Padel. I am especially indebted to Dr Patrick Sims-Williams, Fellow of St John's College, Cambridge, who in recent years kept Professor Jackson in touch with his Alma Mater and enjoyed his friendship and respect. A list of Professor Jackson's published works will be found in *Studia Celtica, XIV/XV* (1979–80) with 'Addenda' in *Studia Celtica, XXVI–XXVII* (1991–92).

PETER HUNTER BLAIR *Edward Leigh*

XXVII

PETER HUNTER BLAIR

1912-1982

PETER HUNTER BLAIR was deeply influenced all his life by his early experience in his native north-east. The mixture of warm affection and reserve, of readiness to learn and caution, of fun and shyness, and the feeling for nature and love of the past that characterized his boyhood and youth distinguished him as a man too. Not just his personal relations but also his teaching and scholarship had their roots in early thoughts and feelings. The toughness he had had to acquire in order to overcome his sensitiveness during his upbringing was too precious a possession to be thrown away on any passing trend that happened to come along. So too was his religious conviction that man is not alone in his struggles. The values he had learned at the beginning continued to direct his private life, the teaching of his pupils and the study of those he admired in history. Truly in his case the child was father to the man.

He was born at Gosforth, in the Newcastle upon Tyne area, on 22 March 1912. He was a rather lonely child, for his father Charles Henry Hunter Blair, a successful businessman, was already 49 when he was born and, because of the death of a sister three years older, Peter was brought up the youngest child by six-and-a-half years. When Peter was $4\frac{1}{2}$ he went to Newcastle Central High School Kindergarten where he was happy in spite of being shy. At 8 he was sent as a boarder to Bow Preparatory School in Durham, because his mother felt he needed younger companionship than the family provided, and thence to Durham School. There he received a traditional, though rather restricted, education: it gave him a good training in the classics and a lifelong enjoyment of sport but no encouragement to develop an aptitude for music or any other aesthetic taste; it was later that he took to playing the recorder and derived increasing pleasure from listening to music. Although strong in appearance when an adult, he was not a straightforwardly robust boy—indeed he once spent a year in a wheelchair after an especially severe bout of whooping cough. Conditions at school were Spartan in winter; he used to recall waking in the dormitory to find snow on his sheet. He stoically hardened himself, however, learning to row and

becoming both captain of boats and, in his last year, captain of rugby. A boy who felt keenly and was easily hurt, he already habitually kept his feelings to himself. He invented a companion to talk to on his walks and wrote a diary; at this stage it consisted of not much more than a catalogue of rowing and rugger dates, but he was to keep a diary (on and off) for the rest of his life and was to see it as 'the only place in which one may legitimately speak of one's own self'. His sister Lesley remembers having a sad feeling for him, though she did not know quite why. Certainly he remained intensely shy and solitary, and a melancholy cast of temperament was to stay with him always. Many years later, watching his own teenage son enjoying a party, he mused, 'At his age an invitation to a dance could cast a gloom over the whole of my Christmas holidays. I wonder why we should be so differently affected by the same thing.' Nevertheless small things easily triggered off bursts of fun in him. (In adult life the gift of a chromed expanding towel-rail would be enough to set off a bout of make-believe trombone playing.) Peter's father was the one relative with whom he had a close bond. Peter and his elder brother did not have much in common, his sister Lesley was a good deal older and when he was 18 his mother died after five years of illness. As a result Peter was all the more attached to his father. It had been a source of some anxiety to his mother that the young Peter did not always find it easy to deal with his father, in his sixties and at once fond, proud, and strict. The two were regular companions in the school holidays. Charles Hunter Blair, a local antiquarian esteemed more than locally, took his son to visit churches and archaeological sites. Peter was to write regular letters to his father for the next thirty-odd years until the old man died at the age of 99.

When his father, ambitious for Peter academically, sent him to the University of Cambridge in October 1930 (to Emmanuel College, where his elder brother had gone before him), the break proved to be more of a watershed in his young life than could have been foreseen at the time; Cambridge was to be his home for the rest of his days. After a term he wanted to go back, abandon Cambridge and enter the family business. He was dissuaded; but he loved to go home in his vacations, to be in the familiar house again, and would walk round picking things up. He still kept himself to himself though, and used to walk alone on the hills for peace and uplift of mind—as he did ever afterwards whenever he visited. He participated in antiquarian society excursions and by now was talking to meetings of the Berwickshire Naturalists'

Club and the Society of Antiquaries of Newcastle upon Tyne about churches and castles. Eric Birley and Ian Richmond were among slightly older men living in the Newcastle area who encouraged and directed his interests during his young manhood, especially in the Roman antiquities so plentifully to hand, and under their aegis during four seasons he became practised in the techniques of Romano-British archaeology. In the summer vacation of 1932 he excavated Milecastle 37 on Hadrian's Wall and the report ('Housesteads Milecastle', *Archaeologia Aeliana*, 4th ser. 11 (1934), 103–20) became his first publication.

His undergraduate terms in Cambridge were passed happily and, in fact, contained the seeds of a promising career away from Northumberland. There were two formative influences above all, his College, Emmanuel, and Professor Hector Munro Chadwick's school of Anglo-Saxon studies. The College set him in an environment that was at once personal and of historical depth; Chadwick's school, in which he studied during his third and fourth years after spending his first two reading for Part I of the Historical Tripos, was a small, highly personal circle centred on Chadwick and his wife Nora Kershaw Chadwick and based on Chadwick's conception of liberal, many-sided study of early societies. Here Hunter Blair was introduced to an interdisciplinary programme and methodology which were to enable him later, in maturity, to publish a comprehensive account of Anglo-Saxon England drawing on historical and literary written sources, geography, place-names, architectural and artistic artefacts and material remains generally. The Chadwicks' benevolence is illustrated in a small way by a diary entry Peter wrote when he sat a preliminary examination in June 1933: 'Took paper in Chadders' dining room, plus bowl of cherries'. He was placed in the First Class in this examination and was awarded a Senior Scholarship by Emmanuel College. A year later he was again placed in the First Class when he took Section B of the Archaeological and Anthropological Tripos, the examination in Anglo-Saxon studies at that time. He proceeded to the BA Degree and was awarded the Dame Bertha Phillpotts Scholarship and the Scandinavian Studentship by the University. He was not registered as a Research Student, but postgraduate work on the Norse occupation of Britain, carried out first in Cambridge and then for most of a year in Sweden, led to his election as a Research Fellow of Emmanuel College in 1937. At the instigation of Professor Chadwick he gave some courses of lectures in the Department of Anglo-Saxon Studies and was soon appointed to an Assistant Lectureship. In 1937 he put roots down

in another way too when he married Joyce Hamilton Thompson, whom he had first met five years before while she was an undergraduate at Girton. Only the war was now to interrupt the tenor of his life: from the autumn of 1939 to July 1945 he was away on National Service, until March 1941 in censorship in Liverpool and then in the Scandinavian section of the European News Services of the BBC in London. Not every occasion he had to rise to was uniformly grim. One day King Haakon of Norway was due to be given the sort of red-carpeted reception that befitted such a symbolic figure at the headquarters of the BBC in Portland Place. Peter was quietly working at his desk in Bush House in the Strand when his secretary came in and said, 'There's a man downstairs who says he's King Haakon . . .'.

On his return to Cambridge in 1945 he resumed his Assistant Lectureship and on its expiry was appointed Lecturer. He was also elected to an Official Fellowship at Emmanuel and for the next twenty years was under heavy demand from both College and University for various services in addition to his teaching as University Lecturer. His College offices included those of Tutor, Praelector and, from 1951 to 1965, Senior Tutor. Beyond the College he held office as University Proctor and at various times was on the Syndicate for the development of the Sidgwick Site (an area scheduled for new University arts and social sciences buildings), the Lodging Houses Syndicate, the Board for the Ordinary Degree, the Tutorial Representatives, and the Committee of Management for Entrance Scholarships. He was a member of the Faculty Board of Archaeology and Anthropology and of the Faculty's Degree Committee for no less than twenty years. Needless to say he examined in both University and College. In all, he examined regularly in Tripos over some thirty years.

Emmanuel College harmonized with his sense of the roundness of life. As a student, by then tall and well-built, he had combined scholarship with rowing and had been Boat Captain in 1932–3. Now, in the busy post-war period with much social change in progress, he served his College strenuously and usually willingly, though sometimes he resented the quantity of humdrum routine business that came his way and occasionally felt alarm and even despair at its encroachments, as the entry in his diary for 20 January 1947 shows only too well:

> Lectured in the morning at 11. Attended the regular meeting of proctors from 2–3.30. Went to the Governing Body meeting from 4 till 6.30. Attended to tutorial business 6.30–7.15 and presided over a meeting of the May Ball committee from 8 till 10. Such is a day in the life of

an idle don. When, in these conditions, do I write books or prepare lectures? Is it surprising that the standard of scholarship declines if this is what other would-be scholars have to do? Went to bed completely exhausted. And then the alarm said it was time to get up at seven.

On the whole, as the diary that he kept, with considerable gaps, from 1946 to 1960 shows, he maintained a steady interest in the main issues and enjoyed a sense of occasion. The entry for 6 December 1947 serves as an example:

> The Regent House today approved recommendations which will make women members of the University next October. So my own 'placet' uttered loud and clear after a suitably dramatic pause was literally the last word in an argument that has been going on for half a century and more. We had made ready for a vote in case there should be any opposition, but there was none. Shall we be arguing about co-educational colleges after another half century?

In College councils he spoke comparatively little, but always to the point and with calm wisdom, standing out sturdily for whatever he believed in. Nor was he the faceless administrator. Any individual involved in a difficult question of College admission or of tutorial arrangements or of discipline commanded his full attention. Any young person in distress or bewilderment brought out in him at once a responsible and fatherly kindness. He took a humane interest in those in his charge and once wrote of undergraduates in the early 1950s that their 'courage, humour and faith (by no means born of blindness) are often an inspiration to their elders'. His boyhood sense of fun never deserted him. Any kind of hat, or pseudo-hat, would be donned immediately, and his wife's shopping lists were apt to acquire humorous additions. I remember well the zest with which one day in the early 1950s he took an affiliated student from Aberdeen (now Director of the National Museum of Antiquities of Scotland in Edinburgh), a young University Lecturer from Melbourne, and myself (a research student) on a high-spirited excursion in his car to the Anglo-Saxon churches at Brixworth and Earls Barton in Northamptonshire. The day began with his collecting an enormous old-fashioned picnic hamper like a laundry basket from the Emmanuel kitchens and ended with his reciting rhymes such as

> There was an old man of St Noots
> Who went to bed in his boots . . .

on the way back. He always delighted in limericks. Birley, Richmond, he, and the rest had amused themselves making up light-hearted verse in this and other forms in the evenings of

archaeological digs on the Roman Wall and much later in life he was to grace a College choir dinner with a sample he had newly composed:

> A respected and elderly prude
> Was determined to sleep in the nude.
> As he climbed into bed,
> He regretfully said,
> 'I find it both chilly and rude.'

His lecture courses dealt with the political and military history of Roman Britain and the history and antiquities of Anglo-Saxon England. He liked lecturing but was characteristically diffident. On 10 October 1953 he wrote:

> A class of 7 at my lecture. There will never be many for such a subject. I enjoy lecturing and can hold an audience, but have not a sufficiently firm belief in the value of the subject not to feel an occasional doubt about thus employing what is in the end the taxpayer's money. But still my own income tax amounts to more than half of what the University pays me and I think my College pay is truly earned.

Attending his lectures with their diverse material, as I did when a newly arrived research student, was like entering an Aladdin's cave or—more appropriately perhaps—like young Wiglaf's experience on entering the mound stacked with treasure in *Beowulf*. For the individual teaching of College supervision, however, he mistakenly felt he did not have much talent.

Hunter Blair's happiest term-time days were undoubtedly those on which he could find time for some family life and open air activity, such as gardening, along with University and College duties. Weekends and vacations gave welcome scope for family sailing on Fenland rivers. An entry in his diary for 3 June 1956 records:

> To the sailing club for tea yesterday and for lunch and tea today on DREDA, our latest extravagance though one which promises to give us much joy: 30 ft. converted ship's boat, 4 berth, gaff rig and 8 h.p. twin cylinder engine: which last has given me blisters and a sore wrist, but I triumphed over it today. Joyce full of enthusiasm and Hatty thrilled with it.

(Andrew, his son, was away at Rugby School at the time.) *Dreda* was to give rise later to publication of a delightful book of fancy for children (Peter Blair, *The Coming of Pout* (London, 1966)). Family holidays—picnicking on the sands, swimming, hill walking, looking at birds and plants in Northern Ireland (where Joyce's forebears came from), and the like—gave him the utmost pleasure

and he was always sad to return. The family circle (not forgetting the family dog) meant a great deal to him as a reserved and private person. Part of the diary entry for 1 January 1952 catches the sentiment:

> This New Year's day finds us all at home, four of us now, with Joyce working harder than ever to make our home the wonderful place it always is. Hatty, now into her third year, has become an engaging 'imp', as Andrew calls her. She begins to know some nursery rhymes.

In spite of the *cri de cœur*, 'When do I write books?', his publications, including a facsimile edition of a major text and two books, kept up a steady pace during the twenty post-war years up to 1965. There had been two pre-war papers, published in 1939, in addition to the earlier one on the Housesteads Milecastle. Both proclaimed that close critical analysis of written sources was to be the foundation of his work. In the one he demonstrated that certain statements in the third part of the source known as the Three Fragments of Irish Annals relate not to ninth-century Scandinavian history as had long been thought but to tenth-century Northumbrian history instead. In the other article he provided a first ever critical study of the material important for early Northumbrian history in the compilation ascribed in its only surviving manuscript to Symeon of Durham, known to have been precentor at that place in the twelfth century. Both these articles, together with the seven he published between 1945 and 1965 and three more published subsequently, have been reprinted in Peter Hunter Blair, *Anglo-Saxon Northumbria*, edited by M. Lapidge and Pauline Hunter Blair, published by Variorum Reprints (London, 1984), and supplying full bibliographical information about the original publication of all its contents. (The thoughtful reviews he published from time to time throughout his career were not included in this collection.) Three early post-war papers published in successive years (1947, 1948, and 1949) and a fourth published after another ten years drew critically on the principal available written sources—Gildas's *De Excidio et Conquestu Britanniae*, the anonymous *Historia Brittonum* and early entries in the *Anglo-Saxon Chronicle*—to clarify the origins of Northumbria and its territorial extent during the sixth, seventh, and eighth centuries. Another article, published in 1963, took his analysis of the Symeon of Durham material much further. The two remaining articles of the 1945–65 period, published in 1950 and 1959 respectively, together with the facsimile edition, *The Moore Bede*, Early English Manuscripts in Facsimile 9 (Copenhagen, 1959), were concerned with

the most important source of all for early English history, Bede's *Historia Ecclesiastica*. The introduction to the facsimile provided an exhaustive palaeographical, codicological, textual and historical study of the manuscript reproduced, one of the two supreme surviving witnesses to Bede's text; the 1950 article was a detailed analysis of the uniquely valuable memoranda relating to early Northumbrian history entered on the last page of the same manuscript; the third item, the Jarrow Lecture for 1959 published in that year, displayed in a general account his intimate knowledge of the nature of Bede's history, its sources and its transmission. In the later of the two pre-1965 books, *Roman Britain and Early England 55 BC–AD 871* (Edinburgh, 1963), Hunter Blair gave a full-length account of his long-standing special interest in the transition from the Roman occupation to the establishment of the Anglo-Saxon kingdoms. The full treatment of Roman Britain, as well as being a valuable synthesis in its own right, served to clarify many problems of the period of the Anglo-Saxon invasions and early rule. In his earlier book, *An Introduction to Anglo-Saxon England* (Cambridge, 1956, dedicated to his father, then aged 93), he provided the survey of all Anglo-Saxon history for which he is best known. Open minded and readable, and exceptional among other general accounts in its attention to linguistic, literary, archaeological, architectural, and artistic evidence, it has been justifiably regarded as a standard book worldwide ever since, being reprinted many times and reissued in a revised second edition in 1977.

A dark period in his life began when his wife Joyce died at Christmas 1963 after prolonged illness. A year later he married Joyce's recently widowed sister-in-law Muriel. But another blow followed within months when she too died. He resigned his Senior Tutorship and withdrew a good deal from College life. Nor, from 1967 when the Department of Anglo-Saxon and Kindred Studies (as it was then called) was transferred from the Faculty of Archaeology and Anthropology to that of English, was he much involved in Faculty and University affairs. As a practising Anglican (though he never formulated his beliefs) he was sustained in his troubles by a seeking and not-to-be-undermined religious faith. A deepened, affectionate relationship with his sister Lesley developed and he gained much comfort from the companionship of his daughter Hatty, still a schoolgirl. (His son Andrew was by now married.) But it was only when (through the publication of his *Pout* book) he met Pauline Clarke, a successful children's writer, and married her in 1969 that his life returned to the sunlight. Sharing tastes for music and the arts generally and

for many other aspects of experience, they developed probably the most intimate relationship of his whole life. Together they made into a beautiful home a house and garden they acquired at Bottisham, a village a few miles out of Cambridge, in October 1979. Regular visits to the National Theatre in London and trips to Italy, southern Germany, and Greece were special joys. His life revived in other ways too, though physically he had slowed up; whereas some years earlier he could have been seen charging along the towpath on a gigantic bicycle exhorting College eights as President of the Emmanuel Boat Club, now, rather, he strode with slow and measured pace through the College gardens. In 1969 he held office as Vice-Master of Emmanuel (resigning on an issue of policy) and in 1974 was appointed to an *ad hominem* University Readership in Anglo-Saxon History. At his own desire in 1978 he took early retirement from this Readership. Becoming a Life Fellow of Emmanuel, he found new ways to serve his College: he undertook substantial fresh duties as its Honorary Archivist. In this office, with suitable help, he painstakingly and skilfully transformed a somewhat neglected and partly unassessed quantity of College records into an orderly, classified collection. Meanwhile, both before and after he retired from his Readership, he accepted invitations to lecture or conduct seminars at various universities, scholarly conferences and other occasions; the trip to Italy (in 1969) and the one to southern Germany (in 1971) were brought about in this way. He was an enthusiastic editor of the first eight volumes of the annual publication *Anglo-Saxon England* (1972-9), with chief responsibility for their historical contents, and suggested the effigy of King Alfred on the silver penny issued to celebrate Alfred's occupation and fortification of London in 886 as the series' emblem.

The intellectual life of Northumbria in the seventh and eighth centuries became the main theme of his publications in this period. Only one paper, published in 1971, a close examination of the chronological problems raised by Bede's account of the mission of Paulinus to Northumbria, stood rather to one side. In a lecture published a year earlier he had tackled his current central concerns head-on. It set forth understandingly the concepts that controlled Bede's writing of his *Historia Ecclesiastica* and the derivation of those ideas, and for good measure discussed Bede's knowledge of the Augustinian mission in Kent. Another lecture, published in 1976, asking probing questions about the body of writings available in post-Bedan Northumbria, particularly in the library of which Alcuin had charge in York, was a pioneering

study of eighth-century Northumbrian learning, and in a last, vintage, lecture, delivered in Cambridge late in 1981 and to be published in 1985, Hunter Blair examined Whitby as a centre of learning in the seventh century.

Two books allowed him to deploy his wide and deep knowledge most fully, *The World of Bede* (London, 1970), intended primarily for fellow scholars, and *Northumbria in the Days of Bede* (London, 1976), imaginatively addressed to general readers. He was never interested just in specialists; like Bede, he respected *opinio vulgi*. He was always ready to address general audiences. Years before, in the autumn of 1949, he had contributed a lecture on 'The Foundations of England' to a course in Cambridge which presented a composite picture of the prehistory and early history of the British Isles to large audiences reading a great variety of subjects other than history. A few months later the series was broadcast and in 1952 was published in book form as M. P. Charlesworth *et al.*, *The Heritage of Early Britain* (London). Then again, in 1957, he had taken the major part in preparing a series of programmes about Anglo-Saxon England on the BBC's Third Programme and had contributed to its attendant literature (*Anglo-Saxon England*, a BBC Publication, no. 3637). *Northumbria in the Days of Bede* reads as though its subject was all round its author, and in a real sense it was, for much of the book was written while Pauline and he were living in an old Manse which they bought near Duns, over the border, west of Berwick upon Tweed, and used for long stays during five years. To Peter it was sharing with Pauline, a southerner, his 'childhood's dream, a stone house in Scotland'. Together they roamed the uplands of the north and visited such places as Mull and Iona and Edinburgh. The magic of the north—for Peter the old magic—took possession of them both and the book, dedicated to Pauline and bearing the motto 'Time will run back and fetch the age of gold', is quickened by it.

In *The World of Bede* he produced an outstanding work of mature scholarship. Full of important new information, handling many controversial matters clearly and succinctly and carrying a weight of exact scholarship lightly, it provides the best picture of Bede and his age that is available. Attaching proper significance to the biblical commentaries as the real centre of Bede's work, without in any way diminishing his stature as a chronologist and historian, it deals more effectively with Bede's attitude to the writing of history than any previous attempt by another. As a result we see Bede in the round, the whole man, carrying out over a lifetime an integrated scheme of work. Furthermore it brings to

bear recent studies concerned with ecclesiastical history and learning in western Europe to delineate Bede's background more thoroughly and convincingly than ever before. Its chapters on such topics as the biblical manuscripts available to Bede (based on thorough investigation of surviving manuscripts and of what can be surmised about lost manuscripts), education, secular learning, and chronology are of the highest interest. This is a distinguished piece of work, giving a sound and vivid picture of a great man in his intellectual and spiritual environment.

Hunter Blair took proper pride in the recognition he received — election as a Fellow of the Royal Historical Society in 1970, award of a Cambridge Litt.D. in 1973, his Readership in 1974, election to a Fellowship of the British Academy in 1980, but his modesty was such that he could not at first believe news of this final honour. From early pre-war days he had had in view a single large work perhaps to be entitled *The History of Northumbria*. Probably it was always an unrealizable goal, but it represented the commitment which steadily inspired his scholarship. Not biased by preconceptions, not striving after originality for its own sake, modest, even self-distrustful, and working scrupulously from primary evidence, he harvested knowledge of the early history of his native region and, with an understanding born of practical living, imparted it to others openly, lucidly and sympathetically as Bede's *verax historicus*. After his health sadly had gone into several months of irreversible decline, looking at the buildings of his College one day, he said to me, 'With four hundred years of history around me it doesn't seem to matter much if I die.' He died on 9 September 1982 greatly loved and respected. His memorial service in Emmanuel College chapel included a reading of the Moore text of Cædmon's Hymn, and an inscription on his tombstone in Fulbourn churchyard, near Cambridge, based on Old English gnomic poetry, recalls his strong sense of oneness with the natural world.

PETER CLEMOES

I am grateful for the help I have received from materials originated by Mrs Pauline Hunter Blair, Miss Lesley Hunter Blair, Dr Michael Lapidge, Dr Frank Stubbings, and the late Professor Dorothy Whitelock.

THOMAS JULIAN BROWN

XXVIII

THOMAS JULIAN BROWN

1923–1987

JULIAN BROWN made a crucial contribution to the study of the script of the earliest surviving manuscripts of the British Isles, those dating between the sixth and the ninth centuries. Equally important, by his public lectures and his teaching and through his wider involvement with scholars in a variety of subject areas both in this country and abroad he established palaeography more firmly and visibly as an academic subject within the British University system.

He was born on 24 February 1923, his father, Thomas Brown, being a landagent in Penrith, Cumberland, whose first wife had died leaving a daughter, Julian's half-sister Betty.[1] Thomas Brown died in 1934. Julian's mother, Helen Wright Brown, received the MBE for services in the Women's Royal Volunteer Service. After education at Westminster School where he was a King's Scholar from 1936–40, Julian went up to Christ Church, Oxford in 1941. He took Honour Moderations in Classics in 1942 and then served in the Border Regiment from 1942–5, being for most of the time attached to the Infantry Heavy Weapons School at Netheravon. Returning to Oxford he completed his degree in Greats in 1948. He had a lengthy viva for a First and the fact that he so narrowly missed it must be attributed to an emotional breakdown the previous summer which led also to his missing the entire Michaelmas term in 1947. Among the teachers who powerfully influenced him were R. H. Dundas and Paul Jacobsthal, both of whom he acknowledged in his first major publication, the facsimile of the Lindisfarne Gospels. Dundas was the Greats tutor

[1] Betty Gilson (Mabel Raven Brown) 1909–65, was a Fellow and Lecturer in Botany at Newnham College, Cambridge from 1939–46. See *Newnham College Roll Letter*, 1960, for a memoir.

for Ancient History at the House. His Mods tutor was Barrington-Ward and it was he who persuaded Julian to take the Special Paper on Greek Art in Mods. Julian wrote of this: 'A weekly class on sculpture with Jacobsthal, attended by one other undergraduate, and two lectures a week on Greek vases by Beazley, attended by half a dozen others at most, for four terms marked me for life.'[2]

In 1950 Julian entered the Department of Manuscripts in the British Museum. The Keeper at that time was A. J. Collins who was succeeded by Dr Bertram Schofield. It was then and still is the custom for newly entering staff to be put to work on describing the uncatalogued material accessioned as 'Additional Manuscripts' and 'Additional Charters'. In this way they received a hands-on training under the supervision of a senior member of staff and they were expected to achieve a general competence in all areas of the collections from ancient to modern.

Julian Brown's earliest publications were thus concerned with literary autographs.[3] Accompanied by well-chosen facsimiles his papers on the script of prominent authors have proved of enduring use, and they already show the qualities of Julian's scholarship as a palaeographer in the way in which they lay down clear principles and criteria for the study of scribal characteristics and for the distinction of genuine from fake documents. At the same time he had had to work on the papers of Bernard Shaw. The expertise he gained at that time he continued to put at the disposal of the Society of Authors, advising them on matters concerned with Shaw's unpublished papers via the Academic Advisory Committee set up by the Society in 1973, of which he served as Chairman from 1974 until it was wound down in 1984. His wisdom and tact in difficult decisions were greatly valued.

In 1953 a project was approved by the Trustees of the Museum to publish a full facsimile of the Book of Lindisfarne. Two publishers had put forward such a proposal, and Urs Graf under the direction of Dr Titus Burkhardt, was entrusted with the task. It was apparently understood from the first that the commentary

[2] 'Names of scripts: a plea to all medievalists'. This is scheduled to appear in *A Palaeographer's View. The Selected Papers of T. J. Brown*, ed. M. B. Brown, J. Bately, J. Roberts, to be published by Harvey Miller, London, 1990. The volume will contain corrected reprints of Julian's most important articles as well as several unpublished papers, and will provide a full bibliography of his writings.

[3] 'The detection of faked literary MSS', *Book Collector*, **2** (1953), 3–14. 'English literary autographs I-L' and 'English scientific autographs I–VIII', *Book Collector*, **2-15** (1953–66). 'Some Shelley forgeries by "Major Byron"', *Keats-Shelley Memorial Bulletin*, **14** (1963), 47–54.

text would be mainly written by internal staff of the Museum. Francis Wormald, who might otherwise have been expected to be involved, had left the Museum for the Chair of Palaeography at London University in 1950. Other senior staff could evidently not be spared from their particular responsibilities. Thus it was that the palaeographical commentary was entrusted to a young man with no formal palaeographical training and at that point no publications on medieval let alone Insular palaeography. The fact that Jacobsthal was an authority on Celtic art is unlikely to have had anything to do with it. The triumphant way in which Julian rose to this challenge was in effect to shape the remainder of his scholarly life.

The facsimile itself appeared in 1956, but the commentary volume not until four years later.[4] The authors apologize for this lapse in time in their preface. It was hardly surprising, however, for the final publications can claim to be the most thorough and scholarly investigation of a single manuscript ever produced. It seems that the Trustees were generous in granting 'Facility time' and Julian thanks them for allowing him seventy-eight days special leave since 1953. Nevertheless to make himself master of the material as he did must have required intense effort and Professor David Wright remembers encountering him in the Warburg Institute working before and after his duty hours at the Museum.

The volume was a collaborative effort. The art historical side was covered by Rupert Bruce-Mitford of the Department of British and Medieval Antiquities. The philological questions involved in the tenth-century Latin gloss were discussed by A. S. G. Ross and E. G. Stanley, who had been working on this aspect for some years. A section on the pigments was contributed by the German scholar H. Roosen-Runge in collaboration with another authority on painting techniques, A. E. A. Werner, then Keeper of the Research Laboratory at the Museum and formerly of the National Gallery. In his preface Sir Thomas Kendrick, at that time Director of the British Museum, wrote that the text: 'represents a consensus of opinion and it is all the more valuable for that reason'. Julian worked particularly closely with Bruce-Mitford, certain parts of the text being written jointly. Bruce-Mitford recalls their feeling a keen sense of responsibility to deal adequately

[4] *Evangeliorum Quattuor Codex Lindisfarnensis*, Vol. 2 (Olten and Lausanne, 1960), ed. T. D. Kendrick, T. J. Brown, R. L. S. Bruce-Mitford, H. Roosen-Runge, A. S. C. Ross, E. G. Stanley, A. E. A. Werner.

in the publication with such a masterpiece. It was certainly a unique opportunity to examine a manuscript in minute detail comparing all aspects of script and decoration on a continuing day-to-day basis and this is very apparent at every point in their text. Their important new conclusions as to the identity of scribe and artist, for example, were reached as a result of observations of changes in plan in the script and decoration which might have passed unnoticed from a less intensive examination.

As has been said, Julian's training as a palaeographer was from practical experience in the Department and he never, so far as I know, had formal instruction through lectures or classes. At Oxford he is unlikely to have had any contact with Neil Ker, who had been appointed University Lecturer in Palaeography in 1936. The Mods part of his degree will have given him a sense of the transmission of classical texts via manuscript sources, however, and no doubt he will have known Housman's famous description of editors clinging to a single manuscript for their readings to drunks clinging to a lamppost. Though one Oxford undergraduate, E. O. Winstedt, went to the Bodleian to look at the manuscripts of Juvenal for himself and thereby made a famous discovery, there is no record of Julian's ever having done the same. In the Museum, however, he will have benefited certainly from the long tradition of expertise in manuscript studies, and from the wide knowledge and international scholarly contacts of his colleagues. The earlier monograph on the Lindisfarne Gospels of 1923 had an introduction by Eric Millar, who retired as Keeper of Manuscripts in 1947. He also thanks Francis Wormald in particular even though, as has been said, he was no longer in the Department. His British Academy memoir of Wormald makes clear how much he felt he owed to him and expresses his affection and respect.[5] Otherwise he was dependent on his own reading and his own first hand examination of originals. Bruce-Mitford recalls that he was impressed from the first by Julian's knowledge of matters textual and liturgical as well as codicological and palaeographical.

Julian's main debt at this stage not surprisingly was to E. A. Lowe who had begun his publication *Codices Latini Antiquiores* with a first volume on the manuscripts in the Vatican Library in 1934. The second volume on manuscripts in Great Britain and Ireland, the most important for Julian at this stage, appeared in 1935. By

[5] 'Francis Wormald', *Proceedings of the British Academy*, **61** (1976 for 1975), 523–60.

1953 C.L.A. had reached volume VI so that the manuscripts in France were covered, also important in that they included the manuscripts of Echternach founded by St Willibrord. Julian was later to entitle his inaugural lecture 'Palaeography since Traube' and he thereby situated himself in a line of descent, for Lowe had studied with Traube in Munich.

Thinking back to what was known of Insular palaeography in 1953 is not easy. Traube had taken the initial step of identifying some of the characteristics of the script to describe which he introduced the term 'Insular'. The term served positively to separate Irish and Anglo-Saxon from Continental scripts, but it also worked negatively by tending to avoid the issue of which manuscripts were in fact written in Ireland or by Irish scribes and which in England or by Anglo-Saxon scribes. Lowe in *C.L.A.* relied on Traube's criteria and extended them as he makes clear in the preface to volume II. And he did not hesitate to distinguish 'Irish' from 'Anglo-Saxon' or even 'Northumbrian'. Julian's work as he constantly acknowledged took *C.L.A.* as a point of departure.[6] But he was to take the process of classification further and that was to entail many revisions and amplifications.

The work had four main aspects and all appear already in *Codex Lindisfarnensis*, though the first two are in the foreground and the second two are rather implied there than fully worked out. First came the identification of individual 'hands'. Julian made a detailed analysis of the script of the Gospels which he concluded had been written by a main hand, identifiable as Eadfrith, bishop of Lindisfarne from 698 to 721, with minor additions by 'the rubricator'. His identification of another scribe whom he argued had written two other manuscripts, the Gospels in Durham (A.II.17) and the Echternach Gospels (Paris, Latin 9389), the man he named the 'Durham/Echternach calligrapher' and whom he considered to have been probably Eadfrith's teacher, will be discussed later.

Second came the establishment of groups of manuscripts which can be ascribed to a particular scriptorium at a particular date. Julian thus isolated five groups of manuscripts ascribed to Northumbria and showed that Lindisfarne, Durham, Echternach and a fourth, Lincoln College, Oxford, Lat. 92, his first group, are

[6] His obituary of Lowe was reprinted from the London *Times*, 11 August 1969: 'Dr. E. Lowe: expert on Latin manuscripts', *Journal of Historical Studies*, Autumn 1969, 213–15. See also 'E. A. Lowe and *Codices Latini Antiquiores*', *Scrittura e civiltà*, **1** (1977), 177–97.

particularly closely related. This was done on the evidence of the script, that is the appearance of the letters and the way they were formed and arranged, but also on what was beginning to be called 'codicology'. By this was meant the study of all the various physical aspects of the book, such as the way the animal skin was prepared, ruled, combined in quires and bound up. The term 'codicology' served as it were as a rallying cry for a new attitude to the manuscript book, one which was to be more comprehensive and more 'scientific'. Belgian manuscript experts centring on the Royal Library in Brussels and involved with the new periodical aptly named *Scriptorium* also used the term 'archéologie du livre' to emphasize the necessity of minute observation of the stages of a manuscript's production, including the evidence of changes of plan or later alterations or additions. The proof that Eadfrith was both artist and scribe depended, as has been said, on such evidence. The codicological approach was espoused perhaps most forcefully and persuasively by a Belgian scholar, Bob Delaissé, whose work Julian greatly admired and whom he later came to know well, especially after Delaissé came to live and work in England. Julian was always sympathetic to 'codicology', which had its own tradition in England in the work of Cockerill, Millar and others, and he many times referred to the contribution it could make. The commentary in *Codex Lindisfarnensis* is thus also exemplary in its deployment of codicology.

Discussion of individual hands and the house styles of different scriptoria inevitably led back to wider questions of origin and training. Thus already in *Codex Lindisfarnensis* Julian had to think about two overarching issues. One was the respective contribution of Irish and Anglo-Saxon scribes to the development of the Insular system of scripts. Since Lindisfarne was one of the very few Insular books whose place and date of making were established through the tenth-century colophon of Aldred the priest, it did not need to be a central issue in the Commentary *except* in terms of origins. But it did arise both in relation to the Durham and Echternach Gospels and also in relation to the Book of Durrow, which Julian and Bruce-Mitford, following Lowe, held to have been produced in Northumbria.

The other overarching question, already adumbrated in *Codex Lindisfarnensis*, concerns the development of the Insular scripts, whether Irish or Anglo-Saxon, out of the writing of the late Roman Empire. The questions raised here concern sources and continuity and also involve complicated issues of the uses different types of script were put to, the way scribes were trained, and

whether the same scribe could and did write different types of script and could be recognized doing so.

These four closely interrelated areas of enquiry continued to exercise Julian for the remainder of his scholarly career. But before tracing the way they appear and reappear in his work like a piece of four-strand Insular interlace, something more may be said to emphasize the strengths of his scholarship as contributed by his training and temperament. First, the Mods/Greats course does I believe (having done it myself) provide an exceptional training in a variety of skills. The philological side of the initial Mods course has already been mentioned as it affects textual studies. The Mods course also gives the student a sense of words, their origins and meanings. Julian wrote well with a prose style which is clear, succinct and elegant, so that it is always a pleasure to read his publications. Evelyn Waugh attributed his own consummate skill in writing the English language to the emphasis placed on translation into and out of Greek and Latin in his schooling, and the same can surely be said of Julian. In the second part of the course, Greats, historical method was taught, that is how to use sources both primary and secondary. The major emphasis was on primary sources which must be pressed for everything they may reveal. Julian mentions by name some of the outstanding Ancient Greek historians teaching in Oxford at that time, Wade-Gery, Meiggs, Andrews, as well as his own tutor Dundas.[7] In *Codex Lindisfarnensis* the careful examination of historical sources, for example the account by Simeon of Durham of the opening of St Cuthbert's coffin, or the various sources for the later history of the community of St Cuthbert, is exemplary.

Thirdly, Greats included a training in philosophy, his Tutor at the House being J. O. Urmson. Of this Julian himself happens to say less, though he was evidently equally engaged by this part of the course.[8] His training in philosophy as it was practised at this time in Oxford, where he was able to attend lectures by Gilbert Ryle, J. L. Austin and A. J. Ayer, is likely to have reinforced a tendency to distrust metaphysics, to embrace the specific, and to be empirical in his approach. In the paper just referred to he quotes the famous last sentence of Wittgenstein's *Tractatus*, 'which', he characteristically writes, 'I sometimes think I understand': 'Wovon mann nicht sprechen kann, darüber muss mann schweigen.' I think there is perhaps one obverse to these qualities

[7] 'Names of scripts', as in note 2.
[8] The viva referred to earlier was conducted by J. L. Austin.

instilled in him by his training, but I will return to this in discussing the work on the 'Durham/Echternach' calligrapher and the Book of Kells.

In 1960 Wormald moved from the Chair in Palaeography to direct the Institute of Historical Research and Julian was appointed to succeed him, which must certainly have been a blow to the Department of Manuscripts, as is clear from a letter Schofield wrote to the Trustees at the time. Once at King's, Julian turned out to be not only a conscientious but an extremely gifted teacher, who was capable of communicating not only his learning, but also his enthusiasm for the subject. The move was undoubtedly good both for him and for palaeography in general. Whether if he had remained in the Department he would have written more is to be doubted. Certainly his teaching took up a great deal of his time. In the early 1960s he must have been especially busy preparing his courses and lectures and extending his knowledge of the script of the later Middle Ages and the Renaissance. But he would have had to devote his energies and time to answering the very large numbers of letters he received asking for advice and expertise in either job, and probably the administrative duties which he fulfilled so conscientiously at King's College would have also lain heavily on him in a different form in the Museum.

His publications followed in any case steadily, and his principles of enquiry, which he set out clearly in his inaugural lecture given in 1962, would never have allowed a flood.[9] This lecture not only traces the history of the discipline to that point in time, but discusses recent trends and developments and clearly sets out a programme for the future. He always stressed that palaeography is 'eine unenthbehrliche Hilfswissenschaft', though one that entitled the palaeographer, as he put it, 'to put one's finger in many pies'. But his view of palaeography's task was broadened and he also wrote of a much wider and more ambitious task: 'we are beginning to find that we can go behind the books to the thoughts and behaviour of men, while they are composing, copying and decorating them; and the time has come to accept that kind of knowledge as a conscious aim.'

The writing of commentaries to facsimiles of Insular manuscripts was a job into which Julian was inevitably drawn and which he no doubt welcomed as an opportunity to extend his knowledge and

[9] 'Latin palaeography since Traube', *Transactions of the Cambridge Bibliographical Society*, **3** (1963), 361–81; reprinted in *Codicologica*, Vol. 1, ed. A. Gruys & J. P. Gumbert (Leiden, 1976), pp. 58–74.

put his thoughts on paper, even though it took him away from his project of a wider synthesis. In 1969 appeared the Roxburghe Club facsimile on the Stonyhurst Gospel of St John.[10] This small manuscript is written in an expert uncial script and, though without illumination, is additionally notable for its original decorated binding.

E. A. Lowe's *English Uncial* had been published in 1960 and so here too Julian was in the position of amplifying Lowe's work, rather than starting *de novo*. Lowe had finally laid to rest the earlier theory that the manuscripts written in uncial script at especially Wearmouth/Jarrow were written by Italian not English scribes. Julian concentrated on the questions of the origin of the script and its date. He made certain suggestions as to which early books acted as models in the British Isles at this date, including the Maccabees fragment still at Durham and an Augustine fragment in Paris. His examination of the historical evidence that the book had been placed in the Coffin of St Cuthbert in 698 and was that described in the sources as discovered there in 1104 led him to a characteristically thorough discussion of the use of books as amulets and of miniature script throughout the Middle Ages. He also argued from the development of its script that Stonyhurst was likely to have been written after the *Codex Amiatinus*, which has an important bearing on the date of the latter.

Also in 1969 appeared the facsimile of the Durham Ritual.[11] Here too the work followed on naturally from *Codex Lindisfarnensis* in which Julian had already discussed the script of the Anglo-Saxon glossator of Lindisfarne, the priest Aldred of Chester-le-Street, where the community of St Cuthbert was resident for a period in the later tenth century. Aldred had long been identified by Neil Ker and Wanley before him as being also one of the scribes of the Ritual.

In 1972 Julian published his paper on the Book of Kells, based on his Jarrow Lecture of 1971.[12] At that point some sort of consensus existed that the Book of Kells was produced at Iona *c.* 800, its decoration being interrupted by the Viking raids which

[10] *The Stonyhurst Gospel of St. John* (Roxburghe Club, Oxford, 1969).

[11] *The Durham Ritual* (Early English manuscripts in facsimile, Vol. 16, Copenhagen, 1969), ed. T. J. Brown with contributions by F. Wormald, A. S. C. Ross, E. G. Stanley. Work had started on this in the early sixties and publication was delayed.

[12] 'Northumbria and the Book of Kells', *Anglo-Saxon England*, Vol. 1, (1972), pp. 219–46.

necessitated the community there fleeing to Kells in Ireland. This was held to account for the illumination being unfinished. That the manuscript was later at Kells is fact, proved by the insertion of charters in the twelfth century. Julian argued that so many features in the Book of Kells of both its script and decoration seemed to depend on the Lindisfarne Gospels that it could well be that it was produced both nearer in date to the Lindisfarne Gospels and nearer geographically to the island of Lindisfarne itself. He was thus prepared to consider Northumbria and also some unknown centre in Pictland as a possible place of manufacture. As usual the arguments were carefully marshalled and the evidence clearly set out.

Inevitably the conclusion, however, judiciously stated, was highly controversial, and it was unlikely that it would go unchallenged. It does not need to be said that contemporary politics have had an effect on the study of Irish art and there have been strands of nationalistic prejudice and even propaganda in at least some of the less scholarly writing on Celtic and Anglo-Saxon art. The Book of Kells, which has been reproduced on Irish stamps and a poster for Aer Lingus has become a potent national symbol. The suggestion that it was in fact made somewhere in North Britain was in the circumstances bold. Julian was very conscious of his Northumbrian links as is shown by his phrase in the preface of *Codex Lindisfarnensis*: 'on the mosses and bogs of my native Bernicia.' But as Bruce-Mitford has recently stressed it is nonsense to call him prejudiced.[13] The conclusion is there because that was the way Julian saw the evidence pointing and he could never shrink from a controversial or unpopular opinion, if it was what he believed in. Nor is the conclusion pronounced *ex cathedra* or as if it was incontrovertible, that never being Julian's way.

I myself do not believe he was right. But if the suggestion provoked debate, as had also been a consequence of the Belgian scholar François Masai's much more polemical intervention of 1947, that was for Julian a good, even if incidental, consequence.[14]

[13] R. L. S. Bruce-Mitford, 'The Durham-Echternach Calligrapher', *St Cuthbert. His cult and his community*, ed. G. Bonner, D. Rollason, C. Stancliffe (Woodbridge, 1989), pp. 175–188.

[14] *Les origines de la miniature dite Irlandaise*, 1947. Bruce-Mitford (as in note 13) discounts the influence of Masai's book on Julian's thinking. He describes Masai as attacking positions already abandoned by up-to-date scholarship. See also C. Nordenflak, 'One hundred and fifty years of varying views on the early insular Gospel Books', *Ireland and Insular Art A. D. 500–1200*, ed. M. Ryan (Dublin, 1987), p. 3: 'Its heresy lacked the charm of novelty: it contained little that had not been already said before by Clapham, Burkitt and Lowe.'

The evidence adduced, matters such as the way in which the manuscript was planned in relation to script and decoration, has to be accounted for by those who favour a different date and a different origin.

Such a debate may take time to develop, but there are interestingly some signs that this is materializing at this moment. Here, however, it may be suggested that the classical training received by Julian, whose strengths have been stressed above, had also one possible disadvantage. It reinforces certain tendencies to value more highly whatever is considered to relate to classical art and culture. Those works which preserve the content or style of that culture are given priority and conversely there is a failure to value properly the creativity of oppositional, that is in this case Celtic achievements. To stress the debt of Kells to Lindisfarne is surely to miss what makes Kells a significant work of art *in opposition* to Lindisfarne.

The view on Kells had much to do with Julian's discovery of the 'Durham/Echternach calligrapher'. Already in *Codex Lindisfarnensis* Julian had concluded that the 'Durham/Echternach calligrapher' was the artist as well as the scribe in both books. From his background Julian was always sensitive to the decoration of manuscripts and keenly aware of art historical evidence. Here he became convinced that the Crucifixion miniature and the single surviving initial in the Durham Gospels were by the same artist as painted the four pages with Evangelist symbols and the initials in the Echternach Gospels. The inevitable consequence was that the stylization of the human figure, also seen in the Book of Durrow, which has been associated particularly with Celtic art, was still being practised in Northumbria, in fact, if Julian was right, at the same moment and in the same community where Eadfrith had produced the new synthesis of Mediterranean and Insular style in using Cassiodoran models for his Evangelist portraits.

In 1980 Julian collaborated once again with a team of scholars in the commentary accompanying another facsimile, this time of the Durham Gospels itself.[15] He did not change his mind on the identity of the 'Durham/Echternach calligrapher', but restated his palaeographical evidence. Meanwhile, however, his conclusions on the attribution of the miniatures had not been accepted by art historians such as Françoise Henry and Carl Nordenfalk. For the

[15] 'Palaeographical description and commentary', in C. D. Verey, T. J. Brown & E. Coatsworth, *The Durham Gospels* (Early English manuscripts in facsimile, Vol. 20, Copenhagen, 1980), pp. 36–52.

moment there is no consensus, though clearly the consequences of Julian's view are very far reaching for the history of Insular book production at this period.[16] For the facsimile Dr Elizabeth Coatsworth wrote on the decoration, concentrating mainly on a different set of questions, the aspects of design, decorative sources and links with contemporary sculpture. Christopher Verey wrote on the text and the history of the manuscript. Verey had written a Durham MA on the texts of three Durham Gospels and embarked on a London Ph.D. under Julian's supervision, 'The Vulgate Gospels in Northumbria', which has not been completed.[17] He had already contributed an Appendix to the Kells paper in which he reported the very important discovery that Lindisfarne and Durham have textual corrections written by the same hand and that in Durham these were written before the rubrics. This seemed to vindicate Julian's view of their relationship and their date, even if certain problems as to the relative date of the three manuscripts remain.

In 1976–7 Julian was appointed J. P. R. Lyell Reader in Bibliography in the University of Oxford. The duties of this Readership, which is held for one year, are to give five lectures, and the subject matter alternates between printed books and manuscripts. Julian must have known several years ahead of this appointment and started to plan the lectures which would give him the opportunity to attempt a wider synthesis on Insular script. He had in fact already begun on this project in two E. A. Lowe Memorial Lectures delivered at Corpus Christ College, Oxford, in 1973. Julian's Lyell lectures, like many of their predecessors and successors, have not been published, but a manuscript exists which may in future be edited or adapted for publication some other way.[18] His later R. W. Chambers Memorial Lecture at University College, London in 1978, 'Tradition, Imitation and Invention in Insular Handwriting of the 7th and 8th centuries', covers some of the same ground. In the Lyell lectures

[16] See Bruce-Mitford (as in note 13) responding to D. Ó Cróinin, 'Pride and prejudice', *Peritia*, **1** (1982), 352–62, and *idem*, 'Rath Melsigi, Willibrord and the earliest Echternach manuscripts', *Peritia*, **3** (1984), 17–49.

[17] C. D. Verey, 'A collation of the Gospel texts contained in Durham Cathedral MSS. A.II.10, A.II.16 and A.II.17 and some provisional conclusions therefrom regarding the type of Vulgate text employed in Northumbria in the eighth century together with a full description of each MS.' (Durham, 1969).

[18] B. Barker-Benfield, 'The Insular hand', *Times Literary Supplement*, 27 January 1978, gives a valuable account of the lectures. I am grateful to Dr Barker-Benfield for sending me a copy of this.

Julian had space to take on what I have described as the third and fourth of the preoccupations already visible in the *Codex Lindisfarnensis*, that is the origin and development of the Insular scripts, both Irish and Anglo-Saxon. This is a huge task and the lectures were extremely complex and detailed. Two papers published in 1982 and 1984 stem from Lyell material.

In the first of these Julian tried to particularize the Irish contribution and to map out the material in a more coherent way.[19] Though the oldest manuscripts, for example those now at Bobbio, were included in *C.L.A.*, for the ninth century he was charting much more of a *terra incognita*, even though he was preceded by such notable palaeographers as W. M. Lindsay, Ludwig Bieler and Bernhard Bischoff. An important part of the paper concerns the question of nomenclature. The necessity of agreeing terms which would describe the variety of scripts in the Middle Ages and Renaissance had become urgent, particularly as scholars paid more attention to the later periods and especially in relation to the project of the Comité internationale de paléographie of producing illustrated catalogues of dated manuscripts.[20] Julian's lecture hand-outs show that he was very aware of these problems and, as Professor de la Mare has pointed out, they were extremely relevant in the teaching he was doing. Part of the students' training lay in learning to describe medieval manuscripts. It was thus essential that the students should be able to describe scripts, that is give them recognizable and accepted names.

For the Insular scripts Julian proposed the terms cursive minuscule which might vary in two opposed directions, an accelerated version to be termed 'current' and a more formal version to be termed 'set'. He also proposed going back to the earlier term 'half-uncial' which Lowe had replaced, in his view wrongly, with the term 'majuscule'. He pointed out that half-uncial is very rare in Insular manuscripts by comparison with 'hybrid minuscule', a script which admits some letters from half–uncial, the 'oc' 'a' and uncial 'd', 'n', 'r', and 's'. Within these scripts it is important to note the slant of the nib and the way it is cut.

Something very important about Julian's palaeography emerges

[19] 'The Irish element in the Insular system of scripts to circa A.D. 850', *Die Iren und Europa im früheren Mittelalter*, ed. H. Löwe, Vol. 1 (Stuttgart, 1982), pp. 101–19.

[20] Especially important was the paper by B. Bischoff, G.I. Lieftinck, G. Batelli, *Nomenclature des écritures livresques* (Paris, 1954).

here, which has not been sufficiently stressed above. He recalled Jacobsthal in the Greek sculpture classes at Oxford hissing at him: 'What do you *see?*' Julian one might say was a 'visual palaeographer' as opposed to a 'philological palaeographer'. That is to say he responded especially to the range of problems connected with the appearance of script, the letter forms and the way they are combined. In this way his work is linked to that of E. A. Lowe rather than to that of W. M. Lindsay or Neil Ker. Not that he neglected any of the questions centring on the text copied, what was the model, what errors a scribe made, what abbreviations he used, or any of the range of questions of provenance and ownership, also relevant to palaeographers, how books were catalogued, used and annotated by their readers. But his visual sense and love of script as a skill are always noticeable in his writings. This also meant that he was keenly aware of the craft of handwriting. He writes of the importance of 'ductus'.[21] It seems likely that Edward Johnston's *Handwriting* was one of the first books he read on script; it remained on his reading lists for students, and he refers to it often.[22] He maintained links with contemporary practitioners through the Society of Scribes and Illuminators, and his own handwriting was a variety of Italic, both legible and full of character.

The second paper re-examining Lyell lecture material addressed what I have called the fourth question, that of origins and the problem of whether there was continuity from Romano-British culture in Britain.[23] Julian had become fascinated by the obscure period of the fifth and sixth centuries and an earlier paper had already contained speculations on the extent to which literacy had survived, using the meagre evidence in Gildas and such other sources as exist.[24] His argument here is that the earliest Irish manuscripts are characterized by features which had been commonplace or standard in the Late Roman world of the fifth century, but which were modified or changed in Italy and the Mediterranean world in the sixth and seventh centuries. These

[21] 'Names of scripts', as in note 2.

[22] See also 'Irish element' (as in note 19), p. 102 n. 1: 'My analysis of scripts is based on Edward Johnston, *Formal Penmanship*, ed. Heather Child (London, 1971).'

[23] 'The oldest Irish manuscripts and their late antique background', *Irland und Europa*, ed. P. Ní Chatháin & M. Richter (Stuttgart, 1984), pp. 311–27.

[24] 'An historical introduction to the use of classical Latin authors in the British Isles from the fifth to the eleventh century', *Settimane di studio del Centro italiano di studi sull'alto medioevo*, **22** (Spoleto, 1975), 237–99.

included systems of quiring and ruling, and the method of preparing membrane, this last, another important topic on which he had written a paper, in 1972.[25] The logical deduction was that these practices existed in the British Isles before the Romans left, and that the succeeding isolation of Ireland allowed them to continue there unchanged. He also hypothesized that the cursive minuscule found in Anglo-Saxon manuscripts of the eighth century was not solely a development from Continental half-uncial of the fifth and sixth centuries, but also represented a continuity from the late Roman world. There must, he argued, have been earlier Irish examples which do not survive but whose existence can be inferred from the later eighth century examples. These must have been based in turn on Late Roman and sub-Roman scripts ranging up from 'scritture di base' and the less formal scripts used for correspondence and administration. From these early Irish examples the Anglo-Saxon scribes derived significant characteristics of their versions of the script. It should incidentally be noted that both papers stress the Irish contribution, since, as hinted earlier, Julian has been accused of a Northumbrian bias in his work. In connection with the problem of the origin of Insular minuscule Julian considered the Vatican manuscript of Paulinus of Nola particularly important. The last piece of work he was able to complete was the commentary for a facsimile of this, which has now appeared posthumously.[26]

It can be seen from even this rapid survey of his publications that Julian, despite his many other interests and the many other calls on his time, worked steadily along a particular path. His premature death is therefore even more tragic, because over nearly forty years concentrated work he had achieved a unique familiarity with the original material which was his primary evidence. The text of the Lyell lectures, which is handwritten, shows that he still had not completed the arrangement of this material and drawn his conclusions from it in a way which finally satisfied him. It is fortunate that in the two papers just discussed and in the Chambers lecture of 1978 there are valuable statements of some of his findings. However, his death cut short a project of great importance which in a sense only he could

[25] 'The distribution and significance of membrane prepared in the Insular manner', *La paléographie hebraïque médiévale*, Colloques internationaux du CNRS 547 (Paris, 1974), pp. 127–35.
[26] *Codex Palatinus Latinus 235, Paulinus Nolanus* with T. Mackay (Armarium Codicum Insignium, Turnhout, Brepols, 1989).

complete, even if some of those taught by him will have gained a knowledge of his way of working and his insights which, one hopes, will enable them to continue his work.

Palaeography is a difficult subject to teach and Julian's skill and the commitment which he communicated so successfully to his students have already been stressed. The effort which went into his teaching finds visible expression in the variety and number of detailed hand-outs which he used.[27] Though most of his published work was concerned with script of the early period, he gave lectures on, for example, 'Script in Italy 12th to 16th centuries' and on 'The handwriting of manuscripts in Middle English', and he often reviewed publications on later script and illumination.[28] As he writes in one of the reports that have been required at such frequent intervals lately from Universities by Government and the U.G.C.: 'For his ordinary teaching, the professor at King's needs to know Western European palaeography (documentary as well as literary), codicology, illumination, book production and the history of libraries at least from the Battle of Actium in 31 BC to the sack of Rome in AD 1527.' To outsiders it might seem that the subject was specialized, the students in consequence few, and the job not very onerous. In fact Julian did a great deal of direct teaching by lecture and class, and a great deal more by advice and correspondence. The same paper quantifies this as: 'Between fifty and sixty students, of whom about half are doing research for an M.Phil/Ph.D. and about half are M.A. students taking a paper in the subject, attend classes and lectures each year; the number of them coming from King's College itself seldom exceeds 15 per cent.' His class on Anglo-Saxon palaeography taught jointly with Dr Jane Roberts of the English Department of King's was a notable instance of successful collaboration. He also writes in a letter in December 1984: 'I have helped a lot of other people's students in a lot of different ways with expert advice on manuscript problems, both particular and general.' Letters to him (chosen at random from many) read: 'I hope that you will forgive me troubling you with this letter but I would be very grateful for any help you can offer on three associated palaeographic problems'; 'This is to ask if you would be kind enough to

[27] File copies of some of these are kept in the Palaeography Room, London University Library.

[28] For example 'French painting in the time of Jean de Berry: a review', *The Book Collector* (Winter 1969), 470–88 is a lengthy discussion of a purely art historical work by Millard Meiss. Note also that Julian translated J. Porcher, *French miniatures from illuminated manuscripts* (London, 1960).

provide an appropriate reference for my footnote citation.' A 'Hilfswissenschaft' indeed! Julian must often have felt that he spent more time on other people's scholarship than on his own, but he seldom showed he begrudged it.

His teaching of palaeography centred on the Palaeography Room in London University Library, which has become an international meeting place for all interested in script, illumination and the manuscript book. To the strengthening of this library which he described as 'an open-access reference library which is now possibly the best of its kind in the world', he devoted much time and energy, working closely with its scholarly librarian, Joan Gibbs. He also took a special interest in the Lambeth Palace Library on whose Committee he served from 1973 on, becoming Chairman and a Trustee in 1979. As his teaching hand-outs and the footnotes to his articles show he was both immensely learned and also up-to-date in his bibliographical knowledge.[29] He knew personally most of those working in the field of the manuscript book, and he took an active part in the work of the Comité international de paléographie. It was due to his initiative that the Comité met for the first and only time in London in 1984, and he undertook all the onerous administration of the conference at a time when he was already ill. It was very pleasant to see the respect and affection in which he was so obviously held by all those present, as well as his own equally obvious joy and enthusiasm on the occasion. These same responses were noticeable in the other colloquies and lectures which Julian organized, the informal classes on the history of the book held two or three times a term with invited speakers, usually graduate students with work in progress, or the more formal palaeography lectures held annually at King's College. These latter brought British and overseas scholars to London and were all part of the way in which Julian worked to make palaeography visible and respected throughout London University. The Manuscripts Committee of the Standing Committee of National and University Libraries was yet another body which has grown and prospered due in no small part to his commitment and hard work on its behalf.

The interests of his own subject as well as his own conscientious-

[29] He also contributed lengthy bibliographies under 'Palaeography', *New Cambridge Bibliography of English Literature* (Cambridge, 1974), cols. 209–20 and under 'Bibliography: palaeography, diplomatic and illumination', in *Anglo-Saxon England*, Vol. 1 (1972) onwards. His contribution with E. G. Stanley and R. Barbour to *Encyclopaedia Britannica*, 15th edn (1974), pp. 645–70, s.v. 'Calligraphy', should also be mentioned.

ness no doubt motivated Julian to play a part in administrative duties at King's College and as usual he gave unstintingly of his time and energy. He was Dean of the Faculty of Arts 1968–70 and served at different times on the General Purposes Committee, Advisory Committee on Staff, Delegacy and Finance Committee and the Accommodation Committee. His work on the King's Library Committee where he served from 1968 to 1975, being Chairman from 1969, was especially important. He was on Council from 1981. There were other University Committees, including Management Committees of the Institute of Classical Studies and the Warburg Institute and the Central Research Fund Advisory Committee 'A' of which he was Chairman from 1977–82. Another area in which he took a leading role was his support of the University archivists, through the Archives and Manuscripts Sub-Committee of the London Resources Co-ordinating Committee. When he decided after much heart searching to take early retirement in 1984, he continued to teach almost as extensively as before. His contribution to the life of the College was recalled at his Memorial Service held in the College Chapel.[30]

Julian was made a Fellow of King's College in 1975 and awarded a D. Litt. *honoris causa* by Durham University in December 1986. Other honours and appointments included Fellowship of the Society of Antiquaries, 1956, Membership of the Institute for Advanced Study, Princeton, 1966–7, Visiting Fellow, All Souls College, Oxford, 1976–7, and Fellowship of the British Academy, 1982. He was a Medieval Academy of America Visiting Professor of Palaeography at the University of Chicago in 1973 and Visiting Distinguished Professor in Medieval Studies at the University of California, Berkeley in 1976.

Julian's first marriage to Alison Dyson, now Alison Chorley, an academic scholar and teacher in the field of Italian Renaissance

[30] Address by the Very Revd Sydney Evans, 17 March 1987. Among obituaries (copies of most of which are kept in the Palaeography Room) mention should be made of those by Professor Sir Michael Howard, one of Julian's oldest friends, *Independent*, 28 January 1987, by Professor Andrew Watson, *The Times*, 24 January 1987, by Professor Janet Bately and Dr Jane Roberts, colleagues at King's, *Old English Newsletter*, xx/2 (Spring 1987), and by Patricia J. Methven, archivist at King's, in *Journal of the Society of Archivists*, ix/1 (1988), 59–60. Another memoir by Dr Jane Roberts will appear in *Medieval English Studies Newsletter* and in *Medieval English Studies: Past and Present*, 1990. A discussion of Julian's scholarly work with a moving tribute to him as teacher and friend, is by M. P. Brown, 'T. J. Brown, An Affectionate memoir', *Scrittura e civilta*, **12** (1988), 305–16. This also contains a partial bibliography. I am very grateful to Michelle Brown for allowing me to read this before publication and for other help.

history, was dissolved in 1979. They had two daughters, Charlotte and Rachel. He then married Sanchia Mary David, née Blair-Leighton. In concluding an account which has concentrated on his scholarly work I am aware that I have said little of Julian personally. It should be stressed, however, that he was a person who was not only trusted and respected, but was also held in great affection by all who knew him. His blue eyes and very engaging smile were welcoming and there was no pride or pomposity about him whatever. More than one of his students have said how much his encouragement and practical help meant at crucial moments to them. He moved round London on a bicycle which was certainly prompted by practicality, but was also typical of his informality. He was a committed member of CND and this was partly prompted by a sense of responsibility as a scholar to the preservation of the artifacts whose survival, none knew better, was so precarious. A side of his activity little known to his professional colleagues at least was his writing of poetry, and here some of his more personal convictions and concerns are revealed. A volume edited by Jenny Stratford and his daughter, Charlotte, and privately printed by Sebastian Carter at the Rampant Lion Press, appeared posthumously in 1988.[31] One of the poems was also printed in *Encounter*.[32]

JONATHAN J. G. ALEXANDER

[31] The manuscript of the poems is in the British Library, Additional 68902–3.

[32] In preparing this memoir I have had the benefit of consulting Janet Backhouse, Charlotte Brown, Michelle Brown, Sanchia Brown, Rupert Bruce-Mitford, Albinia de la Mare, Patrick Gardiner, Joan Gibbs, Michael Howard, Patrick McGurk, Jane Roberts, Jenny Stratford and David Wright, to all of whom I express my thanks.

APPENDIX

PRINTED BIBLIOGRAPHIES OF SCHOLARS WHOSE OBITUARIES ARE INCLUDED IN THE PRESENT VOLUME

I. Whitley Stokes: R.I. Best, 'Bibliography of the Publications of Whitley Stokes', *Zeitschrift für celtische Philologie* 8 (1911), 351–406

II. Walter William Skeat: W.W. Skeat, *A Student's Pastime* (Oxford, 1896), pp. lxxix–lxxxiv [to 1896 only]; for studies on English language, see Arthur G. Kennedy, *A Bibliography of Writings on the English Language from the Beginning of Printing to the End of 1922* (Cambridge, MA, 1927), p. 502 [170 items]; for studies of Old English in particular, see S.B. Greenfield and F.C. Robinson, *A Bibliography of Publications on Old English Literature to the End of 1972* (Toronto and Manchester, 1980), p. 423 [16 items]

III. Sir John Rhys: *PBA* 11 (1924–5), 198–212

IV. Henry Bradley: *The Collected Papers of Henry Bradley* (Oxford, 1928), pp. 261–79

V. Charles Plummer: *PBA* 15 (1929), 474–6

VI. Arthur Sampson Napier: N. [R.] Ker, 'A.S. Napier, 1853–1916', in *Philological Essays: Studies in Old and Middle English Literature in Honour of Herbert Dean Meritt*, ed. J.L. Rosier (The Hague, 1970), pp. 152–81, at 174–81

VII. Joseph Wright: no published bibliography; but see Elizabeth Mary Wright, *The Life of Joseph Wright*, 2 vols. (London, 1932), ii. 709

VIII. W.P. Ker: J.H.P. Pafford, *W.P. Ker, 1855–1923: a Bibliography* (London, 1950)

IX. Sir Israel Gollancz: no published bibliography

X. Sir William Craigie: *A Memoir and List of the Published Writings of Sir William A. Craigie* (Oxford, 1952)

XI. Hector Munro Chadwick: *A List of the Published Writings of Hector Munro Chadwick and of his Wife Nora Kershaw Chadwick presented to Nora Kershaw*

Chadwick on her Eightieth Birthday (Cambridge, 1971); cf. also *PBA* 33 (1947), 330

XII. Raymond Wilson Chambers: *PBA* 30 (1944), 440–5

XIII. Sir Allen Mawer: no published bibliography

XIV. Sir Frank Merry Stenton: *Preparatory to Anglo-Saxon England, being the Collected Papers of Frank Merry Stenton*, ed. D.M. Stenton (Oxford, 1970), pp. vii–xiv

XV. Sir Ifor Williams: A.E. Davies, 'Sir Ifor Williams: a Bibliography', *Studia Celtica* 4 (1969), 1–55

XVI. Robin Ernest William Flower: *PBA* 32 (1946), 375–9

XVII. Kenneth Sisam: *PBA* 58 (1972), 427–8

XVIII. Bruce Dickins: 'Bruce Dickins: a Biographical Note and List of Books and Papers', in *The Anglo-Saxons. Studies in some Aspects of their History and Culture presented to Bruce Dickins*, ed. P. Clemoes (London, 1959), pp. 316–22 [to 1959], to be supplemented by *PBA* 64 (1978), 356–7

XIX. Florence Elizabeth Harmer: no published bibliography; but the small corpus of her published writing is discussed item by item in the course of D. Whitelock's obituary, *PBA* 54 (1968), 301–14, with a list of her reviews at pp. 313–14

XX. Nora Kershaw Chadwick: *A List of the Published Writings of Hector Munro Chadwick and of his Wife Nora Kershaw Chadwick presented to Nora Kershaw Chadwick on her Eightieth Birthday* (Cambridge, 1971)

XXI. Thomas Downing Kendrick: no published bibliography

XXII. Dorothy Whitelock: *England before the Conquest. Studies in Primary Sources presented to Dorothy Whitelock*, ed. P. Clemoes and K. Hughes (Cambridge, 1971), pp. 1–4 [to 1971]

XXIII. Francis Wormald: *PBA* 61 (1975), 556–8

XXIV. Neil Ripley Ker: *Medieval Scribes, Manuscripts & Libraries. Essays presented to N.R. Ker*, ed. M.B. Parkes and A.G. Watson (London, 1978), pp. 371–9 [to 1978], to be supplemented by N.R. Ker, *Books, Collectors and Libraries: Studies in the Medieval Heritage*, ed. A.G. Watson (London and Ronceverte, WV, 1985), pp. xiii-xiv

XXV. Gabriel Turville-Petre: *Speculum Norroenum: Norse Studies in Memory of Gabriel Turville-Petre*, ed. U. Dronke *et al.* (Odense, 1981), pp. 506–8

XXVI. Kenneth Hurlstone Jackson: J.E. Caerwyn Williams, 'Kenneth Hurlstone Jackson', *Studia Celtica* 14–15 (1979–80), 1–11, at 5–11 [to 1977]; to be supplemented by *Studia Celtica* 26–27 (1991–2), 211–12

XXVII. Peter Hunter Blair: no published bibliography

XXVIII. Thomas Julian Brown: *A Palaeographer's View. The Selected Writings of Julian Brown*, ed. J. Bately, M.P. Brown and J. Roberts (London, 1993), pp. 293–5

INDEX

Abbo of Fleury 70, 71
Abbott, Edwin 155
Aberdeen, University of 177
Aberystwyth 53, 142, 231, 232, 242, 327
 National Library of Wales 232, 327, 449
Abingdon 261, 264
Ælfric 41, 42, 109, 114, 342, 474
Aitken, A.J. 177
Alcuin 13, 270, 527
Alderly Edge (Cheshire) 91, 92
Aldhelm 13, 23, 70
Alexander, Henry 109
Alexander, J.J.G. 465–6
Alfred, King 78, 81, 83, 370, 433–4, 437, 462
Allen, Thomas 476
Alma-Tadema, Sir Lawrence 412
Ampleforth 485
Aneirin 293, 295, 296, 302, 509
Anglo-Norman Text Society 183
Anglo-Saxon Chronicle 8, 45, 78, 81, 82, 102, 360, 372, 431, 488
antiquaries, English 24–5, 415, 417, 419–20
Antwerp 121, 476
Ardern, P.S. 333
Aristotle 141
Armitage, F. 99
Armour, A.E. 108
Arnold, Matthew 9, 53, 146, 147
Ashdown, Margaret 369
Assmann, Bruno 114
Athelney 196
Attenborough, F.L. 206
Aubrey, John 403
Auckland (NZ) 332, 333, 336
Austin, J.L. 539
Ayer, A.J. 539

Baldwin, Albert 277, 281
Baldwin Brown, G. 357
Bale, John 24
Balfour, Henry 401
Balfour, Lord 164
Baltimore, Johns Hopkins University 225
Bangor 10, 11, 52, 53, 232, 287, 504, 509
 Friars School 288
 University College of North Wales 288, 289, 293, 295, 299, 301
Bately, Janet 436
Batho, Edith 229
Battiscombe, C.F. 414
Bayeux Tapestry 281, 457, 462, 465

Beazley, Sir John 534
Beddington (Surrey) 503
Bede 13, 77, 360, 433, 434, 437, 528
 Historia ecclesiastica 8, 13, 14, 24, 78, 81, 82, 363, 525, 527
 Historia abbatum 82
 Epistola ad Ecgberhtum 82
Belfast 106, 417
Belfour, A.O. 105, 109
Bell, C.F. 109
Bell, Sir Harold Idris 312–13, 445, 446, 449, 450
Bennett, H.S. 428
Bennett, Joan 428
Benson, A.C. 352
Bentley, Richard 197
Beowulf 2, 6, 7, 41, 45, 71, 97, 102, 103, 104, 223–4, 225, 231, 233, 346, 347, 389, 430, 431, 524
Bergin, Osborn 507, 509
Berlin, University of 92, 93
Bersu, Gerhard 406
Besant, Sir Walter 37
Bethurum, Dorothy 113
Betjeman, John 408, 411
Bieler, Ludwig 545
Binchy, D.A. 513
Binyon, Laurence 162
Birch, W. de G. 17
Birley, Eric 521, 523
Birmingham 399
Bischoff, Bernhard 447, 474, 545
Bishop, Edmund 331, 332, 334, 335, 336, 338, 342, 347
Bishop, T.A.M. 16, 457
Blake, William 313, 453
Bloch, Marc 429
Blunt, C.E. 21, 281, 435
Bober, Harry 461
Boccaccio, Giovanni 156
Bollandists, Society of 80, 456
Bolton (Lancs.) 383
Bosworth, Joseph 4, 37, 40
Bradford 120, 121
 Bradford Grammar School 196
Bradley, A.C. 97, 141, 232
Bradley, Henry vii, 3, 12, 18, 44, 46, **65–73**, 97, 108, 109, 111, 112, 113, 116, 175, 179, 180, 188, 189, 241, 337, 338
Bradshaw, Henry 39, 46; *see also* Henry Bradshaw Society
Brailsford, John 414, 423
Bramley, H.R. 99

INDEX

Brett, Martin 436
Bridges, Robert 66, 72, 189, 342
Bridgewater, Bentley 416, 419, 423
British Academy vii, 2, 6, 7, 8, 14, 25, 33, 38, 47, 70, 95, 135, 155, 158–64, 168–9, 182, 216, 224, 228, 239–40, 266, 270, 272, 277, 282, 303, 324, 342, 358, 364, 380, 385, 436, 454, 481, 514, 529
British Museum *see* London
British Numismatic Society 21, 282
Brook, John 280
Brooke, C.N.L. 436
Brown, Carleton 337
Brown, Thomas Julian viii, 14, 16, 412, 416, 479, **533–51**
Bruce-Mitford, Rupert 19, 535, 536, 542
Brussels 85, 86, 474
Bryce, Lord 164, 180
Bryn Mawr 337
Brynmor-Jones, Sir David 58
Buchtal, Hugo 447, 461, 463
Burns, Robert 175, 184
Bywater, Ingram 92, 99, 160

Cady, F.W. 109
Caird, Edward 140
Cam, H.M. 376
Cambridge 5, 6, 16, 40, 106, 155, 156, 198, 272, 282, 351, 377, 380, 383, 391, 393, 427, 429, 482, 504, 510, 514
 Elrington and Bosworth Professorship of Anglo-Saxon 40, 41, 44, 46, 202, 205, 216, 354, 364, 369, 383, 432, 506
 English Tripos 44
 University Library 114, 355, 359, 362, 479
 Christ's College 6, 37–8, 45, 46, 155, 157
 Clare College 45, 197, 198, 199, 205–6, 216
 Corpus Christi College 335, 354–5, 363, 365, 461
 Emmanuel College 520, 521, 527
 Girton College 206, 369, 370, 377, 380, 385, 522
 Gonville and Caius College 237
 Jesus College 196
 King's College 363
 Magdalene College 352, 353, 364, 445, 456
 Newnham College 383, 384, 427, 428
 St John's College 195, 395, 503, 504, 509
 Trinity College 196, 225
 Fitzwilliam Museum 464, 465, 467
Cameron, Kenneth 18n, 361
Cannan, Charles 175, 179, 180, 337, 338, 341
Cardiff 53, 145
 University College 141
Carr, R.H. 105
Chadwick, Hector Munro 5, 7, 12, 18, 20, 22, 23, 44, 45, **195–218**, 352, 354, 355, 358, 369, 370, 373, 375, 383, 384, 385, 386, 387, 388, 389, 392, 393, 394, 395, 427, 428, 505, 509, 521
Chadwick, Nora Kershaw 6, 7, 9, 10, 12, 14, 208–9, 216, 369, 373, **383–95**, 428, 434, 507, 509
Chambers, Raymond Wilson 6, 7, 158, 201, **221–33**, 326, 342, 358, 460, 544
Charlesworth, M.P. 505, 508, 528
Charterhouse 400, 401
charters, Anglo-Saxon 2, 16–18, 22, 25, 280, 370–1, 374, 454
Chaucer, Geoffrey 40, 103, 104, 107, 115, 158
Cheney, C.R. 474, 475, 480
Chesterfield, Grammar School 65
Chicago 181, 325
 University of 175, 325, 550
 University of Chicago Press 177
Childe, V. Gordon 402, 403
Childs, W.M. 250, 251, 258, 259, 262
Clapham, Sir Alfred 273, 408, 413, 448, 460
Clark, Sir George 273–4
Clarke, Sir Ernest 222
Classen, E. 372
Clay, Sir Charles 271, 278, 469
Clemoes, Peter 434, 435, 436
Clynnog (Caernarvonshire) 288
Coatsworth, Elizabeth 544
Cockayne, Oswald 37
Cockerell, Sir Sydney 447, 448, 458
Coleridge, Herbert 39
Collins, A.J. 446, 449, 534
Collins, Churton 100
Cook, A.S. 356
Copenhagen 2, 174, 185
Corder, Philip 413
Cornford, F.M. 355
Coulton, G.G. 428
Cox, Sir Trenchard 469
Craig, Hardin 108
Craigie, Sir William 3, 4, 12, 69, 109, **173–91**, 337, 338, 342
Crawford, O.G.S. 276, 298, 402, 407, 415
Crawford, S.J. 105, 109, 336
Creswick, H.R. 359
Curry *see* O'Curry
Curzon, Lord 129, 168, 466
Cynewulf 5n, 6, 156, 345

Dafydd ap Gwilym 10, 290, 291
Dafydd Nanmor 291
Dalton, Ormonde 399
D'Alverny, Marie-Thérèse 447, 470
Danelaw 12, 18, 22, 251, 259, 261, 264, 265, 266, 267, 272, 430
Daniel, Glyn 395, 403

INDEX

Dante 141, 149, 151, 152, 231
 Oxford Dante Society 147
Darlington, R.R. 24
Davies, R. Humphrey 299
Davies, W.H. 315
Davis, H.W.C. 255, 258
Day, Mabel 165, 228
De Burgh, W.G. 250, 253, 262
De Clercq, P. 185
Delaissé, Bob 538
De la Mare, Albinia 477, 545
De la Mare, Walter 315
De Navarro, J.M. 393
De Vries, Jan 495
Denham-Young, N.N. 476
Denmark 184, 231, 341
Dewsbury (W. Yorks.) 441, 442
Dickins, Bruce 5n, 7, 12, 19, 20, 25, 216, 217, 276, **351–66**, 369, 375, 389, 395, 432
Dictionary of the Older Scottish Tongue 4, 176, 183, 184, 188
Dillon, Myles 511
Dix, Dom Gregory 465
Dodwell, C.R. 21, 461, 466
Dolley, R.H.M. 281, 282
Domesday Book 254, 255, 256, 259, 270, 271, 274, 276
Donaldson, Gordon 515
Doubleday, H.A. 254, 256
Douglas, D.C. 272
Downside Abbey 475
Dream of the Rood, The 41, 357
Drinkwater, John 315
Dronke, Ursula 486
Du Chaillu, Paul 198
Dublin 85, 135, 316, 422, 504, 509
 Trinity College 8, 30, 416
 University College 188
 Institute for Advanced Studies 302, 514
 see also Royal Irish Academy
Dugdale, Sir William 271
Dumbarton Oaks 408
Dumézil, Georges 495, 496
Dundas, R.H. 533, 539
Dundee 173, 174, 187, 190
Durham 239, 240, 414, 519
 University of 135, 216, 224, 243, 256, 385, 389, 422, 550
 relics of St Cuthbert at 414

Earle, John 78, 93, 100, 102
Early English Text Society (EETS) 3, 5, 39, 40, 42, 71, 108, 109, 113, 114, 156, 165–6, 223, 228, 319, 323–4, 326
East Dereham (Norfolk) 38
Ebel, Heinrich 31

Edinburgh 141, 145, 177, 182, 205, 528
 University of 353, 357, 364, 385, 503, 510, 511
Edwards, Sir Goronwy 279, 431, 452
Edwards, Sir Owen 61
Ekwall, Eilert 240, 241, 269, 341
Ellis, Robinson 67, 99
Emden, A.B. 478
English Dialect Dictionary 4, 43, 125–8, 129, 134, 135
English Dialect Society 4, 38, 43, 125, 126
English Place-Name Society 18–19, 44, 71, 182, 201, 239–41, 266, 268, 276, 356, 360–2, 376, 433, 435, 511
Erbe, Theodore 108–9
Erlingsson, Thorsteinn 185
Eton 444, 469, 473
Evans, A.J. 99
Evans, B.I. 141
Evans, Dame Joan 455
Evans, J. Gwenogvryn 289, 297
Everett, Dorothy 346
Exeter Book 71, 156–7, 224, 326

Farnell, L.R. 97, 99
Findlay, J.A. 308, 309
Firth, Sir Charles Harding 102, 252, 253, 254, 256, 258, 261, 263
Flower, Robin 9, 24, 25, 224, 228, 231, **307–28**, 342, 446, 507, 508
Förster, Max 224, 231, 326, 341, 512
folk-lore 7, 10, 32–3, 59, 85, 318, 508, 514
Forbes, M.D. 356
Forsdyke, Sir John 415, 416
Forster, E.M. 315
Foster, Canon Charles W. 266, 267, 268, 271, 275, 276
Foster, Gregory 222
Fox, Sir Cyril 20, 206, 217, 280–1, 356, 375, 413, 428
Francis, Sir Frank 416
Frazer, Sir James George 211
Frere, Walter Howard 443, 465
Fribourg (Switzerland) 199
Furnivall, Frederick James 3, 39, 46, 69, 71, 92, 95, 99, 101, 102, 113, 114, 155, 163n, 165, 166
Fyfe, Sir William Hamilton 177

Gaborit-Chopin, D. 466
Gaidoz, Henri 53, 59
Galbraith, V.H. 432
Gardner, Dame Helen 430
Garmonsway, G.N. 434
Gaselee, Sir Stephen 352

Gauthier, Marie-Madeleine 469
Gawain and the Green Knight 103, 104
Gell, Lyttleton 68
Geoffrey of Monmouth 403, 420
Gerould, G.H. 98, 108
Gillies, William 511
Gilson, Julius 445
Glasgow 139, 140, 177, 227, 509
 University Library of 474
Gneuss, Helmut 16
Godalming (Surrey) 38
Godley, A.D. 151
Gododdin 288–9, 294, 296, 302, 509
Goethe, J.W. von 143, 163n
Göttingen 2, 52, 92, 95
Gogynfeirdd 11, 290, 302
Goldsmith, Oliver 323
Gollancz, Sir Israel 6–7, 45, 46, 71, 109, **155–69**, 205, 222, 224, 266, 342, 360, 364
Gombrich, Sir Ernst 447
Gordon, E.V. 354
Gough, A.B. 105
Gover, J.E.B. 240
Gow, William 144
Grant, William 183
Granville Barker, Harley 167
Grattan, J.H.G. 228–9, 353
Gray, Basil 446
Great Blasket Island (Kerry) 507
Green, Mrs J.R. 317
Green, T.H. 140, 141
Greg, W.W. 167, 227
Grierson, Sir Herbert 232, 353
Grimm Brothers (Jacob and Wilhelm) 2, 7, 54, 122
 Grimm's Law 107
Grosjean, Paul 447, 458
Gudmundsson, Valtyr 185

Hales, G.T. 446
Hales, John Wesley 37–8, 107, 157
Hales, Sir Matthew 476
Hall, Hubert 450
Hallett, Monsignor Philip 226
Hamp, Eric P. 510
Hardie, Keir 443
Harmer, Florence 18, **369–80**, 433
Harrow 160, 444
Hartwell, C.L. 169
Harvard University 324, 408, 509, 510
Harvey, Sir Paul 341
Havelok 103, 337
Haverfield, F.J. 263
Hawkes, C.F.C. 20, 404, 405, 407
Hawkes, Jacquetta 404
Heidelberg 121, 122, 352
Heine, Heinrich 141

Hencken, Hugh 400–1, 407
Henley, W.E. 223
Henry Bradshaw Society 448, 457–8
Henry, Françoise 543
Herbert, J.A. 108
Herford, C.H. 107
Herkomer, Sir Hubert 308, 312
Hetherington, Sir Hector 177
Heworth (Co. Durham) 77
Hinks, Roger 446, 447
Historical Manuscripts Commission 262
Hitchcock, E.V. 226
Hoare, Samuel, Lord Templewood 253
Holthausen, Ferdinand 126
Hopkins, Gerard Manley 497
Horowitz, Bela 281
Housman, A.E. 221, 340, 505, 536
Howorth, Sir Henry 373
Huddersfield 442, 444
Hughes, Kathleen 385, 434, 435
Hulbert, J.R. 176
Hunt, Holman 156
Hunt, R.W. 447, 474, 476, 481
Hunter Blair, Peter 14, 23, 434, **518–29**

Iceland 11, 146, 147, 174, 177, 178, 181, 182, 184, 185, 186, 207, 405, 485, 486, 488, 498
 National Library of 188
Ilbert, Sir Courtenay 161, 164
India 8, 30, 32, 185
Innsbruck 198
Iolo Goch 291
Irish Folklore Commission 188
Irish Genealogical Society 323
Irish Texts Society 323

Jackson, Kenneth Hurlstone 9, 11, 205, 296n, **503–15**
Jackson, W.W. 99, 100
Jacobsthal, Paul 533, 534
James, M.R. viii, 15, 113, 444, 448, 458, 459, 463, 473, 476, 482
Japan 167–8, 185
Jebb, Sir Richard 160, 161
Jenkins, Claude 450
Jenkinson, Hilary 450
Jessopp, Augustus 92
John, Augustus 412
Johnson, Charles 261
Jones, Thomas 326
Jónsson, Finnur 185
Jope, E.M. 20
Jost, Karl 106, 113, 431
Jowett, Benjamin 174

INDEX

Jubainville, D'Arbois de 53, 86
Junius (Caedmon) Manuscript 164

Kane, George 229
Keatch, Daisy (Mrs Martin Clarke) 369
Keats, John 149
Kemble, John Mitchell 2, 5n, 16–17, 25, 30, 40–1, 200, 360, 364, 374
Kendrick, Sir Thomas 11, 19, 20, 21, 24, **399–424**, 446, 447, 460, 535
Kensington, Donald 114
Ker, Neil Ripley vii, 15–16, 24–5, 444, 447, 457, **473–82**, 536, 541, 546
Ker, William Paton 5, 7, 10, 12, 97, 99, 102, **139–52**, 221, 227, 230, 231, 232, 317, 318, 372
Kershaw, Nora *see* Chadwick, Nora Kershaw
Keynes, Simon 436
Kingsford, H.S. 278
King, Willie 446
Kitzinger, Ernst 408, 410, 414, 415, 423
Klaeber, Friedrich 224
Knowles, Dom David 24
Koehler, Wilhelm 447
Kuhn, Sherman 344, 345
Kurz, Otto 447

Lang, Andrew 175
Lawrence, W.W. 231
Laxdæla Saga 12, 487
Lea, E.M. (Mrs Joseph Wright) 104, 105, 111, 128–9, 135
Lee, Sir Sidney 167
Leeds 121, 307, 308, 354, 355, 427
　Leeds Grammar School 308, 309
　University of 135, 222, 228, 282, 353, 359, 428, 436, 485
　Brotherton Library 354
Leeds, E.T. 266
Lees, B.A. 272
Leicester 206
　University College of 206
Leiden 481
Leipzig 122
Leland, John 24, 360, 420
Leroquais, Victor 458
Lethbridge, T.C. 411
Lewis, C.S. 473
Lhuyd, Edward 54, 57
Liddell, J.R. 474
Lincoln Record Society 261, 266, 275
Lindisfarne Gospels 412, 413, 533, 534–5, 536, 537, 542
Lindsay, W.M. 15, 99, 100, 545, 546
Linguistic Survey of Scotland 511–12

Lisbon 420–1
Liuzza, R.M. 41
Liverpool 522
　University of 239, 317, 353
　Baines Professorship of the English Language 239, 353
Llandovery 255, 256, 257, 259, 260, 267, 277
Llandudno 400
Lloyd, Sir John Edward 10, 292
Llywarch Hen 293, 296, 301
Locke Ellis, Vivian 315
London 8, 30, 37, 67, 107, 145, 155, 156, 231, 248, 249, 267, 376, 473
　Bow 237
　Norwood 249
　Highgate School 37
　City of London School for Girls 369
　University of London 91, 142, 261, 266, 275, 282, 431
　King's College London 6, 16, 21, 45, 141, 156, 157, 163, 450, 456
　King's College School 37
　University College London 155, 157, 221, 225, 231, 232, 237, 242–3, 319, 323, 357, 450, 485, 497
　Quain Professorship of English 45, 141, 157, 222, 230, 232
　Institute of Historical Research 261, 279–80, 449, 452
　Warburg Institute 410, 447–8, 451, 461, 464, 467
　British Museum 9, 15, 21, 32, 68, 71, 114, 115, 221, 232, 265, 266, 312–13, 316–17, 319, 326–7, 335, 353, 399, 402, 413, 415–17, 418, 419, 444, 445–7, 449–50, 453, 455, 465, 479, 508, 534
　Victoria and Albert Museum 312, 414, 418, 453
　Society of Antiquaries of London 270, 304, 376, 385, 407, 413, 431, 448, 452, 454, 467, 550
Loomis, R.S. 107, 109
Lowe, E.A. 15, 335, 447, 450, 473, 475, 536, 537, 541, 544, 546
Loyd, Lewis C. 271, 278
Loyn, Henry 23, 405, 424
Lund 241, 269
　Kungliga Humanistika Vetenskapssamfundet 135, 216
Lyell, J.P.R. 477, 544

Maas, Paul 340
Mabillon, Dom Jean 340
Mabinogion 10, 53, 292–3, 509
MacAlister, J.Y. 221
Macaulay, G.C. 45, 205
MacCunn, John 139

Macdonald, A. 188
Macdonell, A.A. 100, 123
Mackinder, Halford 252
Maclagan, Sir Eric 312
Maclean, Magnus 187
MacNeill, Eoin 512
Madan, Falconer 101n
Magoun, F.P. 433
Mai, Angelo 71
Maitland, F.W. 111, 264, 435
Major, Kathleen 272, 430
Malone, Kemp 231
Manchester 4, 37, 65, 70, 91, 92, 95, 106, 196, 227
 Hulme 196
 Old Trafford 196
 Owens College 91
 University of 282, 364, 371–2, 377, 379
Mann, Sir James 413
Margate 121
Marett, R.R. 401–2, 404
Marstrander, C. 316, 317
Masai, François 542
Mawer, Sir Allen 11, 12, 18, 44, 46, 70, 71, 205, 224, **237–43**, 276, 342, 358
Meanwood (Yorks.) 307
Megaw, Eleanor 395
Meier, Hans 447
Meiss, Millard 447
Menner, Robert 347
Meredith, George 162
Meritt, H.D. 433
Meyer, Kuno 7, 67, 317, 319
Meyer, Paul 111
Middlesborough 119
Mildenhall (Suffolk), Roman treasure of 415
Millar, Eric 446, 448, 449, 454, 458, 459, 463, 465, 536, 538
Milne, Herbert 446
Milton, John 162, 227
Miner, Dorothy 447
Minns, Sir Ellis 445
Mitcham (Surrey) 369
Monkwearmouth-Jarrow 77, 82
Monro, D.B. 100
Moore, Edward 147
Moorman, F.W. 354
Morley, Henry 155, 157, 221, 232
More, Sir Thomas 225–7, 232, 233
Morris, Richard 46, 114, 156
Morris-Jones, John 288, 289, 290, 297, 301
Morshead, Sir Owen 445
Mossé, Fernand 376
Müller, Max 29, 58, 85, 92, 96, 100, 106, 123, 124, 129
Mullins, E.L.C. 280
Munro, General Sir Hector 195
Munro, J.J. 177, 186
Murray, Gilbert 189

Murray, Sir James 3, 12, 42, 46, 65, 67, 69, 95, 100, 108, 109, 111, 112, 115, 124, 175, 178, 188
Mütherich, Florentine 469
Mynors, Sir Roger 14, 444, 447, 473, 474, 481
Myres, J.N.L. 20, 282, 455

Nagel, D.H. 175
Namier, Sir Lewis 279, 280
Napier, Arthur Stanley vii, 5, 7, 15, 17, 72, **91–116**, 124, 132, 253, 334, 336, 338, 341, 346, 348, 356, 370
Neale, Sir John 279
Nettleship, Henry 67, 100
Nettleship, R.L. 99
New English Dictionary 3, 12, 18, 38, 42, 43, 65, 67, 68–70, 111–12, 115, 175–6, 178, 179, 180, 181, 182, 187, 333, 337, 338
New Zealand 331–3, 339, 342
Newcastle, Gosforth 519
 Armstrong College of 237, 256
 King's College 358
Nicol Smith, David 102
Njals Saga 12, 487, 494
Nordal, Sigurdr 487
Nordenfalk, Carl 447, 448, 543
Norway 95, 96, 150, 184, 231, 360, 522
Nottingham 253, 351
 University of 282
Nowell, Laurence 24, 325
numismatics 20–1, 277, 280, 281–2

Ó Crohan, Tomás 317
Ó Cuív, Brian 514
O'Curry, Eugene 7, 30, 31
O'Donovan, John 7, 30–1
Offa's Dyke 280–1
ogam inscriptions 58, 87
O'Grady, Standish Hayes 316, 320, 321, 322
Oldham 196
Oldham, J.B. 478
Ólsen, Björn Magnússon 487
Ó Murchú, Máirtin 512
Onions, Charles Talbut 3, 43, 481
Osler, Sir William 338
Ossian 313
Osthoff, Hermann 122, 123
Owen, L.V.D. 259
Oxford 5, 12, 67, 92, 94–5, 113, 123, 139, 145, 147, 181, 182, 260, 271, 282, 310–12, 401, 422, 429
 Boars Hill 342
 Headington Hill 110
 University of Oxford, administration of 129

INDEX

Final Honour School of English 98–9, 100–1, 103, 106
School of Modern Languages 98, 100, 106, 131–2
Oxford Chair of Poetry 146, 148
Rawlinson and Bosworth Professorship of Anglo-Saxon 40, 175, 181, 340
All Souls 141, 145, 147, 254, 255, 550
Balliol 139, 174
Christ Church 80, 252, 485, 533
Corpus Christi College 77, 544
Exeter College 69, 92
Jesus College 52, 53, 80, 112
Keble College 251, 252, 253, 259
Lady Margaret Hall 128
Magdalen College 70, 106, 473, 476, 481
Merton College 52, 92, 94, 96, 334, 346
Oriel College 100, 174, 175, 177, 181, 400, 401, 422
Pembroke College 308, 310, 312
St Hilda's College 429
St John's College 278
Bodleian Library 17, 20, 32, 108, 115, 221, 260, 264, 335, 341, 473, 475, 479, 481
Ashmolean Museum 412
Taylorian Institution 123, 132, 134, 175
Oxford University Press 68, 180, 339–41
Association for the Education of Women in Oxford (AEW) 101, 106, 111, 123, 128
Oxford Historical Society 78

Padel, Oliver 510
Pächt, Otto 447, 460, 463, 466
Page, Raymond 434
Page, William 254, 256, 260, 262, 269
Palmer, D.J. 98, 99, 102
Panofsky, Erwin 447, 451, 463
Parkes, M.B. 478
Parratt, Sir Walter 250
Parry, Thomas 10, 11, 291, 509
Patmore, Coventry 316, 319, 321
Paues, Miss A.C. 369, 371, 428
Pearl 104, 156
Pedersen, Holger 512
Peile, John 38
Penrith 533
Peterborough 273
Pfeiffer, Rudolf 340
Phillips, C.W. 408, 415
Phillpotts, Dame Bertha 206, 521
Philological Society 3, 18, 31, 38, 42, 69, 95, 169, 183, 185, 225, 376
Piers Plowman 39, 152, 223, 227, 228–9, 233
Piggott, Stuart 403, 407, 415, 419, 423
Pipe Roll Society 268
Piper, A.J. 479
Piper, John 408, 411

place-names 12, 18–19, 22, 66, 67, 70–1, 97, 238–42, 257, 258, 262, 298, 360, 370
Plato 140, 141, 173
Platt, Arthur 221
Plenderleith, Harold 414
Plucknett, Theodore F.T. 279
Plummer, Charles 8, 13, 24, **77–88**, 99, 113, 268, 373
Pokorny, Julius 317
Pollard, A.F. 261
Pollard, A.W. 109, 225, 227, 228
Pollock, Sir Frederick 111
Pontargothi (Carmarthenshire) 507
Poole, A.L. 274, 278
Poole, R.L. 99, 252, 253, 256, 257, 263, 264, 270, 278
Pope, J.C. 114
Porcher, Jean 447
Powell, F. York 68, 99, 100, 252, 488
Powicke, F.M. 480
Princeton, Institute for Advanced Study 451, 550
Prise, Sir John 24, 325, 476

Quiggin, E.C. 205
Quiller-Couch, Sir Arthur 205, 206

Raby, F.J.E. 14
Raleigh, Sir Walter 98, 102, 131
Rask, Rasmus 2, 54
Read, Sir Charles Hercules 412
Reading, 269, 430
 University of 250–1, 252, 253, 254, 258, 260, 261–3, 264, 265, 267, 269, 275, 276–8, 282, 283, 343, 481
Reany, P.H. 239
Reay, Lord 161
Reed, A.W. 226
Reykjavík 18, 189, 486
Rhyl 52
Rhŷs, Sir John 9–10, 29, **51–62**, 67, 83, 85, 100, 111, 174, 293, 324
Richards, I.A. 428
Richmond, Sir Ian 298, 455, 521, 523
Rickert, Margaret 447, 459
Ridgeway, Sir William 204
rímur, Icelandic 13, 185, 188, 499
Rímur Society (Rímnafjelag) 185–6
Ritchie, D.G. 99
Robert, Gruffudd 56
Roberts, Thomas 290, 291
Robinson, F.N. 510
Robinson, J. Armitage 24, 268, 371
Rochdale 195
Roosen-Runge, H. 535

Ross, A.S.C. 354, 357, 412, 535
Roumania 185
Round, J.H. 254, 255, 257, 264, 271
Rous, John 420
Royal Flemish Academy 135
Royal Historical Society 258, 261, 264, 269, 275, 326, 376, 431, 475, 529
Royal Irish Academy 31, 32, 80, 84, 316, 326, 514
Royal Society 160, 162
Royal Society of Literature 326
Rugby 91
runes 5n, 7, 12, 40, 356, 357
Ruthwell Cross 40, 356
Ryle, Gilbert 539

Saintsbury, George 232
Salt, Sir Titus 119
Sawyer, P.H. 17n
Saxl, Fritz 410, 447, 448, 458, 460
Saxo Grammaticus 496
Sayce, A.H. 67, 124
Sayers, Peig 9, 507, 508
scaldic verse 497–9
Schapiro, Meyer 447
Schnitzler, Hermann 463
Schofield, Bertram 534
Schonees, P.C. 186
Schulz, Fritz 340
Scilly Isles 338, 342–4
Scott, Sir Walter 188
Scottish Text Society 183, 230
Seafarer, The, 385, 431
Sedgefield, W.J. 371
Seebohm, Frederic 263
Selden, John 476
Selincourt, Ernest de 98, 102, 104
Sellar, W.Y. 141
Senior, Elizabeth 409–10, 414
Seward, S.S. 108
Shakespeare 157, 162, 166–7, 186, 227, 316, 323
Sheffield 65–6
 University of 237, 282
Sibly, Sir Franklin 276
Sidgwick, Arthur 99
Siegfried, R.T. 30, 31
Sievers, Eduard 93, 111, 112, 348
Sims-Williams, Patrick 508
Sipma, P. 185
Sisam, Celia 331, 338, 342, 343, 345
Sisam, Kenneth 6, 7, 15, 24, 42, 91n, 95, 96, 97, 104, 105, 108, 109, 110, 113, 115, 271n, 274, 283, **331–48**, 356, 430, 431, 474
Skallagrímsson, Egill 498, 499
Skeat, Theodore C. 446, 455

Skeat, Walter William vii, 3, 4, 7, 18, **37–47**, 70, 95, 97, 101, 107, 111, 114, 125, 134, 155, 158, 163n, 202, 205, 229, 241, 337, 369, 370, 506
Skene, W.F. 289
Sloane, Sir Hans 418
Smalley, Beryl 448
Smith, A.H. 239, 326
Smith, A.L. 140, 147
Smith, Reginald 399, 405, 406, 407, 414
Snow, T.C. 99
Society of Antiquaries *see* London
Society for Pure English 342
Southern, Sir Richard 474, 480
Southwell (Yorks.) 22, 247, 248, 249, 253, 254
Spenser, Edmund 158
Spinoza 148
St Andrews, University of 173, 175, 178, 182, 184, 216, 383
St Joseph, J.K.S. 20
Stanstead Bury (Herts.) 243
Stanwick (N. Yorks.) 414
Staxton (Yorks.) 221
Steer, Wilson 148
Stefánson, Jón 185
Stenton, Sir Frank Merry viii, 12, 17, 18, 20, 22–3, 24, 44, 70, 71, 201, **247–83**, 371, 373, 374, 376, 430, 431, 433, 435
Stevenson, W.H. 17, 97, 108, 113, 115, 200, 241, 252, 253, 256, 258, 370, 374, 432
Stewart, H.F. 205, 206
Stiassny, Edith 413
Stokes, Whitley viii, 7–8, 10, **29–33**, 53, 87, 99
Stone, Lawrence 408
Stratmann, F.H. 68
Streeter, B.H. 312
Strong, E.H. 108
Stubbs, William 92, 273
Stukeley, William 413
Sutton Hoo, ship burial at 19, 23, 213, 408, 413, 415
Swansea 232
Swarzenski, Hanns 461
Sweden 184, 269, 341, 521
 Swedish Academy of Letters 422
Sweet, Henry 92–4, 348
Switzerland 231, 336, 341, 379, 480
Sydenham 37
Sylloge of Coins of the British Isles 21, 277, 433, 435, 454

Tait, James 273
Taliesin 293, 295, 297, 302
Taylor, Isaac 66, 67
Taylor, Sir Robert 131
 see also Oxford, Taylorian Institution
Tenbury 77

INDEX

Tennyson, Alfred, Lord 156
Thackley (nr Bradford) 119, 129
Thomas, Dylan 497
Thompson, Sir Edward Maunde 15, 160, 161, 227
Thornhill (Yorks.) 195
Thorpe, Benjamin 2, 114
Thurneysen, Rudolf 7
Timmer, B.J. 347
Todd, James Henthorn 7
Tokyo 167–8
Tolkien, J.R.R. 336, 341, 354, 431
Toller, T.N. 4, 37
Tout, T.F. 268, 272, 372
Tozer, H.F. 92, 99
Traube, Ludwig 335, 459
Trautmann, Moritz 71
Tregarth 287, 288, 299
Tucker, Susie 433
Turville-Petre, Gabriel 13, **485–99**

Union Académique Internationale 454
Uppsala 241, 269, 428, 485
Ure, P.N. 263
Urmson, J.O. 539
Ushaw College 475

Vercelli Book 40–1
Verey, Christopher 544
Victoria History of the Counties of England (*VCH*) 254, 255, 256, 260, 261, 269, 452
Vigfússon, Gudbrandr 67, 174, 176, 488
Viking Society for Northern Research 354, 375, 376, 430, 433, 485
Vinaver, Eugene 341
Vinogradoff, Sir Paul 252, 253, 256, 259, 261, 263, 264, 266, 270, 272

Wainwright, F.T. 512
Wakefield 507
 Wakefield Grammar School 197
Wakefield, Sir Charles 163, 169
Wallace-Hadrill, J.M. 24
Walpole, Horace 323
Wanley, Humfrey 24, 335, 342, 344, 478, 541
Ward, Sir Adolphus 161
Warner, Sir George 316, 448, 458, 459
Warner, R.-D. 114
Warton, Thomas 146, 162
Watson, Andrew 479
Waugh, Evelyn 539
Webster, A.H. 197
Wedgwood, Josiah C., Lord 279
Weitzmann, Kurt 447

Welsford, Enid 383
Welsh Language Society 61
Werner, A.E.A. 535
Wernher, Sir Julius 132
Whatmough, Joshua 510
Wheatley, H.B. 165–6
Wheeler, Sir Mortimer vii, 411, 448
Whitelock, Dorothy 7, 17, 19, 23, 113, 119–202, 208, 275n, 277, 331, 343, 345, 347, 354, 395, **427–37**, 445
Widsith 6, 201, 223, 225
William the Conqueror 255, 436
William of Worcester 420
Williams, Sir Ifor 10, 11, **287–304**, 509
Williams, J.E. Caerwyn 11
Wilmart, André 342, 445, 465
Wilson, Sir David 416, 424
Wilson, Dover 167, 227
Wilson, F.P. 354
Wilson, R.M. 354, 356, 359
Winchester 268, 454, 462
Wind, Edgar 447
Windisch, Ernst 7, 29, 32
Winstedt, E.O. 536
Wittkower, Rudolf 447, 448
Worcester 262, 323
 Cathedral Library 475
Wordsworth, William 151
Wormald, Francis viii, 16, 21, 280, 281, **441–70**, 473, 535, 536, 540
Wrenn, C.L. 6, 181, 190, 431, 488, 489
Wrexham 121
Wright, C.E. 203, 209, 212, 461
Wright, David 535
Wright, Joseph 4, 43, 46, 95, 96, 101, 104, 108, 111, **119–35**, 181–2
Wulf and Eadwacer 71
Wulfstan (of York) 113, 347, 430, 437
Wülker, Richard 114
Wyatt, A.J. 45, 223
Wyld, H.C.K. 108

Yale University 324
York 259, 527
 archbishops of 247, 248
 University of 464
Young, Patrick 476

Zachrisson, R.E. 269
Zarnecki, George 410, 411
Zermatt 150, 151
Zeuss, Johann Kaspar 7, 11, 31
 Grammatica Celtica of 7, 11, 29, 30, 32
Zimmer, Heinrich 7, 58, 83
Zoëga, Geir T. 186
Zupitza, Julius 5, 92, 93, 96, 110, 115, 348

250